T0215760

THE ROUTLEDGE HANDBOOK OF REMIX STUDIES AND DIGITAL HUMANITIES

In this comprehensive and highly interdisciplinary companion, contributors reflect on remix across the broad spectrum of media and culture, with each chapter offering in-depth reflections on the relationship between remix studies and digital humanities.

The anthology is organized into sections that explore remix studies and digital humanities in relation to topics such as archives, artificial intelligence, cinema, epistemology, gaming, generative art, hacking, pedagogy, sound, and VR, among other subjects of study. Selected chapters focus on practice-based projects produced by artists, designers, remix studies scholars, and digital humanists. With this mix of practical and theoretical chapters, editors Navas, Gallagher, and burrough offer a tapestry of critical reflection on the contemporary cultural and political implications of remix studies and the digital humanities, functioning as an ideal reference manual to these evolving areas of study across the arts, humanities, and social sciences.

This book will be of particular interest to students and scholars of digital humanities, remix studies, media arts, information studies, interactive arts and technology, and digital media studies.

Eduardo Navas is Associate Research Professor of Art at The School of Visual Arts at The Pennsylvania State University, PA. He implements methodologies of cultural analytics and digital humanities to research the crossover of art and media in culture. His production includes art and media projects, critical texts, and curatorial projects. Navas is co-editor of *The Routledge Companion to Remix Studies* (2015), *Keywords in Remix Studies* (2018), and has published extensively on remix theory and practice. He is Research Faculty in the College of Arts and Architecture's Art & Design Research Incubator (ADRI).

Owen Gallagher is Programme Manager and Assistant Professor of Web Media at Bahrain Polytechnic, where he lectures in film, sound, animation, and game design. He is the author of *Reclaiming Critical Remix Video* (2018), and co-editor of *Keywords in Remix Studies* (2018) and *The Routledge Companion to Remix Studies* (2015) with Eduardo Navas and xtine burrough. He has published a number of book chapters, journal articles, and conference papers on remix culture, intellectual property, and visual semiotics, and is particularly concerned with the changing role of copyright in the networked era.

xtine burrough is Professor and Area Head of Design + Creative Practice in the School of Arts, Technology, and Emerging Communication at UT Dallas, and she is the Director of LabSynthE, a laboratory for creating synthetic, electronic poetry. She uses emerging technologies and remix as a strategy for engaging networked audiences in critical participation. She is the author of *Foundations of Digital Art and Design with Adobe Creative Cloud, 2nd Edition*, and co-editor of *The Routledge Companion to Remix Studies and Keywords in Remix Studies* with Eduardo Navas and Owen Gallagher.

THE ROUTLEDGE HANDBOOK OF REMIX STUDIES AND DIGITAL HUMANITIES

Edited by
Eduardo Navas, Owen Gallagher,
and xtine burrough

Routledge
Taylor & Francis Group

NEW YORK AND LONDON

First published 2021
by Routledge
52 Vanderbilt Avenue, New York, NY 10017

and by Routledge
2 Park Square, Milton Park, Abingdon, Oxon, OX14 4RN

Routledge is an imprint of the Taylor & Francis Group, an Informa business

© 2021 Taylor & Francis

The right of Eduardo Navas, Owen Gallagher, and xtine burrough to be identified as
the authors of the editorial material, and of the authors for their individual chapters,
has been asserted in accordance with Sections 77 and 78 of the Copyright, Designs and
Patents Act 1988.

All rights reserved. No part of this book may be reprinted or reproduced or utilized in
any form or by any electronic, mechanical, or other means, now known or hereafter
invented, including photocopying and recording, or in any information storage or
retrieval system, without permission in writing from the publishers.

Trademark notice: Product or corporate names may be trademarks or registered
trademarks, and are used only for identification and explanation without intent to
infringe.

Library of Congress Cataloging-in-Publication Data
Names: Navas, Eduardo, editor. | Gallagher, Owen, 1980- editor. | burrough,
xtine, editor.
Title: The Routledge handbook of remix studies and digital humanities /
edited by Eduardo Navas, Owen Gallagher, and xtine burrough.
Description: New York : Routledge, 2021. | Includes bibliographical
references and index.
Identifiers: LCCN 2020055919 (print) | LCCN 2020055920 (ebook) | ISBN
9780367361426 (hardback) | ISBN 9780429355875 (ebook)
Subjects: LCSH: Appropriation (Art) | Digital humanities. | Remix History
and criticism
Classification: LCC NX197 .R385 2021 (print) | LCC NX197 (ebook) | DDC
701/.1--dc23
LC record available at https://lccn.loc.gov/2020055919
LC ebook record available at https://lccn.loc.gov/2020055920

ISBN: 978-0-367-36142-6 (hbk)
ISBN: 978-0-367-69880-5 (pbk)
ISBN: 978-0-429-35587-5 (ebk)

Typeset in Goudy
by KnowledgeWorks Global Ltd.

CONTENTS

ACKNOWLEDGMENTS

This book could not be possible without the relevant and timely contributions by the distinguished scholars who accepted our invitation to participate. We thank them for their willingness to go through a long editing process, especially during unprecedented times of a global pandemic, global political instability, as well as ongoing climate change events. Their commitment to meet the deadlines to make this publication a reality makes more than evident their commitment to each of their respective fields of research. We also thank our editors at Routledge, Erica Wetter and Emma Sherriff, for supporting a book that brings together two areas of research that continue to be very much in development and overseeing this manuscript during all stages of editing, review, and production. We thank the editorial board at Routledge for finding potential in a third anthology on Remix Studies. We thank the remix community of activists, artists, designers, cultural producers, and scholars who continue to be engaged in very real, even life-changing, cultural challenges, and push against norms of creativity—always moving toward a fairer and more inclusive future.

—Eduardo Navas, Owen Gallagher, and xtine burrough

As has been the case for every major publication I have been fortunate enough to work on, I was able to complete this project thanks to the selfless support of colleagues, friends, and family. I must thank xtine and Owen for being amazing friends and collaborators. I hope we can keep working together in future projects. I thank my faculty colleagues in the School of Visual Arts at The Pennsylvania State University, who make me feel fortunate to be part of a thriving community, for which creativity is truly a way of life. I thank B. Stephen Carpenter II, Dean of The College of Arts and Architecture at The Pennsylvania State University, for his ongoing support in all aspects of my teaching and research. I thank William Doan, Director of the Arts & Design Research Incubator (ADRI), for supporting my ongoing research and for creating a strong interdisciplinary community that brings together the arts, humanities, and sciences. I also thank Mallika Bose, Associate Dean for Research in The College of Arts and Architecture and her assistant Barbara Cutler, for helping me in finding support for my ongoing research. I thank my family, especially my partner, Annie Mendoza, who encourages me to do all that I do. And I thank my two sons Oscar Eduardo and Oliver Antonio who continue to amaze me as they remind me, again and again, about what is ultimately important in life.

—Eduardo Navas

Working with my long-time friends and collaborators, Eduardo and xtine, on this, our third remix book together, has been a pleasure once again. We have all experienced challenging circumstances in 2020 and it is a testament to our working relationship that we have produced something that we can all be proud of. I look forward to our next

fruitful collaboration. I thank each and every one of our contributors for their creativity, hard work, and willingness to respond positively to our collective feedback in the pursuit of achieving the best possible outcome. I am grateful to my family—Brendan, Frances, Leona, Vincent, Emily, and Stephanie—for their unconditional love and support through difficult times. Thanks also to Brendan Muller and Paul O'Brien for their ongoing reassurance and counsel. Most importantly, I wish to express my thanks and gratitude to my partner Angela O'Brien and my daughters, Jennifer and Rebecca Gallagher, for always being there for me with words of encouragement, affirmation, and love.

—Owen Gallagher

It is always a pleasure to collaborate with my friends and peers, Eduardo Navas and Owen Gallagher, and this third book collaboration is a tribute to our sustained friendship and our growth as scholars. I hope we will continue to have opportunities to be grateful together. To my partner, Paul Martin Lester, our sons Parker and Martin, my parents Viola and Bill, and my dear friend Sam Martin: "thank you" barely captures the essence of my gratitude. Your support, encouragement, wisdom, and silliness sustained me in this project. I would also like to fondly acknowledge Dean Anne Balsamo and Associate Dean of Research and Creative Technologies, Dale MacDonald, at The University of Texas at Dallas—as well as my life-long mentors, Christopher James, Steven Kurtz, and Humberto Ramirez, for their ongoing support. My personal contribution to this book centers on projects I created with humanities scholars, Sabrina Starnaman and Dan Sutko. I am grateful to call you my friends and collaborators.

—xtine burrough

FIGURES

LIST OF FIGURES

TABLES

CONTRIBUTORS

Mark Amerika is Professor of Distinction at University of Colorado, where he is the Founding Director of the Doctoral Program in Intermedia Art, Writing, and Performance in the College of Media, Communication and Information and a Professor of Art and Art History. His artwork has been exhibited internationally at venues such as the Whitney Biennial of American Art, the Denver Art Museum, the Institute of Contemporary Arts in London, and the Walker Art Center. In 2010, The National Museum of Contemporary Art in Athens, Greece, hosted Amerika's comprehensive retrospective exhibition entitled UNREALTIME. In 2009, Amerika released *Immobilité*, generally considered the first feature-length art film ever shot on a mobile phone. He is the author of many books including *remixthebook* (University of Minnesota Press—remixthebook.com), *Remixing Persona: An Imaginary Digital Media Object from the Onto-tales of the Digital Afterlife* (with Laura Hyunjhee Kim) (Open Humanities Press), *remixthecontext* (Routledge), and *META/DATA: A Digital Poetics* (The MIT Press). His transmedia art work, *Museum of Glitch Aesthetics* [glitch-museum.com], was commissioned by the Abandon Normal Devices Festival in conjunction with the London 2012 Olympics. The project has been remixed for many solo exhibitions including "Glitch. Click. Thunk" at the University of Hawaii Art Galleries and "GlitchMix: not an error" at Estudio Figueroa-Vives and the Norwegian Embassy in Havana, Cuba.

Steve F. Anderson is Professor and Chair of the Department of Film, Television, and Digital Media at the UCLA School of Theater, Film and Television. He is the founder of the public media archive *Critical Commons* and cocreator of the electronic authoring platform *Scalar*. He is the author of *Technologies of History: Visual Media and the Eccentricity of the Past* (Dartmouth, 2011) and *Technologies of Vision: The War Between Data and Images* (MIT Press, 2017), and coeditor (with Christie Milliken) of the anthology, *Reclaiming Popular Documentary* (Indiana University Press, 2021).

Sarah Atkinson is Professor of Screen Media at King's College London and coeditor of *Convergence: The International Journal of Research into New Media Technologies*. Sarah has published widely on the impacts of digital technologies on film, cinema and media audiences, and screen production practices and industries. She has addressed her subject through analyses of narrative, text, process, industry, apparatus, and audience. Sarah also adopts practice-based methodologies through the creation of her own original works which include video essays, short films (including *Live Cinema—walking the tightrope between stage and screen* which was nominated for the Learning on Screen "Best Educational Film" Award 2020), an interactive cinema installation *Crossed Lines* which has been exhibited internationally and an interactive documentary

featurette—*The Anatomy of a Film*—included on both the Artificial Eye UK Blu-ray release and Lionsgate's USA DVD release of *Ginger & Rosa* (Sally Potter, 2012). Sarah coproduced *Hangmen Rehanged* in 2016—a showcase collaboration between the National Theatre, Omnibus Theatre Company, and Edible Cinema which staged the first-ever immersive cinema event to unite the forms and aesthetics of "event" cinema, "live" cinema, "sensory" cinema, and promenade theatre. Sarah has undertaken extensive work into the Live Cinema economy and has worked on numerous funded immersive media projects and mixed reality/virtual reality research initiatives. She has received funding from the Arts and Humanities Research Council and the Engineering and Physical Sciences Research Council in the United Kingdom, the Social Science and Humanities Research Council of Canada and Innovate UK.

David Beard is Professor of Rhetoric in the Department of English, Linguistics, and Writing Studies at the University of Minnesota Duluth. He has published in journals like the *International Journal of Listening*, *Archival Science*, *Philosophy and Rhetoric*, *Southern Journal of Communication*, and *Enculturation*, among other venues. With Heather Graves, he coedited *The Rhetoric of Oil* (Routledge). With John Heppen, he has published several articles and book chapters about professional wrestling. With Lisa Horton, he coedited an issue of the *Journal of Contemporary Rhetoric* on remix theory.

Christine Boone is Associate Professor of Music at the University of North Carolina Asheville. She received her B.M. in Vocal Performance at Indiana University and both her M.M. and Ph.D. in Music Theory at the University of Texas. Christine's research interests are centered around popular music. She has presented papers on the Beatles in both the United States and the United Kingdom. Her current research focuses on mashups, and her work on the subject has been published in several forums, including *Music Theory Online*. Christine, a soprano, is also an active performer in both choral ensembles and solo work. In addition, she has put her musical knowledge to work on National Public Radio's classical music game show, "Piano Puzzler."

Victoria Bradbury is an artist and researcher working with virtual reality, code, and physical computing. She is the coeditor of *Art Hack Practice: Critical Intersections of Art, Innovation and the Maker Movement* (Routledge, 2019) and co-taught "The Glass Electric: Glassblowing, Electroforming, Interactive Electronics" at Pilchuck Glass School, 2019. Victoria was a member of the British Council team for Hack the Space, Tate Modern (London, UK, 2014) and participated in the IMMERSION: Art and Technology workshops (Shanghai, China, 2012) and Digital Media Labs (Barrow, UK, 2014). Her artwork has been showcased on the Radiance Blog and at IEEE-GEM, xCoAx, Black Mountain College Museum + Arts Center Re-Happening, Harvestworks, Revolve Gallery, Albright Knox, and The New Britain Museum of American Art. She has published writing in *Neural Magazine* and the CITAR and *Media-N* journals. Victoria holds a Ph.D. with CRUMB at the University of Sunderland, UK and an MFA from Alfred University. She has been a member of the New Media Caucus Board since 2012 and is Assistant Professor of New Media at UNC Asheville. www.victoriabradbury.com.

Megen de Bruin-Molé (@MegenJM) is Lecturer in Digital Media Practice at Winchester School of Art, University of Southampton. She writes on historical fiction and the

heritage industry, popular monstrosity and adaptation, and remix culture. Her book *Gothic Remixed* (Bloomsbury, 2020) explores the boundaries and connections between contemporary remix and its related modes through the lens of monster studies. Megen is also an editor of the *Genealogy of the Posthuman*, an open-access initiative curated by the Critical Posthumanism Network (http://criticalposthumanism.net/genealogy/). Read more about Megen's work on her blog: frankenfiction.com.

Anne Burdick divides her time between Los Angeles and Sydney where she is a Research Professor and Founding Director of the Knowledge Design Lab at University of Technology Sydney (UTS). Her practice-based research mixes writing and design in diverse media through collaborations with authors and texts. Her most recent project, *Trina*, is a multimedia speculative design fiction created with author Janet Sarbanes. Anne was coauthor and designer of *Digital_Humanities* (MIT Press, 2013), together with Johanna Drucker, Peter Lunenfeld, Todd Presner, and Jeffrey Schnapp. Other award-winning collaborations include the *Writing Machines* book and web supplement (MIT Press, 2002) with N. Katherine Hayles and *phon:e:me*, a net.art work by Mark Amerika for Walker Art Center's Gallery 9. With Literary Scientists at the Austrian Academy of Sciences, she designed the experimental Fackel Wörterbuch series and the Austrian Academy Corpus. *Fackel Wörterbuch: Redensarten* (Austrian Academy of Sciences, 2000) was awarded the prestigious Leipzig Book Fair Prize for the "Most Beautiful Book in the World" in 2000. From 1995 to 2012, she was designer and design editor of *electronicbookreview.com*. Anne holds a B.F.A and M.F.A in graphic design from California Institute of the Arts and a Ph.D. in Design from Carnegie Mellon University. She maintains an affiliation with Art Center College of Design where she was the Professor and Chair of the award-winning Media Design Practices M.F.A from 2006 to 2018.

xtine burrough is an artist who uses emerging technologies and remix as a strategy for engaging networked audiences in critical participation. She is the author of *Foundations of Digital Art and Design with Adobe Creative Cloud, 2nd Edition*, and coeditor of *The Routledge Companion to Remix Studies* and *Keywords in Remix Studies* with Eduardo Navas and Owen Gallagher. burrough values the communicative power of art-making as a vehicle for exploring the boundaries between humans and the technologies they create, embody, and employ. Her projects yield multiple layers of participation and collaborative meaning-making. She archives her work and creative process in articles, chapters, and books. burrough has edited volumes and portfolio sections for other artists to write, reflect on, expose, and archive their practices. Professor and Area Head of Design + Creative Practice in the School of Arts, Technology, and Emerging Communication at UT Dallas, she is the Director of LabSynthE, a laboratory for creating synthetic and electronic poetry.

Vicki Callahan is Professor at the University of Southern California's School of Cinematic Arts in the Media Arts + Practice and Cinema and Media Studies Divisions. She is the author of *Zones of Anxiety: Movement, Musidora, and the Crime Serials of Louis Feuillade* (WSUP, 2005) and editor for the collection, *Reclaiming the Archive: Feminism and Film History* (WSUP, 2010). With Virginia Kuhn she coedited, *Future Texts: Subversive Performance and Feminist Bodies* (2016) and a special issue (11) of *The Cine-Files*: "The Video Essay: An Emergent Taxonomy of Cinematic Writing,"(2017). She published "Introduction to The Video Essay" (coauthor Virginia

Kuhn) and "Introduction to MEmorial with her video essay, *The Just War*," *The Ciné-Files*, 11 (2017). She was an NEH fellow for the inaugural workshop, "Scholarship in Sound and Image," on Videographic Criticism at Middlebury College, and in 2015, she was in residence at University College Cork, Ireland as a Fulbright Scholar with a focus on digital media praxis. She is working on a monograph of the silent film star, Mabel Normand, and with Sarah Atkinson, she is coauthoring, *Mixed Realities (MR): Gender, Precarity, and New Models of Work in the Convergence Economy*. Currently, she is working on a documentary film project, *The Lowcountry*, which has received South Carolina Humanities grants as well as support from the Yip Harburg and Sam and Regina Green Foundations.

Mark V. Campbell [aka DJ Grumps], founder at Northside Hip Hop Archive, is a DJ, Curator, and Assistant Professor of Music and Culture at the University of Toronto Scarborough. As a cofounder at the Bigger than Hip Hop Show at CHRY 105.5fm, Mark has DJed on and hosted the show from 1997 to 2015 and founded Northside Hip hop in 2010. As a scholar, Mark has published widely with essays appearing in the *Southern Journal of Canadian Studies*, *Critical Studies in Improvisation*, *Souls: A Critical Journal of Black Politics, Culture and Society*, and the *CLR Journal of Caribbean Ideas*. He is the coeditor of *We Still Here: Hip Hop North of the 49th Parallel* (2020) and author of *...Everything Remains Raw: Photographing Toronto's Hip-Hop Culture from Analogue to Digital* (2018).

Scott Haden Church, Ph.D., (University of Nebraska-Lincoln) is an Assistant Professor in the School of Communications at Brigham Young University in Provo, Utah, United States. His research primarily uses rhetorical, critical, and aesthetic methods for examining online culture and popular culture. His work on remix has been published in *The Routledge Companion to Remix Studies* (Routledge, 2015), the *Journal of Contemporary Rhetoric* (2017), and *Ancient Rhetorics & Digital Networks* (University of Alabama Press, 2018).

Daniel Clarkson Fisher is a Toronto-based writer and educator whose most recent work is the Chinese Jamaican Oral History Project (CJOHP.org), a digital storytelling initiative inspired by his partner Stephanie Lyn and her family. He holds a Master of Fine Arts in Documentary Media from Ryerson University and is currently a contract lecturer in that program. His work has appeared in H-Net: Humanities and Social Sciences Online, the *Oral History Review* Blog, PopMatters, *New Politics*, Alternet, *Bright Lights Film Journal*, Nonfics, the *Journal of Religion and Film*, and many other publications.

Maggie Clifford's research focuses on climate literacy and communication, interdisciplinary collaboration, and the intersections of art and science. She earned a Master's degree at the University of Florida in Forest Resources and Conservation and is a Ph.D. student in the School of Communication at American University in Washington, DC.

Michael Collins is Assistant Teaching Professor in the Penn State School of Visual Arts where he teaches courses in digital art and design. Collins has been designing and creating online learning technology for over a decade and is an advocate for the use

of open-source technology in online education. His most recent collaboration includes a project called OER Schema—a project that fosters free access to knowledge by helping open educational resources become interoperable. In his words, "this project is an exhilarating ontological romp through pedagogical metadata." Mr. Collins has produced a wide breadth of creative interests including interactive art exhibitions, web interfaces, concept design, 3D animations, and operates a furniture design studio. His most recent exhibition work centers around digital privacy, identity, and security. He coauthored the book chapter, *Artist Research as Praxis and Pedagogy*, published in *Teaching Artistic Research* (De Gruyter, 2020). Mr. Collins is also the lead faculty coordinator for the multi-college World Campus Digital Multimedia Design program and enjoys teaching art and design to students in a variety of subjects. He has been a long-time sub-committee volunteer for ACM SIGGRAPH, an organization whose mission is to nurture, champion, and connect researchers and practitioners of Computer Graphics and Interactive Techniques.

Nick Cope is a British academic and filmmaker who has worked in the higher education sector since 1995, in the United Kingdom and currently as Program Manager Digital Film and Video for RMIT University, Vietnam, following 8 years working in the creative and media industries. He has been a practicing film, video, and digital media artist since 1982 and completed his Ph.D. in October 2012. This locates a contemporary visual music practice within current and emerging critical and theoretical contexts and tracks back the history of this practice to initial screenings of work as part of the 1980s British Scratch Video art movement, and later collaborations with electronic music pioneers Cabaret Voltaire and others. He continues to screen older work and new, and presents papers at conferences, cinemas, concerts, galleries, and festivals; nationally and internationally. A personal website and archive is at www.nickcope-film.com.

Aidan Delaney received his Ph.D. in Digital Arts and Humanities from Trinity College, Dublin, in 2017. His research interests are in sound studies, film studies, and the philosophy of technology. His most recent project to promote listening and acoustic ecology can be found at www.audiophilia.org. Aidan has lectured on film sound, sound design, radio production, European cinema, film history, sound art, video art, and research methods in film practice. He has also led workshops, seminars, and master classes in sound editing, production sound recording, audio postproduction, MIDI composition, and multimedia programming. Aidan is an Avid Certified Instructor in Pro Tools and has worked in the entertainment industry since the 1990s as a live sound engineer. He is currently based in London and works in the Faculty of Arts and Creative Industries at Middlesex University.

Paul Dougherty is an EMMY winning editor with four works in the Permanent Collection of The Museum of Modern Art (MoMA). He holds a Master of Library Science and Certificate in Archives and Preservation of Cultural Material from Queens College, with electives from NYU's Moving Image Archiving and Preservation program. He is currently the Video Archivist for the International Rescue Committee. Dougherty's video work and work with artists started at Syracuse University's Synapse Visiting Artists Program, first as an undergraduate and then on staff. While working at Manhattan Cable's Public Access Department in the summer

in 1975, he became a founding member of Metropolis Video, who first videotaped the bands at CBGB's such as Blondie and Talking Heads in their earliest incarnations. In 1976, Dougherty started work at a broadcast television facility and began making remix work along with an early (noncommercial) music video for "Frankie Teardrop" by the duo Suicide that was acquired by MoMA. He has had one-man shows at the Institute of Contemporary Art in London and the Kitchen in NYC. Dougherty is a generalist who earned his EMMY for the first season of Pee-wee's Playhouse, has worked as an editor for each of the Network News divisions, and edited a series of video "magazines" for the Gagosian Gallery. His postproduction experience ranges from the earliest broadcast formats to the launching of Avid Technology in 1990. Dougherty delivered a lightning talk at the 2015 Personal Digital Archiving Conference and has conducted several presentations at the New York Foundation for the Arts in recent years.

Gavin Feller's research explores the cultural impact of emerging media technologies with a focus on power, community, and identity. His forthcoming book (University of Illinois Press) traces a cultural history of new media and religion in America through the lens of the Church of Jesus Christ of Latter-day Saints (LDS/Mormon). His latest research examines the technical and cultural ideologies guiding the creation of family-friendly media content—from content moderation to platform algorithms to copyright law. Gavin also has experience in video and audio production and has taught several media production courses. Gavin completed his Ph.D. at the University of Iowa in 2017 and worked as an Assistant Professor of Media Studies at Southern Utah University before joining Umeå University (Sweden) as a postdoctoral research fellow in 2019.

Giancarlo Frosio is Associate Professor at the Centre for International Intellectual Property Studies (CEIPI), University of Strasbourg, where he also serves as the codirector of the LL.M. in International and European Intellectual Property (IP) law and academic coordinator of the CEIPI Advanced Training in Artificial Intelligence and IP law. He is a qualified attorney with a doctoral degree (S.J.D.) in IP law from Duke Law School. Additionally, he holds an LL.M. from Duke Law School, an LL.M. in IT and Telecoms law from Strathclyde University, and a law degree from Università Cattolica of Milan. Giancarlo is also Non-Residential Fellow at the Center for Internet and Society at Stanford Law School. Previously—from 2013 to 2016—he was the Intermediary Liability Fellow with Stanford CIS. He is Lecturer of the LL.M. in IP law jointly organized by WIPO and the University of Turin, where he also served as the Deputy Director from 2010 to 2013, and affiliate faculty at the Harvard CopyrightX program, where he launched the Turin University Affiliated Course in 2013. He is Faculty Associate of the NEXA Research Center for Internet and Society in Turin. Previously, Giancarlo served as a postdoctoral researcher at KU Leuven Center for IT & IP (CiTiP), COMMUNIA Fellow at the NEXA Center, and CREATe Fellow at the University of Nottingham. His last book *Reconciling Copyright with Cumulative Creativity: The Third Paradigm* (Edward Elgar, 2018) builds on interdisciplinary research exploring the communal and collaborative nature of creativity from a historical perspective to make predictions about creativity's future policies. He is also the editor of *The Oxford Handbook of Intermediary Liability Online* published by Oxford University Press in May 2020.

Owen Gallagher is the author of *Reclaiming Critical Remix Video: The Role of Sampling in Transformative Works* (2018) and the coeditor of *Keywords in Remix Studies* (2018) and *The Routledge Companion to Remix Studies* (2015) with Eduardo Navas and xtine burrough. Owen received his Ph.D. in Visual Culture from the National College of Art and Design (NCAD), Dublin and is Programme Manager and Asst. Professor of Web Media at Bahrain Polytechnic, where he lectures in film, sound, animation, and game design. He is a designer, animator, filmmaker, and long-time musician, having gigged with multiple bands for the past three decades. Owen is the founder of TotalRecut. com and his remix work has been exhibited at various venues around the world. He is Senior Fellow of the Higher Education Academy (SFHEA) and has published a number of book chapters, journal articles, and conference papers on remix culture, intellectual property, and visual semiotics and is particularly concerned with the changing role of copyright in the networked era.

Lyndsay Michalik Gratch, Ph.D., is Assistant Teaching Professor of Communication and Rhetorical Studies at Syracuse University. Her research, teaching, and creative work plays at the intersections of performance studies, adaptation theory, remix praxis, physical/virtual embodiment, and notions of identity within digital spaces. Her book, *Adaptation Online: Creating Memes, Sweding Movies and Other Digital Performances* (Lexington, 2017), positions the creation and sharing of Internet video memes as communicative practices and performances of adaptation. She has published text, mixed media essays, video art, and video essays in *Text & Performance Quarterly, Theatre Annual, Women & Language Online, Departures in Critical Qualitative Research,* and *Liminalities: A Journal of Performance Studies.* Her short fiction has also been featured in *Electric Literature's* "The Outlet," *The Brooklyn Review,* and *Joyland Magazine.* Her multimedia performance work, theatrical directing, devising, playwriting, video design, and audio design, meanwhile, have been showcased in multiple venues throughout the United States and Canada.

Dejan Grba is an artist, researcher, and educator. He explores the creative, technical, and relational potentials of generative systems. He has exhibited and lectured in Asia, Australia, North and South America, and Europe, and his papers have been published in journals, conference proceedings, and books. Dejan is a Visiting Associate Professor at the School of Art Design and Media, Nanyang Technological University in Singapore. He is a Founding Chair of New Media department at the Faculty of Fine Arts in Belgrade, and a Cofounding Associate Professor with Digital Art Ph.D. Program at the Interdisciplinary Graduate Studies, University of the Arts in Belgrade. http://dejangrba.org.

David J. Gunkel is an award-winning educator, scholar, and author, specializing in the philosophy and ethics of emerging technology. He is the author of over 90 scholarly articles and book chapters and has published 12 internationally recognized books, including *Thinking Otherwise: Philosophy, Communication, Technology* (Purdue University Press, 2007), *The Machine Question: Critical Perspectives on AI, Robots, and Ethics* (MIT Press, 2012), *Heidegger and Media* (Polity, 2014), *Of Remixology: Ethics and Aesthetics After Remix* (MIT Press, 2016), *Robot Rights* (MIT Press, 2018), *Gaming the System: Deconstructing Video Games, Game Studies and Virtual Worlds* (Indiana University Press, 2018), and *An Introduction to Communication and Artificial Intelligence*

(Polity, 2020). He has lectured and delivered award-winning papers throughout North and South America and Europe and is the founding coeditor of the *International Journal of Žižek Studies* and the Indiana University Press book series *Digital Game Studies*. Dr. Gunkel currently holds the position of Distinguished Teaching Professor in the Department of Communication at Northern Illinois University. His teaching has been recognized with numerous awards, including NIU's Excellence in Undergraduate Teaching Award in 2006 and the Presidential Teaching Professorship in 2009.

Eran Hadas is a Tel Aviv-based digital poet and media artist. He has published eight books. Among his collaborative projects are a headset that generates poems from brainwaves, a documentarian robot that interviews people about the meaning of being human, and an artificial intelligence art curator. His most popular collaboration to date is a viral AI Eurovision song, to which he contributed the lyrics generator. Hadas was the 2017 Schusterman Artist-in-Residence at Caltech and he is the 2020 Artist-in-Residence at Weizmann Institute. His projects have been exhibited internationally in various contexts, such as science museums (Heinz Nixdorf, Paderborn), art museums (Tel Aviv Museum of Art), new media festivals (Ars-Electronica, Linz), and literature festivals (Tata Literature Live, Mumbai). He teaches in the Digital Media Program, Tel Aviv University, in the Game Design M.Des, Shenkar, and in College of the Literary Arts Jerusalem.

Marina Hassapopoulou is Assistant Professor in the Department of Cinema Studies, at Tisch School of the Arts, New York University (NYU). She is currently working on her upcoming book, *Interactive Cinema: The Ethics of Participation and Collectivity in the Era of (Dis)Connection*, and is involved in new interdisciplinary initiatives for Virtual/Augmented Reality and web-based projects for nonprofit arts organizations and independent artist groups. Working on a range of media besides print, her projects include cultural videos for folklore archives, multimedia scholarship, DIY no/low-budget media-making, as well as online open-access collaborative initiatives including The student-focused Interactive Media Archive (https://interactivemediaarchive.wordpress.com), the online directory focused on cross-pollinations between cinema, media studies, and digital humanities (https://transformationsconference.net), and the recently launched Weird Wave Archive that provides the first English language scholarly resource on Greek cinema (https://weirdwavearchive.wordpress.com).

Kate Anderson-Song is an artist, writer, and performer who holds a B.A. in Cinema Studies from New York University.

Pedro Cabello del Moral is a Ph.D. candidate in Latin American, Iberian, and Latino Studies at the City University of New York. He holds an M.A. in Cinema Studies from New York University and an M.A. in Spanish Cinema Studies from King Juan Carlos University. Pedro is the author of several documentaries on education, migration, historical memory, and the Francoist Spanish dictatorship. In 2019, he organized the first edition of Brooklyn College's Latin American Film Festival.

Cristina Cajulis holds an M.A. in Cinema Studies from New York University.

Donna Cameron is an internationally exhibited multimedia artist. She teaches at the Open Arts program at New York University's Tisch School of the Arts.

Kelsey Christensen holds an M.A. in Cinema Studies from New York University.

Eric Hahn is a doctoral candidate in the Visual Studies program at the University of California, Irvine and he holds an M.A. in Cinema Studies from NYU.

Da Ye Kim is a Ph.D. candidate in the Cinema Studies program at New York University. Her research interests include virtual reality, interactive media theories, film festival studies, urban media practices, and transnational studies.

Jasper Lauderdale is a doctoral candidate at Tisch School of the Arts, New York University, where he studies race, gender, sexuality, and temporality in radical speculative art. Jasper trained as a documentary filmmaker and editor at Appalshop in Whitesburg, Kentucky, and his work for such artists as Lydie Diakhaté, Manthia Diawara, Amie Siegel, and David Hammons has appeared at the 56th Venice Biennale, the 23rd New York African Film Festival at Lincoln Center, Dia:Chelsea, and Dak'art 2018. He has taught courses on film history, feminist media, cinematic bodies, and vampire culture at Brooklyn College, Hunter College, and NYU.

Hojong Lee holds an M.A. in Cinema Studies from New York University. Lee's recent projects center upon geographically demarcated soundscapes and their mediated depictions in films.

Soyoung Elizabeth Yun is an Undergraduate Presidential Honors Scholar in NYU Cinema Studies. Yun currently works at the Korean Film Council to promote Korean cinema on international academia and markets.

Lisa Horton grew up in northern Minnesota and attended her first year of university at Itasca Community College. She took her B.A. in English from Northwestern College (now the University of Northwestern, St. Paul). For 9 years, she worked in corporate America and freelanced in theatrical stage management, then moved to Duluth to get her M.A. degree from UMD. After several years working on her Ph.D. in Michigan, she returned to UMD to teach. Her interests include science fiction, detective fiction, theater, folk music, and historical reenactment. She got her first taste of tabletop role-playing gaming late but has been gaming since 2012—she has been an avid "Critter" since discovering the show (also late) in August 2019.

Karen Keifer-Boyd, Ph.D., Professor of Art Education and Women's, Gender, and Sexuality Studies at The Pennsylvania State University, coauthored several books: *Including Difference* (NAEA, 2013); *InCITE, InSIGHT, InSITE* (NAEA, 2008); *Engaging Visual Culture* (Davis, 2007); coedited *Real-World Readings in Art Education: Things Your Professors Never Told You* (Falmer, 2000); and has numerous journal publications. Her research on transdisciplinary creativity, feminist pedagogy, cyberart activism, transcultural dialog, action research, and eco-social justice art education has been translated and published in Austria, Brazil, China, Columbia, Finland, Oman, and S. Korea. She is a recipient of a National Art Education Foundation grant (2017–2018) for social justice art education and a National Science Foundation grant

(2010–2012) regarding gender barriers in technology. Cofounder and editor of the journal *Visual Culture & Gender*, she has received Fulbright Awards (2012 Distinguished Chair in Gender Studies at Alpen-Adria-Universität Klagenfurt, Austria; and Finland, 2006) and residencies (Austria, 2009; Uganda, 2010); and several National Art Education Association (NAEA) awards including the 2020 Eisner Lifetime Achievement Award, the 2018 Special Needs Lifetime Achievement Award, NAEA's 2015 Technology Outstanding Research Award, NAEA Women's Caucus 2014 McFee Award, the 2013 Edwin Ziegfeld Award, and is elected as an NAEA Distinguished Fellow (2013). She is a consultant to the Kennedy Center for the Performing Arts serving on the VSA Diversity, Equity, and Inclusion Committee; serves on the Art Education Research Institute Steering Committee, the Council for Policy Studies; and the NAEA Data Visualization research commission. She served on the NAEA's Equity, Diversity, and Inclusion Taskforce (2018–2019), as NAEA Women's Caucus President (2012–2014) and as coordinator of the NAEA Caucus on Social Theory in Art Education. Her lifetime work is based on her deep belief that visual art is integral to forming subjectivity, community, agency, and enacting social change.

Kelley Kreitz is an Associate Professor of English and an affiliate faculty member in the Latinx Studies program at Pace University in New York City. She is also the director of the university's digital humanities center, Babble Lab. Her research on print and digital cultures of the Americas has appeared in *American Literary History*, *American Periodicals*, *English Language Notes*, *Revista de Estudios Hispánicos* and the digital mapping project C19LatinoNYC.org. She serves on the board of the Recovering the US Hispanic Literary Heritage Project at the University of Houston. She is currently completing a book that recovers the leading role played by US-based Latin American writers in the media innovation of the 1880s and 1890s.

Virginia Kuhn is Professor of Cinema in the Division of Media Arts + Practice in the School of Cinematic Arts at the University of Southern California. Her work centers on visual rhetoric, remix culture, digital pedagogy, and algorithmic research methods. She has published several edited collections: One book-based *Future Texts: Subversive Performance and Feminist Bodies* (Parlor Press, 2016 with Vicki Callahan) and several peer-reviewed digital collections: *The Video Essay*: An Emergent Taxonomy of Cinematic Writing (*The Cine-Files*, 2016 with Vicki Callahan); *MoMLA*: From Panel to Gallery (*Kairos*, 2013 with Victor Vitanza) and *From Gallery to Webtext*: A Multimodal Anthology (*Kairos*, 2008, with Victor Vitanza); and *Speaking with Students: Profiles in Digital Pedagogy* (Kairos, 2010 with DJ Johnson and David Lopez). In 2005, Kuhn successfully defended one of the first *born-digital dissertations* in the United States, challenging archiving and copyright conventions. Committed to helping shape open-source tools for scholarship, she also published the first article created in the authoring platform, Scalar titled "*Filmic Texts and the Rise of the Fifth Estate*," (*IJLM*, 2010) and she serves on the editorial boards of several peer-reviewed digital and print-based journals. She received the USC Faculty Mentoring Graduate Students award in 2017 and was the 2009 recipient of the USC Provost's award for Teaching with Technology. Kuhn directs the undergraduate Honors in Multimedia Scholarship program, as well as the graduate certificate in Digital Media and Culture, and teaches a variety of graduate and undergraduate classes in new media, all of which marry theory and practice.

Christina Lane is Chair and Associate Professor of the Department of Cinematic Arts at the University of Miami. She is the author of the book, *Phantom Lady: Hollywood Producer Joan Harrison, The Forgotten Woman Behind Hitchcock* (Chicago Review Press, 2020). She has written *Feminist Hollywood: From Born in Flames to Point Break* (Wayne State UP, 2000) and *Magnolia* (Wiley-Blackwell, 2011), which is the first full-length study of the Paul Thomas Anderson film. Her work has appeared in *Cinema Journal, Feminist Media Histories*, the *Quarterly Review of Film and Video, Cine-Files*, and *Mississippi Quarterly*. She has essays in various edited collections, including *Indie Reframed: Women's Filmmaking and Contemporary American Independent Cinema; Hitchcock and Adaptation; Feminism Goes to the Movies: Understanding Gender in Contemporary Popular Cinema; Culture, Trauma, and Conflict: Cultural Studies Perspectives on War; Contemporary American Independent Film*; and *Authorship and Film*. She is President of the University Film and Video Association and has provided commentary to such outlets as *Air Mail, Turner Classic Movies*, and the *Daily Mail*.

Alessandro Ludovico is a researcher, artist, and chief editor of *Neural* magazine since 1993. He received his Ph.D. in English and Media from Anglia Ruskin University in Cambridge (United Kingdom). He is Associate Professor at the Winchester School of Art, University of Southampton. He has published and edited several books and has lectured worldwide. He also served as an advisor for the Documenta 12's Magazine Project. He is one of the authors of the award-winning Hacking Monopolism trilogy of artworks (Google Will Eat Itself, Amazon Noir, Face to Facebook).

Ian McArthur is Associate Professor of Design at UNSW Art & Design in Sydney and a hybrid practitioner working in the domains of experimental interdisciplinary practice, transcultural collaboration, sound art, experimental radio, Metadesign, and education change. He is currently working on an experimental study using screen-based urban media installations to examine the contribution of Australian innovation and participatory design to the development of urban design and placemaking in Chongqing, one of China's largest and fastest growing cities. The research tests the theoretical assumption that participatory urban media (large and small interactive screens, façades, and devices) can act as a codesigned interface between diverse community, industry, and government stakeholders in the urban environment. It will assess how screen-based interactive media installations can build engagement and dialog between citizens and other city stakeholders about the places in which they live, work, and play. By doing so, it explores the effectiveness of media interfaces in helping government and urban planners better understand and design more liveable urban environments. Ian's practice as creative producer and sound artist involves utilizing granular and generative synthesis, mobile technologies, and open source platforms in exhibitions and telematic, non-idiomatic improvised performances. He has also produced experimental sonifications for responsive interactive media environments used in a series of public art installations and exhibitions in Australia and China.

Eduardo de Moura, Ph.D., is Visiting Professor at the University of São Paulo (USP), where he develops postdoctoral research at the Applied Linguistics Department, under Dr. Walkyria Monte Mor's supervision. His research refers to methods and analysis procedures grounded in a cross-disciplinary approach implemented in remix studies and digital humanities, seeking to provide directions for constructing parameters

centered on rethinking and expanding digital and new literacies. Eduardo de Moura also works writing schoolbooks and with teachers training as Educational Consultant for Portuguese, Literature, Arts, Technologies, and New Media classes. He has developed a Ph.D. thesis on New Literacies and Remix Studies under the supervision of Professor Roxane Rojo at the State University of Campinas, São Paulo (UNICAMP). With the assistance of the São Paulo Research Foundation (FAPESP), Eduardo de Moura had the opportunity to improve his research under the supervision of Professor Eduardo Navas, Ph.D., at The Pennsylvania State University, School of Visual Arts—Arts & Design Research Incubator (ADRI).

Eduardo Navas implements methodologies of cultural analytics and digital humanities to research the crossover of art and media in culture. His production includes art and media projects, critical texts, and curatorial projects. He is the author of *Remix Theory: The Aesthetics of Sampling* (Springer, 2012), *Spate: A Navigational Theory of Networks* (INC, 2016), as well as *Art Media Design and Postproduction: Open Guidelines on Appropriation and Remix* (Routledge, 2018). He is coeditor of *The Routledge Companion to Remix Studies* (Routledge, 2015) and *Keywords in Remix Studies* (Routledge, 2018). Navas currently researches and teaches principles of cultural analytics and digital humanities in The School of Visual Arts at The Pennsylvania State University, PA. He is Research Faculty in the College of Arts and Architecture's Art & Design Research Incubator (ADRI). He is an affiliated researcher at the Cultural Analytics Lab, Cuny (2010–present). Navas received his Ph.D. from the Program of Art History, Theory, and Criticism at the University of California in San Diego, his MFA from The California Institute of the Arts, and his BFA from Otis College of Art and Design.

Ethan Plaut is Lecturer in Communication specializing in computational media at The University of Auckland's School of Social Sciences Te Pokapū Pūtaiao Pāpori in Aotearoa New Zealand. He previously held postdoctoral fellowships in both Computer Science and Rhetoric at Stanford University, where he was also a Rebele First Amendment Fellow and completed his doctoral work focused on digital disconnection, silence, and communication avoidance. He is an award-winning journalist, including three years at an independent, bilingual newspaper in Cambodia, and continues publishing in both scholarly and popular presses as well as producing media projects through collaborations in and out of academia. He holds three degrees from Stanford University (MS Computer Science, M.A. and Ph.D. Communication Research) and two from Northwestern University (ad hoc B.A. formal systems and the arts, MSJ new media journalism from the Medill School). He has written for many publications including *Public Opinion Quarterly*; *Communication, Culture, and Critique*; *First Monday*; and newspapers such as the *Washington Post* and *Boston Globe*. His creative work and representations thereof have appeared in gallery and museum exhibitions, public installations, books, commercial artwork, CDs, DVDs, television, and a range of live performances and online projects. He is currently working on intercultural and decolonial pedagogies for technology ethics, a philosophico-historical account of technical illiteracies, and an interactive digital exhibition for the Auckland War Memorial Museum.

Adrian Renzo is Lecturer in Music at Macquarie University in Sydney, Australia. His research includes work on medley records, musical taste, DIY and automated audio

mastering systems, and mashup production. His work has appeared in journals such as *Musicology Australia, Popular Music and Society,* and the *International Review of the Aesthetics and Sociology of Music.*

Nicole Richter, Ph.D., is a Professor of Media Studies at Wright State University, where she is the head of the Tom Hanks Center for Motion Pictures and teaches courses in philosophy and film, cinema and sexuality, animation, feminist film theory, and film history. She is the author of *The Moving Image: A Complete Introduction to Film* (Cognella, 2018) and has published numerous book chapters and articles in *The Journal of Bisexuality, Queer Love in Film and Television* and *Short Film Studies,* among others. Dr. Richter earned her doctoral degree in communications with an emphasis in film studies from the University of Miami. She is the founder of KinoFemme and KinoQueer, respectively, women's filmmaking, and queer filmmaking collectives. She formerly served on the editorial board for Short Film Studies and as the president of FilmDayton.

Fernanda R. Rosa is Postdoctoral Fellow at the Center for Advanced Research in Global Communication at the Annenberg School for Communication, University of Pennsylvania. She has a Ph.D. in Communication from American University, in Washington, DC. Her research focuses on Internet governance, values, and design, and has received awards and recognition from the Association of Internet Researchers (AoIR), the Research Conference on Communications, information and Internet Policy (TPRC), and Columbia University. She is the coauthor of *Mobile Learning in Brazil* (Zinnerama, 2015).

Aram Sinnreich is Professor and Chair of the *Communication Studies* division at American University's School of Communication. Sinnreich's work focuses on the intersection of culture, law, and technology, with an emphasis on subjects such as emerging media and music. He is the author of three books: *Mashed Up* (2010), *The Piracy Crusade* (2013), and *The Essential Guide to Intellectual Property* (2019). He has also written for publications including The New York Times, Billboard, Wired, The Daily Beast, and The Conversation. Prior to coming to AU, Sinnreich served as Associate Professor at Rutgers University's School of Communication and Information, Director at media innovation lab OMD Ignition Factory, Managing Partner of media/ tech consultancy Radar Research, Visiting Professor at NYU Steinhardt, and Senior Analyst at Jupiter Research. He is also a bassist and composer and has played with groups and artists including progressive soul collective Brave New Girl, dub-and-bass band Dubistry, punk chanteuse Vivien Goldman, and Ari-Up, lead singer of the Slits. Sinnreich was a finalist in the 2014 John Lennon Songwriting Contest and a semi-finalist for the 2020 Bernard/Ebb songwriting award.

Seth M. Walker is a doctoral candidate at the University of Denver studying popular culture, religion, and new media, with a particular focus on remix theory and subversive practices. He regularly writes on topics in these areas, which has included several chapter volumes in the popular culture and philosophy series from Open Court and Blackwell. His dissertation revolves around the development and application of a conceptual metaphorical remix model for studying religious traditions, especially concerning notions of originality, authority, and authenticity. Seth's work, research, and blog can be found at sethmwalker.com.

Paul Watkins is a Professor of English at Vancouver Island University (VIU). He is also a research team member with the International Institute for Critical Studies in Improvisation (IICSI). With Dr. Rebecca Caines, he coedited a special issue of *Critical Studies in Improvisation* focused on Improvisation and Hip Hop. At VIU, he is the Artistic Director of the "Writers on Campus" (Nanaimo) series. He has published widely on multiculturalism, hip hop, Canadian poetry, jazz, DJ culture, and improvisation. Under his DJ alias, DJ Techné, he has completed three DJ projects (https://djtechne.bandcamp.com) that explore the spaces between improvisation, poetry, hip hop, and jazz. He is currently working on a book manuscript that explores sound and music in Black Canadian poetry. www.pauldbwatkins.com.

Joycelyn Wilson is an ethnographic and cultural studies scholar whose research focuses on African American expressive traditions, Hip Hop Culture, digital humanities, and social justice STEM education. She received her B.A. and Ph.D. from the University of Georgia, a Master's from Pepperdine University, and was the 2011–2012 Hip hop Archive Fellow at the W.E.B. Du Bois Institute at Harvard University. Wilson joined Georgia Tech in 2017 as an Assistant Professor in the School of Literature, Media, and Communication.

INTRODUCTION

Eduardo Navas, Owen Gallagher, and xtine burrough

The Routledge Handbook of Remix Studies and Digital Humanities offers a tapestry of critical reflections on practice-based and pedagogical methods relevant in contemporary culture and scholarship. The anthology explores Remix Studies (RS) and Digital Humanities (DH) in relation to multiple subjects, such as archives, Artificial Intelligence (AI), cinema, epistemology, gaming, generative art, hacking, pedagogy, sound, Virtual Reality (VR), and others. Contributors include artists, designers, remix studies scholars, communication scholars, and digital humanists. The *Handbook* is designed to function as a reference manual for research, an introductory resource, and a teaching tool for studies in the arts, humanities, and social sciences. *The Routledge Handbook of Remix Studies and Digital Humanities* expands upon the themes initially discussed in *The Routledge Companion to Remix Studies* (Routledge, 2015) and *Keywords in Remix Studies* (Routledge, 2018).

This *Handbook* is a mashup of the digital humanities and remix studies—two fields of research that function within larger disciplines of cultural investigation. Digital humanities, as its name implies, is part of the larger field of the humanities, while remix studies is a more elusive field. Remix studies has no defined affiliation but has clear roots in art and music. With the emergence of computing in these fields, RS has expanded among emerging practices across media and culture. In time, it has evolved as a relevant framework between disciplines. The critical position of *The Routledge Handbook of Remix Studies and Digital Humanities*, similar to our previous publications, is informed by various schools of thought. Our major points of reference include the visual arts, art history, literary studies, new/digital media, media studies, copyright law, and their relation to the digital humanities.

Remix studies branches out of remix culture, an international movement that began during the late 1990s, informed by open source and Do-It-Yourself (DIY) activities practiced across the Internet. Lawrence Lessig, a copyright lawyer who founded Creative Commons in 2001, can be considered in large part responsible for popularizing the term "remix culture."[1] Remix culture is defined by its practice: the act of using preexisting materials to create something new as desired by any creator—from amateurs to professionals. As an activity, remix in music derives from experimentations with roots in Jamaican Dub, which evolved with hip hop and disco DJs during the 1970s, in New York City. Remixing music became a major creative process for Electronic Dance Music (EDM), gaining much global attention with raves in major cities. As is common knowledge at this point, the act of remixing has led to major legal conflicts between the

private sector, growing social media communities, and participatory cultures on the Internet. Remix studies emerged in the mid-to-late 2000s and became more established after the 2010s as a field of research due to the need to evaluate and understand how creativity functions with the appropriation, recycling, and transformation of content in all forms of communication.[2]

Remix studies has developed into a complex field, often evaluated in relation to other contemporary fields of research. It holds a direct link to the digital humanities due to its use and implementation of quantitative data analysis and qualitative assessments. These shared methods and subjects of inquiry have resulted in a crossover between the fields. This is why we consider this book, which puts the two subjects in conversation, to be a strong contribution to both fields of research. For instance, many researchers who attend conferences and write about remix culture implement digital humanities methods and principles in their assessment of the material they study. Digital humanists, in turn, often focus on subjects that are directly relevant in remix studies. Some common subjects of research include appropriation in art and literature, film and TV remakes, video games, comic books, and video essays, among others; many of which are discussed in the chapters that comprise this volume.

Digital humanities is a broad term used to describe an array of convergent practices for producing, utilizing, and understanding digital information and communication technologies in working with humanities-related content. Since the turn of the century, many leading education institutions in the United States have realized the importance of new media and digital technologies in the practices of teaching, learning, and research. As early as 2001, the Stanford Humanities Laboratory was established to focus on this evolving area, followed closely by other University initiatives such as Duke's John Hope Franklin Humanities Institute and the HASTAC Consortium, the University of Virginia's Institute for Advanced Technology in the Humanities, UCLA's multiple Digital Humanities projects and programs and MIT's innovative Hyperstudio lab.[3]

Digital humanities scholarship is characterized by its interdisciplinary nature, cutting across traditional fields in the humanities and bringing the technological tools and methods of other disciplines to bear on the analysis of society and culture. The nature of digital humanities research is collaborative, networked, and global. Scholars in these areas are socially-engaged and well positioned to address the issues of the emerging networked societies, of which we are all now potential citizens.

Digital humanities is a quickly evolving area and has already passed through at least two significant iterations.[4] The first wave was focused on quantitative research methods, concerned primarily with the use of digital technologies to enhance the study of traditional humanities disciplines, for example: the digitization of material artifacts, digital archiving, search and retrieval technologies, automation and statistical cultural analytics.

The second wave of digital humanities, however, centered on qualitative research methods and was more interpretive, experiential, emotive, and generative in nature, focusing on issues of complexity, medium specificity, analytical depth, historical context, and critique. Both waves now exist concurrently and feed one another, drawing upon complementary strengths, respecting and building on the work done by both science and humanities-based researchers toward a common goal, thus enhancing and reinforcing the overall effectiveness of the field and the research outputs it yields.

Remix studies has interests in both strands of digital humanities, as outlined above. For example, the production and analysis of software mashups and their outputs would

be part of the first wave, while the aesthetic analysis of remixed music and videos would clearly be a consideration made in the second wave. *The Routledge Handbook of Remix Studies and Digital Humanities* brings these areas together and updates them to explore questions relevant to increasingly globally connected societies.

The idea for *The Routledge Handbook of Remix Studies and Digital Humanities* occurred to us, as editors, after we published *The Routledge Companion to Remix Studies* and *Keywords in Remix Studies*. As a third anthology, it contributes to the construction of a foundation for remix studies as an interdisciplinary and international field of research. We consider the *Companion* to set the stage for remix studies as a field, bringing together scholars from the arts, humanities, and social sciences. In turn, *Keywords* expands on themes in the *Companion* to establish a vocabulary specific to RS. This *Handbook*, like the *Companion*, includes interdisciplinary scholars. It emphasizes a comparative approach in its format and functions as a referential publication that puts the digital humanities and remix studies in direct conversation, marking this time in their development.

The cultural and political context in which this handbook was edited and published was unprecedented. When we wrote the proposal in late 2018, it was impossible to foresee the fact that the entire world would be experiencing the global pandemic of COVID-19 in 2020, and that an ongoing series of protests for social and racial justice spearheaded by the Black Lives Matter movement would be taking place not only in the United States but around the world—and all of this while simultaneously experiencing extreme weather changes due to climate change and global warming. As a result, many of the chapters forming part of this anthology include direct or indirect critical reflections on the cultural and political context in which this volume was produced. With rapid increases in technological innovation, the unravelling of cultural events across the world has also sped up, and as a result, the reality in which this volume is to be published is likely to be different from the one in which it was conceived and written, and quite different from the ones in which it will be read in the future.

It follows to consider the fact that we no longer wait for history to come to us with the passage of time, but we now experience history fully aware of its instant documentation in real-time with live-streaming and on-demand technology. Similarly to how a replay is immediately available in sports events for viewers to analyze, the global culture in which this anthology was edited produced headlines that already read as major historical moments, which continuously shaped and reshaped the chapters by our contributors as each of them went through multiple revisions. The political upheavals in response to Donald Trump's leadership, and the national and international protests for racial justice after the deaths of George Floyd, Breanna Taylor, Ahmaud Arbery, and Jacob Blake,[5] which were preceded by several deaths of African Americans across the United States in previous years, add up to an unstable reality in which, as the late John Lewis would have said, *Good Trouble* is necessary for a more inclusive, fair and democratic society.[6] One of his tweets from 2018 resonates even stronger today: "Never, ever be afraid to make some noise and get in good trouble, necessary trouble."[7] Across the world, ongoing struggles of global migration and social injustice remain in play, and instability in Africa, the Americas, Australia, the Middle East, across Europe and Asia continues to escalate the global state of our planet. All of these events informed and are at times reflected upon by our contributors in the chapters that comprise this anthology.

In their own way, each of the two previous publications on remix studies have functioned as markers of the time in which they were published, and *The Routledge Handbook*

of Remix Studies and Digital Humanities is no exception. Some readers may opine that this introduction could have been written in more abstract terms, to sound "academically" correct, with detachment from politics; but abstraction and detachment are modalities out of sync with the issues raised in many of the chapters written by our contributors. Given that both RS and DH focus on how media is shaped and reshaped through creative means to make sense of the world itself, it is necessary for us to engage the political and cultural climate at our time of writing. Just like how the COVID-19 pandemic cannot be separated from the ideological spin doctoring produced by extreme politics, so RS and DH research cannot be treated with "clinical cleanliness." Our common foundational purpose is to understand how we function in subjective and objective terms in a world full of conflicts that, on the surface, appear unsolvable.

Contributions

We consider editing a collaborative process, which, in the case of the *Handbook*, also means that our initial premises for the organization of the different parts are not close to what they evolved to be once we received the actual essays from our collaborators. Chapters moved from one section to another, and parts were eventually renamed to articulate the overall narrative of the contributions.

The volume is organized to be read as a book from beginning to end, if the reader desires, in which case, a certain argument can be extrapolated. The book is also edited to be read in modular fashion—as a reference manual. Each chapter provides a theoretical reflection on the relationship between remix studies and the digital humanities. The chapters offer a range of practical and theoretical approaches and methods specifically written to be of use as needed for research and/or practice by scholars and practitioners; while this is the case, we should also make clear that the chapters do not focus on technical descriptions for the sake of practical competency. When authors mention specific technical methods, it is done directly in relation to the value of critical reflection. Each chapter can stand alone, while also relating to chapters that surround it. Readers will also find that chapters both complement and challenge each other, which brings parity to debates about complex cultural issues. Our initial intent, which remains, was to group chapters according to a focused theme based on comparative methods shared by RS and DH. The chapters were eventually grouped into four sections.[8]

Part I: Epistemology and Theory

Part I brings together chapters that focus, from different critical and methodological positions, on the roles that knowledge plays in culture. This part offers historical and theoretical accounts that combine RS and DH research, in direct juxtaposition with hands-on explanations of methods. The variation in approaches exposes the complexity in the process of knowledge production and the theoretical implications of its interpretation.

Giancarlo Frosio, in Chapter 1, "A Brief History of Remix: From Caves to Networks," provides a concise survey of different forms of appropriation, borrowing, and recycling of content, forms, and ideas that have been at play since the beginning of human cultures. His focus is on Western history's early tendency to borrow freely and how this process evolved into a romantic narrative that privileged the concept of the author as

sole creator of content, which in current times continues to hinder creativity, while information flows across networks with unprecedented efficiency. Frosio connects contemporary research projects to particular texts from the past in order to demonstrate how DH enhances research in RS.

In Chapter 2, "The More Things Change: Who Gets Left Behind as Remix Goes Mainstream?" Fernanda R. Rosa, Maggie Clifford, and Aram Sinnreich share results of a ten-year data analytics study on the state of *configurable culture*, which they define as "a range of different cultural practices and artifacts, including but not limited to, mashups, memes, remixes, mods and machinima." They argue that configurable culture blurs the line between traditional production and consumption online, which, in turn, imposes limits on the democratization of cultural production affecting creativity across age, gender, and race. A key argument proposed in this chapter is that remix is becoming normalized as part of media production itself, which begs reflection on fixed terminology, and asks for openness to ongoing changes in the field of remix studies.

Lindsay Michalik Gratch, in Chapter 3, "Experiments in Performance, Identity, and Digital Space: 48 Mystory Remixes, Remixed," describes a class project she designed based on Gregory Ulmer's "mystory technique." The project guidelines ask students to implement performance and remix practices to explore aspects of digital identity. Gratch shares a personal application of the method by creating her own persona inspired by Cindy Sherman's performative art. She combines creative writing and collage techniques to put into practice what she calls "remix yourself" methods in order to challenge her students and readers to reconsider their assumptions about the meaning-making process.

In Chapter 4, "Production Plus Consumption: Remix and the Digital Humanities," Virginia Kuhn discusses the differences of scholarship between academic remix and the digital humanities. Kuhn argues that as a discipline, digital humanities focuses its efforts on tool development and methods in art and literature, while academic remix implements diverging forms of semiotic analysis to examine all media forms that bring together image, sound, and text. Kuhn analyzes various popular and academic examples of remix and goes on to argue that both RS and DH are important for the combination of "multimodal digital arguments." This enables the production of multimedia work that can be more accessible to general publics with the goal to raise awareness of institutional structures designed for the oppression of diversity in culture.

Karen Keifer-Boyd, in Chapter 5, "Immersive Feminist Remix: An Affect Dissonance Methodology," discusses affect studies methods that are useful to resist and counter forms of oppression, which include, but certainly are not limited to, ableism, classism, colonialism, heterosexualism, imperialism, and racism. Keifer-Boyd delineates how feminist scholarly research is useful for students to engage in remix video projects that include 360-degree virtual immersive environments. Her chapter describes processes she implements for class projects that encourage students to engage in affect dissonance as a critical practice. She juxtaposes her class project case studies with the multidisciplinary media art of Linda Stein to provide clear examples of critical practice defined by feminist pedagogical approaches in remix practice and the digital humanities.

Seth M. Walker brings together Buddhist philosophy and software development in Chapter 6, "Versioning Buddhism: Remix and Recyclability in the Study of Religion." He explains that writer and teacher Stephen Batchelor developed a "basic 'software' analogy" to discuss different Buddhist philosophies and practices. Walker applies theories from remix studies to Batchelor's categorization of Buddhist thought in order to

argue that dialogic developments in religious philosophies can be extrapolated to be useful in other religious traditions. Consequently, one of Walker's core arguments is to question the authority that is established when originality and authenticity are not questioned. He "hacks" remix theory and software development lingo in order to create an intertextual mashup of disciplines that offers ways to subvert and question institutional paradigms that may seem unshakable; Walker's strategies prove to be useful beyond religions.

In Chapter 7, "Monster Theory 2.0: Remix, the Digital Humanities, and the Limits of Transgression," Megen de Bruin-Molé reconfigures remix as "one of the greatest 'monsters' of our age." She takes on the possible implications of remix being proposed by critics as a symptom of degeneration, while considering those who celebrate it as a transgressive tool to rewrite, and recreate contemporary culture. Bruin-Molé reflects on the methodological shifts in critical practice when the meaning of monsters as theoretically discussed in literary studies has moved to the mainstream. She effectively brings together remix studies and gothic monster studies to create an unexpected monster mashup in order to consider the possibilities of decolonizing the humanities through a monstrous hybrid for the twenty-first century, and what this means for RS and DH.

Eduardo de Moura's contribution, Chapter 8, "Sampling New Literacies: Remix Studies and Digital Humanities in a Cross-disciplinary Approach," offers a methodological discussion of image-mining as an example of digital humanities methods for "constructing parameters to rethink and expand digital literacies." Moura provides technical explanation of image-mining processes from his research on Anime Music Videos to offer a clear case of the effective combination of remix studies and digital humanities methodologies toward a multidimensional approach of both quantitative and qualitative methods.

In Chapter 9, "RS (Remix Studies) + DH (Digital Humanities): Critical Reflections on Chance and Strategy for Empathy," Eduardo Navas discusses how RS and DH can be useful in evaluating the manipulation of facts and data usage to justify bias. The chapter focuses on the critical analysis of truth and denial to consider a creative approach toward empathetic and critically objective methods, useful for engaging with information that supports or questions cultural differences. The chapter concludes with a description of *Switch Chess*, a performative work of art developed by the author. In this modified version of Chess, chance is implemented to displace adversarial principles that inform a player's drive for self-interest. The performative work can be enacted by anyone who wishes to explore empathy—the ability to place oneself in the position of another.

Part II: Accessibility and Pedagogy

Part II includes chapters that discuss issues related to archiving and accessibility of knowledge, and the diverging possibilities for teaching that emerge with the combination of RS and DH methods. Classroom experiences with students are included in various chapters providing an intimate evaluation of teaching and learning methods.

In Chapter 10, "Designing the Remix Library," Anne Burdick discusses the architecture and organization of library collections in terms of possibilities for a constant state of remix. She argues that library materials are optimal for constant recombination and recategorization, yet they are administered by sociotechnical systems that resist "the aesthetic disruption of remix." Burdick offers four uniquely innovative examples that

shed light on the possibilities of remix as integral to knowledge design as a specific practice within digital humanities. Her case studies are The Seattle Central Library (SCL); The University of Chicago's Mansueto Library; Sitterwerk, a private library located in St. Gallen, Switzerland; and a speculative Universal Programmable Library, as imagined by Jeffrey Schnapp and Matthew Battles. Burdick makes a strong case for redefining the library as a space where models of knowledge and design are synonymous with regenerative remixing.

Ian McArthur in Chapter 11, "Interdisciplinary Design and Transcultural Collaboration as Transformative Remix Tools" discusses remix tactics for the exploration of "worlding" collaborative design education. He describes numerous activities that take place in mad.lab, a three-week elective course for students, which aims "to deconstruct the monolithic influence of Western design praxis." The chapter offers a theoretical, socially conscious, and practical overview of the international collaboration for city making in the megacity of Chongqing in South West China among UNSW Art & Design (Sydney), Chongqing's Sichuan Fine Arts Institute, and The School of Architecture, Design and Planning's Design Lab at the University of Sydney. McArthur's goal is to decolonize design by fostering hybrid communities defined by experimental mapping and participatory methods shared by students in Australia and China.

For Chapter 12, "In the Mix, the Collaborative Remix to Repair, Reconnect, Rebuild," Vicki Callahan, Nicole Richter, Christina Lane, and Daniel Clarkson Fisher discuss the video essay as an important part of the scholarly toolkit that explicitly brings together RS and DH for creative and critical production. The chapter describes their collaboration, which began well before the SCMS 2018 conference for which they used the prompt of "Post Truth." The authors outline, in detail, the process that took place during the collaboration, which consisted of each participant sharing footage to be used in an initial video. The results were, in turn, remixed among colleagues for a second-order remix video essay. All participants gave each other feedback, and during the SCMS conference they were also able to receive feedback from attendees. The authors continue to plan more collaborative remix interventions, in order to explore surprisingly disruptive elements of collaborative video essay remixes.

Kelley Kreitz in Chapter 13, "Remixing Literature in the Classroom: From Canons to Playlists in the Study of Latinx Literature and Beyond," considers how RS and DH can work together for students to engage in Latinx history. Digitization of archives is a great resource for the classroom, making it possible for students to explore relevant content in nonlinear forms that fall within RS and DH. Kreitz explains how she operationalizes the "playlist" (in terms of music lists) as a conceptual model for students to navigate Latinx literature as "archival collections" over established "literary canons." Kreitz provides examples that help her make a case for considering a playlist approach as a means to democratize the process of accessing and producing knowledge.

For Chapter 14, "Metadata for Digital Teaching: Enabling Remix for Open Educational Resources," Michael Collins describes a metadata project called Open Educational Resource (OER) Schema. The principle behind this project is to expand on the possibilities of sharing information in support of access and production of knowledge. He considers schemas to provide a foundational structure to make "education remix tools" freely available on the web. Collins provides examples of remix tools that support digital authoring while promoting stability of digital information storage which continues to be ephemeral across the Internet. Collins considers how OER Schema will play a role,

along with AI and machine learning in future educational models. He also considers the economic implications of open-source publishing for the educational book market and educational materials and resources.

Victoria Bradbury, in her contribution, Chapter 15, "Hack It! DIY Divine Tools: An Art Hack Implemented as New Media Pedagogy in the Public Liberal Arts," describes art hacking events, in which advanced undergraduates participated as mentors for first year humanities students. The hacking workshop, which was linked to a class on world religions, had the theme of "gods and goddesses." Participants creatively explored "hack-themed literature" while learning technical skills that instilled basic principles of group collaboration. Consequently, Bradbury reflects on the implications of enacting hack-athons, as commonly practiced in commercial tech industries, as a means to explore creativity and criticality in academic contexts.

Chapter 16, "On the Capabilities of Hip Hop-Inspired Design Research: An Annotated Syllabus," by Joycelyn Wilson provides a detailed description of a humanities/computational media elective course she taught in 2018. The purpose of the course was to introduce undergraduate students to hip hop–based design methodologies for critical engagement with race, science, and technology. Wilson taught this class numerous times; as a case example, she considers the course of Spring 2018 to represent a particular moment, in which students were able to engage in "a formulated analysis rubric created specifically for guiding student groups through the ideation, writing, and final production of a humanities-centered computational media product." The final project, in this case, was a podcast; one of Wilson's goals is to provide the opportunity to understand the preservation of content that affords Black culture viability in terms of media production.

In Chapter 17, "Internet Memes as Remixes: *Simpsons* Memes and the Swarm Archive," Scott Haden Church and Gavin Feller contrast Casey Boyle's theory of "rhetorical edition" against DH's method of the "critical edition" in order to expand interpretation beyond academic-textual commentary through the acts of appropriating, transforming, and versioning of texts. Church and Feller consider the Swarm Archive "an iconic primary text in open dialogue with (secondary) scholarship and (tertiary) vernacular commentary, or remixed iterations of the text." The authors propose the unexpected case study of *Simpsons* memes to discuss aspects of versioning through constant appropriation. They connect this memetic process to "Quintilianisms," which can be considered derivatives from a text with no specific author. Church and Feller provide a quantitative study of *Simpsons* memes in order to argue that the Swarm Archive offers the possibility to be inclusive rather than exclusionary by incorporating regenerative remixes as valid forms of cultural production that express people's realities.

xtine burrough in Chapter 18, "Poetically Remixing the Archive," provides an intimate glimpse into her creative collaborations with DH scholars. She explains her position as a creative practitioner grounded in the visual arts who crosses over to DH while differentiating herself from "critical makers." burrough considers "critical making—an emergent 'makers' turn in the humanities centered on research and process." In a discussion of three collaborative projects as poetic remixes of archives: *The Women of El Toro* (2016), *An Archive of Unnamed Women* (2018), and *A Kitchen of One's Own* (2020), this chapter provides an honest account of burrough's connections to and disconnections from DH.

Part III: Modularity and Ontology

Chapters in Part III offer critical analysis complemented with a range of analytical methods that ponder the state of human existence in relation to cultural production defined by principles of modularity, consisting of nonlinear means to create new content with digital technology. Many of these chapters showcase the evolving relationship between modular art and creative coding in an era where AI can be used to generate human-like artistic and literary works.

Eran Hadas for Chapter 19, "Hallucination or Classification: How Computational Literature Interacts with Text Analysis," discusses his creative practice consisting of mashing poetry and code. He provides detailed insight into various methods for poetic text generation remixes with the implementation of machine learning. Hadas reflects on the contention between creative synthesis and the analysis of texts generated. He considers possible acrimonious sensibilities in the initial randomness of texts, which, in effect, defines the content that is produced based on preceding content. Hadas argues that "Text generating algorithms and remixes are closely related," and that "The remix can be seen as a baseline algorithm to the manipulation and generation of texts." Hadas, in effect, expands the creative implementation of machine learning based on remix methods for creative writing.

Alessandro Ludovico discusses text transformation methods in Chapter 20, "Machine-driven Text Remixes." His chapter offers a bifurcating historical account of poetic experimental literature, making connections between aleatory experiments by the OuLiPo group during the 1960s and computer-driven projects developed throughout the decades that followed, moving toward autonomous writing. He describes the role of remix in early experiments from the 1960s in relation to machines designed to mimic writers' styles, effectively "to generate credible fakes," and thereby exposing literary connections between RS and DH.

Mark Amerika contributes an experimental piece of writing for Chapter 21, "Talk To Transformer: AI as Meta Remix Engine." Amerika remixes writing he produced with the online platform Talk to Transformer (now InferKit) with the goal to reflect on recurring questions about authorship. He considers the Transformer language model (GPT-2) to function as both "a meta-remix engine and artistic collaborator." The chapter, as a result, is a mashup of reflective writing that explains Amerika's experience with the Transformer by repurposing the very text produced by the language model algorithm. Amerika considers the process, which he refers to as "Artificial Creative Intelligence," a hybrid form of consciousness that binds the author to the GPT-2 online platform leading to the question, "What does it mean to be human?"

David Beard and Lisa Horton redefine role-playing games in relation to remix culture in Chapter 22, "The Critical Role of New Media in Transforming Gamers into Remixers." They propose the resurgence of tabletop role-playing games, as they have become integrated in networked media, to be closely linked to principles of the "regenerative" remix. Beard and Horton offer a case study example, a group of online gamers, who are active on Twitch as *Critical Role* in order to demonstrate how "tabletop role-players remix using the tools of the digital humanities."

Ethan Plaut in Chapter 23, "Vandalize a Webpage: Automation and Agency, Destruction and Repair," describes the creative process his students experience as they learn to hack HTML and JavaScript for class projects. He reflects on the ethical

implications that emerge as students produce creative works that may be offensive to different groups of people. Plaut argues that the skills students attain from computer science are relevant to digital humanities in terms of remixing as a design method. His chapter argues for a type of pedagogy that "moves too fast for comfort," thus pushing students to engage within the parameters of the critical making movement. This results in works that are not always polished, but which lead to unexpected questions on the relation of "algorithmic and remix cultures."

Chapter 24, "Allegories of Streaming: Image Synthesis and/as Remix," by Steve F. Anderson reflects on the production of digital images, which, for the last twenty years, have been closely defined by their storage in ever-growing databases. Anderson argues that databases have contributed to "the digital transformation of visual culture, giving rise to creative practices predicated on affordances of modularity and remixability." He argues that our reality has been defined by "the logics of data," and currently our culture needs to become more aware of the growing influence of machine vision and image synthesis technologies within the framework of remix culture. Anderson's chapter includes case studies of projects by the Google Brain team, Facebook's AI Research (FAIR), and Turkish media artist Memo Akten.

Dejan Grba for Chapter 25, "Always Already Just: Combinatorial Inventiveness in New Media Art," discusses remix in terms of creative thinking and production in relation to new media art and digital humanities. Grba focuses on generative artworks that combine materials from film, television, and the Internet in order to argue that bricolage proves to be a relevant conceptual model to "leverage complex technical infrastructures, foster curiosity and encourage vigilance in our critical appreciation of the arts, technology, culture, society, and human nature." Grba throughout his chapter describes various media art projects in order to make a case for a form of creativity that brings together artistic and scientific methods defined by a "ludic cognitive drive."

David Gunkel discusses the philosophical questions on authorship raised by the implementation of Artificial Intelligence (AI) in the creative process for Chapter 26, "Computational Creativity: Algorithms, Art, and Artistry." His key argument is on AI not having a sense of originality as part of its functions. He points to what Alan Turing called "Lady Lovelace's objection," which proposes that computers do not have the ability to produce something with a sense of uniqueness on their part because they only perform what they are programmed to do. Yet, Gunkel subversively, as philosophers do, raises questions about the human condition that demonstrate such an assumption is more complex than it appears. He provides various examples that beg readers to reconsider the real issues behind the creative drive solely accredited to humans with the direct question: "Can AI, robots, and/or algorithms be creative?"

In Chapter 27, "Remix Games as Instruments of Digital Humanities Scholarship: Harnessing the Potential of Virtual Worlds," Owen Gallagher analyzes remix games as proactive instruments of participation in digital humanities. Gallagher considers games "inherently remixable," which is why remix can make the game development process more accessible to academics or creative individuals who would not consider themselves game designers. Remix games are specific in that they are "composed of previously published sampled elements," and therefore link remix to digital humanities by opening up new approaches to game design with principles of appropriation, and transformation based on their modular nature. Gallagher discusses the evolution of games in academia and offers evidence on how and why games have become integral in digital humanities to the point that they could be considered proper academic publications.

Part IV: Aurality and Visuality

This final section brings together essays that focus on visual media and sound, including studies on music and its relation to film and DIY aesthetics, as well as their possibilities in the classroom. The part closes the book by making evident the pervasiveness of time-based media across culture, and why sound and moving images, combined with interactivity, remain crucial forms of communication that are relevant for examination in RS and DH.

Christine Boone, in Chapter 28, "Popular Song Remixed: Mashups, Aesthetic Transformation, and Resistance," argues that mashups have the potential to become part of a subculture that remains challenged by mainstream culture, which paradoxically expresses the creative drive behind mashups. She explains that this takes place in two ways. The first is in terms of the set of rules that defines them, which are expected to be broken in order for mashups to be legitimated. This process makes them more complex than some critics have dismissively argued. The second is that mashups are counter-productive to the music industry, because they appropriate material that is protected by copyright law. To reflect on this complexity, she revisits the theories of Theodor Adorno and Walter Benjamin in order to unpack, particularly against Adorno's critical position of popular music, the reasons why mashups have the potential to "give commentary, and allow listeners to zoom out and look at popular song[s] from a wider perspective."

In Chapter 29, "Remixing the Object of Study: Performing Screen Studies Through Videographic Scholarship," Aidan Delaney discusses the video essay as a form of writing performed by film scholars as a means to expand critical analysis in film studies. He argues that remix, in this case, functioning as a form of writing, makes this recent practice possible with the implementation of digital technology: the ability to appropriate and rearrange source material. His main argument is that "videographic scholarship" makes use of remix methods in order to perform analysis of screen media moving well beyond film studies in ways that are relevant in digital humanities as an interdisciplinary field. Delaney further argues that the video essay is relevant to producers and viewers according to analogic syntax that differs from the written text, thus opening new ways of presenting a critical argument with visual language. This is unique in that a video essayist can "intervene" or appropriate the very work they are analyzing in order to discuss its cultural implications defined by audiovisual experience.

Sarah Atkinson, in Chapter 30, "Cinema Remixed 4.0: The Rescoring, Remixing and Live Performance of Film Soundtracks," examines live music performance for films and screen media in contemporary times. She reviews the history of sound in film beginning with the silent era to consider how and why live music performance for a film has evolved beyond the movie theater into other screen media. Atkinson explains that live performances of soundtracks have gone through four waves: The first took place in early silent cinema, the second in the cinema of the 1960s, the third with Video Jockey (VJ) culture in the 1980s, and the fourth, and most recent, borrows methods from previous waves to remix for live performance using post-produced material. Atkinson, in effect, offers a classification of live performance for screen media.

Paul Watkins in Chapter 31, "The Sound of the Future: A Digital Humanities Remix Essay," discusses remix and DH as means to engage with sound "as foundational to research and new knowledge creation." He, in turn, repositions methods used by DJs to rework preexisting material, often forgotten, or not critically evaluated, as valid approaches to perform research in DH while discussing its interrelation with sound

studies. Watkins, in this regard, makes reference to Pauline Oliveros's concept of "deep listening" to suggest hybrid forms for doing research in sound that overlaps RS and DH. He ends his chapter with an honest account of his own practice as DJ and scholar working at the intersection of sounds studies, remix studies, and the digital humanities.

Chapter 32, "Hacking the Digital Humanities: Critical Practice and DIY Pedagogy," was written by Marina Hassopopoulou with Donna Cameron, Cristina Cajulis, Da Ye Kim, Jasper Lauderdale, Eric Hahn, Pedro Cabello, Hojong Lee, Soyoung Elizabeth Yun, Kelsey Christensen, and Kate Anderson-Song. The chapter focuses on alternative modes of writing relevant within DH by students that explore alternative methods outside of data-driven and big data production and analysis. The projects discussed throughout the chapter bring together RS and DH beyond the expected use of computational tools, by emphasizing a hypertextual aesthetic that encourages the modular reading of each project description as in a "choose-your-own-adventure hypertextual modality." To expand RS and DH beyond the digital, some of the projects are "no/low-budget multimedia scholarship projects," while some are produced in analog form (as in a hand cut and bound print book). Projects also include video remixes, short films, and virtual games inspired by or based on appropriated source material. Each project description is accompanied by its own QR code providing immediate online access so that readers can experience the actual project as they read the analysis. Hassapopoulou reflects on the ephemerality of the projects given the instability of content across the Internet as technology keeps changing; she points out that some of the projects discussed are already in danger of becoming inaccessible in the near future.

Mark Campbell, in Chapter 33, "DJing Archival Interruptions—A Remix Praxis and Reflective Guide," reflects on his own practice as a DJ scholar focusing on remix and digital archives. He is interested in people's experiences of "digital saturation" informed by politics that continue to be closely linked with copyright infringement. For Campbell, remix and archives are great resources of material to repurpose in the quest for a creative disruptive praxis. To provide a sense of his direct relation to remix and archives, Campbell describes two of his live video mixing performances; one a keynote at The University of Western Ontario, and the other a performance at The Royal Ontario Museum. Campbell's performances are a reminder of the important history of remix in terms of Afrodiasporic culture, which he honors through the public enaction of DJing techniques that emphasize call and response, as well as repetition. The chapter also offers Campbell's reflections on a procedural guide for DJing digital archives. Campbell's chapter highlights the ethical importance of "oral and sonic innovations indebted to the African diaspora."

Chapter 34, "Exploring Remix Process: The Case of the Spanish Megamix," contributed by Adrian Renzo, discusses the relation of musicology and digital humanities by focusing on the possibilities of close readings of an object of analysis with the combination of methods shared by musicology and DH. Renzo writes a detailed analysis of the Spanish megamix genre, which he explains is specific to the 1980s. He defines the Spanish megamix specifically as a type of intertextual recording consisting of heavy repetition of short phrases complemented with multilayered special effects. Renzo explains that this genre has enjoyed a recent revival in Spain. To provide an intimate account of the Spanish megamix, he includes a detailed description of his own creative production of a megamix in order to expose complexities that are not evident by simply listening to a composition.

Nick Cope's contribution, Chapter 35, "Scratch Video: Analog Herald of Remix Culture," builds on his previous historical account of Scratch Video. In an earlier publication Cope concluded that Scratch Video functions as a "herald" of remix culture. For his contribution to this anthology, Cope builds on this premise to elaborate that Scratch Video's influence in the arts, post-punk, and industrial music scenes are not well historicized and sets out to survey such connections that include the early video industry, DIY cultures, as well as video art. Cope makes a case for Scratch Video not only having been a herald of things to come in the past, but that it also remains in such a perpetual position for our future: Cope argues that Scratch Video "challenged copyright law and anticipated mashup, plunderphonic and remix cultures yet to come."

Paul Dougherty closes the anthology with Chapter 36, "Curating, Remixing and Migrating Archived 'Muse Files'," in which he provides an autobiographical account of his long practice as a video remixer. Dougherty, an EMMY award-winning editor, candidly shares his early experiences remixing late at night in different media studios that provided him with time to work on his creative material. He explains how he understood remixing in his early years through his practice of collecting magazine images. Like the record digger in DJ culture, Dougherty became obsessed with collecting content, which he would eventually remix. His chapter includes personal descriptions of five works with a detailed workflow on how they were put together. Dougherty sees a connection of his work to DH in terms of attitude. He explains that "The Digital Humanities Manifesto 2.0," which offers a means to produce outside academia resonates with his experience of working outside "the academy" of art. Dougherty's detailed discussion of his long creative practice makes evident that video remixing is clearly a form of writing in its own right, which is now closely embedded in digital media production, and bound with both RS and DH.

The brief descriptions of chapter contributions above should provide a strong sense of the diversity of subjects of research and critical approaches by each scholar bringing together RS and DH. Contributors come from diverse areas, such as Art Practice, Art Education, Art History, African Diaspora Studies, Communications, Copyright Law, Cultural Studies, Liberal Arts, Media Design, Musicology, and Feminist and Women Studies, among many other disciplines. Each section provides a narrative arc with variations of approaches that complement and may question each other in ways that build for a future of better understanding founded on diversity of opinions.

Additional resources can be found online at remixstudies.com; a website that was established with our first collaborative publication, *The Routledge Companion to Remix Studies*, which we intend to keep active as support to ongoing research. We consider the chapters brought together in *The Routledge Handbook of Remix Studies and Digital Humanities* as a representative sample of the ongoing research produced across the arts and humanities and hope it becomes a seed for future research on important questions that bring together the arts, humanities, media, science, and technology studies. While our aim for this *Handbook* was to put remix studies and the digital humanities in conversation, our long-term goals as interdisciplinary artists, scholars, and remixers is to make a path for the production of knowledge that supports our global struggle to balance cultural and ideological differences. We believe remix studies, especially in conversation with our arts and humanities kin, digital humanities, offers one such way forward.

Notes

1 Lawrence Lessig, *Remix: Making Art and Commerce Thrive in the Hybrid Economy* (New York: Penguin Books, 2008).
2 For a timeline on the relation of remix to remix studies read: Eduardo Navas, "Remix," *Keywords in Remix Studies*, eds., Eduardo Navas, Owen Gallagher, xtine burrough (New York: Routledge, 2018), 246–58.
3 The Stanford Humanities Laboratory is now referred to as the Stanford Humanities Center and comprises several distinct departments, CESTA, CIDR, CCRMA, and DHFG. Duke, HASTAC, and University of Virginia remain active and relevant; UCLA has a dedicated Digital Humanities program, which they nurture through a broad-reaching network called "HumTech;" MIT's Hyperstudio is still active. There are many others we could mention here.
4 There are a few accounts that outline the stages described. For introductory reference: Jeffrey Schnapp et al., 'The Digital Humanities Manifesto 2.0', UCLA.edu, May 29, 2009, http://manifesto.humanities.ucla. edu/2009/05/29/the-digital-humanities-manifesto-20/. David Berry, "The Computational Turn: Thinking About the Digital Humanities." *Culture Machine*, 12, 2011. ISSN 1465-4121, https://sro.sussex.ac.uk/id/ eprint/49813/1/BERRY_2011-THE_COMPUTATIONAL_TURN-_THINKING_ABOUT_THE_ DIGITAL_HUMANITIES.pdf. Julie Thompson Klein, *Interdisciplining Digital Humanities: Boundary Work in an Emerging Field* (Ann Arbor: University of Michigan Press, 2014), 47–63.
5 We submitted all chapters for this manuscript on August 25, 2020 while we continued to add to and edit this introduction. Jacob Blake was shot in the back seven times by a police officer on August 23, 2020. He was standing at the driver's side door of his car as his three children were in the back seat. While we wrote this very sentence we were simultaneously feeling the collective consciousness of a country and a globe that is not at peace.
6 John Lewis, "Together, You Can Redeem the Soul of Our Nation," *New York Times*, July 30, 2020: accessed August 31, 2020 https://www.nytimes.com/2020/07/30/opinion/john-lewis-civil-rights-america.html.
7 From John Lewis's Twitter account: June 27, 2018: accessed August 27, 2020, https://twitter.com/repjohn-lewis/status/1011991303599607808, an article on a documentary with the quote as the title about John Lewis after his passing: "'John Lewis: Good Trouble' Review: Past Progress, and More to Come," *New York Times*, July 2, 2020: accessed August 27, 2020, https://www.nytimes.com/2020/07/02/movies/john-lewis-good-trouble-review.html.
8 Any direct quotes in the chapter descriptions section of this introduction are taken from the respective chapter or the chapter abstract.

Bibliography

Remix Studies

Aufderheide, Patricia. *Reclaiming Fair Use: How to Put Balance Back in Copyright.* Chicago, Illinois: University of Chicago Press, 2011.
Amerika, Mark. *Remixthebook.* Minneapolis and London: University of Minnesota Press, 2011.
Amerika, Mark. *RemixtheContext.* London and New York: Routledge, 2017.
Boon, Marcus. *In Praise of Copying.* Cambridge, Massachusetts: Harvard University Press, 2010.
Berry, David M.. *Copy, Rip, Burn: The Politics of Copyleft and Open Source.* London: Pluto Press, 2008.
Borschke, Margie. *This is Not a Remix: Piracy, Authenticity and Popular Music.* New York and London: Bloomsbury, 2017.
Bourriaud, Nicolas. *Postproduction: Culture as Screenplay: How Art Reprograms the World.* 2nd Edition. New York: Lukas & Sternberg, 2005.
Chang, Jeff. *Can't Stop Won't Stop: A History of the Hip Hop Generation.* New York: St. Martin's Press, 2005.
Christopher, Roy. *Dead Precedents: How Hip-Hop Defines the Future.* London: Repeater Books, 2019.
Eshun, Kodwo. *More Brilliant Than the Sun: Adventures in Sonic Fiction.* 1st Edition. London: Quartet Books, 1998.
Evans, David. *Appropriation: Documents of Contemporary Art.* Cambridge, MA: MIT Press, 2009.
Gallagher, Owen. *Reclaiming Critical Remix Video: The Role of Sampling in Transformative Works.* New York: Routledge, 2018.

Goldsmith, Kenneth. *Uncreative Writing*. New York: Columbia University Press, 2011.

Guertin, Carolyn. *Digital Prohibition: Piracy and Authorship in New Media*. London: Bloomsbury, 2012.

Gunkel, David. *Of Remixology: Ethics and Aesthetics After Remix*. Cambridge, Massachusetts: MIT Press, 2016.

Jenkins, Henry. *Convergence Culture: Where Old and New Media Collide*. New York: NYU, 2006.

Jenkins, Henry, et al. *Spreadable Media: Creating Value and Meaning in a Networked Culture*. New York: NYU Press, 2013.

Laderman, David and Laurel Westrup. *Sampling Media*. London: Oxford University Press, 2014.

Lessig, Lawrence. *Remix: Making Art and Commerce Thrive in the Hybrid Economy*. New York: Penguin Press, 2008.

Miller, Paul D. *Rhythm Science*. 1st Edition. Cambridge, Massachusetts: MIT Press, 2004.

Miller, Paul D. *Sound Unbound*. Cambridge, Massachusetts: MIT Press, 2008.

Morales, Aaron. *American Mashup: A Popular Culture Reader*. New York: Pearson, 2011.

Mueller, Ellen. *Remixing and Drawing: Sources, Influences, Styles*. New York: Routledge, 2018.

Navas, Eduardo. *Art, Media Design, and Postproduction: Open Guidelines on Appropriation and Remix*. New York: Routledge, 2018.

Navas, Eduardo, Owen Gallagher, and xtine burrough. Editors. *The Routledge Companion to Remix Studies*. New York: Routledge, 2015.

Navas, Eduardo, Owen Gallagher, and xtine burrough. Editors. *Keywords in Remix Studies*. New York: Routledge, 2018.

Navas, Eduardo. *Remix Theory: The Aesthetics of Sampling*. Wien and New York: Springer, 2012.

Poschardt, Ulf. *DJ Culture*, translated by Shaun Whiteside. London: Quartet Books Ltd, 1998.

Reynolds, Simon. *Retromania: Pop Culture's Addiction to Its Own Past*. New York: Farber & Farber, 2011.

Rose, Tricia. *Black Noise: Rap Music and Black Culture in Contemporary America*. Middletown, Connecticut: Wesleyan University Press, 1994.

Sinnreich, Aram. *Mashed Up: Music, Technology and the Rise of Configurable Culture*. Amherst and Boston: University of Massachusetts Press, 2010.

Sinnreich, Aram. *The Piracy Crusade*. Amherst and Boston: University of Massachusetts Press, 2014.

Sinnreich, Aram. *The Essential Guide to Intellectual Property*. New Haven and London: Yale University Press, 2019.

Sonvilla-Weiss, Stefan. *Mashup Cultures*. Wein and New York: Springer, 2010.

Sullivan, Paul. *Remixology: Tracing the Dub Diaspora*. London: Reaktion, 2014.

Veal, Michael. *Dub: Soundscapes and Shattered Songs in Jamaican Reggae*. 1st Edition. Middletown, Connecticut: Wesleyan University Press, 2007.

Williams, Quentin. *Remix Multilingualism: Hip Hop, Ethnography and Performing Marginalized Voices*. London: Bloomsbury, 2017.

Digital Humanities Overview

Battershill, Claire and Shawna Ross. *Using Digital Humanities in the Classroom: A Practical Introduction for Teachers, Lecturers, and Students*. New York and London: Bloomsbury Press, 2017.

Berry, David M. "The Computational Turn: Thinking About the Digital Humanities." In *Culture Machine*, Vol.12. UK: Sussex Research Online, 2011.

Berry, David M. *Understanding Digital Humanities*. New York: Palgrave McMillan, 2012.

Berry, David M., Anders Fagerjord. *Digital Humanities: Knowledge and Critique in the Digital Age*. London: Polity, 2017.

Burdick, Anne and Johanna Drucker. *Digital Humanities*. Cambridge, Massachusetts: MIT Press, 2016.

Carter, Bryan. *Digital Humanities: Current Perspective, Practices and Research (Cutting-Edge Technologies in Higher Education)*. Bingley: Emerald Book Publishing, 2013.

Crompton, Constance, Richard J Lane, and Ray Siemens. *Doing Digital Humanities: Practice, Training, Research*. New York and London: Routledge, 2016.

Gardiner, Eileen and Ronald G. Musto. *The Digital Humanities: A Primer for Students and Scholars*. New York: Cambridge University Press, 2015.

Gold, Matthew K. *Debates in the Digital Humanities*. Minneapolis, Minnesotta: University of Minnesota Press, 2012.

Gold, Matthew K and Lauren F. Klein. *Debates in the Digital Humanities 2016*. Minneapolis, Minnesotta: University of Minnesota Press, 2016.

Gold, Matthew K and Lauren F. Klein. *Debates in the Digital Humanities: 2019*. Minneapolis, Minnesotta: University of Minnesota Press, 2019.

Jones, Steven E. *The Emergence of the Digital Humanities*. New York: Routledge, 2013.

Klein, Julie Thompson. *Interdisciplining Digital Humanities: Boundary Work in an Emerging Field*. USA: University of Michigan Press, 2014.

Sayers, Jentery. *Making Things and Drawing Boundaries: Experiments in the Digital Humanities (Debates in the Digital Humanities)*. Minneapolis, Minnesotta: University of Minnesota, 2018.

Schnapp, Jeffrey et al. *The Digital Humanities Manifesto 2.0*. USA: UCLA.edu, 2009.

Schreibman, Susan, Ray Siemens, and John Unsworth. *A New Companion to Digital Humanities (Blackwell Companions to Literature and Culture)*. Oxford: Blackwell, 2016.

Terras, Melissa and Julianne Nyhan. *Defining Digital Humanities: A Reader (Digital Research in the Arts and Humanities)*. New York: Routledge, 2013.

Warwick, Claire and Melissa Terras. *Digital Humanities in Practice*. (The Facet Digital Heritage Collection). London: Facet, 2012.

Digital Humanities Topics

Benardou, Agiatis, Erik Champion, Costis Dallas, and Lorna Hughes. *Cultural Heritage Infrastructure in Digital Humanities*. New York: Routledge, 2018.

Gardiner, Hazel and Charlie Gere. *Art Practice in a Digital Culture (Digital Research in the Arts and Humanities)*. New York: Routledge, 2018.

Kinder, Marsha and Tara McPherson. *Transmedia Frictions: The Digital, the Arts, and the Humanities*. Oakland, CA: University of California Press, 2014.

Klein, Julie Thompson. *Interdisciplining Digital Humanities: Boundary Work in an Emerging Field*. Ann Arbor: University of Michigan Press: USA, 2015.

Leonhardt, Nic. *The Routledge Companion to Digital Humanities in Theatre and Performance*. New York: Routledge, 2018.

Risam, Roopika. *New Digital Worlds: Postcolonial Digital Humanities in Theory, Praxis, and Pedagogy*. Evanston, IL: Northwestern University Press, 2018.

Sayers, Jentery. *The Routledge Companion to Media Studies and Digital Humanities*. New York: Routledge, 2018.

Simanowski, Roberto. *Digital Humanities and Digital Media Fibreculture*. London: Open Humanities Press, 2016.

Svensson, Patrik. *Between Humanities and the Digital*. Cambridge, Massachusetts: MIT Press, 2015.

Part I

EPISTEMOLOGY AND THEORY

1

A BRIEF HISTORY OF REMIX

From Caves to Networks

Giancarlo Frosio[1]

For most of human history, remix practices dominated the creative process.[2] Premodern creativity sprang from an unbroken tradition of reuse and juxtaposition of pre-existing expressive content. As literary pillars of Western culture, the Iliad and the Odyssey were forged in the cumulative and collaborative furnace of the oral tradition. Out of that tradition grew medieval epics, which appeared under the aegis of Macrobius's art of rewriting and the Latin principles of interpretatio, imitatio, and aemulatio. Continuations, free reuse of stories and plots, and the remodeling of iconic figures and characters, such as Alexander the Great, King Arthur, and Roland, made chansons de geste and romance literature a powerful vehicle for propelling cross-country cultural dissemination. This is, however, by no means only a Western experience. For millennia, until the Enlightenment and Romantic Individualism, Western and Eastern culture shared a common creative paradigm. From Confucian China, across the Hindu Kush with the Indian Mahābhārata, the Bible, the Koran, and Homeric epics to African xhosa imbongi and European troubadours, the most valuable components of our immortal culture were created under a fully open regime of access to pre-existing expressions and reuse.[3]

The following review sheds light on the evolution of premodern, modern, and post-modern notions of appropriation, reuse, creative collaboration, and plagiarism. This might be of use to contextualize how the humanities function today. In particular, this brief history of "remix" helps explain conceptual positions extrapolating how digital humanities has changed the way creative acts are understood since the early days to emerging forms of today. In addition, the application of digital resources and computational tools and methods to the study of the evolution of these notions, which is well ongoing, will hopefully bring about further understanding of the mechanics of creativity throughout history. In turn, this understanding can help clearly in highlighting the role of reuse, appropriation, and collaboration—all acts that are part of remix practice today—in the history of creativity. This insight should then lead to changes to the regulatory framework, so that remix, rather than being a practice just tolerated or outright prohibited by the law, will regain a central role in the creative process.[4]

Cave Art, Cumulative Creativity, and Remix

In Lascaux, the relics of prehistoric art are on display across the vaults and halls of a French cave complex.[5] Lascaux's cave paintings were made thirty-five thousand years ago in the Chauvet Cave, close to the French village of Vallon-Pont-d'Arc.[6] Even older cave paintings were discovered in Indonesia in 2019.[7]

Cave art is arguably the first form of mass collaboration. The entire cave structure could have served as a repository of past stories and information, remixing the old with the new for several millennia. Henri Breuil discerned the collaborative character of cave art with striking acumen by noting "[t]his is no longer the work of an individual, but a collective, social affair, showing a true spiritual unity."[8] Projects like the Xiangtangshan Caves Project, which digitally reconstructs a group of damaged Buddhist cave temples in China's Hebei province with image modeling,[9] will definitely provide more insights regarding the nature and scope of the creative practices of cave art.

Art Is *Mimēsis* of Reality

Reuse and appropriation—foundational elements that inform what we call remix today—found fertile ground in Ancient Greece due to a peculiar approach to art and creativity. Plato said "Art is *mimēsis* of reality." Plato—and later Aristotle—considered imitation the general principle of art.[10] In his *Poetics*, Aristotle added that imitation is the distinctive character of humanity: "indeed we differ from other animals in being most given to *mimēsis* and in making our first steps in learning through it—and pleasure in instances of *mimēsis* is equally general."[11] The practice of reusing, remixing, or even bodily appropriating other works had deep roots in ancient Greek philosophy.[12] Plato's doctrine of artistic imitation powerfully justified the imitative nature of ancient Greek creativity.

The Oral-Formulaic Tradition

The creative process of the *Iliad* and the *Odyssey* demonstrates a tradition of open literary reuse. This process was dissected by Milman Parry. For Parry, a formula is a "group of words regularly employed under the same metrical conditions to express a given essential idea."[13] Using formulas, oral poets could improvise on a subject, develop it, memorize thousands of verses, and recite them. Identifying the reuse of formulas, common stock, and patterns become easier today through the deployment of digital tools, such as in the case of the *Chicago Homer*, a multilingual database that uses the search and display capabilities of electronic texts to make the distinctive features of Early Greek epics accessible to readers with and without Greek.[14]

The poetic diction permeating Homeric works was, therefore, the cumulative creation of many generations of oral poets over centuries. They had created a "grammar of poetry" to be superimposed on the grammar of language.[15] *Aoidoi* and *rhapsodes* could draw from this grammar to perform their poetic speech. In drawing from this literary commons and reusing it, poets would add their own contributions. In the case of a particularly brilliant *aoidous*, such as Homer, the original contribution may have been more substantial than in other instances. A single poet could have changed an old formula, created something new from an old pattern, or put formulas together in different ways. As Parry noted,

under this model, the capacity of taking that quality improvement process to the extreme was recognized as creative genius. Homer was perhaps that creative genius.[16] He was *not* the original genius dear to the Romantics. He was the *aoidos* who gave Unity to a tradition.

In oral poetry, any individual work is ceaselessly reworked and modified. Creativity is the act of blending together individual contributions. Arnold Hauser noted the distance and the irreconcilable tension of the Homeric idea of creativity with the romantic ideal of artistry and authorship:

> It upsets all romantic conceptions of the nature of art and the artist [...] to have to think of the Homeric epics, in all their perfections, as being the product neither of individual nor of folk poetry, but on the contrary, as an anonymous artistic product of many elegant courtiers and learned literary gentlemen, in which the boundaries between the work of different personalities, schools and generations have become obliterated.[17]

If all his work was formulaic, then Homer is no more than a "spokesman for a tradition."[18] Oral-formulaic theories were treated with great suspicion for threatening the perceived originality of Homer. As described by Theodore Wade-Gery:

> [t]he most important assault made on Homer's creativeness in recent years is the work of Milman Parry, who may be called the Darwin of Homeric studies. As Darwin seemed to many to have removed the finger of God from the creation of the world and of man, so Milman Parry has seemed to some to remove the creative poet from the Iliad and Odyssey.[19]

According to oral-formulaic theories, the cultural artifact does not come to life as a perfect final product. Instead, it undergoes a prolonged process of evolution.[20] The Bible also has oral roots that makes it the final textualization of a collaborative and evolutionary creative model,[21] as well as the *Gilgamesh*,[22] the *Mahābhārata* and the *Rāmāyana*,[23] the Koran,[24] and plenty of other ancient and medieval literature.

Interpretatio, Imitatio, and Aemulatio in Ancient Rome

According to modern studies, there were three forms of imitation in ancient Roman literature: *interpretatio*, *imitatio*, and *aemulatio*.[25] *Interpretatio* was unoriginal adaptation involving the direct translation of one source. *Imitatio* was adaptation that involved borrowing the form, content, or both from one or more renowned Greek sources. *Aemulatio*, finally, was a form of creative rivalry. Powerful examples are Virgil's emulation of Homer's epics and Horace's emulation of Alcaeus' lyrics. Imitation also dominated Roman sculpture.[26]

The Roman perception of creativity is far removed from the "modernist value system, which from the Romantic era onwards has valorized originality and artistic genius and, in consequence, denigrated copying."[27] Seneca the Elder explained the rationale for generalized borrowing and reuse in the Latin creative tradition: "not for the sake of stealing, but of open borrowing, for the purpose of having it recognized."[28] This theme would later dominate medieval literature.[29]

Originality of theme or story was far less important for Roman authors than it is today.[30] Quintilian regarded imitation as a way to achieve excellence.[31] Vitruvius wrote: "drawing from [past authors] as it were water from springs, and converting them to our own purposes, we find our powers of writing rendered more fluent and easy, and relying upon such authorities, we venture to produce new systems of instruction."[32]

By the first century BCE, in the *Rhetorica ad Herennium*, Cicero's *Brutus* and *De Oratore*, and Dionysius of Halicarnassus' *On Imitation*, rhetorical doctrine put forward the conviction that imitation of great authors was the surest instrument for attaining excellence in creative endeavors.[33] In the Roman creative experience, originality is only one term of a function, whose desired result is excellence. Lack of originality, therefore, was unlikely to arouse disapproval or even special attention.[34]

The Roman conception of creativity extended literary *mimēsis* to the imitation of earlier literature. In the *Ars Poetica*, Horace crystallized the idea that literary *mimēsis* meant not only imitation of nature, but also imitation of literary precedents and models.[35] The literary *mimēsis* initially included exclusively Greek literature, although it was later extended to include a select group of Roman authors. In the early stages of Roman literature, there were great presumptions that the majority of dramatic writings that appeared in Rome were in great part based upon Greek works.[36]

Ancient Remix: The Art of Cento

The *cento* was originally a cloak made of patches.[37] The term was later used to refer to a form of poetry based on the rearrangement of phrases from other poems. The expression in the *cento* poems is by definition completely unoriginal, nevertheless, that expression is perhaps the highest exploitation of the knowledge of the original work. Mythological, secular, and Christian examples of both Homeric and Virgilian centos have survived.[38] The so-called *Centones Virgilianes* came into being using a great number of pieced-together phrases, ideas, and expressions from Virgil.[39] Again, the reuse of the Homeric verses by the Theodosian Empress Eudocia in the *Homerocentra* was a form of creative rhapsodic art, tightly correlated with the oral-formulaic tradition.[40] The works of Homer, Euripides, Virgil, Ovid, Cicero, and later Petrarch, Shakespeare, Goethe, and many others served as raw material for *cento* composition.[41]

The *Imitatio Vergilii*

Scott McGill noted, the *cento* "became part of a literary world that in various ways treated Virgil as an open work, or as a body of material that could be reworked to yield fresh text."[42] However, Virgil himself was a spectacular imitator of Homer and other Roman authors.[43] Macrobius provided a full account of Virgil's borrowings in the *Saturnalia*, written in the fifth-century CE. Macrobius quoted, "actual lines of Homer which Virgil has translated almost word for word,"[44] and then decided "to go through the Aeneid from the beginning, book by book."[45] Later, Macrobius "tells us of Virgil's borrowings from the old writers of Rome as well."[46] It lasted more than ten chapters of instances of verbatim duplications, borrowings, translations, and rewriting of the Homeric and Roman authors, such as Ennius, Lucretius, Furius, Lucilius, Pacuvius, Naevius, Sueius, Varius, Accius, and Catullus.[47]

Concerned with the reaction that such a massive amount of Virgil's borrowings might have had on his readers, Macrobius endeavored to plead the case of the greatness of Virgil. In doing so, Macrobius sketched out the principles of *imitatio*, and *aemulatio* that governed ancient literary creativity. According to Macrobius, "borrowing both from one another [...] is what our writers have often done."[48] Thus, poets and other writers are "partners holding in common [*haec societas et rerum communio*]."[49]

Following upon Macrobius's study, modern digital humanities research has provided a quantitative picture of text reuse and interactions between poets in the Latin hexameter tradition using the freely available *Tesserae* website.[50] *Tesserae* automatically searches pairs of texts in a corpus of over three hundred works of Latin literature in order to identify instances where short passages share two or more repeated lexemes.[51] In line with poetry scholars' conclusions on intertextual relationships in the Latin hexameter tradition, this study finds that the works of Ovid and Vergil are the most important verbal resources for the later works of the tradition.[52]

Macrobius' *Saturnalia* heavily influenced later mediaeval literature. It laid down the fundamental principles of literary description as an exercise of imitation and emulation through invention.[53] A large proportion of the most representative medieval and early Renaissance works produced in Latin, French, English, and Italian were rewrites, following Macrobius' principles of description.

The *Mouvance* and Art of Rewriting

For about two millennia, similar mechanics of creativity and authorship applied repeatedly to literary production. Bards, minstrels, jongleurs, and troubadours played the same role of ancient Greece's *aoidoi*.[54] Authors of early medieval heroic epics were anonymous, as "even in their literary form heroic tales were regarded as cultural common property rooted in an oral tradition of storytelling in which individualistic claims of authorial achievements were out of place."[55]

The fluidity of traditional epic and popular literature derived from the symbiotic relationship between oral and written tradition. In this respect, Paul Zumthor noted that the medieval work often "has no authentic text properly speaking," but was "constituted by an abstract scheme, materialized in an unstable way from manuscript to manuscript, from performance to performance."[56] *Mouvance*, as Zumthor termed it, was the defining character of the medieval text, which "was generally presumed [...] to be subject to [...] reinterpretation in the light of a new *matiere*, new understanding, new intentions, or a new audience or patron."[57] Recent screen-based visualization and computational approaches have made significant progress in analyzing and visualizing *mouvance*, variant mediaeval traditions, and textual instability.[58]

The art of rewriting, whose principles Macrobius's *Saturnalia* illustrated to medieval authors, characterized most of the medieval romance literature. Tightly connected to the *mouvance* and episodic nature of medieval text, rewritings were created by bringing together different versions or episodes of the legend to form new works. The next teller will pick them up or drop them as irrelevant, according to the environment in which the new retelling is to be told.[59] The proliferation of traditional premodern narrative evolved from the idea that "every story is constituted of many smaller stories or potential stories," because at the intersection of each unit is situated the possibility of new stories, retellings and remixing of the old.[60] This practice has come to be known as lyric

insertions in narrative. A new work was created from the adaptation and development of those borrowed elements through a *bele conjointure*—the blending of elements that is aesthetically pleasing and meaningful. The phenomenon of romance *conjointure* is, thus, described "as a *montage* or even a *collage*."[61]

Most epic and romance literature revolved around the endless exploitation of an iconic character—a hero—and his legendary deeds. Heroic characters, such as Alexander, Beowulf, King Arthur, Lancelot, and Roland became cultural icons. Their stories were repeatedly rewritten and remixed, and their features were reused and adapted to new cultural and social settings.

Social Textuality

For Chaucer, the act of writing was represented by the metaphor of gleaning the harvest of poetry reaped by others.[62] Pearsall elaborated that poems in the medieval manuscript tradition "are no one's property and the whole notion of authorship is in a way irrelevant;"[63] instead, the poetic text is an instrument to be used and not merely read.[64] Arthur Marotti spoke of social textuality, malleability, and textual instability in manuscript culture.[65] What is viewed as corruption from a modern author-centered perspective was viewed in manuscript culture as transformative elaboration, generally accepted, and often welcomed by the author. In the fourteenth and fifteenth centuries, *dérimeurs*— "de-rhymers"—turned the entire *chanson de geste* and romance tradition into prose to meet the needs of an emerging reading audience.[66] They created completely new works by adding prologues, summaries, or dividing their narrative into chapters and headings. The so-called "textual bricolage," both in medieval and modern texts, has been recently studied with text similarity recognition software, such as Factotum.[67]

Publication processes at the time had a critical role in promoting "social textuality." Publication started with the initial delivery of the text, as in the case of an oral "pronunciation."[68] Once in circulation, the text could undergo the author's corrections and revisions. Finally, publication allowed for the participation of the book producers—such as scribes, illuminators, and so on—and readers who made changes to the text they copied and reproduced. Hence, literature before print was in a permanent state of becoming, where writing became the effort of many, endlessly chiseling and adapting the text as sole authors.[69] Jean Gerson, chancellor of the University of Paris in the fifteenth century and one of the most prominent scholars and theologians of his time, wrote in the tract *In Praise of Scribes of Healthy Doctrine* that writing can endure for a thousand years whether "on its own or through the multiplying of exemplars."[70] To map this permanent writing process in manuscript culture, the *Mapping Manuscript Migrations* project links disparate datasets from Europe and North America to provide an international view of the history and provenance of medieval and Renaissance manuscripts. Researchers can analyze and visualize the aggregated data at scales ranging from individual manuscripts to thousands of manuscripts.[71]

Renaissance Workshops and Collaborative Art

The collaborative furnace of the medieval and Renaissance workshop—the *bottega*— [72]forged attitudes toward originality and copying still very different from those of our time, though an enhanced and individualized sense of authorship was powerfully

emerging.[73] Richard Spear recounts an anecdote of the artist Guido Reni that perfectly illustrates the Renaissance mechanics of creativity.[74] Pope Paul V Borghese commissioned Reni to decorate one Chapel of the Quirinal Palace. The Pope clearly spelled out that the work was to be carried out *di sua mano*, meaning by Reni's hand. One day, the Pope visited Reni's studio and, to his great dismay, caught one of Reni's assistants, Lanfranco, painting some draperies of certain figures. The day after, Reni visited the Pope and justified himself by saying "the drawing, sketching, and background painting are not the things that make up the work. [...] In addition to the ideas and the designs that are mine, I go over, finish and redo everything in a way that, if a work given to me does not turn out to be by my hand, I will be content to incur your indignation."[75]

In Reni's opinion, an original "was any work that he designed and approved of, regardless of whether retouchings were added to paintings that were not literally, 'by his own hand'."[76] In similar fashion, in a letter of May 12, 1618, Rubens responded to the complaint of Dudley Carleton, who did not want student works retouched by Rubens, by insisting that the retouched works "are not simple copies but are so well retouched by my hand that it would be difficult to tell them from the originals."[77] In sculpture, the same issues arose. When Colbert commissioned the equestrian statue of Louis XIV from Bernini, the sculptor was told to do the head himself, but to go over everything made by his assistants in such a way that it could be said that it was truly a work by Bernini.[78] The notion of originality in the context of Renaissance artists' studios, therefore, expands well beyond modern boundaries into a collaborative and collective domain.[79]

Additional complexities in grasping the attitude toward originality in the Renaissance period are connected with the tradition of making copies out of the artist's own works as well as works of other artists. In the first case, artist studios' practice substantially blurred the concept of originality by the traditional reliance on the work of assistants and students. As reported by Richard Spear: "many [...] paintings were replicated, but only a few were fully autograph[ed]; more were 'retouchings' (*ritocchi*) by [the Master] of studio versions, and a still greater number were copies by assistants."[80]

Since the mid-fifteenth century, entire workshops were organized to produce copies on a large scale, such as the workshop of the so-called Lippi and Pesellino Imitator.[81] Over forty years, this—apparently legitimate—reproductive enterprise produced more than hundred and sixty paintings derived from the paintings of Fra Filippo Lippi and Francesco Pesellino. In the case of the Lippi and Pesellino Imitator, the degree of precision between the originals and the copies was very high, perhaps by following a copying practice known as *retrahere*—to draw again—that consisted in the use of "pin-pricked drawings used like stencils to replicate the design."[82]

In a letter to Paul Fréart de Chantelou, Nicolas Poussin condemned the rampant practice of copying in the sixteenth century.[83] The chancellor of the Duke Vincenzo I of Mantua refused a group of copies by noting in a letter that the copies were "not suitable for Your Highness, who has no need for copies but rather desires originals by good hand that are worthy to stand among the many others Your Highness has by the most excellent painter."[84]

In contrast, the art collections of many important patrons, such as Cardinal Federico Borromeo or Cardinal Francesco Maria del Monte, also divided paintings according to whether they were "originals by artist of importance," or "originals by less famous painters," and "copies made with diligence."[85] In some other instances, the inventory depended only on two designations, "by hand of" and "copy of." Sometimes the copies were even accredited to be able to surpass the original. For example, part of the early

fame of Guido Reni was attributed to a copy he made of Raphael's Santa Cecilia, which was praised by experts of the time for having "a mellowness and softness that the original lacked."[86] Also Duke Cosimo de' Medici valued copies of high quality. De' Medici is reported to have said that in the case of copies that cannot be distinguished from the original "the copy should be preferred to the original because it contained both skills, that of the originator and that of the copier."[87] As David Quint noted, if the imitator had come up to his model, the counterfeit would have been equal in worth to the original.[88] Digital humanities projects, such as the Medici Archive Project,[89] allow scholars around the world to engage with new research methodologies and trajectories within an ever-growing body of digitized manuscripts to unveil renaissance attitudes toward copying.

Together with pure reproductive copying, adaptations, modifications, and alterations of previous works were commonplace for authors and commonly commissioned by their patrons. This practice often involved the remixing of other works, where faces and figures were lifted from old to new paintings. Cardinal Federico Borromeo, for example, had Raphael's profane images transformed into sacred subjects by Antonio Mariani.[90]

The Plagiarists of the Stage

Extensive—and unacknowledged—appropriations were commonplace in early modern England, especially in drama, though widespread in all literary fields.[91] The *Mock Astrologer* of Dryden is a manifesto of proud plagiarism, and self-conscious reuse of others' plots and stories. In the play's prologue, Dryden laid down his own apologia of plagiarism:

> I am taxed with stealing all my plays [...] [i]t is true that whenever I have liked any story in a romance, novel or foreign play, I have made no difficulty, nor ever shall to take the foundation of it, to build it up, and to make it proper for the English stage.[92]

In writing his play, Dryden had drawn on Pedro Calderón de la Barca's *El Astrologo Fingido* and Thomas Corneille's *Le Feint Astrologue*, from which, by Dryden's own admission, he "rejected some adventures [...] heightened those which [he had] chosen; and [...] added others which were neither in the French or Spanish."[93]

Shakespeare was, in modern terms, a plagiarist on a vast scale. Robert Greene described his younger contemporary, Shakespeare, as "an upstart crow beautified with our feathers."[94] According to Malone, out of 6033 lines of Parts I, II, and III of *Henry VI*, Shakespeare copied 1771 verbatim and paraphrased 2373.[95] Whole passages of *Antony and Cleopatra*, to take just one example, were line-by-line versifications of historical prose works.[96] Again, in *The Tempest*, Gonzalo's description of the ideal state was a word-for-word transposition of Michel de Montaigne's essays *Of the Cannibals*, as translated by John Florio in 1603.[97] Digital humanities could shed further light on the appropriative creative practices of the immortal bard. A digital project called *Shakespeare His Contemporaries* focused on promoting corpus-wide inquiries into Early Modern Drama. This body of work includes five hundred or so non-Shakespearean plays or play-like texts printed before 1660. In 2013, 493 plays written between 1576 and 1642 were completely transcribed and mapped to create a virtual corpus to allow new forms of

exploration on the whole body of text. It is aimed at promoting research on intertextual parallels, patterns, and themes as well as the historical and social contexts of Early Modern Drama.[98]

Borrowing flourished in sixteenth century England to such an extent that Sir Sidney Lee noted: "[t]he full story of the Elizabethan sonnet is, for the most part, a suggestive chapter in the literary records of plagiarism."[99] As Harold White noted: "[n]ot only were Englishmen from 1500 to 1625 without any feeling analogous to the modern attitude toward plagiarism; they even lacked the word until the very end of that period."[100]

In the seventeenth and early eighteenth century, plagiarism was also a consequence of the manuscript culture that still resisted a definitive surrender to print.[101] The late Renaissance and the early Enlightenment were the ages of the commonplace book, manuscript miscellanies, and coterie circulation. Particularly in England, the practice of any aspiring authors or scholars of copying and arranging passages from one's reading—so called "commonplacing"—in a "commonplace book" still promoted a cultural environment of considerably open and unacknowledged reuse.[102] In this regard, the Commonplace Cultures project is meant to study and explore the intertextuality and intellectual relationships of eighteenth century and pre-eighteenth century texts by searching over forty million instances of shared passages.[103] The art of commonplacing allowed individuals to master a collective literary culture and "the 18th century can be seen as one of the last in a long line of 'commonplace cultures' extending from Antiquity through the Renaissance and Early Modern periods."[104] The Commonplace Cultures project uncovers this nexus of intertextual activities through the use of sequence alignment algorithms to compile a database of potential commonplaces drawn from the massive ECCO (Eighteenth Century Collections Online) collection.[105]

Struggling with the "construction of a new sense of self-identity, defined through the dialectic of memory (tradition) and autonomy (originality),"[106] Jonson, Pope, Dryden, and Milton all had to face accusations of plagiarism. In his *Timber*, Ben Johnson is borrowing heavily from the ancients, with twenty-five excerpts from Quintilian, twenty-one from the younger Seneca, eleven from the elder Seneca, and several others from Horace, Plutarch, the younger Pliny, Aristotle, and Plato.[107] Voltaire found that Milton's *Paradise Lost* had reproduced more than two hundred verses from the *Sarcotis* of the Jesuit Masenius, though he concluded that Milton "imitated only what was worthy of being imitated."[108] The paternity of *Paradise Lost* has long been under scrutiny. An extensive monograph of an Italian researcher, Zicari, purported to show that Milton's epic was sired by *Adam Caduto*, a tragedy written by the Calabrian monk, Serafino della Salandra.[109]

The Romantic Sunset of Remix Culture

Targeting Dryden and many at the end of the seventeenth century, Gerard Langbaine published a comprehensive account of plagiarism in English drama, showing how widespread the practice was.[110] As Paulina Kewes argued, since Langbaine's publication, the insisted accusations of plagiarism that spared few authors marked a changing cultural paradigm.[111]

The imitative, cumulative, and collaborative nature of creativity persisted well into the Romantic period, as British authors were repeatedly accused of alleged plagiarism. In the early nineteenth century, appropriation strategies had been most famously

associated with Samuel Taylor Coleridge,[112] but Wordsworth, Shelley, and Byron also collected their share of accusations. According to a study of Tilar Mazzeo, *Plagiarism and Literary Property in the Romantic Period,* early nineteenth century British authors: "consistently privileged strategies of textual appropriation even as they emphasized the value of originality."[113] Mazzeo concludes: "[t]he almost exclusive association of Romanticism with self-origination is largely a belated critical invention."[114]

As Mazzeo noted: "the cultural conventions of Georgian Britain privileged as literary achievements those novels, dramas, and especially poems that demonstrated mastery over a range of sources, and writers were given broad license to borrow from the works of other authors so long as the appropriations satisfied particular aesthetic objectives and norms."[115] In sharp contrast with modern cultural conventions and legal provisions, these norms included borrowing from familiar and well-known sources, improvements and unconscious borrowing among those creative practices that did not constitute plagiarism. In this context, trying to accommodate the tension between originality, appropriation, and plagiarism, so powerfully lacerating in his authorial persona, Coleridge justified one notorious accusation of plagiarism from Schelling by claiming: "I regard the Truth as a divine Ventriloquist: I care not from whose mouth the sounds are supposed to proceed, if only the words are audible and intelligible."[116]

The fundamental change in premodern and modern perceptions of creativity—and construction of plagiarism—takes place at around the time Edward Young in the Conjectures on Original Composition writes: "[t]he mind of a man of Genius […] enjoys a perpetual Spring. Of that Spring, Originals are the fairest flowers: Imitations are of quicker growth, but fainter bloom."[117] Plagiarism became a "sordid Theft" to be ruled out altogether.[118] Soon thereafter, Kant will state: "*originality* must be [the] first property [of aesthetics]."[119] By the beginning of the nineteenth century, Hegel would note: "an ingenious and trivial idea, and a change in external form, is rated so highly as originality and a product of independent thinking that the thought of plagiarism becomes wholly insufferable."[120] From this time on, Groom writes: "the severity of the accusation [of plagiarism] indicates an anxiety of originality becoming an obsession, with the concomitant fears that the sacred well of individual genius can be poisoned or simply drawn dry by intruders."[121]

It is worth noting that, from a historical perspective, the issue in plagiarism is not one of intentionality but of originality vs. imitation. This reflects in copyright standards as well. Arguably, copyright law would contradict a construction of plagiarism as an intentionally deceitful and dishonest act as copyright infringement is a strict liability offense that does not depend on any mental condition.[122] In addition, copyright law knows of "subconscious infringement" according to which innocent copying is not an excuse for infringement as "intention to infringe is not essential to the [copyright] act."[123] Or, again, as Judge Learned Hand puts it, it is "no excuse that memory played a trick."[124]

The Return of (Digital) Remix

For millennia, we have created under a paradigm that promoted creativity through appropriation and the art of rewriting. Yet somehow, the post-Romantic individualistic view emphasized absolute originality and sidelined imitation, collaboration, cumulative creativity, and what we commonly call "remix" today in the discourse on creativity.[125] This theoretical view influenced policy discourse with the emergence of increasingly

restrictive exclusive intellectual property rights.[126] Today, however, in an era of networked mass collaboration; ubiquitous online fan communities; user-based creativity; and digital memes, appropriation, reuse, and collaboration are reemerging in creative practices.

A growing percentage of the creative material being produced in the digital environment is generated by users. Those formally known as the audience have become active participants in their own culture.[127] In this Digital Renaissance—as Lawrence Lessig explained in *Remix*—a read/write culture displaced a read-only culture.[128] In its postmodern reinterpretation of authorship, remix seems to respond to newly reinvigorated ethics of collaboration, and sharing that closely resemble those of pre-copyright creative production.

According to Brett Gaylor's *Remix Manifesto*: "a media literate generation emerged, able to download the world's culture and transform it into something different that we call our new language: remix."[129] Reuse, remix, mashup, and appropriation are at the core of the digital creative process. Remix creativity has emerged as a new cultural motif.[130] Remix is not only a cultural revolution, it is a linguistic revolution or better, it is a "revolutionary" language. In cyberspace, language has evolved and become more complex to include all media. Remix is an advanced metalinguistic device to express meaning, but it is also intrinsically a form of political speech.

Numerous new and old forms of creativity—such as fanfiction, fanvids, mashup, machinima, or trackjacking—are flourishing in online remix communities.[131] Digital technology and networked distribution transformed isolated practices into a globally diverse phenomenon.[132]

The Internet may be a privileged venue for reproducing the mechanics of the oral tradition as also highlighted by the Pathways Project, an early exercise in digital humanities research that built an open access suite of chapter-nodes, linked website, and multimedia meant to explore the relationship between oral tradition and networked communication.[133] It is difficult to overlook the special connection that the mechanics of premodern creativity shares with post-modern forms of digital creativity.

Sampling corresponds to the oral tradition's formula. The formula, the single unit to be used and reused, worked, and reworked, is the inspiring paradigm of remix culture. Moreover, digital creativity re-implements the same mechanics of pre-copyright creativity that conceptualized borrowing and copying as a necessary tribute to previous works. As in the premodern tradition, digital creativity deploys appropriation and borrowing as imitative and emulative instruments. From fanfiction to machinima and fangames, from thematic "sims" in virtual worlds to vidding or musical mashups, modern digital creativity is made of appropriation, borrowing, and imitation that creates new meanings and finds new inferences; they are intended to pay tribute to commercial popular culture's iconography as well as to challenge, deconstruct, and overcome it.

Social textuality and intertextuality, which are dominating features of premodern creativity, play a pivotal role in the digital domain as well. On one hand, the intertextual nature of medieval literary culture, as a constant reference to authority and tradition to which the textile metaphor of the word "text" evokes, shows an affinity with the hypertextuality of digital culture and creativity. Linking is a built-in feature of creativity produced in a digital environment. On the other hand, the social malleability of the text in premodern manuscript culture finds a parallel in mass-collaborative projects in the digital environment, such as Wikipedia.

Finally, the networked society sets preconditions for a social and collaborative idea of authorship that resembles the premodern collectivistic idea of creativity. Digital creativity is deeply intertwined with communitarian actions and reactions. In the digital environment, creativity returns to be an inclusive, rather than exclusive, medium. This may suggest that, in the networked information ecosystem, we are witnessing the demise of the individualistic idea of authorship that gave birth to our copyright system.

The parallels between formula, remix, and mashup, social textuality and mass-collaboration in the manuscript and digital culture may suggest an emerging inconsistency between the post-Romantic paradigm of authorship and the present cultural and creative landscape. It suggests that the communal, collaborative role of creativity should be emphasized and promoted. The emergence of a digital participatory culture may offer an opportunity to realign creativity with its original participatory nature. In particular, the Digital Revolution's collaborative nature may reinforce arguments challenging the commodification of information and culture. As in premodern culture, inclusivity in the discourse over creativity has regained momentum with the digital environment's emphasis on community, participation, and cumulative production. Re-emerging social consciousness indicates that creativity must serve as an instrument to empower the individual to be part of a community, rather than stand outside of it. Creativity in the digital environment tends toward inclusivity rather than exclusivity.

An evidentiary basis for challenging maximalist copyright approaches, and for devising alternative solutions, may thus be found in the premodern mechanics and economics of creativity. In this search, digital humanities can be of great aid. Research and scholarship in history, literature, and the arts is changing by using high-performance computers and vast stores of digitized materials. "Culturomics," as the new field of study has been termed, should extend "the boundaries of rigorous quantitative inquiry to a wide array of new phenomena spanning the social sciences and the humanities."[134]

Digital humanities can reveal unexplored patterns and trends by analyzing unprecedented amounts of data. Since 2009, Google has made a gigantic database from millions of digitized books available to the public for free online searches.[135] The general principle behind this and other projects is digitally researching through large libraries of books and text to see how ideas first appeared and spread. Researchers are using databases of thousands of jam sessions to track how musical collaborations influenced jazz,[136] building web applications to visualize the list and distribution of Dante's primary sources,[137] or coding plays to understand the evolution of performances of early modern travelling theatre.[138] Obviously, digital humanities research can make it more than clear that people have always borrowed and built on the work of others. It can even enable the detection of correlations not necessarily perceivable to a human observer. For example, a comparison using the newly developed DIAS/DENDRON ART (DDA) software of fifty-five oil paintings by Paul Cézanne suggests that Cézanne's *Baigneuse debout, s'essuyant les cheveux*, is highly related to Veronese's *Les Noces de Cana*, in color, saturation, brightness, and complexity.[139] Further computer-assisted analysis suggests that Cézanne drew from Veronese a "hidden" compositional structure to organize his Bather paintings.[140] Empirical data collection and processing through advanced computational tools—that define research in digital humanities—may empower a discourse about the complex matrix of influence, borrowing, and reuse that characterizes creativity at large as "remix" creativity, while defying entrenched modern assumptions on the immutable, individualistic nature of creativity.

Notes

1 I wish to thank my RA, Varnita Singh, for valuable assistance given in preparing this chapter. Please note that this chapter is a remix of plenty of miscellaneous previous writings, including Giancarlo Frosio, *Reconciling Copyright with Cumulative Creativity: The Third Paradigm* (Cheltenham: Edward Elgar, 2018); Giancarlo Frosio, "A History of Aesthetics from Homer to Digital Mashups: Cumulative Creativity and the Demise of Copyright Exclusivity," *Law and Humanities* 9, no. 2 (2015):262–96; Giancarlo Frosio, "Rediscovering Cumulative Creativity from the Oral-Formulaic Tradition to Digital Remix: Can I Get a Witness?," *The John Marshall Review of Intellectual Property Law* 13, no. 2 (2014):341–95.

2 I am aware of the fact that the use of the word "remix," as we understand it today, did not exist prior to modernism, and the term remix itself was not really used extensively until the twentieth century. The use of the word remix in a premodern context is an approximation.

3 The research in this chapter predominantly focuses on Western cultural history, appropriation, reuse, and remix practices. It does so for obvious reasons related to the origins and cultural background of the author but also because the paradigm shift that this chapter describes has been inherently a Western experience. Exclusive rights over creativity are an Enlightenment and Romantic construction. The same cultural transformation has not taken place in the rest of the world. Western countries have finally forcefully imposed on the rest of the world their post-Romantic creative paradigm—and regulatory framework—as part of the Agreement on Trade-Related Aspects of Intellectual Property Rights (TRIPS) and the General Agreement on Tariffs and Trade (GATT), where developing and emerging economies have signed on expansive intellectual property rights in exchange of better terms on tariffs on essential goods.

4 In this chapter, I assume that unauthorized remix infringes copyright, both the right of reproduction, the right to make derivative works or adaptations and the right of display/performance/communication to the public, whichever is relevant depending on legal frameworks that differ from jurisdiction to jurisdiction.

5 Norbert Aujoulat, *Lascaux: Movement, Space, and Time* (New York: H N Abrams, 2005); Mario Ruspoli, *The Cave of Lascaux: the Final Photographs* (New York: H N Abrams, 1987).

6 Jean-Marie Chauvet, Eliette Brunel Deschamps, and Christian Hillaire, *Chauvet Cave: The Discovery of the World's Oldest Paintings* (London: Thames & Hudson, 2001) (1996); Jean Clottes, *Chauvet Cave: The Art of Earliest Times* (Salt Lake City: University of Utah Press, 2003); Jean Clottes, *Cave Art* (New York: Phaidon Press, 2008).

7 Hannah Devlin, "Earliest Known Cave Art by Modern Humans Found in Indonesia" (*The Guardian*, December 11, 2019), https://www.theguardian.com/science/2019/dec/11/earliest-known-cave-art-by-modern-humans-found-in-indonesia.

8 Henri Breuil, *Four Hundred Centuries of Cave Art* (New York: Hacker Art Books, 1979) (1952), 22–3. See also Arnold Hauser, *The Social History of Art* (London: Routledge, 1999) (1951), 3–8.

9 Xiangtangshan Caves Project, https://xts.uchicago.edu.

10 Plato, "Cratylus" [423cd] in XII *Plato in Twelve Volumes*, trans. Harold Fowler (Cambridge: Harvard University Press, 1921). See also, e.g., Willem Verdenius, *Mimesis: Plato's Doctrine of Artistic Imitation and Its Meaning to Us* (Leiden: Brill Archive, 1972).

11 Aristotle, "Poetics" [1448b] in XXIII *Aristotle in 23 Volumes*, trans. WH Fyfe (Cambridge: Harvard University Press, 1932).

12 Eusebious Pamphili, *Evangelicae Preparationis*, 465d, in ed. Edwin Hamilton Gifford (Oxford: Typographeo Academico, 1903); See George Putnam, *Authors and Their Public in Ancient Times: A Sketch of Literary Conditions and of the Relations with the Public of Literary Producers, from the Earliest Times to the Fall of the Roman Empire* (New York: GP Putnam's Sons, 1893), 69–70.

13 Milman Parry, *The Making of Homeric Verse* (New York: Arno Press, 1980) (1971), 272.

14 The Chicago Homer, https://homer.library.northwestern.edu/.

15 Albert Bates Lord, *The Singer of Tales* (Cambridge: Harvard University Press, 2000) (1960), 36.

16 Jan de Vries, *Heroic Song and Heroic Legend* (Oxford: OUP, 1963), 10–1 (noting that "Homer is the crowning end of a long development").

17 Hauser, *The Social History of Art*, 57.

18 Barry Powell, *Homer* (Hoboken, NJ: Blackwell Publishing, 2007), 30.

19 Henry Wade-Gery, *The Poet of the Iliad* (Cambridge: CUP, 1952), 38–9.

20 Nagy, *Homeric Questions*, 41–3 (positing at least five distinct consecutive periods of Homeric transmission).

21 Robert Culley, "Oral Tradition and the Old Testament: Some Recent Discussion," in *Oral Tradition and Old Testament Studies*, ed. Robert Culley (Riga: Scholars Press, 1976), 1–33.

22 Geoffrey Kirk, *The Songs of Homer* (Cambridge: CUP, 1962), 56–7.

23 John Brockington, "The Textualization of the Sanskrit Epics," in *Textualization of Oral Epic*, ed. Lauri Honko (Berlin: Walter de Gruyter, 2000), 39.

24 Henri-Jean Martin, *The History and Power of Writing* (Chicago, IL: University of Chicago Press, 1994) (1988), 114–5.

25 Arno Reiff, "Interpretatio, imitatio, aemulatio: Begriff und Vorstellung literarischer Abhängigkeit bei den Römern" (PhD diss., Universitat Köln, 1959).

26 Elaine Gazda, "Roman Sculpture and the Ethos of Emulation: Reconsidering Repetition," *Harvard Studies Classical Philology* 97 (1995): 121; Rosalind Krauss, "Retaining the Original? The State of the Question" in *Retaining the Original: Multiple Originals, Copies, and Reproductions*, ed. Kathleen Preciado (London: National Gallery of Art, 1989), 7–12.

27 Elaine Gazda, "Beyond Copying: Artistic Originality and Tradition," in *The Ancient Art of Emulation: Studies in Artistic Originality and Tradition from the Present to Classical Antiquity*, ed. Elaine Gazda (University of Michigan Press, 2002), 2.

28 Seneca the Elder, Suasoriae, 37 as cited in Gian Biagio Conte, *The Rhetoric of Imitation: Genre and Poetic Memory in Virgil and Other Latin Poets* (Ithaca, NY: Cornell University Press, 1986), 32.

29 Jan Ziolkowski, "The Highest Form of Compliment: Imitatio in the Medieval Latin Culture," in *Poetry and Philosophy in the Middle Ages: A Festschrift for Peter Dronke*, ed. John Marenbon (Amsterdam: BRILL, 2001).

30 Katharina de la Durantaye, "The Origins of the Protection of Literary Authorship in Ancient Rome," *Boston University International Law* Journal 25 (2007): 37, 70.

31 Marcus Fabius Quintilianus, *IV The Institutio Oratoria*, trans. Harold Butler (Portsmouth: W Heinemann, 1922), § 1021–2.

32 Vitruvius Pollio, *De Architectura*, Book VII, Introduction, 10, in *Ten Books on Architecture*, trans. Morris Morgan (Cambridge: Harvard University Press, 1914).

33 Ziolkowski, "The Highest Form of Compliment," 300.

34 Durantaye, "The Origins of the Protection of Literary Authorship in Ancient Rome," 106.

35 Quintus Horatius Flaccus, "Ars Poetica," ln 119–34, in *The Works of Horace: Translated Literary into English Prose*, trans. Christopher Smart (London: Harper & Brothers, 1863), 306.

36 Putnam, *Authors and Their Public in Ancient Times*, 177–8.

37 Douglas Adams, "Clothing," in *Encyclopedia of Indo European Culture*, eds. Douglas Adams and JP Mallory (Milton Park: Taylor & Francis, 1997), 110.

38 Scott McGill, *Virgil Recomposed: The Mythological and Secular Centos in Antiquity* (Oxford: OUP, 2005), xv–xvi.

39 Ibid.

40 Eudocia Augusta, *Homerocentones*, ed. Mark Usher (Oxford: Teubner, 1999).

41 McGill, *Virgil Recomposed*, 1–21, 92–113.

42 Ibid, xviii.

43 Macrobius, *The Saturnalia*, 290–343 (V3–13) (where Macrobius describes Virgil's adaptations of Latin writers).

44 Ibid, 290 (V31).

45 Ibid, 295 (V41).

46 Ibid, 385 (VI11).

47 Ibid, 290–343 (V3–13), 386–409 (VI1–3).

48 Ibid, 385–86 (VI12–5).

49 Ibid.

50 Neil Bernstein, Kyle Gervais, and Wei Lin, "Comparative Rates of Text Reuse in Classical Latin Hexameter Poetry," *Digital Humanities Quarterly* 9, no. 3 (2015), http://digitalhumanities.org:8081/dhq/vol/9/3/000237/000237.html.

51 Tesserae, tesserae.caset.buffalo.edu.

52 Bernstein, Gervais, and Lin, "Comparative Rates of Text Reuse in Classical Latin Hexameter Poetry," 41.

53 Douglas Kelly, *The Conspiracy of Allusion: Description, Rewriting, and Authorship from Macrobius to Medieval Romance* (Leiden: BRILL, 1999), 36–78.

54 Francis Magoun, "The Oral-Formulaic Character of Anglo-Saxon Narrative Poetry," *Speculum* 28 (1953): 446; John Foley, *Traditional Oral Epic: The Odyssey, Beowulf and the Serbo-Croatian Return-Song* (Berkeley, CA: University of California Press, 1991), 33.

55 Sebastian Coxon, *The Presentation of Authorship in Medieval German Narrative Literature 1220–1290* (Oxford: Clarendon Press, 2001), 146.

56 Paul Zumthor, *Speaking of the Middle Ages* (Lincoln: University of Nebraska Press, 1986), 96.

57 Douglas Kelly, *The Art of Medieval French Romance* (Madison: University of Wisconsin Press, 1992), 68.

58 Stefan Jänicke and David Wrisley, "Visualizing Mouvance: Toward a Visual Analysis of Variant Medieval Text Traditions," *Digital Scholarship in the Humanities* 32, no. 2 (2017):106–23.

59 Nancy Bradbury, *Writing Aloud: Storytelling in Late Medieval England* (Champaign: University of Illinois Press, 1988), 164; Kroeber, *Retelling/Rereading*, 55–76.

60 Karl Kroeber, *Retelling/Rereading: The Fate of Storytelling in Modern Times* (New Brunswick: Rutgers University Press, 1992), 78.

61 Kelly, *The Conspiracy of Allusion*, 214.

62 Geoffrey Chaucer, *The Legend of Good Women*, Prologue, G version 61-5 as cited in Burrow (n 139) 34.

63 Ibid.

64 Derek Pearsall, *Old and Middle English Poetry* (London: Routledge and Kegan Paul, 1977), 221.

65 Arthur Marotti, *Manuscript, Print, and the English Renaissance Lyric* (Ithaca, NY: Cornell University Press, 1995), 135–59.

66 Martin, *The History and Power of Writing*, 165.

67 Tomas Zahora et al., "Deconstructing Bricolage: Interactive Online Analysis of Compiled Texts with Factotum," *Digital Humanities Quarterly* 9, no. 1, (2015), http://digitalhumanities.org:8081/dhq/vol/9/1/000203/000203.html.

68 Elizabeth Eisenstein, *The Printing Press as an Agent of Change: Communications and Cultural Transformations in Early Modern Europe* (Cambridge: CUP, 1980), 11.

69 Hobbins (n 148) 154.

70 Jean Charlier de Gerson, *In Praise of Scribes of Healthy Doctrine* (1423) as cited in Hobbins (n 148) 166.

71 Mapping Manuscript Migrations, https://mappingmanuscriptmigrations.org.

72 Peter Burke, *The Italian Renaissance: Culture and Society in Italy* (Princeton: Princeton University Press, 1999), 51–75; Evelyn Welch, *Art and Society in Italy 1350–1500* (Oxford: OUP, 1997), 81–91; Arnold Hauser, *II The Social History of Art* (London: Routledge, 1999) (1951), 48–9.

73 David Quint, *Origin and Originality in Renaissance Literature: Versions of the Source* (New Heaven: Yale University Press, 1983) (discussing the counterfeit and the original in Renaissance art and literature).

74 Richard Spear, *The "Divine" Guido: Religion, Sex, Money, and Art in the World of Guido Reni* (New Heaven: Yale University Press, 1997).

75 Carlo Malvasia, *The Life of Guido Reni* (University Park: Penn State University Press, 1980) as cited in Spear, *The 'Divine Guido*, 253.

76 Ibid.

77 Letter from Rubens to Dudley Carleton (12 May 1618) as cited in Spear, *The "Divine" Guido*, 253.

78 Rudolf Wittkower, "The Vicissitudes of a Dynastic Monument: Bernini's Equestrian Statue of Louis XIV," in *De Artibus Opuscula XL: Essays in Honor of Erwin Panofsky*, ed. Millard Meiss (New York: New York University Press, 1960), 521.

79 Wade Saunders, "Making Art, Making Artist," *Art in America* 81 (1993):70.

80 Spear, *The "Divine" Guido*, 253.

81 Megan Holmes, "Copying Practices and Marketing Strategies in a Fifteenth-Century Florentine Painter's Workshop," in *Artistic Exchange and Cultural Translation in the Italian Renaissance City*, eds. Stephen Campbell and Stephen Milner (Cambridge: CUP, 2004).

82 Ibid., 41.

83 Letter from Nicolas Poussin to Paul Fréart de Chantelou (12 January 1644) as cited in Spear, *The "Divine" Guido*, 266.

84 Spear, *The "Divine" Guido*, 267.

85 Ibid.

86 Malvasia, *The Life of Guido Reni* as cited in Spear, *The "Divine" Guido*, 269–70.

87 Giulio Mancini, *Considerazioni sulla Pittura* (Rome: Accademia Nazionale dei Lincei, 1956) (1619), 135.

88 Quint, *Origin and Originality in Renaissance Literature*, 1–3.

89 The Medici Archive Project, https://www.medici.org.

90 Federico Borromeo, *Musaeum Bibliothecae Ambrosianae* (1625) as cited in Pamela Jones, *Federico Borromeo and the Ambrosiana: Art and Patronage in Seventeenth Century Milan* (Cambridge: CUP, 1993), 138–9.

91 Paulina Kewes, *Authorship and Appropriation: Writing for the Stage in England 1660–1710* (Oxford: OUP, 1998).

92 John Dryden, "Preface to the Mock Astrologer" (1671), in *The Critical and Miscellaneous Prose Works of John Dryden, Now First Collected*, ed. Edmond Malone (London: Baldwin and Son, 1800), 202.

93 Ibid., 203.

94 Robert Greene, *Groatsworth of Wit* (Hoboken, NJ: BE Blackwell, 1919) (1592), 83.

95 Lindey, *Plagiarism and Originality*, 75.

96 William St Clair, "Metaphors of Intellectual Property," in *Privilege and Property Essays on the History of Copyright*, eds. Ronan Deazley, Martin Kretschmer and Lionel Bently (Cambridge: Open Book Publishers, 2010), 384.

97 Samuel Delany, *Longer Views: Extended Essays* (Middletown: Wesleyan University Press, 1996), 225; Lindey, *Plagiarism and Originality*, 74–5.

98 Martin Mueller, "Shakespeare His Contemporaries: Collaborative Curation and Exploration of Early Modern Drama in a Digital Environment," *Digital Humanities Quarterly* 8, no. 3 (2014), http://digital-humanities.org:8081/dhq/vol/8/3/000183/000183.html.

99 Sidney Lee, "The Elizabethan Sonnet," in *The Cambridge History of English Literature* (Cambridge: CUP, 1918), 248.

100 Harold White, *Plagiarism and Imitation during the Early Renaissance* (Cambridge: Harvard University Press, 1935), 202.

101 Margaret Ezell, *Social Authorship and the Advent of Print* (Baltimore: John Hopkins University Press, 1999), 21–40.

102 Steven Berlin Johnson, "The Glass Box and the Commonplace Book," transcript of the Hearst New Media Lecture, Columbia University, New York, April 22, 2010, http://www.stevenberlinjohnson.com/2010/04/the-glass-box-and-the-commonplace-book.html.

103 Commonplace Cultures: Digging into eighteenth-century literary culture, http://commonplacecultures.org.

104 Ibid.

105 ECCO, https://www.gale.com/intl/primary-sources/eighteenth-century-collections-online.

106 Commonplace Cultures, About, Description of the Project, http://commonplacecultures.org/?page_id=291.

107 Lindey, *Plagiarism and Originality*, 78.

108 Voltaire, *Philosophical Dictionary*, trans. HI Woolf (New York: Alfred Knopf, 1924), 217–8.

109 Lindey, *Plagiarism and Originality*, 77.

110 Gerard Langbaine, *Momus Triumphans: or, The Plagiaries of the English Stage; Expos'd in a Catalogue* (London: Nicholas Cox, 1688).

111 Kewes, *Authorship and Appropriation*, 96–129.

112 Thomas Mallon, *Stolen Words: Forays into the Origins and Ravages of Plagiarism* (Boston: Ticknor & Fields, 1989), 26–40 (discussing Coleridge plagiarism).

113 Tilar Mazzeo, *Plagiarism and Literary Property in the Romantic Period* (Philadelphia: University of Pennsylvania Press, 2007), xi. But see Rebecca Moore Howard, *Standing in the Shadow of Giants: Plagiarists, Authors, Collaborators* (Stamford: Ablex Publishing, 1999) 67, 76 (noting that "by the dawn of the Romantic era, it was no longer acceptable to stand on the shoulders of predecessor").

114 Mazzeo, *Plagiarism and Literary Property in the Romantic Period*, xi.

115 Ibid., 5.

116 Samuel Taylor Coleridge, *Biographia Literaria: Or, Biographical Sketches of My Literary Life and Opinions* (London: Rest Fenner, 1817), 153.

117 Edward Young, *Conjectures on Original Composition In a letter to the Author of Sir Charles Grandison* (London: A Millar and J Dodsley, 1759), 7.

118 Ibid., 15.

119 Immanuel Kant, "Kritik der Urteilskraft" § 46, in *Kant's Critique of Judgment*, trans. JH Bernard (London: Macmillan and Co., 1892) (1790), 189.

120 Georg Friedrich Hegel, *Philosophy of Rights*, trans. Thomas Knox (Oxford: Clarendon Press, 1967) (1821), § 69.

121 Nick Groom, "Forgery, Plagiarism, Imitation, Pegleggery," in *Plagiarism in Early Modern England*, ed. Paulina Kewes (London: Palgrave, 2003), 77.

122 In this context, it should be clarified that copyright infringement is a form of plagiarism. Justice Learned Hand once said, "[b]orrowed the work must indeed not be, for a plagiarist is not himself pro tanto an 'author'". *Sheldon v. Metro-Goldwyn Pictures Corporation*, 81 F.2d 49, 54 (2d Cir. 1936). However, the notion of plagiarism reaches beyond that of copyright infringement and includes copying, and passing off as one's own, content that is actually unprotected under copyright law. Copyright law protects expression rather than ideas. Only the improper appropriation of protectable expressions through copying would trigger copyright infringement. The appropriation of ideas—or in any event arguments that are not qualified enough to be protected as expressions under copyright law—does not trigger copyright infringement but may be reached by social norms that construe it as an act of plagiarism.

123 *Buck v. Jewell-LaSalle Realty Co.*, 283 US191, 198 (1931).

124 *Fisher v. Dillingham*, 298 F. 145 (SDNY 1924).

125 Frosio, *Reconciling Copyright with Cumulative Creativity*, 147–174.

126 Ibid., 187–240.

127 Jay Rosen, "The People Formerly Known as the Audience," (*Pressthink*, June 27, 2006), http://archive. pressthink.org/2006/06/27/ppl_frmr.html.

128 Lawrence Lessig, *Remix: Making Art and Commerce Thrive in the Hybrid Economy* (London: Bloomsbury, 2008), 28–33.

129 Brett Gaylor, dir., Rip: A Remix Manifesto, https://www.youtube.com/watch?v=quO_Dzm4rnk.

130 Lessig, *Remix*, 51–84.

131 Frosio, *Reconciling Copyright with Cumulative Creativity*, 288–97.

132 Lessig, *Remix*, 69 ("the Internet didn't make these other forms of 'writing' [...] significant [...] [b]ut the Internet and digital technologies opened these media to the masses").

133 The Pathways Project, Oral Tradition and Internet Technology, http://www.pathwaysproject.org/pathways/show/HomePage (the project is now discontinued but can be seen at the Internet Archive). See also John Foley, *Oral Tradition and the Internet: Pathways of the Mind* (Champaign: University of Illinois Press, 2012).

134 Jean-Baptiste Michel et al., "Quantitative Analysis of Culture Using Millions of Digitized Books," *Science* 331, no. 6014 (2010):176–82. See also John Bohannon, "Google Opens Books to New Cultural Studies," *Science* 330, no. 6011 (2010):1600.

135 Google Books, Ngram Viewer, https://books.google.com/ngrams.

136 Ricardo Nuno Futre Pinheiro, "The Creative Process in the Context of Jazz Jam Sessions," *Journal of Music and Dance* 1(1) (2011):1–5.

137 Dante Sources, http://perunaenciclopediadantescadigitale.eu/dantesources/en/index.html.

138 Kevin Chovanec, "Episodic Theater and the Digital Text: Editing the Traveling Players' Fortunatus," *Digital Humanities Quarterly* 14, no. 1 (2020), http://digitalhumanities.org:8081/dhq/vol/14/1/000444/000444.html#robinson1996.

139 Melinda Weinstein, Edward Voss, and David Soll, "Dendrography and Art History: A Computer-Assisted Analysis of Cézanne's Bathers," *Digital Humanities Quarterly* 13(3) (2020), http://digitalhumanities.org:8081/dhq/vol/13/3/000423/000423.html.

140 Ibid.

2

THE MORE THINGS CHANGE

Who Gets Left Behind as Remix Goes Mainstream?

*Fernanda R. Rosa, Maggie Clifford,
and Aram Sinnreich*

This chapter examines the results of a longitudinal study based on data from three surveys (fielded in 2010, 2014, and 2017) that reflect developments in the practices and demographics of "configurable culture" in the United States over a period during which Internet usage changed radically, including the widespread proliferation of mobile and app-based access, and the rise of social media as a dominant platform for socializing and information sharing.

We use the term "configurable culture" as we have in past research[1] to encompass a range of different cultural practices and artifacts, including, but not limited to, mashups, memes, remixes, mods, and machinima. While these practices and artifacts vary in their specificities, they share many attributes in common.

First of all, these new cultural forms are intimately tied to the widespread proliferation of networked digital media production and distribution platforms. While "tape culture" and zine subcultures,[2] ascendant from the 1960s through the 1990s, relied on the physical cutting and pasting of magnetic tape and paper media, the relative ease of use and accessibility of digital "cut-and-paste" platforms have helped to mainstream many of the aesthetics and ethics first explored in these earlier styles and subcultures. Additionally, while the distribution of tape and paper-based media were contingent on the use of the postal service and face-to-face meetups, the products of digital cut-and-paste cultural practices may be distributed freely, globally, and without incremental costs per copy among billions of Internet users.

Second, configurable cultural forms share the attribute of a modular structural logic. This applies both to their aesthetic forms (iterative, rather than linear), and to their industrial forms (in contrast to the "distribution chain" that characterizes mass media and other forms of mass production). Thus, for a configurable cultural form, no work has

single origin or a single endpoint; each work may become an element in another work, and each terminus in the creative process may become the starting point for another.

Finally, as a consequence of the factors discussed above the traditional concept of "authorship," which has dominated Western understandings of cultural expression since the Renaissance era, is tacitly undermined, and at times explicitly challenged, by the structures and aesthetics of configurable cultural production. The lines separating artist from audience, and production from consumption, which have always been a bit blurry at the borders, become nearly impossible to apply. Consider, for example, the "Y U NO" meme, in which a portion of an image from a manga comic was flipped horizontally, superimposed on a crudely drawn stick figure, and initially shared to a Tumblr blog with added text reading "I TXT U, Y U NO TXT BAK!?" Within a relatively short span of time, tens of thousands of variations on this textual theme were also superimposed on the image and shared via an array of social media platforms. In a cultural context such as this, there is no single discernable author, origin point, message, authentic version, or distribution endpoint—in fact, as we have argued in prior research,[3] the "meaning" of the meme, such as it is, is produced as a *consequence* of this authorlessness, and not in spite of it.

These dynamics have been well explored within communication research and media studies since the 2000s; in addition to our configurable culture framework, scholars have used terms such as "glomming on" in the sense of bricolage,[4] "convergence culture,"[5] "remix culture,"[6] "produsage,"[7] and "prosumption,"[8] to capture some or all of the dynamics we have described briefly here.

Configurable cultural practices have also been explored through the lens of legal constraints on mediated speech. Specifically, the commercial origins of many cut-and-pasted media elements and the unregulated or minimally regulated channels for the distribution of these cultural expressions have generated significant research on the mounting tensions between Western copyright regimes and the ethics and practices of configurability. Some have explored the premise that "fair use" exceptions to copyright law may apply to the transformations undertaken by digital cutters-and-pasters.[9] Others have argued that open licenses,[10] extending the "free software" ethic first promoted by the General Public License (GPL),[11] to the realm of cultural expression, will alleviate the tensions between emerging cultural practices and laws based on legacy industrial relations. And, finally, others have suggested that we "imagine there is no copyright," arguing that free expression in the digital era requires that we scrap our current approach to intellectual property and build it again from scratch.[12]

In the present work, we aim to explore how the unique technological, cultural, and legal dynamics at work in configurable culture affect the agency of users. We intentionally avoid the terms "producer" and "consumer" because the indeterminacy of those relational positions are themselves the subject of study. We have undertaken similar precautions in the past, in order to make the binarist nature of the producer/consumer dichotomy the subject of critique, rather than a set of givens prior to analysis. To use a term like "production" or "consumption" to describe the process of remixing, for instance, would deprive the cultural behavior of its polysemic, multivocal, and potentially subversive capacity.[13]

While the digital production and distribution technologies that shape configurable culture are often credited with the diffusion of cultural participation, they may also limit social interactions and cultural production in different ways, including through legal regulatory frameworks and the affordances of technology.[14] In this context, intellectual

property laws impose significant constraints on the propagation of these new practices of speech. For example, Digital Rights Management (DRM) tools, embedded in applications such as video streaming platforms to protect copyrighted works from being copied or reproduced, can disregard legal uses protected by national legislations worldwide. In the United States, for example, the fair use provision of copyright law gives users the right to use third party materials independently of the copyright holder's will, subject to the observance of four "factors" aimed at ensuring that authors' incentives to produce and share work are not impinged upon unduly. It works as a safeguard for the US constitutional guarantee of free speech, aiming at a balance between control by the authors and public access to knowledge. Thus, a digital environment that restricts fair uses of content is one that restricts freedom of speech above and beyond the level required by the letter and spirit of copyright law.

The tension between intellectual property laws and freedom of expression directly affects the perceived legitimacy of configurable cultural practices and whether they will be considered piracy, theft, and illegal activity,[15] or something valid, enjoyable, and expressive.[16] Depending on the frame used to characterize those practices, the propensity to engage with them can vary strongly. Previous research has shown that older users and other individuals who are not aware of these cultural practices are more likely to consider remixes and mashups as unoriginal, therefore questioning their validity.[17] These reflexively unfavorable opinions about certain cultural forms can generate some self-censorship and work as a barrier for some groups of individuals to develop necessary skills and capacities.

On the other side, while there is a significant body of literature on digital divides, digital inequalities, and digital literacy,[18] much of it has historically overlooked the kind of cultural expression that we discuss in this article. Perhaps this is because configurable culture is often viewed reflexively through the lens of "piracy" and perceived as ethically illegitimate or legally risky, and also because works in this area commonly establish dialog with international organizations' and governments' normative surveys;[19] a more common focus in this scholarship is what has been called by some as "capital-enhancing activities,"[20] such as searching for information related to health, education, finance, news, and so forth. Such rationale distinguishes some Internet activities as being "more beneficial or advantageous for Internet users."[21] For example, activities such as gaming and social interaction resonate in this literature as "very time-consuming but less capital-enhancing activities."[22]

Despite this fact, digital literacy scholars have rightly shown that status-based differences, in terms of gender, age, and other characteristics, tend to be reproduced in Internet use. Authors concerned with questions surrounding the levels of information and media literacy have argued that access to expertise, cultural, and social capital is the key to improving the value of digital engagement. As Zillien and Hargittai state, "not only the technology, as such, but also patterns of usage should be regarded when explaining status inequalities with respect to a technology's diffusion across the population."[23] These authors show that individuals with more resources, whether technical, financial, social, or cultural—tend to take more advantage of the web than those with fewer resources. This is reflected in more consistent online engagement by groups with more resources, with topics such as economic news, travel information, stock prices, product information and price comparison, email, and search engines.[24] We consider configurable cultural practices to be a crucial aspect of digital literacy that should not be excluded from this debate focused on what has been called capital-enhanced activities.

Configurable cultural practices may also be evaluated through the lens of digital economics and labor. Scholars in this field have called attention to the unpaid work related to the monetization of users' voluntary activities online. Examples range from mere participation in mailing lists and social media platforms, to engagement in games and software modding (modification), which generate profits that sustain the business models upon which the online content industry is based. Terms such as "free labor"[25] or "playbour"[26] try to synthesize the complexity of these relations that involve unwaged activities, joy, and exploitation.[27] In the case of games and their modding communities, Kücklich pointedly observes that "the games industry not only sells entertainment products, but also capitalizes on the products of the leisure derived from them" (n/p) through retaining the intellectual property rights associated with the "mods."[28]

> See additional chapters discussing modding/games: Anderson, Beard, Gallagher, Plaut.

From a Marxist standpoint, the exploitation of user data and cultural expression by giant Internet intermediaries can be read as a critical part of the global division of labor. While the collapsing of the industrial producer/consumer binary may be understood as liberational in a sense, it can also be seen as an *expansion* of industrial power, integrating users into the production chain. This dynamic echoes and extends Lazzarato's argument regarding immaterial labor, namely, that "the consumer is inscribed in the manufacturing of the product from its conception."[29] In the game industry, specifically, the gulf between the love for the work and the pleasure enjoyed by some game developers on the one hand, and the long labor chain on which they depend, on the other, has also been studied under an extended framework of immaterial labor.[30] From underpaid game testers to degrading work of people conducting natural resources extraction to build consoles, gender, race, and the relations between the global North and the global South play key roles in this sector.[31] Thus, the social power dynamics inherent in configurable cultural practices can be approached from a variety of scholarly perspectives. Our choice of considering legal and regulatory issues, digital literacy, and digital labor debates is informed by the data that will be discussed in the following sections.

Methodology

The data presented below is the result of a longitudinal study with English speaking adults in the United States. The surveys were conducted in 2010, 2014, and 2017 using online panels[32] and self-administered questionnaires. The sample sizes, after screening, were 971, 452, and 510 in the three sequential surveys. The research instrument and procedures were kept consistent in the interest of longitudinal analysis.

The questionnaire measured engagement with configurable cultural practices for different categories such as music, video, and games, as well as attitudes and opinions regarding these practices. Questions and alternatives followed the same sequence and were not randomized.

During the analysis, we classified the configurable cultural practices as marginal, transitional, or mainstream, based on their level of prevalence as captured in the question "In the past year, which of the following (…) activities have you engaged in." The thresholds used to define these groups are 0–12.4% for marginal, 12.5–33.2% for transitional, and 33.3% and above for mainstream. These thresholds were based on emergent trends in the data, rather than predefined theory.

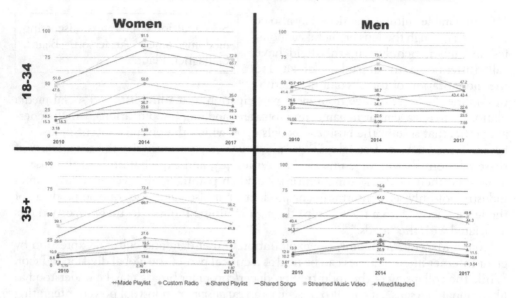

Figure 2.1 Configurable music engagement, 2010–17

Because the balance of ages and genders differed from panel to panel, and because these are both causative factors in configurable cultural engagement, we analyzed engagement data discretely for four categories of respondent: men under 35, women under 35, men 35 and older, and women 35 and older. On gender, we are not considering "others" and "prefer not to answer" responses due to their low incidence.

Results

Configurable Culture: Marginal, Transitional, and Mainstream Practices

Overall engagement with music-related digital configurable cultural practices grew considerably between 2010–14, then dropped in the period between 2014–17 (Figure 2.1). However, the growth trends and engagement rates differed significantly from one activity to another and from one demographic to another.

Configurable activities that are marginally differentiated from traditional modalities of consumption—which we have termed "consumption-adjacent" in previous research[33]—are consistently the most widely adopted and fall into the "mainstream" category for 2017 among all four demographic segments. Specifically, streaming on-demand music videos and making personalized playlists top the list, with both activities showing greater prevalence among younger women than among the other three demographic subgroups. Sharing playlists was also a mainstream activity for men under thirty-five, while creating custom radio stations was a mainstream activity among younger

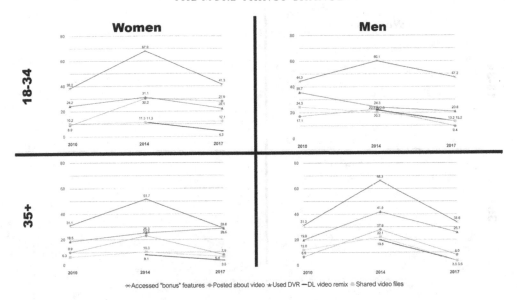

Figure 2.2 Configurable video engagement, 2010–17

women—though this activity has fallen in popularity since 2014 among all four sub-groups. Sharing songs, an activity in the "transitional" category, has fallen in prevalence among three of the subgroups, while remaining at a consistent level from 2014 to 2017 among younger men. Mixing and mashing-up music, a "production-adjacent" practice, remains in the "marginal" category for all four subgroups. While it remains most prevalent among men under thirty-five, it has fallen in popularity among them consistently from 2010 to 2017. By contrast, the number of women under thirty-five who say they have remixed or mashed-up music actually grew slightly in 2017 after dropping from 2010 to 2014.

As with music, video-based configurable cultural activities diminished overall in 2017 relative to previous years (Figure 2.2). However, in this category, adoption trends differed far more between demographic groups.

As with music, the most "consumption-adjacent" activities were also the most popular, across all demographics. The one activity popular enough to be classified as "mainstream" (in three of the four subgroups) was accessing "bonus" features on a DVD or Blu-Ray disc, such as deleted scenes, games, or directors' commentary. And, as with music, this top activity dropped significantly from its 2014 peak prevalence among all ages and genders.

For activities in the "transitional" category (such as using a DVR and posting about videos), as well as those in the "marginal" category (such as sharing video files, or downloading video remixes), trends differ sharply depending on demographics. As

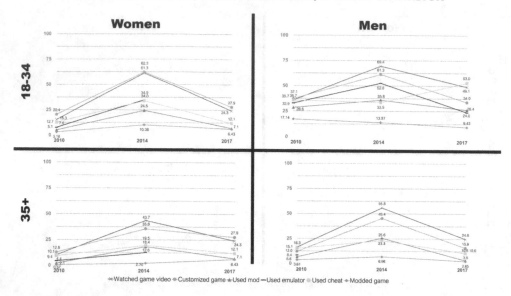

Figure 2.3 Configurable game engagement, 2010–17

with music sharing activities, the decline of video sharing seems to have taken place first among younger men, with a significant drop-off between 2010 and 2014, followed by a decline among other demographic subgroups after a peak in 2014. Additionally, while all configurable video activities have dropped among men of all age groups, some activities have actually climbed among female respondents, including video file sharing (among women under thirty-five) and DVR usage (among women over thirty-five).

Games-related configurable cultural activities followed a similar pattern to music- and video-related activities, climbing steeply in 2014 and then dropping almost back to 2010 levels by 2017 (Figure 2.3). With the exception of cheat usage among younger men and game modding among older women, all configurable cultural activities in this category dropped steeply in the most recent survey. In 2017, none of the activities reached or remained at mainstream adoption levels—although watching game clips online, using cheat codes, and customizing a character or environment using options within a game were all mainstream among younger men. Those three activities were also the only ones that reached transitional levels among the surveyed population as a whole—the remaining activities were classified as marginal, with adoption rates well below 12.5%.

Social Inequalities in Configurable Practices

In addition to the longitudinal changes in the prevalence of configurable cultural activity, we have also investigated difference in usage patterns associated with demographic variables such as age and gender within the 2017 data. We have used our marginal, transitional, and mainstream categories as proxies for "patterns of usage" that vary from

Age Bias — Men

	Mainstream	Transitional	Marginal
1.1			
	0.987		baseline
	0.936	0.934	
		0.914	0.908
0.9			0.864
		0.841	
0.8			0.782
0.7			

— Music — Video — Games

Age Bias — Women

	Mainstream	Transitional	Marginal
1.1			
1			baseline
	0.967	0.979	
	0.94	0.958	0.918
0.9			0.913
		0.886	0.87
0.8			
0.7			

— Music — Video — Games

Figure 2.4 Top: Age bias in configurable cultural activities among men, 2017. Bottom: Age bias in configurable cultural activities among women, 2017

basic (and of limited economic and political benefit) to specialized (and of greater benefit).[34] By examining digital behaviors through this lens, we have identified several demographic usage trends that would not be readily apparent by an examination of the top-level survey data.

Our data reveal striking age biases hidden beneath the surface of our topline results. We examine these age biases separately among men and women (Figure 2.4) in order to control for gender as a factor. Across all categories of configurable cultural practice, among both men and women respondents alike, marginal practices in all categories skew toward a younger user base. Even among activities that skew younger in general, such as games, those who engage with marginal practices are far younger (21.8% among men

43

and 13% among women) relative to the survey baseline than those who engage with transitional ones (15.9% among men and 11.4% among women).

Age bias is most stark among men in the category of music. While men who engage in mainstream, consumption-adjacent configurable music activities, such as making play lists and streaming music videos, are nearly the same age as overall respondents (1.3% below the survey baseline), those who engage in marginal, production-adjacent activities, like mashing-up and remixing songs, are 13.6% younger than the survey baseline.

Among women, a very different pattern emerges: Although there are no mainstream games activities, configurable cultural activities in games, music, and video that fall into the category of "transitional" are all more age-equitable than either mainstream or marginal activities. We interpret this to mean that, among this group of Internet users, subcultural communities are actually less age biased than either mainstream culture or skill-specialized, techno-centric cultures.

The hidden gender bias in configurable cultural activities is even more stark than the age bias—especially among the younger adult population. Among adults aged thirty-five and older (Figure 2.5), mainstream and transitional activities in the music and video categories are either overrepresented by women or equitably represented between genders. But all games activities and all marginal activities in each category skew disproportionately to men, with a 7.8% bias against women in music, an 8.6% bias in video, and a 14.4% bias in video games.

Among younger adults (Figure 2.5), there is again near-parity for most mainstream and transitional activities in the music and video categories, but games are heavily skewed against women, and women's involvement in the most marginal activities drops off precipitously, with an 11.2% bias in music, a 17.8% bias in video, and a 29.1% bias in video games.

Analysis

Our analysis of survey data on configurable cultural activities among American adults in 2010, 2014, and 2017 reveals two principal findings, both of which are, to a certain extent, counterintuitive.

First, there has been a significant drop in nearly all forms of configurable cultural engagement, across nearly all demographic segments, between 2014 and 2017, after a steep climb in the first half of the decade. Given the fact that the number of Internet users, their volume of Internet usage, and the power of the hardware, software, and services they use have continued to grow precipitously since 2014, this finding may initially strain the bounds of credulity. However, it conforms with other recent research suggesting that "remix culture" has waned as digital media and culture have become more mainstream in recent years. In a related conference paper,[35] we analyzed nearly two decades of Google Trends search data to show that interest in remix-related subject matter among American Internet users peaked in 2014 and dropped considerably in the following five years, even as more "instrumental" approaches to understanding digital culture and its relationship to copyright law—such as open educational resources and "access to knowledge"—have grown in prominence. Similarly, Fairchild argues that the "decay" of interest in mashups over the past decade is not evidence of its growing cultural irrelevance, but rather of its "absorption" into mainstream digital culture.[36]

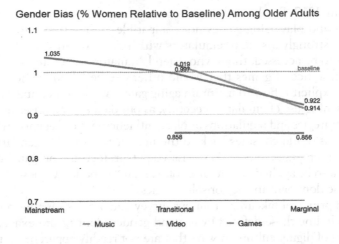

Gender Bias (% Women Relative to Baseline) Among Older Adults

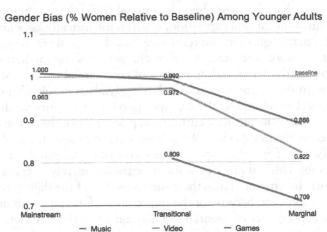

Gender Bias (% Women Relative to Baseline) Among Younger Adults

Figure 2.5 Top: Gender bias (% women relative to baseline) among older adults, 2017. Bottom: Gender bias (% women relative to baseline) among younger adults, 2017

In light of these analyses, we view our data as another strong piece of evidence that the configurable ethics and aesthetics that scholars, makers, and audiences took such interest in a decade ago have now become so commonplace, and so culturally dominant, that they have faded into the "background noise" of mainstream culture. In other words, people do not self-report engaging in configurable cultural activities—just as they no longer search for them on Google—precisely because those activities have become functionally indistinguishable from any other form of engagement. It is rarer nowadays watching a video without at least the option of social media engagement, or listening to online music without the capacity to self-curate. And when Instagram, TikTok, and Snapchat all offer audio and video editing and remixing elements as part of their basic social interfaces, it stands to reason that an increasing number of Internet users have ceased to view these functions as discrete activities.

Of particular note is the waning popularity of game emulators, which reached mainstream popularity in 2014 among younger respondents, before dropping

precipitously in 2017. Emulators bring the issue of copyright to the surface as they are used to access and play aging games not compatible with current devices. While the game industry strongly associate emulators with piracy, given that they allow copyrighted games to be accessed, those who defend emulators see them as archival tools to protect the existence of games that would otherwise be "dead." The challenge that authors make explicit is how to maintain aging games while respecting copyright holders.[37] The lessening use of emulators recently, as our data shows, raises questions about the industry strategies and regulations at place influencing users' agency, which includes bringing replicas of old consoles back to the market featuring "legendary games" and "high definition graphics."[38] As Mia Consalvo puts it, focusing on game cheating software that can also be applied to emulator software, it "embodies values—but values that challenge those dominant in the console business."[39]

The second principal takeaway from our survey data analysis is that historical social inequities, including those defined by age and gender identity, are exacerbated by the mainstreaming of digital culture in ways that are not readily apparent on the surface.

Regarding the age biases at work here, it is useful to think of marginal configurable practices as a form of subcultural expression, which is intrinsically associated with youth and with the idea of transgression and resistance.[40] In the digital era, though, the central role of corporate content intermediaries that characterizes the mediation layer of the Internet[41] intensifies the longstanding process of commercial appropriation of subcultural production. In this context, instead of having symbols of subculture incorporated into brands' physical merchandise, the appropriation is now engineered directly into the architecture of social media services; cutting and pasting, once the hallmark of resistant subcultural style, are the *sine qua non* of playbour and produsage on social media such as Facebook and Twitter. Thus, the unpermissioned use of copyrighted materials inherent in most configurable cultural practices cannot be framed merely as transgression, since they are frequently incorporated into the business models of the digital content companies themselves. Moreover, because of the importance of digital communication technologies and the convergence of essential social dynamics on the Internet, this subculture age gap has implications for the distribution of social power and the extent to which individuals will take advantage of the social benefits available online.

This is why the perspective of online skills and abilities is highly relevant. Although for years the relationship between youth and technology has been erroneously analyzed as a natural relation similar to that which happens between native speakers and their mother languages,[42] research has shown that this kind of assumption disregards other relevant social aspects, such as how social and economic backgrounds affect how individuals use the Internet in general, independently of age, and how heterogeneous young people can be.[43] This makes the age bias of our findings more complex, preventing us from merely accepting the results as an expression of "digital native" culture. While our findings can be attributed in part to youths' motivation to engage in the languages of the digital world, they are also associated with social and economic conditions, such as free time and financial resources, that enable greater access to those digital tools. On the latter, authors have already stated the challenges of lower income individuals not only to have access to equipment and the Internet, but also to maintain such access over time.[44]

Regarding gender, Hargittai and Shafer's (2006) empirical investigation has shown no gender difference in underlying Internet abilities; however, because women tend to lower their self-assessment of Internet skills, they are more likely to restrict their online

experience, prejudging that they would not be successful in some tasks. Research has also shown a lower presence of women in game development roles,[45] and in public discussions on technology, such as the debate about net neutrality.[46] All these perennial gender inequalities contribute to contextualize why women tend to engage less than men in the more marginal activities we tracked. On the one hand, this lack of perceived self-efficacy is likely compounded by social factors that make highly skilled tech-based environments and highly contentious fandom environments equally prone to what Adrienne Massanari refers to as "toxic technocultures and geek masculinity."[47] On the other hand, while the consistent increase of "modding" practices in the segment of women of thirty-five years or more since 2010 may be interpreted as positive, this should also be analyzed in light of the politics of game platforms, in which industry interests and values merge with the games and its tools. As is already known, the development of game "mods" is frequently voluntary, a fact that well illustrates the phenomenon of playbour. At the same time, this kind of work is not totally independent from the formal job market—the success of a "mod" may lead its creator to get a job in the industry.[48] Thus, while the increasing number of women in marginal activities such as "modding" is positive using the lens of the digital inequality field, it also raises questions about the conditions under which such activities are conducted, considering the precarious relations that characterize configurable cultural activities and labor.

Our work discusses Internet practices that have been neglected in the digital literacy and digital inequality literatures, while also building on their concerns with prevailing online social inequalities. By expanding the notion of "Internet-in-practice"[49] beyond traditional capital-enhanced activities, we bring to the forefront imbalances in game, music, and video online activities to problematize them in view of legal and technological regulations. These activities stand between pleasure and labor, paid and unpaid work, and their examination contributes to broadening our understanding on the politics of platforms in general,[50] having Internet users' skills as a constitutive part of it.

In short, although volumes such as the one containing this chapter still position scholarship regarding digital media cultures in terms of "remix studies," it is incumbent upon us as a field not to take these categories as fixed, but rather as contingent, fluid, and, to a great degree, loaded. While configurable technologies and cultures have unquestionably delivered on many of their promises as a democratizing force, their increasing invisibility through absorption into the mainstream poses at least as great a risk of normalizing social inequities, and fixing them into the architecture of future platforms, as it offers the promise of redistributive justice and a more polyvocal digital public sphere.

Notes

1 Aram Sinnreich, Mark Latonero, and Marissa Gluck, "Ethics Reconfigured: How Today's Media Consumers Evaluate the Role of Creative Reappropriation," *Information, Communication & Society* 12, no. 8 (December 2009): 1242–60, https://doi.org/10.1080/13691180902890117; Aram Sinnreich, *Mashed Up: Music, Technology, and the Rise of Configurable Culture* (Amherst, MA: University of Massachusetts Press, 2010); Aram Sinnreich, *The Piracy Crusade: How the Music Industry's War on Sharing Destroys Markets and Erodes Civil Liberties* (Amherst, MA: University of Massachusetts Press, 2013).

2 Stephen Duncombe, *Notes from Underground: Zines and the Politics of Alternative Culture* (Microcosm, 2008).

3 Sinnreich, *Mashed Up.*

4 Jack Balkin, "Digital Speech and Democratic Culture: A Theory of Freedom of Expression for the Information Society," *New York University Law Review* 1, no. 79 (January 1, 2004), http://digitalcommons.law.yale.edu/fss_papers/240.

5 Henry Jenkins, *Convergence Culture Where Old and New Media Collide*, 1st edition (New York: New York University Press, 2006).

6 Lawrence Lessig, *Remix: Making Art and Commerce Thrive in the Hybrid Economy* (London, United Kingdom: Penguin Books, 2008).

7 Axel Bruns, *Blogs, Wikipedia, Second Life, and Beyond: From Production to Produsage* (New York: Peter Lang, 2008).

8 George Ritzer and Nathan Jurgenson, "Production, Consumption, Prosumption: The Nature of Capitalism in the Age of the Digital 'Prosumer,'" *Journal of Consumer Culture (London)* 10, no. 1 (March 2010): 13–36, http://dx.doi.org/10.1177/1469540509354673.

9 William Patry, *How to Fix Copyright*, 1st edition (Oxford: Oxford University Press, 2012); Patricia Aufderheide and Peter Jaszi, *Reclaiming Fair Use: How to Put Balance Back in Copyright*, 1st edition (Chicago, IL: University Of Chicago Press, 2011).

10 Lessig, *Remix*.

11 Sam Williams and 2nd edition revisions by Richard Stallman, *Free as in Freedom*, 2nd edition (Boston, Massachusetts: Free Software Foundation, Inc, 2010); Michel Bauwens and Vasilis Kostakis, "From the Communism of Capital to Capital for the Commons: Towards an Open Co-Operativism," *TripleC (Cognition, Communication, Co-Operation): Open Access Journal for a Global Sustainable Information Society* 12, no. 1 (January 2014): 356–61.

12 Joost Smiers and Marieke van Schijndel, *Imagine There Is No Copyright and No Cultural Conglomorates Too: An Essay* (Institute of Network Cultures, 2009); Owen Gallagher, *Reclaiming Critical Remix Video: The Role of Sampling in Transformative Works*, 1st edition (New York; Abingdon, Oxon: Routledge, 2017).

13 Sinnreich, *Mashed Up*.

14 Balkin, "Digital Speech and Democratic Culture"; Lawrence Lessig, *Code: Version 2.0*, 2nd revised edition (New York: Basic Books, 2006); Aram Sinnreich, *The Essential Guide to Intellectual Property*, 1st edition (New Haven, Connecticut: Yale University Press, 2019).

15 Joe Karaganis, ed., *Media Piracy in Emerging Economies* (Social Science Research Council, 2011), http://piracy.americanassembly.org/the-report/.

16 Sinnreich, *The Piracy Crusade*.

17 Aram Sinnreich and Mark Latonero, "Tracking Configurable Culture From the Margins to the Mainstream," *Journal of Computer-Mediated Communication* 19, no. 4 (July 2014): 798–823, https://doi.org/10.1111/jcc4.12073.

18 Karine Barzilai-Nahon, Ricardo Gomez, and Rucha Ambikar, "Conceptualizing a Contextual Measurement for Digital Divide/s," in *Overcoming Digital Divides: Constructing an Equitable and Competitive Information Society*, ed. Enrico Ferro et al. (Hershey, Pennsylvania: Idea Group Inc., 2009), 630–44; David Bawden, "Origins and Concepts of Digital Literacy," in *Digital Literacies: Concepts, Policies and Practices*, ed. Colin Lankshear and Michele Knobel, 1st edition (New York: Peter Lang Inc., International Academic Publishers, 2008), 17–32; Marcelo El Khouri Buzato, "Letramento e inclusão: do estado-nação à era das TIC," *DELTA: Documentação de Estudos em Lingüística Teórica e Aplicada* 25, no. 1 (2009): 01–38, https://doi.org/10.1590/S0102-44502009000100001; Yoram Eshet-Alkalai, "Digital Literacy: A Conceptual Framework for Survival Skills in the Digital Era," *Journal of Educational Multimedia and Hypermedia* 13, no. 1 (March 22, 2004): 93–106; Eszter Hargittai, "Second-Level Digital Divide: Differences in People's Online Skills," *First Monday* 7, no. 4 (April 1, 2002), https://doi.org/10.5210/fm.v7i4.942; Eszter Hargittai and Amanda Hinnant, "Digital Inequality – Differences in Young Adults' Use of the Internet," *Communication Research* 35, no. 5 (October 2008): 602–21, https://doi.org/10.1177/0093650208321782; Fernanda R. Rosa, "Digital Inclusion as Public Policy: Disputes in the Human Rights Field," *Sur – International Journal on Human Rights*, no. 18 (2013): 32–53; Nicole Zillien and Eszter Hargittai, "Digital Distinction: Status-Specific Types of Internet Usage," *Social Science Quarterly* 90, no. 2 (2009): 274–91; Teresa Correa, "Digital Skills and Social Media Use: How Internet Skills Are Related to Different Types of Facebook Use among 'Digital Natives,'" *Information, Communication & Society* 19, no. 8 (August 2, 2016): 1095–1107, https://doi.org/10.1080/1369118X.2015.1084023; Neil Selwyn, "Reconsidering Political and Popular Understandings of the Digital Divide," *New Media & Society* 6, no. 3 (June 2004): 341–62, https://doi.org/10.1177/1461444804042519; Amy Gonzales, "The Contemporary US Digital Divide: From Initial Access to Technology Maintenance," *Information, Communication & Society* 19, no. 2 (February 2016): 234–48, https://doi.org/10.1080/1369118X.2015.1050438; Daniel Calderón Gómez, "Technological Capital and Digital Divide among Young People: An Intersectional Approach," *Journal of Youth Studies*

22, no. 7 (August 9, 2019): 941–58, https://doi.org/10.1080/13676261.2018.1559283; Alexander JAM van Deursen and Jan AGM van Dijk, "The Digital Divide Shifts to Differences in Usage," *New Media & Society* 16, no. 3 (May 2014): 507–26, https://doi.org/10.1177/1461444813487959.

19 Calderón Gómez, "Technological Capital and Digital Divide among Young People"; Fernanda R. Rosa and Maria Carolina Nogueira Dias, "Por um Indicador de Letramento Digital: uma abordagem sobre competências e habilidades em TICs" (Masters in Public Policy and Management, São Paulo, Fundação Getulio Vargas, 2012), https://gvpesquisa.fgv.br/sites/gvpesquisa.fgv.br/files/fernanda_ribeiro_rosa_maria_carolina_nogueira_dias.pdf.

20 Hargittai and Hinnant, "Digital Inequality – Differences in Young Adults' Use of the Internet."

21 van Deursen and van Dijk, "The Digital Divide Shifts to Differences in Usage," 509.

22 Correa, "Digital Skills and Social Media Use."

23 Nicole Zillien and Eszter Hargittai. "Digital Distinction: Status-Specific Types of Internet Usage," Social Science Quarterly, (2009): 279.

24 Zillien and Hargittai, "Digital Distinction."

25 T. Terranova, "Free Labor," in *Digital Labor*, ed. Trebor Scholz (New York: Routledge, 2012), 258, https://doi.org/10.4324/9780203145791.

26 Julian Kücklich, "Precarious Playbour: Modders and the Digital Games Industry," *Fibreculture Journal* 5 (January 1, 2005), http://five.fibreculturejournal.org/fcj-025-precarious-playbour-modders-and-the-digital-games-industry/.

27 Terranova, "Free Labor."

28 Kücklich, "Precarious Playbour."

29 Maurizio Lazzarato, "Immaterial Labor," in *Radical Thought in Italy a Potential Politics/*, 1st edition, vol. 7 (MN; London, UK: University of Minnesota Press, 1996), 133–47, https://doi.org/10.5749/j.ctttssjm.6

30 Ergin Bulut, *A Precarious Game: The Illusion of Dream Jobs in the Video Game Industry*, 1st edition (Ithaca, New York: Cornell University Press, 2020), https://www.cornellpress.cornell.edu/book/9781501746536/a-precarious-game/.

31 Ibid.

32 The 2010 panel was provided by Intellisurvey, the 2014 panel was provided by Amazon Mechanical Turk, and the 2017 panel was provided by Survey Sampling International.

33 Sinnreich, *Mashed Up*.

34 Zillien and Hargittai, "Digital Distinction."

35 Aram Sinnreich, Patricia Aufderheide, Maggie Clifford and Saif Shahin, "Access Shrugged: The Decline of the Copyleft and the Rise of Instrumental Openness," in *International Communication Association Annual Conference*, Washington, DC, 2019.

36 Charles Fairchild, "The Emergence and Historical Decay of the Mash Up," *Journal of Popular Music Studies* 29, no. 4 (2017): e12246.

37 Jeffrey S. Libby, "The Best Games in Life Are Free: Videogame Emulation in a Copyrighted World," *Suffolk University Law Review* 36 (2002): 843. 2002–2003; James Newman, "Illegal Deposit: Game Preservation and/as Software Piracy," *Convergence: The International Journal of Research into New Media Technologies* 19, no. 1 (2012): 45–61, https://doi.org/10.1177/1354856512456790.

38 Quotes from the SEGA Genesis Mini webpage that exemplify a trend in the game industry (genesismini.sega.com, last access on July 27, 2020).

39 Mia Consalvo, *Cheating: Gaining Advantage in Videogames*, 1st edition (Cambridge, Massachusetts: MIT Press, 2007), 65.

40 Dick Hebdige, "The Function of Subculture," in *The Cultural Studies Reader*, ed. Simon During, 2nd edition (London; New York: Routledge, 1999), 441–50.

41 Jack Goldsmith and Tim Wu, *Who Controls the Internet?: Illusions of a Borderless World*, 1st edition (New York: Oxford University Press, 2006); Laura DeNardis, *The Global War for Internet Governance* (New Haven, Connecticut: Yale University Press, 2014).

42 Marc Prensky, "Digital Natives, Digital Immigrants," *On the Horizon* 9, no. 5 (October 2001): 6.

43 Eszter Hargittai, "Digital Na(t)Ives? Variation in Internet Skills and Uses among Members of the 'Net Generation," *Sociological Inquiry* 80, no. 1 (January 21, 2010): 92–113, https://doi.org/10.1111/j.1475-682X.2009.00317.x; Calderón Gómez, "Technological Capital and Digital Divide among Young People."

44 Gonzales, "The Contemporary US Digital Divide."

45 Bulut, *A Precarious Game: The Illusion of Dream Jobs in the Video Game Industry.*
46 Deen Freelon et al., "Narrowing the Gap: Gender and Mobilization in Net Neutrality Advocacy," *International Journal of Communication* 10 (January 2016): 5908–30. (19328036).
47 Adrienne Massanari, "'Damseling for Dollars': Toxic Technocultures and Geek Masculinity," in *Race and Gender in Electronic Media: Content, Context, Culture*, ed. Rebecca Ann Lind, 1st edition (New York: Routledge, 2016), 312–27. 312.
48 James W. Au, "Triumph of the Mod: Player-Created Additions to Computer Games Aren't a Hobby Anymore – They're the Lifeblood of the Industry," *Salon*, April 16, 2002, https://www.salon.com/2002/04/16/modding/; Kücklich, "Precarious Playbour."
49 Zillien and Hargittai, "Digital Distinction."
50 Tarleton Gillespie, "The Politics of 'Platforms,'" *New Media & Society* 12, no. 3 (May 1, 2010): 347–64, https://doi.org/10.1177/1461444809342738.

Bibliography

Au, James W. "Triumph of the Mod: Player-Created Additions to Computer Games Aren't a Hobby Anymore – They're the Lifeblood of the Industry." *Salon*, April 16, 2002. https://www.salon.com/2002/04/16/modding/.

Aufderheide, Patricia, and Peter Jaszi. *Reclaiming Fair Use: How to Put Balance Back in Copyright.* 1st Edition. Chicago: University of Chicago Press, 2011.

Balkin, Jack. "Digital Speech and Democratic Culture: A Theory of Freedom of Expression for the Information Society." *New York University Law Review* 1, no. 79 (January 1, 2004). http://digitalcommons.law.yale.edu/fss_papers/240.

Barzilai-Nahon, Karine, Ricardo Gomez, and Rucha Ambikar. "Conceptualizing a Contextual Measurement for Digital Divide/s." In *Overcoming Digital Divides: Constructing an Equitable and Competitive Information Society*, edited by Enrico Ferro, Yogesh K. Dwivedi, J. Ramon Gil-Garcia, and Michael D. Williams, 630–44. Hershey, PA: Idea Group Inc, 2009.

Bauwens, Michel, and Vasilis Kostakis. "From the Communism of Capital to Capital for the Commons: Towards an Open Co-Operativism." *TripleC (Cognition, Communication, Co-Operation): Open Access Journal for a Global Sustainable Information Society* 12, no. 1 (January 2014): 356–61.

Bawden, David. "Origins and Concepts of Digital Literacy." In *Digital Literacies: Concepts, Policies and Practices*, edited by Colin Lankshear, and Michele Knobel, 1st Edition, 17–32. New York: Peter Lang Inc., International Academic Publishers, 2008.

Bruns, Axel. *Blogs, Wikipedia, Second Life, and Beyond: From Production to Produsage.* New York: Peter Lang, 2008.

Bulut, Ergin. *A Precarious Game: The Illusion of Dream Jobs in the Video Game Industry.* 1st Edition. Ithaca: Cornell University Press, 2020. https://www.cornellpress.cornell.edu/book/9781501746536/a-precarious-game/.

Buzato, Marcelo El Khouri. "Letramento e inclusão: Do estado-nação à era das TIC." *DELTA: Documentação de Estudos em Lingüística Teórica e Aplicada* 25, no. 1 (2009): 01–38. https://doi.org/10.1590/S0102-44502009000100001.

Calderón Gómez, Daniel. "Technological Capital and Digital Divide Among Young People: An Intersectional Approach." *Journal of Youth Studies* 22, no. 7 (August 9, 2019): 941–58. https://doi.org/10.1080/13676261.2018.1559283.

Consalvo, Mia. 2007. *Cheating: Gaining Advantage in Videogames.* 1st Edition. Cambridge, Massachusetts: MIT Press.

Correa, Teresa. "Digital Skills and Social Media Use: How Internet Skills Are Related to Different Types of Facebook Use Among 'Digital Natives'." *Information, Communication & Society* 19, no. 8 (August 2, 2016): 1095–1107. https://doi.org/10.1080/1369118X.2015.1084023.

DeNardis, Laura. *The Global War for Internet Governance.* New Haven: Yale University Press, 2014.

Deursen, Alexander JAM van, and Jan AGM van Dijk. "The Digital Divide Shifts to Differences in Usage." *New Media & Society* 16, no. 3 (May 2014): 507–26. https://doi.org/10.1177/1461444813487959.

Duncombe, Stephen. *Notes from Underground: Zines and the Politics of Alternative Culture.*

Microcosm, 2008. https://search.proquest.com/docview/1686418272?pq-origsite=summon.

Eshet-Alkalai, Yoram. "Digital Literacy: A Conceptual Framework for Survival Skills in the Digital Era." *Journal of Educational Multimedia and Hypermedia* 13, no. 1 (March 22, 2004): 93–106.

Freelon, Deen, Amy B. Becker, Bob Lannon, and Andrew Pendleton. "Narrowing the Gap: Gender and Mobilization in Net Neutrality Advocacy." *International Journal of Communication* 10 (January 2016): 5908–30. (19328036).

Gallagher, Owen. 2017. *Reclaiming Critical Remix Video: The Role of Sampling in Transformative Works*. 1st Edition. New York; Abingdon, Oxon: Routledge.

Gillespie, Tarleton. "The Politics of 'Platforms'." *New Media & Society* 12, no. 3 (2010): 347–64.

Goldsmith, Jack, and Tim Wu. *Who Controls the Internet?: Illusions of a Borderless World*. 1st Edition. New York: Oxford University Press, 2006.

Gonzales, Amy. "The Contemporary US Digital Divide: From Initial Access to Technology Maintenance." *Information, Communication & Society* 19, no. 2 (February 2016): 234–48. https://doi.org/10.1080/1369118X.2015.1050438.

Hargittai, Eszter. "Digital Na(t)Ives? Variation in Internet Skills and Uses Among Members of The 'Net Generation'." *Sociological Inquiry* 80, no. 1 (January 21, 2010): 92–113. https://doi.org/10.1111/j.1475-682X.2009.00317.x.

Hargittai, Eszter. "Second-Level Digital Divide: Differences in People's Online Skills." *First Monday* 7, no. 4 (April 1, 2002). https://doi.org/10.5210/fm.v7i4.942.

Hargittai, Eszter, and Amanda Hinnant. "Digital Inequality – Differences in Young Adults' Use of the Internet." *Communication Research* 35, no. 5 (October 2008): 602–21. https://doi.org/10.1177/0093650208321782.

Hargittai, Eszter, and Steven Shafer. "Differences in Actual and Perceived Online Skills: The Role of Gender." *Social Science Quarterly* 87, no. 2 (2006): 432–48.

Hebdige, Dick. "The Function of Subculture." In *The Cultural Studies Reader*, edited by Simon During, 2nd Edition, 441–50. London; New York: Routledge, 1999.

Jenkins, Henry. *Convergence Culture Where Old and New Media Collide*. 1st Edition. New York: New York University Press, 2006.

Karaganis, Joe. Media Piracy in Emerging Economies. *Social Science Research Council*, 2011. http://piracy.americanassembly.org/the-report/.

Kücklich, Julian. "Precarious Playbour: Modders and the Digital Games Industry." *Fibreculture Journal*, no. 5 (January 1, 2005). http://five.fibreculturejournal.org/fcj-025-precarious-playbour-modders-and-the-digital-games-industry/.

Lazzarato, Maurizio. "Immaterial Labor." In *Radical Thought in Italy a Potential Politics*, 1st Edition, 7:133–47. Minnesota, US, London, UK: University of Minnesota Press, 1996. https://doi.org/10.5749/j.ctttssjm.

Lessig, Lawrence. *Code: Version 2.0*. 2nd Revised Edition. New York: Basic Books, 2006.

———. *Remix: Making Art and Commerce Thrive in the Hybrid Economy*. London, United Kingdom: Penguin Books, 2008.

Libby, Jeffrey S. "The Best Games in Life Are Free: Videogame Emulation in a Copyrighted World." *Suffolk University Law Review* 36 (2002): 843. 2002–2003.

Massanari, Adrienne. 2016. "Damseling for Dollars: Toxic Technocultures and Geek Masculinity." In *Race and Gender in Electronic Media: Content, Context, Culture*, edited by Rebecca Ann Lind, 1st Edition, 312–27. New York: Routledge.

Nemer, David, and Padma Chirumamilla. 2019. "Living in the Broken City Infrastructural Inequity, Uncertainty, and the Materiality of the Digital in Brazil." In *Digital STS: A Field Guide for Science & Technology Studies*, edited by Janet Vertesi, and David Ribes, 1st Edition, 20. Princeton, N.J: Princeton University Press. https://digitalsts.net/wp-content/uploads/2019/11/15_digitalSTS_Living-in-the-Broken-City.pdf.

Newman, James. "Illegal Deposit: Game Preservation and/as Software Piracy." *Convergence: The International Journal of Research into New Media Technologies* 19, no. 1 (2012): 45–61. https://doi.org/10.1177/1354856512456790.

Patry, William. *How to Fix Copyright*. 1st Edition. Oxford: Oxford University Press, 2012.

Prensky, Marc. "Digital Natives, Digital Immigrants." *On the Horizon* 9, no. 5 (2001): 6.

Ritzer, George, and Nathan Jurgenson. "Production, Consumption, Prosumption: The Nature of Capitalism in the Age of the Digital 'Prosumer'." *Journal of Consumer Culture London* 10, no. 1 (March 2010): 13–36. http://dx.doi.org/10.1177/1469540509354673.

Rosa, Fernanda R., and Maria Carolina Nogueira Dias. "Por um Indicador de Letramento Digital: uma abordagem sobre competências e habilidades em TICs." Masters thesis, Fundação Getulio Vargas, 2012. https://gvpesquisa.fgv.br/sites/gvpesquisa.fgv.br/files/fernanda_ribeiro_rosa_maria_carolina_nogueira_dias.pdf.

Rosa, Fernanda R. "Digital Inclusion as Public Policy: Disputes in the Human Rights Field." *Sur – International Journal on Human Rights*, no. 18 (Fall 2013): 32–53.

Selwyn, Neil. "Reconsidering Political and Popular Understandings of the Digital Divide." *New Media & Society* 6, no. 3 (June 2004): 341–62. https://doi.org/10.1177/1461444804042519.

Sinnreich, Aram. *Mashed Up: Music, Technology, and the Rise of Configurable Culture*. Amherst, Massachusetts: University of Massachusetts Press, 2010.

Sinnreich, Aram. *The Piracy Crusade: How the Music Industry's War on Sharing Destroys Markets and Erodes Civil Liberties*. Amherst, Massachusetts: University of Massachusetts Press, 2013.

Sinnreich, Aram. *The Essential Guide to Intellectual Property*. 1st Edition. New Haven: Yale University Press.

Sinnreich, Aram, and Mark Latonero. "Tracking Configurable Culture from the Margins to the Mainstream." *Journal of Computer-Mediated Communication* 19, no. 4 (July 2014): 798–823. https://doi.org/https://doi.org/10.1111/jcc4.12073.

Sinnreich, Aram, Mark Latonero, and Marissa Gluck. "Ethics Reconfigured: How Today's Media Consumers Evaluate the Role of Creative Reappropriation." *Information, Communication & Society* 12, no. 8 (December 2009): 1242–60. https://doi.org/10.1080/13691180902890117.

Sinnreich, Aram, Patricia Aufderheide, Maggie Clifford, and Saif Shahin, "Access Shrugged: The Decline of the Copyleft and the Rise of Instrumental Openness." Presented at *International Communication Association Annual Conference*. Washington, DC, 2019.

Smiers, Joost, and Marieke van Schijndel. Imagine There Is No Copyright and No Cultural Conglomorates Too: An Essay. *Institute of Network Cultures*, 2009.

Terranova, T. "Free Labor." In *Digital Labor*, edited by Trebor Scholz, 258. New York: Routledge, 2012. https://doi.org/10.4324/9780203145791.

Williams, Sam, and 2nd edition revisions by Richard Stallman. *Free as in Freedom*. 2nd Edition. Boston, MA: Free Software Foundation, Inc, 2010.

Zillien, Nicole, and Eszter Hargittai. "Digital Distinction: Status-Specific Types of Internet Usage." *Social Science Quarterly* 90, no. 2 (2009): 274–91.

3

EXPERIMENTS IN PERFORMANCE, IDENTITY, AND DIGITAL SPACE

48 Mystory Remixes, Remixed

Lyndsay Michalik Gratch

Make a sudden, destructive unpredictable action;

Incorporate,

Mute

And continue.
— (Brian Eno and Peter Schmid)t[1]

I'm really just using the mirror to summon something I don't even know until I see it.
— (Cindy Sherman)[2]

In Autumn 2019, I designed a project for my Remix Culture course titled "Remix Yourself."[3] The project, informed by Gregory Ulmer's mystory technique,[4] asks students to use performance and remix praxis to explore issues of digital identity. In this chapter, I discuss phenomenological, pedagogical, and reflexive aspects of "Remix Yourself," including assignment guidelines and goals, descriptions of my experience using it, and examples from students' projects. I also include insight into how the method might work as inspiration for academic writing, and suggest how the assignment might be adapted for expanded contexts and topics within the digital humanities.[5] In doing so, I demonstrate the creative, critical, communicative, and reflexive skills the project can activate for both students and pedagogues.

In this chapter, I use a writing style inspired by mystory and collage, performing how the project was applied and experienced in a communication and performance studies

course. Multiple qualitative scholars have demonstrated mystory's usefulness and flexibility as a performative writing style.[6] Academic mysteries break from the traditional essay structure, often asking readers to be active in meaning-making processes. Text-based mysteries can also offer insights into an author's creative processes that a traditionally formatted essay may not. In collage writing, meanwhile, the thesis of a work is sometimes found best "in the gaps,"[7] as performance studies scholar Amy Kilgard suggests. Meaning is made through disruptive juxtapositions and strange intertextualities. I thus use this writing style to offer a meta-mystory—a mystory about mysteries—that both performs and explains the possibilities of "Remix Yourself" as it might foster discovery, creative/critical thinking, and the "theoretical curiosity" that Ulmer laments is missing in academic writing.[8]

In what follows, I interweave four major threads: 1) An explanation of mystory and "Remix Yourself" methods as performance and remix praxes; 2) a description of the "Remix Yourself" assignment; 3) examples from digital public projects and reflexive writings the assignment inspired; and 4) fragments from the mystory site I created to write this chapter, inspired by Cindy Sherman's public persona and photography.[9] To mirror the logic of mystory in print, I entangle these threads to resist singular or obvious interpretation and ask readers to (at times) make mental leaps between sections. While juxtapositions within this chapter may not always be straightforward, they are intentional.

Remix/Performance: Doing/Something Done

Remember:
Echo only a part, not the whole.
Emphasize the flaws.
— (Brian Eno and Peter Schmidt)[10]

Performance studies scholar Diana Taylor describes performance as "a doing" and "something done,"[11] encompassing process and product. This description, for me, also resonates with remix as process and product. Remix is crucial to how I understand creation, interpretation, communication, and everyday life performances. I have taught versions of Remix Culture, a course I designed in 2014, as communication studies, rhetoric, performance studies, and cinema studies.[12] Despite discipline-specific content, students in the course always study remix history and theory (e.g. issues of digital culture, ownership, authorship, creativity, and authority), along with remix praxis. Students also use remix techniques (applying best practices for transformative and fair use of copyrighted material)[13] to address multiple purposes and audiences.

A difficult aspect of my Remix Culture course, for many students, is the focus on process. The course doesn't include many definitive correct answers, and some students seem not to know *what to do*. Following Ulmer, I believe that "learning is much closer to invention than to verification."[14] Yet many students equate learning with absolutes and correctness. Further, according to Ulmer, academic writing regularly privileges the "already known" over "theoretical curiosity," and contemporary education often discourages "learning how to learn."[15] Perhaps this is due to the academy's changing tides, which seem to be shifting from ideals of *Learning* to *The Student Experience*—which may or may not include coursework. Students also seem increasingly less interested in work

that does not result in a passed test or "useful" product. Yet, in Remix Culture, my reminder that creativity and innovation are useful (and enjoyable, and *employable*) skills encourages many students to view the world through a "remix" lens, despite the lack of an immediate and tangible return on investment. Thinking about processes and products *as remix*, rather than ontologically about *what remix is*, also generatively narrows the frame for my students. Investigating how a digital artifact functions as a remix within specific sociocultural constructs, for instance, is more intriguing than determining the artifact is a remix. This frame is central in my Remix Culture course, aside explanations and applications of remix and its relevance in multiple disciplines.[16]

While not an explicit critique of the entrepreneurial turn in higher education, this chapter illustrates how some university students still appreciate learning via process-based, experimental projects—like "Remix Yourself"—which require they examine their creative and interpretive processes, communicative tendencies, and sociocultural positionalities. I also show how remix praxis via digital technologies can inspire students to explore personal and critical-cultural questions relevant to the digital humanities. Students in my courses, for example, are often surprised by what they find (and what is absent) in digital archives. These absences are often due to cultural oppressions and beliefs about which histories and knowledges are worth archiving. Discovering such absences encourages students to challenge historical trends regarding memory and privilege—which they can do through digital remix. This chapter thus offers one example of how to apply remix in higher education using a project that is adaptable for multiple courses and goals in the digital humanities.[17]

Mystory: Our Version

I am trying to make other people recognize something of themselves rather
than me.
— (Cindy Sherman)[18]

To integrate the topic of digital identity into my Remix Culture course, in Autumn 2019 I designed "Remix Yourself,"[19] a project that applies compositional methods I know via performance studies and remix studies to issues of identity construction and discovery in digital spaces.[20] The goal of "Remix Yourself," as I used it, was to examine how personal identity (when considered as both performance and remix) is crafted, interpreted, and explained through digital media.[21] The semester-long project remixes Ulmer's mystory method, Ruth Laurion Bowman and Michael Bowman's *Handbook for Performance Composition*[22] (written for live performance devising), Michael Jarrett's "Recipe for Mystory"[23] (which focuses on using mystory online), and several prompts from projects I developed for previous versions of Remix Culture.

Mystory is Gregory Ulmer's term for a digital composition genre that uses pattern formation rather than logical argument and that is unique to digital contexts. To create a mystory, one makes, gathers, and curates digital artifacts related to four discourses: the personal, popular, expert, and any fourth area of one's choice (e.g. school, religion, art, history, fun, nostalgia). Embracing relational meaning and associative thinking, mystory remixes image, text, video, memory, story, association, emotion, and artifact into a non-linear, multimedia work. After enough material is generated or collected, Ulmer suggests mystorians will discover patterns or themes within their work. These patterns create

through-lines that cross the boundaries of the mystorian's selected discourses and connect these "different dimensions of experience."[24] Through-lines also ideally reveal something new or previously unknown about the mystorian.

Mystory thus emphasizes the politics, problems, and pleasures of intertextuality without privileging writing or literacy as the primary means of knowledge-making. Mystory uses remix to explore public memory, archiving, cultural narrative, personal narrative, and the relations between identity, popular culture, and digital media. Foregrounding process and invention over product and interpretation, mystorians find or invent stories of self which might otherwise remain buried within unexamined historical discourses. Further, according to Ulmer, mystory is "an autocommunication, addressed first to [oneself], as a self-portrait."[25] Unlike personal narrative or portraiture (which inspire self-editing and inhibition), the mystorian looks at themselves indirectly through several cultural lenses.

In the sections that follow, I juxtapose explanations of the "Remix Yourself" assignment and several examples from student projects. Following Ulmer's claim that mystory is in part autocommunication, I also interweave self-portraiture as sections of fragmented text (my own responses to "Remix Yourself" prompts) from or inspired by the mystory website I created to write this chapter. By including this autocommunication, I hope to illustrate both the types of content *and* the thought processes the assignment can invoke. Additionally, I write as several versions of "me," including first person narrative (Lyndsay, as of the date of this writing), third person narration (the historical Lyndsay[s]), academic Lyndsay, and pedagogue Lyndsay. I use this polyvocal and performative writing style in an attempt to evoke, for the reader, an affective text- and image-based experience akin to how it might feel to explore a digital mystory, where identity and voice are necessarily fragmented and filtered through multiple cultural lenses.

In terms of cultural lenses, an early "Remix Yourself" prompt asks students to choose a cultural icon to research. This is cultural lens number one.[26] For me, it's Cindy Sherman.

Iconicity: The Imitation of Life[27]

> I've looked into a thousand mirrors
> Thinking I'd see you,
> Or at least myself.
> — (Lyndsay Michalik Gratch)[28]

A "Cindy Sherman Day" was included in my first Remix Culture schedule (Autumn 2019) but did not make the final draft. Perhaps I hoped to inspire discussion about Sherman's use of remix, genre, character, and cultural commentary in photography. Maybe I intended to explain how I construct and maintain my identities online, comparing my "authentic" posturing to Sherman's generic "posing." It is also possible I imagined a study of Sherman's Instagram stream, where her grotesque, heavily filtered/altered selfies perform her thoughts about the genre.[29] In an interview with Laura Brown, for example, Sherman states she is "physically repulsed" by "dead" and "set-up" selfies, and the self-involvement of brand culture.[30] Blake Gopnik, meanwhile, draws a lineage between selfies and Sherman's photography, noting the "deliberate shape-shifting that goes on in an Instagram selfie stream has roots in the infiltration of Shermanalia into our culture."[31]

I have forgotten exactly what I planned for that day in class. Yet Sherman's inclusion in that initial schedule, along with the many possible ways I imagine the day may have developed, speaks to the iconic nature of her work—specifically for me. It also shows that I began mystory-style research about Sherman and her work months before I completed my version of the "Remix Yourself" assignment. Thus, Cindy Sherman was the obvious, instant choice for my "Remix Yourself" icon.

Role Models: Fairy Tales and Disasters[32]

I've always played with make-up to transform myself, but everything, including the lighting, was self-taught. I just learned things as I needed to use them. I absorbed my ideas for the women in these photos from every cultural source that I've ever had access to, including film, TV, advertisements, magazines, as well as any adult role models from my youth.

— (Cindy Sherman)[33]

While she did not appear in my Remix Culture class, Sherman enters this chapter as the icon from my "Remix Yourself" site. What fascinates me about Sherman and her work are the—sometimes eerie or uncanny—ways our aesthetic tendencies mirror one another via performativity, excess, and masquerade. According to MoMA's biography of Sherman, "throughout her career, [she] has presented a sustained, eloquent, and provocative exploration of the construction of contemporary identity and the nature of representation, drawn from the unlimited supply of images from movies, TV, magazines, the Internet, and art history."[34]

"Contemporary identity" connected to "unlimited supply" intrigues me.
I think about the infinity mirror effect.
Sherman and I are both "self-taught." We distrust social media images.
I reflect again upon the infinity mirror.
I continue searching online.

What I find: According to Gopnik, "In 1999, Ms. Sherman insisted that 'I'm under so many layers of makeup that I'm trying to obliterate myself in the images. I'm not revealing anything.' Now she admits to a more 'personal aspect' in her images of aging stars: 'I, as an older woman, am struggling with the idea of being an older woman.'"[35]

I mirror: In 1999, Ms. Lyndsay Michalik (later plus Gratch)—a 19-year-old club kid in phat pants and glitter—lied through *possibly* dilated pupils and *potentially* clenched jaws: "I'm under so many layers of makeup that I'm trying to obliterate myself. I'm not revealing anything." She was clearly hiding a *"Look at me!"* plea in plain sight.

And I mirror again: Now, Dr. Lyndsay Michalik Gratch (i.e. academic me, December 2019) has no time for glitter and allows herself to be seen in public only when there is no other option: "As I am slowly becoming an older woman, I am struggling with the idea of this 'becoming.'"[36] One *might* argue Dr. Gratch, reckoning with such becoming, designs projects—"sustained, eloquent, and provocative exploration[s]," perhaps—that allow her to examine "the construction of contemporary identity and the nature of representation"[37] in digital spaces—spaces where one *might* become anyone, yet many simply become who they already are. Projects involving remix and mystory, for example (Figure 3.1).

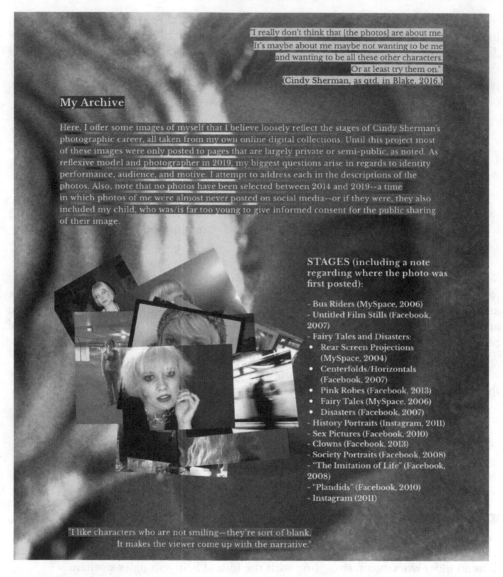

Figure 3.1 Screenshot of "Personal: images and writing" webpage from *Lyndsay/Cindy confidential* by Lyndsay Michalik Gratch (2019) (Image courtesy of the author)

Trust the Process

The pupils of the eyes staring back
Are black holes;
Even those I've seen before.[38]

I tell students they will work on a semester-long project that may not make sense until week 10. I am met with blank stares. I explain mystory and speak about the goal of "Remix Yourself," as it relates to our course goals, including discovery of the self through digital remixing.

Crickets.

I explain they will create a website, respond to prompts, and add digital content to make a "final" remix. At semester's conclusion, they will create a multimedia performance or video to apply their knowledge of remix praxis to a final topic: personal identity.

By Prompt 3, when I ask for questions, many hands raise.

What about ____*? Is this right?* There is no wrong; Trust the process.
What are you looking for with ____*?* Follow the prompts; Trust the process.
Do I understand this? There are multiple interpretations. Trust the process.
How long should I spend ____*?* As long as you need. Trust the process.

After a month of "trust the process," most students accept that I will not tell them *exactly* how to make their project. Weeks pass. I notice some are taking greater creative risks. Writing is stronger and more committed. A sense of earnestness emerges in their work. Their online visual aesthetics also start to take shape—an aspect of the project that worried students with *creativity anxiety* (e.g. "I am not a creative person").

How to Age Successfully as a Woman and Other Anxieties: Society Photos[39]

I, as an older woman, am struggling with the idea of being an older woman.[40]

Step 1. Do not be old. Maintain a youthful appearance and vitality despite being old.
Step 2. See step 1.
Step 3. You are doing it wrong. See step 2.

Some of Sherman's recent photographs imply an anxiety about feminine aging, fashion, and performance ideals, according to Pamela Church Gibson.[41] Abigail Solomon-Godeau posits that while Sherman's earlier photographs suggest the woman in the photo was not real, her recent photos "imply that these are indeed... 'realistic' representations of a certain type of woman."[42] According to Gibson, criticism of these recent photos also implies criticism of *real* aging women and their "efforts in self-preservation."

Note to self: You think about the "real" in relation to the performer's body often.

Pam Cobrin and Debra Levine also use performance vocabulary to describe Sherman's attempts to approximate youth, qualifying her recent photographs as complex failures: her "mask" is obvious. The "always-visible seams" leave the performer and the performance as always already failed.[43]

Note to self: Your standards are NOT realism and believability. Some people's are. Move on.

Michelle Meagher, meanwhile, concludes, "[W]hat emerges from [Sherman's recent] images, perhaps more than anything, is the futility of the struggle that these women

(characters)—and so many women—face while negotiating the lived incongruities between femininity and age."

Note to self: Women should not appear to age. Women appear to age by trying not to.

Meagher questions the possibility of a body being an unmarked canvas, bringing Sherman's "real" physical body into conversation with her photography. Meagher resists the idea that someone could put on identities through costume, make-up, and prosthetics. Instead, Meagher situates Sherman's physical body in context. Based on Sherman's "failed" performances, she—despite makeup or prosthetics—is always *white*, a *woman*, and *feminine*. Further, Sherman grew up in a time and place that would have exposed her to specific popular culture tropes and beauty ideals. Our bodies are "repositories of culture," and—via *habitus*—we are "pre-disposed (but not bound to) behave in particular ways." Thus, in her bodily activities, Sherman reveals implicit "cultural values, morals, and social markings."[44]

Note to self: Do I see myself? Values, morals, markings? The privileged invisibility of whiteness? Youth turned visceral backlash against feminine aging?

The unsmiling character that makes readers piece together some narrative?

Perhaps.

Infinity Mirror Effect and the Not Not Me

I like characters who are not smiling—they're sort of blank.
It makes the viewer come up with the narrative.
— (Cindy Sherman, not not me)[45]

Proprioception:
A sense we take for granted,
Or remember once
We've lost it.

— (Me)[46]

Though Sherman has used the infinity mirror effect (to my knowledge) once,[47] mirrors are prevalent throughout her oeuvre. In collections I notice mirrors everywhere: surfaces to gaze into, props, reflective objects Sherman seems unaware of, and sometimes the only surface her physical image appears upon. I see my "not not me" in these mirrors.

The "not not me," according to performance studies scholar Richard Schechner, is a persona who exists in various degrees in the liminal space between the performer (me) and character (not me). Performances of the self and alter-persona fall between these roles.[48] "Me" and "not me" are *also* performances of identity, of different sort. The "not not me" is difficult to get *just right*. Too little alteration from "me," and the performance is indistinguishable from me; too much and the performance crosses into the impossible realm of becoming another person. If one gets close enough to the "not me" without achieving it, the image seems uncanny and audiences become uncomfortable. (Sherman's early photographs were often referred to as "uncanny.")

Along these lines, Meagher concludes Sherman's photography "might be understood as something more complex and more revealing than theatrical performances that

exemplify some capacity for effortless self-transformation."[49] We cannot be embodied blank slates. Sherman's self-photography performs in the theatrical sense and also encompasses self, culture, and everyday life performance. Sherman documents photographically the liminal space between herself/selves and the cultural tropes she plays. Her performances are her "me," "not me," and "not not me," all at once.

Remix Yourself: Prompts

I really don't think that [the photos] are about me. It's maybe about me maybe not wanting to be me and wanting to be all these other characters. Or at least try them on.[50]

Beyond icon selection, students follow nine other prompts to complete "Remix Yourself." In Autumn 2019, I introduce the prompts one-by-one. I worry about losing students during this experimental, semester-long project, and want to avoid self-consciousness that can manifest when one is asked to create something about themselves. I present prompts a week or two apart:

Prompt 1: Choose a website builder. Create your site, including a home page, title, and five themed pages: Personal, Popular (Icon), Expert, "Your Choice," and Works Remixed.

Prompt 2: Choose a popular icon (person, fictional character, etc.) that is mythical (*to you*) to use as an object of study. As an anecdote, write what you know about his/her/their story (Figure 3.2).

Figure 3.2 Screenshot of "Personal" webpage from *Mystory* by Averi Davis (2019) (Image courtesy of Averi Davis)

Prompt 3: Read "Borges and I."[51] Write your own piece, adapted from his. Investigate notions of self, identity, persona, performance, and acts of "constructed presence."[52]

Prompt 4: Research your icon. Read, watch, look, listen, feel, remember, invent, repeat. Add as much information as you can find to your site. (Minimum eight sources. Compile your works cited as you create on your "Works Remixed" page.)

Prompt 5: Compose a "ground-zero" narrative (story, essay, play, poem, interview, etc.) explaining how you first learned about and became interested in your icon.

Prompt 6: Add six or more sources to your site. Think about your site as an archive. Look for patterns. Sift through your materials and choose one striking image. Set it aside, mentally. Let it ferment.

Prompt 7: Discuss your icon as a "fan" might. Include three hyperlinks: one to an image, one to a video, and one to a text. Add seven or more new sources to your site every week (Figure 3.3).

Figure 3.3 Screenshot of "Personal" webpage from *Mystory Space: Where Ideas Are Made* website by Jordan Rose (2019) (Image courtesy of Jordan Rose)

Prompt 8: Rewrite the story you composed for Prompt 2, knowing what you know now about your icon. Keep both versions visible. Allow the image you selected in Prompt 6 to ferment long enough, and it should become readable as a metaphor that can help you compose the final pieces of this project. You should also begin to see a theme or pattern emerge on your site, which may suggest a method of arrangement for your final work or help you decide what to include.

Yes, Remix *Yourself*

Is it finished?[53]

I post Prompts 9 and 10 a month before the project is due, "revealing" that the final product is about how the student's identity has been shaped by the cultural forces they

have investigated all semester. Panic ensues. Many were so focused on curating artifacts they forgot this aspect of the project. Several students complain: They would have chosen a different icon or content if they knew the final product would be about them. I explain that this is why I focus on process in early prompts. Curating content without a product in mind is a different experience than planning a story about one's identity. Many students later admit that working on a project without thinking about the end product was a unique and welcome experience. The "Remix Yourself" process was a refreshing change from their usual coursework.

Prompts 9 and 10 are explained in depth on my "Remix Yourself" website.[54] I thus offer brief versions below:

Prompt 9: Plan your final product understanding that what you create will be *about you* and not your icon. Create a "theme" page on your website. Think about what you have gathered (consciously, by making choices), your trope/metaphor and your pattern (from Prompt 8). What do these things, and your aesthetic, say about you? Read into your site's intertextuality. Post a list titled "Things about Me": things you discover via your website content and arrangement.

Prompt 10: Following this list, think about how to tell *your story* in a video remix or multimedia performance.

1. Select sources from your site to remix. Create a script. List how these artifacts will be arranged. Confuse the verbal and the visual. Adapt. Remake. Remix. Mix again.
2. Fill in your script. Decide how to include yourself in the work:

 a. Add 30 seconds of video/images of yourself.
 b. Add 1 minute of your voice.
 c. Cite two relevant course readings.

3. Create your remix. Note it will be more dream-like than logical. Show (*don't tell*) who you are, and how you have been influenced by the artifacts and personal materials you have remixed from your website (Figure 3.4). REMIX YOURSELF!

Figure 3.4 Screenshot of *orders and chaos* (video) by Lee Chen (2019) (Image courtesy of Lee Hsin Chen)

Prompt 9 (finding a theme) is difficult for some. I suggest they *stop looking* and focus on intertextual meaning-making. Eventually, an identity-based pattern or theme appears for every student. A website about Alexander Hamilton, for example, transforms into "Ambition"; a site about Arsène Lupin inspires "Orders and Chaos"; Odysseus elicits "Nostalgia" while Marilyn Monroe inspires "Façade"; Coco Chanel brings about "Legacy" and Pocahontas inspires "Survivance." Beyoncé: "Independence"; Bob Marley: "Home-Grown"; Salvador Dalí: "Daring to Dream"; Barbie: "Positive Change."[55] Forty-seven unique projects emerge, despite identical prompts and even overlap in icons. (Forty-eight, if you include mine.)

Who Said It? Lyndsay/Cindy

The truth is that play seems to be one of the most advanced methods
nature has invented to allow a complex brain to create itself.[56]

In class I offer no examples of a mystory "final product" and ask students repeatedly to *trust the process*, as this is more important than the product they ultimately create. I answer many questions with "trust the process" through month 1. By month 2, likely tired of my answer, nearly all students attempt to trust the process. A few ask what I mean by that phrase; they seem convinced that what I am looking for must be more complicated than simple responses to creative prompts. I respond that I am not *looking for* anything in particular. Read the prompts, I say. Think about them, respond to them, don't be afraid to play, and let's see what happens.

Here, I'll offer a final example from my mystory process. This exercise in truthiness represents the type of playful self-prompting I hope for (but am not *looking for*) from students by the end of their "Remix Yourself" process.

Imagine I invented a game out of how I see my "not not me" in Sherman's photography while you were reading the "Remix Yourself" prompts (yes, you).

Rules: I write, you guess. (The reliable narrator Lyndsay has fact-checked the answers in the footnotes, truly.)

> *Let's play!!!*
> "The work is what it is and hopefully it's seen as feminist work."[57]
> "Sometimes I just write down things I overhear. Like this week: 'If you're forced, you can always see a heart, anywhere.'"[58]
> "My fashion sense hasn't changed much since I was four."[59]
> "It seems boring to me to pursue the typical idea of beauty."[60]
> "How about this face, or that character?"[61]
> "I packed picture frames, I packed glassware, two sweaters and a lampshade."[62]
> "I'm disgusted with how people get themselves to look beautiful."[63]
> "I made some poor choices when I imagined how this was going to work."[64]
> "The challenge is more about trying to make what you can't think of."[65]

Remix Yourself: Finales

The way I see it, as soon as I make a piece, I've lost control of it.[66]
— (Cindy Sherman)

The experimental run of "Remix Yourself" was successful insofar as, through their work, most students demonstrated a mastery of multiple course goals. They remixed, adapted, recombined, and recontextualized culture(s) via digital media through their processes. They expressed how the self is influenced by social constructs in their products. They demonstrated communication skills (personal expression and community building) by sharing their products, responding to each other's work, and writing reflexively about their work.

My "Remix Yourself" project inspired parts of this chapter, along with my performative choices while writing. Creating the website offered insight into affective aspects of the project (e.g. confusion, joy, surprise, anger, amusement, shame, frustration, anxiety, pride). Site construction also gave me space (and time) to work through feelings via digital artifacts, image-based communication, design, metaphor, and bridled audacity. I learned I am fascinated by mirrors, tend toward academic irreverence, and am uncomfortable with aging (despite feminism). I *remembered* things: the "poor choices [I made] when I imagined how this [chapter] was going to work."[67] I also reinforced why I created "Remix Yourself." I am interested in digital identity, sought new ways to think about it, and wanted to revisit mystory anew, as remix.

Finally, while I designed the project for Remix Culture class, "Remix Yourself" could be useful (with adaptation) for multiple course topics in the digital humanities. Lessons/units about digital composition, visual culture, public memory, archives, identity politics, digital communication, performance, cinema studies, and digital anthropology, for example, could benefit from an adapted version of the project, based on course goals. Beyond class, meanwhile, student responses from the project's initial run indicate that many are proud of their work and found value in the process, including skills like web design, audio/video editing, and digital storytelling. Meanwhile, students who were hesitant to trust their creative and aesthetic judgments often surprised themselves by remembering or reinventing, their creativity.

Infinity Mirror: Mirror: Mirror: Mirror

I am watching the final "Remix Yourself" products in class at the end of the semester.

Stress and self-doubt and searching are a part of life. Everybody is going through something.[68]

I am, at times, holding back reactions—shock, pride, empathy, happiness, tears.

I am just built out of several variations of myself... Which self is the most I? We never fully realize who our I's are, because our contexts change more times than we can count.[69]

Phrases catch me off guard; Phrases I read in scripts and on websites, but when voiced resonate as palpable, human.

Maybe she is a show I present as if I were a director and she was a leading lady. But even then, how much of the actress lies in her character and how much of the character was always inherently in the actress?[70]

Fresh voices emerge, hinting, "I think I've got this," or "I'm still not sure," or "I'm taking a huge risk here, but—."

> *I entered the room, the reflector of me. The room is orderly and chaotic, it's warm and frosty, it's lively and lifeless. And that's me.*[71]

Voices every classroom should invite.

> *It is quite possible (after all)*[72]

Notes

1 Brian Eno and Peter Schmidt, "Oblique Strategies: Text by Brian Eno and Peter Schmidt." *Stoney's Zone* (2018). http://stoney.sb.org/eno/oblique.html.

2 As qtd. in Betsy Berne, "Studio: Cindy Sherman – Interview." *Tate* (June 1, 2003). https://www.tate.org.uk/art/artists/cindy-sherman-1938/studio-cindy-sherman.

3 This was in the Department of Communication and Rhetorical Studies at Syracuse University.

4 Gregory L. Ulmer, *Heuretics: The Logic of Invention* (Baltimore, MD: Johns Hopkins University Press, 1994).

5 I completed the project, following the same guidelines as my students, as inspiration for this chapter.

6 Michael S. Bowman, "Killing Dillinger: A Mystory." *Text and Performance Quarterly*, 20.4, 342–374. 2000; Nandita Dinesh. "In-between spaces: theatrical explorations from Rwanda to Kashmir." *South African Theatre Journal*, 28.1, 43–57. 2015; Lori Howe and Dilnoza F. Khasilova. "The Bread of Two Worlds: A Duoethnography on Multilingualism." *Journal of Poetry Therapy*, 31.1, 40–55. 2018; Ronald E. Shields. "Chasing Kundry's Shadow," *Text and Performance Quarterly*, 26.4, 371–388. 2006; Tracy Stephenson Shaffer. "Busted Flat in Baton Rouge." *Text and Performance Quarterly*, 25.1, 57–69. 2005

7 Amy Kilgard. "Collage: A Paradigm for Performance Studies." *Liminalities: A Journal of Performance Studies*, 5.3, 1–19. 2009.

8 Ulmer, *Heuretics*.

9 Cindy Sherman is known for her collections of photographic self-portraits. Her relevance to "Remix Yourself" is explained in greater detail throughout the chapter.

10 Eno and Schmidt, "Oblique Strategies" as qtd. in Lyndsay Michalik Gratch, "Infinity Mirror." *lyndsay/cindy confidential*, 2019. https://legratch.wixsite.com/mystory.

11 Diana Taylor and Abigail Levine, *Performance* (Durham, NC: Duke University Press, 2016), 7.

12 To date (May 2020), I have designed seven versions of this course as a major elective in Oberlin College's Department of Cinema Studies (Oberlin, OH, 2014–15) and Syracuse University's Department of Communication and Rhetorical Studies (Syracuse, NY, 2018–20).

13 Patricia Aufderheide, "Copyright and Fair Use in Remix," *The Routledge Companion to Remix Studies*, eds. Eduardo Navas, Owen Gallagher, xtine burrough (New York: Routledge, Taylor & Francis Group, 2017), pp. 270–282.

14 Ulmer, *Heuretics*.

15 Ibid.

16 For example art, composition, performance, communication, rhetoric, cultural studies, history.

17 Several of my course goals are included in this chapter's conclusion.

18 As qtd. in "Art.sy Insight: Cindy Sherman the Painter." *Artsy*, December 21, 2012. https://www.artsy.net/article/editorial-art-dot-sy-insight-cindy-sherman-the-painter.

19 This title is similar to "Remix it Yourself," a phrase Vito Campanelli uses to explain notions of creativity in relation to digital remix. Campanelli posits that digital remix is not driven by an "internal creative drive," but rather by the electronic "flow of information in which [remixers] are immersed." "Remix Yourself," as a title, is not meant to be a reference to Campanelli; it is meant to interrogate how remix might be related to digital performances of personal identity. In my experience, numerous students believe that they have no "internal creative drive." This assignment asks them to find it. See: Vito Campanelli, "Remix It Yourself. A Do It Yourself Ethic," *Comunicação e Sociedade*, 22, 8–15, December 2012.

20 A step-by-step guide to project prompts is included later in the chapter.

21 The "Remix Yourself" prompts are, however, broad enough to be adapted for additional topics.

22 Ruth Laurion Bowman and Michael Bowman, *Handbook for Performance Composition*. 2011.

23 Michael Jarrett, "Writing, Rhetoric, and Digital Studies." Mystory | *Writing, Rhetoric, and Digital Studies*, July 5, 2012. https://wrd.as.uky.edu/mystory.

24 Gregory L. Ulmer, *Internet Invention: From Literacy to Electracy* (New York, NY: Longman, 2003).

25 Ibid.

26 I explain project prompts in detail later.

27 This title references Sherman's 2016–17 photography.

28 Lyndsay Michalik Gratch, *lyndsay/cindy confidential*, 2019. https://legratch.wixsite.com/mystory.

29 See @cindysherman on *Instagram*.

30 Laura Brown, "Cindy Sherman: Street-Style Star." *Harper's Bazaar*, October 11, 2017. https://www.harpersbazaar.com/culture/features/a14005/cindy-sherman-0316/.

31 Blake Gopnik, "Cindy Sherman Takes on Aging (Her Own)." *The New York Times*, April 21, 2016.

32 This title references Sherman's 1980s photography.

33 As qtd. in Monique Beudert and Sean Rainbird, eds., *Contemporary Art: The Janet Wolfson de Botton Gift* (London: Tate Gallery Publishing, 1998).

34 Kristen Gaylord and Nancy Newhall, "Cindy Sherman | MoMA." *MoMA (The Museum of Modern Art)*, 2016. https://www.moma.org/artists/5392.

35 Gopnik, "Cindy Sherman Takes on Aging (Her Own)."

36 Phrase is adapted from Gopnik, "Cindy Sherman Takes on Aging (Her Own)."

37 Ibid.

38 Umberto Eco and William Weaver, *Foucault's Pendulum* (Orlando, FL: Harcourt, 2007).

39 This title is a reference to Cindy Sherman's 2008 photography.

40 As qtd. in Gopnik, "Cindy Sherman Takes On Aging (Her Own)."

41 Gibson defines these "performances" as "using the tools of self-adornment." See Pamela Church Gibson, "Cindy Sherman in a New Millennium: Fashion, Feminism, Art and Ageing," *Australian Feminist Studies*, 33.98, 481–497. 2018.

42 Abigail Solomon-Godeau, *Photography after Photography: Gender, Genre, History* (Durham: Duke University Press, 2017).

43 Pam Cobrin and Debra Levine. "Introduction." *Women and Performance*, 22.1, 1–7. 2012.

44 Michelle Meagher, "Against the Invisibility of Old Age: Cindy Sherman, Suzy Lake, and Martha Wilson." *Feminist Studies*, 40.1, 101–143. 2014.

45 As qtd. in Mark Stevens, "40th Anniversary: Q&A With Cindy Sherman on Making Her 'Untitled Film Stills'— New York Magazine – Nymag." *New York Magazine*, April 3, 2008.

46 Gratch, "Infinity Mirror," *lyndsay/cindy confidential*.

47 @cindysherman. "Outside in." *Instagram*, March 18, 2018. https://www.instagram.com/p/BgdoMdDArgd/.

48 Richard Schechner and Victor Turner, *Between Theater and Anthropology* (Philadelphia: University of Pennsylvania Press, 1985).

49 Meagher, "Against the Invisibility of Old Age."

50 Gopnik, "Cindy Sherman Takes On Aging (Her Own)."

51 Jorge Luis Borges, *1899–1986. Collected Fictions* (New York, NY: Penguin Books, 1999).

52 This prompt was adapted from a blog prompt on Mark Amerika's 2017 Remix Culture Syllabus. See America, Mark. "Remix Culture." 2017. http://www.altx.com/remix/syllabus.html.

53 Eno and Schmidt, "Oblique Strategies."

54 Gratch, *lyndsay/cindy confidential*.

55 Described sites (and more) are linked on Gratch, *lyndsay/cindy confidential*, 2019. https://legratch.wixsite.com/mystory.

56 Stuart L. Brown, *Play: How It Shapes the Brain, Opens the Imagination, and Invigorates the Soul* (New York, NY: Avery, 2010), 40.

57 Sherman as qtd. in Berne, "Studio: Cindy Sherman – Interview."

58 Lyndsay.

59 Ibid.

60 Sherman, as qtd. in Peggy Zeglin Brand, *Beauty Matters* (Bloomington, IN: Indiana University Press, 2000), 8.

61 Sherman, as qtd. in Parul Sehgal, "The Ugly Beauty of Cindy Sherman's Instagram Selfies." *The New York Times*, October 5, 2018.

62 Lyndsay.

63 Sherman as qtd. in Gaylord and Newhall, "Cindy Sherman | MoMA."
64 Lyndsay.
65 Sherman as qtd. in Berne, "Studio: Cindy Sherman – Interview."
66 As qtd. in Diane Lindquist, "Cindy Sherman," *GURL Museum Day*, February 26, 2018. http://gurlmuseumday.com/viewallmagazine/2018/2/21/uncover-cindy-sherman.
67 As referenced in footnote 58. Specifically: Do not write a chapter in the weeks following a new semester-long experimental assignment. Data collection was not possible during most of the "Remix Yourself" process.
68 Sydney Saroken, "Authenticity." *Mystory*, 2019. https://sydneysarokin.wixsite.com/mystory/final-mystory-video.
69 Kari Karsten, "Daring to Dream." *Karis Mystory*, 2019. https://kfkarste.expressions.syr.edu/.
70 Hannah Hamermesh, "Hannah's Mystory." *Hannah's Mystory*, 2019. https://hnhamerm.expressions.syr.edu/.
71 Lee Hsin Chen, *Orders & Chaos* (film). 2019.
72 Eno and Schmidt, "Oblique Strategies."

Bibliography

Aufderheide, Patricia. "Copyright and Fair Use in Remix: From Alarmism to Action." In *The Routledge Companion to Remix Studies*, edited by Eduardo Navas, Owen Gallagher, and Xtine Burrough, 270–279. New York: Routledge, 2015.

Baldry, Nathan. "Nostalgia." *CRSMyStory*, 2019. https://njbaldry.expressions.syr.edu/nostalgia/.

Borges, Jorge Luis. "Borges and I" *1899-1986*. *Collected Fictions*. New York, NY: Penguin Books, 1999.

Brown, Laura. "Cindy Sherman: Street-Style Star." *Harper's Bazaar*, October 11, 2017. https://www.harpersbazaar.com/culture/features/a14005/cindy-sherman-0316/.

Cachia, Amanda. "The (Narrative) Prosthesis Re-Fitted: Finding New Support for Embodied and Imagined Differences in Contemporary Art." *Journal of Literary & Cultural Disability Studies* 9, no. 3 (2015): 247–264, 373.

Chen, Lee Hsin. "Mystory Reflection." 2019.

"Cindy Sherman." *Museum of Modern Art*. MoMa.org. 2012.

Cobrin, Pam, and Debra Levine. "Introduction." *Women and Performance* 22, no. 1 (2012).

Church Gibson, Pamela. "Cindy Sherman in a New Millennium: Fashion, Feminism, Art and Ageing." *Australian Feminist Studies* 33, no. 98 (2018): 481–497.

Davis, Averi. "AMBITION." *Averi's Mystory*, 2019. https://davisaveri4.wixsite.com/averismystory.

Delormier, Katelynn. "Personal." *Katelynn's Mystory*, 2019. https://sites.google.com/view/katelynns-mystory/personal.

Gaylord, Kristen, and Nancy Newhall. "Cindy Sherman | MoMA." MoMA. *The Museum of Modern Art*, 2016. https://www.moma.org/artists/5392.

Grant, Amber. "Gallery." *MyStory*, 2019. https://akgrant.wixsite.com/mystory/about-1.

Gratch, Lyndsay Michalik. "'Infinity Mirror.'" *lyndsay/cindy confidential*, 2019. https://legratch.wixsite.com/mystory.

Gopnik, Blake. "Cindy Sherman Takes on Aging (Her Own)." *The New York Times*, April 21, 2016. https://www.nytimes.com/2016/04/24/arts/design/cindy-sherman-takes-on-aging-her-own.html.

Hamermesh, Hannah. "Hannah's Mystory." *Hannah's Mystory*, 2019. https://hnhamerm.expressions.syr.edu/.

—. "Remix Yourself Reflection," 2019.

Jarrett, Michael. "Writing, Rhetoric, and Digital Studies." *Mystory | Writing, Rhetoric, and Digital Studies*, July 5, 2012. https://wrd.as.uky.edu/mystory.

Karsten, Kari. "Daring to Dream." *Karis Mystory*, 2019. https://kfkarste.expressions.syr.edu/.

Kilgard, Amy," Collage: A Paradigm for Performance Studies." *Liminalities: A Journal of Performance Studies* 5, no. 3 (2009): 1–19.

Kinka, Emily. "Courage." *Emily's Mystory*, 2019. https://www.emilykmystory.com/courage.

Knafo, Danielle. "Dressing Up and Other Games of Make-Believe: The Function of Play in the Art of Cindy Sherman." *American Imago* 53, no. 2 (1996): 139–164.

Li, Yuhao. "This Is Me." *Mystory*, 2019. https://yli359.wixsite.com/mystory.

Meagher, Michelle. "Against the Invisibility of Old Age: Cindy Sherman, Suzy Lake, and Martha Wilson." *Feminist Studies* 40, no. 1 (2014): 101–143, 218.

"Oblique Strategies: text by Brian Eno and Peter Schmidt." *Stoney's Zone*. n.d. http://stoney.sb.org/eno/oblique.html.

Risk, Shantal. "Latin Culture." *Everything is a Remix*, 2019. https://shantalrisk.wixsite.com/remix-culture/latin-culture.

Rose, Jordan. "The Past Makes the Present." *Mystory Space*, 2019. https://jordan9221.wixsite.com/mysite.

Saroken, Sydney. "Authenticity." *Mystory*, 2019. https://sydneysarokin.wixsite.com/mystory/final-mystory-video.

Schechner, Richard and Victor Turner. *Between Theater and Anthropology*. Philadelphia, PA: University of Pennsylvania Press, 1985.

Smith, Christina. "School." *Mystory*, 2019. https://christinamarys99.wixsite.com/mystory.

Stewart, Cameron. "Positive Change." *Mystory*, 2019. https://cstewa06.wixsite.com/mystory.

Solomon-Godeau, Abigail. *Photography After Photography: Gender, Genre, History*. Durham, NC: Duke University Press, 2017.

Taylor, Diana, and Abigail Levine. *Performance*. Durham, NC: Duke University Press, 2016.

Ulmer, Gregory L. *Heuretics: The Logic of Invention*. Baltimore, MD: Johns Hopkins University Press, 1994.

—. *Internet Invention: from Literacy to Electracy*. New York, NY: Longman, 2003.

4
PRODUCTION PLUS CONSUMPTION
Remix and the Digital Humanities
Virginia Kuhn

The last few years have seen a surplus of scholarship centered on the digital humanities: Is it a method? A field? A subfield? How is it different from the humanities proper? What about humanities computing? How does digital humanities compare to media studies? Multimodal scholarship? It sometimes seems as though there is more discussion *about* the digital humanities than there is scholarship borne *of* the digital humanities.[1] The salient distinction between digital humanities and remix, in my view, has far less to do with the "digital" and far more to do with the "humanities" side of the term, and its impact is seen largely when we look at its scholarship, or rather the formal qualities of its scholarship. The written word holds sway in most humanities-based fields. This was very much the case in the late 1990s and early 2000s when I began requiring image-based projects of my students, while I was also creating a media-rich, natively digital dissertation in an English department. Writing *about* extratextual media elements—sound, images, film—was fine, but writing *with* such media was simply not done.

My experience was certainly not unique. In academia, the bias for the written word remains strong, particularly in the humanities. And it has certainly had a long history: For example, in tracing the rise of college writing classes, Sharon Crowley finds rampant evidence of the "humanist contempt for mass media and popular culture" running through the professional literature. By way of example, she notes one scholar's 1950 lament about the "visual minded illiteracy of a generation of television watchers," just as in 1890, Adams Sherman Hill worried that novels and newspapers would ruin people's language skills as well as their morals.[2] The humanistic tendency to view literature—a certain type of rarefied literature, actually—as the height of human expression is at odds with the study of mass media, and this privileging of these texts in turn has implications for the type of critical response deemed appropriate. Poets and dramatists are considered artists; as such, they are granted creative use of language. The corresponding academic essay, however, is *about* literature and so it must take the form of prose. Clarity is valued above all so there is no room for creativity. And yet, language scholars have long challenged the notion that clarity is an ideologically neutral facet of the written word, even as the form of eight and a half by eleven inch, double-spaced, thesis-driven essay in the

ubiquitous typeface, Times New Roman, carries its own value system, and dictates what can be expressed within its form.

Given these roots, it is not surprising that many digital humanities projects build digital tools to study literature and art, developing databases of ancient texts, for instance. And, insofar as many film studies programs grew out of literature studies, the situation is similar—cinema is the art that is written about, but only using academic prose.[3] The realm of the creative and the critical are separate and the form of critical writing does not shift much, nor is it questioned. However, digital technologies are nearly as amenable to the extratextual registers of sound, image, video, and linking structures as they are to words. As such, their use is paramount to anyone interested in the production of knowledge, a key function of the university. Further, I regard this issue as one of contemporary literacy—that is to say, the bombardment of screen-based media requires us not only to decode their meanings, but it also requires us to use the multiple registers of meaning in a critical way if we are to be literate. Put another way, the rhetorical choices involved in creating multimodal texts—those that span the registers of word, image, and sound—cannot be fully understood unless one is forced to actually make those choices, too. This is where remix, in the form of digital argument, becomes a powerful way of fostering digital literacy.

Remix and Lettered Orality

My use of the term remix and its importance to twenty-first century literacy is premised on the conception of *lettered orality*, a term I use to indicate the sort of mindset one needs to navigate the contemporary world of screen-based media.[4] Lettered orality combines techniques associated with oral cultures such as rhyme, repetition, and rhythm, with features of (print) literate culture such as statistics, logic, and abstraction. In this way, lettered orality encapsulates the type of associational, empathic subordinative ways of knowing, while it is also deeply anchored in the hierarchical and analytic potentials of the written word. Lettered orality resists the narrative of progress that suggests the digital is somehow superior to or completely distinct from analog media. The stance is not founded on one register of meaning or another, but rather embraces them all as potentially appropriate to a given situation. In fact, I frequently find that analog media can perform a necessary step in the production of a digital argument: Wireframes and storyboarding are useful for planning and analog elements such as hand-drawn or painted images can also be captured digitally and incorporated in digital work—or any mix thereof.

This mixing of media echoes the intermedia movement of the 1960s as Dick Higgins and the Fluxus artists combined many forms of analog media. It should be no surprise then that this movement gave rise to the seminal video work of Nam Jun Paik. However, the advent of digital media changes things in a few important ways. First, the immediacy of reaching disparate constituencies via a networked society is unprecedented, if not completely novel. While there are analog ways of disseminating texts via the fax machine or the postal mail, these are "push" technologies that require an addressee. Online digital texts, by contrast, are pull technologies—these texts can be accessed by anyone, assuming they can be found; ostensibly, this means the potential audience is massive. More importantly, however, the digital adds the element of inexhaustibility: Unlike a hard copy book, I can share a copy of a digital text without losing my own copy;

if I give my physical book to you, I no longer have one. The inexhaustibility of the original, paired with digital networks, allows remix to become a widely available means of communication and expression.

A particularly germane example of lettered orality and remix comes by way of *The Daily Show with John Stewart*, an early "news" show that began airing on Comedy Central in 1996. *The Daily Show* pioneered the technique of sampling the early 24-hour cable news environment by compiling copious segments. Indeed, *The Daily Show* famously combined these clips in order to comment on popular culture, but also on the news media itself and its coverage of pop culture. Just as the first vidders used their VCRs to record and assemble video remixes, so too *The Daily Show* used freelance labor to record the clips on home VCRs, which were then broadcast on cable television. Clips for two of these early compilation videos were recorded in 2002 by Tamara Federici, a young writer who was just breaking into the entertainment industry. The first surveys the numerous news sources made possible by cable television's many channels, focusing on the advertising used to win viewers and boost ratings. Viewing these ads in sequence, as they accumulate, gives a sense of the unsavory nature of such ratings wars in an environment in which these many news shows are dependent on product advertising for survival. The second segment shows the other side of the coin in its overview of the tedious programming of the nonprofit channel, C-Span (Figure 4.1). The clips feature roll calls, small, dull civic meetings, and dreary bureaucratic happenings—these dreary events masquerading as news, all seemingly included only to fill airtime. No glitzy advertising or competing for viewers on C-Span.

Both of these segments, which aired as part of *The Daily Show's* "I on News" feature, foster a critical relationship to broadcast media by highlighting the forces behind these news outlets. And if the number of potential news sources increased greatly via cable television, a few decades later the situation is significantly amplified by the incorporation of social media into the news ecosystem. The ethics of these sites and the veracity of the content pushed through them are questionable and, as such, demand investigation. The form of these remixed segments is equally interesting, or rather *the trajectory* of the form of these segments is interesting: Analog media were recorded on a home VCR, then broadcast to millions via cable, after which they were digitized and

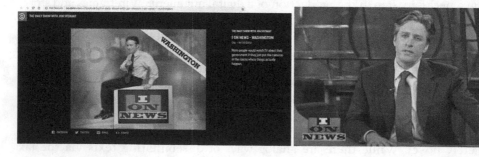

Figure 4.1 Left: Screenshot of the "I on News," featured segment of The Daily Show, 2002. http://www.cc.com/video-clips/4s9r5v/the-daily-show-with-jon-stewart-i-on-news—washington. Right: Screenshot of the "I on News," featured segment of The Daily Show, 2002. http://www.cc.com/video-clips/an05ak/the-daily-show-with-jon-stewart-i-on-news—advertising

Figure 4.2 Screenshot from "Scary Mary," Christopher Rule, 2006. https://www.youtube. com/watch?v=2T5_0AGdFic

placed online where I accessed them on my home computer, completing the circle of media distribution and consumption. This combination of texts, the meaning of which lies in its form as well as its content, is the stuff of lettered orality.

Likewise, a video remix born of lettered orality might combine anecdotal and statistical evidence via video testimony over which numbers and other graphics are placed, or perhaps use sound effects to animate political speech; these techniques are launched in order to make a point that resonates both emotionally and intellectually. A straightforward example of the combination of emotion and logic comes by way of "Scary Mary," a video that remixes the *Mary Poppins* movie trailer by stripping out the original soundtrack and inserting sounds culled from horror movies (Figure 4.2). Watching the familiar footage of the kindly British nanny set to this suspenseful soundtrack demonstrates the extent to which sound is an important mood setter and emotion is a powerful, if unacknowledged, interpretive force—most Western viewers know that Mary Poppins is not a horror film and yet, it is quite difficult to shake this haunting, "scary" reading of the trailer when viewed this way.[5] If the Mary Poppins example seems frivolous beyond providing a quick lesson in mise-en-scène, its power actually lies in its accessibility and its immediacy. With this quick lesson in tone and mood, we might more productively consider an academic remix that uses sound and image to make a nuanced digital argument.

In "Repetition in the Mirrors of Reason," we find a very compelling example of a manipulated soundtrack that provides an emotional appeal, one which resonates formally and conceptually (Figure 4.3). The short video includes newsreel footage of Mexican revolutionary movements intercut with clips of Sergei Eisenstein's *¡Que Viva México!* and key passages from Octavio Paz's poem *The Labyrinth of Solitude*. Over this footage, we hear one repeated dialogue in Spanish (with English subtitles) which says "We will do this as long as God allows it. What are we going to do? We come from poverty. If we were doing better we would be like you. Traveling the world or doing nice clean jobs like you guys."[6] The dialogue shifts just slightly with each repetition; the words carefully chosen such that our sympathies lie with the narrator, whose clear

thecine-files.com/repetition-issue11/ ☆

REPETITION IN THE MIRRORS OF REASON

The Cine-Files, issue 11 (fall 2016)

Sophia Serrano

Graduate Student, School of Cinematic Arts, USC

> Modern man likes to pretend that his thinking is wide-awake. But this wide-awake thinking has led us into the mazes of a nightmare in which the torture chambers are endlessly repeated in the mirrors of reason.
>
> Octavio Paz

Repetition in the Mirrors of Reason utilizes a range of Mexican archival and documentary footage juxtaposed with a repeating dialogue in order to explore the ways in which the mythology of *revolution* resurfaces and shifts slightly, in terms of political discourse as well as visual representation. Beginning with the Revolutionary War (1910–1920), moving through the student movement of 1968 (which resulted in the Tlatelolco massacre), and on to the uprising of the Zapatista Army of National Liberation in the 1980s–1990s, the video reflects upon the various ways Mexican leftist political groups have been documented and portrayed to international audiences. Alongside these images is a repeating soundtrack, in which the speaker emphasizes a lifelong devotion to one's cause. However, in the final section, the dialogue is replayed with its original visual track which is taken from Matthew Heinemann's Cartel Land (2015), revealing the "revolutionary" rhetoric to be spoken by a cartel member discussing drug production and trafficking.

Figure 4.3 Screenshot depicting the opening lines from "Repetition in the Mirrors of Reason." http://www.thecine-files.com/repetition-issue11/

revolutionary moment we want to support. This dialogue is heard over a visual track of the revolutionary war of 1910, the student uprising of 1968, and the 1980s uprising of the Zapatistas. When the soundtrack is finally synced to its original image track, it is revealed to be contemporary footage from the documentary, *Cartel Land*, the voice is one of a drug manufacturer as he and his associates stir a vat, cooking drugs to sell over the US border.[7] This reveal challenges a US audience—it is easy to understand the plight of the narrator, with his invocation of God and the desperation of his poverty. However, when we find out the source of the voice, it becomes difficult to reconcile notions about revolutionary justice with this alternative way of doing business, which is ostensibly feeding the addictions of the United States. Forcing the viewer into this position of judgment is a worthy goal on its own, I would argue, given the complex and typically exploitive relationship between the United States and Mexico. But this video makes an even more complex argument through its formal qualities.

Although the reveal occurs only upon the first viewing, its impact persists as further viewings become more, not less, meaningful. Indeed, the first time is merely about surprise; subsequent informed viewings actually strengthen the point as one begins to understand the nuances among the clips and their resonance with the spoken dialogue. The form also reveals information about archival practices: The newsreel footage of Pancho Villa as well as the more recent footage of the Zapatista movement are worn and

faded, while the clips from the well-preserved Eisenstein film ¡Que Viva México! are really rich and luxurious by contrast. This difference is a visual indicator of the relative un/importance that we place on events surrounding Mexico. The Octavio Paz excerpts that speak to history repeating itself become especially striking as we realize that these days history is not only written by the victors but also filmed and archived by them.

If this type of historical argument requires an accumulation of examples to make its point, the technique can also become discouraging as it seems to disempower the individual. Yet the simple awareness of such histories can help bring about change: If a problem cannot be identified, it certainly cannot be fixed. At its best, remix plays with form and uses inventive rhetorical devices to lend nuance and sophistication to an argument, rather than resorting to simple drama or preachiness. This type of remix is closely related to Eduardo Navas's category of the "selective remix" in which features have been carefully chosen but which retains some facet that is recognizable.[8] I am less concerned about the recognizability of the original because in the remixes I make and teach in my classes, all elements used are cited and, when appropriate, chyrons (watermarks) are retained or even added to footage in order to show provenance. I have long argued that if we cite words but clear images (by either asking permission or paying), we effectively let Hollywood dictate who may speak and who is silenced. However, a fair use claim can be made by citing sources, by only using the amount necessary to make one's point and by transforming the media in some way. This sort of rigor is necessary for a digital argument and it is consonant with academic practice.[9]

By including different registers of meaning—the poetic as well as the prosaic—remix naturally uses a larger range of evidence to make its points. In this respect, the meme or popular song or any of those cultural elements are equally as influential and similarly offered as evidence to make one's point. This is particularly the case since both fiction and nonfiction constitute the stories of our time and so when you take the sort of supposedly more objective evidence from history and pair it with the creative, you can spread out the range of meanings across several registers. This work, therefore, can prove more accessible to a wider range of audiences, including the general public. But too often making things is considered non-scholarly and does not count for academic credit. We must push back against the notion that working with technologies is manual labor. In an excellent overview of the digital humanities, Christopher Magis stages a reading of the theory/practice divide through the lens of Adorno, Horkheimer, and the Frankfurt school. In current culture, he argues, the division of labor between manual and intellectual is no longer based on scarcity but on social control.[10] As such, academics ought to focus on "the rediscovering of an actual theory" in the work of academia, and also to rediscover a praxis that is distinctly political.[11]

The Ivory Tower and the Ongoing Life of Culture

A residual effect of the digital on the humanities is the public nature of networked technologies, which serve to make parts of academic work more visible. Accessibility to academic work is particularly important in the arts and humanities if we understand them to be vital sources of cultural critique, as the conscience of culture, those who speak truth to power. Indeed, discussions of the digital humanities often include public humanities, forcing us to remind ourselves that we cannot and should not be untethered from the life of culture or we are "academic" in the worst, most politically anemic sense of the word. Given the recent evidence of anti-intellectualism that accompanies much

of the blind nationalism in the United States and many parts of the world today, we sequester ourselves at our peril—morally, as well as politically.

Might remix help bring us out of the Ivory Tower and encourage us to be better keyed into culture? A 2015 article in *The Guardian* makes this very point in a brief piece about *[in]Transition Journal of Videographic Film & Moving Image Studies*, the peer-reviewed digital arm of *The Journal of Cinema and Media Studies*, suggesting that video essays have the potential to connect with the public in ways that have not been available heretofore.[12] But there is more reason for academics to attend to culture: In these times of political darkness, the best cultural news is coming from remix and we would be advised to take notice. An amazing example of a remix that works for a more inclusive public sphere finds Lil Nas X sampling part of the Nine Inch Nails' 2008 instrumental track "34 Ghosts IV," using it as a basis for "Old Town Road," a song that, as of this writing, is the longest running song to be number one on the Billboard Hot 100 list. This is a first for both Reznor and his writing partner Atticus Ross, who are given a writing credit, as well as for Lil Nas X. What is more striking than this long run at number one is the fact that Lil Nas X came out as gay shortly after "Old Town Road" made it to the top of the charts. One could say this was a relatively safe time for the rapper to come out, and yet its impact is definitely enhanced by the song's status as a number one. For his part, Trent Reznor has resisted taking media attention away from "Old Town Road," noting that the material sampled was transformed into something new, that "those guys should be the ones the spotlight is on," and that it is not his place to weigh in.[13]

"Songs of Our Native Daughters," an album recorded by Rhiannon Giddens, Amythyst Kiah, Allison Russell, and Leyla McCalla, is another key politically charged musical project. These women, all solo artists or with other bands, came together under the mantle of *Our Native Daughters* as an act of solidarity and cultural critique and remedy. All four are women of color who also play the banjo and have been repeatedly expected to justify their instrument, which is commonly seen in the United States as the domain of white men. The 13 songs on the album are explicitly political in varying measures, but they all implicitly question the origin stories that surround American myths. For example, "Polly Ann's Hammer," is sung from the point of view of Paul Bunyan's woman, who wields a hammer as well as any man when she must fill in for the ailing Bunyan (Figure 4.4). All songs reimagine such legends and many touch on the Native Daughters' individual family histories and the plight of the Black women who are their forebears. These talented musicians celebrate their music, but also acknowledge the history of the many racist institutions that have formed it. And the album has been well received. In fact, Amethyst Kiah's song, "Black Myself," was nominated for a Grammy Award in 2019. This album is another great example of lettered orality, as the women remix their past and help secure their own future.

Will liberation happen as a result of lettered orality? As the father of critical pedagogy Paolo Friere argued, critical awareness is required for literacy to have any sort of liberatory potential. And while lettered orality may not bring the end of oppressive structures, there will certainly be no just society without it. Indeed, in an era that is dominated by screen-based media, fluency with these semiotic systems is vital. The digital humanities can play a pivotal role in contributing to the sort of educated citizenry that is so desperately needed in this era but only if we reexamine both our tools and the ways we deploy them. It is useful to remember that the humanities' reliance on rarefied literature was

Figure 4.4 Amethyst Kiah singing the Grammy-nominated "Black Myself" at the Troubadour February 25, 2020

purposeful; it was informed by the notion that studying the height of human accomplishment would educate students, raising them to their highest potential. Of course, the extent to which the Western canon has been exposed to be as limited (pale and male) in its authorship, as it once was in its studentship; basic literacy was assumed when wealthy white European men were the typical college student so the study of literature was connected to class, wealth, and status. Those days are long gone.

Contemporary academia is far more diverse, mediated, and connected than ever before in human history. Not only is the mediascape incredibly complex, but it is also intentionally manipulated by world leaders such as Donald Trump, who gain and hold power by public bullying and making frequent contradictory statements that sow the seeds of confusion.[14] Assessing credibility in this swarm of misinformation is a constant and unrelenting task requiring a high level of lettered orality. Add to this the pandemic of COVID-19 and the concomitant need for medical and logistical information that changes daily, if not hourly, and the result is an amplification of current uneven power structures; those who have the time and ability to sort through the information and find resources will be able to protect themselves. Perhaps more importantly though, if we are to solve the major world problems of our time and not become extinct in the near future, it will take all of our collective human ingenuity and imagination as well as the broadest range of opinions and skills possible. Insofar as remix born of lettered orality embraces a wider range of speech and speakers, it has the potential to help bring once silenced voices into the mainstream. Further, the digital humanities, by embracing remix culture, may help bring academe closer to the public/s it is supposed to serve.

Notes

1 cf: McCarty (2005); McPherson (2009); Fitzpatrick (2002); Burdick et al. (2012); Gold, (2012); Grusin (2013); Cong-Huyen (2013) for just a small sample.

2 Sharon Crowley, *Composition in the University* (Pittsburgh, PA: University of Pittsburgh Press, 1998), 105.

3 The production of film is typically separated into another department or division, although this situation is changing as the tools of cinematic language are becoming far more common and as videographic criticism (writing about film and media using film and media) is becoming accepted.

4 For a fuller discussion of lettered orality, please see: Virginia Kuhn, "From Marcy to Madison Square: The Rise of the JayZ Brand," *Star Power: The Impact of Branded Celebrity Volume 2*, ed. Aaron Barlow (Santa Barbara, CA: Praeger Press, 2014), 45–68.

5 The limits of this print-based form I am using are clear here: One must view the Scary Mary video to fully understand its new meaning/s, however, short lived they may be.

6 Sophia Serrano, "Repetition in the Mirror of Reason" and "An Emergent Taxonomy of Cinematic Writing." *The Cine-Files*, no. 11 (2016). 00:58–01:26.

7 Ibid. 00:33.

8 Eduardo Navas, *Remix Theory: The Aesthetics of Sampling* (New York: Springer Wein, 2012), 68.

9 One practical citation issue concerns the way a references list works: Should it be done alphabetically or in order of appearance? The latter model makes sense in a dynamic medium. Further, this approach mimics the way footnotes work and the reference list offers the exact place to find the source. There may be no agreement about citation methods but the main thing is to explain one's citation system and, in so doing, stage an argument for fair use.

10 Christophe Magis, "Manual Labour, Intellectual Labour and Digital (Academic) Labour: A Critical Enquiry of the Practice/Theory Debate in the Digital Humanities." *Triple C: Communication, Capitalism and Critique* 16, no.1 (2018): 167–8.

11 Ibid.

12 "[in]Transition: Where Action Meets Academia." *The Guardian*, July 02, 2016. Accessed November 10, 2019. https://www.theguardian.com/film/2016/jul/02/intransition-where-action-meets-academia.

13 Kory Grow, "Trent Reznor Breaks Silence on 'Undeniably Hooky' 'Old Town Road'." *Rolling Stone Online*, October 25, 2019. Accessed October 27, 2019. https://www.rollingstone.com/music/music-news/trent-reznor-old-town-road-903889/.

14 According to many news sources' fact checkers, Donald Trump has made over 16,000 false claims in his first three years in office. This article by *The Hill* holds the latest tally: https://thehill.com/homenews/administration/479041-fact-checker-counts-16k-false-misleading-claims-by-trump-in-three.

Bibliography

Burdick, Anne, Johanna Drucker, Peter Lunenfeld, Todd Presner, and Jeffrey Schnapp. *Digital Humanities*. Cambridge, MA: MIT Press, 2012.

Cong-Huyen, Anne. "#CESA2013: Race in DH – Transformative Asian/American Digital Humanities." *anitaconchita.wordpress.com*, 2013. Accessed February 20, 2017. https://anitaconchita.wordpress.com/2013/09/24/cesa2013-race-in-dh-transformative-asianamerican-digital-humanities/.

Crowley, Sharon. *Composition in the University: Historical and Polemical Essays*. Pittsburgh, PA: U of Pittsburgh Press, 1998.

"The Daily Show with John Stewart." *I On News*, 2002. Accessed December 12, 2019. http://www.cc.com/video-clips/4s9r5v/the-daily-show-with-jon-stewart-i-on-news—washington and http://www.cc.com/video-clips/an05ak/the-daily-show-with-jon-stewart-i-on-news—advertising.

Federici, Tamara. "Personal Text Message to Author." December 6, 2019.

Fitzpatrick, Kathleen. "The Humanities, Done Digitally." *The Chronicle of Higher Education*, 2002. Accessed January 20, 2020. http://www.chronicle.com/article/The-HumanitiesDone-Digitally/127382/.

Gold, Matthew K. editor. *Debates in the Digital Humanities.*. Minneapolis, MN: University of Minnesota Press, 2012.

Grow, Kory. "Trent Reznor Breaks Silence on 'Undeniably Hooky' 'Old Town Road'." *Rolling Stone Online*, October 25, 2019. Accessed October 27, 2019. https://www.rollingstone.com/music/music-news/trent-reznor-old-town-road-903889/.

Grusin, Richard. "The Dark Side of the Digital Humanities – Part 2." *Thinking C21*, 2013.

Hight, Jewly. "'Songs of Our Native Daughters' Lays Out a Crucial Updated Framework for Americana," *National Public Radio*, 2019. Accessed February 14, 2019. https://www.npr.org/2019/02/14/693624881/first-listen-our-native-daughters-songs-of-our-native-daughters.

"[in]Transition: Where Action Meets Academia." *The Guardian*, July 02, 2016. Accessed November 10, 2019. https://www.theguardian.com/film/2016/jul/02/intransition-where-action-meets-academia.

Kuhn, Virginia. "The Rhetoric of Remix." *Transformative Works and Cultures* 9 (2012).

Kuhn, Virginia. "From Marcy to Madison Square: The Rise of the JayZ Brand." In *Star Power: The Impact of Branded Celebrity*, edited by Aaron Barlow, 45–68. Santa Barbara, CA: Praeger Press, 2014.

Magis, Christophe. "Manual Labour, Intellectual Labour and Digital (Academic) Labour: A Critical Enquiry of the Practice/Theory Debate in the Digital Humanities." *Triple C: Communication, Capitalism and Critique* 16, no. 1 (2018). Accessed October 10, 2019. https://doi.org/10.31269/triplec.v16i1.847.

McCarty, Willard. *Humanities Computing*. Basingstoke, Hampshire: Palgrave MacMillian, 2005.

McPherson, Tara. "Introduction: Media Studies and the Digital Humanities." *Cinema Journal* 48, no. 2 (2009): 119–23.

Navas, Eduardo. *Remix Theory: The Aesthetics of Sampling*. New York: Springer Wein, 2012.

Rule, Christopher. "Scary Mary." 2006. Accessed November 10, 2019 https://www.youtube.com/watch?v=2T5_0AGdFic.

Serrano, Sophia. "Repetition in the Mirror of Reason," An Emergent Taxonomy of Cinematic Writing." *The Cine-Files: A Scholarly Journal of Cinema Studies* (2015). Vicki Callahan and Virginia Kuhn, eds. Accessed October 19, 2019. http://www.thecine-files.com/repetition-issue11/.

5

IMMERSIVE FEMINIST REMIX

An Affect Dissonance Methodology

Karen Keifer-Boyd

Affect dissonance methodologies envision non-hierarchal systems of integrative power for co-creation of the present and future. Feminist remix goals to disrupt patriarchy intersected with other varied, complex, overlapping, and entangled forms of oppression (e.g. racism, classism, ableism, heterosexualism, colonialism, imperialism) might be achieved with affect dissonance methodologies. Feminist scholars reflexively explore how affect is an experienced difference between our own sense of being and the world's judgments upon us as gendered beings. For feminists, explorations of affect generate questions about power and how the world works through power structures within the material conditions of lived experience.[1] Affect dissonance methodology is the study of how affective experiences have political effects. Studies of affect move beyond the study of individual emotions to explore agency from deeply experienced sensations and intensities generated by living in a world constructed by historical and political contexts. Thus, affect studies are firmly situated in the humanities' focus on understanding what drives societal formations of values such as empathy for others and ethical beliefs and actions toward social justice.

 This chapter explores affect dissonance methodologies in feminist pedagogical experiments of remixing realities for immersive experiences. In doing so, this essay is particularly relevant to digital humanities with its transdisciplinary and collaborative examples of digitally remixed works. I discuss three cases of guiding student-created immersive experiences with attention to affect dissonance potential in the remix of video footage with elements from historical and contemporary culturally situated-perspectives. My purpose is to investigate and offer insights into feminist pedagogical approaches to remix practices in critical artmaking that elicit affect dissonance through immersive experiences.

Affect Dissonance

An interest in affect necessarily involves a focus on bodies. Some scholars understand affect as energies transmitted through bodily encounters.[2] Nigel Thrift suggests that affect can be understood as a "set of embodied practices" or as a form of "indirect and

non-reflective" thinking that never quite rises to the level of an emotion.[3] For Brian Massumi, affect is not something that can be reduced to one thing because affect is not a thing but an event or a dimension of every event.[4]

A focus on how gendered bodies matter includes attentiveness to how notions of masculinity and femininity are constructed and reproduced, especially how bodies are positioned and valued in relation to other bodies. Gender informs social norms about bodies and, crucially, relationships between different bodies. What is more, while it is possible to analyze gender experiences without feminism, a feminist perspective on gender always includes discussions of power. In a cultural context of patriarchy and sexism, feminist activist scholarship and creative practice challenge the politics of what is assumed as normative by which all else is judged. Feminist praxes strive toward political and social justice systemic transformation. Thus, a feminist approach to the politics of affect through gender concerns revealing, challenging, and changing power structures that influence how people become invested in oppressive social norms, and about the affective investments in gender constrictions through social norms.

Feminist theorists have long been concerned with the relationships between affect, knowledge, and power.[5] According to Linda Åhäll, "There is no feminism without affect. This is because how we feel (consciously or unconsciously) about the world already tells us about how the world works."[6] Moreover, "affect impacts our sense of self *before* emotions" erupt.[7] Clare Hemmings notes that "feminist theory has privileged affect as a marker of the relationship between ontology and epistemology."[8] Hemmings discusses affective dissonance as "the judgment arising from the distinction between experience and the world."[9] This notion of dissonance might be sensed as injustice and elicit a desire to rectify the injustice. Hemmings argues that "in order to *know* differently we have to *feel* differently."[10] According to Sara Ahmed:

> Feminism often begins with intensity: you are aroused by what you come up against. You register something in the sharpness of an impression. Something can be sharp without it being clear what the point is … Things don't seem right.[11]

Feminist knowledge is often derived from lived experiences that challenge norms, the normative, and the normal. Feminist theorizing attends to silenced and/or ignored "truths." How might our scholarship and teaching speak truth to power and counter the current sociopolitical agendas of hate, bullying, sexism, racism, religious persecution, deportation, environmental devastation, suppression of news, and broadband inequality, among other injustices?

According to Linda Åhäll, affect dissonance occurs when "a representational gap is identified, and a feminist curiosity about gender, agency and political violence is sparked. And, it is about how a feminist gut feeling might put into question the emotional representation that was immediately mediated as commonsensical."[12] Linda Stein's remix collages (Figure 5.1) contextualized in her poetic narrative and video titled *Covid Story: An Artist Sheltered in Place on the 31st Floor* are examples of feminist affect dissonance.[13] Stein's video begins with a panoramic sweep of the view from her apartment balcony, where she has been quarantined for months, which directly faces the 9/11 Memorial tower that stands in place of the collapsed twin towers of the World Trade Center. The camera pauses on the memorial and moves upward and back down to the height of the surrounding buildings. A representation gap exists in the space between the world and

Figures 5.1 Shapeshifters Above Skyscrapers 1005, 2020, Collage, 8.25 × 8.25" by Linda Stein

Stein's sense of safety, agency, and empowerment. Through a remix of collage, text, and film, Stein works in the gap, teeters precariously on the edge, and reflects on a world filled with heroes and villains. Stein's body forms, which she refers to as sentinels, protectors, and heroes, are both gender-rich and unmarked with gender. They appear to have agency (Figure 5.2) even amidst the uncertainty and potential fall of democracy.

Stein's feminist gut feeling questions the emotional representation of the 7:00 PM "ebullient cheers, whooped yays, whistled thank-yous" for health-care providers from the balconies and rooftops near and far.[14] She states, "I ponder their valor and notice that yelling *yay* is easier than voicing *thank you*"[15] At first what seemed "immediately mediated as commonsensical" is questioned, probed for power imbalances, and remediated with the creation of a "world of conviviality, without the virulence of virus."[16] In affective inflection, Stein states in the video:

> And now, with the memory of
>
> running for safety during 9/11,
>
> figures arrive from my previous art,
>
> symbolizing the superhuman,
>
> transformed into monumental edifices
>
> intermixing with buildings around them.

Figures 5.2 Freedom Tower and Sentinels 1010, 2020, Collage, 16.75 x 22 x 1" by Linda Stein

You see, almost two decades after my full day

running from the falling trade towers in 2001,

I still feel viscerally that some scoundrel

can take a gun and shoot down a

skyscraper before me.

And so I engage the figurative symbol

to confront this villain,

erecting this form again and again

so that it becomes part of, and

mirrors, its architectural environment.

My long-nurtured figures—

my cadre of protectors, defenders, sentinels—

brandish the solidity and dominance

of the buildings around them,

or recalibrate themselves into

ghostlike, gusty, translucent shapeshifters.

The misty ones breathe and blow in the wind,

and coexist with those having

more presence and permanence.

Do they take up negative or positive space?

Are they background or foreground?

Are they riveted to a mission,

or agency-less?

I like to think that

they are purposely penetrating the

crevices of the structures around them,

searching for clues to immunity and invulnerability,

much as our medical professionals

seek the same in the course of our

cosmic contamination.

…

My surreal thoughts of illness

morph into a more sanguine surrealism.

I feel empowered

to make *anything* happen now

in a landscape of my creation

(so long as my defenders are

here and standing guard).[17]

Stein's collages are remixes, and they are also remixed with video footage and what she refers to as her "love-poem to New York." Affect dissonance methodologies ask: How does the world affect you? How do you affect the world? Through feminist remix, Stein grapples with these questions using an artistic methodology that evokes affect dissonance. Feminist remix as affect dissonance methodology includes the vantage points of those who have been excluded from knowledge production, reveals and critiques hierarchical power structures, recognizes differences in sociocultural material conditions of lived experience, exposes the unmarked, reenvisions how people are marked by race and other identity markers, reveals what is absent, and critiques prevalent cultural narratives that establish social norms.

Immersive Feminist Remix as Affect Dissonance Methodology

Technologies impact worldviews. How does digital media change our experiences, perceptions, and expressions? Each semester since the mid-1990s, I have asked this question in teaching a junior-level preservice art education university course on educational technologies and visual culture. The Internet, hyperlinks, and multimodality have drastically changed forms of communication and access to knowledge since the 1990s. Wikipedia, digital mobile devices, 3D printing, video blogs, social media, crowdsourcing, memes, and Virtual Reality (VR) have significantly changed communication and learning in the twenty-first century. The media of 360-degree video and immersive art raises unique aesthetic considerations such as the positionality of the viewer in controlling multiple points of view, a blurring between virtual and physical reality, 360-degree composition, and how 360-degree video affects narrative and storytelling, among other issues. The immersive experience is simulacra, mixed reality, dynamic, and interactive.

How might the artistic creation of 360-degree video produce affect dissonance? Each fall semester, since 2017, I have guided groups of undergraduate and graduate students in creating 360-degree videos from shared footage and experiences in which they, individually or in teams of two or three members, select, remix, and edit 360-degree immersive experiences populated with data visualization to ignite affect dissonance. In the immersive experience, we come face-to-face, sometimes at alarmingly close range, with another person, in both a place and among people that may differ from our familiar worlds. For example, the 360-video, *Traveling While Black*[18] calls attention to "the histories that come before subjects" in order to understand how "the immediacy of bodily reactions are mediated."[19] In an interview for *Forbes* magazine, Roger Ross Williams, the first African American film director to win an Oscar, describes why he ventured into Virtual Reality (VR) documentary filmmaking.

> "When you experience this documentary in VR it's all around you, and you can't escape it," said Ross Williams. "Once the headset goes on, there are no external distractions. In the same way, we can't escape our blackness or the reality of being black in America, I didn't want people to be able to escape the experience they have when watching Traveling While Black and this immersive feeling could only be achieved through VR."[20]

Students in my courses create immersive experiences with 360-degree filming, editing, data visualizations, photography, drawing, and painting as arts-based research and in collaboration with other groups of students such as in Fall 2019 with students at

Makerere University in Kampala, Uganda, in the project "Sensory Immersion in Narratives of Places: (re)Creating Histories." In what follows, I discuss affect dissonance potential in the digital remixes of student-created immersive experiences in three cases to investigate and offer insights into feminist pedagogical approaches intended to elicit affect dissonance in critical remix artmaking.

Case 1: Games (Get a Life, Guess Who: Who Are You?, Clue: An Unsolved Mystery with the Usual Suspects, Pictionary Perfect, Monotonous Monopoly)

Although artists, such as Roger Ross Williams, are beginning to explore creating immersive experiences, as yet, there is minimal research on aesthetic, affective, and socio-critical considerations in creating immersive experiences. Artists who create immersive 360-degree video art must consider the virtual and corporeal positionality of the viewer, blurring of virtual and physical reality in which one feels like they are in the artwork, composing a 360-degree space, and multimodal aesthetic dimensions. Dan Getz, from the University's Maker Commons, the technological wizard behind the projects that I have facilitated each Fall semester since 2017, stated when I began to incorporate 360-degree video art into my art education courses that no other courses had used immersive technologies to create art, and that my Fall 2017 project was the third course to use immersive technologies working with Maker Commons. The first course used the immersive technologies to teach agricultural processes and the second had used it to document students learning in a study abroad program. Moreover, I employed affective dissonance methodologies and feminist remix approaches[21] to investigate how I guided students in five courses from 2017 to 2019 to create art as 360-degree immersive experiences.

To consider with students how 360-degree video affects a sense of presence within a situation, and how one's attention to certain elements composes the narrative of the place and experience, we each put on a VR headset (Figure 5.3), sat down (to not fall over while viewing), and selected from a playlist of 360-degree videos. The carefully selected playlist for each group of students introduced them to a range of 360-degree filmic strategies, yet all selected were socially responsive to issues such as racism, climate crisis, and poverty. We then discussed our experience, 360-degree aesthetic criteria, and the potential of incorporating multiple perspectives. Since students watched the same set of 360-degree videos, yet depending where they looked (up, down, behind, etc.), their immersive experiences in virtual places and understanding of the work varied. When I asked: "When there is choice in how to view the place, how does this change the viewer's relationship to the place?", students began to consider their own sense of agency in how the place they visited affected them and how they affected the narrative of the place by what they attended to in the immersive environment.

Additionally, following viewing video excerpts from *Against the Grain: An Artist's Survival Guide to Peru*, directed by Ann Kaneko, and DemocracyNow! videoclips of Bree Newsome taking down the Confederate flag at the state capital (South Carolina in June 2015) and Takiyah Thompson placing a rope around a Confederate statue (Charlotteville, Virginia, September 2017) in which others on the ground pulled the statue down, I facilitated a discussion with the preservice art educators in response to the question: "Is expression a right or a privilege?"[22] We recorded the discussion to share with a group of

Figure 5.3 The Penn State art education program, including students and faculty, set-up a month-long performance, presentation, and exhibition space in October 2019 that included a comfortable place to sit while wearing a virtual reality headset to view a playlist of 360-degree videos.

students in a course on Art, Expression, Environments, and Culture taught by Dr. Martina Paatela-Nieminen at the University of Helsinki in Finland. The students in Helsinki responded with comments to our discussion, and we responded to the recorded discussion they sent us. The purpose of the activity was to lay the groundwork for inclusion of multiple perspectives on an issue. The two groups of students also shared selfies taken within a place that was to convey something about themselves and their responses to the question: "What does a particular place teach inhabitants of the place?" The question generated reflection on affective experience of place in terms of one's sense of belonging or not, and in relation to the sociopolitical histories of the place. We intended to experiment with inclusion of a remix of images of the self-identity places created by Helsinki and Penn State students in the 360-degree immersive film.

The group of five undergraduate Penn State art education students showed and discussed their drawings of places as self-identity, as I facilitated a brainstorming conversation seeking ways to bring their narratives into a theme for the group's 360-degree film. There were many ideas and possible directions that cumulated into a plan to film ourselves playing board games together to produce footage that each would draw upon to create a three-minute vignette for the collaboratively created immersive experience. We discussed how games convey values of what it means to be a winner and teach what is valuable. For example, the game *Monopoly* teaches to succeed by accumulating property. In researching about the origins of the game, we learned that a feminist woman, Lizzie Magie, created the *Landlord's Game* to teach about the evils of capitalism, which became

popular among Quakers in Pennsylvania, among others, in the early twentieth century. Thirty years later, during the Great Depression, an unemployed man, Ralph Anspach, claimed ownership of the game and sold the rights to the game to a corporation known as Parker Brothers, which made millions of dollars in selling their remake of the game. In the revised game, capital greed is rewarded.[23] We learned that the game *Guess Who,* with the same set of White men and a few White women, in which players learn to describe subtle facial features to guess the person on the key card, is played throughout the world in places such as Turkey and Brazil, according to participants who commented about their experience with 360-degree immersive art. The game *Life* is about the life events of status quo White middle-class people. We also played the game of *Clue,* drawing attention to issues of valorizing violence. We chose two other games to play, *Pictionary* and *Reminisce,* for impromptu performances with us as actors challenging the embedded values in the games of capitalism, White Supremacy, and domination of White middle-class social norms. With the playing of *Pictionary,* the vignette focused on creativity and notions of what is valued as art. The *Reminisce* game provided an opportunity to tell stories from our lived experiences in relation to how sociocultural norms impacted our sense of self. These stories served as transitions between each of the five vignettes from playing *Monopoly, Guess Who, Life, Clue,* and *Pictionary.* Each vignette was layered with data visualizations, popular culture, news broadcasts, and selected cuts from the footage of our performances of game playing to challenge the status quo values of the games.[24]

While there are many moments that could be analyzed from an affective dissonance methodology, I selected a moment in the 360-degree remix of the vignette titled, *Get a Life,* from playing the game of *Life.* An image of the box cover in the video shows a White middle-class family of two parents, male and female, and two children, male and female, as one player reads the game of *Life* directions, in which male players are to select blue pegs and female players pink pegs to represent oneself in the game, while the video shows some players who appear female select blue pegs. Disrupting heterosexuality norms, a player who appears to be a woman who represents self with a blue peg as male, when they land on the opportunity to marry and collect gifts, they select a blue peg to marry. To the sounds of Amber Alert, a baby pink (girl) peg falls from the blue plastic car that is the means, literally the vehicle, to advance in the game of *Life.* Ultimately, this player accumulates the most wealth and wins the game stating in the process: "I get another opportunity. It must be because I am a boy." How the player felt about the world in regard to privileges conveys her lived experiences in how the world works, impacting her sense of self.

Case 2: Overlap: Full Circle

For the *Overlap: Life Tapestries* exhibition at Penn State's HUB-Robeson Gallery in Fall 2018, students in my graduate and undergraduate courses developed activities to facilitate pedagogical encounters with the works displayed in the exhibition.[25] Our immersive experience project, called *Overlap: Full Circle,* brought student groups from nine university courses, public school teachers, and librarians to the gallery and utilized a 360-degree camera to film, with their signed permission, their reactions, and conversations instigated by the pedagogical encounters with the art. The footage was then edited to create eight VR immersive experiences. This project wove together the conversations inspired by the art into a curation of provocations.

One of the activities developed by three graduate students (Elham Hajesmaeili, Xalli Zúñiga, and Alvaro Jordán) in my course *Including Difference* was especially fruitful in

generating and documenting affective responses to the art in the exhibition by inviting participants to write letters to the work. The activity prompt[26] was:

"How would a letter from this artwork to you look like? What would it be telling you? And then, how would you respond to that? What would YOU like to tell the piece? Think of your personal experiences and how they might connect with the artwork you chose." The letter does not need to be signed with the participant's name. After finishing writing their letters, participants should seal them, and leave them nearby Arlene Rush's piece again. Gather participants once more and have them select a sealed envelope. Each participant will read out loud the letter chosen. All participants will then discuss and guess which artwork the letter refers.[27]

The readings and visuals of the handwritten letters became elements in many of the 360-degree videos created by students in my graduate and undergraduate courses in Fall 2018 such as in Brooke Burkhart and Lacie Solt's video, *The Pen is Mightier*, and Alvaro Jordán, Elham Hajesmaeili, and Xalli Zúñiga's *Letters to the Unknown*.[28] The activity itself, as well as elements from the activity brought into the videos, elicited affective dissonance. A sense of being is projected on the art through handwritten letters in ways that seek to comfort or at least recognize the psychologically and physically painful experiences communicated by the art in the *Life Tapestries* exhibition. For example, one letter, in the *Letters to the Unknown* video, is read in a deep slow voice stating:

You sealed and unsealed envelopes remind me of us who struggle to come out. It's hard to tell my story when someone speaks out. Right now, my letter is closed. Coated in a coat of blood and shame. I want to read my story, open my own letter but thank you for telling me it is okay to seal it too.[29]

During the letter reading in the 360-degree sphere that the viewer inhabits, if wearing a VR headset, the space is divided like a cantaloupe sliced in two. One side has an arcade claw grabbing machine in which all items to grab are the same yellow rabbit-like stuffed toy, along with a visual of a person reading the letter in the *Life Tapestries* exhibition transposed with other images, including several children filling water into five-gallon Jerry Cans, which are bright yellow plastic containers originally filled with fuel. Juxtaposed on the other side of the sphere, there is sense of being at the intersection of corporate-sterile empty hallways with many closed doors, which transforms, as if entering one of the doors, to two people talking inside a room with walls of circuit connections for communication (Figure 5.4). Within these twelve seconds, as it is throughout the seven-minute video, the overlapping, changing images suggest the complexity, contradictory, and disharmonious communication mediated through bodies, technologies, places, and objects.

Case 3: Sensory Immersion in Narratives of Place: (Re)Creating Histories

In Fall 2019, students at Makerere University in Kampala, Uganda, and at Penn State University in Pennsylvania in the United States, filmed themselves painting, drawing, and conversing in and about places they went to as a class. Research about the place, its indigenous roots and histories informed their editing and the creation of

Figure 5.4 The screen capture is on view from the *Letters to the Unknown* 360-degree video remix by Alvaro Jordán, Elham Hajesmaeili, and Xalli Zúñiga (2019)

two-dimensional work, including data visualizations, which they placed within their 360-degree films. The data visualizations included maps of indigenous territories overlaid on video footage of the land, digital images of keychains digitally pinned to maps to show relationships between particular places and the place's unique features, infographics of extinct species that once were abundant in a particular place, and pie charts or graphs of comparative ratios of women and male artists represented in museum collections. In these instances, the data visualizations offer a digital humanities critical lens to reinterpret the 360-degree video footage of particular places.

Collectively, prior to the premiere of the work at an exhibition online and in an immersive experience lab at Penn State, at the end of the semester, students wrote the following description of our Fall 2019 project:

> Join us as we explore the influence of our past on our present, and how we can shape our future. Dive into a critical history of the world and connect histories of place to your ongoing personal life journey.
> … Combining footage from Penn State and places in Uganda, we tell stories about place and what it means to us.
> … Through this project we have crossed cultures and examined ourselves.
> Our data visualizations focus on recreating histories of places we have lived or traveled. This exhibition involves the personal narratives of both Penn State and Ugandan college students and how we define place in our life. The exhibition is an immersive video experience that puts you directly into these narratives!
> …This immersive experience will allow viewers to feel as though they are right beside us as we explore indigenous roots, how the past impacts the future, special collections, community, friends, and college-life stress.[30]

Throughout a 15-week semester, students at the two universities responded to each groups' questions in three real-time Zoom conversations, which we also recorded. For example, the Ugandan students asked the US students: "What is your knowledge about African Art and how do you relate it to Western art? What are the outstanding historical sites in your country?" The art education students at Penn State asked the Makerere University students, for example: "Could you share a specific memory of art education from your childhood or youth?" The dialogue provided opportunity to challenge (mis) perceptions of each other, and to learn about oneself.

The dialogue also provided shared material for the collaborative remix of 360-degree video. My facilitation of the dialogue was intended as an affective dissonance methodology as I guided creative artmaking from deeply experienced sensations and intensities of the places that we inhabit along with critical inquiry into the world constructed by historical and political contexts. For example, Cassidy Sullivan's 360-degree video, contributed as part of the collaborative video, a remix of places and histories, is titled "State Roots: Indigenous Cultures and Sustainability." She describes her film as follows:

> "State Roots," acknowledges and pays respect for the cultures and environment that came before the Penn State University campus and culture today. This segment also touches on current cultural experiences, connecting campus sustainability with environmental acts of Native American tribes around the United States.[31]

Filmed with a 360-degree camera on the Penn State campus, Sullivan's affective dissonance methodology contrasts the current use of the land-grant university that she and her classmates "occupy today" with its erased history of unceded territories from the Susquehannock people and their practices of sustainability.[32] Her work acknowledges that she, a settler White woman, benefits from learning on the site in which the Indigenous peoples "are still not acknowledged or appreciated to this day. So, it is ongoing battle for recognition and full equality."[33] Her work investigates how she affects the world and how the world affects her. The questions posed by the students to viewers to respond in audio recordings or written comments to the collaboratively created 360-degree remix video call for similar affective investigations and reflections in asking:

Find a moment in the video that makes you think of your own community.
How have your communities influenced you?
How have you influenced your communities?

Responses concern how self-identity is shaped by the communities in which a person is immersed, and how choices each makes (unconsciously or consciously) have more of an impact than realized in their "auto-pilot" rhythms of each day.

Conclusion: Affective Dissonance Methodology as Remix Pedagogy and Critical Analysis

In this chapter, I demonstrate how I have been using affective dissonance methodology as pedagogy and as a critical approach to analyze remixes of collage, video, data, and

popular culture as the digitized materials are juxtaposed, overlaid, and edited into 360-degree immersive experiences. As humanities-based pedagogy, a feminist affective dissonance methodology begins with dialogue about how students feel about the world events shown through news footage, films, immersive experiences, and artworks. As a facilitator, selection of the work to discuss and reflection prompts should expose power structures that uphold oppression within the material conditions of lived experience. Moreover, in emphasizing issues of complacency and perceptions of choice, students begin to envision the co-creation of the present and future in collaborative projects, which are remixes from the same (re)source materials they have generated.

Feminist affect dissonance methodologies for critical analysis of remix work begin with exploring one's own, other viewers, and/or the artist's subjectivity in relation to social norms as conveyed in the art. Critical inquiry should seek to reveal affective dissonance between experience and dominant sociopolitical power structures that conscript, constrict, and inscribe one's sense of self. Further, an affect dissonance methodology investigates how politics of affect in remix work challenge oppressive social norms through juxtapositions, overlaps, and disruptions to privileged ontologies and epistemologies. These examples of 360-degree digital projects in my art education courses are intended to inform and engage the public beyond the classroom with the broad reach that social media affords and a transdisciplinary approach to humanities-based digital art.

Notes

1 For example, see Marina Tyquiengco, "Black Velvet: Aboriginal Womanhood in the Art of Fiona Foley. Indigenous Feminisms in Settler Contexts," *Feminist Studies* 45, no. 2–3 (2019): 467-500.

2 Teresa Brennan, *The Transmission of Affect* (Ithaca, NY: Cornell University, 2004).

3 Nigel Thrift, *Non-representational Theory: Space, Politics, Affect* (New York: Routledge, 2008), 175.

4 Brian Massumi, *Parables for the Virtual: Movement, Affect, Sensation* (Durham, NC: Duke University Press, 2002); *Politics of Affect* (Cambridge: Polity Press, 2015).

5 Pedwell, Carolyn and Whitehead, Anne, "Affecting Feminism: Questions of Feeling in Feminist Theory," *Feminist Theory* 13, no. 2 (2012): 115–29.

6 Linda Åhäll, "Affect as Methodology: Feminism and the Politics of Emotion," *International Political Sociology* 12 no. 1 (2018): 38.

7 Åhäll, "Affect as methodology," 39.

8 Clare Hemmings, "*Affect and Feminist Methodology, or What Does it Mean to be Moved?*" In Structures of Feeling: Affectivity and the Study of Culture, eds. D. Sharam and F. Tygstrup (Berlin: DeGruyter, 2015), 148.

9 Hemmings, "*Affect and feminist methodology,*" 157.

10 Ibid., 150.

11 Sara Ahmed, *Living a Feminist Life* (Durham, NC: Duke University Press), 2017, 22.

12 Åhäll, "Affect as methodology," 22.

13 Linda Stein, Artist Reflects on Covid, High above Tribeca, *The Tribeca Trib*, June 1, 2020, http://tribecatrib.com/content/artist-reflects-covid-high-above-tribeca.

14 Stein, "Artist Reflects," para. 12

15 Ibid., para. 14

16 Ibid., para. 18

17 Ibid.

18 Roger Ross Williams, "Traveling While Black," YouTube 19 min. VR Trailer, December 12, 2019, https://www.youtube.com/watch?v=aOBwXOgIIb8.

19 Sara Ahmed, *The Cultural Politics of Emotion* (Edinburgh, UK: Edinburgh University Press, 2014), 212.

20 Williams quoted in Jennifer Kite-Powell, "Why You Need to See this VR Documentary, 'Traveling While Black'," *Forbes* (February 25, 2019), para. 5), https://www.forbes.com/sites/jenniferhicks/2019/02/25/why-you-need-to-see-this-vr-documentary-traveling-while-black/#cbee4d66d5d6.

21 Karen Keifer-Boyd and Christine Liao, "Feminism," in *Keywords in Remix Studies*, eds. Eduardo Navas, Owen Gallagher, and xtine burrough (New York: Routledge, 2018) 147-157.

22 I provide more regarding the discussion prompts in an essay for the online publication, *Films for the Feminist Classroom* (Keifer-Boyd, 2018) and a recording of our discussion is at http://cyberhouse.arted.psu.edu/322/projects/4_ExquisiteEngendering.html

23 Mary Pilon, *The Monopolists: Obsession, Fury, and the Scandal Behind the World's Favorite Board Game* (New York: Bloomsbury USA, 2015).

24 The producers, directors, actors, artists, and educators of the immersive 360-degree film are (in alphabetical order) Grace Collins, Victoria Davenport, Alexis Drobka, Emma Karpinski, Karen Keifer-Boyd, Shelby Young, with guest appearance by Ilayda Altuntas Nott. The identity collages within the film are from students in Dr. Martina Paatela-Nieminen's courses at the University of Helsinki in Finland. The work, best viewed with virtual reality headset, can be accessed at http://cyberhouse.arted.psu.edu/322/exhibition2017F.html.

25 More information about the exhibition, artists, curator, and student-created activities to engage with the art is at http://cyberhouse.arted.psu.edu/322/projects/1_overlap.html.

26 The activity, *Letters to the Art: Encounter "Overlap: Life Tapestries"* is available at http://cyberhouse.arted.psu.edu/322/encounters/Letters_encounter_XZ_EH_AJ.pdf.

27 Elham Hajesmaeili, Xalli Zúñiga, and Alvaro Jordán, "Letters to the Art: Encounter 'Overlap: Life Tapestries'," 2018, http://cyberhouse.arted.psu.edu/322/encounters/Letters_encounter_XZ_EH_AJ.pdf.

28 These two 360-degree videos and the other six created by students in my courses in 2018 are available to view at http://cyberhouse.arted.psu.edu/322/exhibition2018.html.

29 1:12–1:34.

30 The 360-degree video can be accessed at http://cyberhouse.arted.psu.edu/322/exhibition.html.

31 Cassidy Sullivan, *State Roots: Indigenous Cultures and Sustainability*, December 6, 2019, http://cyberhouse.arted.psu.edu/322/exhibition.html/.

32 Frey Brownson, *Land Acknowledgement: Doing the Work, Never Enough* (USA: Heliotactic, 2019). https://heliotactic.github.io/acknowledgement/.

33 Sullivan, *State Roots*, 1:08–1:14 min.

Bibliography

Åhäll, Linda. "Affect as Methodology: Feminism and the Politics of Emotion." *International Political Sociology* 12, no. 1 (2018): 36–52.

Ahmed, Sara. "Happy Objects." In *The Affect Theory Reader*, edited by M. Gregg & G. J. Seigworth, 29–51. Durham, NC: Duke University Press, 2010.

Ahmed, Sara. *The Cultural Politics of Emotion*. Edinburgh, UK: Edinburgh University Press, 2014.

Ahmed, Sara. *Living a Feminist Life*. Durham, NC: Duke University Press, 2017.

Brennan, Teresa. *The Transmission of Affect*. Ithaca, NY: Cornell University, 2004.

Brownson, Frey. (2019). *Land Acknowledgement: Doing the Work, Never Enough*. https://heliotactic.github.io/acknowledgement/

Hajesmaeili, Elham, Xalli Zúñiga, and Alvaro Jordán. "Letters to the Art: Encounter 'Overlap: Life Tapestries'" 2018. http://cyberhouse.arted.psu.edu/322/encounters/Letters_encounter_XZ_EH_AJ.pdf

Hemmings, Clare. "Affect and Feminist Methodology, or What Does It Mean to Be Moved?" In *Structures of Feeling: Affectivity and the Study of Culture*, edited by D. Sharam & F. Tygstrup, 147–58. Berlin: DeGruyter, 2015.

Keifer-Boyd, Karen. Art Activism Creating Spaces for Herstories. *Films for the Feminist Classroom* 8 no. 1–2 (2018): http://ffc.twu.edu/issue_8-1-and-2/rev_Keifer-Boyd_8-1-and-2.html

Keifer-Boyd, Karen and Liao, Christine. "Feminism." In *Keywords in Remix Studies*, edited by Eduardo Navas, Owen Gallagher, and Xtine Burrough, 147–57. New York: Routledge, 2018.

Kite-Powell, Jennifer. "Why You Need to See this VR Documentary, 'Traveling While Black.'" *Forbes*, February 25, 2019, https://www.forbes.com/sites/jenniferhicks/2019/02/25/why-you-need-to-see-this-vr-documentary-traveling-while-black/#cbee4d66d5d6.

Massumi, Brian. *Parables for the Virtual: Movement, Affect, Sensation*. Durham, NC: Duke University Press, 2002.

Massumi, Brian. *Politics of Affect*. Cambridge: Polity Press, 2015.

Pedwell, Carolyn and Whitehead, Anne. "Affecting Feminism: Questions of Feeling in Feminist Theory." *Feminist Theory* 13, no. 2 (2012): 115–29.

Pilon, Mary. *The Monopolists: Obsession, Fury, and the Scandal Behind the World's Favorite Board Game*. New York: Bloomsbury USA, 2015.

Stein, Linda. Artist Reflects on Covid, High above Tribeca. *The Tribeca Trib*, June 1, 2020, http://tribecatrib.com/content/artist-reflects-covid-high-above-tribeca.

Sullivan, Cassidy. *State Roots: Indigenous Cultures and Sustainability*, December 6, 2019, http://cyberhouse.arted.psu.edu/322/exhibition.html.

Thrift, Nigel. *Non-Representational Theory: Space, Politics, Affect*. New York: Routledge, 2008.

Tyquiengco, Marina. (2019). "Black Velvet: Aboriginal Womanhood in the Art of Fiona Foley. Indigenous Feminisms in Settler Contexts." *Feminist Studies* 45, no. 2–3 (2019): 467–500.

Williams, Roger Ross. *Traveling While Black*. YouTube 19 min. VR Trailer, December 12, 2019. https://www.youtube.com/watch?v=aOBwXOgIIb8.

6

VERSIONING BUDDHISM

Remix and Recyclability in the Study of Religion

Seth M. Walker

A famous story in the Alagaddupama Sutta features the Buddha telling his followers about a man who built a raft to cross a body of water in order to get to a more pleasant shore. The teaching moment is in what the man should do with the raft after he makes the journey. It is mostly a rhetorical question, however. The idea is that the Buddha's teachings (the raft) were to be understood "as having the purpose of crossing over, not the purpose of being clung to."[1] In other words, the raft is not meant to be dragged around after making the crossing; it served its purpose, and the intricacies and details of its construction are not exactly what matter most. Whether or not the teachings can successfully bring one to the other side of the shore (enlightenment) becomes the more crucial consideration. Over the course of more than two thousand years, such Buddhist rafts have seen a vast variability in form as they have spread throughout Asia and beyond—from the scriptural and monastic cultures of Theravāda schools, to the emphasis on direct "awakening" and meditative practice found in Zen lineages, and notions of "celestial" realms comprising the teachings among those in Pure Land traditions.

The varying Buddhisms around the globe, the practices and worldviews of which might differ either subtly or substantially, can be thought of as cultural constructs that operationalize concepts and perspectives occupying a metaphorical space of archival data, which can be continuously accessed and mixed in unique ways. Such a conceptualization aligns with how scholars in diverse fields are starting to apply "remix" outside of audio-visual settings. As a critical concept in digital media, remix allows scholars to rethink normative assumptions regarding authorship, production, and ownership, as creative construction is necessarily predicated upon either influence or material sampling. Remix helps scholars do the same sort of thing when it is extended outside of digital contexts. The digital age has not only shaped the formation and hybridity of its media, but also its features are directly implemented in the ways people make the most sense out of, and find meaning in, the cultural practices and artifacts connected to them. Building upon a rudimentary Buddhist "software" analogy conceived by renowned author and teacher Stephen Batchelor, this chapter considers how studying the variations among Buddhist traditions might benefit from the application of remix theory and the adoption of concepts like remix, recyclability, and versioning. In other words, this

chapter shifts the framing in the study of religion to consider the content of religious traditions as sets of data corresponding to particular archival material in respective databases subject to being sampled and remixed over time through different iterations.

While this analysis more narrowly concerns Buddhist thought and practice, the framework presented here could be *ported* to other religious traditions as well.[2] Thus, the chapter more broadly: 1) emphasizes how dialogic developments are inherent within religious traditions, and that points of *origin* must be reconsidered in light of such cultural dialogue, 2) shows how authenticity within traditions is generally measured based on what has been legitimated with cultural value and cycled back into an archival space of acceptable remixable data, and 3) indicates how authority operates in relation to ideas of originality and authenticity, and how such operative authority might be challenged when these two concepts are problematized and subverted.

Buddhism 2.0

In the wake of an early life spent as an ordained Buddhist monk, Batchelor has spent the latter part of his life pursuing and ruminating upon a form of Buddhism specifically aligned with modern sensibilities. His "secular" (from the Latin *saeculum*, referring to the here and now, "this age")[3] Buddhism and the movement it has inspired are grounded in early canonical texts that are reexamined in order to discern translations and interpretations of key Buddhist concepts and teachings that are more fitting for the twenty-first century. This reexamination has resulted in a particular delineation between "traditional" forms of Buddhism (those inherited from Asian lineages) and the form of Buddhism Batchelor argues most likely aligned with what was taught over two thousand years ago. In brief, he calls for a reconfiguration of the foundational Four Noble Truths into a sequential fourfold task.

In "A Secular Buddhism" (2012), he outlines his argument in the form of a basic "software" analogy to distinguish between and categorize the varying forms of Buddhist thought and practice. Those traditional forms of Buddhism "are like software programs that run on the same operating system," Batchelor claims.[4] Their particular differences aside, Buddhist forms such as Zen, Shin, Nichiren, Tibetan, all share "the same underlying soteriology."[5] This operative soteriology is termed "Buddhism 1.0" by Batchelor and is predicated upon a propositional and metaphysical belief-based orientation to the Four Noble Truths. Rather than pursue the writing of another software program to match the current milieu and address the disparity between these forms and the outcome of his analysis, he indicates, "the cultural divide that separates traditional Buddhism from modernity is so great" that the operating system itself may need to be rewritten—what Batchelor calls a praxis-oriented "Buddhism 2.0."[6] My research extends this initial analogy as it engages the development and evolution of Buddhist traditions through remix and related concepts. It further demonstrates how Buddhist "programs" interact with each other in an "operating system" to create different and future iterations, and how rising classes of amateurs—*programmers* and lay *hackers*—might challenge the hierarchical power of elite monastic or priestly classes as the propriety "coders" and "debuggers" for such programs.

In *After Buddhism: Rethinking the Dharma for a Secular Age*, Batchelor (2015) aims to shed the centuries-long additions of miscellaneous theological baggage and hierarchical agendas to Buddhist thought and practice through a rather pointed and secularly romanticized reconfiguration of the teachings that harken back to the Buddhism that the

Table 6.1 Dharmic Source Code

Dukkha (suffering)
Samudaya (arising)
Nirodha (ceasing)
Magga (path)

Buddha probably taught. In addition to pointing toward a Buddhism for "this age," Batchelor's use of the term "secular" also signals both its normative understanding (i.e., the opposite of "religious" in a metaphysical sense) and general notions of secularization processes in the West, wherein cultural authority among religious institutions diminishes with power shifting to those formerly under their control.[7] He is careful about his critique of traditional forms of Buddhism, too, indicating that what he is doing is not meant to be better than what is already in existence; his is just a more relevant and timelier reconfiguration that brings the teachings into better alignment with modernity. Of course, reading between the lines in his work, and understanding the implications of discerning what is *actually* contained in the canonical sources, it is clear that he thinks his project is both reformative and necessary. However, it is impossible to know what the Buddha thought or actually said, which is why he tries to balance his agenda between absolute certainty and clinging to the preserved teachings. All that can be consulted are the texts, and Batchelor simply wants to re-examine them to see what can be found.

Diving into a full exposition of Batchelor's ideas is beyond the scope of this chapter, but the most important feature is his textual analysis: Drawing on a philological study from 1992, he reiterates that "the earliest form" of the Buddha's first sermon did not include the Pali word for "noble truth." It was a qualification added at a later date. "All that can reasonably be deduced," he concludes, "is that instead of talking of four noble truths, the text merely spoke of 'four'": *dukkha* (suffering), *samudaya* (arising), *nirodha* (ceasing), and *magga* (path).[8] Imagine these "four" functioning as a primary source code of sorts—a *dharmic* source code, perhaps (Table 6.1).

According to Batchelor, the "four" are more accurately understood as underlying a set of sequential tasks rather than the strangely patterned "effect, cause, effect, cause" propositional "truths" that have characterized Buddhist traditions for centuries (Table 6.2). While the "therapeutic" framing commonly derived from this traditional rendering (e.g., recognition of illness, its diagnosis, notification of cure, prescription given for remedy) might be a helpful way to think about the Buddha and his teachings, Batchelor pushes back against it, indicating that it simply perpetuates the "incongruous ordering" and propositional status of the Four Noble Truths.[9]

The 2.0 sequence based on that source code goes something like this: "fully knowing suffering leads to the letting go of craving, which leads to experiencing its cessation,

Table 6.2 The Four Noble Truths

1. Life is suffering (effect ↓)
2. The origin of suffering is craving (cause ↑)
3. The cessation of suffering is *nibbāna* (effect ↓)
4. The noble eightfold path is the way that leads to cessation of suffering (cause ↑)

which leads to the cultivation of the path."[10] In other words, the path is not how enlightenment is attained; the cessation of cravings allows a life to be lived in this way—as a goal in itself, rather than the means to a goal. The path is not the raft, to draw on the story included at the start of this chapter. Coming to full terms with an existential condition (*dukkha*) is how one achieves a more complete (rather than *right*) understanding of the world and lives a more fulfilling life.[11] Both operating systems guide the dharmic source code in their own ways, of course, and the programs that are built on them rely on the vast banks of conceptual data that are constantly generated, archived, and cycled through varying Buddhist iterations.

Buddhist Archives

In his essay, "Archive" in *Keywords in Remix Studies*, Rinehart (2017) notes that "archives" might be best thought of as the primary source material around which histories are based and selectively constructed, and that they function as instruments of social and collective memory, existing as remixed collections of history and cultural heritage where people have chosen "what to remember and what to leave out."[12] Considering archives in this context as remixed collections of history and cultural heritage can help inform, for example, the variations on schools of thought and practice among diverse iterations all commonly referred to as Buddhism, along with the overall drive to remix source material in new ways to create unique versions of Buddhist thought and practice. Moreover, in keeping with the current analogy, these collections might also be likened to conceptual *databases* housing a vast, ever-increasing, and ever-shifting repository of remixable source material for programs to build upon in their establishment and development.

As cultural constructs, religious traditions like Buddhism can be understood as signaling very specific cultural creations, with their variant schools and teachings pulling acceptable elements from these conceptual databases to be considered as such. They remain unique to a given context, while still maintaining a tie to historic lineage, as they conform to source material that determines what can be utilized in such iterations. The background imperative to create a unique form of Buddhism is certainly one that is also dialogic in relation to other forms already in existence. There is a historical tendency for Buddhist traditions to believe they have the truer dharmic interpretation and that other schools have gotten some part of it wrong, so a different version might be framed as *better*, or more suitable for a given context, than what is already being peddled among other groups of varying adherents. This is the goal of Batchelor's project, too: "to bring the dharma into closer alignment with the needs and concerns of people living in modernity" and "to formulate an understanding of the dharma that is consistent with both core Buddhist teaching and the worldview of modernity."[13]

Traditional forms of Buddhism, with their reliance upon teachings like the Four Noble Truths, are accessing the Buddhism 1.0 operating and archival space, remixing its features in unique contextual settings. Batchelor's sequential tasks and secularly reimagined concepts and translations comprise the Buddhism 2.0 space—the new database for which he is arguing—which can also be accessed and remixed accordingly (Table 6.3). The content of these databases—which consists of not only raw elements and features, but individual programs that have been culturally legitimated as well—serves as the hub of Buddhist thought, practice, and conceptual evolution.

Table 6.3 Buddhist Operating Systems

Buddhism 1.0	Buddhism 2.0
Belief-based and propositional	Praxis-based and sequential
The Four Noble Truths:	The Fourfold Task:
1. Life is suffering (*dukkha*)	1. Embrace *dukkha*
2. The origin of *dukkha* is craving	2. Let go of the craving that arises in reaction to it
3. The cessation of *dukkha* is *nibbāna*	3. Experience the fading away and ceasing of that craving
4. The noble eightfold path is the way that leads to the cessation of *dukkha*	4. Cultivate the eightfold path
Moralistic overtones to the path:	No moralistic overtones to the path:
• "Right" view, intention, speech, action, work, effort, mindfulness, concentration	• "Complete" view, intention, speech, action, work, effort, mindfulness, concentration

Legitimate Buddhist Data

There are, however, certain limitations and parameters guiding the creative assemblage of Buddhist archival data. To continue the analogy, one cannot exactly write or compile a program for a system that is structurally incompatible. In other words, there are restrictions in place that guide what one is actually able to do, and much of this pertains to how concepts, practices, and teachings are culturally legitimated as authentic, and thereby successively *acceptable*, data. Eduardo Navas's "framework of culture" and the "feedback loop" upon which he demonstrates culture functions, imbues the processes being discerned here among varying Buddhist iterations with a more technical sense of how such recyclability works in these types of contexts. He locates two layers of operation in this feedback loop: 1) "when something is introduced in culture" and 2) "when that which is introduced attains cultural value and is appropriated or sampled to be reintroduced in culture."[14] The production of value and the ascribing of meaning can be broken down more specifically: There is an initial stage of appropriation—or, the "taking from that which we know"—with "three supporting elements" of implementation (the repurposing of what is being appropriated), contextualization (how what was repurposed is being presented), and legitimation (whether or not something will be culturally accepted and if it will be subsequently repurposed).[15] Only when what has been introduced into culture has attained value can it then be sampled and appropriated, to then be introduced back into culture as something unique.[16]

When certain Buddhist data is culturally accepted, it cycles through the archival space as authentic and legitimate, capable of being repurposed as part of a collective of material that can be accessed and utilized by future variations. The operating system, in other words, hosts an ever-evolving dialogic interactivity between programs and their data that results in an ever-increasing complexity between origins of traditions and their historical legacies, which is both ideologically illuminative and hegemonically disruptive. Remix theory thus allows for a problematizing of established paradigms of authenticity in that it questions what is genuine or primary (i.e., if there is no original in the most extreme sense of the term) and what is accurate or reliable (i.e., if authoritative systems have been subverted). This does not, however, merely result in a move from the authentic to the chaotic turmoil of the inauthentic, nor does it simply lead to a shallow terminological swap in the wake of critical realizations surrounding time-honored traditions and regimes. Through its problematizing of originality and authority, remix heralds a deconstructive shift that instead yields a realization that, what is genuine or accurate is no longer based upon an unbroken descent of unsullied information, but upon its significance and purpose at a given cultural moment and its manifestation at a specific point within the loop. Framing Buddhist programs as operating in this way can result in a better understanding of how they—and the raw data they are accessing—become part of broader Buddhist systems as legitimated and alternative iterations.

When traditions attain cultural value, they are assimilated into a particular historical reference point that "informs new forms of critical production."[17] Thus, a more specialized and particular metalevel exists within the broader feedback loop, which further informs the role of recyclability among established traditions.[18] Particular schools of Buddhist thought function at this metalevel, in which already introduced material is yet again remixed and goes through various reintroductions and evaluations by teachers and students as it is further recycled and updated in order to develop and better inform material well within the established Buddhist discourse. Metalevel-produced material certainly appears innovative, but since this level of material production is situated within the broader feedback loop of culture, such material is already culturally valuable and familiar. Meta-production occurs in its own metaloop "to come back to the subjects one appears to leave behind only to make them different as this process takes place."[19] It is at this level of production where Buddhist iterations develop and progress in a process akin to versioning in digital practices.

Versioning Buddhism

As noted above, the sampling of archival material and how it is being remixed is what sets Buddhist programs apart from each other. Similar to the compiling and editing of computer software, the success or acceptance of different versions simply depends on the creative decisions of what changes are to be made, or what to keep or omit, in order to create a corrective or fulfilling work. Buddhist traditions are unquestionably dependent upon context and circumstances that are unique to time and place, with each being "contingent upon the wide array of particular and unique circumstances out of which it arose."[20] According to Batchelor, "The history of Buddhism is the history of its own ongoing interpretation and representation of itself."[21] Traditions, then, are the remixed results based on when and where they are temporally and geographically situated, and how they may have interacted with or accommodated any preexisting indigenous systems or alternative ideologies as they evolved.

Figure 6.1 Versioning Buddhism

Buddhist programs and their relation to each other can be framed as a versioning dialogic process of building upon what came before, either to the point of retaining a similar association, such as how Rinzai and Sōtō are both recognizably traditions of Zen Buddhism, or establishing a much different trajectory altogether, like at the point of departure or inauguration in a particular lineage. Mahāyāna Buddhism might be thought of, then, as a particular environment for Buddhism 1.0, with something like Yogācāra functioning as an early Indian program that Chan Buddhism mashed-up with Taoist philosophy in China to suit its own context and circumstances, which was later remixed into Zen Buddhism in Japan (Figure 6.1).

That is, of course, a fairly simplified version of an intricate and lengthy process that is not so clearly structured or defined. Traditions, texts, teachers, and students have interacted with each other in all sorts of ways, emphasizing, de-emphasizing, and innovating Buddhism 1.0 data that continues to be mashed-up and remixed amid further interaction. For example, in something like the Sōtō variant of Zen, there is a strong emphasis on the importance of meditative technique alongside an equally strong de-emphasis on the importance of sacred texts that sets it apart from other programs. These types of dynamics exist across the array of all Buddhist programs.

Remix theory succinctly indicates that "everything is built from preexisting elements."[22] *Anything* composite can be taken apart, which leads to both the negation of the object itself—its essential "nothingness" measured by its disparate parts—and an explicit recognition of the constituent pieces necessary for its existence. Aligning with the Buddhist notion of emptiness (*suññatā*), or more specifically, lack of essence, the principles guiding remix processes demonstrate that there is not some sort of key ingredient underlying all objects. Their cultural value and meaning are determined by the relationships they form as aggregates.[23] Everything is interdependent (captured in Buddhist philosophy as *paṭiccasamuppāda*, or dependent origination); everything is caused, joined together, or taken apart through inherent interactional and momentary

relational processes. Versioning explicitly highlights these processes by demonstrating that cultural constructs build upon what preceded them, and that this procession is not *just* about endless change and fluctuation, but also the interaction that makes this possible in the first place.

Critical Dharma

There is also a critical edge in all of this that places Batchelor's reformative project alongside many pointed remix practices around the globe. As indicated above, remix theory engages processes that establish authenticity among cultural constructs; it also inherently maintains a critical perspective regarding notions of authority and originality. Critical perspectives among remix artists emphasize the utility of remix practices in their confrontation with, and reformation of, corrosive dominant ideologies. Such practices can be used to uniquely amplify the inadequacies or harmful qualities of targeted subjects at the hands of various power structures and repressive social categories as they push for a dismantling of dominant (mis)understandings of authorship and ownership, especially since digital media have broadened access and control to those seeking to utilize its forms, tools, and techniques in order to resist and reform hegemonic constructs.

In a similar way, the varying iterations of Buddhism function as subversive developments since they remain in dialogue with both other programs in their shared operating systems and the foundation of the systems themselves—especially since their newfound existence as alternative traditions and schools implies something reactive, corrective, and transformative in their motives. Buddhism's *secularization* is considered by Batchelor to be "a sign of the waning power of the orthodoxies that have held sway for the past two thousand or so years,"[24] and he is fairly explicit about the criticism being launched at Buddhism 1.0: Version 2.0 is subverting its predecessor's very foundation as an operating system. According to Navas, remix culture itself "is a culture of resistance" with operative layers that push for "ongoing critical reflection" and provide "the potential to create new possibilities for culture's creative drive."[25] Buddhism 2.0 pushes back against notions of a religious elite that can attain enlightenment while holding a certain authority over a less powerful laity relegated underneath as it aims to provide a reformed Buddhist orientation to the contemporary world.

According to Batchelor, Buddhism 1.0 programs are set on "preserving time-honored doctrines and practices by endlessly repeating past teachings and instructions."[26] A certain irony exists in this sort of pattern: Foundational to Buddhist thought is the emphasis on dissolving attachments and clinging, including toward established doctrines and teachings, as pointed out in the Alagaddupama Sutta above; not that those established doctrines and teachings should be abandoned so dismissively, but one should always remain inquisitive and questioning for the sake of arriving at a personal understanding. The Kalama Sutta is famed for this emphasis, with its push for adherents to not simply "go by reports, by legends, by traditions, by scripture, by logical conjecture, by inference, by analogies," and the like, in determining if something should be accepted or abandoned, or if it will lead to welfare or suffering.[27]

In Batchelor's analogy, the reclaiming of experiential knowledge associated with Buddhism 2.0 might best be understood as a sort of participatory "hacking" of the Buddhist 1.0 operating system, wherein the institutional authority established by elite monastic or priestly classes as proprietary coders and debuggers for their respective programs is challenged by rising classes of amateur programmers and lay hackers in a new,

reformative environment. Buddhism 2.0 coders are not among the elite class found in Buddhism 1.0; they are the nonhierarchical disrupters of traditional modes of authority found in that *other* operating system. In hacker culture, the term "hacker" itself refers to a "person who enjoys exploring the details of programmable systems and how to stretch their capabilities."[28] An *ethic* is attached to this persona as well: "the belief that information sharing is a powerful positive good, and that it is an ethical duty of hackers to share their expertise by writing free software and facilitating access to information and to computing resources wherever possible."[29] The hacker sensibility is also both inherently antiauthoritarian and something that can be (and often is) extended outside of a computational context into culture at large. As Eric S. Raymond notes, "Anyone who can give you orders can stop you from solving whatever problem you're being fascinated by... So the authoritarian attitude has to be fought wherever you find it, lest it smother you and other hackers."[30]

Although Buddhism does not have a centralized authoritative body, per se, the established teachings, doctrines, and monastic communities have become the authoritative models for the legitimacy upon which subsequent developments depend.[31] As outlined previously, Buddhism 1.0 is predicated upon the conveyance and acceptance of certain claims to truth, and claims to truth can also function as claims to power. In a 2015 interview with *Tricycle: The Buddhist Review*, Batchelor further elaborated on this feature: "If I claim that my teacher has access to ultimate truth in a direct, nonconceptual way, then that is not just a neutral description of that person's knowledge. It's also what gives that person authority over others...In other words, a critique of certain orthodox ideas is implicitly a critique of certain structures of power."[32] Buddhism 1.0 programs do maintain established chains of lineage and tutelage that create closed-off structures of power within their systems that are at odds with some of the sentiments found in texts like the Kalama Sutta. Thus, Buddhism 2.0 might be framed as a sort of "open source" challenge among hackers to the proprietary systems of elite teachers in Buddhism 1.0, where remixing the underlying code and operative parameters in the latter is encouraged less (or remains inaccessibly impossible) than the acceptance of what is already in place.

In technological contexts, hackers demonstrate not just a strong familiarity with computational systems, but a profound understanding of how these systems are structured, communicate, and express the aims of their coding. The zeal for the language underlying their projects similarly reflects the semantic elements behind Batchelor's project and reforms as well: a fluency of the canonical texts, i.e., a critical and philological mastery of how they are structured and syntactically implemented. Batchelor might be considered a Buddhist hacker, developing his own translations and creating more accessible and relevant versions of dense poetry and prose through commentary or analytical paraphrasing, embodying the effort to expand and spread access to and knowledge of the coding behind the programs themselves so that others can equally understand and build upon them in Buddhist 2.0 iterations. According to Peter Ludlow, "hacking is fundamentally about refusing to be intimidated or cowed into submission by any technology, about understanding the technology and acquiring the power to repurpose it to our individual needs, and for the good of the many."[33] Considering the subversion of Buddhism 1.0 as a sort of *hacking* of the system among Buddhist 2.0 programmers, Batchelor's project can itself be considered here as its own unique form of hacktivism—pointedly hacking for social causes or changes—geared toward more communal, egalitarian, and nongendered forms of power and structure that guide the dharma among adherents.[34]

Batchelor's project, however, can easily run the risk of replacing one authoritative structure for another, no matter how reformative the latter may aim to be: As a challenge to historic authority through its reassertion of originality in the teachings, it can itself become a claim to authority. But, one of the main assumptions in remix theory is that *originality* is itself a problematic conceptual construct: There are no originals, only contextual configurations of cultural artifacts. While something simply unique to the moment might *appear* to be original, Navas indicates, it is effectively "a cultural node, or in terms of complexity, a module that will lead to other forms that will build on top of it, or incorporate it materially or conceptually for the eventual development of new unique forms in the future."[35] The Buddha is understood to have taught for about forty-five years of his life, which, as Gil Fronsdal points out in his work on early Buddhist texts, "is long enough for him to have developed, elaborated, and systematized his teachings."[36] In other words, just because certain teachings and textual iterations might be some of the earliest, or *original*, does not mean that they are inherently the most representative of the Buddha's overall message, creating a disjunction between notions of originality and authority. The later teachings might arguably be more developed from the Buddha's perspective, so maybe *those* teachings should be prioritized over what preceded them.[37]

Batchelor might prioritize a return to the dharmic source code in order to write a new operating system and disparage its historic counterpart, but the process of versioning and that cultural loop of legitimation cannot be neglected in the history of Buddhist development. Thus, a challenge to the notion of originality implicates a challenge to any authority based on a claim to it. Such an understanding further reveals the developmental process as well, allowing for the engagement of knowledge "in ways that no longer look for discovery in terms of origins, but rather in terms of recursive nodes where unique forms and ideas developed, understanding that such nodes are preceded by others."[38] This understanding remains crucial for a critical perspective as well: Cultural variables always recur; they often go unnoticed without close analysis.[39] These types of challenges further demonstrate such recyclability within culture—especially one characterized by its digitality—which has made concepts like remix all the more relevant in terms of considering how cultural repositories expand and evolve. Remix critically elucidates culturally repetitive processes and allows for greater insight into the fact that *everything* is being constantly recycled—if not technically, then at least in principle—and that cultural artifacts and processes are authenticated based not on some authoritative original form, but on what has been legitimated among adherents.

Conclusion

The application of concepts like remix, recyclability, and versioning to the development of religious traditions uniquely reflects the digital age as they specifically signal its communicative and consumptive sensibilities, and how those sensibilities shape conceptions and cultural interactions. It particularly reflects the sort of cultural "computerization" pointed out by scholars like Lev Manovich, in that "cultural categories and concepts are substituted, on the level of meaning and/or language, by new ones that derive from the computer's ontology, epistemology, and pragmatics."[40] The

influence of digital technology, especially with the rise of software and electronic music, has uniquely shaped the reservoirs of cultural metaphors and meaning-making practices in the Western world, and remix has steadily become foundational in this process.[41] The critical dimensions behind the application of it and related concepts in this chapter are particularly useful, in terms of dismantling hegemonic and oppressive structures within traditions through a recognition and awareness of how they operate and reinsert themselves into their respective contexts via assumptions regarding originality, authenticity, and authority. "Once individuals invested in cultural production remain critically conscious of this ongoing process of sublation and recycling of material and immaterial elements and objects, and how resistance itself thrives within the loops," Navas states, "it becomes possible to develop a critical position well within the very system being critiqued and challenged."[42] Such is meant to be the case, this chapter has shown, with Buddhist traditions in particular and other religious traditions more broadly. The analytical and metaphorical repositioning and perspective taken in this chapter bridges the study of religion with remix theory and digital culture, allowing scholars to rethink religious development in ways that invite both a newfound criticism and appreciation.

New media features are fundamentally shifting self-definition and the ways people relate and communicate, and the overarching point of this chapter is that religiosity is certainly not immune to these types of cultural and communicative processes. Rethinking the development of religious traditions in terms of datasets being remixed and versioned as they evolve and manifest in different times and places demonstrates not just a simple application of remix theory to the study of religion, but how the networked processes underlying cultural traditions at large can be more clearly and critically recognized through concepts and tools most familiar to those living through a digital age as well. Thus, this chapter exists not merely as a narrow case study or unique metaphorical analysis; it demonstrates how the application of tools from remix studies to religious studies—a move that has yet to be made in serious depth by scholars in either field[43]—can help demonstrate that *all* cultural traditions are inherently in dialogue with each other and not absolutely distinct. It also aims to help dissolve exclusivist perspectives and amplify the larger dialogic and evolutionary processes underlying culture, allowing people to better understand not only why they view the world and their roles in it the way that they do, but how these roles are changing given the cultural context in which they are situated.

Notes

1 Nyanaponika Thera, trans., "Alagaddupama Sutta: The Snake Simile," Access to Insight: Readings in Theravāda Buddhism, 2006, https://www.accesstoinsight.org/tipitaka/mn/mn.022.nypo.html.
2 This term generally refers to the process wherein another version of a computer program is created in order to work on other hardware or in other environments.
3 Stephen Batchelor, "A Secular Buddhism," *Journal of Global Buddhism* 13, (2012): 87.
4 Batchelor, "A Secular Buddhism," 90.
5 Ibid., 90.
6 Ibid.
7 Ibid., 87.

8 Ibid., 92.

9 Ibid., 99.

10 Ibid., 99–100.

11 Stephen Batchelor, *After Buddhism: Rethinking the Dharma for a Secular Age* (New Haven, CT: Yale University Press, 2015), 83.

12 Richard Rinehart, "Archive," in *Keywords in Remix Studies*, eds. Eduardo Navas, Owen Gallagher, and xtine burrough (New York: Routledge, 2017), 31.

13 Batchelor, "After Buddhism," 4–5.

14 Eduardo Navas, "Culture and Remix: A Theory on Cultural Sublation," in *The Routledge Companion to Remix Studies*, eds. Eduardo Navas, Owen Gallagher, and xtine burrough (New York: Routledge, 2015), 120.

15 Eduardo Navas, *Art, Media Design, and Postproduction: Open Guidelines on Appropriation and Remix* (New York: Routledge, 2018), 196–8.

16 Navas, "Art, Media Design, and Postproduction," 198.

17 Navas, "Culture and Remix," 124.

18 Ibid., 124–5.

19 Navas, "Art, Media Design, and Postproduction," 200.

20 Batchelor, "A Secular Buddhism," 90.

21 Ibid.

22 Eduardo Navas, "The Originality of Copies: Cover Versions and Versioning in Remix Practice," *Journal of Asia-Pacific Pop Culture* 3, no. 2 (2018): 183.

23 Navas, "The Originality of Copies," 183–4; for more on the notion of "emptiness" and "lack of essence" in Buddhist thought, as it pertains to copying and creative potential, see Scott Haden Church, "Remix, *Śūnyatā*, and *Prosōpopoeia*: Projecting Voice in the Digital Age," in *Ancient Rhetorics & Digital Networks*, ed. Michele Kennerly and Damien Smith Pfister (Tuscaloosa, AL: University of Alabama Press, 2018), and Marcus Boon, *In Praise of Copying* (Cambridge, MA: Harvard University Press, 2010).

24 Batchelor, "A Secular Buddhism," 106.

25 Navas, "Culture and Remix," 119.

26 Batchelor, "After Buddhism," 313.

27 Thanissaro Bhikkhu, trans., "Kalama Sutta: To the Kalamas," Access to Insight: Readings in Theravāda Buddhism, 1994, https://www.accesstoinsight.org/tipitaka/an/an03/an03.065.than.html.

28 Eric S. Raymond, comp., *The New Hacker's Dictionary*, 3rd ed. (Cambridge, MA: MIT Press, 1996), 233.

29 Raymond, "The New Hacker's Dictionary," 234.

30 Eric S. Raymond, "How to Become a Hacker," appendix to *The Cathedral & the Bazaar: Musings on Linux and Open Source by an Accidental Revolutionary*, rev. ed. (Sebastopol, CA: O'Reilly & Associates, 2001), 199.

31 Batchelor, "After Buddhism," 315.

32 James Shaheen, "After Buddhism: An Interview with Stephen Batchelor," *Tricycle: The Buddhist Review*, Winter 2015, https://tricycle.org/magazine/after-buddhism/.

33 Peter Ludlow, "What Is a Hacktivist?" *The New York Times*, January 13, 2013, Opinionator, https://opinionator.blogs.nytimes.com/2013/01/13/what-is-a-hacktivist/.

34 Ludlow for more on "hacktivism."

35 Navas, "Art, Media Design, and Postproduction," 197.

36 Gil Fronsdal, *The Buddha before Buddhism: Wisdom from the Early Teachings* (Boulder, CO: Shambhala Publications, 2016), 141.

37 Ibid.

38 Navas, "Art, Media Design, and Postproduction," 203.

39 Ibid., 194.

40 Lev Manovich, *The Language of New Media* (Cambridge, MA: MIT Press, 2002), 47.

41 Lev Manovich, "What Comes After Remix?" Lev Manovich, Winter 2007, http://manovich.net/index.php/projects/what-comes-after-remix. For a more elaborate engagement of "software" and its fundamental role in contemporary societies, see Lev Manovich, *Software Takes Command* (New York: Bloomsbury Academic, 2013).

42 Navas, "Culture and Remix," 128–9.

43 Some have engaged in comparisons and examinations, but an extensive and robust critical analysis remains to be seen; this chapter is part of a larger dissertation project by the current author that aims to fill this void. For work that *has* paved some of the way in explicitly bridging the study of religion with concepts found in remix theory, see Scott Haden Church, "Remix, *Śūnyatā*, and *Prosōpopoeia*: Projecting Voice in the Digital Age," in *Ancient Rhetorics & Digital Networks*, ed. Michele Kennerly and Damien Smith Pfister (Tuscaloosa, AL: University of Alabama Press, 2018); Lynn Schofield Clark, "Religion and Authority in a Remix Culture: How a Late Night TV Host Became an Authority on Religion," in *Religion, Media and Culture: A Reader*, ed. Gordon Lynch, Joylon Mitchell, and Anna Strhan (New York: Routledge, 2012); C. Wess Daniels, *A Convergent Model of Renewal: Remixing the Quaker Tradition in a Participatory Culture* (Eugene, OR: Pickwick, 2015); John S. McClure, *Mashup Religion: Pop Music and Theological Invention* (Waco, TX: Baylor University Press, 2011); and Graham St John, "Aliens Are Us: Cosmic Liminality, Remixticism, and Alienation in Psytrance," *Journal of Religion and Popular Culture* 25, no. 2 (2013).

Bibliography

Batchelor, Stephen. "A Secular Buddhism." *Journal of Global Buddhism* 13 (2012): 87–107.

Batchelor, Stephen. *After Buddhism: Rethinking the Dharma for a Secular Age*. New Haven, CT: Yale University Press, 2015.

Bhikkhu, Thanissaro, trans. "Kalama Sutta: To the Kalamas." Access to Insight: Readings in Theravāda Buddhism, 1994. https://www.accesstoinsight.org/tipitaka/an/an03/an03.065.than.html.

Boon, Marcus. *In Praise of Copying*. Cambridge, MA: Harvard University Press, 2010.

Church, Scott Haden. "Remix, *Śūnyatā*, and *Prosōpopoeia*: Projecting Voice in the Digital Age." In *Ancient Rhetorics & Digital Networks*, edited by Michele Kennerly, and Damien Smith Pfister, 229–51. Tuscaloosa, AL: University of Alabama Press, 2018.

Clark, Lynn Schofield. "Religion and Authority in a Remix Culture: How a Late Night TV Host Became an Authority on Religion." In *Religion, Media and Culture: A Reader*, edited by Gordon Lynch, Joylon Mitchell, and Anna Strhan, 111–21. New York: Routledge, 2012.

Daniels, C. Wess. *A Convergent Model of Renewal: Remixing the Quaker Tradition in a Participatory Culture*. Eugene, OR: Pickwick, 2015.

Fronsdal, Gil. *The Buddha before Buddhism: Wisdom from the Early Teachings*. Boulder, CO: Shambhala Publications, 2016.

Ludlow, Peter. "What Is a Hacktivist?" *The New York Times*, January 13, 2013, Opinionator. https://opinionator.blogs.nytimes.com/2013/01/13/what-is-a-hacktivist/.

Manovich, Lev. *Software Takes Command*. New York: Bloomsbury Academic, 2013.

Manovich, Lev. *The Language of New Media*. Cambridge, MA: MIT Press, 2002.

Manovich, Lev. "What Comes After Remix?" Lev Manovich, Winter, 2007. http://manovich.net/index.php/projects/what-comes-after-remix.

McClure, John S. *Mashup Religion: Pop Music and Theological Invention*. Waco, TX: Baylor University Press, 2011.

Navas, Eduardo. "Culture and Remix: A Theory on Cultural Sublation." In *The Routledge Companion to Remix Studies*, edited by Eduardo Navas, Owen Gallagher, and Xtine Burrough, 116–31. New York: Routledge, 2015.

Navas, Eduardo. *Art, Media Design, and Postproduction: Open Guidelines on Appropriation and Remix*. New York: Routledge, 2018.

Navas, Eduardo. "The Originality of Copies: Cover Versions and Versioning in Remix Practice." *Journal of Asia-Pacific Pop Culture* 3, no. 2 (2018b): 168–87.

Raymond, Eric S. "How to Become a Hacker." *Appendix to The Cathedral & The Bazaar: Musings on Linux and Open Source by an Accidental Revolutionary*, 195–213. Revised Edition. Sebastopol, CA: O'Reilly & Associates, 2001.

Raymond, Eric S., comp. *The New Hacker's Dictionary*. 3rd Edition. Cambridge, MA: MIT Press, 1996.

Rinehart, Richard. "Archive." In *Keywords in Remix Studies*, edited by Eduardo Navas, Owen Gallagher, and Xtine Burrough, 23–32. New York: Routledge, 2017.

Shaheen, James. "After Buddhism: An Interview with Stephen Batchelor." *Tricycle: The Buddhist Review*, Winter 2015. https://tricycle.org/magazine/after-buddhism/.

St John, Graham. "Aliens Are Us: Cosmic Liminality, Remixticism, and Alienation in Psytrance." *Journal of Religion and Popular Culture* 25, no. 2 (2013): 186–204.

Thera, Nyanaponika, trans. "Alagaddupama Sutta: The Snake Simile." Access to Insight: Readings in Theravāda Buddhism, 2006. https://www.accesstoinsight.org/tipitaka/mn/mn.022.nypo.html.

7
MONSTER THEORY 2.0
Remix, the Digital Humanities, and the Limits of Transgression

Megen de Bruin-Molé

Monstrous metaphors abound in remix and new media scholarship. Stefan Sonvilla-Weiss paints remix as "a coevolving, oscillating membrane of user-generated content (conversational media) and mass media."[1] For David Gunkel, remix is a Frankensteinian creation: "the monstrous outcome of illegitimate fusions and promiscuous reconfigurations of recorded media that take place in excess of the comprehension, control, and proper authority of the 'original artist.'"[2] Wendy Hui Kyong Chun highlights how, in digital networked culture, "individual actions coalesce bodies into a monstrously connected chimera."[3] Monstrosity and transgression, however, are slippery subjects in twenty-first century digital culture. If we take postmodernism at its word—rarely a stable strategy, but here a useful experiment—transgression has long since "run its course, become absorbed or exhausted within a new world order of a generalized homogeneity of signs, commodities, bodies, informational flows."[4] As Marxist critic David McNally writes, "it is a paradox of our age that monsters are both everywhere and nowhere,"[5] absorbed into the everyday monstrosities of late capitalist existence. Similarly, remix, that "monstrous hybrid,"[6] seems both everywhere and nowhere in twenty-first-century digital culture.

This chapter begins with the question: Is remix a monster, and digital humanities (DH) the means through which it is destined to bring down the old-fashioned, exclusionary, and hierarchical modes of humanities past? Using the metaphor of Frankenstein and his creature, I will stitch together theories of monstrosity and transgression from both literary and media studies to explore this question. The answer, I argue, is that the transgressive potential of remix and the digital humanities lies less in the form of these disciplines, and more in their practice: how they are allowed to intersect, evolve, and escape their traditional (anti)humanist foundations.

To some, remix in digital humanities is seen as a figuration akin to Donna Haraway's cyborg, a recombinant tool that promises to transform the humanities into "a hybrid of machine and organism,"[7] and that fuels "the mutual co-constitution of technology and the human [...which is] an essential part of any work undertaken within the digital humanities."[8] Haraway's cyborg rejects historical nostalgia and humanist logic. "In a sense," writes Haraway, "the cyborg has no origin story."[9] As a field of scholars who are

"born native," rather than traditional practitioners "grafting old habits onto the digital,"[10] digital humanities is comparably framed as existing "outside salvation history" and therefore able to offer a salvation for the humanities that is not determined by patriarchal, colonial, or other oppressive systems.[11] Digital humanities is also interdisciplinary, often presented as belonging to a humanities scholar who is networked and mobile.

Remix is a key tool or practice through which digital humanities becomes cyborg, helping to establish more firmly its narrative of progress. Remix culture is similarly seen as a post-digital phenomenon, "consisting of the creative and efficient exchange of information made possible by digital technologies that is supported by the practice of cut/copy and paste."[12] Many remix scholars, including Margie Borschke and Eduardo Navas, have pointed out the problems with this assumption, and with setting up a binary divide between the digital and the non-digital more generally, but in digital humanities as in contemporary culture more broadly, this conception of digital remix culture often persists in one way or another. As Julia Flanders suggests in *Defining Digital Humanities*, "the narratives that surround technology tend, understandably, to be progressive."[13] As with so many "digital" movements, considerations of remix practices in digital humanities abound with promises of progress, transformation, and transcendence. Because they are "digital," the logic often goes, they must somehow offer a clean break with our old technologies and humanities frameworks.

Federica Frabetti writes that the "digital humanities are generally understood as embracing all those scholarly activities that involve using techniques and methodologies drawn from computer science (image processing, data visualisation, network analysis) to produce new ways of understanding and approaching humanities texts."[14] As part of this drive toward computer-aged newness, remix has become a central metaphor— one of digital humanities' key "forms of coproduction and crowd sourcing."[15] Within this discourse, remix is often touted as a vital tool in a digital humanities revolution, framed as a progressive practice that, in the thread of Lawrence Lessig's writings, offers "a critical expression of creative freedom that in a broad range of contexts, no free society should restrict."[16] Outlining UC Riverside's Critical Digital Humanities research focus for 2012–13, Steve Anderson describes remix practices as one of several key "opportunities for resistance to the challenges of neoliberal ideology" that beset the contemporary university.[17] Similarly, in "The Digital Humanities Manifesto 2.0" (assembled at UCLA in 2008) anything "that stands in the way of the perpetual mashup and remix stands in the way of the digital revolution."[18] Here digital humanities itself is framed as a kind of mashup between traditional humanities and digital cultures. "Hack into old hierarchical university systems and send a few remixed ones our way!," the manifesto beseeches.

The digital breaks enacted by remix and by digital humanities are also often positioned as transgressive or revolutionary. Perhaps unsurprisingly, in the context of remix, scholars and practitioners tend to refer to transgression from the perspective of legality (or perceived illegality), framing transgression as "the appearance of violating cultural norms."[19] This is applied to debates around fair use and intellectual property infringement, where the (il)legality of appropriation is pitted against the (im)morality of corporate copyright culture. In the 2011 edited collection *Transgression 2.0*, remix scholars examined instances of appropriation for political satire and resistance, considering how "transgression against power and corruption, whether national or transnational can take very different forms" in digital culture.[20] Here power and corruption are generally weighed against the liberal values of democratic participation and the free movement

of digital content, and the issues around identity politics that arise in such an environment. As the editors of this collection point out, whether or not we agree that remix is inherently transgressive, transgression remains a central theme of the debate: "we have been inundated with both proclamations and examples of the importance, or lack thereof, of digital media for altering perceptions and breaking down social constructions, for shifting lines of debate and pushing the limits of the knowable, the understandable, the containable."[21] digital humanities operates under similar conditions, with the common suggestion being that it builds on the 1970s and 80s fights to "address issues of social, political, and cultural disenfranchisement and possibilities for re-enfranchisement [...] The Humanities was no longer the domain of the proverbial 'old white man'."[22] Digital humanities purports to be deconstructive and decolonial, questioning "the very materiality, methods, and media of humanistic inquiry and practices,"[23] and harnessing "the expanded, global nature of today's research communities [...to] leverage the increasingly distributed nature of expertise and knowledge and transform this reality into occasions for scholarly innovation, disciplinary cross-fertilization, and the democratization of knowledge."[24]

As remix and digital humanities strive toward newer and more egalitarian futures, however, the old hierarchical attitudes toward authorship, scholarship, and the humanities persist. In the case of the humanities, the scholar is placed in a position of dominance over digital technology and must attempt to quantify and control it for the sake of future generations. The result is largely framed as one of two equally problematic options, summed up neatly by Luciano Floridi in a 1995 article on the future of the humanities after the Internet. Floridi argues, "we are giving the body of organized knowledge a new electronic life, and in so doing we are constructing the digital heritage of the next millennium. Depending on how we meet the challenge, future generations will consider us as new Pygmalions or as old Frankenstein."[25]

Floridi's Classical/Gothic divide may seem melodramatic but is a common one in metaphors of humanism and technology. Writing five years later, Timothy Clark makes the same distinction, pointing to a millennial shift in our relationship with technology, and framing the digital turn as a monstrous one:

> The traditional, Aristotelian view is that technology is extrinsic to human nature as a tool which is used to bring about certain ends. Technology is applied science, an instrument of knowledge. The inverse of this conception, now commonly heard, is that the instrument has taken control of its maker, the creation control of its creator (Frankenstein's monster).[26]

Similarly, in 2012, Virginia Kuhn writes that remix is not "the bright and shining answer to the anxiety of loss surrounding humanities inquiry or its attendant echo of loss in the digital humanities—remix culture will not save *The Iliad*."[27] In this scenario, the application of remix and other digital practices in digital humanities either carries us toward a classical humanist utopia, in which remix conquers "past tired ideological divides" to elevate the humanities to new heights,[28] or into the arms of a Gothic monster, where the wrong configuration of parts might spell the end of the humanities altogether, the creatures turning on their makers. In this chapter, I want to suggest the third option that we have ultimately been misreading Floridi's monster metaphor altogether. As in Shelley's *Frankenstein*, it is not the remix monster that will destroy the humanities, but us as digital humanities scholars, attempting to shape it to our narrow, humanist image.

Instead, we need to reenvision ourselves as a Gothic Humanities, not in charge of shaping new generations, but curators of a grand "crypt of body parts that can be stitched together in myriad different permutations."[29]

Gothic Humanities

What does it mean to compare digital humanities to Frankenstein and remix to his monster—both generally and in a specifically digital context? In popular culture, the monster's status as a hybrid, transgressive cultural symbol has become accepted as a given, its transgressions welcomed by mainstream media as a source of endlessly rejuvenating profit and delight. The monster (as quirky-but-lovable-outsider) has even become the hero of children's entertainment, from *Hotel Transylvania* (2012) and its many sequels to Mattel's *Monster High* (2010–now) and Disney's *Vampirina* (2017–now). Are these adaptations and remixes monstrous or transgressive in any meaningful sense, or does the only horror they inspire lie in their repetitive banality? This is certainly not what scholars of the monstrous envisioned twenty years ago when they defined the monster along socially progressive lines, as a figure that foregrounded differences of a predominantly "cultural, political, racial, economic, sexual" nature, and promoted reevaluations of civil rights.[30] Similarly, digital humanities's engagements with remix as a tool for transgression have not always produced the results we might have hoped for.

Borschke points out how the use of "remix as a generic description of a creative approach" hides "a rhetorical agenda meriting scrutiny."[31] She cites Sebastian Faber, who once again has a monstrous metaphor at the ready to describe the situation:

> The slip into ideology occurs when one ceases to distrust the power of language; when simplifications, summaries or short cuts take the place of the complexities that inspired them. Ideology occurs when language, in a Frankensteinian way, "takes over" from its producers and consumers—which is a way of describing what happens when a trope stops being conceived as one.[32]

Scholars have used the term "remix" to describe practices as diverse as musical mashup, adaptation, photomontage, fan fiction, and retweeting or reposting content on social media. This ideological looseness is what makes remix interesting from a monster studies perspective: Monsters too are "disturbing hybrids whose externally incoherent bodies resist attempts to include them in any systematic structuration."[33] Digital humanities is a similarly loose-skinned monster: "performed whenever the humanities engage with some instances of digitality—be it an open access database, a blog, or an algorithm."[34] In a sense, all twenty-first-century humanities research is digital research, since it is often conducted through digital technology (the computer, the online archive), written up using digital platforms (the word processor), and almost always published and circulated through a digital framework (the library catalog, the online journal, the eBook, social media). Remix in the digital humanities is certainly monstrous, occurring "everywhere and nowhere."[35] This is a looseness resisted by many digital humanities scholars, particularly given the discipline's continued attempts to justify its existence and relevance in an already precarious environment for the humanities. In 2012, as the field saw a rapid growth in popularity and recognition, Matthew K. Gold charted the "fault lines" in digital humanities "between those who use new digital tools to aid relatively traditional scholarly projects and those who believe that digital humanities (DH) is most

powerful as a disruptive political force that has the potential to reshape fundamental aspects of academic practice."[36] The "Big Tent" approach to digital humanities does indeed risk diluting its potential as a set of revolutionary computational practices, but I would suggest that, as with all monsters, dilution is not the field's biggest problem. As David M. Berry suggests, arguing for the "third wave" of digital humanities research in 2013, "neither first- nor second-wave digital humanities really problematised" either "the unspoken assumptions and ontological foundations which support the 'normal' research that humanities scholars undertake on an everyday basis."[37] At this moment, what is needed is a reconsideration of the ways digital remix and other computational techniques "are not merely an instrument wielded by traditional methods," but "have profound effects on all aspects of the disciplines," as modes of mediation that fundamentally alter our perceptions of the world and our work within it.[38]

While attempts to generalize digital humanities may be read as dismissive, this is not at all how it is intended here. Instead, I believe there is a different and more productive way we can examine this ideological looseness in digital humanities, namely, through the lens of monster theory. In discussing what defines the typical or traditional monster in Western culture, Cohen's (1996) oft-cited "Monster Culture" outlined seven theses. Most notably, a monster is anything that is other and hybrid, signifying "something other than itself," inhabiting "the gap between the time of upheaval that created it and the moment into which it is received," born at a "metaphoric crossroads, as an embodiment of a certain cultural moment—of a time, a feeling, and a place."[39] The monster's traditional function is not to be completely other, but to show us what is normal and abnormal, possible and impossible, within the framework that already exists.[40] The monster is thus a powerful cultural tool, and a powerful tool for reading culture. The same monster can inhabit different meanings at different times: Our 1930s Frankenstein is not the same as our 2020s Frankenstein. This is in part due to the way stories are continually adapted and remixed, but the passage of time can also lend an old story new resonances and meanings.

As a "monster," digital humanities occupies a particularly poignant moment, straining between a nostalgia for the Classical ideals of the humanities, and the knowledge that many of these ideals have led to as much harm as good for humanity, creating Frankenstein's monsters that cannot peacefully exist in the same universe as their creators. Many digital humanities scholars realize the problematic nature of both options— in fact, much digital humanities research grapples with precisely this issue. As Flanders suggests,

> If the rhetoric at the heart of the "digital" side of "digital humanities" is strongly informed by a narrative of technological progress, the "humanities" side has equally strong roots in a humanities sensibility which both resists a cumulative idea of progress (one new thing building on another) and yearns for a progressive agenda (doing better all the time).[41]

For Flanders, this conflict results in a "productive unease," where despite "prevailingly progressive narratives surrounding the impact of digital technology on modern academic culture, the field of digital humanities is characterized at a deeper level by a more critical engagement with technology."[42] In the rest of this chapter, accordingly, I explore the following question: What would it actually mean for us to embrace the unease of Floridi's binary, Classical/Gothic metaphor, and to consider remixes in digital humanities as

Frankensteinian monsters? Employing readings of *Frankenstein* from Gothic, postcolonial, and adaptation studies perspectives, I suggest that the answers to this question do not reflect as positively on us as we might wish. Fortunately, they also reveal new opportunities for growth and change.

Frankenstein Meets the (Digital) Humanities

The epigraph to *Frankenstein*, taken from *Paradise Lost*, frames the act of creation as one in which the created is an unwilling participant: "Did I request thee, Maker, from my clay/To mould me Man, did I solicit thee/From darkness to promote me?"[43] In Frankenstein's case the issue is compounded, since the creature is not formed of inert and shapeless clay, but from the dismembered pieces of humans and other animals.[44] These objects have shifted from living to dead and were meant to remain at rest. What gives Victor Frankenstein the authority, this passage seems to ask, to reassemble the pieces of preexisting bodies into such a monstrous new whole? And is the creature or the creator responsible for the results of this resurrection? The creature certainly did not ask to be given such monstrous life, and in the course of Shelley's novel, it becomes clear that he would rather not be assembled at all. For this and other reasons, *Frankenstein* has been a tale of special interest for scholars writing on postcolonialism and imperialism.[45] As Giyatri Spivak warns, it "should not be possible to read nineteenth-century British literature without remembering that imperialism, understood as England's social mission, was a crucial part of the cultural representation of England to the English. The role of literature in the production of cultural representation should not be ignored."[46] This warning holds equally true in the twenty-first century, particularly as a Western humanities attempts to reinvent itself for a new global audience, and particularly in the "Gothic times" of late capitalist culture.[47] As Catherine Spooner pointed out in 2006, the contemporary Gothic is a mode in which "one of the dominant features is the repercussion of the past within the present."[48] The present repercussions of imperialism and colonialism are all around us, both in and outside of the academy, but particularly acute in digital humanities, which is simultaneously built on and attempting to challenge these legacies.

In examining remix and digital humanities in light of *Frankenstein*, we do well to remember that this story has at least two monsters, Frankenstein's creature but also Frankenstein himself, both of whom are exorcised by the novel's conclusion. As the Internet maxim has it, "Knowledge is knowing that Frankenstein is not the monster. Wisdom is knowing that Frankenstein is."[49] Most importantly, when talking about how remix can revitalize digital humanities, we need to remember that the university (like the museum and the archive) is an inherently imperialist space, with a colonial heritage. The library, likewise, "is a highly Gothic space" not only because of the sense of hidden or forgotten treasure that pervades it, but also in the colonial politics and heritage of such curatorial institutions, many of which were established to promote nationalist agendas, using funds from the slave trade and/or the exploitation of foreign resources.[50]

As Cohen writes, "Because it is a body across which difference has been repeatedly written, the monster (like Frankenstein's creature, that combination of odd somatic pieces stitched together from a community of cadavers) seeks out its author to demand its raison d'etre."[51] Like Frankenstein, remixers and digital humanists act as curators of the past, and the politics of this act differ depending on who is doing the curation. Persistent hierarchies and histories of authorship become another stumbling block in

digital humanities attempts at decolonization, and remix is often implicit in this. For Mickey Vallee, scholarship often overlooks the way remix replicates existing cultural binaries, instead focusing on how mashups seem to embody "the promise of unity and coherence that is lacking within the symbolic order."[52] He questions why, for instance, if the musical mashup seems designed to free us from the "historical weight" or burden associated with adaptive texts, "so little has been done to perturb the well-established fantasy of crossing boundaries that has characterized the virtual cosmopolitanism of the popular music industry for over a century."[53]

Instead of a disruption or transgression of traditional authorship, then, we are left with a paradoxical situation. As Vallee persuasively argues, the mashup deconstructs various binary oppositions (normal versus other, past versus present, high culture versus low culture) but is too often "silent regarding the inner mechanisms of the system it deconstructs, for even though users actively create multiple lines of flight, they are unidirectional: towards the social imaginary of pop cosmopolitanism."[54] In the case of the literary mashup *Pride and Prejudice and Zombies*, for example, despite the much-lauded transformative *potential* of such a text on the form and composition of the publishing industry, no such transformation ultimately took place. The literary mashups that went on to achieve financial or cultural success were generally those produced by major companies and publishing houses, and by a largely White, middle class, and male body of authors and publishers. Likewise, a vast majority of digital humanities institutes are located in the West, and in terms of staffing and leadership are not markedly more diverse than their non-digital counterparts. As Isabel Galina writes, the digital humanities (DH) community:

> has traditionally viewed itself [...] as welcoming and open. Collaboration and cooperation are seen as specific traits of DH that differentiate it from the more 'lone-scholar' traditional humanist. It seems to be that openness and a desire to work with others is fundamental to the way we think of ourselves. And yet, over the past few years this community has become aware that this isn't so open, universal as it thought it was.[55]

All of this seems to suggest that we have been too focused on how *we* will transform the institution, rather than *who* will transform the institution. It is not remix itself that will ultimately decolonize digital humanities: It is the remixers. In true Gothic fashion, the specter of digital humanities allows us to view the analog and isolated scholar as "a past horror that raises a gleeful shudder even as we congratulate ourselves on the collective progress of humanity,"[56] while in reality, too little has changed at a systemic level.

Another issue in the decolonization of digital humanities, and the mission to unleash the remix monster, is linguistic. For Jacques Derrida, writing about how the past haunts the present, it is important for our culture to learn how to let our monsters (our ghosts) "speak or how to give them back speech, even if it is in oneself, in the other, in the other in oneself."[57] In James Whale's 1931 film, Frankenstein's creature is famously silent. In Shelley's novel, the creature speaks at great length—but of course in a sense the creature is not really speaking in its own voice or language at all. The creature does not belong to the world of "man" but has gone out of his way to learn his creator's native languages, learning to speak by listening to an idealized peasant family. In many adaptations, including the 2014 television series *Penny Dreadful*, the creature learns from Victor's own books, often texts ripped straight from humanities canon like Shakespeare and the

Romantic poets. Victor and the creature share a mode and language of discourse, and they are both Victor's, not the creature's. Historically, digital humanities likewise has a language and diversity problem, despite its efforts to the contrary. This is partly due to the "digital" aspects of its development. As Simon Mahony points out, digital humanities "has developed in a very anglophone environment as English became the language of the Internet (with ICANN) and the *lingua franca* of the Web (with the W3C Consortium), along with the domination of the ASCII code."[58] Since then, however, this problem has been compounded by the dominance of Western journals and centers in the field. As Domenico Fiormonte suggests, "the over-representation of US and UK Humanities titles will always support arguments in favor of using English as the lingua franca, and the misrepresentation of knowledge production and geopolitical imbalance will continue to thrive."[59]

In light of digital humanities's attempts to employ remix as a decolonizing tool, a final key difference between remix as a popular practice and remix in the arts and digital humanities involves the former's claim to ephemerality and triviality. In a section of his book problematically littered with value judgments about "good" art and student work, Lawrence Lessig suggests that "remix is just 'crap'."[60] He implies that remix is often seen as random, casual, and made to be discarded, and that this is also part of its transgressive value and potential. Lessig uses the term in a general sense, making little distinction between different genres and contexts of remix, but his analysis applies particularly to remix as a popular practice. A meme has no author and makes no pretense at authority, which allows it to be circulated, recycled, and remixed with impunity. It belongs to the realm of the joke—though as I argue elsewhere, this does not stop the meme or parodic remix from being read seriously.[61] Remix in a scholarly, artistic, or curatorial context and, on the other hand, is generally seen as "accompanied by meticulous guidelines for citation, contextualization and reflection."[62] While many kinds of remix might consist of "play within a system that likes to think of itself as serious,"[63] digital humanities curators in particular remix to sustain and preserve a particular tradition—to re-archive and re-index. Curation (here essentially a highbrow version of collecting or popular remix practices) is viewed as serious play and implies a relative permanence or power.

While I would certainly argue that the politics and relative power of the academy are reflected in its remixes, it is a mistake to equate a remix's power with either its ephemerality and superficiality or its permanence and rigor. Like all monsters, remix gains power and visibility through repetition, not through any individual act—though some remixes certainly carry more weight than others. As Cohen writes, with each revival "the undead returns in slightly different clothing, each time to be read against contemporary social movements or a specific, determining event," but "each reappearance and its analysis is still bound in a double act of construction and reconstitution." Frankenstein's monster is still recognizable as the monster, and its strength as a cultural symbol is its repetition, not its permanence; its power lies in its continual remixing, "signifiers of monstrous passing that stand in for the monstrous body itself."[64] Even the most ephemeral remix signifies and reinforces something, and it is ultimately that larger network of meanings digital humanities is working to shift. If it succeeds as a monster, remixing the "old hierarchical university systems,"[65] it will not be as single, permanent

unit but as a many-headed beast struggling more or less in the same direction, new limbs growing and being reabsorbed as it goes.

Frankenstein's monster—here a metaphor for the radical destruction of the traditional humanities—is not incarnated perfectly anywhere, or at any time. Instead, it is everywhere, in many different forms. The monster is a process not a product; its power is collective not singular. This does not mean that individual acts of curation or remix cannot be revolutionary, even if they are ephemeral or extra-institutional. It simply means that we need to continuously and seriously consider what we mean when we set out to "save" the humanities, particularly when we aim to do so through metaphors of monstrosity or transgression. As Stephen Curtis points out, salvation is an ambiguous act, both revelatory and conservative. Curtis cites Heidegger's definition of "to save," meaning alternately "to loose, to emancipate, to free, to spare and husband, to harbor protectively, to take under one's care, to keep safe."[66] Salvage, curation, and other preservational practices likewise harbor a "telling contradiction," keeping their objects safe or segregated in one sense while also collecting or remixing them in new contexts for new audiences.[67] In addition to building new traditions through remix, it is also vital to keep deconstructing the old ones.

Revision Through Repetition

Haraway pits the cyborg against Frankenstein's monster: "Unlike the hopes of Frankenstein's monster, the cyborg does not expect its father to save it."[68] Frankenstein's monster wishes to pattern himself on his creator, but for Haraway, this model of monstrosity is no longer adequate in twentieth-century identity politics. The cyborg, like Frankenstein's monster, is an "illegitimate offspring," but its parentage—and by association its relationship to oppressive histories and hegemonies—is "inessential."[69] In other words, for Haraway, if we are to move forward as a culture we must, to some degree, do away with the past. Of course, as subsequent studies in postmodernism, posthumanism, and other "post-" disciplines have shown, this is neither as simple nor as inherently revolutionary as it may seem. Borschke suggests that despite its "claim to newness," remix also "signifies a return, or a repetition of sorts."[70] And as Navas argues, "[w]ithout a history, the remix cannot be Remix."[71] The parallels again run closer to Frankenstein and his monster than to Haraway's cyborg. Like Frankenstein's monster, remix in the digital humanities "demonstrates how the past returns in unexpected ways, even as it is transformed."[72] Like Frankenstein's monster, some remixes are built to last, and thus ultimately built to be compared with what has come before. The monster comes off with an advantage in his juxtaposition with humans: "I was more agile than they and could subsist upon coarser diet; I bore the extremes of heat and cold with less injury to my frame; my stature far exceeded theirs."[73] Can we say the same of our digital humanities remixes, or do we, like the creature, still need to take the old creators down a few notches before our potential can be achieved? The answer, I would suggest, is always the latter. This is the nature of the monster.

The process of archiving is as much about dismantling as it is about collecting. In his postcolonial analysis of Frankenstein, Lewis R. Gordon (like Haraway) points out how the creature "imagined creation only from his creator. He demanded repetition."[74] From a Gothic perspective, however, repetition can also be an important tool for transformation. For instance, as Kamilla Elliott argues,

> Gothic film parodies go beyond simple mockery to reveal inconsistencies, incongruities, and problems in Gothic criticism: boundaries that it has been unwilling or unable to blur, binary oppositions it has refused to deconstruct, and points at which a radical, innovative, subversive discourse manifests as its own hegemonic, dogmatic, and clichéd double.[75]

Here familiarity and repetition have a critical function, indicating when a particular theme, form, or interpretation has begun to lose its power or take itself too seriously. Elliott cites the Abbott and Costello monster mashes of 1948 and 53, which signal the point at which Universal's monster movies began to cannibalize themselves, identifying the moments at which certain tropes and representations become fixed. They parody not to comment on sociopolitical reality, but to reveal the structure of the status quo itself. Similarly, as many scholars have pointed out, ideas of decolonization, and of postcolonial studies itself, derive "from continental European philosophy—not the local concerns of the people it purports to represent."[76] Despite their repetition of Western logics and frameworks, however, and despite the impossibility of fully escaping Western logics, these fields are still productive. As Roopika Risam suggests:

> Nevertheless, the tendency of postcolonial studies toward self-critique and its insistence on foregrounding the particular over the universal—that is to say, the local over the global—keeps alive the possibility of using it in spite of its British or Euro-centric framing; the act of contesting its possibilities for critique are themselves productive and perhaps even transformative.[77]

The transgression and monstrosity of remix in digital humanities are perhaps not the transgression and monstrosity that some might expect. Rather than the shiny transgressive newness with which the digital is branded, it displays the dark monstrosity of the gothic monster. Ultimately, however, this monstrosity is still productive: It shows us the limits of our transgression, and also what we must do to push through these limits.

Writing about the limits of transgression in contemporary culture, Matt Foley, Neil McRobert, and Aspasia Stephanous ask:

> To what extent has transgression been nullified or negated by the co-option of the term as a marketing tool and the financial sanction—indeed, incentive—to pursue the extreme and taboo? [...] if transgression has become mainstream then are we all deviant?[78]

The answer to this rhetorical question is both yes and no. We exist in a complex and networked relationship with transgression. Though the language Cohen uses throughout his essay paints the monster as an inviting figure, at no point does he argue that the monster always invites us to embrace progressive political change. In fact, in his very first thesis, he stresses that the monster can embody either "ataractic or incendiary"

fantasies: It can spur us to action or lull us into a sense of security.[79] It is true that monsters have often been used to vilify a society's Others, and that the dominance of sympathetic monsters is a relatively recent phenomenon, but as the twenty-first-century "friendly" monster illustrates, examples of both categories can and do exist. A monster is never wholly transgressive or entirely conservative—its position is always relative to other monsters, and other constructions of (ab)normality.

As Gunkel suggests, "the mashup, like any critical practice, must continually rework its own transgressions, repurposing its own interventions and remixing its remix, so as to avoid the efforts of the opposition as well as the well-intended but unfortunately just as repressive labor of its advocates."[80] Likewise, we must re-digitize our digital humanities, moving away from obsessions with purely new or transgressive forms of expression, and reconsidering our relationship with transgression as a whole. To assume transgression is "inherently radical" is "to romanticize the nature of transgression and to dismember the different cultural, historical and political moments in which it has been articulated."[81]

For Gordon, decolonization requires not just a different and more transgressive kind of imagination, "but also taking on the responsibility of what is to be done."[82] In Selma Dimitrijevic's gender-swapped adaptation of *Frankenstein* for the theater in 2017, the creature points to Victoria Frankenstein's complicity in his destruction: not by spurring the creature to violence as in Shelley's novel, but by assuming the creature is violent because he is Other. Frankenstein allows the creature to be degraded and neglected through her unwillingness to interrogate and take action on these assumptions, and his call to her is a call to the privileged elite of global imperialist culture: "You think your violence should not be met with violence. You are surprised when it is. You think there is virtue in where you are born, who you were born to or how you sound. You see the injustice, you lie to yourself that your silence is not all it requires to continue."[83] Contemporary academia is still dominated by hegemonic structures, and the job of remix and digital humanities is not just to construct an alternate framework. Instead, digital humanities must become a Gothic monster, "cannibalistically consuming the dead body of its own tradition" as it works through it.[84] Decolonizing the humanities requires a constant reevaluation of our ways of reading, thinking, and doing transgression through remix and other "digital" technologies. It also requires a continual re-politicization of our actions and institutions. As Cohen writes, the monster "always escapes," our conception of monstrosity continually evolving, and our searches for it "connected by a logic that always threatens to shift; invigorated by change and escape, by the impossibility of achieving."[85] If we want to embrace the monstrous potential of digital humanities, we must also commit ourselves to a lifetime of monster hunting.

Notes

1 Stefan Sonvilla-Weiss, "Introduction: Mashups, Remix Practices and the Recombination of Existing Digital Content," *Mashup Cultures*, ed. Stefan Sonvilla-Weiss (Wien: Springer, 2010), 9.

2 David J. Gunkel, *Of Remixology: Ethics and Aesthetics after Remix* (Cambridge, MA: MIT Press, 2016), xxix–xxx.

3 Wendy Hui Kyong Chun, *Updating to Remain the Same: Habitual New Media* (Cambridge, MA: MIT Press, 2016), 3, my emphasis.

4 Fred Botting, "After Transgression: Bataille, Baudrillard, Ballard," *Transgression and Its Limits*, eds. Matt Foley, Neil McRobert, and Aspasia Stephanou (Newcastle upon Tyne, UK: Cambridge Scholars Publishing, 2012), 37.

5 David McNally, *Monsters of the Market: Zombies, Vampires and Global Capitalism* (Chicago, IL: Haymarket Books, 2012), 2.

6 Gunkel, *Of Remixology*, 163.

7 Donna J. Haraway, "A Manifesto for Cyborgs: Science, Technology, and Social Feminism in the 1980s," in *Feminism/Postmodernism*, ed. Linda J. Nicholson (New York: Routledge, 1990), 190.

8 Federica Frabetti, "Have the Humanities Always Been Digital? For an Understanding of the 'Digital Humanities' in the Context of Originary Technicity," in *Understanding Digital Humanities*, ed. David M. Berry (Basingstoke: Palgrave Macmillan, 2012), 161, https://doi.org/10.1057/9780230371934.

9 Haraway, "A Manifesto for Cyborgs," 192.

10 Geoffrey Rockwell and Stéfan Sinclair, "Acculturation and the Digital Humanities Community," *Digital Humanities Pedagogy: Practices, Principles and Politics*, ed. Brett D. Hirsch (Cambridge: Open Book Publishers, 2012), 183.

11 Haraway, "A Manifesto for Cyborgs," 191.

12 Eduardo Navas, "Remix: The Bond of Repetition and Representation," Remix Theory, 16 January 2009, http://remixtheory.net/?p=361; see also Lawrence Lessig, *Remix: Making Art and Commerce Thrive in the Hybrid Economy* (London: Penguin, 2008), 51.

13 Julia Flanders, "The Productive Unease of 21st-Century Digital Scholarship," in *Defining Digital Humanities: A Reader*, ed. Melissa Terras, Julianne Nyhan, and Edward Vanhoutte (London: Routledge, 2013), 206.

14 Frabetti, "Have the Humanities Always Been Digital?," 161.

15 Niels Ole Finnemann, "Digital Humanities and Networked Digital Media," *MedieKultur: Journal of Media and Communication Research* 30, no. 57 (19 December 2014): 57, https://doi.org/10.7146/mediekultur.v30i57.15592.

16 Lessig, *Remix*, 56.

17 Steve Anderson, "Rhetoric and Remix," Critical Digital Humanities, 5 October 2012, https://cdh.ucr.edu/2012/10/05/rhetoric-and-remix/index.html.

18 Jeffrey Schnapp et al., "The Digital Humanities Manifesto 2.0," UCLA.edu, 29 May 2009, http://manifesto.humanities.ucla.edu/2009/05/29/the-digital-humanities-manifesto-20/.

19 Grant Kien, "BDSM and Transgression 2.0: The Case of Kink.Com," in *Transgression 2.0: Media, Culture, and the Politics of a Digital Age*, ed. Ted Gournelos and David J. Gunkel (New York: Bloomsbury, 2011), 119.

20 Ted Gournelos and David J. Gunkel, "Introduction: Transgression Today," in *Transgression 2.0: Media, Culture, and the Politics of a Digital Age*, eds. Ted Gournelos and David J. Gunkel (New York: Bloomsbury, 2011), 1.

21 Ibid.

22 Schnapp et al., "Digital Humanities Manifesto 2.0," 8.

23 Ibid., 8.

24 Ibid., 5, my emphasis.

25 Luciano Floridi, "Internet: Which Future for Organized Knowledge, Frankenstein or Pygmalion?," *International Journal of Human-Computer Studies* 43, no. 2 (August 1995): 274, https://doi.org/10.1006/ijhc.1995.1044.

26 Timothy Clark, "Deconstruction and Technology," in *Deconstructions: A User's Guide*, ed. Nicholas Royle (Basingstoke: Palgrave MacMillan, 2000), 238.

27 Virginia Kuhn, "The Rhetoric of Remix," *Transformative Works and Cultures* 9 (15 March 2012), https://doi.org/10.3983/twc.2012.0358.

28 Virginia Kuhn and Vicki Callahan, "Nomadic Archives: Remix and the Drift to Praxis," in *Digital Humanities Pedagogy: Practices, Principles and Politics*, ed. Brett D. Hirsch (Open Book Publishers, 2012), 297, https://doi.org/10.11647/OBP.0024.

29 Catherine Spooner, *Contemporary Gothic* (London: Reaktion Books, 2006), 156.

30 Jeffrey Jerome Cohen, "Monster Culture (Seven Theses)," in *Monster Theory: Reading Culture*, ed. Jeffrey Jerome Cohen (Minneapolis, MN: University of Minnesota Press, 1996), 7.

31 Margie Borschke, "Rethinking the Rhetoric of Remix: Copies and Material Culture in Digital Networks," (Doctor of Philosophy: Journalism and Media Research, Australia, University of New South Wales, 2012), 85.

32 Sebastian Faber, "Trope as Trap," *Culture Theory & Critique* 45, no. 2 (2004): 156.

33 Cohen, "Monster Culture," 6.

34 Frabetti, "Have the Humanities Always Been Digital?," 17.

35 McNally, *Monsters of the Market*, 2.

36 Matthew K. Gold, ed., *Debates in the Digital Humanities* (Minneapolis: University Of Minnesota Press, 2012), 10.

37 David M. Berry, "Introduction: Understanding the Digital Humanities," in *Understanding Digital Humanities*, ed. David M. Berry (Houndmills: Palgrave Macmillan, 2012), 4, https://doi.org/10.1057/9780230371934.

38 Berry, 13.

39 Cohen, "Monster Culture," 4.

40 Cohen, 13.

41 Flanders, "Productive Unease," 209.

42 Flanders, 206.

43 John Milton, *Paradise Lost*, ed. Merritt Yerkes Hughes (1819; repr., Indianapolis, IN: Hackett, 2003), 256; Mary Shelley, *Frankenstein; or, The Modern Prometheus* (1831; repr., London: The Folio Society, 2015), 1.

44 Shelley, *Frankenstein*, 46.

45 see esp. Gayatri Chakravorty Spivak, "Three Women's Texts and a Critique of Imperialism," *Critical Inquiry* 12, no. 1 (1985): 243–61; Chris Baldick, *In Frankenstein's Shadow: Myth, Monstrosity, and Nineteenth-Century Writing* (Oxford: Clarendon, 1987); Mark A. McCutcheon, 'Frankenstein as a Figure of Globalization in Canada's Postcolonial Popular Culture', *Continuum*, 3 October 2011, https://www.tandfonline.com/doi/pdf/10.1080/10304312.2011.590577.

46 Spivak, "Three Women's Texts and a Critique of Imperialism," 235.

47 Angela Carter, "Appendix: Afterword to *Fireworks*," in *Burning Your Boats: Collected Short Stories* (New York: Henry Holt, 1995), 460.

48 Spooner, *Contemporary Gothic*, 156–57.

49 Barry Popik, "Knowledge Is Knowing That Frankenstein Is Not the Monster. Wisdom Is Knowing That Frankenstein Is," The Big Apple, 10 June 2018, https://www.barrypopik.com/index.php/new_york_city/entry/knowledge_is_knowing_that_frankenstein.

50 Stephen Curtis, "You Have Been Saved: Digital Memory and Salvation," in *Monstrous Media/Spectral Subjects: Imaging Gothic from the Nineteenth Century to the Present*, eds. Fred Botting and Catherine Spooner (Manchester: Manchester University Press, 2015), 164.

51 Cohen, "Monster Culture," 12.

52 Mickey Vallee, "The Media Contingencies of Generation Mashup: A Žižekian Critique," *Popular Music and Society* 36, no. 1 (2013): 85.

53 Ibid., 96.

54 Ibid.

55 Isabel Galina, "Is There Anybody Out There? Building a global Digital Humanities community," *Humanidades Digitales* (blog), 19 July 2013, http://humanidadesdigitales.net/blog/2013/07/19/is-there-anybody-out-there-building-a-global-digital-humanities-community/.

56 Spooner, *Contemporary Gothic*, 20.

57 Jacques Derrida, *Specters of Marx: The State of the Debt, the Work of Mourning and the New International*, trans. Peggy Kamuf (1993; repr., New York: Routledge Classics, 2012), 221.

58 Simon Mahony, "Cultural Diversity and the Digital Humanities," *Fudan Journal of the Humanities and Social Sciences* 11, no. 3 (September 2018): 371–88, https://doi.org/10.1007/s40647-018-0216-0.

59 Domenico Fiormonte, "Towards Monoculture (Digital) Humanities?," *Infolet: Cultura e Critica Dei Media Digitali* 7 (2015), https://infolet.it/2015/07/12/monocultural-humanities.

60 Lessig, *Remix*, 92.

61 Megen de Bruin-Molé, *Gothic Remixed: Monster Mashups and Frankenfictions in 21st-Century Culture* (London: Bloomsbury, 2020), 127–30.

62 Kuhn and Callahan, "Nomadic Archives," 297.

63 Gournelos and Gunkel, "Transgression Today," 7.

64 Cohen, "Monster Culture," 5–6.

65 Schnapp et al., "Digital Humanities Manifesto 2.0".

66 Martin Heidegger, "The Turning," in *The Question of Technology and Other Essays*, trans. William Lovitt (New York: Harper & Row, 1977), 42.

67 Curtis, "You Have Been Saved," 157.

68 Haraway, "A Manifesto for Cyborgs," 192.

69 Ibid., 193.

70 Margie Borschke, *This Is Not a Remix: Piracy, Authenticity and Popular Music* (New York: Bloomsbury Academic, 2017), 51, 33.

71 Navas, "Remix," para. 7.

72 de Bruin-Molé, *Gothic Remixed*, 38.

73 Shelley, *Frankenstein*, 116.

74 Lewis R. Gordon, "Decolonializing Frankenstein," Common Reader, 26 October 2018, https://commonreader.wustl.edu/c/decolonializing-frankenstein/.

75 Kamilla Elliott, "Gothic—Film—Parody," *Adaptation* 1, no. 1 (1 March 2008): 24.

76 Roopika Risam, "Decolonizing the Digital Humanities in Theory and Practice," in *The Routledge Companion to Media Studies and Digital Humanities*, ed. Jentery Sayers (New York: Routledge, 2018), 82.

77 Risam, 82.

78 Matt Foley, Neil McRobert, and Aspasia Stephanou, "Introduction: Limits of Transgression and the Subject," in *Transgression and Its Limits*, eds. Matt Foley, Neil McRobert, and Aspasia Stephanou (Newcastle upon Tyne, UK: Cambridge Scholars Publishing, 2012), xii.

79 Cohen, "Monster Culture," 4.

80 David J. Gunkel, "Audible Transgressions: Art and Aesthetics after the Mashup," in *Transgression 2.0: Media, Culture, and the Politics of a Digital Age*, eds. Ted Gournelos and David J. Gunkel (New York: Bloomsbury, 2011), 55.

81 Colin Trodd, "The Discipline of Pleasure; or, How Art History Looks at the Art Museum," *Museum and Society* 1, no. 1 (2003): 19.

82 Gordon, "Decolonializing Frankenstein".

83 Selma Dimitrijevic, *Dr Frankenstein* (London: Oberon Books, 2017), 82.

84 Spooner, *Contemporary Gothic*, 10.

85 Cohen, "Monster Culture," 6.

Bibliography

Anderson, Steve. "Rhetoric and Remix," *Critical Digital Humanities*, 5 October 2012. https://cdh.ucr.edu/2012/10/05/rhetoric-and-remix/index.html.

Baldick, Chris. *In Frankenstein's Shadow: Myth, Monstrosity, and Nineteenth-Century Writing*. Oxford: Clarendon, 1987.

Berry, David M. "Introduction: Understanding the Digital Humanities." In *Understanding Digital Humanities*, edited by David M. Berry, 1–12. Houndmills: Palgrave Macmillan, 2012. https://doi.org/10.1057/9780230371934.

Borschke, Margie. *Rethinking the Rhetoric of Remix: Copies and Material Culture in Digital Networks*. Doctor of Philosophy: Journalism and Media Research, University of New South Wales, 2012.

———. *This Is Not a Remix: Piracy, Authenticity and Popular Music*. New York: Bloomsbury Academic, 2017.

Botting, Fred. "After Transgression: Bataille, Baudrillard, Ballard." In *Transgression and Its Limits*, edited by Matt Foley, Neil McRobert, and Aspasia Stephanou, 37–57. Newcastle upon Tyne, UK: Cambridge Scholars Publishing, 2012.

Bruin-Molé, Megen de. *Gothic Remixed: Monster Mashups and Frankenfictions in 21st-Century Culture*. London: Bloomsbury, 2020.

Carter, Angela. "Appendix: Afterword to *Fireworks*." In *Burning Your Boats: Collected Short Stories*, 459–60. New York: Henry Holt, 1995.

Chun, Wendy Hui Kyong. *Updating to Remain the Same: Habitual New Media*. Cambridge, MA: MIT Press, 2016.

Clark, Timothy. "Deconstruction and Technology." In *Deconstructions: A User's Guide*, edited by Nicholas Royle, 238–57. Basingstoke: Palgrave MacMillan, 2000.

Cohen, Jeffrey Jerome. "Monster Culture (Seven Theses)." In *Monster Theory: Reading Culture*, edited by Jeffrey Jerome Cohen, 3–25. Minneapolis, MN: University of Minnesota Press, 1996.

Curtis, Stephen. "You Have Been Saved: Digital Memory and Salvation." In *Monstrous Media/Spectral Subjects: Imaging Gothic from the Nineteenth Century to the Present*, edited by Fred Botting and Catherine Spooner, 157–69. Manchester: Manchester University Press, 2015.

Derrida, Jacques. *Specters of Marx: The State of the Debt, the Work of Mourning and the New International.* Translated by Peggy Kamuf. 1993. Reprint, New York: Routledge Classics, 2012.

Dimitrijevic, Selma. *Dr Frankenstein.* London: Oberon Books, 2017.

Elliott, Kamilla. "Gothic—Film—Parody." *Adaptation* 1, no. 1 (2008): 24–43.

Faber, Sebastian. "Trope as Trap." *Culture Theory & Critique* 45, no. 2 (2004): 133–59.

Finnemann, Niels Ole. "Digital Humanities and Networked Digital Media." *MedieKultur: Journal of Media and Communication Research* 30, no. 57 (19 December 2014): 21. https://doi.org/10.7146/mediekultur.v30i57.15592.

Fiormonte, Domenico. "Towards Monoculture (Digital) Humanities?" *Infolet: Cultura e Critica Dei Media Digitali* 7 (2015). https://infolet.it/2015/07/12/monocultural-humanities.

Flanders, Julia. "The Productive Unease of 21st-Century Digital Scholarship." In *Defining Digital Humanities: A Reader*, edited by Melissa Terras, Julianne Nyhan, and Edward Vanhoutte, 205–18. London: Routledge, 2013.

Floridi, Luciano. "Internet: Which Future for Organized Knowledge, Frankenstein or Pygmalion?" *International Journal of Human-Computer Studies* 43, no. 2 (August 1995): 261–74. https://doi.org/10.1006/ijhc.1995.1044.

Foley, Matt, Neil McRobert, and Aspasia Stephanou. "Introduction: Limits of Transgression and the Subject." *Transgression and Its Limits*, edited by Matt Foley, Neil McRobert, and Aspasia Stephanou, xi–xxiv. Newcastle upon Tyne, UK: Cambridge Scholars Publishing, 2012.

Frabetti, Federica. "Have the Humanities Always Been Digital? For an Understanding of the 'Digital Humanities' in the Context of Originary Technicity." *Understanding Digital Humanities*, edited by David M. Berry, 161–71. Basingstoke: Palgrave Macmillan, 2012. https://doi.org/10.1057/9780230371934.

Galina, Isabel. "Is There Anybody Out There? Building a global Digital Humanities community." *Humanidades Digitales* (blog), 19 July 2013. http://humanidadesdigitales.net/blog/2013/07/19/is-there-anybody-out-there-building-a-global-digital-humanities-community/.

Gold, Matthew K., ed. *Debates in the Digital Humanities.* Minneapolis, MN: University of Minnesota Press, 2012.

Gordon, Lewis R. "Decolonializing Frankenstein." *Common Reader*, 26 October 2018. https://commonreader.wustl.edu/c/decolonializing-frankenstein/.

Gournelos, Ted, and David J. Gunkel. "Introduction: Transgression Today." In *Transgression 2.0: Media, Culture, and the Politics of a Digital Age*, edited by Ted Gournelos and David J. Gunkel, 1–24. New York: Bloomsbury, 2011.

Gunkel, David J. "Audible Transgressions: Art and Aesthetics after the Mashup." In *Transgression 2.0: Media, Culture, and the Politics of a Digital Age*, edited by Ted Gournelos and David J. Gunkel, 42–56. New York: Bloomsbury, 2011.

———. *Of Remixology: Ethics and Aesthetics after Remix.* Cambridge, Massachusetts: MIT Press, 2016.

Haraway, Donna J. "A Manifesto for Cyborgs: Science, Technology, and Social Feminism in the 1980s." In *Feminism/Postmodernism*, edited by Linda J. Nicholson, 190–233. New York: Routledge, 1990.

Heidegger, Martin. "The Turning." *The Question of Technology and Other Essays*, translated by William Lovitt, 36–49. New York: Harper & Row, 1977.

Kien, Grant. "BDSM and Transgression 2.0: The Case of Kink.Com." In *Transgression 2.0: Media, Culture, and the Politics of a Digital Age*, edited by Ted Gournelos and David J. Gunkel, 118–33. New York: Bloomsbury, 2011.

Kuhn, Virginia. 'The Rhetoric of Remix'. *Transformative Works and Cultures* 9 (15 March 2012). https://doi.org/10.3983/twc.2012.0358.

Kuhn, Virginia, and Vicki Callahan. "Nomadic Archives: Remix and the Drift to Praxis." In *Digital Humanities Pedagogy: Practices, Principles and Politics*, edited by Brett D. Hirsch, 291–308. Open Book Publishers, 2012. https://doi.org/10.11647/OBP.0024.

Lessig, Lawrence. *Remix: Making Art and Commerce Thrive in the Hybrid Economy.* London: Penguin, 2008.

Mahony, Simon. "Cultural Diversity and the Digital Humanities." *Fudan Journal of the Humanities and Social Sciences* 11, no. 3 (September 2018): 371–88. https://doi.org/10.1007/s40647-018-0216-0.

McCutcheon, Mark A. "Frankenstein as a Figure of Globalization in Canada's Postcolonial Popular Culture." *Continuum*, 3 October 2011. https://www.tandfonline.com/doi/pdf/10.1080/10304312.2011.590577.

McNally, David. *Monsters of the Market: Zombies, Vampires and Global Capitalism*. 1st Edition. Chicaco, IL: Haymarket Books, 2012.

Milton, John. *Paradise Lost*, edited by Merritt Yerkes Hughes. 1819. Reprint, Indianapolis: Hackett, 2003.

Navas, Eduardo. "Remix: The Bond of Repetition and Representation." *Remix Theory*, 16 January 2009. http://remixtheory.net/?p=361.

Popik, Barry. "Knowledge Is Knowing That Frankenstein Is Not the Monster. Wisdom Is Knowing That Frankenstein Is." *The Big Apple*, 10 June 2018. https://www.barrypopik.com/index.php/new_york_city/entry/knowledge_is_knowing_that_frankenstein.

Risam, Roopika. "Decolonizing the Digital Humanities in Theory and Practice." In *The Routledge Companion to Media Studies and Digital Humanities*, edited by Jentery Sayers, 78–86. New York: Routledge, 2018.

Rockwell, Geoffrey, and Stéfan Sinclair. "Acculturation and the Digital Humanities Community." In *Digital Humanities Pedagogy: Practices, Principles and Politics*, edited by Brett D. Hirsch, 177–212. Cambridge: Open Book Publishers, 2012.

Schnapp, Jeffrey, Todd Presner, Peter Lunenfeld, and Johanna Drucker. "The Digital Humanities Manifesto 2.0." UCLA.edu, 29 May 2009. http://manifesto.humanities.ucla.edu/2009/05/29/the-digital-humanities-manifesto-20/.

Shelley, Mary. *Frankenstein; or, The Modern Prometheus*. 1831. Reprint, London: The Folio Society, 2015.

Sonvilla-Weiss, Stefan. "Introduction: Mashups, Remix Practices and the Recombination of Existing Digital Content." In *Mashup Cultures*, edited by Stefan Sonvilla-Weiss, 8–23. Wien: Springer, 2010.

Spivak, Gayatri Chakravorty. "Three Women's Texts and a Critique of Imperialism." *Critical Inquiry* 12, no. 1 (1985): 243–61.

Spooner, Catherine. *Contemporary Gothic*. London: Reaktion Books, 2006.

Trodd, Colin. "The Discipline of Pleasure; or, How Art History Looks at the Art Museum." *Museum and Society* 1, no. 1 (2003): 17–29.

Vallee, Mickey. "The Media Contingencies of Generation Mashup: A Žižekian Critique." *Popular Music and Society* 36, no. 1 (2013): 76–97.

8
SAMPLING NEW LITERACIES

Remix Studies and Digital Humanities in a Cross-Disciplinary Approach

Eduardo de Moura

Digital technologies change how we engage in research processes, profoundly affecting academic programs of the humanities. In that regard, digital humanities point toward new ways of working with representation and mediation, making it possible to approach culture in radically new ways.[1]

The purpose of this chapter is to reflect upon new methodological approaches to account for the complexity of the remix phenomenon. The argument presented here is part of my ongoing research carried out since 2019. It refers to methods and analysis procedures, grounded in both remix studies and digital humanities, designed to provide directions for constructing parameters to rethink and expand digital literacies.

In what follows, I will first explore epistemic changes afforded by the digital medium to present three theoretical premises within the areas of acting, producing, consuming, and distributing meanings. Based on the assumption that, in late modernity, we have established ourselves as Homo samplers and designers of space-time, I argue in favor of a cross-disciplinary method centered on concepts of selectivity and architectonics.[2]

Hence, in the last section, I will present the results of my recent research on Anime Music Video (AMV) to illustrate how to implement a multilayered methodology influenced by remix studies and digital humanities. By doing so, I claim that it is productive to adopt a multidimensional approach, which yields creative links between quantitative–qualitative dimensions into a more abstract computation mixed process.

Homo Sampler

Nestor García-Canclini and Juan Villoro[3] contextualize how literacy practices change with the development of Information and Communications Technology (ICT) through three different forms: Homo sapiens, Homo videns, and Homo sampler, each of which occurs in the areas of acting, producing, consuming, and distributing meanings. These meanings also correlate to different moments of media revolutions: print, electronic, and digital.[4]

As Garcia-Canclini and Villoro argue,[5] the Homo sapien develops from the writing and print *techne* and consolidates by the middle of the fifteenth century with the invention of movable type and the printing press, where the multiplication and circulation of written texts change the ways of producing, reproducing, and expressing knowledge, requiring more typological,[6] sequential, and hierarchical reasoning.

On the other hand, Homo videns would be the result of a transformational process in which written culture is affected by electronic technology and the culture of teletransmission (mainly by video and television), configuring itself in *videns* culture, which is dominated by a remote-controlled epistemology. In this process, in the face of productions that follow this logic, its aesthetics, and its ways of acting, we should likewise, as critical readers, consider a videopolitics, more precisely, assuming a political-teleplasma stance ("*Politica video-plasmada*" in the original, in Italian).[7]

However, Homo sampler, according to Eloy Porta,[8] would be the result of the process and consolidation of contemporary creative strategies, which eventually establish us to function as information DJs—architects of space and time. In sampler culture, we define ourselves above all as space-time architects, or chronotope designers, in Bakhtinian terms.

Mikhail Bakhtin's chronotope idea was drawn from physics and mathematical science; however, it is deeply grounded in his sociolinguistic concept of language. It expresses the inseparability of time and space in historical, social action. In Bakhtin's theory of dialogic discourse, chronotope refers to the spatio-time matrix that shapes text. More precisely, specific chronotopes correspond to particular genres, which represent specific worldviews.

To this extent, chronotope can be understood as both a cognitive concept and a narrative feature of the utterance, which operates via a principle of indexicality. This indexical *nexus*, as Jan Blommaert points out, creates what we call "style" in ways that shape recognizable meaning effects "created by history and society"[9]—an important aspect tied to chronotopic values, which I will discuss later in this chapter.

Hence, sampler epistemology deals with the meaning-making that emerges from ICT development and therefore intervenes in hegemonic space and time constructions, from printed and electronic media. In effect, Homo sampler can be distinguished through its development of new literacies, skills, and capacities aimed at the selection, interruption, and restructuring of rhythmic fluxes, creating and recreating new spatiotemporal correlations and values, which can be an object of interest to both digital humanities and remix studies.

In this context, we become agents capable of merging, decomposing, and manipulating chronotopic values; we can consider ourselves DJs, appropriating different predefined rhythms to change them. Concerning a sampler epistemology, creative forms of synchronisms, links, and connections are much valued, supported by designs structured by looping, repetitions, and recurrences of modes, themes, visual fragments, or phrases.

Following a similar logic, Garcia-Canclini and Villoro characterize the Homo sampler's creativity through practices of collection, (de)collection, and (re)collection: processes of hybridization and reconversion, strategies for using previous economic and symbolic resources in new contexts.

Garcia-Canclini sees the music video as critical to sampling culture. It offers "multiple cultural appropriations" and "numerous possibilities for original experimentation and communication,"[10] enabling the general public to access experimental/transgressive audiovisual languages through reconfigured fragments (excerpts, clippings, samples) and hybridized discourses (genres, styles, practices, and specific cultural objects).

The AMV *Safety Dance*[11] is an interesting example of these new literacies that circulate among fans of Japanese pop culture. The video was edited by Shin, a well-known AMV editor, who won the 2012 Viewer's Choice Awards (VCA) for "Best Dance Video" and "Best Video That Made You Want to Watch the Anime." VCA is a prestigious award, given by the AMV portal *animemusicvideos.org* to "acknowledge the videos that stand out above and beyond the rest of the video crowd."[12] According to Shin, this remix is not so original, but it has undoubtedly given him a strong reputation in the community. As he emphasizes, *Safety Dance* was very well appreciated by the online community.

AMVs like *Safety Dance* are an example of a sampler epistemology. They follow traditions related to otaku culture.[13] Furthermore, it results from the dialogue between Western pop culture and Japanese pop culture: a concrete representation of transnational cultural flows, in which the editor not only handles a semiotic and linguistic repertoire, hybridizing cultural references but also shows mastery of the audiovisual language required to produce a video remix.

To move further with the above-mentioned analysis in the following sections, I focus on the configuration of a cross-disciplinary method centered on the concepts of architectonics (Bakhtin and his Circle) and selectivity (Navas), proposing directions for constructing parameters in the field of digital humanities, to rethink and expand digital literacies in light of a sampler epistemology.

Architectonics of Selectivity

In Bakhtinian aesthetics studies, architectonics designates the process through which an author forges a kind of wholeness out of the relation of parts, or how entities relate to each other into a (possible) consummated whole.

For Bakhtin, the architectonics determines the external creative procedures, or the compositional form: the order, the disposition, the concatenation, and the consummation of the aesthetic object. In addressing this question in The Formal Method in Literary Scholarship, Pavel Medvedev argues that the artist, during his creative process, does not merely fit a given material onto the preexisting surface of his work: The surface helps him "to see, understand, and select his material."[14]

Medvedev exemplifies this orientation of the creative act by describing how an anecdote is created:

> The ability to find and grasp the unity of an anecdotal event of life presupposes a certain ability to construct and relate an anecdote, and to a certain extent, presupposes an orientation toward the means for the anecdotal development of the material.[15]

In this sense, the external artwork (the compositional form) is the realization of an aesthetic object conceived architectonically: The architectonics consummates aesthetic objects or defines the design of a given artwork, whereas the compositional form—the specific mode of structuring the external artwork—is modeled on the architectonics conception.

> So long as we simply see or hear something, we do not yet apprehend the artistic form; one must make what is seen or heard or pronounced an expression of

one's own active, axiological relationship, one must enter as a creator into what is seen, heard, or pronounced, and in so doing overcome the material, extra creatively determinate character of the form, its thingness.[16]

According to Alberto Faraco, Bakhtin and his Circle focus mainly on "the formal, constructivist conceptions of art."[17] For Faraco, Bakhtin's aesthetic studies would be "formal-aesthetic"—a conception exhaustively studied and problematized by Medvedev. The problem formulated by the formal-aesthetic that seeks the constructive character of an aesthetic activity would be acceptable to Bakhtin and his Circle. However, what was not acceptable to them was "the philosophical basis upon which these solutions are proposed."[18]

In formulating his thinking on aesthetic activity, and consequently, on the architectonics concept, Bakhtin and his Circle radically opposed traditions that believed the study of art should not be mixed with art history and its sociocultural implications. Thus, Bakhtinian aesthetics incorporated in their studies what would be considered external by this formal thought; the result is that society, history, and culture become essential elements to Bakhtin's analysis of aesthetic activity.

To understand the Bakhtinian solution for this problem, it is necessary to observe the constitutive formal-aesthetic function that gives shape to what Bakhtin and his Circle call the aesthetic object. So, we must focus on the pivot that sustains the "architectonic and compositional unity consummated aesthetically as a whole."[19] Bakhtin concentrates his aesthetics on what he conceives as the aesthetic object, something distinct from artifact, as Faraco explains,

> While the artifact is a thing, a factual entity, the aesthetic object, is not. However, it is not also a metaphysical essence. On the contrary, it is effectively a set of axiological relations (the aesthetic object is, therefore, a relational reality) that the artifact concretized. Alternatively, in other words, it is an architectonics, a content axiologically shaped by the author-creator in a particular composition embodied in a specific material.[20]

Therefore, Bakhtin's aesthetic stands out as the study of the axiological relations assumed by the author-creator, which shapes both the aesthetic object and its reception during the enunciative context. Moreover, the architectonics is the axiological–aesthetic pivot that would be the principal regent that determines the compositional form, the selection of the material, and the thematic content of the esthetic object informed.

As will be discussed later, the Bakhtinian concept of architectonics can illuminate the analysis of contemporary aesthetic practices that characterize new literacies, especially the analysis of sampling/remix and principle of selectivity.

Reframing Selectivity

Sampling plays a crucial role in any remix creation. According to Owen Gallagher, sampling is a fundamental stage of remix, which necessarily comprises the actions of appropriation, manipulation or editing, and resignification. In Gallagher's point of view, sampling is the first act of remix; it is the compilation of elements that should later be used in the creation of something new: "When any sample is inserted or pasted into a new composition, the process of creating a remix has begun."[21]

David Gunkel points out that sampling, in common sense, is understood as a representative part or a single item of a whole or group. However, in the context of music technology, the term takes on at least three different meanings:

1. A method used to fragment a continuous signal into a set of discrete (digital) data.
2. The act, or the result by which a small fragment of audio is "captured," processed, and "replayed" digitally.
3. A process to capture, store, and reconfigure a complete musical passage digitally.[22]

According to Gunkel, this causes at least three consequences that may define our present understanding of what can be considered sampling: 1) It links sampling intimately to the idea of technology recording, 2) It connects sampling to the practice of citation, and, finally, 3) It brings to any semiosis the action of copy and paste (sampling is not exclusive to audio).

For this reason, by emphasizing the process of extracting, storing data, and citation, sampling has been defined (and confused), with remix itself. Nevertheless, we must judge sampling as the act that precedes remix and consider remix as a postproduction stage that follows sampling. This leads to a moment in which the author-creator (editor) must decide which sample to use, where to put it, in which position, creating a juxtaposition of meanings, through numerous methods of union between samples (for example, mixing, fading, masking, transitions).[23]

Similarly, Marcelo Buzato et al. propose a multidimensional definition of remix, conceiving sampling as the necessary operational procedure that characterizes it:

> The first action involved [in many operational procedures that characterizes remix] is to copy and paste, or, in the jargon of musicians, to sample. That means, to sample a source object, which can become a pattern or motif to be glued several times in a later stage.[24]

When reflecting on how remix culture would have appropriated sampling practice, Navas argues that the *Regenerative Remix* discourse, among the other three predominant ones (Extended, Selective, and Reflexive), have allowed the passage of copy and paste operational procedure for other media—making possible what Lev Manovich defines as *deep remix*:

> Normally a remix is a combination of content from a single medium (like in music remixes), or from a few mediums (like Anime Music Video works which combine content from anime and music video). However, the software production environment allows designers to remix not only the content of different media types, but also their fundamental techniques, working methods, and ways of representation and expression.[25]

Moreover, Navas notes that remix and sampling can only occur through copy and paste—a necessary action in selective remix practice. In this sense, he proposes the necessity of including the notion of selectivity in remix studies, which can also provide a valuable link between different studies developed in the fields of Digital Humanities, New Media, and Applied Linguistics—notably, through the Bakhtinian concept of architectonics.

129

For Navas, both remix and sampling are only possible due to elements intrinsic to Selectivity. When we select something to be remixed, we assume three basic operational options: 1) Either modify the selected object, 2) Add something to it, or 3) Delete something from it. These elements can be combined, which makes remixing quite complicated. However, remix only comes into being because of a meta-level specific to sampling, which makes the meaning of the remix possible: "in order to appropriate something one must have the capacity to know that there is something of value to actually appropriate."[26]

In other words, sampling only occurs when something is defined axiologically as an object of interest through specific architectonics. When we consider the Selectivity element of an object, three epistemological principles participate actively and follow the appropriation act: implementation, contextualization, and legitimation.

Implementation: Being able to appropriate something, means that we must consider its implementation—which can occur in different formats and languages. One considers appropriating (sampling) a specific material before the many possibilities that envisage its incorporation in all types of compositional forms and semiotic systems: video clip, trailer, advertisement. In brief, during the appropriation act, one must take into account the passage from one value system to another.

Contextualization: Refers to how an author-creator must reframe the material to be appropriated (sampled), according to the intention of transmission, reinterpretation, and reframing (reconceptualization and reaccenting) of the speech/discourse of another. According to Navas, contextualization decisions play an important role in different cultural contexts and can define whether or not something is a remix, and the type of remix created.

Legitimation: The result of dialogue and "negotiations" established between the author-creator and the cultural context in which the object will circulate. As Navas states, legitimation has a vital place in remix practice. In a way, it defines the actions and values involved during the act of appropriation, and (re)framing, according to a particular *ethos* and social evaluation.[27]

Through this conception, remix's originality falls precisely on the processes of selectivity, mainly, through postproduction techniques. From this point of view, a remix is the second mix of something preexisting, only possible due to specific values that circulate in a given culture, in a specific historical time and before a social evaluation that appropriates and defines its implementation, contextualization, and legitimation.

In that sense, an object to be sampled and implemented in a new context (remixed) must be appropriated through a unique axiological atmosphere and social reality (social evaluation), which determine its outcome. So, the architectonics and the social evaluation determine the selectivity, the choices of content, their form, and the connection between them, also known as enformation,[28] which is defined as a fundamental category in Bakhtinian theory, meaning the connection between content and form, and process of constructing literary–artistically in meaningful wholes:

> Social evaluation actualizes the utterance both from the standpoint of its factual presence and the standpoint of its semantic meaning. It defines the choice of subject, word, form, and their individual combination within the bounds of the given utterance. It also defines the choice of content, the selection of form, and the connection between form and content.[29]

Therefore, a remix is always allegorical: The preoccupation with reading sustains it. The remix always relies on "the spectacular aura" of its original. The reader must recognize the source of the new version and the axiological relationship established with the original material. Otherwise, the remix can be understood as plagiarism.[30]

Thus, the object of contemplation and reading in a remix depends highly on the recognition (*replica*) of a preexisting text, its codes, and cultural values. Without recognizing its historical trait (the dialogic/ideological relationship with the object sampled), the remix may not be recognizable as such.

The relation established between the other's sampled speech and its recontextualization in a new axiological atmosphere is fundamental for its legitimation: Recognizing values and dialogues settled during the act of appropriation allows us to clearly distinguish terms and practices that are usually confused in a remix. For instance, this appropriation value (applied in a unique axiological atmosphere) and its epistemology can establish a better approximation toward different video remixing practices, and so to establish a productive distinction between remix genres within different spheres of human action, like those created by otaku culture, as we will see below.

In the following section, I illustrate how the new forms of appropriating, (re)framing, and sharing meaning in the contemporary world can be explored and described through a cross-disciplinary approach, implemented in both remix studies and digital humanities.

A Cross-disciplinary Approach

During the development of research for my dissertation, it was proposed to work for six months—from September 2017, until February 2018—under the supervision of professor Eduardo Navas, Ph.D., as a Visiting Scholar supported by the School of Visual Arts (SoVA) and The Arts & Design Research Incubator (ADRI), to improve, exchange, and deepen the understandings and knowledge on media visualization techniques and remix studies.

During this stage, I adopted the methodological model proposed by Navas to reveal relationships and patterns existing in the AMV's audiovisual dataset. The research produced can be understood under the perspectives of remix studies and digital humanities. Fundamentally, it is grounded in a cross-methodology approach that, by itself, has a syncretic character based on various disciplinary and methodological sources: 1) Humanities or social sciences, 2) Language sciences, and by the recent development of mathematics and computer science, and by the inclusion of a third axis, 3) Computer-assisted analysis.

Aiming toward the evaluation of creativity in times of social media, my collaboration with professor Navas remains productive. In that regard, I have been adopting a practical, interpretative attitude, assuming the quantitative and qualitative paradigms as parts of a more complex process and not as exclusionary poles, exploring a path guided by digital humanities principles of looking to the digital in light of its medium specificity, an approach relevant across software studies, critical code, and remix studies.

Thus, I propose to integrate a quantitative and qualitative methodology based on the statistical distributions of formal and stylistic choices and to prepare the *corpus* for description and analysis, using visualization techniques adopted in media analytics, which allow us to create different images and graphs, to reveal relationships and existing standards in our audiovisual dataset (Figure 8.1).

Action

Humor

Drama

Figure 8.1 Visual rhythm: *AMV's genre. Color code: Dark grey = scene cuts*

For instance, knowing how to read/use the frame scale variation (close-up, medium shot, and long shot)[31] is a significant element in AMV creativity. It enables editor-creators to establish different dialogues between the sampled content and the original material (Figure 8.2).

Figure 8.2 Frame scale variation: Visualization composed of the dataset obtained through ML model and from the density correlation between episodes 2, 8, and 11, according to the use of frame scale variation

As seen in Figure 8.2, there is a framing reconfiguration in the passage from the anime sampled into the AMV. One could say that Japanese animation has a distribution centered on medium shots. Furthermore, there is a tendency to apply close-ups at the beginning, medium shots in the middle, and long shots at the end of the animation.

One could infer that this use is, in some way, representative of the typical anime narrative approach. Furthermore, Japanese animation structures itself around the main character's inner conflict (experienced and portrayed in close-up scenes), which the hero must overcome, learning and coexisting with other characters (medium shots), a conflict that usually culminates in battle (long shots).

In other words, the AMV montage would be the result of a dialogue-based plot materialized through the frequent use of *medium shots* already seen in the sampled material.

However, what is essential in the AMV montage design is the distancing/proximity illusion created: a *chronotope value* and not so much the narrative logic (*raccord*).[32] This creative act is meaningful to the evaluative judgment established by the editor-creator before the material sampled by him. Hence, even if there is a tendency to emulate the aesthetics and anime's planification, it is not possible to infer that the AMV selectivity and enformation represent and follow the same logic found in the original material.

For instance, in the dataset analyzed (Figure 8.2), the AMV's frames follow the logic of the episodes sampled. However, if we consider the different AMV genres (drama, action, and comedy), the frame distribution between them provides us with a different understanding (Figure 8.3).

Thus, the editor-creator seeks to articulate the frames selected to inform their perspective/reading, searching for a connection point that can establish distinct links between the content sampled, assuming an architectural perspective.[33] Furthermore, it seems that editor-creators appropriate music video aesthetics in favor of a correspondence montage logic, which focuses on both the formal structure of the song—intro, verse, chorus, verse, bridge—and the visual, conceptual relationship with the song lyric (Figure 8.4).

Consequently, the rhythm created by the succession of frames, linked with the music structure, promotes a montage logic that emphasizes creative audiovisual sensations (correspondence montage), resulting in the anime community's so-called aesthetics of synchronization.[34]

Figure 8.3 Frame scale variation: AMV's *genre*

According to Kalium, a well-known AMV editor, synchronization (or sync) is the most important element of an AMV: It interconnects audio and video sampling in a comprehensive aesthetic whole.[35] Kalium states that if an inadequate sync is established, creating no connection between visual and sound elements, we cannot have an AMV. Sync can be subdivided into rhythmic (beat or musical sync) and lyrical (literal or lip-sync): Rhythmic (beat or musical sync), through this practice, different visual elements (cuts, effects, and/or events in a video) are timed to match the audio; lyrical (literal or lip-sync) is the practice and act through it the editor interconnects "what is being said" in a song and what is being shown in the video.[36]

For an AMV editor, it is critical to know how to create a *visual feel*, to establish a connection between the viewer and a character, to promote a specific anime, and to attract more participants to the otaku community. In this architectural context, the editor evaluates the content and cinematographic stylistic choices to sample scenes for his project.

Furthermore, Buzato et al.[37] argue that remix creativity usually corresponds to the juxtaposition or encoding of sampled segments following two practices: intercalation (horizontal montage) and composition (vertical montage).

For instance, a horizontal montage demands that the remix editor searches for connecting points or hooks between sampled fragments, either from linear logic (as is more common) or from any other temporal reasoning that the reader could follow. These connecting points can be formal, mixing the samples plastically—in the AMV case, the editor probably would seek the same rhythmic beat.

Although rhythmic synchrony sometimes can be "easily" performed, it can also be tricky. Kalium states that the songs can vary a lot in terms of "style, beat, volume, and tone." Thus, it should be with AMV. Therefore, the editor must always start with a choice that is not very simple to make. He must choose which sound element is the most important to

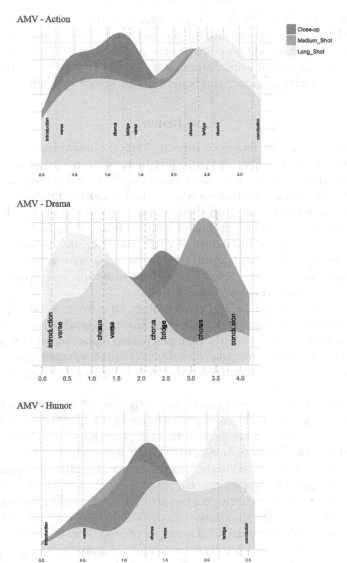

Figure 8.4 Frame scale variation: *Song structure*

synchronize with the visual aspects of his project. Only within this choice, an AMV editor defines "what" and with how much "strength" and "frequency" it must be shown.

Thus, rhythm *syncs* may unfold in two directions: first, structuring, along with thematic content and style choices, the compositional form, and second, reinforcing an axiological statement (theme, as in Bakhtin/Volochinov).[38]

So, rhythm is at the same time an architectonic form (from its axiological and social structure point of view) and a compositional form (from its technical and mechanical aspects). As a compositional form, rhythm is achieved by ordering materials, both acoustically and visually. Nevertheless, it is also an architectonic form when stylistically linked to a chronotope value by inner striving tension.

In our context, rhythm can be directly associated with the conception and perception of different AMV categories—action, drama, and comedy—but also linked with the AMV's content, or with an editor's point of view and their evaluation from the original material selected to form their work. Further, it is essential for it to be computed, layered, and visualized in the mixing of space-time scales, aiming toward its heterochronous nature.

Conclusion

As David Berry and Anders Fagerjord suggest, "digital humanities is now very much identified with a certain digital 'way' of doing humanities research, which has been described as a computational turn in the humanities." [39] Following the path of this computational turn, digital humanists deepen its critical understanding of computer technology and should continue to magnify their interest in history, aesthetics, language, and culture, in a philosophical understanding of human life and thought. [40]

In that sense, to recognize the nature of rhythmic sync, such as we saw in AMV's practice, requires from digital humanities researchers the same ability to process and translate the new literacies and capacities to select, interrupt, and restructure chronotopic values visually in various synchronized fluxes.

In other words, it requires a sampler epistemology. In essence, a sort of phenomenology that may enable us to conceptualize how space, time, and movement are used as semiotic resources in digital media (for example, pacing, duration, synchronization, and felt space-time). Moreover, it may also reveal possibilities for humanities researchers to explore (quantitatively and qualitatively) how we (re)code multiple experiences of time and space in meaningful ways.

Consequently, I argue in favor of classifying remix through a gradient notion: a multilayered methodology, in which remix practice is established in a critical and multidimensional way that takes into account operational procedures (sampling) and creative processes (horizontal and vertical montage). Thus, it is essential to adopt a more practical interpretative attitude, assuming the quantitative and qualitative paradigms not as exclusionary poles but as a complex process.

Considering this view, the quantitative moment (characterized by statistical and visualization techniques) and the qualitative moment (characterized by exploratory and interpretive procedures) can be unfolded into a set of procedures of observation, description, and analysis that lead to a better understanding of remix/sampling objects.

Therefore, I believe it is productive to adopt a multidimensional perspective proposed by Bakhtinian aesthetics, [41] centered on the articulation of: 1) The aesthetic object, 2) The extra-aesthetic material givenness of a work, and 3) The teleological understood composition of a given material. [42] This methodological approach yields creative links between remix studies and digital humanities' critical layered notion of quantitative–qualitative dimensions into a more abstract computation remixed process.

Notes

1 David Berry, "The Computational Turn: Thinking about the Digital Humanities" (2011), http://sro.sussex.ac.uk/id/eprint/49813.

2 My uses of terms "selectivity" and "architectonics" are influenced by the works of Eduardo Navas and Mikhail Bakhtin, respectively. I refer to both works throughout this essay. To see more about "selectivity," read Eduardo Navas, "The Elements of Selectivity: After-thoughts on Originality and Remix" (2017), https://remixtheory.net/wp-content/uploads/2017/12/Elements__Selectivity.pdf. To more details about

"architectonics," see Mikhail M. Bakhtin, "Art and Answerability: Early Philosophical Essay by Mikhail M. Bakhtin" (Texas: University of Texas Press. 1990[1919–24]); and Pavel Medvedev/Mikhail Bakhtin, "The formal method in literary scholarship," (London: Johns Hopkins University Press, 1991[1928]).

3 Nestor García-Canclini and Juan Villoro, *La creatividad redistribuida* (Mexico: Siglo XXI Editores, 2013).

4 Roxane Rojo and Eduardo Moura, *Letramentos, mídias, linguagens* (São Paulo: Parábola Editorial, 2019).

5 Nestor García-Canclini and Juan Villoro, *La creatividad redistribuida*, 2013.

6 Typological meaning refers to the processes of reducing to a categorical difference a continuous variation, mostly by interpreting a form as an instance of a sign (Lemeke, 1998, 2).

7 Giovanni Sartori, *Homo videns: Televisao e Pos-Pensamento* (São Paulo: EDUSC, 2001), 49.

8 Eloy Porta, *Homo sampler: tiempo y consumo en la era afterpop* (Barcelona: Editorial Anagrama, 2008).

9 Jan Blommaert, "Are chronotopes helpful?" *Working Papers in Urban Language & Literacies* (2018), https://www.academia.edu/36905272/WP243_Blommaert_2018._Are_chronotopes_helpful.

10 Nestor García-Canclini, *Culturas híbridas: Estratégias para entrar e sair da modernidade* (São Paulo: EDUSP, 2015), 35.

11 Available in https://bit.ly/2ZuQv02. Accessed October 15, 2019.

12 Available in https://bit.ly/2t6gHC9. Accessed October 16, 2019.

13 "Otaku" means, in Japanese, a social outcast fanatic. However, it also has been used to refer to fans of manga, anime, and other Japanese media, without the negative connotations. The otaku culture sees the ability to access, translate, transmit, and produce original remixes as valuable and as a statement of engagement within their community. Remix productions done by overseas fans to publicize Japanese animation in the Western world constitute one of the fundamental characteristics of otaku culture and anime fandom.

14 Pavel Medvedev/Mikhail Bakhtin, *O método formal nos estudos literários: Introdução crítica a uma poética sociológica* (São Paulo: Editora Contexto, 2012 [1928]), 134.

15 Medvedev/Bakhtin, *O método formal nos estudos literários*, 134.

16 Mikhail Bakhtin, *Questões de literatura e de estética: A teoria do romance.* (São Paulo: Hucitec, 2010[1934–35]), 58–9.

17 Carlos Alberto Faraco, *Aspectos do pensamento estético de Bakhtin e seus pares.* (Porto Alegre: Letras de Hoje, 2011), 22.

18 Medvedev/Bakhtin, *O método formal nos estudos literários*, 53.

19 Faraco, *Aspectos do pensamento estético de Bakhtin e seus pares*, 22.

20 Faraco, *Aspectos do pensamento estético de Bakhtin e seus pares*, 23.

21 Owen Gallagher, "Sampling". In *Keywords in Remix Studies*, eds. by Eduardo Navas *et al.* 259–72 (New York: Routledge, 2018), 261.

22 David J. Gunkel, *Of Remixology: Ethics and Aesthetics after Remix.* (Cambridge, Massachusetts: MIT Press, 2016), 7–8.

23 Gallagher, "Sampling," 261.

24 Marcelo Buzato *et al*, "Remix, mashup, paródia e companhia: por uma taxonomia multidimensional da transtextualidade na cultura digital," *Revista Brasileira de Linguística Aplicada*, (2013): vol. 13, 1198, https://doi.org/10.1590/S1984-63982013000400011.

25 Lev Manovich, *Software Takes Command: Extending the Language of New Media* (New York, NY: Bloomsbury Publishing, 2013), 46.

26 Eduardo Navas, *The Elements of Selectivity: After-thoughts on Originality and Remix* (2017): 3, https://remixtheory.net/wp-content/uploads/2017/12/Elements_Selectivity.pdf.

27 Navas, *The Elements of Selectivity*, (2017): 5.

28 "Enformation/Enformação" is how in Brasilian/Portuguese Bakhtinian studies recent tradition we translate *oformlenie* (in Russian), usually mistakenly understood as "formalization." Enformation" is a fundamental category in Bakhtin theory, meaning the connection between content and form, and process of constructing literary–artistically in meaningful wholes.

29 Medvedev/Bakhtin, *O método formal nos estudos literários*, 121.

30 Navas, *The Elements of Selectivity*, (2017): 6–7.

31 Available in http://goo.gl/YthDg5, accessed January 12, 2016.

32 *Raccord* is an editing practice that seeks, as much as possible, to "erase" plan's passage in a scene, aiming the viewer to forget that he is facing a movie, thus focus on the narrative.

33 To see in more detail how it was done, read the essay *Anime Music Video (AMV): Data-visualization methods for video remixes*, available in https://bit.ly/37s3Edl.

34 The *synchronization* is crucial within the AMV community: Through an editing that produces proper sync between *music*, *lyric*, and *mood* of original material, editors can materialize different categories of AMVs (horror, drama, humor, and action).

35 Kalium, *An AMV Theory Primer*, (2006), http://www.animemusicvideos.org/guides/kalium/.

36 Kalium, *An AMV Theory Primer*, (2006).

37 Marcelo Buzato *et al*, *Remix, mashup, paródia e companhia*, 1199–1200.

38 Mikhail Bakhtin and Valentin Volochinov, *Marxismo e Filosofia da Linguagem* (São Paulo: Hucitec, 2009 [1929]).

39 David Berry and Anders Fagerjord, *Digital Humanities: Knowledge and Critique in a Digital Age* (Cambridge: Polity Press, 2017), 3.

40 Berry and Fagerjord, *Digital Humanities: Knowledge and Critique in a Digital Age*, 7–9.

41 Faraco (2011) highlights the importance of Bakhtin's thoughts for the research on new aesthetic activity. By Faraco's point of view, although Bakhtin and his Circle were passionately devoted to the aesthetic studies and generated "ingenious, innovative and surprising theoretical-philosophical formulations on aesthetic activity," it is at the same time "astounding that Bakhtinian aesthetics has had so little repercussion so far" (Faraco, 2011: 21).

42 Bakhtin, *Questões de literatura e de estética*, 23.

Bibliography

Bakhtin, Mikhail M. *Art and Answerability: Early Philosophical Essay* by M. M. Bakhtin. Texas: University of Texas Press. 1990.

Bakhtin, Mikhail M. *Questões de literatura e de estética: A teoria do romance*. São Paulo: Hucitec, 2010.

Bakhtin, Mikhail M. *The Dialogic Imagination*. Texas: University of Texas Press, 1981.

Bakhtin, Mikhail M. *Speech Genres and Other Late Essays*. Texas: University of Texas Press, 2010.

Bakhtin, Mikhail M./Volochinov, Valentin N.. *Marxismo e Filosofia da Linguagem*. São Paulo: Hucitec, 2009.

Bakhtin, Mikhail M./Volochinov, Valentin N.. *Marxism and the Philosophy of Language*. New York and London: Seminar Press, 1973.

Berry, David. "The computational turn: thinking about the digital humanities". *Culture Machine* 12 (2011). http://sro.sussex.ac.uk/id/eprint/49813, accessed January 25, 2020.

Berry, David, and Anders Fagerjord. *Digital Humanities: Knowledge and Critique in a Digital Age*. Cambridge: Polity Press, 2017.

Blommaert, Jan. "Are chronotopes helpful?". *Working Papers in Urban Language & Literacies*, Paper 243, 2018 https://www.academia.edu/36905272/WP243_Blommaert_2018._Are_chronotopes_helpful, accessed January 25, 2020.

Buzato, Marcelo El Khouri, Dáfnie Paulino da Silva, Débora Secolim Coser, Nayara Natalia de Barros, and Rafael Salmazi Sachs. "Remix, mashup, paródia e companhia: por uma taxonomia multidimensional da transtextualidade na cultura digital". *Revista Brasileira de Linguística Aplicada*, 13, no. 4 (2013): 1191–1221. https://doi.org/10.1590/S1984-63982013000400011, accessed January 30, 2020.

Duchasterl, Jules, and Danielle Laberge. "Au delà de l'opposition quantitatif/qualitatif. *Convergence des opérations de la recherche en analyse du discours*".*Corela*, [s. l.], n. HS-15, 2014: accessed January 30, 2020 https://doi.org/10.4000/corela.3524.

Faraco, C. Alberto. *Aspectos do pensamento estético de Bakhtin e seus pares*, 21–6. Porto Alegre: Letras de Hoje, 2011.

Gallagher, Owen. "Sampling". In *Keywords in Remix Studies* edited by Eduardo Navas *et al*. 259–72. Nova Iorque: Routledge, 2018.

García-Canclini, Nestor. *Culturas híbridas: estratégias para entrar e sair da modernidade*. São Paulo: EDUSP, 2015.

García-Canclini, Nestor, and Juan Villoro. (Cord.). *La creatividad redistribuida*. Mexico: Siglo XXI Editores, 2013.

Gunkel, David J. *Of Remixology: Ethics and Aesthetics after Remix*. Cambridge, MA: MIT Press, 2016.

Kalium. *An AMV Theory Primer*. (2006): accessed January 25, 2020, http://www.animemusicvideos.org/guides/kalium/.

Lemke, Jay L. "Typological and Topological Meaning in Diagnostic Discourse," accessed January 25, 2020. *Discourse Processes*, (1999): 173–85. https://www.tandfonline.com/doi/abs/10.1080/01638539909545057.

Manovich, Lev. *Software Takes Command: Extending the Language of New Media.* New York: Bloomsbury Publishing, 2013.

Medvedev, Pavel N., Mikhail M. Bakhtin. *O método formal nos estudos literários: introdução crítica a uma poética sociológica.* Tradução Sheila Camargo Grillo Ekaterina Vólkova Américo. São Paulo: Editora Contexto, 2012[1928].

Medvedev, Pavel N., Mikhail M. Bakhtin. *The Formal Method in Literary Scholarship.* London: Johns Hopkins University Press, 1991[1928].

Navas, Eduardo. *The Elements of Selectivity: After-thoughts on Originality and Remix:* 2017, accessed January 25, 2020, https://remixtheory.net/wp-content/uploads/2017/12/Elements__Selectivity.pdf.

Porta, Eloy. *Homo sampler: tiempo y consumo en la era afterpop.* Barcelona: Editorial Anagrama, 2008.

Rojo, Roxane, and Eduardo Moura. *Letramentos, mídias, linguagens.* São Paulo: Parábola Editorial, 2019.

Sartori, Giovanni. *Homo videns: televisão e Pos-Pensamento.* São Paulo: EDUSC, 2001.

9

RS (REMIX STUDIES) + DH (DIGITAL HUMANITIES)

Critical Reflections on Chance and Strategy for Empathy

Eduardo Navas

This chapter is a reflection on how measurement of cultural data as practiced in the Digital Humanities (DH), and appropriation and recyclability of cultural material, as practiced in remixing and analyzed in Remix Studies (RS), can be valuable in countering cultural reluctance to acknowledge facts that go against people's beliefs. Resisting the acknowledgement of facts appears to be happening in contemporary times regardless of accurate data access with tools used to analyze and verify the validity of information. One of the reasons for this, arguably, is that as we gain better understanding of creative cultural production, we find ourselves increasingly divided based on ideology. Empathy appears also to play a pivotal role in this cultural conundrum. Scientific studies that appear relevant across the world demonstrate that empathy, the ability to place oneself in the position of another, has diminished since the 1970s.[1] Jamil Zaki explains that in "one study, the average American college student in 2009 scored as less empathic than seventy-five percent of students in 1979. This suggests our care is eroding, but you might not need a study to tell you that."[2] In the same time period, there has been technological innovation for accurate measurement of cultural and social interaction. Consequently, there appears to be a paradox at play in these simultaneous occurrences: Why does access to accurate information not lead to fair decisions but rather push toward misinformation often for the sake of supporting a comfortable point of view? Perhaps the most obvious examples in recent times of this recurrence are "fake news," and conspiracy theories promoted by Alt-Right groups across the United States and the world at large. What this means is that knowing a fact does not lead to the conclusion that such knowledge will change a person's belief or behavior. In effect, our time has been dubbed the "post-truth" era.[3]

People in denial find ways to distort facts to support their world view. On January 22, 2017, during the NBC news show *Meet the Press*, Kellyanne Conway coined the term

"alternative facts" apparently on the fly during an interview with Chuck Todd who questioned the credibility of the White House when Press Secretary, Sean Spicer, claimed that The National Mall in Washington, D.C. was completely filled with people; albeit photographs clearly demonstrated that this was not the case. Conway responded to his pervasive questioning, "Don't be so overly dramatic Chuck, what you're saying is a falsehood and they're giving… Sean Spicer, our Press Secretary, gave alternative facts … to that …." Chuck Todd quickly responded, "… look, alternative facts are not facts…they're falsehoods."[4] Conway calmly responded again with a list of "whataboutisms" on decisions made by the Obama administration, in effect evading the validity of her claim of "alternative facts" being *actual facts*. The strategy of this pivoting (which is a common skill in political interviews) on her part is to imply for the sympathetic viewer to consider her claim of "alternative facts" to be legitimate and valid, because she is equating such a nebulous term with actual provable facts of poverty and education that, at the time, were not considered a problem of the Trump administration.

Conway's gesture is deeply unethical, because she is deliberately distorting verifiable information for political gain. When reading her body language during the interview, one can sense her struggle not to lose face.[5] The reality is that she is not willing to acknowledge a fact on television because of the political consequences that would follow. What she demonstrates with her strategic answers is how information that can be verified in our age of extreme data accuracy can still be distorted to appear to be "true" not based on what the facts prove, but how they are deliberately mispresented to appear to be true. Perhaps the greatest irony of the Trump administration is that they project their misdeeds on anyone they see as their enemies.

In this toxic environment, remix methods combined with analytics are being weaponized to create not just alternative facts but also alternative realities. Consequently, this chapter focuses on arguments, that while relevant to RS and DH, clearly move into other areas, particularly of the social sciences. This is necessary in order to come to terms with possibilities to be objective when passing judgment on circumstances individuals encounter in an increasingly data-saturated world. Given that access to accurate information is not the automatic answer for objectivity, but our awareness of its interpretation, I end with the description of a work of art that brings together performance art and game theory in *Switch Chess*, a game based on chance I developed and have preliminarily tested as a work of art that can help players project themselves into the position of their opponent, not for the sake of winning the game, but with the goal to understand why another person may make certain decisions based on unique circumstances. After discussing the different performances of the work, I reflect on how the premises that emerge from it are relevant to RS and DH in direct relation to empathy and the limitations of human anxieties.

Limitations of Measuring Among Disciplines

The ability to measure just about everything around us has been used to push people to become more polarized and find ways to justify their world view. This may be surprising given that an assumption could be made based on a general concept of objectivity that if something is shown to be a fact, one should accept it as such after verification and adjust one's actions to live up to what the facts demonstrate. But as studies show, this is not the case when it comes to personal beliefs. Research shows that polarization among

people with different political views and social beliefs has increased over the last few decades.[6] This trend becomes more noticeable as technology is incessantly optimized to produce concrete data and measure trends that prove that people are not willing to accept facts if what they learn demolishes their beliefs. This is the case for people of all levels of education, not just working-class individuals, as the popular stereotype tends to present it, but also people with a college degree.[7] This trend correlates with the decline of empathy during the same time period, which implies that the trends may be connected.

People appear to respond to messages that appeal to their sentiments over messages that are accurate and factual. If straightforward information delivery does not engage the sentiments of a person, then what options does society have to encourage individuals to engage with different views? This is actually the strength of art. Art consists of paradoxes that push people to question their world view through sensory experience. As Picasso observed,

> We all know that Art is not truth. Art is a lie that makes us realize truth, at least the truth that is given us to understand. The artist must know the manner whereby to convince others of the truthfulness of his lies. If he only shows in his work that he has searched, and re-searched, for the way to put over lies, he would never accomplish anything.[8]

Looking past Picasso's assumption of artists always being men, we can evaluate this statement as a strong argument for the importance of interpretation of facts today, especially because people currently have access to information with greater ease. Variety of information, however, is not always available to everyone, due to the pervasiveness of social media echo chambers. People need to develop critical approaches and methods to access specific information for the purpose of gaining knowledge.

Picasso's quote is of great importance in this case because it makes evident that what all humans do, not just artists, is interpret information. Facts ultimately are interpreted and told as a story for others to understand. This was a major issue of contention with the exponential growth of data throughout the twentieth century, and it is even a larger issue in the twenty-first. In current culture wars, whether or not something is true is not necessarily disputed in terms of cultural adoption of a fact, but how the truthfulness of a fact relates to the current reality. In other words, for there to be change based on fact, a story needs to be created that compels humans to relate to a subject. This has been a key point for funding and legitimation of research in the sciences since the 1800s, becoming more than evident during the postindustrial period closely linked with information growth dependent on computing, as Jean François Lyotard noted,

> Today, the problem of legitimation is no longer considered a failing of the language game of science. It would be more accurate to say that it has itself been legitimated as a problem, that is a heuristic driving force. [...] It is remarkable that for a long time it [science] could not help resorting for its solutions to procedures that, overtly or not, belong to narrative knowledge.[9]

Lyotard relies on Wittgenstein's method of language games to explain that facts in relation to truth and knowledge are dependent on storytelling to be legitimated by culture at large:

A crude proof of this: what do scientists do when they appear on television or are interviewed in the newspapers after making a "discovery"? They recount an epic of knowledge that is in fact wholly unepic. They play by the rules of the narrative game; its influence remains considerable not only on the users of the media, but also on the scientist's sentiments. This fact is neither trivial nor accessory: it concerns the relationship of scientific knowledge to "popular" knowledge, or what is left of it.[10]

Lyotard's research post-1968 became known for being dismissive of "grand narratives"[11] and remains relevant, in this case, because he identified the necessity to make facts relatable as a story. He effectively points to the necessity to explain why a fact might be worth taking into consideration based on specific cultural contexts a particular society can understand. This does not mean that a fact needs to be distorted in order to be accepted by society. However, this does happen, at which point we get "alternative facts" enacted by someone like Conway who in turn accuses others of creating falsehoods, based on the very falsehoods she and her political cronies incessantly create.

There are two major global events taking place at the time of this writing that are constantly being reshaped in public debates: The COVID-19 Pandemic and climate change. Both can be measured and proven scientifically, but how they are presented as a narrative to people is an interpretation by groups with specific political views. There is a third global event that began in the United States with the death of George Floyd on May 25, 2020, which is the call for social justice for black people and the people of color. Social injustice is more difficult to prove because it functions at a meta-level of interpretation prone for distortion by those who disagree with the reality data and facts presents. No matter which position one may take, interpretation will be spun to encourage specific forms of affect, with a strategic appeal to sentiments (not rationality) that will resonate with specific communities. This means that facts will be understood based on the context of a particular culture—a set of shared codes. The issue, as Lyotard explains in his quote above, is how to present content that may go against certain beliefs of a community so that people remain open to the facts presented. Such a challenge remains, which is why it is worth noting that art production at its foundation has always implemented methods that can help us practice self-criticism; such artistic approaches are important to narrative knowledge at this moment more than ever before due to the growing division we face with deliberate manipulation of data by interest groups with binary opposition leaving little room for civil dialog.

Art is a subjective practice that provides individuals who engage with a creative work the opportunity to question what they experience. Often times, the questioning is really the viewer's own projections onto the work. The ability to project oneself onto an object during the 1890s was discussed in terms of aesthetics and was eventually framed as the ability to empathize.[12] Empathy became a major focus of study in psychology particularly after World War II because during the 1960s and 70s social scientists and psychologists became concerned about another World War and began to push the term in the public sphere.[13]

Susan Lanzoni in her historical account of empathy explains that the term was first discussed in the psychological analysis of aesthetics. Empathy derives from the German term Einfühlung, meaning "in-feeling."[14] It was introduced in the English language around 1908 as Lazoni explains to capture "… the aesthetic activity of transferring one's own feeling into the forms and shapes of objects."[15] Eventually, such ability was discussed

to be applicable not only to art but also to all things in the world, especially other people. Empathy for artists consists of including cultural codes that encourage a type of abstract affection from the viewer: the ability to tap into someone else's feelings; to move someone emotionally.[16] Such a calling encourages people to project themselves onto the art object: to see themselves in the work. How well an artist is able to encourage empathy from the viewer is always the creative challenge. This is the "lie that makes us realize truth" that Picasso explains. What this means is that facts and truths will not matter to people if they cannot relate to them on some personal level. We could argue that they should care and possibly change their minds because it is important to know the truth. But the dire reality of the COVID-19 Pandemic, climate change, and protests against racial injustice are proof that people are more likely to accept facts presented to appeal to their already preconceived views of the world. In this regard, President Trump has exposed the limits of empathy in his populist rhetoric. He consistently turns factual data into a political narrative that will benefit his political hopes for reelection. He is willing to distort facts by appealing (through tribal or in-group empathy) to his base, disregarding the reality that facts make evident when verifying data. In the case of the Pandemic, he has made matters worse by downplaying the growing number of infections and deaths in the United States. He deliberately focuses on issues that will resonate with his core supporters, not based on facts, but on pure sentiment: empathy. It must be made clear that empathy, just like remix, can be used for diverse agendas, and it does not necessarily align with a progressive or good-hearted message to communicate feelings toward a better future for humanity or the world.

The issue with measuring the world, then, is not so much about interpretation, but about developing a critical awareness of how people practice interpretation of information, and how to cross-reference with a diverging number of interpretations for fairness. How do people move past bias, especially now that individuals have the ability to endlessly remix and simultaneously track how each person does this with data analytic tools implemented in the field of digital humanities? Can such a possibility exist if individuals are constantly functioning in a highly biased world? A major challenge against moving past such questions is an implicit search for absolutes: of concrete results that can be considered to point to a single source for causes and effects. This is binary thinking at its core, which supports the misleading concept of originality as a pure source of legitimation for both culture and nature. There is a need to examine in more detail such an approach, which forms part of the foundation of bigotry, ethnocentrism, homophobia, misogyny, racism, and xenophobia.

The Search for Originality and Objectivity

The human drive to find the source of an occurrence in order to understand how something develops or takes shape is informed by an assumption that there is an origin. Perhaps, the most popular scientific question on this is the origin of the universe: The big bang; arguably, the most popular and accessible book on this subject is Stephen Hawking's A Brief History of Time.[17] The question of the origin of everything in the universe is informed by the concept of a single unit: a monad from which all else evolves. We know this to be the case in science in terms of natural objects in the world built with atoms. There is constant debate about atoms and how the universe is built with four fundamental particles that by combining and working together make possible all things we find in nature and the universe.[18] In this sense remixing is at the core of our natural

world, formed through constant recombination of basic particles: Scientific research explains that things we find in nature are constructed with the same basic units. This was not evident prior to the scientific age due to our limited ability to measure the material world without tools that enhance human perception.

Remix studies (RS) and digital humanities (DH) emerged during our advanced stage of technological innovation: When measuring holds a privileged position in the world, as a means to analyze how things function. Shared interests come together in the analysis of image, sound, and text with data-mining tools that offer unprecedented precision.[19] RS and DH are interdisciplinary fields that can bridge science and culture: Two areas that in the age of enlightenment became separated. This paradox was developed by science to legitimate itself as an objective discipline, different from storytelling, yet, as previously noted, science has always relied on narrative knowledge not only to legitimate itself in the public sphere but also to acquire necessary funding for ongoing research.[20]

Grant writing, when stripped to its basics, is a form of storytelling using specialized language that experts in particular fields will understand. Interdisciplinary grant writing encourages specific but nonspecialized language, so that researchers who crossover from one field to another can understand the core premise and relevance across disciplines of a grant application. RS and DH function at the crux of interdisciplinary studies along these lines. For this reason, it is worth examining their relation in terms of narrative knowledge in the arts, humanities, and sciences; this will make clear how and why they are useful as critical vectors in the interpretation of facts with the goal of moving past the current impasse on the denial of truth, and strong preferences to support preexisting bias.

DH shares some similarities with new media because both are contingent with the creative possibilities of advancements in computing. There is a clear difference between both fields, however, which in large part is defined by the period of time in which they emerged. New media is specifically identified with production by artists, designers, and cultural media producers invested in new technologies. While artists during the mid-twentieth century yielded creative investigations in the cross-disciplinary arena of art and technology, new media became popular as an artistic and academic field during the early 1990s—a time which also saw the introduction of creative computing applications such as Adobe's Photoshop and Illustrator.[21] Humanists participated in new media, but DH, as a proper field, emerged later, after much of the language explored creatively with art and design software evolved into a supporting branch to visualize big data.[22] If we need to make a clear separation between new media practice in the arts, and DH in the broader field of the humanities, the former focused on production with computing as a medium in its own right, as well as a technology implemented to develop exhibitions and public presentations, and media content,[23] while the latter focused on the analysis of such production with big data tools. In this sense, DH evolved as a meta-stage, meaning that it emerged as a proper field after the normalization of what was once called new media, now often referred to as digital media, or just media.[24]

RS emerged in the 2010s after remix which, as a creative practice throughout the mid-to late 1990s, became a subject of interest not just in the arts but also across other areas of production.[25] RS examines ways people recycle preexisting material using digital tools with increasing possibilities to create something unique with some type of autonomy. This was not so obvious in the past, but with the rise of data-mining tools, primarily developed for data analytics (by major corporations including Apple, Google, and

Microsoft), now commonly used in DH for research (along with customized tools developed by digital humanists), we are able to keep track of creative production in unprecedented ways.[26] DH tools since at least the late 2000s into the 2010s have played a major role in making the analysis of recyclability, as researched in RS, more evident.[27] Thus, we can now also track how certain narratives are created, versioned, remixed, and distributed. With machine learning and big data, corporations can accurately evaluate the development of cultural discourse and figure out how to use such knowledge to optimize their business model for profits, while digital humanists can implement similar methods to evaluate how knowledge itself is produced. In both cases, what is being evaluated is how narratives designed for empathy are operationalized across networks; hence, people are constantly trying to find ways to connect through forms of storytelling. We have arrived at a moment when experts across disciplines understand that, ultimately, it is stories with empathetic value that are at play across all fields. Even the field of economics has openly begun to evaluate how stories that are part of social narratives eventually shape the capitalist market. Robert J. Shiller writes,

> An economic narrative is a contagious story that has the potential to change how people make economic decisions, such as the decision to hire a worker or to wait for better times, to stick one's neck out or to be cautious in business, to launch a business venture, or to invest in a volatile speculative asset. Economic narratives are usually not the most prominent narratives circulating, and to identify them we have to look at their potential to change economic behavior.[28]

Shiller goes on to explain how bitcoin is a contagious economic narrative that has been successful due to its ongoing combination of success stories of young people in juxtaposition with those of bureaucrats. The stock market goes up and down day in and day out, partly in reaction to stories that are released on the news. President Trump has been credited with affecting the market with decisions made for trade with China, for example.[29] In this sense, we can see how narratives are embedded in our daily reality and affect factual outcomes that shape our world. Our interpretation of data—the remixing of information to create compelling headlining stories that may actually affect economies—can now be traced as subjects of RS with the implementation of DH methods and tools. The challenge to the current reality is that bias appears to play a role that is proving detrimental as we become increasingly globally connected.

The Tenacity of Bias

Bias is perhaps the biggest challenge humans face when engaging with other people as well as animals and things of all shapes and forms in the world. Brian Bardon explains that a strong bias can lead a person into a state of denial.[30] According to Bardon, denial is different from misinformation, ignorance, mendacity, and wishful thinking, in which such ideological states of cognition are not denouncing a specific reality outright but may shape a person's reality in a way that does not account for all the facts. Each of them can actually help support a state of denial itself.[31] Bardon's analysis overlaps the necessity of empathy to support denial. This can be noted when he explains that denial is based on a sentiment—that is not rationality but a feeling: "Individual factual beliefs often derive not from a cold assessment of probabilities but, rather, from a psychological

146

phenomenon sometimes simply called denial. Denial involves the emotionally moti-vated rejection (or embrace) of a factual claim in the face of strong evidence to the contrary."[32]

Notice that this definition is about what a person feels. Denial is founded on feeling, which means that it needs empathy for people within a group to connect with each other. Empathy in this case is not extended to people outside of one's group. This con-duct is not rational, meaning that it does not rely on logic for decisions that are made. Bardon also explains that denial is linked to tribalism,[33] which is a term that pundits increasingly use to refer to the binary separation between political groups.[34] If one agrees with Bardon's assessment of truth and denial, what the Trump administration does on a daily basis is to perform mendacity for self-interest: It denies facts in order to preserve a growing set of inaccurate statements that increase each day as the President tweets state-ments that are factually untrue when verified against actual data. At the time of this writing, President Trump is credited to have made more than twenty thousand mislead-ing claims with an average of at least 12 inaccurate statements per day.[35] Perhaps the most poignant situation that the Trump administration has engaged in at the time of this writing has been the COVID-19 Pandemic, which they have handled by playing down the consequences, releasing messages designed to distract from the growing num-ber of infections and deaths, as well as repurposing factual data outrightly in hyperbolic stories for the sake of assuaging the discomfort of Trump's political base, who are resent-ful toward anyone they perceive to be different from them.

These are extreme times in which the human struggle for life during a Pandemic has become political fodder. Even one of the most basic safety precautions one can take during an airborne Pandemic—wearing a mask—has been politicized. Following his example, people who support Trump tend not to wear one (even when he eventually came to wear one occasionally) and disregard scientific evidence that wearing one will slow down the spread of the virus, thus flattening the Pandemic's curve. Perhaps the most blunt action by the Trump administration is their deliberate manipulation of facts to create ideological stories designed to go viral across social networks. Brad Parscale, Trump's social media strategist, is well aware that stories can be effective to trigger empa-thy in people, "When I give a speech, I tell it like a story," he said. "My story is my story."[36]

People, such as Parscale, understand what is unethical and morally corrupt; yet, they are more than willing to game the system for sheer power. What are we left with when the struggle is not so much about having access to information to attain knowledge but what to do about people using such access for deliberate manipulation of facts with the goal of self-gain? The result is a political party that tells a story directed at their follow-ers, who will comply by accepting a reality that fits a narrow world view based on con-stant disinformation that is increasingly being imposed on others outside their party base. Ultimately, we have to face a personal struggle to find a way to empathize, not just with those we already agree with (one's in-group) but, most importantly, with those with whom we do not.

The Struggle for Empathy

The question we face is how can people move beyond their biases to make decisions—not for their own self-interest but for the good of others—based on fairness? Certainly, there are major stories of people who have done this in the past, and religions are

actually founded on the ability of humans to care for the well-being of others based on empathy. The Golden Rule, arguably, is the most direct example of encouraging someone to have empathy for another. Its phrasing varies depending on the time, religion, and/or cultural context, but the basic idea is to treat others how you would like to be treated. This is the closest a person can get to asking to place oneself in the position of another person—in other words to empathize. But is this possible when one may have strong self-interest or bias? I argue that it is possible if one takes the time to understand how we engage with the world, both on analytical and emotional terms. We can break down this process in semiotic terms.

According to semiotics, meaning comes about based on three terms: The signifier, the signified, and the sign (Figure 9.1). A signifier is an object that is associated with a concept. You can think of it as a "vessel" that can be filled with meaning. A signified is the concept that is associated with the object, and both of these terms create a sign. Understanding of the sign is called signification, or simply meaning.[37] The basic sign (meaning) can, in turn, become a second order signifier, which can be filled with new meaning. The sign can also function as a second order signified as well and can be combined with a signifier to create new meaning, and so the chain of signification begins to run and produces the ongoing multiplicity of meanings we engage with in the world.

We have no immediate relation to the terms signifier, signified, and sign based on the abstract explanation provided earlier. The terms form part of a diagrammatic abstraction, when the sign has not been named. Basic signs include objects such as apple, baby, pen, photo, water, and so on, but let us choose a sign that builds on other signs: voting rights. This sign is much more complex because it is not only higher in the chain of signification, but it is also composed of two concepts that have no concrete objects to represent them in the world. They are cultural signs that rely on a constantly shifting understanding of culture itself. To unpack the multiple signs (connotations) that help us understand the meaning of voting rights on a personal level is not so much the point here, but rather a consideration of the term's general cultural implications for

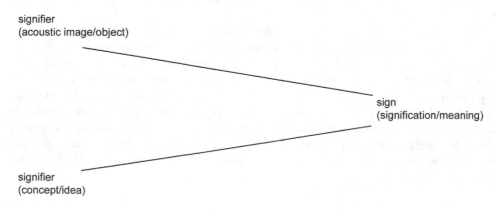

Basic Process of Signification

signifier
(acoustic image/object)

sign
(signification/meaning)

signifier
(concept/idea)

Figure 9.1 In the basic process of meaning production (signification), a concept (signified) is associated with an object (signifier) in order to create meaning (a sign). Recognizing the sign is called signification. According to this process, people are able to identify basic concepts and things in the world

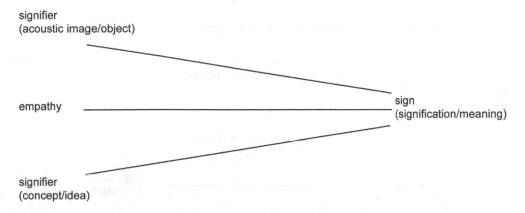

Figure 9.2 Empathy takes place when people identify with something that is meaningful to them; without critical awareness, a strong sense of empathy can lead to the inability to analyze how such meaning was produced

the assessment of ideological templates that should be questioned. What one likely infers when encountering such a term is a quick recognition of the many political struggles associated with it. This is not only true for the United States but many countries around the world; likely, at this point, empathy plays a role. Depending on one's personal position and identity, one may be privileged or not when it comes to the right to vote. In the United States, a White person will have a very different relation with voting rights than a Black person. And here empathy may take over, and one may not be able to move further when analyzing the term with the goal to understand better the difficulties people of diverse backgrounds may have when it comes to voting rights. The reason for this is that empathy cuts through our understanding of the sign (Figure 9.2). Empathy, in this case, may push us to view voting based on our relation to an in-group and ultimately self-interest and encourage an "us versus them" mentality, which supports the suppression of voting rights against people of color particularly in the United States.[38]

If we have strong feelings about voting rights according to our own background, our views may take over and we may not be able to see how the politics behind voting suppression are at play. Studies show that this appears to be the case.[39] So the question for us is how can we break through our bias to suppress voting rights, for example (if we have it), or how can we understand why a person may have this bias (if we are the ones being oppressed)? We need to detach the signifier from the signified to understand how the sign is constructed (Figure 9.3). This is a critical process that takes practice and hard work to perform, but it can be done. It will likely be uncomfortable, awkward, and perhaps even emotionally painful for each person who decides to engage in the process. It can and must be done if we are to move past basic in-group thinking which has led to toxic populist demagoguery, at this point, all around the world. Art and game theory can be useful in providing a hands-on method to encourage people to engage with the position of another who may be a direct adversary.

Basic Process of Critical Analysis

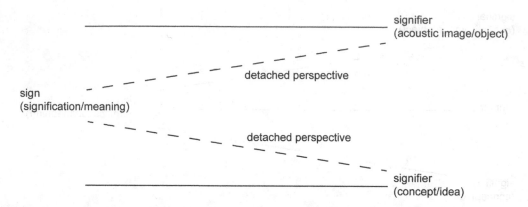

Figure 9.3 In critical analysis, meaning (a sign) is examined with the goal to understand how it is constructed with concepts (signifieds) that are combined with objects (signifiers). Each element needs to be evaluated separately (with detached perspective) while keeping in mind how their combination means something specific

Switch Chess: A Performative Work of Chance and Strategy

I grew up playing chess. I do not consider myself very good and have not played professionally, but the game continues to be a recurrent activity in my life. As an artist, chess is a game that connects me to Marcel Duchamp, who was also an avid Chess player. Duchamp saw a lot of creative potential in the game.[40] One of Chess's compelling features is its basic binary formula: black or white wins, but advanced players and certainly artistic figures such as Duchamp found aesthetic value in the moves and combinations that emerge during the game.[41] This project dawned on me one day during the toxic reality—one that combines a biological (COVID-19) and an ideological (racism/ethnocentrism) pandemic—in which I wrote this chapter. I wondered if the game of Chess could be hacked so that the interest in winning would be displaced. My goal was for players not to be invested in winning from a personal position but rather to encourage them to consider multiple positions that could lead to a win by either the black or white game pieces. The idea behind this is simple: To be placed in a situation in which you have to think not based on your preexisting situation (who you are), but on the situation that you encounter unexpectedly and have contributed to with your previous actions. You must make the best decision for your current position in order to plan for an optimal outcome, that at the end of the game may not be for personal gain, but for that of a collective (in this case two people), both players. Based on these premises, I developed *Switch Chess*.[42] The rules are straight forward:

Play *Switch Chess* based on chance by flipping a coin.

1. Flip the coin to decide who will initially play white or black.

 a. One of the players calls heads or tails when the coin is tossed.
 b. The player who wins the call decides to play white or black for the first move.

2. After each full move (one white, one black), players flip the coin again.

 a. Heads results in a switch—players reverse their positions.

 b. Tails results in no switches—players maintain their current positions.

3. Repeat 2: Players continue to flip the coin after each full move until the game is over.

My overall assessment from a player's point of view is that individuals who engage with *Switch Chess* need to come to terms with their preconceptions of "winning."[43] If the goal is not to win, what is in it for them? This question can be answered in at least two ways, depending on how *Switch Chess* is approached. The game could be of use for learning Chess, or it could be played as a work of art that asks people to reflect on one's position at any one time; or, ideally, both.

At this point, it is worth revisiting Picasso's statement on lying: "Art is a lie that makes us realize truth, at least the truth that is given us to understand." With this premise in mind, *Switch Chess* should be considered an aesthetic space designed for critical reflection, in which the players can think how moves that normally would matter, do not matter, because they are "lies," in that the competition is false: Nobody wins, yet, both players can gain knowledge through a purposeless process, which is that of art making; searching for an open question that says more about the person than the opponent. Artistic "lies" help us understand why we make moves that shape our lives in ways we cannot fully understand at the time we make them. This is the difference between appropriation art, and fake news. The former provides means to understand one's way of thinking, while the latter asks us to continue believing what we believe without question. Empathy is operationalized in *Switch Chess* with the goal to examine one's relation to the "other," which at one point we become in the game. Empathy is certainly at play in the actual game of Chess as well, but for the sake of understanding the other in order to destroy it—if one uses empathy in such a case, it is to overtake the opponent, and in this sense, we need to consider the limitations of binary thinking that certainly can be aestheticized as is the case with Chess. We need to find ways to subvert binary thinking to engage with difference as an opportunity to grow as a diverse culture, while understanding that the opposition of the two players does not go away but rather can function in terms of multiplicities.

Conclusion

We could dismiss *Switch Chess* as a superfluous marginally fun way to play a board game and argue that it should not be taken seriously. For those unable to see the value, we can go back to semiotics and extract the basic signs from the game itself to write general instructions that can be implemented with a different set of signifiers. We could develop variations on the rules for a randomized set of actions that would at the flip of a coin place the players in a privileged or unprivileged position: White and rich, black and poor, white and poor, black and rich, brown and rich, brown and poor; this can be broken down further into gender, ability, and multiple minority groups, and we can begin to engage with the need to understand the position of another person or group of people one may consider irrelevant based on one's prejudices. The issue that arises from this type of game is that the players have to think about the issues of another person,

similarly to how the moves in *Switch Chess* function. The goal is to think outside of your comfort zone and take seriously other people's reality.

Considering ways to implement methods that enable us to put our biases on hold is proving to be crucial for civil society, because what has become increasingly clear as we have access to information, as was alluded to in previous sections, is that cultures do not resolve contentions by learning facts, but by having the capacity to interpret such facts with empathy, in search of fairness. The most resonant examples at the time of this writing are the cultural frictions of the COVID-19 Pandemic and the protests for police violence against African Americans and people of color.[44] Historically, in the United States, in particular, people who disagreed on cultural ideas were able to come together in times of crisis for the good of the country. With the Pandemic, however, people quickly found ways to spin the facts to justify their beliefs. Some people who did not want to face the dire reality of rising deaths across the world have gone as far as to claim that the Pandemic is a hoax.[45] At the same time, police abuse of African Americans and people of color became evident due to the killing of George Floyd caught on video, giving rise to a national and global movement of Black Lives Matter.[46] On top of this, reports have been made that The Trump Administration appears to be trying to manipulate data to show lower numbers of COVID-19 cases across the United States.[47] All of this is done for a zero-sum game by the current administration. Some people have suggested to walk away from people with extreme isolationist views as promoted by Trump supporters,[48] but is disengagement the way to deal with individuals unwilling to practice empathy beyond their in-group? I am optimistic to claim that we can be fair while keeping our bias at bay, if we keep in mind a set of parameters that put into practice the combination of empathy and critical thinking:

- Empathy is a personal projection on another (person, thing, or situation) to relate to and/or understand.
- Criticism can be considered a state of disinterested analysis in which personal stakes are suspended.
- Criticism is not empathy, but a formalized and systematic approach to take apart a subject in order to analyze it and evaluate how it works.
- Criticism and empathy can work together in order to have a fair assessment while understanding one's biases. One should not implement them separately when developing narrative knowledge.

These points may be difficult to put into practice together, but they must be if we are to move past the current existential crisis our global society finds itself in (Figure 9.4). RS and DH have been useful tools in my own research to develop arguments on how to engage with our own biases, which I share in this essay. Both disciplines have made it possible for me to access information and knowledge that led me to develop *Switch Chess*, which I encourage anyone interested to play. DH makes it possible to measure the creative process, while RS evaluates, based on DH methods, in order to understand the implications of originality as part of the human struggle between the individual and the collective. But better tools to measure how we appropriate, recycle, and implement materials will not be helpful if we do not acknowledge that; ultimately, we interpret facts and all other things we encounter in the world through narrative knowledge. We create stories that move us toward change. It will not matter how sophisticated or accurate future data-mining tools can be, if we are not willing to put into

Figure 9.4 Critical analysis and empathy can be combined in order to develop a fair assessment of an object or situation with the goal to keep at bay one's biases

practice critical skills that enable us to acknowledge—especially when it is most uncomfortable—the truth. Creativity as practiced in art can be the means toward understanding the complexity of interpretation. Art resonates with people not because it presents the truth, but because it asks people to realize how they relate to the truth. And for this reason, art remains a relevant form for engaging with empathy.

Notes

1 The decline of empathy has been a recurring focus in the medical field. It has gained much attention in popular media in current times due to the Pandemic. For the medical field: Pohontsch, N J; Stark, A; Ehrhardt, M; Kötter, T; Scherer, M., "Influences on students' empathy in medical education: an exploratory interview study with medical students in their third and last year," *BMC Medical Education* 18 (2018). DOI: 10.1186/s12909-018-1335-7. Emily C. Strattal, David M. Riding2, Paul Baker, "Ethical erosion in newly qualified doctors: perceptions of empathy decline," *International Journal of Medical Education*. 2016; 7:286–92 ISSN: 2042-6372 DOI: 10.5116/ijme.57b8.48e4. A relevant book: Jamil Zaki, *The War for Kindness: Building Empathy in a Fractured World* (New York: Crown, 2019).

2 Seppälä, Emma, "Empathy is on the decline in this country. A new book describes what we can do to bring it back," *The Washington Post* (Online), Washington, D.C.: WP Company LLC d/b/a The Washington Post, June 11, 2019: accessed July 24, 2020, https://www.washingtonpost.com/lifestyle/2019/06/11/empathy-is-decline-this-country-new-book-describes-what-we-can-do-bring-it-back/.

3 For an art and activist engagement with post-truth see the zine by Garnet Hertz, Disobedient Electronics: http://www.disobedientelectronics.com/, accessed August 7, 2020. Also see: Ralph Keyes, *The Post-Truth Era: Dishonesty and Deception in Contemporary Life* (New York: St. Martin's Press, 2004).

4 "Conway: Press Secretary Gave 'Alternative Facts'," Meet the Press, January 22, 2017: accessed July 1, 2020, https://www.nbcnews.com/meet-the-press/video/conway-press-secretary-gave-alternative-facts-860142147643.

5 Analysis of body language is not an actual science, but it is performed extensively. For an analysis of Kellyanne Conway's body language see "Body Language Analysis No. 4263: Kellyanne Conway regarding James Comey's Interview — Nonverbal and Emotional Intelligence (VIDEO, PHOTOS)": accessed August 7, 2020, https://medium.com/@DrGJackBrown/body-language-analysis-4263-kellyanne-conway-regarding-james-comeys-interview-nonverbal-and-98bef5f5bd89.

6 Salvatore Nunnari1 and Jan Zápal, "Dynamic Elections and Ideological Polarization" *Political Analysis* 2017; 25:505–34 DOI:10.1017/pan.2017.24. Mast, Jason L., "Action in culture: Act I of the presidential primary campaign in the U.S., April to December, 2015," *American Journal of Cultural Sociology* Oct 2016; 4(3):241–88. DOI:10.1057/s41290-016-0009-3.

7 Adrian Bardon, "Bias and Belief," *The Truth About Denial* (New York: Oxford Press, 2019), 47.

8 Pablo Picasso, "Statement, 1923," *Theories of Modern Art*, edited by Herschell B. Chipp (Berkley, Los Angeles, London: University of California Press, 1968), 264.

9 Jean Francois Lyotard, "8. The Narrative Function and the Legitimation of Knowledge," *The Postmodern Condition: A Report on Knowledge* (Minneapolis: University of Minnesota Press, 1983), 27.

10 Ibid., 27–8.

11 This is already acknowledged in the Foreword by Fredric Jameson to Lyotard's book. Also see Charlie Gere "Digital Resistances," *Digital Culture* (London: Reaktion Books, 2008), 159–60.

12 Susan Lanzoni, "Roots of Einfühlung or Empathy in the Arts," *Empathy: A History* (New Haven and London: Yale University Press), 21–3.

13 For an accessible view on Empathy since WWII listen to "The End of Empathy," Invisibilia, April 12, 2019: accessed July 5, 2020, https://www.npr.org/programs/invisibilia/712280114/the-end-of-empathy. For the history of empathy as an ideology listen to 30:59–40:00.

14 Lanzoni, 3.

15 Ibid.

16 "Affect" as defined in *The New Oxford American Dictionary*, 2019.

17 Stephen Hawking, *A Brief History of Time* (New York: Bantam Books, 1988).

18 Görnitz, T. "A century of quantum theory: Time for a change in thinking". *Foundations of Science* 2017; 22:749–62. https://doi.org/10.1007/s10699-016-9497-4.

19 I have worked on data mining for image, text, and sound for over 15 years at this point. For ongoing research visit: http://remixdata.net and http://remixtheory.net.

20 Lyotard, 6–14. Scientists inevitably need to produce a narrative to explain and justify their findings. In this regard, read Steven French, *Philosophy of Science* (London: Bloomsbury, 2016), 53–93.

21 A book that marks the emergence of new media is Lev Manovich, *The Language of New Media* (Cambridge, MA: MIT Press, 2001).

22 A major anthology that presents digital humanities as an emerging field: Matthew K Gold, editor, *Debates in the Digital Humanities* (Minneapolis and London: University of Minnesota Press, 2012).

23 I take this categorization of digital technology as medium and forms of production from Christiane Paul; see Christiane Paul, *Digital Art* (New York: Thames and Hudson, 2015).

24 The anthology edited by Oliver Grau on digital art covers the complexities of new media art, now more commonly called "media art" although the term "digital art" is also often used: Oliver Grau, *Media Art Histories* (Cambridge, MA: MIT Press, 2010).

25 For a more detailed development of remix studies in relation to remix and remix culture read: Eduardo Navas, "Remix," *Keywords in Remix Studies*, eds., Eduardo Navas, Owen Gallagher, and xtine burrough (New York: Routledge, 2017), 246–58.

26 One of the most popular academic examples is "Bookworm" by Jean-Baptiste Michel and Erez Aiden in collaboration with Yuan Shen from MIT and Steven Pinker. The project preceded Google's nGrams: https://books.google.com/ngrams.

27 In terms of image analysis, for example, the Cultural Analytics Lab has produced ongoing research on image usage across social media: http://lab.culturalanalytics.info/.

28 Robert S. Shiller, "The Bitcoin Narratives," *Narrative Economics: How Stories go Viral and Drive Major Economic Events* (Oxfordshire: Princeton University Press, 2019), 3.

29 The stock market continuously goes up and down whenever Trump tweets something about China, or the White House announces an official decision. This has been happening to the very end of Trump's first term in office: Alexander Osipovich and Joe Wallace, "Stocks Turn Lower on China Tensions," *Wall Street Journal*, May 28, 2020: accessed on July 13, 2020, https://www.wsj.com/articles/global-markets-0528-11590641107.

30 Bardon, 8.

31 Bardon, 4–14.

32 Ibid., 2.

33 Ibid., 24.

34 George Packer, "A New Report Offers Insights into Tribalism," *The New Yorker*, October 13, 2018: accessed July 14, 2020, https://www.newyorker.com/news/daily-comment/a-new-report-offers-insights-into-tribalism-in-the-age-of-trump. Amy Chua and Jed Rubenfeld, "The Threat of Tribalism," *The Atlantic*, October 2018: accessed July 14, 2020, https://www.theatlantic.com/magazine/archive/2018/10/the-threat-of-tribalism/568342/.

35 Glenn Kessler, Salvador Rizzo and Meg Kelly, "President Trump has made more than 20,000 false or misleading claims," July 13, 2020: accessed August 8, 2020, https://www.washingtonpost.com/politics/2020/07/13/president-trump-has-made-more-than-20000-false-or-misleading-claims/.

36 As quoted in McKay Coppins, "The Billion-Dollar Disinformation Campaign to Reelect the President,"

The Atlantic, February 10, 2020: accessed July 14, 2020, https://www.theatlantic.com/magazine/archive/2020/03/the-2020-disinformation-war/605530/.

37 Roland Barthes, "Myth Today," *Mythologies* (New York: Hill and Wang, 2012), 215–74.

38 Voting trends can be analyzed since 1788: Curtis Gans, editor, *Voter Turnout in the United States 1788–2009* (Washington, DC: CQ Press, 2011). A close analysis is provided by Gilda R. Daniels, *Uncounted: The Crisis of Voter Suppression in the United States* (New York: New York University Press, 2020).

39 Omer Yair, Raanan Sulitzeanu-Kenan, "When do we care about political neutrality? The hypocritical nature of reaction to political bias" *PLOS ONE*, May 3, 2018: accessed July 26, 2018, https://journals.plos.org/plosone/article?id=10.1371/journal.pone.0196674.

40 Duchamp's games are available online: https://www.chessgames.com/player/marcel_duchamp.html. A book on his passion for art and Chess: Frances M. Nauman, Bailey, Bradley, Shahade, Jennifer, *Marcel Duchamp: The Art of Chess* (New York: Readymade Press, 2009).

41 There are many variations of chess, but none have taken the approach of Switch Chess, perhaps because there is no way to declare a winner in the version I developed. There are variations on chance: accessed July 26, 2020, https://www.chessvariants.com/cards.dir/chance.html; also see: https://www.chessvariants.com/d.betza/chessvar/fair1st.html.

Bobby Fischer also developed his version of "Random Chess" in which the pieces are played in different positions: accessed July 26, 2020, https://www.frchess.com/. A work of art appropriating Chess is Thinking Machine by 4 by Martin Wattenberg & Marek Walczak: accessed July 26, 2020, http://turbulence.org/project/thinking-machine-4/.

42 The term was coined by my 10- and 8-year-old sons, Oscar and Oliver. One morning they asked me, "Are we going to play *Switch Chess?*" I had been struggling with a name for the performative work of art, and I realized that I should use the term my sons had conceived based on their own experience playing the game. I also realized they used this term because I used it repeatedly to describe the change of player's position.

43 So far I played this game as a performative work of art with my two 8- and 10-year-old young boys, Oscar, and Oliver, and my wife Annie. I plan to play it over time with other people, including advanced chess players. For *Switch Chess*, specifically, my son Oscar explained that he did not feel so concerned about losing the game as he usually would and that he liked it because he could focus on making the best move regardless of being black or white. My younger son, Oliver, did not explain things to me so directly, but he appeared to make moves with greater freedom than when he played only one position. I should point out that both of them like the black pieces over the white ones; apparently, they think they are "cooler." In turn, they sometimes rooted to be black again. They eventually began to play with some abstract notion of wanting to win, which could mean that they like to play for fun, but eventually the urge to compete sets in.

When I played with Annie, my wife, it was quite different. She is learning how the game works, so she is not necessarily thinking moves ahead. She appears more distanced from the idea of winning, in general, because she is interested in understanding the logic behind chess; but I noticed she was more assertive and made bolder moves when we switched pieces. To learn more about *Switch Chess* visit: http://navasse.net/switchchess.

44 At the time of this writing, there have been ongoing protests nationally for the death of George Floyd and others who followed soon after his death.

45 President Trump when the pandemic emerged in the United States called it a hoax: David Choi, "Trump's campaign is trying to remove a video in which he appears to call the coronavirus a 'hoax,' saying it's misleading," March 26, 2020: accessed July 26, 2020. *Business Insider*: https://www.businessinsider.com/trump-campaign-remove-video-saying-coronavirus-hoax-2020-3.

46 Evan Hill, Ainara Tiefenthäler, Christiaan Triebert, Drew Jordan, Haley Willis and Robin Stein, "How George Floyd Was Killed in Police Custody," *New York Times*, May 31, 2020: accessed July 26, 2020, https://www.nytimes.com/2020/05/31/us/george-floyd-investigation.html.

47 Adriel Bettelheim, "Trump's Covid-19 data reporting switch draws outcry from health groups," Politico, July 15, 2020: accessed July 26, 2020, https://www.politico.com/news/2020/07/15/trumps-covid-19-data-reporting-switch-draws-outcry-from-health-groups-364589.

48 Deborah Handover, "Confessions of a Trump Supporter's Daughter," *Medium*, June 25, 2020: accessed July 26, 2020 https://gen.medium.com/confessions-of-a-trump-supporters-daughter-7206f678cd41.

Bibliography

Bardon, Adrian. *The Truth About Denial*. New York: Oxford Press, 2019.

Barthes, Roland. *Mythologies*. New York: Hill and Wang, 2012.

Daniels, Gilda R. *Uncounted: The Crisis of Voter Suppression in the United States*. New York: New York University Press, 2020.

Gans, Curtis. Editor. *Voter Turnout in the United States 1788–2009*. Washington, DC: CQ Press, 2011.

Gere Charlie. *Digital Culture*. London: Reaktion Books, 2008.

Gold, Matthew K. Editor. *Debates in the Digital Humanities*. Minneapolis and London: University of Minnesota Press, 2012.

Görnitz, T. "A Century of Quantum Theory: Time for a Change in Thinking". *Foundations of Science* 22(2017): 749–62. https://doi.org/10.1007/s10699-016-9497-4.

Grau, Oliver. *Media Art Histories*. Cambridge, MA: MIT Press, 2010.

Hawking, Stephen. *A Brief History of Time*. New York: Bantam Books, 1988.

Keyes, Ralph. *The Post-Truth Era: Dishonesty and Deception in Contemporary Life*. New York: St. Martin's Press, 2004.

Lanzoni, Susan. *Empathy: A History*. New Haven and London: Yale University Press. 2018.

Lyotard, Jean François. *The Postmodern Condition: A Report on Knowledge*. Minneapolis: University of Minnesota Press, 1983.

Manovich, Lev. *The Language of New Media*. Cambridge, MA: MIT Press, 2001.

Mast, Jason L., "Action in Culture: Act I of the Presidential Primary Campaign in the U.S., April to December, 2015." *American Journal of Cultural Sociology*, 4, no. 3 (Oct 2016): 241–88. DOI:10.1057/s41290-016-0009-3.

Navas, Eduardo, Owen Gallagher, and xtine burrough, editors. *Keywords in Remix Studies*. New York: Routledge, 2017.

Nauman, Frances M., Bradley Bailey, and Jennifer Shahade. *Marcel Duchamp: The Art of Chess*. New York: Readymade Press, 2009.

Nunnari, Salvatore, and Jan Zápal. "Dynamic Elections and Ideological Polarization" *Political Analysis* (2017) vol. 25:505–534 DOI:10.1017/pan.2017.24.

Picasso, Pablo. "Statement, 1923." In *Theories of Modern Art*, edited by Herschell B. Chipp, 263–66. Berkley, Los Angeles, London: University of California Press, 1968.

Pohontsch, N J, A Stark, M Ehrhardt, T Kötter, and M. Scherer "Influences on Students' Empathy in Medical Education: an Exploratory Interview Study With Medical Students in Their Third and Last Year." *BMC Medical Education* 18 231 (2018). https://doi.org/10.1186/s12909-018-1335-7.

Shiller, Robert S.. *Narrative Economics: How Stories Go Viral and Drive Major Economic Events*. Oxfordshire: Princeton University Press, 2019.

Stratta, Emily C., David M. Riding, and Paul Baker. "Ethical Erosion in Newly Qualified Doctors: Perceptions of Empathy Decline." *International Journal of Medical Education* 7 (2016): 286–92 ISSN: 2042-6372 DOI: 10.5116/ijme.57b8.48e4.

Yair, Omer, and Raanan Sulitzeanu-Kenan, "When Do We Care About Political Neutrality? The Hypocritical Nature of Reaction to Political Bias" *PLOS ONE*, May 3, 2018: accessed July 26, 2018. https://journals.plos.org/plosone/article?id=10.1371/journal.pone.0196674.

Zaki, Jamil. *The War for Kindness: Building Empathy in a Fractured World*. New York: Crown, 2019.

Part II

ACCESSIBILITY AND PEDAGOGY

10

DESIGNING THE REMIX LIBRARY

Anne Burdick

Libraries are collections of cultural materials that are modular and mobile, at the ready for remixing. Yet, most libraries restrict the movement of their books through sociotechnical systems[1] guided by order and efficiency that are resistant to the aesthetic disruption of the remix. Imagining how these systems might be otherwise is a concern of knowledge design, a specialized design practice born out of the digital humanities. Knowledge designers undertake projects with an eye toward the epistemic effects of design choices, based on the idea that knowledge is design-dependent.[2]

This chapter will consider how remix in the context of the digital humanities might be understood as a question of knowledge design through a discussion of the systems and spaces that define the book circulation of four contemporary libraries. The Seattle Central Library's (SCL) spiral stacks materialize the relative positionality of the Dewey Decimal Classification (DDC); in spite of its unique form, the architecture is built upon age-worn disciplinary categories. At the University of Chicago's Mansueto Library, a giant glass dome sits atop subterranean stacks that are inhospitable to humans but suited to retrieval robots. The public spaces are filled with light but the library's collection is literally and metaphorically a black box. While both the SCL and Mansueto are prized for their innovative architecture, the model of knowledge embodied in the design of each is top-down, managerial. In contrast, Sitterwerk, a private art library in Switzerland, employs a small army of robots that spend each night tracking books, allowing readers, by day, to place them in arrangements of their own choosing on shelves and tables. What results is a library that is in a dynamic state of remix. Taking this notion one step further, the speculative Universal Programmable Library (UPL), imagined by Jeffery Schnapp and Matthew Battles in *The Library Beyond the Book*,[3] uses algorithmic logistics to create a library in a perpetual state of flow, what Eduardo Navas would call a Regenerative Remix.[4]

As will be evident in the discussion that follows, the design of the storage, access, and retrieval systems of each library is where epistemology and material become one and the same. The way in which each library's architectures and protocols structure assemblies of people, robots, algorithms, and books will demonstrate the inseparability of design and models of knowledge and point the way toward a conception of remix as a matter of design.

From Material Form to Mechanisms of Knowledge

Remix studies and the digital humanities overlap in their attention to the collection, access, and use of cultural materials—in dynamic media. While brick-and-mortar libraries are decidedly fixed in their physicality, their operations are hybrid: physical and digital, social and scholarly, repository and network, fixed and fluid. In many places, the library itself, once a hub of research activity in close proximity to a physical mass of books, has become a distributed network of such activity, only some of which takes place within the heavy metal bookstacks of library buildings. Thus, we have seen libraries modify their floor plans to include cafés or, say, maker spaces, relegating the open stacks, a defining feature since the late 1800s, to storehouses offsite or underground. While diversifying the activity within library buildings adds new dimensions to our understanding of what a library is and does, this chapter is concerned specifically with the spaces and systems that delimit the movement of the books and stacks that have been the centerpiece of the modern library, and the performance of search and retrieval therein, to see remix as a matter of design.

The base unit that underlies the library's contemporary form—the dense body of the rectilinear printed codex—has long given definition to the building's shape and internal structures. Indeed, the steel grid of the bookstacks is a common architectural feature (Figure 10.1). "The library is born as a container shaped by its contents... The structure itself is summoned into being... as the external manifestation of an internal treasure."[5] That external manifestation, the architectonics of the library, gives material form to mechanisms of knowledge management and control. Libraries are defined by "the architectures for storing, managing, parsing, dispatching, and controlling information."[6] "Architectures" includes bureaucratic mechanisms, such as the library classification that maps knowledge to linear shelves, a sociotechnical system that underlies most contemporary library design. This marriage of operations, epistemologies, and architectures is not new. In Étienne-Louis Boullée's proposition for the design of the Bibliothèque du Roi in the late 1780s, "the handing down of knowledge would be literal in every sense. A human chain of attendants would pass books from one hand to the next, until they were in the hands of their readers,"[7] writes Molly Steenson, emphasizing a feature that to her is more distinctive than the barrel vault ceiling widely considered Boullée's architectural achievement. From the Bibliothèque du Roi to the steel stacks of Harvard's Widener Library, the assemblage of books, metadata, mechanisms, and infrastructures are manifest in a kind of material epistemology, designs (architectural and otherwise) that give form to each configuration. The apparent stability of the shelves, walls, and systems of the library conceals what Schnapp and Battles call the "ceaseless struggle between epistemology and the material."[8]

But how might the physical bodies of the books, stacks, floors, and walls themselves be reconfigured—rather than displaced—in an era of computation? And what new structures of thought might result? The history of remix as a creative cultural form in music, that is interwoven with the history of electronic reproduction, offers some clues.[9] The "technological modularity of media," which appeared in the 1950s when the flow of a musical composition could be separated into tracks, was later taken up in social situations that gave the act of sampling and recombining new meaning.[10] Similarly, the algorithms and spatiotemporal tracking technologies that underlie logistics and the Internet of Things could be appropriated—described, in Madeleine Akrich's terms[11]—to turn the modularity and mobility of the library's physical components into a new

Figure 10.1 An interior view of Harvard's Harry Elkins Widener Memorial Library under construction. Several levels of the building's ten-stack framework can be seen in this image taken before the floor panels were installed. Unknown author, circa 1914, public domain

cultural form, the remix library. But new technology alone is not enough. As we will see in the examples that follow, the library's systems and structures must be designed from the ground up to actualize a combinatory model of knowledge.

The Seattle Central Library and the Spatiotemporal Segmentation of the World

The SCL, designed by Rem Koolhaas and his Office for Metropolitan Architecture (OMA) with LMN Architects, is widely recognized for OMA's process, which involved analyzing, consolidating, and layering the library's "contents."[12] The analysis can be seen in diagrams that make visible a condition found in many libraries, the collections and activities of which have accreted over the years: prior to the redesign, spaces were rearranged incrementally, resulting in a disjointed organizational layout (Figure 10.2). To streamline the library's activities and procedures, the architects segregated them by floor, giving each its own purpose-built space, with the open bookstacks placed on top. Behind the scenes, they installed a system of conveyor belts, tracking mechanisms and automated

Figure 10.2 Top: Diagrammatic analysis showing the distribution of the SCL's contents before and after its redesign by the Office for Metropolitan Architecture (OMA). Reprinted with permission. © OMA. Middle: Diagram showing the continuous loop of the SCL's book spiral. Reprinted with permission. © OMA. Bottom: Interior view of the book spiral showing the DDC notation indicated by removable floor mats. Book spiral—Seattle Central Library, October 1, 2006, by brewbooks/CC BY-SA 2.0 (https://creativecommons. org/licenses/by-sa/2.0)

sorting machines, the SCL's automated materials handling system, one of the fastest in the country.[13] But it is the topmost section, the airy "book spiral" that is frequently lauded as the library's key innovation, a continuous pathway that encircles multiple floors, allowing a visitor to walk the entire length of the collection in an uninterrupted loop.

As can be seen in Figure 10.2, books populate the spiral in a sequence determined by the DDC, which begins at the top with 000 (computer science, information, and general works) and concludes at the bottom with 999 (History and Geography). The DDC was invented in the late 1800s by Melvil Dewey to bring order to an ever-expanding world of knowledge production. The system introduced the novel organizational mechanisms of *relative index* and *relative position*, which became standard features of the major bibliographic classification schemes, including the Library of Congress. At the time of the DDC's introduction, holdings in many libraries held fixed locations in collections closed to the public, some of which were sequenced according to acquisition date and book height. Relative position changed all that by placing a book according to its content in relation to the content of other books, grouped within disciplinary categories that were considered amenable to public browsing, search, and retrieval. The DDC's notation introduced *decimal classification* that uses the positional notation of the Hindu-Arabic system: three-digit numbers identify the hierarchy's ten main classes while fractional decimals allow for the introduction of ever-more granular categorical distinctions. The system, meant to cover "the entire world of knowledge," was built to accommodate periodic changes and additions; relative position allows new books and categories to be inserted anywhere in the collection, not just at the beginning or end.[14] In response, the SCL's redesign introduced repositionable floor markers to subdivide the winding path as needed (Figure 10.2).

The way the DDC is manifest in the design of the SCL demonstrates how, in Geoffrey Bowker and Susan Leigh Star's words, "a classification is a spatial, temporal, or spatio-temporal segmentation of the world."[15] Spatialization is integral to the three major functions of a library classification system: knowledge mapping, information retrieval, and shelf arrangement.[16] Notation, the symbolic coding that indicates a scheme's organizational sequence, makes each function possible. The DDC's decimal classification is meant to be easily translated to the linear arrangement of shelves; the system's model of knowledge, a nested hierarchy, can be realized as a line. In the SCL, books are placed along this line according to a unique address, a book number that combines decimal notation with the Seattle Public Library's own numbering system. Thus, each individual book occupies a fixed position on not only the shelves but also in the world of knowledge. To defy the disambiguation of the categorizing regime would require burdensome physical measures: multiple copies of a book title would be needed to populate multiple categories or a discipline-straddling researcher would need to crisscross the stacks.

Library classification systems, like all classifications, are defined by their mutually exclusive categories and totalizing impulses, ordering human interaction and structuring the built information environment. "Each standard and category valorizes some point of view and silences another."[17] The DDC, like many of the dominant library classification schemes, has long been subject to critique, particularly where human culture is concerned.[18] Though revisions to the DDC are regularly integrated in order to ameliorate the problematics of the system's more egregious cultural offenses, the classification scheme remains a product of its history and is even considered by some to be irreparably out-of-date.[19] Indeed, one could say that in spite of the SCL's cleverly executed floor plan, at its base is a schema that is considered in library science parlance to be "culturally inhospitable."[20]

Though it has been years since the card catalog gave way to the flexible operations of the search engine (for better or worse), the library stacks themselves have remained relatively unchanged, organized according to worldviews rooted in a different time. While many of the features of the book spiral are indeed innovative, the line that defines it is not only a physical form but also an outmoded model of knowledge. Within the library's shelves, a taxonomic administration restricts the movement of readers who cruise the stacks out of curiosity and limits books to a single set of relations. While the SCL's holdings may be modular, the design of the stacks renders them immobile, resistant to remixing.

The Dark Architectures of the Mansueto Library

The reading room of the Joe and Rika Mansueto Library at the University of Chicago, designed by the architect Helmut Jahn, is a glass-encased domed structure. The sunlit bubble is designed for student and faculty researchers as a space for contemplation and study. A massive documents collection sits underneath its light- and climate-controlled subterranean archive accessible only through a system of barcodes, storage algorithms, human workers, and robots (Figure 10.3). The library's automated storage and retrieval system (ASRS), which traces its origins to warehouses and fulfillment centers, is housed in an underground cavern scaled for machines and organized for economy and efficiency. Instead of shelves, there are bins, and instead of stacks, there are racks that are monstrously tall and inhospitable to humans. Robotic cranes retrieve the bins that hold

Figure 10.3 Underground Robot Library, an illustration by Graham Murdoch, shows how the Mansueto Library's automated search and retrieval system works (Reprinted with permission. © Graham Murdoch, www.mmdi.co.uk)

books of similar dimensions, recalling the logic of some of the closed stacks of the nineteenth century. Readers are "served up" the physical products that result from their interaction with an online search portal, much like a shopper on Amazon.com. The physicality of the collection—its scale and conceptual breadth—is inaccessible to readers. Colocation and relative position are no longer features of the library's shelving interface; its classification scheme is black-boxed. The order of logistics gives shape to the library's physical spaces and human–book exchanges.

Logistics is a kind of infrastructure concerned with the movement of goods over space and time. While it has been historically connected to military science, in the era of globalization, logistics is associated with the transport and coordination of commerce. The Mansueto Library replaces the hand-to-hand transfer of books imagined by Boullée with the conveyor belts, UPC codes, and human pickers of distribution centers. The library has undergone what Jesse LeCavalier calls "logistification," which "… works to flatten, connect, smooth, and lubricate as it organizes material in both space and time."[21] The goal of logistification is to bring costs down, increase efficiency, and maximize profit.

In warehouse management, there are three systems for distributing contents and their access by humans and/or machines.[22] *Specific* or *fixed location* applies a consistent organizing logic to the mapping of the storage space that determines an object's location, providing people with easy access without the assistance of Information Technologies (IT). The DDC, with its hierarchical order and indexical notation, falls into this category, as do most major library classification systems. With *random location*, which may also be called *chaotic*, *free*, or *varied*, objects are placed into open storage slots identified by a Warehouse Management System (WMS) or similar inventory control software that tracks the location of each individual unit, facilitating storage and retrieval according to the workflow of an organization. The arrangement of goods looks shambolic to the human eye but is decipherable by an IT system, the most well-known example being Amazon's chaotic storage, pictured in Figure 10.4. Mansueto's ASRS uses random

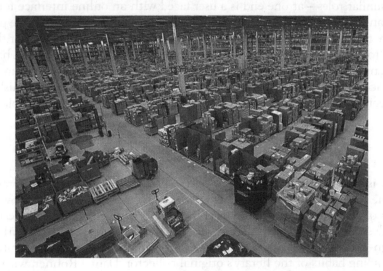

Figure 10.4 What chaotic storage looks like. "Governor Hogan Tours Amazon Fulfillment Center at 2010 Broening Hwy, Baltimore MD 21224," Maryland GovPics, September 15, 2017, by Joe Adrucyk/CC BY 2.0 (https://creativecommons.org/licenses/by/2.0)

location: books are placed according to packing algorithms that match artifact charac-teristics with available space. They cannot be retrieved by humans alone. *Mixed* or *semi-random location* combines aspects of both. For instance, in a dark supermarket designed to fill online shopping orders, boxed or canned goods may be picked and packed by robots from conveyor belts and racks while fresh produce would be set in bins and shelves organized for human pickers.

Warehouse (and library) management relies upon networks and technologies that allow the transfer of data amongst objects, people, and systems. The flow is enabled by addressability, meaning each object must have its own unique address, such as the Uniform Resource Identifier (URI) that is used in the Internet of Things to provide an object with an internet address. A URI is defined by a standardized syntax and set of protocols developed and maintained by a governing body, not dissimilar to the notation and book numbering of library classification. Once a book or other object is assigned an identifier, a marker is adhered to the physical object in one of three ways: as a machine-readable optical barcode or QR code, as a Radio-Frequency Identification (RFID) tag, or as an embedded microcontroller. Barcode labels, which are used at Mansueto, require reading by a visual scanner, which is frequently facilitated by people at key points along an object's journey; librarians check books in and out with the same actions that an Amazon warehouse picker fills an order. Through scanning, the physical object is tied to inventory control software that not only tracks its movement but also its metadata, such as contents, price, or provenance. RFID tags, used at SCL, include a tiny radio transponder that receives and transmits information when it is in close proximity with an RFID reader. Since RFID tags do not require being seen to be read, they can be embedded inside an object, but they are tracked much like a barcode—they are inert until they come in contact with a reading device, which can be facilitated by humans or machines.

Fulfillment centers, dark supermarkets, and the Mansueto Library place their human actors in similar roles—at one end is a user faced with an online interface for finding, selecting, and ordering goods, and at the other is the picker, whose actions are prescribed by software that manages either the picker's movement through the goods or that bring the goods to a stationary picker. Hand-to-hand becomes hand-to-robot-to-hand. The management software that organizes these chains is designed to optimize movement, time, and accuracy. The order of logistics and the algorithms of search demolish associa-tive connections, turning the collection into atomized bits hidden away in black boxes, by design.

The Dynamic Remix of the Sitterwerk Library

Sitterwerk is a small institutional center for the production, research, and preservation of art on the grounds of the former Sitterthal textile dye-works in St. Gallen, Switzerland. It consists of an art library, a materials archive, and studios for artists in residence in former industrial buildings renovated by Flury Furrer Architekten. Sitterwerk's knowl-edge design—its interior layout and information-retrieval system—was inspired by the eclectic reading habits of the library's original collector, Daniel Rohner, with a nod to Aby Warburg. The library eschews the use of a universal classification system in favor of what it calls "continuous inventory" enabled by a system of RFID tags and readers. By day, books are placed on tables and shelves in changeable configurations arranged by library patrons. These get recorded and added to the database that fuels the library's

Figure 10.5 Left: The reading antenna of Sitterwerk's "mobile reader" scans books as it moves along the shelves powered by an automated mechanical system. Reprinted with permission. © Sitterwerk, photograph: Katalin Deér. Right: Sitterwerk's Werkbank allows users to compose analog and digital materials. Reprinted with permission. © Sitterwerk, photograph: Katalin Deér

catalog and on-site research operations. Each night, robots scan the shelves, tracking the address of every book situated in the library's alphanumeric grid[23] (Figure 10.4).

Sitterwerk provides a range of ways that its users can create a remix, or as Lev Manovich defines it, "a composition that consists of previously existing parts assembled, which is edited to create particular aesthetic, semantic, and/or bodily effects."[24] While the library's shelves provide a temporary address for the book's physical body within a composed gathering of materials, the database allows the book to occupy an infinite number of positions within the context of user-created collections. The "Werkbank," seen in Figure 10.5, is an actual table within the library that boasts ten RFID antennas that continuously record the books and material samples arranged on its surface. A wide format screen combines with a flat table for the creation of mixed digital and physical arrangements, allowing the researcher to explore materials and ideas by using visual display strategies, the contextual associations of which, indicated through juxtaposition, say, or proximity—remix compositions—are part of the research. Each such arrangement gets added as a "collection" in the Werkbank's online "interactive workspace," where its creator can further embellish it through annotations of text, images, and other reference material. At Sitterwerk, this curating and composing activity is considered "knowledge-linking work."[25]

Within the interface of the library's online catalog, formal juxtapositions and associative connections are amplified. As Figure 10.6 shows, an entry is indicated by its title, author name/s, images of its cover and spine, and its current position on the shelves. In the example, *Portrait of Picasso* by Roland Penrose sits, for the moment, at 1.6F, meaning shelf F, at 1.6 m from the left edge. A facsimile of the book's spine is shown positioned within a graphical display of a "virtual bookshelf" that includes the spines of books that sit a 0.5 m to either side of the selection in real time on the actual shelf. The title may also appear in the online Werkbank in a collection, the assembled books of which call up a list of "related collections," the assemblage of which in turn call up other collections, and so on, allowing a user to follow lines of thought, book by book, crafted by fellow readers (Figure 10.6).

Figure 10.6 (a) A Kiva Systems robotic drive unit supports an inventory pod that services Amazon's chaotic storage. The barcodes that are visible on the floor guide the robots. "Governor Hogan Tours Amazon Fulfillment Center at 2010 Broening Hwy, Baltimore MD 21224," Maryland GovPics, September 15, 2017, by Joe Adrucyk, CC BY 2.0 (https://creativecommons.org/licenses/by/2.0). (b) Screenshot showing the results of a query for Portrait of Picasso in Sitterwerk's online catalog. (Sitterwerk Katalog, accessed May 5, 2020, http://sitterwerk-katalog.ch/books/GM00404317). (c) Screenshot showing the Werkbank collection, "An Enormous Bump of Marvelousness," on the Sitterwerk website. (Werkbank.Sitterwerk, accessed May 5, 2020, http://werkbank.sitterwerk-katalog.ch/table/55f1b1c4fbfcd67e04750b59).

Sitterwerk calls their approach "dynamic order," a system that is non-hierarchical, emergent, multivalent, and perpetually in flux. By describing technologies made for inventory control, Sitterwerk gives agency to the users who power the library's knowledge practices. At any given moment, the library shelves hold a community-composed gathering that is *sui generis*, a design that intentionally defies the universalizing impulse to map all the world's knowledge or to deliver it efficiently.

The Algorithmic Improvisation of the Universal Programmable Library

In *The Library Beyond the Book*, Schnapp and Battles sketch out an array of future library scenarios, seeking to identify some of the qualities that define the institution in an increasingly networked world. One such scenario, titled the "Universal Programmable Library" (UPL), envisions the library as a machine that produces serendipity by combining remix-like curatorial processes with automated movable storage. Like Sitterwerk, their library is exploratory, playful, and unpredictable with a key difference: books and people are no longer the only moving parts. The UPL is inspired by the robotic shelving of Kiva Systems, deployed in some Amazon warehouses. Kiva's "inventory pods" (as opposed to shelves, bins, or tables) sit atop Robotic Drive Units (RDUs) that follow a grid of barcodes along the floor of a warehouse (Figure 10.6). Pod traffic, in which a fleet of moving units seeks out stationary human pickers, is managed through software informed by up-to-the-minute inventory data. In the UPL, that data includes the idiosyncrasies of the personal interests of patrons. "Books swiftly flock and congregate in novel patterns... forming an ever-shifting spatial sodality... presenting the reader with generative labyrinths of renewable serendipity."[26]

But one doesn't have to travel to the future to find examples of how the personal choices of users can influence the spatiotemporal configurations of material objects and people; we need look no further than today's supermarkets and fulfillment centers. To optimize traffic in the chaotic storage of the latter, WMS software moves popular items closer to stationary pickers where, "the fluid constitution and configuration of the inventory is a dynamic index of consumer demand mediated through the bar code and mapped onto space."[27] If the picker is mobile, their actions may be directed through wearable devices, working "hands-free" (scanning rings and armbands) or "eyes-free" (headset with synthetic human voice), as they move methodically along paths shaped by far away shoppers. Grocery store chains such as Kroger, Inc. and Walmart attempt to choreograph the movement of shoppers themselves, tracking their trajectories in an endless feedback loop. "Planograms," or updatable, algorithmically generated shelving layouts, combine purchasing patterns with analytics such as "walk rates" and even eye movement to generate arrangements that aim to maximize sales.[28]

The IT systems that manage the modular and mobile materials of the warehouse floor or the grocery store aisle to increase profit can easily be appropriated to support remixing, as we saw with Sitterwerk. But a flow of changeable materials does not in and of itself constitute a remix, rather it is the logic by which the materials are combined and the compositions that result that give the form its cultural potency.[29] In his discussion of social media and newsfeeds, Manovich makes a distinction between the *collection*—a searchable selection of elements—and the *remix*—an intentioned, composed arrangement. Schnapp and Battles also call for a "propositional machine that configures instead of just collecting."[30] While the same contents may appear in a collection and a remix, it is the "software-enabled remix operations"—the designed architectures of the reconfigurations—that sets

them apart. To illustrate this difference, Manovich contrasts two browser-based feed readers, one whose content is spatially configured by the user and another served up as a list that can be filtered by categories and keywords. The former is a remix in that a user assembles pre-existing parts that "add up to a gestalt—an organized whole which mirrors the structure of my thinking and behavior."[31] By contrast, the filtered list is merely a collection, given that the relationship between parts is governed by organizing mechanisms, the form and function of which hinder aesthetic composition.

The UPL proposes novel uses for the flow of data and goods enabled by what LeCavalier calls algorithmic logistics in which certain rules are able to play out in unanticipated ways (as distinct from notational logistics that controls the exact paths of things through space and time).[32] In the age of logistics, software, and the cloud, modularity combines with the mobility of media objects that are constantly on the move, multiplying across platforms, devices, and contexts. Indeed, the UPL is exponentially more complex than Sitterwerk. "If pre-software-modularity leads to repetition and reduction, post-software-modularity can produce unlimited diversity."[33] Manovich points to the promiscuity of atomized "microcontent" in which media objects no longer cohere or reference a point of origin as they are manipulated by both human and nonhuman actors. Such "'real time' or 'on demand' modularity," driven by information flows including RSS feeds, social media, user-generated content, APIs (application programming interfaces), or, in the case of warehouse management, consumer choices, complicates the notion of the remix. To address the introduction of updatable media, Navas uses the term "Regenerative Remix" to theorize the "software mashups" that are created by "juxtaposing two or more elements that are constantly updated, meaning that they are designed to change according to data flow."[34] Unlike other forms of Remix (Extended, Selective, and Reflexive), whose "effectiveness depends on the recognition of pre-existing recordings" to achieve their allegorical effects, the cultural validity of the Regenerative Remix is "based on how well those sources are sampled."[35]

The architectures of a library built for the distinctive sampling of the regenerative remix would be unrecognizable to today's researchers. With fixed steel stacks made obsolete, the building itself would be low and flat, expanding horizontally in every direction, the undifferentiated box of the industrial warehouse. The floor would no longer be simply a weight-bearing surface, it would become a spatiotemporal navigation system, its gridded barcodes and GPS coordinates essential infrastructure to manage the rush of books, robots, and people within. As Keller Easterling has observed, in the logistics landscape, "the floor is now arguably the most important architectural surface."[36] Within the cavernous space, everything would be on the move, and all movement would be tracked in feedback loops, joined by data flows from both inside and outside the library. Inventory pods could become small, composed collections of books riding on the backs of RDUs. Users themselves might sit atop electric scooters, small automated vehicles, or moving desks. Interfaces between moving parts would be manifold, distributed across bodies, floors, materials, and devices. Data could include citation chains, bibliographies, idiosyncratic individual collections, use algorithms, user histories, user behaviors, and more. In response to a query, the landscape would reconfigure and the user would be presented with divergent paths leading to surprising intellectual encounters. The ripples of a particularly long reading session, or the naming of a new inventory pod, or the relocation of a single volume might be felt throughout the system. Over time, users would learn to read the landscape itself as a kind of meta remix. The epistemic model that would structure the flow would be the aesthetic potentiality of the regenerative remix.

Conclusion

Inventory management technologies, along with the standard components of the library are ready to be scripted into the practices and ideals of the remix. But as the four case studies demonstrate, having the parts alone is not enough, for it is the mechanisms, the spaces, and systems that govern how those parts work together, which bring the remix model of knowledge into being. To capture this performative dimension, I will conclude with a short thought experiment. Suppose we have a corpus of "previously existing parts," say 50,000 books on a variety of topics. Now consider how one's conception of that collection and its purpose—its constitution, connections, and possibilities—might differ if it were housed in each of the libraries that have been discussed. Let's return to Penrose's *Portrait of Picasso* and imagine the experience of seeking and finding a copy of it through the spaces and systems of SCL, Mansueto, Sitterwerk, and the UPL.

In the SCL, one would find *Portrait* about two-thirds of the way down the spiral line, far from information, past religion, language, the natural sciences, and coming up on history. In Dewey Decimal parlance, the book would sit in 759.6—7 Arts and Recreation/75 Painting/759 Historical, geographic, persons, treatments/759.6 Spanish and Portuguese. That last subcategory—geographic regions of the world—provides a snapshot of the worldview baked into the library's architectures: (1) American and Canadian/; (2) British Isles, England/; (3) Germany and Central Europe/; (4) French/; (5) Italian/; (6) Spanish and Portuguese/; (7) Eastern Europe, Russia/; (8) Scandinavian/; and (9) other geographic areas. On the shelf, the book's neighbors would include other artists with the same national origin, such as Goya or Dali. Further down the line, one would find a jumble of artists from an area encompassing the entire non-Western world.

Within Mansueto, search and retrieval would be a utilitarian exercise, culminating in a delivery that would be quick and precise. Any association the book might have with the ideas embodied in other books would have to be gleaned from lists of entries wrought by algorithms in the online catalog. Querying by keyword would return over a hundred titles that also include the words "Picasso" and "portrait," regardless of whether or not the latter is used literally or figuratively. Oddly, the browse button would deliver a list of books that share little more than a similar sequence of letters in their titles. *Portrait of Picasso* would be followed by *Portrait of Pilar*, a musical recording of opera singer Pilar Lorengar, after which would come the 1959 travel book, *Portrait of Poland*, an outcome that "mirrors the structure" of a search algorithm rather than the thinking of a person.

In Sitterwerk, the book could be found with numerous associates in compositions that appear online and off. On the shelves, for a time, it might sit between Kandinsky and Marc's *Der Blaue Reiter* and the catalog *Sizilien: Von Odysseus bis Garibaldi*; weeks later it would be accompanied by *Diagrams & drawings* by Zdenek Felix and *Begegnungen von Dada bix heute* by Hans Richter. Without a fixed address, the book may also appear in Werkbanks with titles such as "An Enormous Bump of Marvelousness," "Florian," "Sitterwerk Summer Heat," "Play," or the more expected, "Picasso und Seine Werk."

While the previous examples were derived from actual results at the three existing libraries, we can only imagine what the UPL might deliver. To retrieve *Portrait of Picasso*, one would glide through a landscape made legible through a combination of wearable tech and human senses to arrive at the pod "Constructing the Modern: MoMA and Penrose." Moments later, a train of pods titled "Goddesses and Doormats" would pull

up, inviting the reader to place the document within its thematic composite. Though the book would be whisked away down a #MeToo pathway, the digital traces it would leave behind might take the researcher's journey in a new direction.

From this experiment, one can see how a conception of the book is designed into the architectures that determine its mobility—as a unit of knowledge in its rightful place, a product conveniently procured, or a multidimensional cultural object ready to be remixed. Similarly, the design of both built spaces and sociotechnical systems brings into being a concept of use, agency, and action—browsing, retrieving, locating, discovering, connecting, composing, and more. Knowledge design has materialized the difference between an ordered universe, an efficient machine, an aesthetic practice, and a perpetual state of becoming. Realizing the latter two, bringing the remix library into being, can thus be understood as a matter of design.

Notes

1 Madeleine Akrich, "The De-Scription of Technical Objects," in *Shaping Technology/Building Society: Studies in Sociotechnical Change*, ed. John Law and Wiebe E. Bijker (Cambridge, MA: MIT Press, 2010), 205–24.

2 Jeffrey T. Schnapp, "Knowledge Design," in *Herrenhausen Lecture*, Herrenhausen Lectures (Herrenhausen Conference "(Digital) Humanities Revisted—Challenges and Opportunities in the Digital Age," Hannover, Germany: Volkswagent Stiftung, 2013), http://jeffreyschnapp.com/wp-content/uploads/2011/06/HH_lectures_Schnapp_01.pdf; Johanna Drucker, "Knowledge Design and Illusions/Delusions of Agency," *Dialectic* I, no. 2 (October 18, 2017), https://doi.org/10.3998/dialectic.14932326.0001.201.

3 Jeffrey T. Schnapp and Matthew Battles, *The Library Beyond the Book* (Cambridge, MA: Harvard University Press, 2014).

4 Eduardo Navas, "Regressive and Reflexive Mashups in Sampling Culture, 2010 Revision," in *Mashup Cultures*, ed. Stefan Sonvilla-Weiss (Wien/New York: Springer, 2010).

5 Schnapp and Battles, "The Library Beyond the Book," 29.

6 Molly Wright Steenson, "Processing the Library," in *MCHAP Book One, The Americas: The Inaugural Mies Crown Hall Americas Prize Book* (New York: Actar Publisher, 2016), 149.

7 Steenson, "Processing the Library," 150.

8 Schnapp and Battles, "The Library Beyond the Book," 89.

9 Eduardo Navas, "Remix," in *Keywords in Remix Studies*, ed. Eduardo Navas, Owen Gallagher, and xtine burrough (New York: Routledge, Taylor & Francis Group, 2018), 246–58; Lev. Manovich, *The Language of New Media* (Cambridge, MA: MIT Press, 2002).

10 Lev Manovich, "Remix Strategies in Social Media," in *The Routledge Companion to Remix Studies*, ed. Eduardo Navas, xtine burrough, and Owen Gallagher, 1st ed. (New York: Routledge, 2015), 136, https://doi.org/10.4324/9781315879994.

11 Akrich, "The De-Scription of Technical Objects."

12 Samuel Nguma, "Are Libraries Dying? OMA's Seattle Central Library Thinks Not!," *Archute* (blog), January 25, 2016, https://www.archute.com/seattle-central-library/.

13 Jack Stone Truitt, "King County Library System Book-Sorting Crew Reclaims 'National' Title," *The Seattle Times*, November 10, 2015, https://www.seattletimes.com/seattle-news/eastside/when-it-comes-to-sorting-library-books-king-county-is-the-champion/.

14 M.P. Satija and Daniel Martinez-Avila, "Features, Functions and Components of a Library Classification System in the LIS Tradition for the e-Environment," *Journal of Information Science Theory and Practice* 3, no. 4 (December 30, 2015): 62–77, https://doi.org/10.1633/JISTAP.2015.3.4.5.

15 Geoffrey C. Bowker and Susan Leigh Star, *Sorting Things out: Classification and Its Consequences*, First paperback edition, Inside Technology (Cambridge, MA; London, England: The MIT Press, 2000), 10.

16 Satija and Martinez-Avila, "Features, Functions and Components of a Library Classification System in the LIS Tradition for the e-Environment," 64.

17 Bowker and Star, "Sorting Things Out," 5.

18 Doreen Sullivan, "A Brief History of Homophobia in Dewey Decimal Classification," *Overland*, July 23, 2015, https://overland.org.au/2015/07/a-brief-history-of-homophobia-in-dewey-decimal-classification/; Sanford Berman, *Prejudices and Antipathies: A Tract on the LC Subject Heads Concerning People* (Metuchen, NJ: Scarecrow Press, 1971).

19 Tali Balas Kaplan, "Done with Dewey," *ALSC Blog* (blog), April 17, 2012, https://www.alsc.ala.org/blog/2012/04/done-with-dewey/.

20 Satija and Martinez-Avila, "Features, Functions and Components of a Library Classification System in the LIS Tradition for the e-Environment."

21 Jesse LeCavalier, *The Rule of Logistics: Walmart and the Architecture of Fulfillment* (Minneapolis ; London: University of Minnesota Press, 2016), 6.

22 "Chaotic Warehousing: Pros and Cons," Corporate, *Interlake Mecalux Warehouse Storage Solutions*, July 10, 2019, https://www.interlakemecalux.com/blog/chaotic-storage-advantages.

23 "Dynamic Order and the Kunstbibliothek," Institutional, *Stiftung Sitterwerk*, n.d., https://www.sitterwerk.ch/En/Dynamische-Ordnung.

24 Manovich, "Remix Strategies in Social Media," 142.

25 "Dynamic Order and the Kunstbibliothek."

26 Schnapp and Battles, "The Library Beyond the Book," 95.

27 LeCavalier, "The Rule of Logistics," 220.

28 Annie Gasparro and Jaewon Kang, "Grocers Wrest Control of Shelf Space From Struggling Food Giants," *Wall Street Journal*, February 19, 2020, https://www.wsj.com/articles/grocers-wrest-control-of-shelf-space-from-struggling-food-giants-11582108202.

29 Navas, "Remix"; Manovich, "Remix Strategies in Social Media."

30 Schnapp and Battles, "The Library Beyond the Book," 89.

31 Manovich, "Remix Strategies in Social Media," 143.

32 Jesse LeCavalier, "The Restlessness of Objects," *Cabinet*, no. 47 (Fall 2012): 97.

33 Manovich, "Remix Strategies in Social Media," 156.

34 Navas, "Regressive and Reflexive Mashups in Sampling Culture, 2010 Revision."

35 Navas.

36 Keller Easterling, "Floor.Dwg," *Cabinet*, no. 47 (Fall 2012): 98.

Bibliography

Akrich, Madeleine. "The De-Scription of Technical Objects." In *Shaping Technology/Building Society: Studies in Sociotechnical Change*, edited by John Law, and Wiebe E. Bijker, 205–24. Cambridge, MA: MIT Press, 2010.

Berman, Sanford. *Prejudices and Antipathies: A Tract on the LC Subject Heads Concerning People*. Metuchen, NJ: Scarecrow Press, 1971.

Bowker, Geoffrey C., and Susan Leigh Star. *Sorting Things Out: Classification and Its Consequences*. First paperback edition. Inside Technology. Cambridge, MA; London, England: The MIT Press, 2000.

Drucker, Johanna. *Graphesis: Visual Forms of Knowledge Production*. Cambridge, MA: Harvard University Press, 2014.

———. "Knowledge Design and Illusions/Delusions of Agency." Dialectic I, no. 2 (October 18, 2017). https://doi.org/10.3998/dialectic.14932326.0001.201.

Easterling, Keller. "Floor.Dwg." *Cabinet*, no. 47 (Fall 2012): 98–101.

Gasparro, Annie, and Jaewon Kang. "Grocers Wrest Control of Shelf Space From Struggling Food Giants." *Wall Street Journal*, February 19, 2020. https://www.wsj.com/articles/grocers-wrest-control-of-shelf-space-from-struggling-food-giants-11582108202.

Interlake Mecalux Warehouse Storage Solutions. "Chaotic Warehousing: Pros and Cons." Corporate, *Interlake Mecalux Warehouse Storage Solutions*, July 10, 2019. https://www.interlakemecalux.com/blog/chaotic-storage-advantages.

Kaplan, Tali Balas. "Done with Dewey." *ALSC Blog* (blog), April 17, 2012. https://www.alsc.ala.org/blog/2012/04/done-with-dewey/.

LeCavalier, Jesse. "The Restlessness of Objects." *Cabinet*, no. 47 (Fall 2012): 90–7.

———. *The Rule of Logistics: Walmart and the Architecture of Fulfillment*. Minneapolis; London: University of Minnesota Press, 2016.

Manovich, Lev. "Remix Strategies in Social Media." In *The Routledge Companion to Remix Studies*, edited by Eduardo Navas, xtine burrough, and Owen Gallagher, 1st Edition, 135–53. New York: Routledge, 2015. https://doi.org/10.4324/9781315879994.

Manovich, Lev. *The Language of New Media*. Cambridge, MA: MIT Press, 2002.

Navas, Eduardo. "Regressive and Reflexive Mashups in Sampling Culture, 2010 Revision." In *Mashup Cultures*, edited by Stefan Sonvilla-Weiss. Wien/New York: Springer, 2010.

———. "Remix." In *Keywords in Remix Studies*, edited by Eduardo Navas, Owen Gallagher, and xtine burrough, 246–58. New York: Routledge, Taylor & Francis Group, 2018.

Nguma, Samuel. "Are Libraries Dying? OMA's Seattle Central Library Thinks Not!" *Archute* (blog), January 25, 2016. https://www.archute.com/seattle-central-library/.

Satija, M.P., and Daniel Martinez-Avila. "Features, Functions and Components of a Library Classification System in the LIS Tradition for the E-Environment." *Journal of Information Science Theory and Practice* 3, no. 4 (December 30, 2015): 62–77. https://doi.org/10.1633/JISTAP.2015.3.4.5.

Schnapp, Jeffrey T. "Knowledge Design." In *Herrenhausen Lecture*. Herrenhausen Lectures. Hannover, Germany: Volkswagent Stiftung, 2013. http://jeffreyschnapp.com/wp-content/uploads/2011/06/HH_lectures_Schnapp_01.pdf.

Schnapp, Jeffrey T., and Matthew Battles. *The Library Beyond the Book*. Cambridge, MA: Harvard University Press, 2014.

Steenson, Molly Wright. "Processing the Library." In *MCHAP Book One, The Americas: The Inaugural Mies Crown Hall Americas Prize Book*, 148–6. Actar Publisher, 2016.

Stiftung Sitterwerk. "Dynamic Order and the Kunstbibliothek." Institutional, *Stiftung Sitterwerk*, n.d. https://www.sitterwerk.ch/En/Dynamische-Ordnung.

Sullivan, Doreen. "A Brief History of Homophobia in Dewey Decimal Classification." *Overland*, July 23, 2015. https://overland.org.au/2015/07/a-brief-history-of-homophobia-in-dewey-decimal-classification/.

Truitt, Jack Stone. "King County Library System Book-Sorting Crew Reclaims 'National' Title." *The Seattle Times*, November 10, 2015. https://www.seattletimes.com/seattle-news/eastside/when-it-comes-to-sorting-library-books-king-county-is-the-champion/.

11
INTERDISCIPLINARY DESIGN AND TRANSCULTURAL COLLABORATION AS TRANSFORMATIVE REMIX TOOLS

Ian McArthur

Omnipresent digital environments, rapid urbanization, and light speed technological advances are just some challenges eliciting an urgent need for radical transformation in how we educate the designers of the future. Challenging students from diverse cultures and societies to work together on decolonizing design is even more pressing in an era of retrogressive populism turbocharged by the COVID-19 Pandemic, which is the period when this essay was written. Because few design educators have attempted this, we do not have coherent ideas about how to generate the processes to mobilize a decolonized, collaborative ethos to address such totalizing problems. This chapter reflects on remix tactics that generate transformative interdisciplinary and transcultural spaces for "worlding" collaborative design education in ways that deconstruct the assumed dominance of Western design praxis. It does this by unpacking relational cultural processes and discussing synergies emergent from a range of mapping tools and methods applied within China's sociocultural context and its art and design education traditions. The narrative focuses on mad.lab, an intensive 3-week elective for students studying design and design-related curriculum areas, including digital media, computational design, landscape architecture, fine arts, and interaction design at UNSW Art & Design (Sydney), Chongqing's Sichuan Fine Arts Institute, and The School of Architecture, Design and Planning's Design Lab at the University of Sydney. I argue that inroads into design's decolonization are achievable via recombinant frameworks that foster authentic culturally hybrid communities of practice though experimental approaches to mapping, codesign, and participatory methods.

Introduction to mad.lab—An Immersive Urban Collaboration Space

Contemporary design education does not generate enough of the collaborative, transcultural, and interdisciplinary synergies required for "shared vision"[1] on designing resilient, sustained global and urban futures. This stems from our colonial histories and the design industry's perpetuation of a Eurocentric neoliberal status quo. More recently, political trends toward isolationism have exacerbated this.

mad.lab—the mapping and design laboratory—creates immersive collaboration spaces for envisaging new approaches to city-making in the megacity of Chongqing in South West China. mad.lab is an intensive 3-week elective for students studying design and design-related curriculum areas, including digital media, computational design, landscape architecture, fine arts, and interaction design at UNSW Art & Design in Sydney, Chongqing's Sichuan Fine Arts Institute, and The School of Architecture, Design and Planning's Design Lab at the University of Sydney.

Participants engage in studio and fieldwork where experimental and orthodox mapping techniques are adapted, subverted, recombined, and remixed (Figure 11.1). Through a process of direct collaborative interaction, discovery, and de-othering, participants map the city and prototype interactive narratives, placemaking concepts, innovative services, applications, and site-specific public art.

I begin with a description of mad.lab's heutagogy[2] of transcultural, interdisciplinary design-led mapping and collaboration and discuss its relevance to the digital humanities and remix studies (RS). This precedes analysis of the Sino-Australian urban context, Chongqing's uniqueness as a laboratory for prototyping urban futures, and how digital humanities and remix studies are relevant to these themes. I follow this with an account

Figure 11.1 mad.lab is designed to immerse diverse communities of practice and culture in situated collaboration (Image: McArthur, 2018)

of mad.lab's collaborative methods and mapping tools. A case study illustrates how dérive-like urban drifts and sound mapping were remixed as participatory research within "The Grid,"[3] a collaborative sonic exploration of Chongqing, Sydney, and London for Project Anywhere, a global art project exploring "the outermost limits of location specificity."[4] I then outline mad.lab's transcultural and interdisciplinary framework with reference to issues of otherness and "elsewhere." In conclusion, I reflect on possible implications and impact of COVID-19 on the future of mad.lab and transcultural, interdisciplinary design collaboration.

mad.lab, Remix Studies, and Digital Humanities

mad.lab is a "co-languaging" platform. It extends on calls for a re-languaging of design[5] in its bilingual deconstruction of Western design discourse and practice. Approaching Chongqing's urban context through the lens of mapping, mad.lab generates new urban narratives through experimentation, storytelling, journeys, film, audiovisual recordings, cartographic techniques, and explorations. Project briefings, critiques, and interactions are conducted in Chinese and English in a mode where the ubiquitous use of mobile translation technologies is augmented by bilingual boundary agents who emerge as information and process brokers from within the participating cohort. This ensures cohesion and coherence of the group processes in the studio and fieldwork. These boundary agents[6] tend to be Chinese international students who help mediate the digital and analog boundary objects[7] that emerge.

As Schofield et al. observe, Digital Humanities (DH) is an ill-defined and contested domain[8] where design and design education are outsiders. However, mad.lab's collaborative methodologies and the use of digital tools align with claims of equivalence between digital humanities and co-creation. digital humanities is "an umbrella term for a wide array of practices for creating, applying, and interpreting new digital and information technologies."[9] mad.lab participants experience the design process as a "…sustained, multidisciplinary, and collaborative engagement with digital processes and materials."[10] Fraser's integration[11] of: 1) the interdisciplinary nature of cities as objects of inquiry, 2) applications of diverse overlapping disciplinary traditions and methodologies to urban phenomenon, and 3) the theorizing of interdisciplinary hypotheses around contemporary and future (digital) city projects is similarly resonant in establishing mad.lab in relation to emerging geospatial and urban fields within digital humanities.

mad.lab taps into the potency of "remix" to "powerfully appropriate anything that comes to hand."[12] The plurality of the "mix: : match: : mash: : manifest" formulation in digital humanities posed by Schnapp et al.[13] describes mad.lab's dialogic, generative "mashing-up" of creative processes, disciplinary skill sets, mapping tools and techniques, art and design technologies, Western and non-Western ontologies, traditional and contemporary urban cultures, pedagogic practices, languages, and stakeholder agendas. This mirrors Irvine's description of how street artists

> use the city as a visual dub studio, extending the combinatorial principles from multiple image and graphic genres to expand appropriation, Remix, and hybridity in every direction: image sources, contemporary and historical styles, local and global cultural references, Remixed for contexts and forms never anticipated in earlier postmodern arguments.[14]

Figure 11.2 mad.lab projects produce outcomes at scales from the body to the precinct. Left image: *Abject Glass*, Eliza MacDonnell, 2018. Right image: *The Layer*, Ruoxue Chen, Jiahao Li, Jinlong Li, 2018

Integrating these tactics with a transcultural and interdisciplinary framework where recombinant methods and tools are deployed, mad.lab models an immersive decolonizing and de-othering design-led heutagogy. Through collaboration, participants in mad.lab begin to interrogate and question dominant Eurocentric understandings of design.[15] This acts as a platform for generating transformational collaborative urban art and design practice at a range of scales from the body to the precinct (Figure 11.2). Our ubiquitously constructed and mediated otherness is ruptured as students grapple with the complexity of co-creation, culture, communication, and city-making. The transformative potential of this immersive experience of language, culture, media, food, urban space, and design on individuals and their creative practices quickly becomes apparent.

Metadesign, Digital Humanities, and the Sino-Australian Urban Context

The spatial turn in digital humanities [16] has relevance for how designers might think critically and collaboratively about the complex interconnected Sino-Australian urban context mad.lab is enacted in. China is the fastest urbanizing country.[17] By 2030, one in eight people on earth will live in a Chinese city.[18] The McKinsey Global Institute's "Preparing for China's Urban Billion" Report[19] famously forecast that by 2025, China will have 8 megacities, 11 economic clusters of, on average, 60 million people each and over 900 smaller cities. In 2019, rates of urbanization in China had reached 60% with projected rates of 70% by 2030. It is less well acknowledged that China and Australia share a common destiny as societies where urbanization is reaching saturation levels. By 2014, Australia was already experiencing rates of urbanization[20] approaching 90%, with 90% of the population living in just 0.22% of the country's land area.[21]

Sino-Australian problems with rapid urbanization exemplify the need for practitioners and educators to work in ways that reflect the "joined-up"[22] nature of our relationships to the world and the need to be cognizant of the organic, biologic nature of the cities that humans create. China's reemergence exerts conspicuous economic, political, social, cultural, and ecological effects globally. Therefore, understanding China and how

to collaborate with its people is crucial for sustained urban futures. Despite this, the extremes, consequences, and contradictions of wild capitalism have set China, Islam, and the West on a collision course. Unless a constructive engagement is found, economic, social, and ecological collapses are realistic scenarios.[23] China's recent tensions with the West make this even more apparent.[24]

As a potential and optimistic remedial tactic, Metadesign prompts designers to use collaborative, re-combinatory, and relational processes involving many stakeholders to find solutions through codesign rather than dominant commerce-driven models of design.[25] mad.lab applies Metadesign via a diversity of synergistic practices. The intent is to promote transcultural, interdisciplinary, and collaborative literacy in an open codesign environment that resists the status quo and reforms current design education practices. When creatives from diverse disciplinary, cultural, and language traditions work together in joined-up ways to develop common ideas, there is greater potential to glimpse what new sustainable ways of urban living might be like. Wood observes that bringing the "art of recombination" up-to-date, transformation designers must move away from designing single products and pay increased attention to the relationships that interconnect them. "This will mean learning to think beyond the dualistic and reductionist mindset of Western thought."[26]

The communication and collaboration challenge for the West is highlighted by Juillien[27] who asserts: "China is often presented to us in this category of the inverse or flipside [envers]. Because that way, we don't step out of our thought: since the opposite is nothing but the reversal of our position."[28] Juillien asks: "...how can we knit together an encounter between two patches of thought that are ignorant of each other, as is the case with Chinese and European thought, and introduce a mediation between them?"[29] Our response is made more complex because interpretations of information, concepts, and experiences are shaped by semiotic structures embedded within cultural environments. The relevance of semiotics to the Chinese experience, however, is a question for further research. Chinese artists and academics have suggested anecdotally to me that Western semiotic theory may not be applicable to Chinese ontology. However complex the context, an urgent need for an authentic decolonized shared vision for our conspicuously problematic urban futures remains.

The impasse is entangled with emergent hydra-headed global crises, which design is complicit in perpetuating. In part, the deficiency of contemporary design to deal with this is due to the design education process—generally, we teach to simple problems and are ill-equipped to solve the many complex problems of the twenty-first century. China's urban environments face the similarly complex challenges we see emerging around the planet, but they manifest at an enormously amplified scale and speed, and in particularly provocative forms.[30] mad.lab's response is to formulate and action collaborative methods of addressing urban challenges through adaptive, recombinant, experimental group methods applied in the context of Chongqing's unique urban fabric. Before discussing this further, it is important to understand the relevance of Chongqing to the overarching conditions outlined earlier.

Chongqing—A Laboratory for the Future

Although most in the West remain unaware of its existence, some suggest that Chongqing is the largest, most rapidly expanding city on the planet. Situated 2500 km up the Yangtze River from Shanghai, Chongqing is the primary economic hub of South

West China and the fourth municipality in China (after Beijing, Shanghai, and Tianjin). Chongqing covers an area of 82,000 km[2] with an estimated total population of up to 32 million.[31] Depending on the source of information, around 8.5 million people live in urban Chongqing. The Chongqing culture is known locally as "wharf culture" due to the city's location at the confluence of the Yangtze and Jialing rivers.[32] Because of the high level of traffic along these waterways, local people have become both tolerant and curious about the new and tend to be very open to innovation in the urban context. This has also been attributed to the influx of people from different parts of China in the wartime period when Chongqing was the capital of China[33] and many different ethnic cultures mixed together. Although there have been moves to restrain growth, around 1500 people move to Chongqing every day.[34]

As an important "benchmark" city, Chongqing has been allocated the responsibility of demonstrating the principle of "Priority to carry and try" with the accompanying "Right to trial-and-error."[35] Decentralized from central government to the local level: "the basic requirement is to boldly try, dare to break without fear of misunderstanding, be unafraid to oppose, tolerate error and failure."[36] Under these conditions, innovation is an essential requirement for the development of advanced forms of urbanization in Chongqing. This has created a unique environment in which to test new forms of art, design, and education practice. In the next section, I discuss mad.lab's methods and tools for this purpose, followed by a case study exampling how remix techniques have been applied.

mad.lab's Mapping and Design Methods and Tools

mad.lab's underpinning methodology is to focus on small pieces of the city. Here interactions, perceptions, and experiences can be observed, recorded, and re-expressed through collaborative adaptation and reuse of a toolbox of mapping methods. mad.lab uses five mapping tools as experimental, visual, emotional, and intuitive processes designed to disrupt and reframe assumptions about urban experiences. Initial dérive-like tactics are subsequently augmented with observational processes, development of cultural probes, personas, scenarios, and user experience mapping in bespoke combinations. They function as departure points, or in the language of remix—the "stems" from which participants develop their own reformulations. New tools emerge through iteration, customization, and testing in public space. These tools help create concepts, observational studies, urban narratives, and in gathering and recording data in visual, audio, and spatial forms, on public attitudes, specifics of urban typology, hierarchies, movement, flow, infrastructure, and density. The mad.lab toolbox includes the following features.

The Dérive

DeBord's dérive[37] is the molecule that all mad.lab's processes are built upon. It prompts an experiential, psychogeographic response to the city informing trajectories of enquiry into previously unforeseen issues or opportunities for intervention. Participants are introduced to the notion of the "drift" through urban space[38] via key texts,[39] software applications, walking methods, points of departure, and historical precedents, including Baudelaire's flâneur.[40] By developing personal narratives, participants document their journeys in any medium, remixing their own dérive methodologies on the fly. The resulting drawings, photographs, videos, notations, and audio recordings are critiqued and discussed in studio.

Figure 11.3 Observational map created using "The Stakeout" tool (Image: Peter Davidson, 2015)

The "Stakeout"

The "Stakeout" was originally formulated by mad.lab participants in 2015 (Figure 11.3) and is distributed as a rudimentary kit for documenting sequential site surveys conducted over 2-hour period.[41]

The following data is recorded at 15-minute interval over a predetermined period: 1) Head count, 2) average age, 3) individuals, 4) groups, 5) activities/spaces/people engaged with, 6) entry and exit points and times, 7) assumed intentions, 8) estimated time of stay, 9) areas of congregation, 10) passive and active space, 11) special activities, 12) weather, 13) traffic, 14) areas of congregation, 15) congestion points, 16) light, 17) ventilation, 18) use of exits/entries, 19) atmospheres, 20) mood and feel, 21) engagement w/retailer, 22) lighting, 23) wayfinding, 24) engagement with digital artifacts, 25) seating, 26) event spaces, and 27) what people are doing in the space. This is recorded in a range of diagrammatic and tabular formats for reuse and integration into more detailed graphic mappings, or to articulate an overview of the way a site is used by citizens.

Cultural Probes

Cultural probes[42] build on ideas proposed by the Situationists and function as an adaptive, creative tool rather than a scientific mechanism for gathering hard data. Instead of providing subjects with kits, including maps and postcards as proposed by Gavers et al.,[43] the probe is reformulated in response to the cultural context of mad.lab. For example, in mad.lab 2015, cards were distributed to local people asking them to cite their personal mantra about the city. This was iterated upon using chalk and pavement

181

Figure 11.4 Remixed cultural probes. Left image: Community lighting installation designed by Harry Copas mapping local resident's daily journeys using mobile GPS apps (Image credit by Eloise McCrea-Steele, 2019); Right image: Mapping to learn how citizens describe and feel about Chongqing (Image credit: Jacinta Stewart-O'Toole, 2015)

by passersby in one of Chongqing's public squares. In 2019, a mobile phone with a GPS tracking app was given to residents to map daily journeys as the basis of a proposed lighting installation for dark entrances in local community housing (Figure 11.4). These instances also illustrate the fluid interplay between digital and analog tools within mad.lab.

Personas and Scenarios

Personas and scenarios encourage an articulation of potential end users, contextual, or problem scenarios that are then interpreted and inform design processes, documentation, and presentation. Methods for communicating how design concepts will work in the real world distributed via the OpenIDEO platform[44] provide templates. These are adapted to make discoveries that may otherwise be bypassed because of bias, preconceptions, and assumptions about factors, including end users, interface design, culture, or site.

User Experience Mapping

User Experience Mapping enables testing of concepts in terms of user experiences from the moment of contact and throughout the experience journey. Adaptive remixing of open-source tools from OpenIDEO[45] and Adaptive Path[46] enables participants to better understand how their project will function. Mapping user interactions across a project ecosystem generates visual artifacts that students have acknowledged reveal critical factors that may not have been considered and provide more holistic overviews of the systems being designed.

The five tools are framed as reconfigurable urban research methods for responding to the range of possible trajectories outlined in the mad.lab design brief. Encouragement is given to adapt, remix, and redesign the tools to formulate site-specific research methods. Formulation of new mapping tactics for engaging with citizens and the urban fabric facilitates the conceptualization of new interventions. Iterating and reinterpreting these cognitive mappings of the city then informs and supports the development of a design proposal.

Since 2016, mad.lab has attracted much more participation from media students working in digital interaction and sound-based practice. This has expanded the available tactics for mapping the city. Sound mapping has been introduced as an augmentation of the dérive with dedicated activities directing engagement in this method of urban encounter. The following case study exemplifies synergies drawing on adaptive, participatory repurposing of mad.lab's dérive as fieldwork, the urban fabric of Chongqing, and a collaborative sound art practice encompassing telematic improvisation and radio art.

Case Study—Remixing the Dérive

UK-based artist and academic Annie Morrad[47] has collaborated with me on transcultural and interdisciplinary projects since 2001. The networked, emergent qualities of our more recent online sonic collaborations[48] situate our work within telematic[49] and technoetic[50] art practices. Annie plays improvised alto, tenor, and soprano saxophone from her base in the United Kingdom, while I broadcast electronic sounds, guitars, and field recordings from Sydney. "The Grid" is a research project where we explored methods for how artists in diverse global cities could co-create new online performance spaces.[51]

Throughout 2018, we engaged with urban grids via improvised music, participatory processes, street interviews, and field recordings. We composed, performed, and remixed material derived from or inspired by our activities in London, Sydney, and Chongqing and deployed them in broadcasts, video, and installation works. Where possible, we collaborated with others.

mad.lab provided an opportunity to introduce recombinant participatory processes by gathering and remixing the collective responses to Chongqing's sonic environment by the 60 mad.lab participants in 2018. A fieldwork activity was facilitated, adapting the dérive into a soundwalking process.

Instructions drawing on the work of Hildegard Westerkamp[52] were remixed leaving scope for individualized, self-directed, and interpreted outcomes (Table 11.1). The outputs were compiled by participants and an interactive sound map was produced. Additional sound works were created by participants and integrated into installations exhibited as mad.lab outcomes. The field recordings of all participants were remixed into an hour-long composition and broadcast on the Wave Farm[53] program *Itinerant Mind* in December 2018.[54] This activity was repeated during mad.lab 5 in December 2019.[55]

This type of adaptive collaborative, transcultural, and interdisciplinary learning is urgently needed to motivate and equip graduates as transformation agents in our rapidly urbanizing, hyper-connected world. Because so few educators have focused on bringing together participants from diverse cultures in codesign processes, we do not have many coherent ideas about how new synergies emerge from transcultural, interdisciplinary, collaborative creativity. The rationale behind transculturalism and interdisciplinarity as a remix framework is discussed in the next section.

Transculturalism and Interdisciplinarity as a Remix Framework

Transculturalism appeared in Russia as a concept useful in comparative analysis of different cultures during the 1980s as a response to the "systemic crisis of the Soviet civilization."[56] Hofstede[57] argued that culture is "…the collective programming of the mind which distinguishes the members of one group or category of people from another."[58] Epstein states the transcultural lens frames culture and cultural development as "an

Table 11.1 The dérive as sound-walking process

Groups and destinations:	On site:	Deliverables:
Form self-organised groups. Each group will be randomly allocated destinations across Chongqing.	Go to your destination; wander and find somewhere to sit. Be patient and quiet. Give yourself and your ears time to open up. It's important to privilege your sense of hearing over your sense of sight. Try to listen deeply into the environment. Begin to note or draw a response to the sounds you hear (a blindfold is a good idea). Draw but do not look at your environment. Note as much information as you can. Try a combination of sketches and words. Give yourself 45 minutes for this. Alternatively, blindfold yourself and have a partner guide you through the space noting sounds you encounter. Create a map of your route and the sounds heard. During your encounter: make a recording of 10 minutes of sound; photograph your environment; and take a selfie as evidence of your visit.	A sound-map. Notate and/or draw the soundscape (minimum of 45 minutes). A sound recording (10 minutes duration). Photographs documenting the site. A 'selfie' photograph at the location.

alternative to both levelling globalism and isolating pluralism."[59] This allows us to transcend the limitations of traditional backgrounds constrained by "ethnic, national, racial, religious, gender, sexual and professional" mores and practices: "…transculture depends on the efforts of separate individuals to overcome their identification with separate cultures."[60]

This presents an ambiguity that can be difficult to manage. Epstein suggests that we must go to the edge of our own experiences as individuals because:

> "We acquire transculture at the boundaries of our own culture and at the cross-roads with other cultures through the risky experience of our own cultural wanderings and transgressions ... Transculture is the sphere of all possible differences from existing cultures inasmuch as we cognize them and distance ourselves from them. Transculture cannot be described in positive terms, as a set of specific cultural symbols, norms, and values; it always escapes definition."[61]

Similarly, when discussing interdisciplinarity, ambiguity is present. Jensenius argues,

> interdisciplinary research addresses topics that are too broad to be understood by a single discipline, and have too many aspects than could even be addressed by a multi-disciplinary team working on a single subject.[62]

The term *interdisciplinary* is somewhat contested. In Stember,[63] Repko et al.,[64] and Jensenius,[65] the word interdisciplinary is sometimes used to refer to processes that are in fact multidisciplinary. But whereas multidisciplinary processes are characterized by individuals from different professional areas of practice working together and drawing on their own disciplinary expertise, interdisciplinary implies a more integrated approach, process, and outcome. Repko[66] asserts: "Multidisciplinarity refers to the placing side by side of insights from two or more disciplines," arguing that in multidisciplinary processes: "the relationship between the disciplines is merely one of proximity...there is no real integration between them."[67] Stember breaks down the structure of interdisciplinary suggesting,

> The word interdisciplinary consists of two parts: Inter and disciplinary. The prefix inter means "between, among, in the midst," or "derived from two or more." Disciplinary means "of or relating to a particular field of study" or specialization. So a starting point for the definition of interdisciplinary is between two or more fields of study...[68]

How this framework is deployed in mad.lab is critical to the decolonizing of design through the voices, histories, concepts, and practices of the non-Western world. mad. lab activates experiences that are nontraditional for all its participants, and this begins to break down the endemic "Otherness" of practitioners located "Elsewhere," that delineates so much of what design is understood to be.

Otherness and Elsewhere

Maturana asserts the human cultures in which we live constitute the medium in which we are realized. By engaging in conscious reflexive de-othering, we become more aware that we may choose the way we live: "...according to our aesthetic preferences, and live in one way or another according to the human identity we wish to conserve..."[69] In the recognition of ourselves in the Other, we are empowered to consciously choose to build authentic people-to-people relations. However, as in the "real world" of practice, including academic and research contexts, these processes have historically proven to be

problematic due to the hegemonic influences and forces of colonialism. Spivak[70] refers to Foucault's assertion of a form of epistemic violence against the Other and suggests it is important that:

> ...the subtext of the palimpsestic narrative of imperialism be recognized as "subjugated knowledge", "a whole set of knowledges that have been disqualified as inadequate to their task, or insufficiently elaborated: naïve knowledges, located low down on the hierarchy, beneath the required level of cognition or scientificity".[71]

Under colonialism, the subaltern has had to affect Western ways of knowing the world and to articulate their experience of the world within the "validated" constraints of the West. Sharp posits,

> Western intellectuals delegate other, non-Western (African, Asian, Middle Eastern) forms of knowing—of acquiring knowledge of the world—to the margins of intellectual discourse, by re-formulating said forms of knowing as myth and as folklore.[72]

Postcolonial discourse acknowledges the constructed Other has a voice and the capacity to express itself.[73] Because such expression is often coded in ways that Westerners, in particular, may be unable, or not equipped to hear, this voice is commonly forgotten, ignored, or erased.

More problematic is the Westerner's attempt to represent the voice of Others. Already stifled in colonial histories, the Other may remain silent and inarticulate despite attempts on the part of Western intellectuals to restrain themselves from speaking on their behalf.[74] Bignall and Patton point to the inconvenient reality that:

> ...the act of "speaking about" oneself, others or particular aspects of the world involves constructing and delimiting a representation of the object of one's speech, which renders it manageable and comprehensive, but also threatens to ossify into a set of assumptions and understandings, a habitual knowledge outside of which one eventually finds it hard to think. It also becomes difficult to "hear" alternative representations when they are spoken, because they do not neatly fit with established ways of making sense. In the context of postcolonialism, the problem of representation is highly politicised because many of the world's established and ossified forms of representation emerged and were consolidated with colonialism; for the "West" to think outside of these established structures of meaning and 'hear' the alternative sense of the Other involves a certain effort and a political and ethical choice, which rarely seems to be made—either because the effort required to register the existence of the problem is "too great", or because the West has a vested interest in remaining "deaf" to the alternative worlds "spoken" by post-colonial subjects.[75]

How we use language to understand, and describe our: "...progressive construction of alterity..."[76] is manifestly important. Immersion in the world of the constructed Other and a journey of experiential transformation may be the only ways to occupy the postcolonial in a substantial and transformational way. It is through a desire to engage with the ambiguity of the constructed Other that we activate and amplify modes of collaborative practice

that reflect the actual nature of our relationships to the world. This requires us to question "...the pre-notioned, or the pre-categorized, or the pre-questioned, that is to say, that which constitutes our theoretical pre-suppositions."[77] Recognizing the Other as an embedded linguistic and philosophic instrument, Jullien posits the "elsewhere." He states,

> Elsewhere is indeed a given: the Chinese and European worlds didn't communicate with each other until relatively recently. The other, as it has been known since Plato's Sophist, is the tool of a philosophical grammar, the necessary instrument of every dialectical elaboration. ... the elsewhere establishes itself, while alterity or otherness, if there is any, is to be constructed, and here this entails an operation of reflection—reflection in the proper sense—between the two fields concerned.[78]

As Jullien and others such as Hall[79] suggest, even with our unprecedented state of interconnectivity, our histories and sociocultural constructs constrain our perspectives, confine us to stereotypical representations[80] of cultural Others that do not necessarily reflect the physical or social entities they ostensibly represent.[81] The following conclusions seek to frame mad.lab as a mediator, and in a sense, as a microcosm of the Sino-Australian problem of collaboration.

mad.lab—Conclusion and Implications

A key element of this chapter has been situating mad.lab—an urban design laboratory—within the digital humanities and remix studies. This is substantiated in mad.lab's use of digital tools and spaces for mapping and narrativizing the Chinese city, and in its recognition of,

> ...the expanded, global nature of today's research communities as one of the great disciplinary/post-disciplinary opportunities of our time. It dreams of models of knowledge production and reproduction that leverage the increasingly distributed nature of expertise and knowledge and transform this reality into occasions for scholarly innovation, disciplinary cross-fertilization, and the democratization of knowledge.[82]

mad.lab's model of knowledge production and reproduction manifests a collaborative, co-language, and distributed expertise that deconstructs the assumptions, prejudices, and biases of Western design, re-modulating the relationships between culture, discipline, and the megacity. Narratives that emerge from the remix of methods and tools used in mad.lab also re-modulate relationships between participants, institutions, city, and digital tools.

Critically, mad.lab's collaborative processes also produce the conscious reflexive de-othering to which Maturana refers.[83] The recursive conversations within the studio and fieldwork enable what participants experience and seek to express in terms of their cultural and disciplinary backgrounds, to be heard. This disrupts the cultural and disciplinary status quo by accelerating intense development of deep learning, new relationships, conciliant behaviors, understandings, and attitudes. As Maturana posits, it is in achieving this we can say that we understand each other more than would be otherwise possible. The impact on participants has the effect of deconstructing underlying prejudice, bias, or misunderstandings, and reformulates their understandings of what design

is and what it can do. mad.lab's replication of this process through five successive annual iterations evidences a worlding process for remixing Western-centric design to meet the wicked challenges of transcultural and interdisciplinary collaboration.

By responding directly to Maturana's call for becoming more responsible for what we do,[84] mad.lab confronts participants with critical questions about our desires for the kind of world we want to design and what our responsibilities are in bringing that world into existence. The sustainment and complexity of our shared urbanized futures demands a codesigned coexistence. This is a responsibility artists, designers, and educators in the West or non-West could choose to relinquish regardless of discipline and culture, but the already visible consequences are severe.

mad.lab's heutagogy is premised on the argument that creative practitioners and educators should be actively facilitating, redefining, and decolonizing design's status quo. In practice, this means collaboratively de-othering and remixing the described methods and mapping tools, to sustain a new cultural and disciplinary framework for conceptualizing our shared and interconnected twenty-first century urban futures.

Within the Sino-Australian urban context, further design research is urgently required to explore whether our Euro-centric design professions can meet the collaboration challenges related to China's inherently collective cultural context. This uncertainty is also characteristic of the Sino-Australian relationship more broadly. What theories, technologies, and processes can design, digital humanities and remix studies contribute in a changing global urban paradigm where China's role is more significant than ever? These complex questions have been made more difficult by the COVID-19 pandemic in 2020.

In hindsight, The Grid's remix of the dérive, sound mapping, and online radio was prescient in anticipating the recent rapid emergence of new experimental online performative and education spaces as a response to COVID-19. The increasing profile of digital technologies in mad.lab combined with Chongqing's extraordinary urban media ecology provides opportunities for exploring the questions emerging out of mad.lab's collaborative experience.

Central to the questions emerging are those sticky ones that pertain specifically to the themes and potentiality of Sino-International collaboration. The experience of mad.lab is one where participants continued to encounter and challenge existing assumptions that are based on our respective performative cultures and design histories. Such assumptions serve to create misunderstanding and entrench the status quo of Western design and design education. To a significant degree, these assumptions have been shaped by the colonialism inherent to Western design. This is a constraint on codesign that Australian, Chinese, and other international practitioners working in design, Digital Humanities (DH), and remix studies must work to transcend in the post-COVID-19 era.

Notes

1 Ezio Manzini, "A Laboratory of Ideas: Diffuse Creativity and New Ways of Doing." MERONI, Anna. *Creative Communities*. Milão: POLI.design (2007): 13–15.

2 "What is Heutagogy?." *Heutagogy Community of Practice*. Accessed May 3, 2020, https://heutagogycop. wordpress.com/history-of-heutagogy/.

3 Ian McArthur and Annie Morrad, "The Grid." Accessed May 6, 2020, https://www.projectanywhere.net/the-grid/.

4 Project Anywhere, http://www.projectanywhere.net/.

5 John Wood, "Re-languaging the creative: Designing as a comprehensive act of combination." *Journal of Writing in Creative Practice* 6, no. 1 (2013): 59–70.

6 Yasmin Merali, "The role of boundaries in knowledge processes." *European Journal of Information Systems* 11, no. 1 (2002): 47–60.

7 Susan Leigh Star, and James R. Griesemer, "Institutional Ecology, Translations' and Boundary Objects: Amateurs and Professionals in Berkeley's Museum of Vertebrate Zoology, 1907–39." *Social Studies of Science* 19, no. 3 (1989): 387–420.

8 Ibid.

9 Patrik Svensson, "The Digital Humanities as a Humanities Project." *Arts and Humanities in Higher Education* 11, no. 1–2 (2012): 42–60.

10 Tom Schofield, Mitchell Whitelaw, and David Kirk, "Research through Design and Digital Humanities in Practice: What, How and Who in an Archive Research Project." *Digital Scholarship in the Humanities* 32, no. suppl_1 (2017): i103–i120.

11 Benjamin Fraser, *Digital Cities: The Interdisciplinary Future of the Urban Geo-humanities.* New York: Springer (2015).

12 Eduardo Navas, and Monica Tavares, "Conversation between Monica Tavares and Eduardo Navas." *ARS (São Paulo)* 17, no. 35 (2019): 117–127.

13 Jeffrey Schnapp, Todd Presner, and Peter Lunenfeld, "Digital humanities manifesto 2.0." Accessed May 6, 2020, 2012, https://www.humanitiesblast.com/manifesto/Manifesto_V2.pdf.

14 Martin Irvine, "Remix and the Dialogic Engine of Culture: A Model for Generative Combinatoriality." In *The Routledge Companion to Remix Studies.* Routledge (2014): 39–66.

15 Wendy Siuyi Wong, *Contemporary Design in China: The Road to Modernity and Commercialization.* Lisbon: Design Research Society (2006).

16 Todd Presner and David Shepard, "Mapping the Geospatial Turn." In *A New Companion to Digital Humanities,* West Sussex, UK: Wiley (2015): 199–212.

17 Neville Mars and Adrian Hornsby, *The Chinese Dream: A Society under Construction.* Rotterdam, Netherlands: 010 Publishers (2008).

18 Debra Bruno, "China Expert: China Is Fast Approaching Urban Disaster." *City Lab,* February 8, 2013. Accessed April 23, 2020, https://www.citylab.com/life/2013/02/chin-expert-china-fast-approaching-urban-disaster/4634/.

19 J. Woetzel, et al., *Preparing for China's Urban Billion Report.* The McKinsey Global Institute, New York (2009). Accessed May 2, 2009 from http://www.mckinsey.com/insights/urbanization/preparing_for_urban_billion_in_china.

20 "World Urbanisation Prospects," United Nations. Accessed April 27, 2020, https://population.un.org/wup/Country-Profiles/.

21 Australia, State of the Environment Report 2016, "Population as a Driver of Environmental Change," *Drivers* (2016). Accessed May 2, 2020, https://soe.environment.gov.au/theme/drivers/topic/population-driver-environmental-change.

22 John Wood, Changing the Change: A Fractal Framework for Metadesign, In *Changing the Change: Design Visions, Proposals and Tools. An International Conference on the Role and Potential of Design Research in the Transition towards Sustainability.* Italy: Allemandi Conference Press (2008).

23 Peter Nolan, *Crossroads: The End of Wild Capitalism.* Singapore: Marshall Cavendish Business (2009).

24 Jordan Schneidler, "Two Views On U.S.-China Relations from China: Don't Decouple." April 28, 2020. Accessed May 2, 2020 from https://supchina.com/2020/04/28/two-views-on-u-s-china-relations-from-china-dont-decouple/.

25 John Wood, "Metadesigning Paradigm Change." *Metadesigners Open Network.* 2012. Accessed March 3, 2012, from http://metadesigners.org/tiki/Metadesigning-Paradigm-Change.

26 John Wood, *unpublished.* Accessed October 16, 2019, https://metadesigners.org/.

27 François Jullien, Simon Porzak, and Marcel Gauchet, "Thinking between China and Greece: Breaking New Ground: An Interview with Marcel Gauchet." *Qui Parle* 18, no. 1 (2009): 181–210.

28 Ibid., 183.

29 Ibid., 183

30 "Designing China Seminar in Experimental Critical Theory (SECT)." University of California Humanities Research Institute (UCHRI), 2009. Accessed May 9, 2020, https://uchri.org/events/uchri-summer-seminar-in-experimental-critical-theory-vi-designing-china/.

31 Ian W. McArthur, Matthew Priestman, Brad Miller. "Collaborative Mapping as a New Urban Design Heutagogy." In *Investigating the Visual as a Transformative Heutagogy in the Asia Region.* McArthur, I. W., Bamford, R, Xu, F., Miller, B., eds. Champaign, IL: Common Ground Publishing (2017).

32 Ian McArthur, "Mapping Chongqing's Urban Media Ecology." In *Proceedings of the 4th Media Architecture Biennale Conference*, 1–10. 2018.

33 Ibid.

34 Doug Saunders, "In 100 Years We Will Be an Entirely Urban Species." *The Spectator*, August 7, 2010.

35 Jingwei, Q. I. N. G., and Z. H. O. U. Ling. "Paths for New Urbanization in Chongqing, China: Study on Overall Design and Strategic Framework." *Canadian Social Science* 9, no. 5 (2013): 22–30.

36 Ibid.

37 Guy Debord, "Theory of the Derive."(1958). *Situationist International Anthology* (2012): 50–54.

38 Ibid.

39 Michel De Certeau, *Heterologies: Discourse on the Other*. Vol. 17. Minneapolis, Minnesota: University of Minnesota Press (1986).

40 James Corner, *The Agency of Mapping: Speculation, Critique and Invention*, Wiley Online Library, 2011. DOI: 10.1002/9780470979587.ch12

41 The Stakeout, example template, https://tinyurl.com/yde25b8b.

42 Bill Gaver et al., "Design: Cultural Probes." *interactions* 6, no. 1 (1999): 21–29.

43 Ibid.

44 "Scenarios and Personas." OpenIDEO. Accessed September 2, 2014, https://challenges.openideo.com/challenge/impact/inspiration/using-scenarios-and-personas-to-guide-conceptualization.

45 "User Experience Mapping." OpenIDEO. Accessed September 2, 2014, http://tinyurl.com/h5u4fft.

46 "User Experience Mapping." Adaptive Path. Accessed October 13, 2015, https://tinyurl.com/ugtvseq.

47 Annie Morrad's website, http://annie-morrad-soudandimage.com/.

48 "Itinerant Mind." Wave Farm, https://wavefarm.org/radio/wgxc/schedule/y1e2ta.

49 Michael Rofe and Federico Reuben. "Telematic Performance and the Challenge of Latency." *Journal of Music, Technology & Education* 10, no. 2–3 (2017): 167–183.

50 Roy Ascott, "Cybernetic, Technoetic, Syncretic: The Prospect for Art." *Leonardo*, MIT Press 41 no. 3 (2008): 204–204.

51 Ian McArthur, and Annie Morrad. "The Grid – A film by Morrad+McArthur." *Art Anywhere Symposium*, University of Melbourne, 22 Mar 2019.

52 Hildegard Westerkamp, "Soundwalking." *Sound Heritage* 3, no. 4 (1974): 18–27.

53 "Itinerant Mind." Wave Farm, https://wavefarm.org/radio/wgxc/schedule/y1e2ta.

54 "Itinerant Mind." December 2018, Wave Farm, https://wavefarm.org/wf/archive/x18nrv.

55 "Itinerant Mind" December 2019, Wave Farm, https://wavefarm.org/wf/archive/h2kj56.

56 Mikhail Epstein, "12. Transculture: A Broad Way between Globalism and Multiculturalism." *American Journal of Economics and Sociology* 68, no. 1 (2009): 327–351.

57 Geert Hofstede, "The Archimedes Effect." MH Bond. *Working at the Interface of Cultures: 18 Lives in Social Science*. (1997): 47–61.

58 Oxana Karnaukhova, "Networking through Cultures: Communicative Strategies in Transnational Research Teams." In *Cultural and Technological Influences on Global Business*. IGI Global (2013): 437–446.

59 Epstein, Transculture, 327–351.

60 Ibid.

61 Ibid.

62 Jensenius, Alexander Refsum, "Disciplinarities: Intra, Cross, Multi, Inter, Trans." Jensenius, AR, blog posts,[Megtekintve: 2015.03. 05.], University of Oslo, http://www. arj 2012/03 (2012): 12. Accessed November 10, 2014, http://www.arj.no/2012/03/12/disciplinarities-2.

63 Marilyn Stember, "Advancing the Social Sciences through the Interdisciplinary Enterprise." *The Social Science Journal* 28, no. 1 (1991): 1–14.

64 Allen F. Repko, and Rick Szostak, *Interdisciplinary Research: Process and Theory*. Los Angeles: SAGE Publications, Incorporated (2020): 16.

65 Jensenius, Disciplinarities.

66 Repko and Szostak, Interdisciplinary research, 16.

67 Ibid., 16–17.

68 Stember, Advancing the social sciences, 4.

69 H. R. Maturana, "Metadesign: Human Beings versus Machines, or Machines as Instruments of Human Designs?." (1997).

70 Gayatri Chakravorty Spivak, "Can the Subaltern Speak?." *Can the Subaltern Speak? Reflections on the History of an Idea* (1988): 21–78. p. 77.

71 Ibid.

72 Joanne Sharp, *Geographies of Postcolonialism*. Los Angeles: Sage (2008).

73 Simone Bignall, and Paul Patton, "Deleuze and the Postcolonial: Conversations, Negotiations, Mediations." PhD diss., Scotland: Edinburgh University Press (2010).

74 Ibid., 4–5.

75 Ibid., 4–5.

76 François Jullien, Simon Porzak, and Marcel Gauchet. "Thinking between China and Greece: Breaking New Ground: An Interview with Marcel Gauchet." *Qui Parle* 18, no. 1 (2009): 181–210. p. 182.

77 Ibid., 182.

78 Ibid.,182.

79 E. Hall, "Why China is Misunderstood." ABC Radio, Tuesday, February 5, 2013. Interview with Linda Jakobson, 2013.

80 Zsuzsanna I. Abrams, "Surfing to Cross-Cultural Awareness: Using Internet-Mediated Projects to Explore Cultural Stereotypes." *Foreign Language Annals* 35, no. 2 (2002): 141–160.

81 Angela Mullin-Jackson, *Racial and Cultural Otherness: The Lived Experience of Americans of Korean Descent*. Boca Raton, Florida: Universal-Publishers (2010).

82 Schnapp, Presner, Lunenfeld, Digital humanities manifesto 2.0, 5.

83 Maturana, Metadesign.

84 Ibid.

Bibliography

Abrams, Z. I. "Surfing to Cross-cultural Awareness: Using Internet-Mediated Projects to Explore Cultural Stereotypes." *Foreign Language Annals* 35, no. 2 (2002): 141–160.

Adaptive Path. "User Experience Mapping." Accessed October 13, 2015. https://tinyurl.com/ugtvseq.

Ascott, Roy. "Cybernetic, Technoetic, Syncretic: The Prospect for Art." *Leonardo* 41, no. 3 (2008): 204.

Australia, State of the Environment Report 2016. "Population as a Driver of Environmental Change." *Drivers*. Accessed May 2, 2020. https://soe.environment.gov.au/theme/drivers/topic/population-driver-environmental-change.

Bignall, Simone, and Paul Patton. "Deleuze and the Postcolonial: Conversations, Negotiations, Mediations." PhD diss., 5–6. Edinburgh, Scotland: Edinburgh University Press, 2010.

Bruno, Debra. "China Expert: China is Fast Approaching Urban Disaster." *CityLab*, 2013. Accessed April 17, 2014 from https://www.citylab.com/life/2013/02/chin-expert-china-fast-approaching-urban-disaster/4634/.

Corner, James. *The Agency of Mapping: Speculation, Critique and Invention*. Wiley Online, 2011. DOI 10.1002/9780470979587.ch12.

Debord, Guy. "Theory of the Derive." (1958). *Situationist International Anthology* (2012): 50–54.

De Certeau, Michel. *Heterologies: Discourse on the Other*. Vol. 17. Minneapolis, Minnesota: University of Minnesota Press, 1986.

De Certeau, Michel. *The Practice of Everyday Life*. Berkeley and Los Angeles, CA: UC Press, 1984.

"Designing China Seminar in Experimental Critical Theory (SECT)," University of California Humanities Research Institute (UCHRI). 2009. Accessed 12 December 2012 from http://www.uchri.org/sect.php?cat_id=1&page_id=1337.

Epstein, Mikhail. "12. Transculture: A Broad Way between Globalism and Multiculturalism." *American Journal of Economics and Sociology* 68, no. 1 (2009): 327–351.

Fraser, Benjamin. *Digital Cities: The Interdisciplinary Future of the Urban Geo-Humanities*. West Sussex, UK: Springer, 2015.

Gaver, Bill, Tony Dunne, and Elena Pacenti. "Design: Cultural Probes." *Interactions* 6, no. 1 (1999): 21–29.

Hall, E. "Why China is Misunderstood." *ABC Radio*. Tuesday, February 5, 2013. Interview with Linda Jakobson, 2013.

Heutagogy Community of Practice. "What is heutagogy?." Accessed May 3, 2020, https://heutagogy-cop.wordpress.com/history-of-heutagogy/.

Hofstede, Geert. "The Archimedes Effect." *In Working at the Interface of Cultures: 18 Lives in Social Science*, edited by M. H. Bond, 47–61. 1997.

Irvine, Martin. "Remix and the Dialogic Engine of Culture: A Model for Generative Combinatoriality." In *The Routledge Companion to Remix Studies*, edited by Eduardo Navas, Owen Gallagher and xtine burrough, 39–66. New York: Routledge, 2014.

Jensenius, Alexander Refsum. "Disciplinarities: Intra, Cross, Multi, Inter, Trans." Jensenius, AR, blog posts, [Megtekintve: 2015.03. 05.], University of Oslo, http://www. arj 2012/03 (2012): 12. Accessed November 10, 2014. http://www.arj.no/2012/03/12/disciplinarities-2.

Jingwei, Q. I. N. G., and Z. H. O. U. Ling. "Paths for New Urbanization in Chongqing, China: Study on Overall Design and Strategic Framework." *Canadian Social Science* 9, no. 5 (2013): 22–30.

Jullien, François, Simon Porzak, and Marcel Gauchet. "Thinking between China and Greece: Breaking New Ground: An Interview with Marcel Gauchet." *Qui Parle* 18, no. 1 (2009): 181–210.

Karnaukhova, Oxana. "Networking Through Cultures: Communicative Strategies in Transnational Research Teams." In *Cultural and Technological Influences on Global Business*, 437–446. Pennsylvania: IGI Global, 2013.

Manzini, Ezio. "A Laboratory of Ideas: Diffuse Creativity and New Ways of Doing." In *Creative Communities*, edited by Anna Meroni, 13–15. Milão: POLI.design, 2007.

Mars, Neville, and Adrian Hornsby. *The Chinese Dream: A Society under Construction*. Rotterdam, Netherlands: 010 Publishers, 2008.

Maturana, H. R. "Metadesign: Human Beings versus Machines, or Machines as Instruments of Human Designs?" *Instituto de Terapia Cognitiva*. Santiago, 1997. Accessed August 1, 2020. https://cepa. info/652.

McArthur, Ian. "Mapping Chongqing's Urban Media Ecology." In *Proceedings of the 4th Media Architecture Biennale Conference*, 2018. 1–10.

McArthur, Ian. "Activating a Framework for Transcultural Interdisciplinary Collaboration in Design Education: Sino Australian Field Studies." PhD dissertation, Sydney, Australia: UNSW, 2015.

McArthur, Ian, and Annie Morrad. "The Grid." In *Anywhere, Art at the Outermost Limits of Location Specificity*, edited by S. Douglas and S. Lowry, viii. Project Anywhere; Centre of Visual Art (University of Melbourne) and Parsons Fine Art (Parsons School of Design, The New School), 2019a. Accessed March 22, 2019. https://spaces.hightail.com/receive/E9WZy3DuG3 19/12/2019.

McArthur, Ian, and Annie Morrad. "The Grid – A film by Morrad+McArthur." *Art Anywhere Symposium*, University of Melbourne. March 22, 2019b.

McArthur, Ian, Matthew Priestman, and Brad Miller. "Collaborative Mapping as a New Urban Design Heutagogy." In *Investigating the Visual as a Transformative Heutagogy in the Asia Region*, edited by I. W. McArthur, R. Bamford, F. Xu, and B. Miller. Champaign, IL: Common Ground Publishing. 2017.

Merali, Yasmin. "The Role of Boundaries in Knowledge Processes." *European Journal of Information Systems* 11, no. 1 (2002): 47–60.

Moran, Joe. *Interdisciplinarity*. New York: Routledge, 2010.

Mullin-Jackson, Angela. *Racial and Cultural Otherness: The Lived Experience of Americans of Korean Descent*. Boca Raton, Florida: Universal-Publishers, 2010.

Navas, Eduardo, and Monica Tavares. "Conversation between Monica Tavares and Eduardo Navas." *ARS (São Paulo)* 17, no. 35 (2019): 117–127.

Nolan, Peter. *Crossroads: The End of Wild Capitalism*. Singapore: Marshall Cavendish Business, 2009.

OpenIDEO. "Scenarios and Personas." Accessed September 2, 2014. https://challenges.openideo.com/ challenge/impact/inspiration/using-scenarios-and-personas-to-guide-conceptualization.

OpenIDEO. "User Experience Mapping." Accessed September 2, 2014. http://tinyurl.com/h5u4fft.

Presner, Todd, and David Shepard. "Mapping the Geospatial Turn." In *A New Companion to Digital Humanities*, 199–212. Los Angeles: Sage 2015.

Rahimi, Sadeq. "Is Cultural Logic an Appropriate Concept? A Semiotic Perspective on the Study of Culture and Logic." Σημιοτκή-*Sign Systems Studies*, no. 2 (Fall 2002): 455–464.

Repko, Allen F., and Rick Szostak. *Interdisciplinary Research: Process and Theory*. Los Angeles: Sage, 2020.

Rofe, Michael, and Federico Reuben. "Telematic Performance and the Challenge of Latency." *Journal of Music, Technology & Education* 10, no. 2–3 (2017): 167–183.

Saunders, Doug. "In 100 years we will be an entirely urban species," *The Spectator*, August 7, 2010, https://www.spectator.co.uk/article/in-100-years-we-will-be-an-entirely-urban-species.

Schnapp, Jeffrey, Todd Presner, and Peter Lunenfeld. "Digital humanities manifesto 2.0." 2012. Accessed May 6, 2020 from https://www.humanitiesblast.com/manifesto/Manifesto_V2.pdf.

Schofield, Tom, Mitchell Whitelaw, and David Kirk. "Research Through Design and Digital Humanities in Practice: What, How and Who in an Archive Research Project." *Digital Scholarship in the Humanities* 32, no. suppl_1 (2017): i103–i120.

Schneidler, Jordan. "Two Views On U.S.-China Relations From China: Don't Decouple." *SupChina*, April 28, 2020. Accessed May 2, 2020 from https://supchina.com/2020/04/28/two-views-on-u-s-china-relations-from-china-dont-decouple/.

Sharp, Joanne. *Geographies of Postcolonialism*. Sage, 2008.

Spivak, Gayatri Chakravorty. "Can the Subaltern Speak?" Can the Subaltern Speak? Reflections on the History of an Idea, 21–78. New York: Columbia University, 1988. Accessed May 12, 2011 from http://www.mcgill.ca/files/crclaw-discourse/Can_the_subaltern_speak.pdf.

Star, Susan Leigh, and James R. Griesemer. "Institutional Ecology, translations' and Boundary Objects: Amateurs and Professionals in Berkeley's Museum of Vertebrate Zoology, 1907–39." *Social Studies of Science* 19, no. 3 (1989): 387–420.

Stember, Marilyn. "Advancing the Social Sciences through the Interdisciplinary Enterprise." *The Social Science Journal* 28, no. 1 (1991): 1–14.

Svensson, Patrik. "The Digital Humanities as a Humanities Project." *Arts and Humanities in Higher Education* 11, no. 1–2 (2012): 42–60.

Westerkamp, Hildegard. "Soundwalking." *Sound Heritage* 3, no. 4 (1974): 18–27.

Woetzel, J., L. Mendonca, J. Devan, S. Negri, Y. Hu, L. Jordan, X. Li, A. Maasry, G. Tsen, and F. Yu, et al. *Preparing for China's Urban Billion Report*. The McKinsey Global Institute. 2009. Accessed May 2, 2009 from http://www.mckinsey.com/insights/urbanization/preparing_for_urban_billion_in_china.

Wong, Wendy Siuyi. *Contemporary Design in China: The Road to Modernity and Commercialization*. Lisbon: Design Research Society, 2006.

Wood, John. unpublished. Accessed October 16, 2019 from https://metadesigners.org/.

Wood, John. "Re-Languaging the Creative: Designing as a Comprehensive Act of Combination." *Journal of Writing in Creative Practice* 6, no. 1 (2013): 59–70.

Wood, John. "Metadesigning Paradigm Change." *Metadesigners Open Network*, 2012. Accessed March 3, 2012 from http://metadesigners. org/tiki/Metadesigning-Paradigm-Change.

Wood, John. *Co-designing Team Synergies within Metadesign*, 165. Shanghai, 2010.

Wood, John. "Changing the Change: A Fractal Framework for Metadesign." In *Changing the Change: Design Visions, Proposals and Tools. An International Conference on the Role and Potential of Design Research in the Transition towards Sustainability*. Allemandi Conference Press, 2008.

"World Urbanisation Prospects." *World Urbanization Prospects: The 2018 Revision*. United Nations, Department of Economic and Social Affairs, Population Division, 2018. Accessed April 27, 2020, https://population.un.org/wup/Country-Profiles/.

12

IN THE MIX, THE COLLABORATIVE REMIX TO REPAIR, RECONNECT, REBUILD

Vicki Callahan, Nicole Richter, Christina Lane, and Daniel Clarkson Fisher

As a group of scholars that work within and across the critical and creative divide, we began thinking about a workshop on the possibilities of the video essay for the Spring 2018 Society for Cinema and Media Studies Conference.[1] As we all had distinct research and creative interests within media studies, we originally thought it might be productive to take one topic and see how we might each approach it differently across strategies within the remix form, such as the videographic essay, digital argument, and Gregory Ulmer's "MEmorials" or "electronic monuments" (i.e., media works that serve to witness the spectacle of violence in contemporary culture).[2] In our conversations, we were excited by how our collaborative workshop, which we entitled *In the Mix*, might particularly address the issue of "authorship" so central to the video essay and media studies. However, the historical moment looming over us inspired our further interrogation of the term. How might we contest a singular voice and narrative trajectory as an apt response to an increasingly homogenous and autocratic governing regime? As per Virginia Kuhn, remix can be an especially effective way to speak truth to power due to its dialogic potential of setting multiple materials and viewpoints into critical juxtaposition with hegemonic presumptions.[3]

> See Chapter 4 for Virgina Kuhn's discussion of remix in the digital humanities.

We were particularly concerned with the rhetoric of "alternative facts" that needed to be addressed in a way that did not play into the "both sides" narrative that had become increasingly deployed in the political arena in the aftermath of the Charlottesville white supremacist Unite the Right rally, which resulted in the death of Heather Heyer, a protestor against the march.[4] Building on Kuhn's dialogic strategy, we wondered if another turn of the screw might be useful, that is an iterative remix process, whereby we shared footage and exchanged edits and produced not a singular response, or a counter to be dropped into the both-sides binary, but an ongoing critique of the larger media

culture that erases or displaces difference and differing perspectives into an apocalyptic spectacle, a process that alienates the populace, fractures community, and discourages civic engagement.

In the Digital Humanities Manifesto 2.0, there was a call for work that expands the possibility of research and praxis through transdisciplinary collaboration and multimedia forms, alongside the understanding that such work can and must be accessible across and beyond the walls of academia.[5] In Matthew Gold and Lauren Klein's "Introduction" to *Debates in the Digital Humanities 2019*, they push the idea of public engagement further into one of explicit resistance to the election and policies of the Trump administration.[6] While we applaud this focus on direct action, we must also consider what might be happening to the viability of the public arena itself. Corporate influence (and control) pervades key institutions—from media, to government, to education—and envelopes each sphere with a profit-driven value system. Whose voices are heard is typically determined by who can purchase time or whose time can be turned into a commodity or spectacle for sale. In this case, our understanding of the public diminishes to private and increasingly isolated transactions with the individual mainly envisioned as a consumer or, even a product, or brand.

Creating the conditions for conversations not dependent upon winners and losers or outside our particular echo chamber is dependent upon a series of related and reparative strategies. This space might include our individual autonomy outside the commodity culture, fostered through our connection to a shared "Beloved Community,"[7] and with a viable and vibrant public arena for dialog and debate. By moving to a model of iterative remix, absent of complete control of content reviewed and edited, we situate ourselves within what Eve Kosofsky Sedgwick calls a "reparative" versus a "paranoid" epistemology where the exposure of absolute truths and singular narratives gives way to multiple possibilities and counter-narratives.[8] We have the tools to disrupt the endless loop of "both sides" that can shine light on shared spaces that may serve to reconnect our communities and rebuild our public space and civic engagement.

The Collaborative Remix Manifesto

Our collaborative remix video manifesto takes its inspiration from multiple sources and especially three prior manifestos: The Situationist International (1960); Digital Humanities 2.0 (2009); and Feminist Data Manifest-No (2019). Each of these manifestos speaks to our desire to imagine the parameters of scholarly praxis in an era of neoliberal spectacle, where the marketplace replaces the public sphere, and all values are determined via transaction rather than dialog and consensus.[9] Another way we might say this is market forces replace human action. In the Trump era, we have slipped from the pedestrian propaganda of Kelley Anne Conway's "alternative facts" to an alternative universe where what Hannah Arendt identifies as "factual truth," or historical events and individuals who partake in them, are reduced, ontologically speaking, to the shadowy, contingent world of opinion.[10] In this universe, it is normalized to equate the crucifixion of Christ, the bombing of Pearl Harbor, and the impeachment of Donald Trump, as two Congressional representatives have done. Rep. Barry Loudermilk, (Republican, Georgia) stated on the floor of the House that "Pontius Pilate afforded more rights to Jesus than the Democrats have afforded this President and this process," while Rep. Mike Kelly (Republican, Pennsylvania) piled on noting that December 18, 2019, the

day the House approved the articles of impeachment, would be "another date that will live in infamy" (as Franklin Roosevelt called the attack on Pearl Harbor on December 7, 1941).[11] It is this specific downward spiral of reason that has transpired from the time of our original workshop to today and which drives our desire to set out a manifesto that argues for the value of the collaborative remix video.

Our goal with the manifesto is to re-center cultural engagement from passive consumerism to one where, following the Situationists: "Against the spectacle, the realized situationist culture introduces total participation," where "everyone will become an artist, i.e., inseparably a producer-consumer of total culture creation."[12] Following our Digital Humanities Manifesto colleagues, our collaborative remix is one where: "**Process is the new god**; not product. Anything that stands in the way of the perpetual mashup and remix stands in the way of the digital revolution."[13] Our objective is to produce an iterative, generative dialog through the remix, one focused on opening new perspectives and possibilities rather than arriving at a singular or essentialist response in contradistinction to the "alternative facts." Our commitment to materialist aesthetics does not abandon the many layers of materiality and experiential diversity that are presented to us in the facticity of our daily lives and which are often overlooked in the binary logic gripping our political discourse. Here we take guidance from the Feminist Data Manifesto-No, which establishes a data ethical framework attentive to difference: "**We refuse** to understand data as disembodied and thereby dehumanized and departicularized. **We commit** to understanding data as always and variously attached to bodies; we vow to interrogate the biopolitical implications of data with a keen eye to gender, race, sexuality, class, disability, nationality, and other forms of embodied difference."[14]

It is the difference, or plurality concomitant with equality, following Arendt again, that makes speech and action possible. For Arendt, our words and deeds place us in the world, mark our distinctiveness, and both establish and necessitate a public space for our differences to engage in ongoing dialog, which is, in short, a confirmation of our humanity.[15] As Arendt notes: "A life without speech and without action … is literally dead to the world; it has ceased to be a human life because it is no longer lived among men."[16] Our collaborative remix video as dialog among ourselves and offered as part of an open and distributed project online and through our conference workshop was a concerted effort to challenge both alternative facts and the very mechanism of the marketplace that produces these "facts" and erodes our public sphere. For Arendt and our workshop's ethos, this connection of speech and action in the public arena is the core of praxis.

Manifesto

1. The collaborative remix video is a generative exercise with an outcome directed more to process than product. As we go through each iteration, sharing clips, edits, and re-examining content in the light of different contexts and different remixes we wonder, what have we created? Is it an argument, a provocation, a series of questions, a dialog, the Socratic method unfolding? With each video, we see the possibilities of the form alongside the limits and biases which we bring to an individually shaped project. Working with clips shaped by theme but selected by others in our group provides material we might have overlooked for our "authored" work. Prior remixes challenge us with juxtapositions we might not have considered. The

collaborative remix is in some sense the performance of a dialog, showing what can be done when we share our information, ideas, and analysis. It asks for you, the audience, to pick up this publicly shared remix and continue the dialog.

2. Often when we participate in collaborative work in media, it is about a sharing of individualized skills (research, editing, filming, music, etc.) that is often weighted to the practical side, but in our version of the collaborative remix, all skills were shared and the attention was turned to the conceptual issue at hand, in this case, how editing generates knowledge and how that might inform veracity, disinformation campaigns, and "alternative facts."

3. In what ways might the collaborative video essay inform how you teach praxis? Again, like collaborative media, praxis is typically weighted toward the side of *practice*, but we are interested in the intersection between speech and action (specifically within the public sphere) as central to the term's understanding. Hence, our pedagogy should be directed to repairing and rebuilding a robust and diverse public discourse about the challenges we face today.

This is a concrete way to enact teaching in the Digital Humanities, encouraging students to produce "socially oriented work—work that is informed by the digital, but extends beyond it," as proposed by Gold and Klein.[17]

> See Chapter 29 for Aidan Delaney's documentation of the audiovisual essay as a remix practice and methodology in the study of cinema.

4. The collaborative remix video should then be part of a larger ethos that generates a reparative strategy toward a culture that isolates and values us solely through market categories. Public remixes/dialogs disrupt the single narrative and singular truth and connect us to diverse experiences and possibilities. From here, we learn to speak with each other, to listen, to learn, and rebuild a more inclusive sense of community.

5. We must disrupt the single author along with the single story. This must begin with our own work where the preciousness of academic objects contributes to our own isolation, competitiveness, and, at times, immobility and the lack of creativity. We too often approach a project within an institutional framework where the preferred format is as rigidly preordained as any long-standing commodity specifications.

6. We might consider the collaborative remix video as a type of joyful play not unlike meme generation. The experience of collaborative remix could also be employed as a type of open dialog on particular films, genres, or series, a public conversation on our shared film criticism, operating as an ongoing updated wiki page.

7. The collaborative remix video offers us another opportunity to intervene in the push against copyright restrictions and into open-source materials. As scholars, we need to push for this. Our collective edits and shared materials can be seen as efforts to destabilize authorship as well as media conglomerate ownership of our shared culture and expression.

Provocations, Procedurals, Praxis

The video essay is a vital part of the scholarly toolkit. The scholarly video essay has been primarily driven toward an auteurist focus, which is often mirrored by single authorship

or a singular perspective. *In the Mix* endeavors to disrupt this approach by modeling a pathway into collaborative video work. Collectively, we take an agnostic approach to the variety of possible forms of the video essay and explore if new forms may materialize as we work together.

The project begins several months prior to our SCMS conference: using the prompt "post-truth," each of the workshop participants adds ten files (image, audio, video, text) that we each draw from to create video essays of ninety seconds to five minutes each. Participants must use a designated number of clips that they did not individually select in their remix. We then share this first round of remix essays on the online Scalar platform so that our group can comment, annotate, and consider the next round of edits. For the second round of edits, each workshop participant edits another participant's video essay. These second essays are shared on our Scalar site, along with links to the original files, and our SCMS colleagues are invited to comment, annotate, reedit, and post.

At the SCMS workshop, we extend the dialogic process further through a session that includes discussion of the basic process, sample viewings, editorial reflections, and attendee feedback. We also share our materials with attendees so that they may do their own remix. Our goal with this workshop is to find new ways of thinking about the video essay as well as reimagining scholarly dialog.

Goal: We each make ninety seconds to five minutes videos in response to a prompt to create explorations of "post-truth" in two rounds as follows.

Each person provides ten clips of any length to contribute to our pool.

Round 1: We all make a remix video drawing from our pool of 60 clips with each participant using a designated number of clips that they have not selected.

Round 2: We select one person's video to remix (each video only can be remixed once by our team), and we must use their clips (that is drawing from the lengths they have used) but we can swap out three clips from our collective pool of material.

Nina Bradley's first-round video essay from our *In the Mix* workshop entitled "Who Do You Believe?" approaches the "post-truth" topic by foregrounding whose story is told or centered as the foundation for "truth-telling." The video opens with a clip from *The Outer Limits* television program, and a voice which orders viewers not to adjust the television as "we are now controlling the transmission," thereby placing spectator agency in question. Bradley follows this with the implicit face of White male supremacy behind the command as we have a cut of then candidate Donald Trump on the presidential debate stage spouting his xenophobic mantra on the need for a wall to deal with "bad hombres." But here the video essay counters the veracity of opening narrative by draining Trump of all color, there is no nuance from the candidate here but rather a black and white opposition with the accompanying text: "Do you trust in him?" The piece continues with a series of counternarratives to hegemonic White male patriarchy by musical and visual disruptions from communities of color from an activist dancing defiantly with a Mexican flag through an anti-immigration rally; Public Enemy's music video warning "Don't Believe the Hype" paralleling Trump's increasingly distorted image, and a young child dancing joyfully to "Mississippi Goddam." The essay ends with clips taken from the pool of material outside Bradley's collection, which underlines the increasingly totalitarian and deceptive tactics of the Trump administration from media manipulation to its Congressional allies and enablers, visualized with a clip of a conspiracy touting Joseph McCarthy.

In the second round with our instruction to remix a colleague's video from round one, Liz Cambron took an experimental approach to the charge. Cambron selected Daniel Clarkson Fisher's *The Outer Limits* for round two. Cambron's remix unmasked the propensity of presidential lies beginning with the façade of a distinctive element of Trump's physical presence, his dense but, in reality, fake hair. The video decelerates the well-known footage of Trump's climb up the windy jet stairway, lingering in tight close-up with the President's turn to wave goodbye. The distorted audio and overlapped blurred image breaks with his usual preserved *Apprentice*-era aesthetic and shows us the con in agonizing detail. The audiovisual distortion continues in the next sequence designating further signal jamming. Trump's lie on rejecting the KKK, overlaid with images from the White supremacists' march in Charlottesville, is put next to images of another well-known lie, President George Bush, Sr.'s infamous speech where he proclaimed, "read my lips, no new taxes." The trajectory of Republican deception with increasingly authoritarian consequences is skillfully relayed in Cambron's remix.

Process

Although the group collectively represents a range of research interests, we were all interested in the emergent field of the video essay and intrigued by hitherto unexplored possibilities of collaboration. Generally speaking, it seems to us that the video essay is a creature born of auteurist ideas about media-making. In the typologies of video essays that have emerged in both academic and nonacademic circles, for example, many of the observed categories and trends—everything from the "explanatory audiovisual essay"[18] to "the supercut and the fan tribute"[19]—seem to privilege the single author. At the very least, they suppose that video essays are the work of individuals. We wanted to interrogate such assumptions about process essentials in the video essay; what would happen, we wondered, if we approached the production of video essays in much the same way that, say, a radical film collective might approach political cinema?

In this section, we provide several accounts of methodologies by some of our conference workshop participants. In the digital humanities context where process takes precedence, it is well-worth taking time to reflect on some of the concrete and varied participatory approaches, including iterations that were generated following the workshop.

Christina Lane

As I entered the preparatory phase of our *In the Mix* workshop, the idea of collaborating on video essays was an attractive, if speculative and indeterminate, prospect. I came into the process having coauthored articles and authored video essays, but I had never attempted video essays that hinged on group collaboration. The project promised to be both hands-on and out of my hands in ways that were both exciting and nerve-wracking. What I could not have anticipated was how gratifying and illuminating the *In the Mix* work would be. The very parameters that were initially most daunting turned out to be the most freeing and productive.

I cannot overstate the value of doing this kind of open-source, generative work, and specifically the re-remix or follow-up phase. (In this case, it was our group's second edit.) It was through this attention to process that *In the Mix* became conceptual. Practice

became praxis. For me this meant that, by the project's conclusion, my thinking was changed in relation to post-truth and adjacent themes surrounding contemporary politics, media, and representation. Our group work, particularly the pooling together of collective clips, the time carved out for online discussion, and the space provided for annotations, made a serious impact in what form this scholarship took. In my view, our ideas flowed in a multichanneled way, facilitating multiple perspectives and interdisciplinarity. This is because we were each building off of one another's unique ideas, decontextualizing and recontextualizing samples from the existing cultural and political sphere so that we were able to build layers toward a new public sphere.

My initial pool of ten media clips consisted primarily of samples from contemporary news coverage, such as a September 2017 White House press conference addressing President Trump's inflammatory remarks toward NFL players who chose to "take a knee" during the American national anthem. I put two clips from the *Scandal* television series into my pool, from "Mercy" (Season 6, episode 12) and "Watch Me" (Season 7, episode 1). I found *Scandal*, which was still on air at the time, intriguing for a few reasons. I was interested in the way the series flirted with fantasies of African American female power (and interracial female friendship). I was also beleaguered by *Scandal*'s outrageous and unrealistic portrayal of power "backstage" at the White House and how the fictional series seemed to have paved the way for the even more outrageous real-life era of Trump.

For my first round of the remix, I ended up using approximately fifty percent of clips from my own pool. I began under the assumption that I would work mostly off of my own archive but quickly shifted once I saw what others were contributing. My initial instinct was to bristle against the rules established by consensus. My preference, I thought, would have been to reedit my mix (not someone else's) after receiving group feedback. And for the second edit, at first, I was not so sure about limiting each member to only three swap-outs (when it seemed more variation allowed for greater creativity). Yet in the process of handing off my work and giving in to constraints, I learned a lot. I was reminded that the remix essay was not mine; it was ours. I learned this lesson again when I went about conducting a second edit on another group member's "round one" essay. I was very reluctant to make changes until I reminded myself that this was a *remix*; messing with the author's work was in fact a requirement. Doing this collaborative work has been an invaluable lesson because it has reminded me to recognize internal biases, helping me to let go of the notion of academic work as a *precious object*.

Daniel Clarkson Fisher

Like Christina Lane, I was keen to participate in this project, having never worked collaboratively on a video essay before. At the time we first convened, I felt that video essayism was overdue for disruptive innovations; the ideas proposed promised to at least mix things up in exciting and significant ways. Even if we failed to truly disrupt, it was exploratory work well worth doing.

For my part, I came into our process as a practicing video essayist especially interested in the political analysis of American popular cinema. Two of my video essays have received online attention—one

See Chapter 9 for Eduardo Navas' analysis of truth and denial to consider a creative approach towards empathetic and critically objective methods, useful for engaging with information that supports or questions cultural differences.

about surveillance and social control as major themes across Steven Spielberg's oeuvre [20] and one (staff-picked by Vimeo) that underscores the evergreen leftist politics of John Carpenter's 1988 classic *They Live*.[21] As such, I was intrigued by our group's suggestion that we put special focus on the concept of "post-truth."

My pool of ten media clips split three ways. First, there were intentionally on-the-nose snippets from films and television in which characters openly discuss matters of truth, facts, journalism, myth, reality, and so on. These include clips from John Ford's *The Man Who Shot Liberty Valance* (1962), *They Live*, Carpenter's *In the Mouth of Madness* (1994), Roger Spottiswoode's 007 outing *Tomorrow Never Dies* (1997), the *Simpsons* episode "Girly Edition" (1998), and Mark Achbar and Jennifer Abbott's epochal documentary *The Corporation* (2003). Part of my reason for including these clips was the suspicion that it might be useful for the group to have some material in the pool that pointed directly at our theme; subtlety is well and good, but we all might have been stuck without some bits that spelled things out clearly. Second, I also included clips of some prominent intellectuals talking about ancillary "post-truth" concerns. These include Pulitzer Prize-winning journalist Chris Hedges on PBS's *Moyers & Company* (2012), recalling his professionally costly decision to speak out against the Iraq war; noted filmmaker Errol Morris warning against confirmation bias in an interview for *Big Think* (2012); and Dr. Keeanga-Yamahtta Taylor underscoring the importance of solidarity in the fight against injustice as part of her 2017 Hampshire College Commencement speech. Lastly, in a category by itself, I included a clip of Donald Trump haranguing journalists at his first press conference as president-elect in 2016.

For my first round of the remix, I began with fellow workshop participant Nina Bradley's clip from the television show *The Outer Limits*, which offered some comic inspiration. In it, a broadcaster receives a strange and frightening signal on a television screen. This gave me the idea to edit one of the Donald Trump clips into the screen-within-the-screen for satirical effect. I was pleased when it got a laugh from the assembled audience during our workshop at SCMS. The visualized audio waves in the clip also nudged me to do something with the audio from another of Bradley's clips: a music video for Public Enemy's "Don't Believe the Hype" (1988). Thus, the video continues as a musical montage, with the song playing under a collection of clips from the pool that highlights Trump's racism and xenophobia in particular. I took a similar route in round two remix, streamlining Vicki Callahan's "Willkommen" into a montage built around the title song from Bob Fosse's *Cabaret* (1972).

While the experience of working collaboratively in this way was a welcome and novel experience, I also observed some pragmatic and conceptual challenges by the end of our work. Our pool of clips might not have been quite large and/or diverse enough. I was not really sure what my first-round piece was "about," and at least part of that has to do with limitations in terms of available material. The second round felt like a simple editing job; essentially, I just trimmed and tightened Vicki Callahan's video essay. I was eager to do something more explicitly conversational, but, again, felt limited by the parameters we set for ourselves.

Finally, it might have been interesting to figure out ways to work more collaboratively at every stage of the process. Like Kevin B. Lee, I have begun to take "a more active interest in thinking about how video essays could show the unseen hands at work behind every frame, and less about how the cinematic frame presents itself as a finished work of art."[22] So much so that I felt that we could extend this to thinking about video essay production as well. While certain aspects of our collaboration, such as the jointly

assembled pool of clips, do usefully push against what we might call the "auteurist ten-dencies of video essayism," we probably did not disrupt the tradition of "single author along with the single story" as much as we could have. For instance, once all of our contributions had been added to the pool, we each then went off to our individual silos to assemble our respective video essays. I am left to wonder then what (arguably) more radical steps we might take as part of future collaborations.

Nicole Richter

This section on the process of collaborative video-essay-making will focus not on the work done in the initial project, but instead on a video essay project that I assigned students in my 2019 Motion Picture History II class at Wright State. The idea was to embrace the spirit of our remix video essay workshop to create a class assignment that involved small groups of students working together to coauthor short video essays, with the focus being on a period or movement of film history that the groups had preselected. While the format of the class project did not follow the exact process or guidelines of the remix essay as done by myself and others, it provides a helpful example for those interested in how the collaborative video essay can be modified for a wide variety of projects radiating from the initial concept.

I found the core idea of a video essay whose author cannot be pinpointed as a single individual to be one that was easy to adapt and one which the coauthors in question (my students) immediately understood. The guidelines for the project were presented to the students as follows:

Video Essay Project
Prepare a collaborative video essay on the history of a post-1950s national film movement. Include the social context, historical events, landmark films and important directors of your chosen country/movement. Discuss the relationship that your country of choice shares with other historical film movements and its influence on film history.

Despite clear differences with the remix project, I believe that the Film History essay kept intact the core of the collaborative video essay in four key ways: all students were required to contribute to their group's final project, film clips were emphasized, essays were to be created on a shared central topic, and otherwise the final project could take shape as the students wished, aside from required content.

My students' projects far exceeded my expectations in terms of quality and variety of expression. The ample space for creativity that a collaborative video essay provides was most apparent when watching the final cuts of the essays back-to-back. Given free rein, each group tackled the project in its own way. Collaboration began similarly for each group with an informal discussion of what area of film history to cover, but from there the various processes naturally became unique, with each group dividing labor differently.

While there was an expected variance in quality, the engagement with the project and the resulting work was generally exceptional. While some students struggled in their work, the numbers were few and, on the whole, the level of student interest was much greater than with traditional essay writing.

Elevated student engagement is particularly notable. Even at this pilot stage, it is worth making the following observations about the value of the video essay in the classroom. In the context of current media culture, the video essay is readily understood by college-level students. I received few questions about what was required, as the format is one with which most students are already intimately familiar (via YouTube, memes, etc.). While watching final cuts of the projects, it became clear that many of the students had already created similar projects on their own time.

In short, the collaborative video essay is a format that I believe instructors will find to be understood by most college-aged students already and is thus an excellent tool not only to encourage engagement with classwork but also to allow the current generations to produce potentially higher quality work on a subject than they would with traditional writing assignments. The video essay is simply the medium of their time. Student responses echoed this, going so far as to say that the project reengaged them with scholarly activities and theory in a way that the written word does not. While I firmly believe in the vitality of the written word in an academic setting and beyond, this project and its results were enough to raise questions about the potential need for the academy to adapt its requirements to the times. I wonder if by putting such a heavy emphasis on writing assignments, and relegating video essays to either a novelty project or not featuring them at all in a course, is like asking Montaigne to put his thoughts in the form of a Socratic dialog, i.e., being an out-of-touch academic stickler for a format that limits the expression possible by a new form by those most ready and able to use it simply because "that's how we've always done it." While we can argue the theoretical merits of traditional essay writing versus alternate forms of analytical classwork, what is important in practice is the results, i.e., quality of student engagement with material and the resulting work. In terms of those results, I have found the video essay to be an exceptional tool. I am not arguing for the abandonment of the written essay, but instead that the video essay is a useful addition to the educator's toolbelt that merits more widespread use in the classroom than is currently the standard. Opening ourselves up to new forms such as this can only help our educational goals, and I imagine that in doing so through the video essay, we may find that it is only one of many new such tools that we can incorporate into the academy.

The Toolkit

We wish to share a manual, which we created out of our original conference workshop upon realizing that we needed a standardized paradigm of tools and a workflow that could be accessed and utilized by anyone in the project.

Our toolkit was created in-process as needs arose. It is presented here in a refined format that is meant to be easily usable and accessible to any who might follow in our footsteps and create their own video essay remixes. We encourage others to modify the toolkit to fit the needs of their own projects and to share their remixed toolkits.

The Tools

1. Email. Due to the amount of link- and file-sharing that is likely to be needed when remixing, we suggest the use of a standardized, feature-rich, sharing-friendly platform such as Gmail by all participants.[23]

2. Video conference tools. We found that live conversations were essential as they encouraged spontaneous creativity and collaboration and were well in-line with and supported the spirit and goals of our project. We used Skype but there is an excellent guide by Mozilla on video conferencing that reviews many of the available tools for privacy issues and utility.[24]

3. Chat/Collaborative software. While we did not use them in our own project, we recognize the vast potential for the use of chat/collaboration software such as Slack or Discord. They feature private, running, permanent chat rooms that allow for easier navigation and searchability of project conversation, the ability to create sub-rooms for side conversations, the easy sharing of media, and optional voice chat rooms that may eliminate the need for video chat software. Employing a chat software would have been a great benefit to our collaboration process, especially given the difficulty of scheduling video conference times across multiple time zones.[25]

4. Document sharing tools. We found Google Drive/Google Docs to be the best option due to their ubiquity and inherent compatibility with Gmail. Other groups may have preferred software; the important thing is that there can be a shared folder of documents accessible and editable by the group that tracks the edits of each member.

5. Video clip storage tools. We again used Google Drive. Staying within the Google family of tools allowed for cohesion and compatibility between the various parts of the work done for the project. Alternatives such as Dropbox may work better for other groups, but Drive's simplicity, storage space, and stability are helpful.[26]

6. Video editing tools. Our group used an array of tools from Adobe Premiere to WeVideo. WeVideo, an online video-editing system, has several benefits in that it is "simple-to-learn" and (almost) free. Adobe Rush, available in desktop and mobile versions, is also almost free. The key is to select a common file type to make storing and sharing files easy, and we selected MP4. Standardizing the file type enabled the smooth organizing, reviewing, editing, and presenting of the finished remixes. It should be noted that while some of our project members were skilled at video editing already, there was a varying degree of prior expertise in this area between the members, and everyone was able to create a video successfully using our chosen tool. We are excited to see what other editing tools might be available and used going forward. We encourage experimentation in this area.[27]

7. Final presentation and annotation. In order to present our videos as a group, we looked for software that was, as in the editing, simple-to-learn and free. We had the additional requirements that it present the remixes together in a professional manner that was permanent, accessible through the web and navigable, meaning it was not just a folder of videos or a playlist, but instead a cohesive production. We chose the digital scholarship platform Scalar.[28] Scalar allows for the creation of a website with nested pages that can present a project while (in our case) giving each video its own page and allowing for an easy way for viewers to navigate the videos. Scalar has the added benefit of allowing for annotation of the videos; creators can comment on their own remixes and on those of others. Annotations display at chosen times as the videos play (in the same vein as a bookmark), functioning as an additional textual element of the video essay. This furthered the commentary being performed by the remixes and added another collaborative facet.

Rules for Collaboration

This is a step-by-step guide to creating remixes based on the way our project came about.

Note: This is by no means a hard-and-fast rulebook meant to be the "only way" to remix; instead, we present it as one set of creative obstructions in the toolkit that can be deployed, revised, or rejected as needed or wanted.

How to Make Remix Video Essays

1. The group chooses a topic around which to focus collaborative video essays.
 a. We chose the topic of post-truth. This was chosen for its timeliness and its inherent relation to the idea of ownership and control of media and message.
2. Each member of the group finds and uploads ten video clips to Google Drive that they deem relate to the chosen topic. *Clips are chosen freely by the individual participant and do not have to relate obviously to the topic.*
3. Individuals draw from the pool of clips (from all group members) to create a 3–5 minutes video essay that edits whichever clips they choose together to create a single video essay. The video is titled and uploaded to a unique Scalar page.
 a. We limited the number of clips each participant could use from their own selections. The number of outside clips required per individual video essay was essentially arbitrary and can be set however the group feels might be most challenging. This particular obstruction encouraged collaboration and made space for more interesting, spontaneous, and complex final products.
4. Organize the collective videos of the group (which represent the first round of the project) into a page on Scalar that guides users through the videos.
5. Members add text annotations as they wish to their own videos and to those of other members of the group. This adds an extra element of content and collaboration that "spills off the screen."
6. We proceed to round two. Each project member takes a video made by one of the other members in the first round and "remixes" it into a new video that is 90 seconds to 5 minutes long. This involves taking the list of clips used in one single other video and editing a new video that uses those clips to make a new video. The second round of remix videos is limited to the clips used in the initial video, but with three new clips swapped in as well. The second videos were assigned arbitrarily to participants.
7. The second round of videos is uploaded to Scalar in the same way as the first, making a second set of videos that can be navigated through by the viewer as a set. The remixed videos are annotated in the same way as the original round.

The work was presented at the 2018 Society for Cinema and Media Studies conference in Toronto. We presented our videos and website on a screen before the conference and took questions afterward. Subsequently, we left our Scalar site and all our Google files available online, so that the project would remain accessible and shareable going forward. For the complete documentation of our conference workshop, including information on files used for remixing, please visit website: https://scalar.usc.edu/works/scms_2018/index. As always, we highly encourage the remixing of our toolkit and ruleset. We hope it helps in the creation of your work, and we look forward to it being transformed, edited, chopped up, and put back together into something new.

Conclusion

We conclude our thoughts concerning the *In the Mix* workshop while in the midst of the 2020 presidential election cycle alongside a global Pandemic and economic crisis. The lies and failures of the Trump administration have been staggering. As Robert Reich notes, the delay by the administration in responding to the coronavirus meant that, at the time of this writing, the United States led the globe in mortality.[29] The economic conditions have been equally dire with unemployment reaching levels unseen since the Great Depression and food lines stretching for miles in many locales. Reich argues that Trump does not bear the responsibility alone for the health and economic disaster the country is facing but points to the structural failures of the legislative, business, financial, and health-care sectors.[30] In response, the people of the United States have been offered only fantasy by Trump, such as the virus is "going to disappear. One day it's like a miracle – it will disappear."[31]

The marks of White supremacy have followed closely alongside the legal, financial, and health care downward spiral. Linda Villarosa's article: "'A Terrible Price': The Deadly Racial Disparities of Covid-19 in America," documents in detail the devastating impact of the virus, and the structures of inequity that produce the disproportionate impact on Black Americans.[32] In tandem with the racial divide found in health care, the February 2020 shooting of an unarmed Black jogger, Ahmaud Arbery, by two White men and the lack of prosecution by Georgia authorities brought echoes of Charlottesville and Trump's prior "bothsidesism."[33]

Despite the magnitude of the spiraling crises that took place at the time this chapter was written, one way we might frame our *In The Mix* workshop is as an exercise in speculative design. As Arundhati Roy has declared in her article, *The Pandemic is a Portal*:

> The virus has moved freely along the pathways of trade and international capital, and the terrible illness it has brought in its wake has locked humans down in their countries, their cities and their homes.
>
> But unlike the flow of capital, this virus seeks proliferation, not profit, and has, therefore, inadvertently, to some extent, reversed the direction of the flow. It has mocked immigration controls, biometrics, digital surveillance and every other kind of data analytics, and struck hardest—thus far—in the richest, most powerful nations of the world, bringing the engine of capitalism to a juddering halt. Temporarily perhaps, but at least long enough for us to examine its parts, make an assessment and decide whether we want to help fix it, or look for a better engine.[34]

The collaborative remix video imagines new ways of analysis, discourse, and creativity. We are not tied to individualism and exceptionalism but can share, listen, and build together. While we might believe the virus and social isolation has broken our bonds of community, networked collaboration today offers a variety of tools to reconnect. We suggest a toolbox and set of instructions to initiate your own collaborative video, but as noted earlier, the parameters are arbitrary and tools are many. Of crucial importance, we felt, was the conceptual turn away from individualism, auteurism, exceptionalism, meritocracy, that is, the foundational elements of an ideology that hinders association and, indeed collective action. What begins as a public conversation, the exchange of ideas, and new ways of thinking about problems, might end in praxis.

IN THE MIX, THE COLLABORATIVE REMIX

Notes

1 Workshop participants were Christina Lane, Nicole Richter, Vicki Callahan, Daniel Clarkson Fisher, Nina Bradley, and Elizabeth Cambron. Our videos and all resources, including workshop presentation and location of files, can be found at the website: https://scalar.usc.edu/works/scms_2018/index.

2 Gregory Ulmer, *Electronic Monuments* (Minneapolis: University Of Minnesota Press, 2005), xxi–xxiii.

3 Virginia Kuhn, "Remix in the Age of Trump." *Journal of Contemporary Rhetoric* 7, no. 2/3 (2017): 87–90.

4 Michael D. Shear and Maggie Haberman, "Trump Defends Initial Remarks on Charlottesville; Again Blames 'Both Sides.'" *The New York Times*, August 15, 2017, sec. U.S. https://www.nytimes.com/2017/08/15/us/politics/trump-press-conference-charlottesville.html.

5 Todd Presner et al., *The Digital Humanities Manifesto, 2.0*, 2009. https://391.org/manifestos/2009-the-digital-humanities-manifesto-2-0-presner-schnapp-lunenfeld/.

6 Matthew K. Gold and Lauren F. Klein, "'Introduction, A DH that Matters' in 'Debates in the Digital Humanities 2019' on Manifold." https://dhdebates.gc.cuny.edu/read/untitled-f2acf72c-a469-49d8-be35-67f9ac1e3a60/section/0cd11777-7d1b-4f2c-8fdf-4704e827c2c2.

7 The King Center describes the philosophy behind the "Beloved Community" in detail on their site, but for a sense of the core ideals: "Dr. King's Beloved Community is a global vision, in which all people can share in the wealth of the earth. In the Beloved Community, poverty, hunger and homelessness will not be tolerated because international standards of human decency will not allow it. Racism and all forms of discrimination, bigotry and prejudice will be replaced by an all-inclusive spirit of sisterhood and brotherhood." The King Center, https://thekingcenter.org/king-philosophy/.

8 Eve Kosofsky Sedgwick, "Paranoid Reading and Reparative Reading, or, You're so Paranoid, You Probably Think This Essay Is About You," in *Touching Feeling: Affect, Pedagogy, Performativity* (Duke University Press, 2003), 123–51.

9 Stephen Metcalf. "Neoliberalism: The Idea That Swallowed the World." *The Guardian*, August 18, 2017, sec. News. https://www.theguardian.com/news/2017/aug/18/neoliberalism-the-idea-that-changed-the-world.

10 Hannah Arendt, "Truth and Politics." *The New Yorker*, February 17, 1967. www.newyorker.com/magazine/1967/02/25/truth-and-politics.

11 Rep. Barry Loudermilk (R-GA) and Rep. Mike Kelly (R-PA), see *GOP Lawmakers Compare Trump Impeachment to Jesus and Pearl Harbor*. https://www.youtube.com/watch?v=xQzyDt5SMgg.

12 "Situationist International Online," translated by Fabian Thompsett, June 1960. https://www.cddc.vt.edu/sionline/si/manifesto.html.

13 Presner, *The Digital Humanities Manifesto, 2.0*.

14 M. Cifor et al. *Feminist Data Manifest-No*. https://www.manifestno.com/.

15 Hannah Arendt et al. *The Human Condition*. 2nd Edition (Chicago: University Of Chicago Press, 1998), 175–176.

16 Ibid., 176.

17 Gold and Klein, "Introduction: A DH that Matters."

18 Ian Garwood, "The Poetics of the Explanatory Audiovisual Essay." *Journal of Videographic Film & Moving Image Studies* 58, no. 3 (2014). http://mediacommons.org/intransition/2014/08/26/how-little-we-know.

19 Paula Bernstein, "What is a Video Essay? Creators Grapple with a Definition." *Filmmaker Magazine*, May 2016. https://filmmakermagazine.com/98248-what-is-a-video-essay-creators-grapple-with-a-definition/.

20 Daniel Clarkson Fisher, "Spielberg and Surveillance." Vimeo video, 11:49, February 17, 2017, https://vimeo.com/204631958.

21 Ibid., "We Sleep: On the Enduring Propheticism of John Carpenter's *They Live*." Vimeo video, 13:12, March 23, 2017. https://vimeo.com/209768155.

22 Kevin B. Lee, "On the Career of Paul Thomas Anderson in Five Shots." *The Audiovisual Essay. REFRAME (Research in Media, Film and Music)*, September 15, 2014. https://reframe.sussex.ac.uk/audiovisualessay/reflections/intransition-1-3/kevin-b-lee/.

23 Gmail. Google, https://mail.google.com/.

24 See Mozilla's guide on video conferencing tools: "*Privacy Not Included: A Buyer's Guide for Connected Products." https://foundation.mozilla.org/en/privacynotincluded/categories/video-call-apps/.

25 Slack https://slack.com and Discord https://discord.com are excellent chat tools that would have helped us communicate and organize tasks both in sync and asynchronously.

26 We used Google Drive for document and video clip sharing. Our selection of this tool was based on all of the participants' access to Google Drive's large storage capacity.

27 WeVideo and Adobe Rush have free options with several restrictions. They both offer some very afford-able options that allow for more robust use. Adobe Premiere can be quite expensive as part of Creative Suite but also offers a still somewhat pricey version without the CC bundle.

28 Scalar is a media-friendly, versatile, and free platform that can be quite valuable in a variety of scholarly contexts, from classrooms to publishing.

29 Robert Reich, "Under Trump, American Exceptionalism Means Poverty, Misery and Death." https://www. theguardian.com/commentisfree/2020/may/10/donald-trump-covid-19-coronavirus-us-healthcare-unem-ployment.

30 Ibid.

31 Oliver Milman, "Seven of Donald Trump's Most Misleading Coronavirus Claims." *The Guardian*, March 31, 2020, sec. US news. https://www.theguardian.com/us-news/2020/mar/28/trump-coronavirus-mislead-ing-claims.

32 Linda Villarosa, "'A Terrible Price': The Deadly Racial Disparities of Covid-19 in America." *The New York Times*, April 29, 2020, sec. Magazine. https://www.nytimes.com/2020/04/29/magazine/racial-dispar-ities-covid-19.html.

33 Fadel Allassan, "Trump Calls Apparent Video of Ahmaud Arbery Shooting 'Very Disturbing.'" *Axios*. https://www.axios.com/trump-ahmaud-arbery-shooting-video-disturbing-45e246af-cccc-4a10-9758-e691864ef3e5.html.

34 Arundhati Roy, "The Pandemic Is a Portal." *Financial Times*, April 3, 2020, https://www.ft.com/content/10d8f5e8-74eb-11ea-95fe-fcd274e920ca.

Bibliography

Adobe. "Adobe Premiere." https://www.adobe.com/products/premiere.html.

Adobe. "Adobe Rush." https://www.adobe.com/products/premiere-rush.html.

Allassan, Fadel. "Trump Calls Apparent Video of Ahmaud Arbery Shooting 'Very Disturbing'." *Axios*. https://www.axios.com/trump-ahmaud-arbery-shooting-video-disturbing-45e246af-cccc-4a10-9758-e691864ef3e5.html.

Arendt, Hannah, Margaret Canovan, and Danielle Allen. *The Human Condition*. 2nd Edition. Chicago: University of Chicago Press, 1998.

Arendt, Hannah. "Truth and Politics." *The New Yorker*, February 17, 1967. www.newyorker.com/mag-azine/1967/02/25/truth-and-politics.

Bernstein, Paula. "What is a Video Essay? Creators Grapple with a Definition." *Filmmaker Magazine*, May 3, 2016. https://filmmakermagazine.com/98248-what-is-a-video-essay-creators-grapple-with-a-definition/.

Cifor, M., P. Garcia, T. L. Cowan, J. Rault, T. Sutherland, A. Chan, J. Rode, A. L. Hoffmann, N. Salehi, and L. Nakamura. *Feminist Data Manifest-No*. 2019. https://www.manifestno.com/.

Discord. https://discord.com.

Fisher, Daniel Clarkson. "Spielberg and Surveillance." Vimeo video, 11:49. February 17, 2017. https://vimeo.com/204631958.

——. "We Sleep: On the Enduring Propheticism of John Carpenter's *They Live*." *Vimeo video*, 13:12. March 23, 2017. https://vimeo.com/209768155.

Garwood, Ian. "The Poetics of the Explanatory Audiovisual Essay." *Journal of Videographic Film & Moving Image Studies* 58, no. 3 (2014). http://mediacommons.org/intransition/2014/08/26/how-little-we-know.

Gold, Matthew K, and Lauren Klein. "'Introduction' in 'Debates in the Digital Humanities 2019' on Manifold." https://dhdebates.gc.cuny.edu/read/untitled-f2acf72c-a469-49d8-be35-67f9ac1e3a60/section/0cd11777-7d1b-4f2c-8fdf-4704e827c2c2.

Gmail. Google. https://mail.google.com/.

Google Drive. Google. https://www.google.com/drive/.

GOP Lawmakers Compare Trump Impeachment to Jesus and Pearl Harbor. https://www.youtube.com/watch?v=xQzyDt5SMgg.

"The King Philosophy." *The King Center* (blog). https://thekingcenter.org/king-philosophy/.

Kuhn, Virginia. "Remix in the Age of Trump." *Journal of Contemporary Rhetoric* 7, no. 2/3 (2017): 87–93.

Lee, Kevin B. "On the Career of Paul Thomas Anderson in Five Shots." *The Audiovisual Essay.* REFRAME *(Research in Media, Film and Music)*, September 15, 2014. https://reframe.sussex.ac.uk/audiovisualessay/reflections/intransition-1-3/kevin-b-lee/.

Metcalf, Stephen. "Neoliberalism: The Idea That Swallowed the World." *The Guardian*, August 18, 2017, sec. News. https://www.theguardian.com/news/2017/aug/18/neoliberalism-the-idea-that-changed-the-world.

Milman, Oliver. "Seven of Donald Trump's Most Misleading Coronavirus Claims." *The Guardian*, March 31, 2020, sec. US news. https://www.theguardian.com/us-news/2020/mar/28/trump-corona-virus-misleading-claims.

Mozilla Foundation. "*Privacy Not Included: A Buyer's Guide for Connected Products." https://foundation.mozilla.org/en/privacynotincluded/categories/video-call-apps/.

Reich, Robert. "Under Trump, American Exceptionalism Means Poverty, Misery and Death | Robert Reich | Opinion | The Guardian." https://www.theguardian.com/commentisfree/2020/may/10/donald-trump-covid-19-coronavirus-us-healthcare-unemployment.

Rogers, Katie, Christine Hauser, Alan Yuhas, and Maggie Haberman. "Trump's Suggestion That Disinfectants Could Be Used to Treat Coronavirus Prompts Aggressive Pushback." *The New York Times*, April 24, 2020, sec. U.S. https://www.nytimes.com/2020/04/24/us/politics/trump-inject-disinfectant-bleach-coronavirus.html.

Roy, Arundhati. "The Pandemic Is a Portal." *Financial Times*. April 3, 2020. https://www.ft.com/content/10d8f5e8-74eb-11ea-95fe-fcd274e920ca.

Sedgwick, Eve Kosofsky. "Paranoid Reading and Reparative Reading, or, You're so Paranoid, You Probably Think This Essay Is About You." In *Touching Feeling: Affect, Pedagogy, Performativity*. Duke University Press Books, 2003.

Shear, Michael D., and Maggie Haberman. "Trump Defends Initial Remarks on Charlottesville; Again Blames 'Both Sides.'" *The New York Times*, August 15, 2017, sec. U.S. https://www.nytimes.com/2017/08/15/us/politics/trump-press-conference-charlottesville.html.

"Situationist International Online." *Translated by Fabian Thompsett.* June 1960. https://www.cddc.vt.edu/sionline/si/manifesto.html.

Scalar. *The Alliance for Networking Visual Culture.* https://scalar.me/anvc/.

Slack. https://slack.com.

Presner, Todd, Jeffrey Schnapp, Peter Lunenfeld et al., *The Digital Humanities Manifesto, 2.0*, 2009. https://391.org/manifestos/2009-the-digital-humanities-manifesto-2-0-presner-schnapp-lunenfeld/.

Ulmer, Gregory. *Electronic Monuments.* Minneapolis: University of Minnesota Press, 2005.

Villarosa, Linda. "'A Terrible Price': The Deadly Racial Disparities of Covid-19 in America." *The New York Times*, April 29, 2020, sec. Magazine. https://www.nytimes.com/2020/04/29/magazine/racial-disparities-covid-19.html.

WeVideo. https://www.wevideo.com.

13

REMIXING LITERATURE IN THE CLASSROOM

From Canons to Playlists in the Study of Latinx Literature and Beyond

Kelley Kreitz

During the first session of my Introduction to Literature, Culture, and Media under-graduate course at Pace University, I typically ask students to share what comes to mind when they hear the word "literature." In this course that attracts an interdisciplinary group of students from across the university, English majors and nonmajors alike gener-ally tell me they think of old books, outdated language, "classics" that some students may want to read—but that few would argue are truly relevant to their lives today. In this and other courses that I teach drawing on US and Latin American literary studies, Latinx Studies, and the digital humanities, that stale idea of literature is what we spend the semester unpacking, understanding, and revising.[1] As we read a mix of canonical and less-familiar recent and archival texts, we ask: What is literature? Why does it mat-ter? How have ideas of literature changed over time? And how might the study of litera-ture provide insight into ongoing struggles to achieve racial justice?

For most students, the archival research that we conduct to help answer these ques-tions is the most challenging part of the course. It is not until we have spent some time interrogating familiar stories of literary and media history and locating lost or understud-ied voices that the students start to see the possibilities of entering into the cultural record for themselves. We do this through exploration of digital archives, including the University of Detroit, Mercy's *Black Abolitionist Archive*,[2] Northeastern University's *Early Caribbean Digital Archive*,[3] Duke University's *Women's Travel Diaries*,[4] and the Recovering the US Hispanic Literary Heritage Project's *Hispanic American Newspapers, 1808–1980* Readex database.[5] We also visit physical archives accessible from our Manhattan cam-pus—such as the community-based Interference Archive in Brooklyn and Barnard Zine Library—which introduce students to the varying ways in which archivists collect, cata-log, and provide access to knowledge. As students share their findings from the range of texts available to them in the archive, we begin to rethink literature as a dynamic cat-egory whose boundaries have shifted over time in relation to changes in media practices and to cultural negotiations. For some students, our reading provides new perspectives on their own cultural heritage. For many, literature becomes a means of understanding

the history of today's social issues. Along the way, this transformation in my courses has raised a new set of questions: How do I empower my students to engage with the vast, yet also incomplete, collection that literature becomes when we enter into and debate the cultural record? What would it look like to design courses with such a goal in mind? And within such courses, how might professors and students become partners in putting the omissions and injustices of our past in conversation with the pursuit of racial justice in the present?

This chapter takes up these questions to consider how insights from remix studies might contribute to current efforts within the digital humanities to decolonize the archival record. I am especially interested in how to engage students in understanding history through its making, in order to gain insight into histories of colonialism and the enduring presence of systemic racism. I argue that recent research on today's remix culture, which elucidates the increasingly central role of user-generated content in contemporary media, can help digital humanities scholars to rethink the production of knowledge. Within the classroom, shifting our frameworks from canons to archival collections into which students may enter to find their own pathways—or to use another perhaps more fitting metaphor, to create their own playlists—provides a means of increasing participation in humanistic inquiry. Ultimately, my aim in this chapter is to help digital humanities scholars articulate more fully how classrooms (both physical and digital) might become sites for pursuing what Roopika Risam has called "the great promise of the digital humanities," which she describes as "the opportunity to intervene in the digital cultural record—to tell new stories, shed light on counter-histories, and create spaces for communities to produce and share their own knowledge should they wish."[6]

Locating Digital Humanities Pedagogy in the Remix Era

The concept of remix—as "the act of using preexisting materials to create something new as desired by any creator from amateurs to professionals"—has long animated discussions of the potential of the digital humanities.[7] In their 2009 "Digital Humanities Manifesto 2.0," Jeffrey Schnapp and Todd Presner envisioned "hack[ing] into old hierarchical university systems and send[ing] a few remixed ones our way."[8] Remix appears here as a means of reconfiguring traditional university structures—namely, the academic department—in order to create new types of university programs. The authors point out that such change will create much-needed "models of knowledge production and reproduction that leverage the increasingly distributed nature of expertise and knowledge and transform this reality into occasions for scholarly innovation, disciplinary cross-fertilization, and the democratization of knowledge."[9] This changing nature of expertise that provides the context for Schnapp's and Presner's predictions for the future of higher education looks quite similar to what scholars within remix studies have called "remix culture."

While scholars typically locate the beginnings of remix as a practice specific to music in the analog context of New York City's disco and hip hop communities of the 1970s (where DJs first modeled the practice of sampling, looping, and reassembling existing tracks of music to offer new creations), "remix culture" refers to a more recent development in what Lawrence Lessig has called "a world in which technology begs all of us to create and spread creative work differently from how it was created and spread before."[10] Following Lessig's influential reflections on remix culture as the impetus for rethinking copyright and laying the foundation for Creative Commons licensing, scholars within

and outside of remix studies have evoked a similar context to describe the defining features of what Lev Manovich has called "software culture."[11] As Manovich explains,

> The twentieth century paradigm in which a small number of professional producers sent messages over communication channels that they controlled to a much larger number of users was replaced by a new paradigm. In this model, *a much large[r] number of producers publish content into 'a global media cloud'; the users create personalized mixes by choosing from this cloud.*[12]

Remix, Manovich has suggested, provides the prevailing logic of software culture, especially since the rise of social media, which he locates in the mid-2000s: "As the user-generated media content (video, photos, music, maps) on the Web exploded in 2005, an important semantic switch took place. The terms 'remix' (or 'mix') and 'mashup' started to be used in contexts where previously the term editing had been standard."[13] In the context of software culture, remix has expanded from a music-specific practice to a defining feature of a media system in which "a message continually moves between sites, people, and devices ... Frequently, its parts are extracted and remixed with parts of other messages to create new messages."[14] These same characteristics of our "remix era" that are so evident in the production and consumption of current media are also relevant to recent reconsiderations within the digital humanities of practices of knowledge production about the past.[15]

Scholars associated with the digital humanities have long contemplated the possibilities of the digital for the archival record, while also recognizing the politics of archives and the resulting absences and omissions. Many early digital humanities projects attempted to translate the idea of the scholarly or critical edition into digital form. Jerome McGann describes the goals of the foundational digital humanities project *The Rossetti Archive*, for example, as "explor[ing] the critical and interpretive capabilities of digital technology, and ... creat[ing] a scholarly edition of Rossetti's work."[16] More recently, in conversations that have gone by varying names—including "decolonizing DH," "engaging absence," and "postcolonial digital humanities"—scholars have sought to ensure that the digital humanities does not reproduce the knowledge paradigms and omissions of the past.[17] These include the digitization efforts undertaken by the Recovering the US Hispanic Literary Heritage project, in order to make accessible the earliest Spanish-language periodicals published in the United States. Following their massive indexing project started in the 1990s, the Recovery Project's Readex and EBSCO databases now make hundreds of US-based Spanish-language newspapers published in the nineteenth and early-twentieth centuries—many of which have rarely been studied—accessible to students and scholars. Another example is the *Colored Conventions Project*, which "uses innovative, inclusive models and partnerships to locate, transcribe, and archive this nearly forgotten history" of nineteenth-century Black organizing.[18] The site includes extensive guidelines for teaching partners to incorporate units dedicated to adding content to the database, making this an ongoing and continually growing archive. These and many other recent projects have moved away from the digital critical editions model (or, as Manovich might put it, from the twentieth century paradigm of providing information from experts through a controlled channel to an audience) to online archives that facilitate exploration and provide multiple points of entry. In this way, digital archives might be considered illustrations of the remix paradigm in digital humanities form.

Elizabeth Maddock Dillon employs the notion of remix to describe how Northeastern University's *Early Caribbean Digital Archive* makes use of metadata to help researchers make more visible the absence of the voices of enslaved people in the archive. As she points out, the project makes it possible to locate easily second-hand accounts of the experience of enslaved people in texts written by enslavers.

> Acts of juxtaposition, decontextualization, and recontextualization—what we can call remix and reassembly—allow the archive to tell a different story from the one that colonial knowledge regimes reproduce. Deforming the archive also enables creative revisions of the metadata used to access the archive, thereby changing what counts and is available as knowledge.[19]

Dillon's choice of words illustrates how the idea of a remix era characterized by user-generated content might extend to the archive. She envisions remixing digital archives to generate greater understanding of the injustices of our past—including omissions in the archival record itself—by facilitating reading that goes against the grain of narratives that provided the perspectives of enslavers.

Another vision of archives as sites of exploration and liberation animates xtine burrough's and Sabrina Starnaman's *An Archive of Unnamed Women*, which features historical photographs of unidentified women culled from the New York

See Chapter 18 for xtine burrough's discussion of *An Archive of Unnamed Women* and other projects emphasizing liberation.

Public Library's photograph collection. The site invites users to click on the photographs to find information drawn from the collection's metadata, as well as "a juxtaposed description drawn from a parallel collection of women's writing about women."[20] The juxtaposition of the photographs and the quotes creates a kind of remix of the archival record, inviting users to see and contemplate these forgotten photographs and the women they feature. In addition, the site invites users to participate in selecting quotes to pair with the photographs, while also promoting a crowd-sourcing effort to help identify the women they picture. Users may click on a tab to suggest their own quotes or to provide information about a photograph if they recognize a subject or setting. In this way, the project provides users with multiple pathways for entering into the archive to "facilitate a critical discussion about how and why these images have been shifted to the background of the archive through algorithms and gendered power relations writ large."[21]

Dillon's reflections and burrough's and Starnaman's *An Archive of Unnamed Women* point toward the broader potential of our software culture to enable and inspire what David Berry articulated in his 2012 *Understanding Digital Humanities* as "the promise of a collective *intellect* … a society or association of actors who can think critically together, mediated through technology."[22] Berry's idea from almost a decade ago of a collective intellect made possible by digital media undeniably appears a world apart from the reality of today's media system. The logic of remix has not prevented (and, in many cases, has facilitated) the spread of misinformation and racist ideas, as well as the escalation of passionately divisive rhetoric.[23] In addition, as Rachel O'Dwyer has noted, the idea that remix culture represents "a more critical and democratic culture driven by users as opposed to corporations" must be considered alongside the fact that "the activities associated with remix culture are now productive to the economy. Forms of human attention, creativity, and bottom-up circulation are now the main sources of value for software

companies, advertising agencies, and crowd-sourcing marketplaces."[24] While it would be an oversimplification to suggest that critique and capital are always at odds with each other, it is clear that profit-driven social media platforms have not been equipped to pursue other vitally important goals, including knowledge, civil and informed public debates, and the health of democracy itself. According to Risam: "Scholars must contend not only with the colonial hangovers from the cultural record, but also with the forces that are actively constructing the medium of the digital cultural record—the Internet—as a hostile environment where universities, libraries, and the cultural heritage sector are under threat, right along with the knowledge being produced and made publicly available by them."[25]

If the potential resides within remix culture to increase participation in the production of knowledge about the past and present, remix culture also holds competing possibilities that are being actively pursued by those who see the Internet as an opportunity to reinforce existing power structures. In the face of that challenge, the classroom provides a site where the potential of remix culture to put the past in conversation with the present like never before might be imagined, explored, and modeled.

Emergent Revolutionary Remix Culture in the Classroom

The kind of revolutionary remix culture that I have been describing appears in incipient and incomplete forms in some current approaches to digital humanities pedagogy. Identifying and contemplating some of these emergent examples offers a means of articulating more fully how the digital humanities might provide a bridge from greater understanding about the past to a remix culture that thinks more deliberately about history, its making, and the possible futures that it might inspire.

In my own experience, the most powerful pedagogical examples come from providing students with greater understanding of the gaps in the archival record and empowering them to create the knowledge that they believe is missing. In my courses that introduce students to Latinx literature in the United States, I start with a unit on nineteenth-century US-based Spanish-language publishing. The goal is to engage students in recent efforts within Latinx Studies to demonstrate the enduring presence of people of Latin American descent in the United States. In recent years, scholars have launched a rich debate about the use of the terms "Latina/o" and, more recently "Latinx," in the study of nineteenth-century and earlier texts published in the United States. On the one hand, the term "Latino" did not enter into widespread use in English until the late twentieth century—with "Latinx" making its widely debated entry even more recently.[26] On the other hand, as Kirsten Silva Gruesz has noted, these terms make it possible to "test out the possibility of a meaningful commonality of the idea of Latino expression, even before the term was invented."[27] To help students to consider the nineteenth-century origins of Latinx writing in the United States, I begin with a digital mapping project.

Launched through Pace University's digital humanities center Babble Lab, "Mapping New York City's Nineteenth-Century Spanish-Language Press" enables students to engage with the largely forgotten history of Spanish-language publishing in the neighborhood that surrounds the university's lower Manhattan campus. Students plot the addresses of nineteenth-century Spanish-language printers, publishers, and bookstore owners, in order to gain awareness of this understudied publishing community, whose

most famous member was the Cuban writer and revolutionary José Martí.[28] As they research this community, students quickly realize how much work is left to do. With the exception of Martí, the stories of many members of this community—including Rafael Serra, Sotero Figueroa, and Nestor Ponce de León—have rarely been told or are only beginning to capture scholarly attention. The students find, in other words, that in order to understand the history of New York's nineteenth-century Spanish-language press, they need to enter the archive themselves.

Fortunately, providing students with access to the archive is becoming easier to do. While the archive of texts relevant to Latinx history in the United States is, as scholars have noted, widely dispersed and filled with absences and omissions, recent digitization initiatives have made it far easier to access some archival materials. Created from the Recovering the US Hispanic Literary Heritage Project's collection, the *Hispanic American Newspapers, 1808–1980* Readex database, for example, brings together one of the largest digital collections of US-based Spanish-language newspapers from the nineteenth and twentieth centuries. In a Fall 2018 section of my Latinx literature course, I asked students to work in small groups to explore this database and to research and write about publications of their choosing.

The research resulted in group presentations that made it possible for students to draw on their own findings from the archive to expand on the discussions generated by the mapping project mentioned previously and by the texts already included in our syllabus. Among the newspapers that the students considered were *El Clamor Público*, founded by Francisco P. Ramírez, an 18-year-old *californio*.[29] Ramírez began publishing the periodical in 1855, just 7 years after the signing of the Treaty of Guadalupe Hidalgo at the close of the Mexican American War, in order to expose oppression of former Mexican citizens by the US government. Another group compared *Las Dos Américas* and *El Ciudadano*, both of which were published in El Paso, Texas in the late nineteenth century. Since these newspapers, along with many of the publications included in the Readex Hispanic American Newspapers database, are only beginning to capture scholarly attention, students gained a glimpse of the process of navigating material that has not been widely discussed by scholars. They learned to look for the ways in which the articles they read aligned with and also pushed against prevailing ideas from the field. In addition, this assignment made it possible to confront a major challenge with incorporating texts relevant to the nineteenth-century origins of Latinx culture. Since few of these texts have been translated into English, it can be difficult to incorporate them into a syllabus for a course taught in English. Some students chose from the English-language publications included in the database, while others drew on their Spanish-language skills. As they shared their findings with the rest of the class, language itself became a topic that we contemplated as we considered Latinx history and its making.

As an example of the potential of a revolutionary remix culture, this classroom project offers only a preliminary glimpse. Students gained introductory familiarity with the politics of archives and with the skills needed to enter into the archival record and choose the stories that they wanted to understand and retell. Along the way, many of them became energized in participating in this work, and I saw them also start to think for themselves about Latinx history and its making. Yet, a more fully-developed model of remix culture in the classroom might have gone further to make students partners in researching and compiling the texts and the stories brought together by the course.

One such example is Melissa Dennihy's American Literature courses at CUNY's Queensborough Community College, where students design their own courses and literary anthologies. As Dennihy explains,

> In a classroom where all but one of twenty-one students were people of color, and the majority were first-generation Americans, children of immigrants from nations including Guyana, the Dominican Republic, Korea, Taiwan, and the Philippines, definitions of and approaches to American literature took on new forms when students constructed the field. The texts and approaches students used to create their courses allowed them to find pleasure and meaning in literature, while providing me with a myriad of ideas about how I might construct future courses in ways that would generate more student interest and engagement.[30]

In this model, the students become partners with Dennihy in contemplating how knowledge about American literature has been constructed—and in building on that understanding to create new configurations. As Dennihy puts it, the students become "active creators, rather than passive consumers, of the American literary canon."[31] While she references canons and critical editions as the guiding frameworks of her course, one might carry Dennihy's idea still further by drawing a new conceptual model from the convergence of remix studies and the digital humanities that I have been discussing here.

Just as the field of digital humanities has shifted from critical editions to collections that are tagged and organized to invite exploration and discovery, one might shift the focus of the syllabus from canons to playlists that draw on the vast (yet also fragmented and incomplete) collection that literature becomes through digital and physical archives.[32] Presenting the selection of texts brought together on a syllabus as a playlist emphasizes the selection process—that the texts have been chosen from a larger array of options. When they are created by humans, playlists clearly reflect subjective tastes and personal preferences and experiences. When they are created by algorithms, as in Spotify's Daily Mixes, they provide data-driven reflections of those same personal interests. In the classroom, then, approaching the syllabus as a playlist invites thinking about other possible compilations—including the personalized mixes that the students might create themselves from their explorations of archival materials.

It is worth noting here that Manovich has defined remix in its historically specific form within software culture in contrast to the collection, where "the defining relationships are those between the items that are present and other potential items that are absent."[33] While the collection showcases the unique choices made through a process of curation, he argues, remix is about creating something new from older materials with an emphasis on "the effect produced by the arrangement of parts that are present."[34] I would argue that the playlist created from archival materials lies somewhere in between. Like the collection in Manovich's sense, selecting from an archive is always about engaging absence. Indeed, this is what Dillon is referring to when she employs the word remix (as quoted earlier) to describe what might be accomplished through metadata in the *Early Caribbean Digital Archive* that makes it possible to locate paraphrasing of enslaved people's voices in narratives by enslavers. At the same time, the playlist composed from archival research as I have been describing it here is also, like Manovich's notion of

remix, about creating something new—a new kind of cultural record that points toward better possible futures.

Playlists are certainly not the only forms through which scholars and students might remix the archival record, but as guiding metaphors, they can help to illustrate what increased participation in the production of knowledge about the past might look like. Perhaps the best recent articulation of this possibility is MIT's Active Archive Project, announced through its new email newsletter in Fall 2019. According to a statement on the project's website, an "active archive" constitutes a "digital repository in which users have the ability to interact with resources in order to craft, discover and share links between content previously unknown."[35] The examples cited in the statement demonstrate the challenging of colonial knowledge regimes that I have been discussing throughout this chapter:

> Two of our current projects—Blacks in American Medicine and US-Iran Relations—… are being refined to make sure that their vast repositories are not only open to all users but responsive to these users' wishes and needs. By thinking of users first, we aim to create archives that will engage a new generation of audiences who play active roles in shaping the stories that have been handed down to us all.

What the founders describe here is the very promise of remix that digital humanities scholars have been articulating for over a decade. But where will projects like these find the audiences they seek—and the partners they need to help them become truly collaborative, constantly changing projects? The classroom is a key site for modeling a very different world—one where we can talk about end goals not only in terms of profit or financial sustainability but also in terms of where we have been and where we want to go.

Reimagining Our Remix Era: Increased Participation in the Production of Knowledge

Admittedly, I am sounding a note of hopefulness at a time when conversations that offer dire predictions about the future of the university—especially from the perspective of a humanities discipline such as literary studies—are far more prevalent. Certainly, there is no shortage of dismal indicators—from the downward trend in humanities majors, to the impending dip in numbers of students who are of college age, to the declining view of the value of a humanities education altogether at the very moment when college has never been more expensive, to the added financial crises that most institutions face as a result of the COVID-19 global pandemic. Yet, among my students, I see their hunger for opportunities to understand and find solutions to the world's most pressing social issues. I see their eagerness to become thoughtful, savvy media consumers and producers. I also understand that, even recognizing the politics of archives and the resulting absences and omissions, the combined efforts of scholars alone are not enough to pursue all of the potential new pathways made possible by the digital cultural record.

I would add that the twenty-first century is certainly not the first time that writers, editors, and scholars have confronted the possibilities of media. Media scholars have widely discussed the tendency for new media to inspire utopianism and its opposite (apocalyptic thinking) about what the results will be. And yet, I do not think we have investigated past experiments (and the passions, hopes, and fears that accompanied them) enough to realize

the potential of various media innovations to expand, strengthen, and increase participation in democracy. This was the driving passion of the largely forgotten and understudied Spanish-language publishing community that surrounded Martí in New York City in the late nineteenth century.[36] As that community fought for independence from Spain in Cuba and Puerto Rico, and against the rising threat of autocratic rule in many of the newly established democracies of Latin America, they envisioned a more participatory future for modern media. That was a vision of greater participation limited by those writers' and editors' print-dominated media system into which only the most privileged could truly gain access. But one of the realizations of the most prescient writers of that community—especially Martí himself—was that the goal was not ultimately to create the most successful publication (or we might say today, platform). It was to increase access to the creation, exchange, and spread of ideas. Today, this is a lesson that we should all take to heart. Pursuing profit as the only goal is certainly not enough to drive digital media to their true potential. Nor is it reasonable to expect today's media companies to have vision that extends beyond that horizon. That role resides, at least in part, in universities and in the communities that they can help to mobilize and empower.

How do we talk about the future—of the Internet, of democracy, of humanity—in a way that takes our media forms and platforms into account but does not expect them to lead the conversation? Our classrooms provide one of our most hopeful forums. There, we can find another kind of logic driven by values such as racial justice, creativity, and appreciation of beauty. Perhaps—to borrow a provocative idea included in one of the precursors to this volume, *The Routledge Companion to Remix Studies*—professors and students might serve as partners in becoming "the innovators of the future [who] will be the DJs of Thought, sampling, mixing, and spinning all existing ideas and thought-objects into ever-new structures. They will remix what we know into what we could know. They will show the Academy how to dance."[37]

Notes

1 I use the term Latinx here following its growing prevalence in, and referring specifically to, a US context. At the same time, I recognize the ongoing debate about when and how broadly to apply the term "Latinx" vs. "Latina" and "Latino"—and whether to use it at all given its Anglocentrism. In my writing and my teaching in recent years, I have increasingly used the term "Latinx" not because I see these debates as resolved, but rather because I see the use of the term "Latinx" as a way to connect current debates about the term to the long history of writers of Latin American descent in the United States in articulating notions of community and identity in opposition to—and also on terms that operate independently from—US imperialism. Two essential resources that offer perspectives for and against the term "Latinx" are Catalina de Onís, "What's in an "x"?: An Exchange about the Politics of 'Latinx'" and Claudia Milian's special issue of *Cultural Dynamics* journal, "Extremely Latin, XOXO: Notes on Latinx."

2 University of Detroit Mercy, Libraries/Instructional Design Studio, Special Collections, *Black Abolitionist Archive*, https://libraries.udmercy.edu/find/special_collections/digital/baa/.

3 Northeastern University, Department of English, NULab for Texts, Maps, and Networks, and the Digital Scholarship Group in Snell Library, *Early Caribbean Digital Archive*, https://ecda.northeastern.edu/.

4 Duke University, Repository Collections and Archives, *Women's Travel Diaries*, https://repository.duke.edu/dc/womenstraveldiaries?facet=Source_Collection=American%20Woman%27s%20Travel%20Diary,%201878.

5 Readex, Recovering the U.S. Hispanic Literary Heritage Project, Hispanic American Newspapers, 1808–1980, https://www.readex.com/content/hispanic-american-newspapers-1808-1980.

6 Risam, New Digital Worlds, n.p.

7 Navas et al., "Introduction," 1.

8 Schnapp and Presner, "Digital Humanities Manifesto 2.0," 13.

9 Schnapp and Presner, "Digital Humanities Manifesto 2.0," 5.

10 Lessig, *Remix*, n.p. On remix's stages of development "from a basic creative concept in music production to its role as a cultural binder that gained relevance in remix culture, and eventually remix studies," see Eduardo Navas's chapter on "remix" in *Keywords in Remix Studies*, n.p. Also helpful on remix culture are Navas's *Remix Theory* and Owen Gallagher's *Reclaiming Critical Remix Video*.

11 See Manovich's *Software Takes Command*. I have discussed the relationship between digital humanities pedagogy and software culture in more detail in my "Toward a Latinx Digital Humanities Pedagogy."

12 Manovich, "Remix Strategies in Social Media," 139.

13 Ibid.

14 Ibid., 139.

15 Ibid., 138.

16 McGann, *A New Republic of Letters*, 137.

17 See, for example, Roopika Risam's "Decolonizing the Digital Humanities in Theory and Practice." "Postcolonial digital humanities" is the term she employs in her 2019 *New Digital Worlds*. On "engaging absence," see Thomas Padilla's blog post with that title.

18 "Introducing the Colored Conventions Project," n.p.

19 Dillon, "Translatio Studii and the Poetics of the Digital Archive," 259.

20 xtine burrough and Sabrina Starnaman, *An Archive of Unnamed Women*, http://visiblewomen.net/unnamed-women/index.html.

21 Ibid.

22 Berry, "Introduction," 9.

23 See, for example, Derek Stanovsky's discussion of "Remix Racism."

24 O'Dwyer, "A Capital Remix," 323, 326.

25 Risam, *New Digital Worlds*, n.p.

26 On the history of the terms "Hispanic" and "Latina/o" in the United States, see, for example, Suzanne Oboler, *Ethnic Labels, Latino Lives: Identity and the Politics of (Re)presentation in the United States* and G. Cristina Mora, *Making Hispanics: How Activist, Bureaucrats and Media Constructed a New American*. On "Latinx," see footnote 1.

27 On this topic, see also Raúl Coronado, *A World Not to Come*, pp. 28–30 and Rodrigo Lazo, "Introduction," *The Latino Nineteenth Century* (2016), edited by Rodrigo Lazo and Jesse Alemán, pp. 1–19.

28 I have also discussed this project in my "Toward a Latinx Digital Humanities Pedagogy," where I situated it within what was then an emerging approach to digital humanities pedagogy within Latinx Studies. My purpose here is to contemplate this project alongside other recent ones within and outside of Latinx Studies through the lens of remix studies—in order to better articulate their potentialities for the future of education and of public engagement in the making of history.

29 By *californio*, I mean a person of Latin American descent born in the Mexican state of Alta California before the territory became part of the United States in 1848. Ramírez's editorship rests on his identity as someone born as a *californio* who finds himself, along with his community, transformed into second-class American citizens after the Treaty of Guadalupe Hidalgo. On *californio* identity, see Marissa López's analysis, which includes a consideration of Ramírez, in Chapter Two of *Chicano Nations: The Hemispheric Origins of Mexican American Literature*.

30 Dennihy, "New Canons," 25.

31 Dennihy, "New Canons," 23. Thank you to my student Riley Kalt for calling my attention to this article through her own research on rethinking the teaching of the US literature.

32 As Thomas Augst has noted in reference to the impact of digital archives on the study of literature: "Encountered across digital archives, US literature becomes a collection rather than a canon" (4).

33 Manovich, "Remix Strategies in Social Media," 142.

34 Ibid.

35 "Introducing the Active Archives Initiative," n.p.

36 See my "American Alternatives."

37 Falconer, "The New Polymath (Remixing Knowledge)," *The Routledge Companion to Remix Studies*, 397.

Bibliography

Augst, Thomas. "Archives: An Introduction." *American Literary History* 29, no. 2 (Summer 2017): 1–9.

Berry, David M. "Introduction: Understanding Digital Humanities." In *Understanding Digital Humanities*, edited by David M. Berry, Kindle. New York: Springer, 2012.

burrough, xtine, and Sabrina Starnaman. *An Archive of Unnamed Women*. Accessed May 1, 2020. http://visiblewomen.net/unnamed-women/index.html.

Coronado, Raúl. *A World Not to Come: A History of Latino Writing and Print Culture*. Cambridge, MA: Harvard University Press, 2013.

Dennihy, Melissa. "New Canons: Students Constructing American Literature Courses and Anthologies." *Teaching American Literature: A Journal of Theory and Practice*, no. 22 (Fall 2015): 23–44.

Dillon, Elizabeth Maddock. "Translatio Studii and the Poetics of the Digital Archive: Early American Literature, Caribbean Assemblages, and Freedom Dreams." *American Literary History*, no. 29.2 (Fall 2017): 248–66.

Falconer, Rachel. "The New Polymath (Remixing Knowledge)." In *The Routledge Companion to Remix Studies*, edited by Navas, Eduardo, Owen Gallagher, and xtine burrough, 397–408. New York: Routledge, 2015.

Gallagher, Owen. *Reclaiming Critical Remix Video : The Role of Sampling in Transformative Works*. Abingdon, Oxon: Routledge, 2018.

Gruesz, Kirsten Silva. *Ambassadors of Culture: The Transamerican Origins of Latino Writing*. Princeton, NJ: Princeton University Press, 2002.

"Introducing the Active Archives Initiative: Making Stories within the Archive." *MIT HyperStudio*. Last modified April 25, 2018. http://hyperstudio.mit.edu/blog/blog-research/introducing-the-active-archives-initiative-making-stories-within-the-archive/

"Introducing the Colored Conventions Project." *Colored Conventions Project*. http://www.coloredconventions.org.

Kreitz, Kelley. "American Alternatives: Participatory Futures of Print from New York's Nineteenth-Century Spanish-Language Press." *American Literary History* 30, no. 4 (Fall 2018): 677–702.

Kreitz, Kelley. "Toward a Latinx Digital Humanities Pedagogy: Remixing, Reassembling, and Reimagining the Archive." *Educational Media International*, no. 54.4 (Fall 2017): 304–16.

Lazo, Rodrigo. "Introduction: Historical Latinidades and Archival Encounters." In *The Latino Nineteenth Century*, edited by Rodrigo Lazo and Jesse Alemán, 1–19. New York City: NYU Press, 2016.

Lessig, Lawrence. *Remix: Making Art and Commerce Thrive in the Hybrid Economy*, Kindle. London: Bloomsbury, 2008.

López, Marissa. *Chicano Nations: The Hemispheric Origins of Mexican American Literature*. New York City: NYU Press, 2011.

Manovich, Lev. "Remix Strategies in Social Media." In *The Routledge Companion to Remix Studies*, edited by Navas, Eduardo, Owen Gallagher, and xtine burrough, 135–53. New York: Routledge, 2015.

Manovich, Lev. *Software Takes Command*. London: Bloomsbury, 2013.

McGann, Jerome. *A New Republic of Letters: Memory and Scholarship in the Age of Digital Reproduction*. Cambridge: Harvard UP, 2014.

Milian, Claudia. "Extremely Latin, XOXO: Notes on LatinX:" *Cultural Dynamics*, October 4, 2017.

Mora, G. Cristina. *Making Hispanics: How Activists, Bureaucrats, and Media Constructed a New American*. Chicago, IL: The University of Chicago Press, 2014.

Navas, Eduardo. "Remix." In *Keywords in Remix Studies*, edited by Eduardo Navas, Owen Gallagher, and xtine burrough, 244–58. New York and London: Routledge, 2018. Kindle edition.

Navas, Eduardo. *Remix Theory [Electronic Resource] : The Aesthetics of Sampling*. New York: Springer, 2012.

Navas, Eduardo, Owen Gallagher, and xtine burrough. "Introduction." In *The Routledge Companion to Remix Studies*, edited by Navas, Eduardo, Owen Gallagher, and xtine burrough, 1–12. New York: Routledge, 2015.

O'Dwyer, Rachel. "A Capital Remix." In *The Routledge Companion to Remix Studies*, edited by Navas, Eduardo, Owen Gallagher, and xtine burrough, 323–32. New York: Routledge, 2015.

Oboler, Suzanne. *Ethnic Label, Latino Lives: Identity and the Politics of (Re)Presentation in the United States*.Minneapolis: University of Minnesota Press, 1995.

Onís, Catalina (Kathleen) M. de. "What's in an 'x'?: An Exchange About the Politics of 'Latinx'." *Chiricú Journal: Latina/o Literatures, Arts, and Cultures* 1, no. 2 (2017): 78–91.

Padilla, Thomas. "Engaging Absence." *Thomas Padilla*. Last modified, February 26, 2018. https://www.thomaspadilla.org/2018/02/26/engaging-absence/

Risam, Roopika. "Decolonizing the Digital Humanities in Theory and Practice." (2018). English Faculty Publications. 7.https://digitalcommons.salemstate.edu/english_facpub/7

Risam, Roopika. *New Digital Worlds: Postcolonial Digital Humanities*, Kindle. Chicago: Northwestern University Press, 2019.

Schnapp, Jeffrey and Todd Presner, "Digital Humanities Manifesto 2.0," 2009, Accessed December 20, 2019. jeffreyschnapp.com/wp-content/uploads/2011/10/Manifesto_V2.pdf.

Stanovsky, Derek. "Remix Racism: The Visual Politics of the 'Alt-Right'." *Journal of Contemporary Rhetoric* 7, no. 2/3 (2017): 130–38.

14

METADATA FOR DIGITAL TEACHING

Enabling Remix for Open Educational Resources

Michael Collins

I visited the Huntington Library, Art Museum, and Botanical Gardens in San Marino, California in March of 2015. It was there I first set my eyes on a Gutenberg Bible, printed in 1455.[1] It is one of the first examples of a mass-produced text, now approaching 600 years in age, and it is a beautifully crafted object from its binding to illustrations and typographic innovations. This object, displayed in a glass case, seemed to travel through time, unencumbered by the forces that typically seek to destroy and decay most things. I had a similar experience when I saw the Rosetta Stone at the British Museum[2] later that year, one of the most famous pieces of written information and created more than 1600 years before the Gutenberg Bible was first printed. The Rosetta Stone did not quite make it through history as unscathed as the Gutenberg Bible, though who is to say the Bible I saw will make it through the next 1000 years intact. Of course, there are many examples of even older ancient writings that have stood the test of time, suggesting that stone, clay, animal skin, and paper are relatively hardy recording media. Or, perhaps the information contained calls upon people to carefully shelter and protect these vessels of information from deterioration and other dangers.

In contrast to these objects, the Internet is just over 30 years old at the time of this writing and the first electronic texts emerged from IBM only 20 years earlier. The rate by which data is currently created has been increasing exponentially, with 463 exabytes[3] expected to be created every single day by 2025.[4] To help search, sort, filter, and make use of this data, an additional type of data, called metadata, is also generated. Metadata has the potential to transform knowledge systems and the ways in which people teach, learn, and create new knowledge.

Emerging digital tools and services afford new information publishing power to individual members of communities where they can remix, shape, and steward information—a change from the traditional organizational power values of opacity and exclusivity found in many textbook and journal publishers[5]—thereby improving human rights issues pertaining to knowledge access. To appreciate this transition, one needs to understand the dynamic forces that drive technological trends and to anticipate what

such trends might look like in the future. This critical process requires evaluating aspects of networked information as it pertains to learning and presenting new projects aimed at harnessing the power of digital publishing to revolutionize digitally mediated teaching. In this chapter, I examine the issues pertaining to the survival of information and look at the role metadata plays in this process. I then describe Open Educational Resources (OER) and related educational metadata projects which support digital teaching technology and access of digital information. Finally, I explore theories related to digital teaching and digital infrastructure and then highlight innovative publishing tools for digital teaching that will contribute to the long-term preservation of digital information.

Information Survival in the Natural World

In all living organisms on Earth, Deoxyribonucleic Acid (DNA) is used to store digital information describing observable traits as well as instructions for self-replication.[6] The human genome, containing about three billion base pairs,[7] requires about 750 MB of data, assuming it needs two bits to record each base pair. DNA information undergoes a kind of remix that not only helps it preserve itself through replication but also enables it to alter itself in order to adapt to changing forces of destruction (the processes of evolution and adaptation). One could argue that the primary purpose of DNA is not just for the long-term storage of information but to ensure that information survives when introduced to new contexts.

A fairly comprehensive evaluation of issues related to the survival of information was conducted at the behest of the US Department of Energy, which exercised a moral obligation to warn future societies about the dangers of interfering with underground radioactive material deposits that will remain dangerous for the next 10,000 years. A multidisciplinary team called the Human Interference Task Force, which included experts in nonverbal communication, linguistics and semiotics, material sciences, anthropology, archeology, climatology, behavioral psychology, and public policy, published a 1984 report describing how the nature of language, materials, human nature, and economic incentive creates paradoxical challenges to communicating present day information to future societies. It included suggestions for monument designs, offsite records, and institutional engagements as well as a recommendation for a message relay system that contained two messages: One that would describe the danger and a second meta-message that would call upon the current society to periodically re-encode the messages according to communication standards of the time.[8]

Just as DNA mutates over time to account for changing environmental contexts, the methods evaluated by the Human Interference Task Force attempted to account for the eventual mutation of a future society's language, mutating the message's encoding and perhaps the message itself and unknowingly referencing part of the system for how information replicates in the natural world. Craig Venter, an American scientist, credited with creating the world's first synthetic life, said in an interview: "Life is a DNA software system ... All living things are solely reducible to DNA and the cellular apparatus it uses to run on."[9] Others consider this DNA-centric perspective overly simplistic, ignoring the impact of environmental contexts evident in epigenetic markings.[10] Though a detailed comparison of naturally occurring information systems is beyond the scope of this chapter, it may be feasible to extrapolate overarching ideas

pertaining to data survival and adaptation to other digital information, engineering it to navigate through changing digital environments. What scenario would be required for information to transcode itself into other formats or to configure its own software and hardware?

Metadata

Metadata is descriptive information that refers to the data embedded in other information. An early account of metadata usage was in the Great Library of Alexandria around 280 BCE. Small tags were attached to the end of scrolls that displayed the author, subject, and title.[11] This information helped researchers understand the content of the scroll without having to read it. This system eventually gave way to card catalog systems used in libraries today. For information to be preserved, we must be able to retrieve it, and, therefore, it must be findable. This is a primary reason that modern libraries employ metadata librarians, who develop and use descriptive metadata to aid in search and access of materials in their collections.[12]

> See Chapter 10 for Anne Burdick's discussion of remix in the design of libraries.

Metadata can be both generated and manually created. A digital image, for example, contains autogenerated metadata to describe date, time, location of image, the camera used, and others. While computer scientists work on machine learning and computer vision to try to automatically identify and tag objects contained in video or images, those algorithms will likely never capture nuanced contexts or significance; something best created by people. On the Web,[13] metadata is used to assist search engines in filtering through ever increasing volumes of data to locate the most relevant high-quality search results. For instance, if a searcher wants to find a webpage about a band, metadata will help a search engine algorithm understand whether a webpage contains a punk rock band or a wedding band. Who or what decides what is considered to be of high quality and relevant when optimizing search algorithms? The answer comes in part from more metadata that is based on a set of standards. Specifically, the "semantic Web," a term originally coined by Sir Tim Berners-Lee, will be the means by which "linked data," or two pieces of information and the relationship between them, will allow search filters to locate the content most accurate and relevant to the searcher's wants and needs.[14] The semantic Web is largely facilitated by the Schema.org[15] project, a popular example of metadata standards developed and adopted by search engine companies to promote the use of semantic HTML. Before exploring examples of metadata standards projects, I will first examine the principles and impact of open publishing.

Empowerment Through Open Publishing

The ubiquitous availability and access to information and technology can be referred to using the term "open." *Open* in this sense means that the majority of people can participate. When the potential for the reuse and remix of information is open to the majority of people, that information is more likely to be perpetuated and creatively acted upon; therefore, open publishing of information is essential to its long-term survival, helping to expand collective human knowledge.

Johannes Gutenberg is popularly attributed to mass producing the Bible in the mid-1400s by combining food press technology with wood block printing methods. Hindsight shows this to be one of the premiere examples of the role and impact technology continues to have on disrupting and subverting entrenched power hierarchies. It achieved this by opening previously closed access to knowledge and the means for its production and dissemination. Five hundred years later, the paradigm of the small group of elite crafts people and knowledge workers has given way to billions of people armed with mobile devices who can now publish instantaneously through social media to their own followers, which can number in the millions. This dramatic change is made possible only with technology developed over hundreds of years of innovation in tools, language, and social organization.

Based on how technology has progressed, it is no surprise that software and hardware empower the average person to create sophisticated media using photographs, films, games, and other forms of storytelling that once required the labor of many specialists and extensive financial resources. Consumer electronics companies, such as Apple, Inc., capitalize on this and have long featured advertising campaigns highlighting short films created with their consumer electronic devices to insinuate that it can be done by anyone. Industries are also lowering costs and speeding up production through a reliance on automation and machine learning, and if technological innovation trends continue, these tools will eventually become available for use by the average person.

The United Nations Educational, Scientific and Cultural Organization (UNESCO) "seeks to build peace through international cooperation in Education, the Sciences and Culture." The UNESCO Open Educational Resources (OER) Recommendation published the following support for OER in late 2019:

> ...the principles embodied in the Universal Declaration of Human Rights, which states that all people have rights, duties and fundamental freedoms that include the right to seek, receive and impart information and ideas through any media and regardless of frontiers (Article 19), as well as the right to education (Article 26), and the right to freely participate in the cultural life of the community, to enjoy the arts, and to share in scientific advancement and its benefits; and the right to the protection of the moral and material interests resulting from any scientific, literary, or artistic production of which one is the author (Article 27)...,[16]

UNESCO's public support for OER is centered around the gains that can be made in improving human rights through increased access to information.[17] Therefore, software that can improve OER access, production, and publication will ultimately improve related knowledge issues pertaining to global human rights needs.

Schemata for OER Remix

Remixing educational materials is only possible with the presence of a few key elements. First, there needs to be a common understanding of the nature of objects in an educational context. Second, there needs to be a commonly understood way to modify, reassemble, and contextualize digital information. If there are no established rules for how to use a given set of vocabulary, semantic meaning becomes diminished or dissolved. This suggests that to maintain semantic meaning for educational materials, a standards

system must be established and implemented. Authors of educational resources rely on their spoken language(s) to create pedagogical materials based on instructional terminology they have been trained to use, that they have seen other educators use, or that they have invented. Although this affords educators an array of interesting language to describe their own educational resources, it does a disservice to those from a different cultural or linguistic background they attempt to interface with those materials.

How can educators maintain the use of their own language in their pedagogy and yet make their materials understandable and usable for others? Consider how teaching resources are constructed from language and the inherent difficulty of translating from one language to another. A primary issue of translation is that certain syntax paradigms simply do not exist and require additional explanatory materials to make translation possible. Instead of additional explanation being conveyed in the end language, semantic meaning could instead be conveyed with standardized metadata.

For software to act upon educational resources, the vocabulary and the method for creating semantic relationships between multiple resources must be standardized. An educational resource standard has three primary requirements for success, including a comprehensive vocabulary that is able to describe the meaning of any educational resource, a flexible structure able to describe semantic relationships for any pedagogical scenario, and widespread adoption of the standard. The third requirement, widespread adoption, is rather challenging for a new standard, as there needs to be a perceived imperative and willing developers to integrate the standard into digital authoring tools.

Educational Metadata

The Dublin Core Metadata Initiative (DCMI) is a nonprofit organization supporting innovative projects in metadata design and oversees related conferences, workshops, and task groups.[18] The Learning Resource Metadata Initiative (LRMI) was initially funded by the Bill and Melinda Gates Foundation and William and Flora Hewlett Foundation and was transferred in 2014 to DCMI for stewardship. LRMI extends a variety of Resource Description Framework in Attributes (RDFa) schema vocabularies, including those hosted on the schema.org website. It adds its own vocabulary for describing education resources used around the world.

Generally, Open Educational Resources (OER) are any educational material or tool licensed for remix. OER initiatives come at a time when student loan debt in the United States has soared and textbooks can cost hundreds of dollars. Universities have created internal task forces to evaluate how to get the cost of educational materials down and have grant initiatives for not only locating and using OER but also paying faculty to author OER.

Acting as the primary curriculum developer for the online Digital Multimedia Design (DMD) Bachelor of Design program at Penn State University, I became intrigued by the potential of OER to allow for educational content to be remixed through open licensing and obtained permission from my college's Dean early on to develop OER materials currently used by multiple courses. Courses were stored in a publicly accessible online repository to enable collaborative editing and act as a primary source when content was imported into online learning software. During the development of these OER courses for the DMD Program, I became aware of forward-thinking online education technology staff in the Penn State Smeal College of Business, which ultimately led to a multi-year

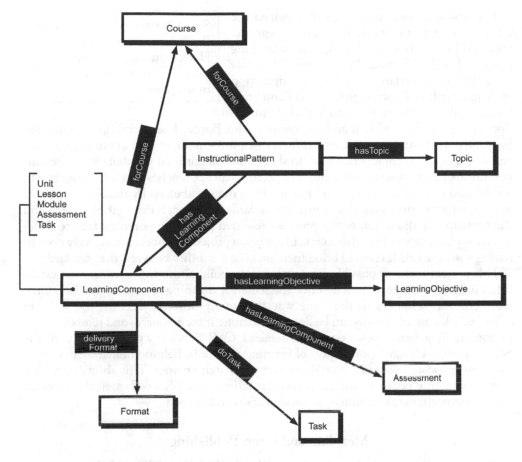

Figure 14.1 Diagram depicts an example web of relationships between linked information established by OER Schema. This is a reproduction of a visualization originally created by Phil Barker in "OER Schema in comparison to LRMI/Schema."

collaboration pursuing a new schema vocabulary to help describe pedagogy on the web, called OER Schema.

OER Schema

Open Educational Resources (OER) Schema[19] is an RDFa project that semantically describes a teacher's pedagogy using standard metadata laying important groundwork for the future of interoperable learning media. It does this by establishing an educationally relevant vocabulary and hierarchical relationships (Figure 14.1),[20] that can be embedded in HTML using metadata. Creativity is popularly thought of as an expression of original innovation; however, the modularity inherent in language and knowledge itself suggests that there is always a foundation upon which to assemble new ideas.[21] The OER Schema project extends existing RDFa vocabularies to bring additional pedagogical terminology previously absent from the semantic Web, and while not profoundly novel, it adds practical innovations needed to describe pedagogical paradigms.

The first workshop, in a series that helped the OER Schema team define, structure, categorize, and build out a new taxonomy, was a day-long event called OER Summer Workshop held on July 18, 2016. I organized the workshop in conjunction with an interdisciplinary team from the Penn State Smeal College of Business which included instruc-

> See Chapter 15 for Victoria Bradbury's discussion of an Art Hack workshop at the intersection of remix and the digital humanities.

tional designer Katrina Wehr and programmer Alex Boyce. The workshop was attended by faculty and instructional designers from disciplines including communications, arts, and sciences. The goal was two-fold: to show that standardized vocabulary can be universally applied to describe all manner of pedagogical approaches and subject matter in syllabi, and to see if any terms were missing from the vocabulary. By the end of the day, workshop participants were able to attach standard vocabulary terms to their syllabi, and the participants' discussion of the process presented promising potential for the widespread applicability of the schema.[22] OER Schema project members are actively coordinating with the LRMI team to bring increased compatibility between the standards.

This project makes it possible for developers to build authoring software that establishes links and references that describe the semantic meaning of structured educational materials and resources in the same way that many other objects on the web are described. Automation tools can be designed to mine these resources and remix content to potentially generate new courses on demand. OER Schema will also help with the Search Engine Optimization (SEO) of learning materials, helping human searchers to more easily locate relevant materials on popular search engines. This ability to readily transfer semantic pedagogy will help digital teachers establish a pedagogical commons, where approaches are continually expanded upon and refined.

Metadata and Open Publishing

In the openly licensed book and website, *OPEN DESIGN NOW!* (2011), many new and exciting projects, essays, and interviews are explored surrounding the meaning, implications, and wondrous possibilities of open design paradigms for governance, business, design, education, and production.[23] Despite the book being freely viewable online,[24] I purchased a print copy with the understanding that it was a comprehensive snapshot in time of open ideologies having a collective moment of significant forward momentum. Every few years, I page through the physical copy of the book and try to visit the projects' hyperlinks—more often than not, the URLs are broken, and the projects referenced in the book no longer exist. The juxtaposition of the authors' fervor and ideological commitment evident in the text with the projects' now broken hyperlinks brings forth questions about the viability of open projects, and perhaps, more importantly, the sustainability of digital formats for the long-term safekeeping of information. How long will it take until the website version of *OPEN DESIGN NOW!* disappears?

A distinctive element in the book's layout is that whenever key topics or ideas emerged that were shared between essays and interviews, they were written at the end of the sentence or paragraph in a visually distinct manner through highlighting and differentiation of the typeface. This visual contrast indicated it was not to be read in the same way as the other text. These additional text items operate like exposed metadata, threading different essays in the book together. This worked well in printed text, but when displayed as a website, the highlighted text became active hyperlinks that sent the

reader to a page that listed the other associated texts sharing similar highlighted topics and themes. This is a visual and functional representation of metadata, though not implemented as metadata in the source code. It highlights a major affordance of a digital hypertext publication over a printed book—the interactive exploration, real-time filtering, and connecting of information. When I copied the text, as I was legally permitted via the Creative Commons (CC) license, the inline metadata could not be translated visually in the same manner by my editing software, making my reuse of the texts an imperfect derivative. I lost the utility of the metadata. This introduced additional labor into the process of reusing the materials in my own course texts.

A team of educational technology developers at Penn State University has introduced a new software application called HAX that presents a novel way to author and publish fully-featured digital media on the web. HAX stands for *headless authoring experience*, where "headless" refers to a paradigm in software development when a software interface is disassociated from an underlying database and media storage.[25] This tool significantly reduces the technical complexity related to publishing remixable text, video and image, 3D objects, interactive educational elements, and many others to the web. More fundamentally interesting, it allows an author to modify and directly attach metadata to text and media content as it is created. Unlike most word processing or website creation software, it is possible to use tools available in HAX to semantically define relationships between text and media and then publish standards-based educational content to the web for reuse and remix by other educators. HAX and software tools like it will allow authors a visual way to apply metadata, creating content that begins to realize the promise of networked knowledge only possible in digital formats.

Digital Teaching Is Software

Teaching in its most raw form is the act of creating scenarios where a student learns information. The origin of the word *teaching* comes from an Old English word for "show," "present," and "point out."[26] Inherent in this definition is a kind of performance. When the learner is taught while physically remote from the teacher, this is known as distance learning. Distance learning can be traced back to correspondence courses first introduced in the 1700s. In a modern distance learning context, courses are taught digitally. In asynchronous online learning, the labor required for the performance of teaching is conducted at the beginning of the semester during a course set up. Students can then engage asynchronously with digital media in Learning Management System (LMS) software that stewards them through their learning scenarios at their convenience. Teachers engage with students when necessary to clarify ambiguities or through virtual office hours or e-mail messages.

Manovich argues: "there is no such thing as 'digital media,'" stating that "for users who only interact with media content through application software, the 'properties' of digital media are defined by the particular software."[27] Therefore, digital media becomes part of the software itself. There is no digital media object that can live on its own, with self-contained affordances. Once a digital image is printed, it becomes an analog representation of digital code. The light that reflects from the surface of this print is sensed by the onlooker's eyes and interpreted by their brain—an analog process.

Analog film photography, developed in the late nineteenth century, contained certain properties and visual artifacts inherit in film emulsion and developing processes that were left behind during the shift toward digital photography in the early 2000s.

Despite a certain desire for the aesthetic of film photography and videography, these appeals were eventually traded for the gains in efficiency, savings in cost, and lowered barrier to entry for new photographers. However, the look derived from film has been so embedded in visual culture, that analog artifacts are digitally added to mimic these effects.

If this analog-to-digital transition of photography is compared to the current state of teaching, where analog materials are converted to digital media and/or are created and disseminated via functions of software, certain questions arise. Is recording a video lecture the teaching equivalent of adding film grain to a digital photograph, and should a different technique have been explored to steward the learning process? The performance of teaching has gained new functions available from software and lost certain analog functions that can only occur in a physical performance space. Just as the term *New Media Art* references art that is produced due to new affordances brought about by the constant state of software and hardware innovation, perhaps distinct terminology should be used to describe the innovations in teaching mediated by digital technology. Although digital media may not exist from Manovich's perspective, it is useful terminology to generally refer to media within software. The act of creating learning scenarios that are accessed only through digital software can be thought of as *digital teaching*. Like digital media, digital teaching is also inseparable from software. I hesitate to call learning that occurs as a result of interacting with software "digital learning," because learning is an analog process that relies on visual, haptic, and auditory stimuli to transmit information. Although learning occurs in multiple sensory modes and in a variety of contexts and settings, the outcomes are predominantly centered in the learner's brain; however, if this process begins in the software, this could spur a fundamental shift in the way teachers steward learning and education for their students.

Duke University's Learning Innovation group has developed a way for teachers to independently use clusters of software applications that are managed through a single interface—a tool they refer to as a "kit."[28] Through this tool, they are enabling nonexpert users to deploy and manage independent software that acts as digital infrastructure for their courses. Another example is the ELMS: Learning Network (LN) project. Originally developed by the Penn State education technologists and learning designers, rather than a single software application, a "suite of tools" approach helps digital teachers educate online students.[29] ELMS: LN is similar to other LMS software but is able to dynamically self-install new software capabilities that are seamlessly networked together for users. These capabilities are designed to coalesce into a pedagogically sound digital teaching environment. As digital learning materials grow to include links to other texts and media, the course itself becomes a network of connected information expressing particular pedagogical methodologies.

Knowledge as Network

According to Siemens, behaviorism and cognitivism consider knowledge to be external to the learner, and that learning is a knowledge-absorption process. Alternatively, constructivism assumes that learners act not as empty vessels but actively create meaning.[30] Artistic production from a connectivism perspective is the recognition of patterns within networked information that coalesce into objects of aesthetic, cultural, and social being—knowledge. This notion of knowledge as networked information is central to the idea that artists are in fact knowledge workers.

Schemas describe organizational and categorical patterns and are used to establish semantic relationships between information. These semantic relationships enable information to engage more fully with the affordances of the digital network in which they are enmeshed. Downes explains that learning occurs when connections between information are created, destroyed, strengthened, and broken.[31] This solidifies the idea that artistic practice is the process of learning and inquiry. By identifying and presenting new or existing connections, artists expose information networks and the means by which those networks are established, making them perceivable by others. This revealing is inherent in the nature of any critical making or works of subversion. When formulating an artist statement, a framework of understanding or ontological lens is used to describe the relationships (schema) that are formed in the work. Therefore, an art critique can also be thought of as a way to map the information networks traversed by the artist when producing the work. Schemas are both present at the beginning and the end of the production of artworks and revealing them helps contextualize the work in a knowledge network.

Expanding Networks Through Dialog

The Digital Multimedia Design Program caters to a particular market of art and design students who are not able to enroll in a traditional face-to-face campus experience.[32] The DMD program is accredited with the understanding that a laptop computer is the digital equivalent of an art or design studio space. Students use software on their computers to find a community of practice, digital tools and infrastructure to produce their work, gather feedback and critique, to gain inspiration and advice from instructors, and so on. They log into software to access their courses and conduct research with the help of search engines and digital card catalogs. Students in face-to-face courses also perform some of the same functions using the same digital workflows, so in some sense, all modern-day teaching in higher education, and to a considerable amount in K-12 education, contains some features of digital teaching.

Digital teaching has done a fairly comprehensive job acquiring many of the affordances of the face-to-face classroom. This is not a linear relationship, the face-to-face classroom experience is adopting pedagogical approaches from digital teaching methods as well. For instance, lectures, presentations, examples, and materials must be pre-developed for online course environments and can be optionally provided to face-to-face students in digital repositories where they can revisit digital materials as many times as they need in order to grasp difficult concepts. One major difference between online and face-to-face course communication is that providing feedback to students in-person and providing the same feedback asynchronously is very different. Asynchronous feedback may be typed or recorded, but it removes the possibility of enriching the learning process through real-time dialog. While it is not the only avenue, dialog is important for discovering and connecting new information and expanding student knowledge.

This lack of classroom interaction found with asynchronous feedback problematically de-emphasizes what Freire describes as being crucial for critical teaching practice, whereby "...a correct way of thinking that goes beyond the ingenuous must be produced by the learners in communion with the teacher responsible for their education." Freire points out that a correct critical pedagogy is not a transference of enlightenment, rather it "involves a dynamic and dialectical movement between 'doing' and 'reflecting on

doing."[33] Dialogic pedagogical approaches can be hard to facilitate in digital teaching due to the asynchronous nature of many online courses, enrolled with students from different time zones and schedule limitations. Digital teachers often miss out on a students' moment of insight, when a concept is grasped for the first time, which is important feedback to let teachers know their pedagogy is effective and functioning as intended. Skilled digital teachers instead use the strengths of online environments to compensate for the lack of consistent synchronous dialog and incorporate multiple modes of formative assessment and feedback into courses, empowering students to become independent learners who must take an active role in learning and reflecting rather than merely engaging in rote behavior.

Conclusion

During the writing of this chapter in early 2020, the COVID-19 global pandemic erupted. This event eliminated the possibility for social gatherings for months and forced K-12 schools and universities around the world to swiftly implement digital teaching practices with varying degrees of success. Live video lectures conducted via Zoom video conferencing software were a popular means of holding class, a technology choice that afforded dialogical aspects present in face-to-face learning.[34] Digital technology allowed educators to swiftly meet unexpected distance education needs on a global scale, adding a layer of complexity to what is described in this chapter.

Just as knowledge exists as networked information, digital teaching is manifesting as networked software. Encouraged by developments in metadata and software, open access, and remix-oriented licensing, the economics and culture around information publishing will continue to change. In doing so, more people will be able to take part in teaching and learning—aiding human rights initiatives focused on literacy and education.

Technology like Gutenberg's helped mitigate information loss through proliferating information duplicates; it is no doubt responsible for the survival of many texts that would have otherwise disappeared. Though digital media formats and hardware introduce new affordances for information production, publication, and access, they also introduce problems of stability and sustainability. Much like the process, DNA uses to adapt biological information to new contexts, digital information must be continually duplicated, indexed, and transcoded to contemporary formats with the aid of metadata, or else risk being lost due to obsolescence or network obscurity. For these reasons, future authors of educational materials may also be metadata editors, adding explanations of context, meaning, and relationships to digital texts.

Expanded metadata standards like OER Schema and LRMI will set the stage for the development of more intelligent automation tools, expanding and improving the affordances in digital teaching while helping search tools to sift through increasing quantities of information. These metadata projects are optimistic visions of the future, where all educators can participate in authoring digital materials that more fully contain the affordances of digital technology. By implementing open-access practices and recognizing the critical value of metadata, improvements to digital authoring and publishing will continue, addressing fundamental issues related to the preservation of digital information and expanding human capability for adding to and traversing information networks.

Notes

1 https://www.huntington.org/gutenberg-bible

2 "Object: The Roseta Stone," *The British Museum*, https://research.britishmuseum.org/research/collection_online/collection_object_details.aspx?objectId=117631&partId=1

3 One Exabyte equals 1 billion gigabytes.

4 Raconteur, *A day in data*, 2019, Accessed December 23, 2019, http://rcnt.eu/un8bg.

5 Jeremy Heimans and Henry Timms, "Understanding 'New Power,'" *Harvard Business Review* 2014, https://hbr.org/2014/12/understanding-new-power.

6 James Watson and Francis Crick, "Genetical Implications of the Structure of Deoxyribonucleic Acid," *Nature* 171, no. 4361 (1953): 964–67, https://doi.org/10.1038/171964b0.

7 "Human Genome Project," Genome.gov, Accessed January 20, 2020, https://www.genome.gov/human-genome-project/Completion-FAQ.

8 Human Interference Task Force, *Reducing the Likelihood of Future Human Activities That Could Affect Geologic High-Level Waste Repositories* (Report ONWI-537) (Columbus, OH: Office of Nuclear Waste Isolation. 1984).

9 Available from: http://www.theguardian.com/science/2013/oct/13/craig-ventner-mars.

10 For a deeper discussion on the topic of DNA and its role in information replication, see "Life is More than a Computer Running DNA Software," *World Journal of Biological Chemistry* 5, no. 3 (2014): 275–278, Published online 2014 Aug 26, doi: 10.4331/wjbc.v5.i3.275.

11 Alex Wright, *Glut: Mastering Information through the Ages* (Washington, DC: Joseph Henry Press, 2007), 73.

12 Myung-Ja Han and Patricia Hswe, "The Evolving Role of the Metadata Librarian," *Library Resources & Technical Services* 54, no. 3 (2011): 129–41.

13 "World Wide Web," *The World Wide Web Project*, CERN, http://info.cern.ch/hypertext/WWW/TheProject.html. Accessed December 23, 2019.

14 Tim Berners-Lee, James Hendler, and Ora Lassila, "The Semantic Web," *Scientific American* 284, no. 5 (2001): 34-43.

15 https://schema.org

16 *Draft Recommendation on Open Educational Resources*, In: UNESCO, General Conference, 40th. [online] France, 2019, https://unesdoc.unesco.org/ark:/48223/pf0000370936.

17 Zeynep Varoglu, "New UNESCO Recommendation will promote access to educational resources for all," 2019, https://en.unesco.org/news/new-unesco-recommendation-will-promote-access-educational-resources-all.

18 "About DCMI," DCMI, https://dublincore.org/about/, Accessed February 8, 2020.

19 "Open Educational Resource Schema," *OER Schema*, Accessed February 8, 2020. http://oerschema.org/docs/.

20 The diagram seen in Figure 14.1 was shared with the author on August 22, 2018.

21 Eduardo Navas, "The Originality of Copies: Cover Versions and Versioning in Remix Practice," *Journal of Asia-Pacific Pop Culture* 3, no. 2 (2018): 183.

22 Michael Collins, "OER Summer Workshop, PSU," *Meduim.com* (blog), September 28, 2016, https://medium.com/@_mike_collins/oer-summer-workshop-psu-23ca239b73e5.

23 Bas Van Abel, Lucas Evers, Peter Troxler, and Roel Klaassen, *Open Design Now: Why Design Cannot Remain Exclusive* (Creative Commons Netherlands: BIS Publishers, 2011).

24 http://opendesignnow.org/

25 Bryan Ollendyke, "HAX, Web Components and the Distributed NGDLE Future," Penn State University, February 7, 2018, https://psu.app.box.com/s/gk6013odcl3115j3ibfzudj3bqar059v.

26 *Lexico (Oxford)*, "Teach," accessed June 13, 2020, https://www.lexico.com/en/definition/teach.

27 Lev Manovich, *Software Takes Command* (London: Bloomsbury Press. 2013), 152.

28 https://github.com/DukeLearningInnovation/kits

29 Michael Collins and Bryan Ollendyke, "ELMS Learning Network: An EdTech Platform for Sustaining Innovation," Penn State University, May 8, 2015, https://psu.app.box.com/s/3318wac7ob987bxpwb2olf1fv8uskauy.

30 George Siemens, "Connectivism: A Learning Theory for the Digital Age," *International Journal of Instructional Technology and Distance Learning* 2, no. 1 (2005), http://www.itdl.org/Journal/Jan_05/article01.htm.

31 Stephen Downes, "Connectivism and Connective Knowledge: Essays on Meaning and Learning Networks," National Research Council Canada, 2012.

32 Michael Collins and Graeme Sullivan, "Artistic Research as Practice and Pedagogy," In *Teaching Artistic Research. Conversations across Cultures*, edited by Mateus-Berr, R and Jochum, R., 29–42, (Berlin: Walter de Gruyter & Co., 2020).

33 Paulo Freire, *Pedagogy of Freedom: Ethics, Democracy, and Civic Courage* (Lanham: Rowman & Littlefield Publishers, 2001), 42–3.

34 Colleen Flaherty, "Zoom Boom," Inside Higher Ed, April 29, 2020, https://www.insidehighered.com/news/2020/04/29/synchronous-instruction-hot-right-now-it-sustainable.

Bibliography

"About DCMI." DCMI. https://dublincore.org/about/. Accessed February 8, 2020.

Berners-Lee, Tim, James Hendler, and Ora Lassila. "The Semantic Web." *Scientific American* 284, no. 5 (2001): 34–43.

Collins, Michael. "OER Summer Workshop, PSU." *Meduim.com* (blog), September 28, 2016. https://medium.com/@_mike_collins/oer-summer-workshop-psu-23ca239b73e5.

Collins, Michael, and Sullivan, Graeme. "Artistic Research as Practice and Pedagogy." In *Teaching Artistic Research. Conversations Across Cultures*, edited by R Mateus-Berr, and R Jochum, 29–42. Berlin: Walter de Gruyter & Co, 2020.

Collins, Michael, and Bryan Ollendyke. "ELMS Learning Network: An EdTech Platform for Sustaining Innovation." Penn State University, May 8, 2015. https://psu.app.box.com/s/3318wac7ob987bxpwb2olf1fv8uskauy.

Downes, Stephen. "Connectivism and connective knowledge: Essays on Meaning and Learning Networks." National Research Council Canada, 2012.

Draft Recommendation on Open Educational Resources. In: UNESCO. General Conference, 40th. [online] France, 2019. https://unesdoc.unesco.org/ark:/48223/pf0000370936.

Flaherty, Colleen. "Zoom Boom." *Inside Higher Ed*, April 29, 2020. https://www.insidehighered.com/news/2020/04/29/synchronous-instruction-hot-right-now-it-sustainable.

Freire, Paulo. *Pedagogy of Freedom: Ethics, Democracy, and Civic Courage.* 1st Edition. Lanham: Rowman & Littlefield Publishers, 2001.

Han, Myung-Ja, and Patricia Hswe. "The Evolving Role of the Metadata Librarian." *Library Resources & Technical Services* 54, no. 3 (2011): 129–41.

Heimans, Jeremy, and Henry Timms. "Understanding 'New Power.'" *Harvard Business Review*, 2014. https://hbr.org/2014/12/understanding-new-power.

"Human Genome Project." Genome.gov. Accessed January 20, 2020. https://www.genome.gov/human-genome-project/Completion-FAQ.

Human Interference Task Force. *Reducing the Likelihood of Future Human Activities That Could Affect Geologic High-Level Waste Repositories (Report ONWI-537).* Columbus, OH: Office of Nuclear Waste Isolation, 1984.

Manovich, Lev. *Software Takes Command.* London: Bloomsbury Press, 2013.

Navas, Eduardo. "The Originality of Copies: Cover Versions and Versioning in Remix Practice." *Journal of Asia-Pacific Pop Culture* 3, no. 2 (2018): 168–87.

Ollendyke, Bryan. "HAX, Web Components and the Distributed NGDLE Future." Penn State University, February 7, 2018. https://psu.app.box.com/s/gk6013odcl3115j3ibfzudj3bqar059v.

"Open Educational Resource Schema," *OER Schema.* Accessed February 8, 2020. http://oerschema.org/docs/.

Raconteur. *A day in data.* 2019. Accessed Dec. 23, 2019. http://rcnt.eu/un8bg.

Siemens, George. "Connectivism: A Learning Theory for the Digital Age." *International Journal of Instructional Technology and Distance Learning* 2, no. 1 (2005). http://www.itdl.org/Journal/Jan_05/article01.htm.

Van Abel, Bas, Lucas Evers, Peter Troxler, and Roel Klaassen. *Open Design Now: Why Design Cannot Remain Exclusive.* Netherlands: BIS Publishers, 2011.

Varoglu, Zeynep. "New UNESCO Recommendation will promote access to educational resources for all." 2019. https://en.unesco.org/news/new-unesco-recommendation-will-promote-access-educational-resources-all.

Watson, J. D., and F. H. C. Crick. "Genetical Implications of the Structure of Deoxyribonucleic Acid." *Nature* 171, no. 4361 (1953): 964–7. https://doi.org/10.1038/171964b0.

"World Wide Web." *The World Wide Web Project*, CERN, http://info.cern.ch/hypertext/WWW/TheProject.html. Accessed December 23, 2019.

Wright, A. *Glut: Mastering Information through the Ages*. Washington, DC: Joseph Henry Press, 2007. https://doi.org/10.17226/11733.

15

HACK IT! DIY DIVINE TOOLS

An Art Hack Implemented as New Media Pedagogy in the Public Liberal Arts

Victoria Bradbury

Hack events, which rely on collaboration and interdisciplinarity, have moved from the commercial tech sector into the arts and other fields, including Digital Humanities (DH). In my Advanced Interactive Media (AIM) course at the University of North Carolina Asheville (UNC Asheville), I lead students to plan and produce an art hack, a co-making event in which new media and humanities students collaborate to build creative technological objects over a short time frame around a theme. During the 2019 "Hack It! DIY Divine Tools,"[1] which was part of the first Asheville Mini Maker Faire, students studying world religions were guided to combine physical computing and sculptural materials to create tools that each team's assigned god or goddess could conceivably use. This chapter describes the planning process and day of the event, followed by a discussion of learnings that emerged from implementing "Hack It! DIY Divine Tools" at the UNC system's designated public liberal arts college.

Contexts: Art and Digital Humanities Hackathons

An art hack uses the format of the hackathon from the commercial tech sector[2] while reflecting collaborative modes employed in some twenty-first century avant-garde art movements such as the Italian Gruppo T.[3] Participants are brought together to create an artistic project over a short time frame, usually a day but sometimes as long as several days or a weekend.[4] Teams work through phases of ideation, prototyping, and execution. An overarching theme couches the making under a central subject area. Final outcomes are presented, with varying levels of formality, at the end of the event. Judging or exhibiting the projects may be a factor, though this has been controversial in some instances when the labor and compensation of participants is not centered by the organizers.[5]

Hacks result in prototypes; final products or finished artworks are rarely realized in the short timeframe allotted. Physical computing works use both technological materials

(sensors, microcontrollers, wires, etc.) and craft and sculptural materials. Combining these can be complex and often requires a prototyping step as a key part of the creative process. Abigail Susik, in "Art with a Life of its Own: Questioning Mimesis in Media Art Prototypes" underscores the form of the prototype as specific to art and technology, because of the nature of some physical computing artworks to remain in a form that may appear unfinished or incomplete.[6] Gabriella Arrigoni emphasizes the importance of the prototype to physical computing practices and contextualizes the creation of prototypes as an activist mode of making.[7] A hack adds the constraints of time and often untested collaborative partners to the prototyping process. Together, these factors result in ephemeral objects or code that may be preserved only as documentation.

The DIY Divine Tools art hack took place in the context of a public liberal arts university. UNC Asheville is among a Consortium of Public Liberal Arts Colleges (COPLAC[8] institutions) around the United States that pair the low tuition of a state university with the increased attention, small class size, and arts/sciences/humanities focus of a liberal arts college. Humanities courses at UNC Asheville are taught by a team of core faculty as well as those from other disciplines who create special topics modules that are related to their primary subject area or other research interests. For example, Dr. Angel Kaur, who specializes in Neurobiology, also teaches a film studies Humanities course that focuses on neuroscience-themed films.[9]

In the field of Digital Humanities, scholars research relationships between computing and human cultures. In the related field of Media Archaeology (MA), texts such as *Deep Time of the Media*[10] and *Media Archaeology*[11] frame technologies as they link media studies, new media practices, anthropology, and digital humanities. Media Archeology scholars elucidate origins of media in ancient pursuits such as alchemy[12] and encourage interdisciplinarity by undertaking "…a conceptual and practical exercise in carving out the aesthetic, cultural, and political singularities of media."[13] Digital humanities (DH) "…involves both the examination of how digital tools can be applied to humanities subjects, and how these humanities subjects influence knowledge of computing."[14] Both DH and Media Archeology scholars centralize technologies while broadening their research to include overlapping contexts from other fields.

As in the digital arts, DH scholars extend notions of hacking and remixing to apply to a broad range of topics through data, physical computing, and other techniques. Universities have created DH interdisciplinary research labs, including King's Digital Lab[15] at King's College, London and hack events, such as the Hack the Book Festival,[16] which coalesced experts from applied and theoretical disciplines to examine the notion of the book and to prototype emerging forms that books can take. Other DH hackathons are forthcoming, including the Helsinki Digital Humanities Hackathon,[17] which was planned for Spring 2020 but was postponed due to the COVID-19 Pandemic. Often, DH research aligns scholars with deep knowledge of a particular subject, such as ancient history or world religions, with technologists or computer scientists who can ideate and prototype practical projects. Increasingly, historians and other scholars in the humanities have technological skills and can implement coding and other technical aspects of projects on their own. An example of this is the work of Nina Belojevic[18] who creates DH projects including "Kits for Cultural History."[19] These kits use maker materials, such as Rhino software and laser cutting, to reconstruct historical artifacts. In the re-creation of outmoded devices, new knowledge is acquired. In "Physical Computing, Embodied Practice," Belojevic and Shaun Macpherson discuss ways in which physical computing

projects can delve deeply into critical inquiry through the making process in ways that cannot be achieved through scholarly research alone. They state,

> Embodied interactions [...] encourage unique ways of seeing and studying tech-nologies—techniques that do not rely on a removed study of an object, but rather encourage the development of situated knowledge that experiences what is at hand and then follows a path of inquiry.[20]

Belojevic and Macpherson highlight the importance of the act of making to learning. The notion of "thinking through making" is also cited by artists and art historians as a research methodology.[21] While making, one has the opportunity to follow materials as an integral part of a tactile and iterative research process.

Our "DIY: Divine Tools" event was framed as an "art hack" rather than a "digital humanities hack," although it traversed the two categorizations. The hack focused on religious studies themes across a humanities and a new media course in a liberal arts con-text. We chose to frame the event as an art hack to give the participants the flexibility to broadly interpret the historical and theoretical information presented to them. Metaphor and hyperbole can be pursued in projects created in a one-day art hack that allow histori-cal themes to be referenced without adhering precisely to historical accuracy.

This art hack took place as part of Asheville's first Mini Maker Faire, which was produced by Christa Flores[22] from Asheville Museum of Science and Asheville Makers[23] (a local maker space). The event was hosted by UNC Asheville and held on the campus quad, where publics were invited to visit vender stalls and showcases by local and regional "makers," including hobbyists, technologists, kids, brewers (a favorite "making" venture in Asheville), weavers, and craftspeople. The Asheville Mini Maker Faire 2019 was significant as it was the first Maker Faire in Western North Carolina and had taken several years to plan. This led to a strong energy around the event from both the organizers and local attendees. In this environment, "DIY Divine Tools" was unique in that it was a closed event with student participants that took place largely in the morning before the Maker Faire began. The showcase and judging of the outcomes occurred when the public was just beginning to arrive at the Maker Faire. Attendees to the Faire then mingled with the hack participants at the later stage of the event.

Planning

One of my key pedagogical goals for AIM is for students to augment new media skills with organizational knowledge that will be useful as they graduate. Our students often go on to work in web design, animation, video production, and other applied fields. Planning the art hack is relevant to their professional pursuits as it allows them to prac-tice skills in production, organization, and collaboration.

In AIM, students work through a series of web-based and physical computing assign-ments. In Spring 2019, "DIY Divine Tools"[24] was among the other major projects in the class. Early in the semester, I began to acquaint the students with the art hack concept, hack-themed literature,[25] and best practices. Questions posed by the students in class dis-cussions focused on how to organize a "good" event, particularly since the discussion of "best practices" can be intimidating. I emphasized that they should not only be informed by the readings but also allow room for experimentation and testing new approaches.

At the outset of the project, students formed groups (marketing and promotion, participant management, organization of the day and materials) responsible for different aspects of planning the hack. The selection and catering of quality materials is of prime importance to planning an art hack. It has been my experience that the materials selected and offered to participants guide the results of what is made on the day. For example, if more sculptural materials are provided, then 3D projects will result. If datasets are emphasized, more algorithmic projects will be seen as outcomes.

UNC Asheville Lecturer Leslee Johnson agreed to collaborate and include the hack as part of her Humanities: The Ancient World course, the introduction to the Humanities sequence.[26] Early in the semester, Johnson provided her first-year students with the curricular context for "DIY Divine Tools." Although the art hack and applied technology might have appeared to the students as a departure from discussing the ancient world, Johnson linked the event as a key example of cultural value in our twenty-first century moment. She related today's creative and communication technologies to the values held by the ancient cultures that the students were studying.

Simultaneously, the AIM students, who had taken the Ancient World course in years past, brainstormed topics for the hack event that would serve as prompts for project ideation. They settled on the theme "gods and goddesses" and then refined this further to focus on tools that the gods and goddesses use. These tools would serve as conceptual instruments for hack participants to ground their prototyping process. During in-class planning, the AIM students synergized as they discussed what they remembered from their ancient world coursework. The deities they selected were Aphrodite,[27] Enkidu,[28] Xbalanque and Hunahpu,[29] Vishnu,[30] and Buddha.[31] They were chosen for their recognizability and for possible implementations that could be created after researching their characteristics.

Student Planning Groups

The AIM groups worked on producing the event over three class sessions; during this planning period, they were reminded to center the experience of the participants in their decision-making. Participant management created a survey for the humanities students that collected information about their skills, interests, experience with technology, craft, or code and whether they had classmates with whom they preferred to work. The completed surveys were used to pre-organize teams comprising a range of skillsets, majors, and interests. The marketing group created posters, email announcements, and social media accounts. The materials group gathered supplies, which included traveling to a Goodwill[32] thrift store to buy craft materials and scrap electronics to have on hand. They also planned several small Arduino circuits that would be available during the event as demonstrations for the participants and visiting public. The organization of the day group developed an introductory presentation that would provide context for the gods and goddesses theme. They also planned the schedule, which is another key strategic aspect of organizing an art hack; the amount of time allotted for the phases of ideation, prototyping, and execution of projects will drive the outcomes.

Day-of "DIY Divine Tools"

The organization of the day team launched the art hack with a presentation about the theme and schedule, and a sample of professional artists' works for inspiration. The

artists selected were racially and gender diverse and used physical computing and/or god/ goddess themes, such as Morehshin Allahyari's "She Who Sees the Unknown"[33] and Lee Blalock's "sy5z3n_4: Medi(a)tation for Virtual Respiration."[34] The materials team presented the "Divine Offering" boxes which would be given to each team. These included an Arduino microcontroller and basic sensors. Cardboard, craft materials, and electronics were available at a central table and a soldering, cutting, and hot glue station was nearby. The materials group also delivered a brief introduction to using Arduino and sensors in a project.

Team Formation and Ideation

The humanities students were grouped into their preplanned teams, which were then paired with one or two mentors from the AIM class. Each team selected a god/goddess from a random pool. The teams moved to a table with their "Divine Offering" boxes and the ideation phase began. During ideation, mentors and participants brainstormed on large paper tablets to imagine how they would coalesce research about their god/goddess into a tangible project using the supplied materials. Most of the participants did not self-identify as makers—their intended majors were diverse. Most had also not worked with Arduinos or circuits; it was, therefore, up to the mentors to guide teams and provide examples. Some teams were more dynamic than others and arrived at an idea quickly. For the rest, mentors strategically led the participants toward a plan that could be realized in the allotted time.

Prototyping and Execution

The intended prototyping and execution phases ran together as the teams were working at different speeds once they delved into the materials and started progressing the projects. Team members were using their "Divine Offering" kits and also visiting the materials table to check out additional sensors, LEDs, or craft materials.

Some teams were more synergistic in their process than others. For example, each member of the Buddha group was actively making and took on aspects of the project based on their skills and interests. The result was sculpturally complex in its use of papier-mâché, fabrics, and cardboard. Their mentor, Anitra Griffin (Figure 15.1), did the majority of the coding while teaching one of the group members how to use the Arduino. The Aphrodite group also worked well together. They were all dynamically building the code and troubleshooting problems while alternating between making and testing their prototype. This energy came from a pair of mentors, Matthew Wilson and Alex Nielsen, who were truly engaging the humanities students by actively sketching ideas that they could create with the Arduino. Several Aphrodite group members were intending to major in Computer Science or Engineering and had emerging interests in physical computing and code. The Xbalanque and Hunahpu group seemed to be slow to a consensus in the ideation phase, but near the end of the execution phase, all were working together to accomplish their project. The Vishnu group appeared to lack enthusiasm for the event altogether and the task of coming up with and executing an idea fell largely on their mentor's shoulders. The Enkidu group mentors pulled their initially quiet participants along as they eventually became engaged with the making process.

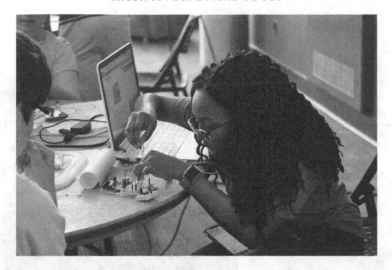

Figure 15.1 Advanced Interactive Media student Anitra Griffin, mentor of the Buddha group, builds an Arduino circuit with her team

Resulting Prototypes and Judging

After the execution phase, the groups gathered and presented the results of their collaborations. The five prototypes were the "Pulse of Love" for Aphrodite, which detects if someone is in love; a "Curse Detector Wand" from the Enkidu group, which shrieks when it touches someone to indicate they have been cursed; a bolas for the Xbalanque and Hunahpu group; a discus thrower from the Vishnu group; and a Buddha statue (Figure 15.2) that invites offerings (Bradbury, 2019).

Figure 15.2 Completed interactive prototype from the Buddha group

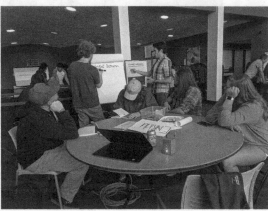

Figure 15.3 Left: 3D printed gold and silver awards, designed by AIM student Logan Bates. Right: Ideation phase with Enkidu group

The presentation of the prototypes was performative. For example, people were able to place precious objects in front of the Buddha statue as an offering, or they could touch the Aphrodite sensor for the "love test." When the bolas was eagerly demonstrated by the Xbalanque and Hunahpu group, one of the ends flew off into the air, breaking the prototype. The discus thrower from the Vishnu group was a latecomer to the presentations as they were finishing their prototype until the last minute, but the quarter-sized discus was propelled across the table nonetheless.

After the presentations concluded, Team Aphrodite was selected as "Best in Show." Factors considered included the functionality of their interface, the sculptural aspects of the prototype, and how well their team had worked together. Bespoke 3D printed medallions were distributed to each participant—gold for the Aphrodite team and silver for the rest (Figure 15.3).

Learning Outcomes

Here, student-learning outcomes are discussed alongside considerations for educators who aim to produce a similar event. In "DIY Divine Tools," student makers were thinking through materials that had been carefully selected and presented to them. The physical computing supplies and sculptural materials they were given resulted in 3D interactive objects rather than screen-only outputs. The making process became a reciprocal and iterative method for researching the assigned gods and goddesses.

As users of technology, students are familiar with clicking on apps and inputting text and images into content-management systems. Creative engagement with physical

computing, however, tasks them with problem-solving through electronics and code. As Belojevic and Macpherson state,

> The landscape of the circuit can be felt with our hands and seen with our eyes; and while the transduction of energy may not be fully visible to us, its operations are more easily felt and discerned when we become physically invested in them.[35]

By designing and building electronic circuits and connecting them to concepts through sculptural interface, students can begin to make links to algorithmic approaches used by ancient cultures, such as if/then statements of political decision-making or object-oriented processes that underlie the building of a temple. Students can reflect on the flows of electrical energy that cause computations to occur and energies that are created and sustained through religious practices.

The ethics of applying religious figures as the subject of a hack event were not examined during "DIY Divine Tools"; however, this should be discussed with students in future events. While many of the deities selected are archaic, Vishnu and Buddha are central to the major world religions of Hinduism and Buddhism. Conceiving and building tools for these figures was not meant to trivialize these religions but rather was intended to foster productive engagement with course subject matter as students experienced new methods for building knowledge through creative technologies. It is hoped that through the process of creatively interpreting these tools, participants in the hack reinforced their understanding of the deities.

The hack event became a form of pedagogical engagement for the AIM students (Figure 15.3). In "DIY Divine Tools," I observed more difficulty in the dynamics between the mentors and teams than I did in my 2017 AIM art hack "Hack It! DIY Dystopia: Surviving a Techno-apocalypse."[36] Some of the 2019 mentor/group combinations were more effective at communicating than others. The Buddha team, for example, were energetically working on different aspects of the project as individuals and shaping these into the final sculpture—one student on the team who studies fine art was particularly excited about using papier-mâché techniques to build the Buddha form. The mentor of the Vishnu group struggled to encourage his group members to participate or show enthusiasm for the project; he built the prototype almost completely on his own and completed it during the judging while his team members either sat back or wandered off. To counter this in the future, one or two student mentors could be available to assist a struggling classmate. It is also important to give the AIM students strategies for different mentoring situations they may encounter—such as silence or lack of interest from team members, or a group member who does not listen to peers' ideas.

An active collaborator is advantageous when organizing a university art hack. Working across disciplines creates opportunities for learnings to arise from combining methodologies, in this case, humanities and new media. It is also useful to have a committed class of students who are accountable to their professor, as it guarantees participation, which leads to more fully realized projects and outcomes. First-year student participants may also be motivated to pursue New Media or Computer Science programs after taking part in a hack.

Direct impacts on learning are difficult to measure, but I have heard anecdotal evidence from students who have moved into their careers. Mallory Evans, who took the AIM course in 2017, in which we organized "Hack It! DIY Dystopia: Surviving a Techno-apocalypse," said that the experience was useful in job interviews with tech

companies because hackathons were a well understood part of office culture.[37] The prevalence of future hacks, however, could be affected by social distancing measures required after the COVID-19 Pandemic.

Finally, partnering with a public event such as the Mini Maker Faire worked well to create context for participants and to expose new media and digital humanities concepts to the public. Holding "DIY Divine Tools" on a Saturday rather than a regular class day allowed students to focus on the entire event as they were not coming and going to other classes. Most UNC Asheville students have jobs but were able to preplan this Saturday morning to be free for the activity. The judging and awards ceremony were successful in "DIY Divine Tools" as they were kept light and lively. With students as participants, not professional artists or researchers, the inclusion of a judging process appeared to be motivating, helping the groups maintain their focus.

Conclusion

Undergraduate students at liberal arts institutions benefit from participating in arts and humanities hack events. Positive outcomes are evident in a structure that places first-year students at work alongside upper-level students as mentors. Skill-sharing takes place between more advanced learners and beginners as well as amongst those focusing their studies in different disciplines. Scheduling a hack over a short timeframe of a few hours makes the event accessible; structuring the time through phases of making allows students to dynamically problem-solve and test ideas through prototyping. Applying creative technologies to humanities subjects can bridge the pervasive use of media today and ways in which ancient cultures sustained cultural value through shared stories. Students can make connections between algorithmic processes and the subjects they are studying when building with sculptural and technological materials through physical computing. The greater community who visits the hack event can learn about emerging modes of remixing humanities and media. This provides engagement with the university curriculum to both participants and audiences, broadening public knowledge of and connection with the liberal arts.

Notes

1 Video documentation and additional images of the event can be viewed at: http://blurringartandlife.com/vb/hackit_2019/hackit2019.html.
2 J.H. Brearly, *New Playgrounds: An Introduction to Hacks in the Arts* (Ebook, British Council: Future Everything, 2014), https://futureeverything.org/news/new-playgrounds-an-introduction-to-hacks-in-the-arts/.
3 Serena Cangiano, Davide Fornari, and Azalea Seratoni. "Reprogrammed Art, a Bridge between the History of Interactive Art and Maker Culture," *Art Hack Practice: Critical Intersections of Art, Innovation and the Maker Movement*, 31 (New York: Routledge, 2019).
4 Victoria, Bradbury, and Suzy O'Hara, "Evaluating Art Hacking Events Through Practice," Proceedings of the 22nd International Symposium of Electronic Art, 2016.
5 Allison Ordnung, "An interview with Constant Dullaart (2014)," *Atractivoquenobello*, accessed June 15, 2015, http://www.aqnb.com/2014/03/12/an-interview-with-constant-dullaart/.
6 "Prototypes are 'early' or 'primitive' versions of various kinds of operative entities that gesture toward future iterations based upon information learned from the testing process, although in current art practices most prototypes are rarely meant to reach an endpoint of perfection or finality. They embrace an aesthetic of the rudimentary and the developmental." (Susik, 2015)
7 "The recent spread of artworks based on physical computing widened and enhanced the role of prototyping in the making of new media art. Indeed prototyping can be now considered as a medium in its own

right. [...] artistic prototypes are often created for activist purposes too, as a way to critique current behaviours and attitudes and to demonstrate that alternative ones are possible." (Arrigoni, ii)

8 Council of Public Liberal Arts Colleges, accessed August 15, 2020, https://coplac.org/.

9 See Angel Kaur's page, accessed August 15, 2020, https://www.unca.edu/person/angel-kaur-ph-d/.

10 Siegfried Zielinski, *Deep Time of the Media* (Cambridge, MA: MIT Press, 2009).

11 Erkki Huhtamo and Jussi Parikka, *Media Archaeology* (Berkeley, CA.: University of California Press, 2011).

12 Zielinski (2009)

13 Jussi Parikka, "CTheory Interview, Archaeologies of Media Art: Jussi Parikka in Conversation with Garnet Hertz," *CTheory*, April 1, 2010, accessed August 15, 2020, https://journals.uvic.ca/index.php/ctheory/article/view/14750/5621.

14 Kirschenbaum as cited in Roger Gillis, "Libguides: Digital Humanities: What Is Digital Humanities?" *Dal.Ca.Libguides.Com*, 2019, accessed August 15, 2020, https://dal.ca.libguides.com/digitalhumanities/home.

15 Kings Digital Lab, accessed August 18, 2020, https://www.kdl.kcl.ac.uk.

16 Open & Hybrid Publishing, accessed August 15, 2020, https://www.europeana-space.eu/hackathons/open-hybrid-publishing-hackathon/hacking-culture-bootcamp/.

17 Helsinki Centre for Digital Humanities, accessed August 15, 2020, https://www.helsinki.fi/en/helsinki-centre-for-digital-humanities/helsinki-digital-humanities-hackathon-2020-dhh20.

18 Nina Belojevic portfolio website, accessed August 15, 2020, https://ninabelojevic.wordpress.com.

19 Maker Lab in the Humanities, University of Victoria, accessed August 15, 2020, http://maker.uvic.ca/category/kits/.

20 Nina Belojevic and Shaun Macpherson, "Physical Computing, Embodied Practice," in *The Routledge Companion to Media Studies and Digital Humanities* 1st edition, edited by Jentery Sayers (New York: Routledge, 2018).

21 Tim Ingold, *Making* (Abingdon, Oxon: Milton Park, 2013).

22 Author of Making Science: Reimagining STEM Education in Middle School and Beyond (Torrance, California: Constructing Modern Knowledge Press, 2016) https://inventtolearn.com/making-science/.

23 Asheville Makers, accessed August 15, 2020, http://ashevillemakers.org/.

24 Art Hack Planning and Delivery Instructions, see my website, accessed August 15, 2020, http://blurringartandlife.com/UNCA/NM420/420_assignment_art_hack.html.

25 Readings Included: "New Playgrounds: An Introduction to Hacks in the Arts" (Brearly, 2014), "Evaluating Art Hacking Events Through Practice" (Bradbury and O'Hara, 2016), and "Art with a Life of its Own: Questioning Mimesis in Media Art Prototype" (Susik, 2015).

26 University North Carolina Asheville, Hum 124 course description, accessed August 15, 2020, https://humanities.unca.edu/learn/hum-124-the-ancient-world/.

27 Greek goddess of love and sexuality (Cartwright, 2018).

28 The wild companion of Gilgamesh (Helle, 2018).

29 Mayan Hero Twins from the Popol Vuh (Maestri, 2019).

30 Member of the holy trinity of Hinduism (Cartwright, 2012).

31 "...the individual whose teachings form the basis of the Buddhist tradition." (Siderits, 2020).

32 Goodwill is a chain of thrift stores or charity shops where used goods can be purchased.

33 Moreshin Allahyari, She Who Sees the Unknown, accessed August 15, 2020, http://shewhoseestheunknown.com.

34 Lee Blalock, *sy5z3n_4: Medi(a)tation for Virtual Respiration*, accessed August 15, 2020, https://leeblalock.com/shrine.html.

35 Belojevic and Macpherson (2018).

36 Victoria Bradbury, HACK IT! DIY Dystopia: Surviving a Techno-apocalypse, see my website, accessed August 15, 2020, http://blurringartandlife.com/vb/hackit2017.html.

37 "It's exactly the kind of work companies are looking for from recent college grads, conceptual, complex and cutting edge." Mallory Evans, UNC Asheville Alumnus, 2018.

Bibliography

Arrigoni, Gabriella. "Artistic Prototypes: From Laboratory Practices to Curatorial Strategies." Ph.D., Newcastle upon Tyne, UK: Newcastle University, 2017.

Belojevic, Nina, and Shaun Macpherson. "Physical Computing, Embodied Practice." In *The Routledge Companion to Media Studies and Digital Humanities*. 1st Edition, edited by Jenterey Sayers. New York: Routledge, 2018.

Bradbury, Victoria. "HACK IT: DIY Divine Tools." 2019. http://blurringartandlife.com/vb/hackit_2019/hackit2019.html.

Bradbury, Victoria, and Suzy O'Hara. "Evaluating Art Hacking Events Through Practice." In *Proceedings of the 22nd International Symposium of Electronic Art*, 2016.

Brearly, J. H. *New Playgrounds: An Introduction to Hacks in the Arts*. eBbook. British Council, Future Everything, 2014. https://futureeverything.org/news/new-playgrounds-an-introduction-to-hacks-in-the-arts/.

Cangiano, Serena, Davide Fornari, and Azalea Seratoni. "Reprogrammed Art, a Bridge between the History of Interactive Art and Maker Culture." In *Art Hack Practice: Critical Intersections of Art, Innovation and the Maker Movement*, 31. New York: Routledge, 2019.

Cartwright, Mark. "Vishnu." *Ancient History Encyclopedia*, 2012. https://www.ancient.eu/Vishnu/.

Cartwright, Mark. "Aphrodite." *Ancient History Encyclopedia*, 2018. https://www.ancient.eu/Aphrodite/.

Gillis, Roger. "Libguides: Digital Humanities: What Is Digital Humanities?" *Dal.Ca.Libguides.Com*, 2019. Accessed August 15, 2020. https://dal.ca.libguides.com/digitalhumanities/home.

Helle, Sophus. "New Gilgamesh Fragment: Enkidu's Sexual Exploits Doubled." *Ancient History Encyclopedia*, November 28, 2018. https://www.ancient.eu/article/1286/new-gilgamesh-fragment-enkidus-sexual-exploits-dou/.

Huhtamo, Erkki, and Jussi Parikka. *Media Archaeology*. Berkeley, CA: University of California Press, 2011.

Ingold, Tim. *Making*. Abingdon, Oxon: Milton Park, 2013.

Kirschenbaum, Matthew G. "What Is Digital Humanities and What's It Doing in English Departments?" *ADE Bulletin* (2010), pp 55–61 (7). doi:10.1632/ade.150.55.

Maestri, Nicoletta. "The Mayan Myth of the Hero Twins – Stories from the Popol Vuh." *ThoughtCo*, August 14, 2019. https://www.thoughtco.com/hunahpu-xbalanque-maya-hero-twins-171590.

Ordnung, Alison. "An interview with Constant Dullaart by Alison Ordnung". *Atractivoquenobello*, March 12, 2014. https://www.aqnb.com/2014/03/12/an-interview-with-constant-dullaart/.

Parikka, Jussi. "CTheory Interview, Archaeologies of Media Art: Jussi Parikka in Conversation with Garnet Hertz." *CTheory*. April 1, 2010. http://www.ctheory.net/articles.aspx?id=631.

Siderits, Mark. "Buddha." *Stanford Encyclopedia of Philosophy*, 2020. https://plato.stanford.edu/entries/buddha/.

Susik, Abigail. "Art with a Life of its Own: Questioning Mimesis in Media Art Prototype." In *Proceedings of the 21st International Symposium of Electronic Art*, 2015.

Zielinski, Siegfried. *Deep Time of the Media*. Cambridge, MA: MIT Press, 2009.

16

ON THE CAPABILITIES OF HIP HOP-INSPIRED DESIGN RESEARCH

An Annotated Syllabus

Joycelyn Wilson

In his song "The Formula,"[1] Tracy Curry, known to the hip hop community as "The D.O.C.," offers a design framework for creating what he refers to as "Rhythmic American Poetry," or rap music. "The Formula" consists of four verses. Each verse builds on a set of processes and ideas formulated to manufacture a style of engagement to generate active interactivity between Curry and his audience. The principles of originality and humility for the creative process culminate in a set of design-thinking characteristics for making his "funky composition."[2] Curry marries these elements to a four-minute melody produced by Andre "Dr. Dre" Young; it samples the bassline of Marvin Gaye's "Inner City Blues (Make Me Wanna Holla)"[3] and percussive elements extracted from The Magic Disco Machine's "Scratchin."[4] As it relates to the art and approach to remix, it is important to note how many of these components are extracted from the archive of Black performance traditions and repurposed using the unique design fundamentals for making music and media inspired by the hip hop aesthetic. Rarely, however, are these fundamentals framed as design remix. This chapter seeks to fill this gap. Like The D.O.C., early MCs of hip hop culture boasted about the form and function of their lyrical skill sets. For instance, William Griffin, Jr, the rapper known as "Rakim" from the classic duo Eric B. and Rakim, writes in his book *Sweat the Technique: Revelations on Creativity from the Lyrical Genius,*

> I hear the same questions all the time. What's it mean to be a writer? A rapper? A lyricist? Where do I go in my mind to create the perfect rhyme? What energy do I channel to move an audience? To manipulate syllables into syncopated flow and paint a story with words and music? How do I get someone to stop a record, rewind, replay, and rethink everything they thought they heard the first time?[5]

The questions presented by Griffin are design questions, in which he poses the practice of rapping as a design issue within the overall hip hop aesthetic. Emerging out of the arts

247

and aesthetics that documented the civil rights inequities of the early 1970s—particularly as it relates to the desegregation of schooling—hip hop has evolved beyond beats and rhymes. It has influenced dance, theater, photography, as well as the approaches taken to archiving, pedagogy, as well as computing, to become one of the most impactful and transformative aesthetics for experiencing the world around us. How so? In other words, what is gained from examining the hip hop aesthetic through the lens of design theory? How can its intersectionality and abilities to adapt across various industries and disciplines be explored within the principles of design? These two essential questions frame my current research on hip hop-inspired design studies and support the purpose of this chapter, which is to better understand the capabilities of hip hop-inspired design thinking in the making of digital media by annotating a course syllabus.

Hip hop-inspired design thinking reframes hip hop as a design remix, an application, and as a technology of education that adapts its ideologies, practices, and sensibilities across areas such as digital media, computing, the humanities, and industries, including business, technology, and education. In this way, hip hop design research—which I also refer to as *hip hop-inspired design studies* —is inherently pedagogical and technological. It centers the relationship between the art and craft of hip hop with its ability to use multiple modalities to communicate amongst diverse audiences. Hip hop-inspired design thinking is a critical framework. It is concerned with how this mapping process influences, and is influenced by, the sociocultural context and emotional identities of users, learners, gamers, and practitioners who identify with the culture to various degrees. In this way, HHDS interrogates the process of choices and decisions that necessitate creative problem-solving methods, skills, and mindsets for developing digital platforms. It advances the broader field of hip hop studies, hip hop pedagogies, and their relationship with design research. Using my course syllabus as a case study, I demonstrate in this chapter the capabilities of hip hop-inspired design thinking in post-secondary humanities-centered computational media instruction and the digital preservation of student-produced media artifacts within *The HipHop2020 Innovation Archive*[6]—specifically as it relates to digital archival design. In the case of HipHop2020, the approach is applied to spark students' creative capacities to design justice-centered media products that utilize their technological skill sets.

In this chapter, my annotation focuses on Science, Race, and Technology, a 3300-level humanities/computational media elective taught during the Spring 2018 semester. The annotation employs a narrative style of writing to illuminate the course aims, objectives, and outcomes, and describe how their triangulation introduces undergraduate students to hip hop-inspired design methodologies as a critical approach for understanding relationships between three interrelated concepts: race, science, and technology. Although I have used this technique before with undergraduate students who attended a historically Black college located in the American South,[7] Spring 2018 represents a deliberate execution of hip hop-inspired design thinking as a formulated analysis rubric created specifically for guiding student groups through the ideation, writing, and final production of a humanities-centered computational media product—in this case, a podcast episode. The seven episodes culminate into season one of a student-produced show called "Hacking Hip Hop" that is preserved as a modified educational resource on the *HipHop2020* platform. Using as an example the production process of the podcasts from beginning to end, I describe the highs and lows of how hip hop-inspired design thinking operates as a cultural approach that is based on the teaching and learning of ideas, concepts, functions, and form of things as expressed through written, oral, visual, electronic, and nonverbal

interactive modalities.[8] Pedagogical innovation is also fundamental to the other human-ities-centered computational media courses that I teach. Students produce documentary shorts, artist-focused curriculum projects, interactive games and animations, and other forms of experimental digital art using hip hop design thinking.

If Black media studies—with all of its integrative and interdisciplinary complexities—is concerned with the (re)production of knowledge, ideas, languages, kinship and life-style norms, practices, and embodied performances that are created, marketed, curated, consumed, and preserved through culture-producing industries such as music, film, tel-evision, social, and virtual platforms, then my HHDS research is essential to its ongoing development. Hip hop-inspired design research is, therefore, relevant to cultural schol-ars, digital humanists, technologists, game designers, computer scientists, interaction designers, digital pedagogues, and ethnographic methodologists. Pulling back the main-stream notoriety associated with the genre of hip hop, one of the chapter's main goals is to describe why an indigenous understanding of the culture matters when examining, curating, and preserving content that utilizes the larger affordances of Black culture and media production.

What Is Hip Hop-inspired Design Studies (HHDS)?

Hip hop culture and its intersections with the science of teaching and learning has rapidly become a significant area of educational research.[9] Scholars and practitioners continue to make significant contributions to hip hop pedagogies, praxis, and theories as the field enters its twentieth year since Greg Dimitriadis wrote *Performing Identity/ Performing Culture: Hip Hop as Text, Pedagogy, and Lived Practice* (2001). In a number of fields, including policy studies, computing, and music technology, ground-breaking research inspired by the hip hop aesthetic has also been produced.[10] What if, however, the learning science of hip hop was framed as a design problem? What kind of world would hip hop allow one to inhabit or experience? Variations of these questions have been asked in educational research, yet not substantially funneled through the lens of critical design theories, which is mostly concerned with the set of principles and thoughts that interrogate the who, what, when, how, and why of creativity.

To address these questions, I consider hip hop-inspired design studies as a natural extension of hip hop-based education, or HHBE.[11] In theory, hip hop-inspired education asserts its attention beyond the cognitive outcomes associated with the integration of popular culture, media, rap music, breakdancing, fashion and style, turntablism, graffiti culture, and language in school curriculum. Attention is on the ways in which hip hop sensibilities shape, and are shaped by, the lived experiences of students, educators, and other youth influencers. As the field continues to intersect with digital media, which currently impacts multiple disciplines and industries outside of areas in educational research, it is the key to interrogate its techno-pedagogical sensibilities as a design issue. No longer is the gravity of hip hop-inspired design thinking a surprise in the shifting of the educational enterprise, including K-12 public and private education, post-secondary instruction, and higher education administration. However, few of these studies frame their methodological approach using the concepts and ideas of design theory and design thinking. This chapter tailors the research to an explicit focus on form and function, including the design choices, implementation strategies, and framings that go into its creative application in digital archival design and computational media instruction.

The theoretical framing and methodological approach of hip hop pedagogies has traditionally oscillated between the field conventions of hip hop studies, educational policy studies, and ethnography, with the attention primarily on the pedagogical "how." That is, the art and science of acquiring, constructing, and remixing knowledge that is subsequently presented as a media artifact and produced using a set of techniques for engaging people in the learning of some *thing* or *idea*. Through this process, information recycles itself until a message is formulated. These messages are then spread through music, dance, and other modalities. Denzin refers to this process of message distribution as "pedagogical performance." The pedagogical performances—and the media artifacts that emerge from them—follow as a process in hip hop culture called *schoolifying*. To schoolify is to:

> craft new lenses through which to view these words, images, and motifs of hip hop. Using metaphor, metonym, and other techniques, rappers press the meanings of words in order to create new significances and construct new word associations in the minds of their listeners. In so doing, they are able to quickly and effectively educate their listeners on who they are and what their expression(s) represents. They are able to provide instructions as to how their subsequent utterings should be interpreted.[12]

Integrating this process of design remixing into the teaching of design thinking is to consider the aims, methods, and content necessary to utilize new media technologies that facilitate interactive and immersive user experiences.

Hip hop-inspired design studies are a critical framework that considers the ways in which hip hop's principles and affordances impact design and design thinking. Similar to the digital humanities where critical approaches to archival design remains paramount, this framework considers the curatorial and archival preservation practices of hip hop-inspired media products along with artifacts that are not necessarily hip hop in nature but incorporate its design thinking as an overall creative strategy.[13] In this way, hip hop-inspired design centers the pedagogical and technological sensibilities *of* and *in* the artform.

In the design of my course and platform, two postulates of the hip hop aesthetic ground the hip hop-inspired design approach. One: The story of hip hop is the story of the sample. Baked into the principle of schoolifying is the extraction and remix of artifacts to create new ones, sometimes with different meanings. The second postulate assumes hip hop is obsessed with doing "school." Anytime a user enters into a hip hop space, the goal is to learn something—good, bad, or indifferent. These two assumptions cause new questions to emerge in my research. For example, what best practices are applicable to the building of an interactive narrative platform where hip hop-inspired artifacts and educational content are experienced through new media technologies such as virtual reality? How does a cultural approach to interaction design influence the architectural infrastructure of the digital environment? I am interested in these kinds of questions as they relate to college students who enroll in all of my courses, including science, race, and technology; communication and culture; interactive narrative, and expressive digital art.

The subject of inquiry in HHDS is the nature of the design, which forces an extension to further understand the impact of hip hop as both a technology of representation and technology of education, therefore centering its pedagogical, methodological, aesthetic,

and technological affordances in the creation and ultimately curatorial preservation of media artifacts across multiple areas of inquiry and platforms, including interactive/transmedia storytelling, and digital archiving. As such, critical hip hop design includes teaching design alongside the affordances of technologies for the development and presentation of media artifacts, and interrogating the choices made in the process of making, performance or exhibition, and preservation. In this way, HHDS moves hip hop-inspired education (or what I have come to refer as *hip hop-inspired educational design*) beyond mere incorporation of hip hop elements into teaching, learning, and curriculum to achieve cognitive results or understand student's relationship to the culture. Hip hop-inspired design research recognizes that the currency in hip hop-inspired design thinking rests in the inherent decisions, methods, patterns, and sensibilities of the culture and how design principles are adapted to serve both an emotional and functional purpose in media production.

The Course

I teach four courses over a 9-month academic year: Interactive Narrative; Experimental Digital Art; Communication and Culture; and Science, Race, and Technology. Each course is fused with hip hop-inspired design thinking. Used properly, it can assist in helping designers, practitioners, and creative influencers understand the relationship between form and function when addressing specific objectives. My current research addresses this line of inquiry. Broadly speaking, it interrogates the acquisition, (re)making, curation, and preservation of hip hop-inspired artifacts within the security of an archive designed to serve as a database of educational resources. This techno-pedagogical usability is directly linked to hip hop's obsession with schooling within digital spaces like the HipHop2020 Innovation Archive.

The point of this chapter is to make design thinking the explicit object of inquiry in the thematic implementation and practical structuring of assessments for a set of course modules used in a 14-week course taught as a post-secondary humanities-based computational media elective. I have applied this design approach across other undergraduate and graduate humanities and computational media courses I teach. For a couple of reasons, I focus specifically on *Science, Race, and Technology*, a course that "examines specific historical and contemporary constructions of race, within prevailing scientific theories and ideologies in order to determine the role played by race in scientific and technological culture."[14] The course has increased in popularity among students since I first taught it in Spring 2017. It was the first hip hop studies course taught in the School of Literature, Media, and Communication at Georgia Tech. Then, the topical name of the course was "Interrogating the Politics of OUTKAST." The activities culminated into a semester of guest speakers including Antwan "Big Boi" Patton from the Atlanta rap duo Outkast. Widely known through popular media as "The Outkast Class at Georgia Tech," the course aim focused on the analysis of science, race, and technology as abstract concepts that informed the production of student-designed curriculum resources slated for preservation on the HipHop2020 application. By Spring 2018, the course direction shifted slightly. Using the hip hop-inspired design approach taught to them as both an analysis and design rubric, student groups wrote and produced a set of seven podcast episodes for "Hacking Hip Hop." Each group interviewed an invited guest expert.[15]

The topical "Outkast, Atlanta, and the Aesthetic Politics of Trap Music: The Data Mixtape" was designed for students to exit with a fundamental understanding of the

trap aesthetic and how to produce justice-oriented media for educational consumption.[16] Its overall design was to use the pedagogical performance of rap duo Outkast as an access point to investigate issues of racial politics, social justice, and cultural innovation in post-Civil Rights Atlanta. This was an undergraduate humanities course that also served as an elective for computational media majors. Paired with assigned readings, the course sampled from a group of existing titles to produce original content as part of the HipHop2020 application. Music lyrics, along with digital media hosted on platforms such as Netflix, YouTube, and Genius served as resources for interrogating theoretical, linguistic, meta-linguistic, and cultural practices of the trap aesthetic.

The course had several objectives. One was to frame the trap aesthetic as a sonic and ideological hybrid of hip hop as introduced by its southern network of practitioners. Trap is the American South's offspring of hip hop, taking a melting pot of sounds from each region and combining it within the musical styles significant to the South, its narrative craft, and some of the hardships southerners have endured, turning that into a style of music that's relatable and obtainable. Students were tasked with conceptualizing trap music as the pedagogy of voice, collaboration, inclusion, and resilience.[17]

One of the most important lessons was to look at hip hop on both a global and local scale, since each region influences its style of hip hop. These networks are nuanced by localized, environmental traditions that impact the design thinking that went into the production of the episodes. Students sampled from a rich dataset of artifacts, particularly lyrics from curated Spotify playlists, to reimagine hip hop as a global community of practice with sensibilities nuanced by location and geography. From this initial learning stage—where we talked about how to analyze and interact with lyrics—students were tasked with completing listening assignments that focused mainly on sentiments of justice and truth—or the lack thereof. The data generated from this ethnographic coding informed the strategies students took to generate questions and write the script for their specific show. Overall the course diachronically examined hip hop's four major decades while integrating the role of Black music in the American South. However, the two main artist catalogs that shaped the structure of the semester were Outkast and Kendrick Lamar—both present a cultural shift in the history of the music. Outkast's release of the award-winning *Southernplayalisticadillacmuzik* (1994) and Kendrick Lamar's *DAMN* (2017), which won the Pulitzer Prize, were presented as case "lessons" in order to focus on particular issues, ideas, or problem-solving methods contained in the narratives. Students were tasked with investigating sentiments of racial and cultural politics within the lyrics to generate topics for their podcasts.

The course was designed to achieve three primary learning outcomes: 1) engagement in historical analysis, 2) application of interpretive frameworks and ethnographic analysis methods, and 3) team-building through media production. Over the course of the semester, students studied cultural texts, screened documentary films, listened to relevant podcasts, and analyzed lyrics in order to form a working definition of hip hop culture. Through these exercises, students grounded hip hop's historical relationship to African diasporic, African American cultural traditions, and Black music in the American South—particularly the traditions of message music, resilience, and joy. The films, readings, coding exercises, and assignments were designed to enhance the civic engagement capacities and social justice literacies of these youth influencers and their relationship to the technological world. Students applied a set of analysis techniques and ethnographic methods for describing, analyzing, and

advancing critique of hip hop's kinship norms, lifestyle practices, social innovations, worldviews, and ideological acquisition practices. They explored its pedagogical performance tendencies by examining music collections and posing critical questions about the creative and political implications of the culture's forms and communication practices. Doing so offered opportunities to explore contemporary ideas of hip hop, innovation, and the role of Down South Trap Music in its development. Students worked in their assigned production teams to draft a podcast script. Each team consisted of two hosts, a videographer, time-keeper, and production assistant. Each group worked together to analyze the final episode.

The Platform

The HipHop2020 Innovation Archive is currently supported by the Digital Integrative Liberal Arts Center (DILAC) located in the School of Literature, Media, and Communication at the Georgia Institute of Technology. Using hip hop-inspired design thinking in the courses presented HipHop2020 as a design issue separate from the course design. The issues of process, space, use of space, the technological disruption of traditional learning spaces, the creation of new modes of learning, and its relationship to platform innovation all revealed themselves as design issues that needed addressing—particularly as HipHop2020's design journey intersects with the rise of hip hop pedagogies and that of digital tools such as Wix, Wordpress, and now, the Unity game platform. The geographic time and space in which this work began is significant to where it is currently in relation to the global Pandemic that has forever shifted schooling in American society.

HipHop2020's foray into digital humanities began in 2009 as an archival platform designed using a Wix interface. I should note here that "2020" is not in relation to the year 2020. Rather, it is a play on 20/20 vision as the project's mission is to bring clarity to the culture's techno-pedagogical principles in the teaching and learning of abstract ideas, concepts, and processes. To do this, HipHop2020 was designed to primarily host open discussion forums, interactive blog posts, video lessons, and videos of guest speakers participating in HipHop2020 programming. In 2011, this content was moved to a customized Wordpress platform. With the acquisition of the Michael Webster vinyl collection in 2013, assets were transferred to Unity 5 in 2014, then later Unity 2017 to work on tooling the interactivity and content management of the application. The digital archive uses the current version of Unity for 3D interaction and virtual reality. Founded as the HipHop2020 Curriculum Project and later renamed the HipHop2020 Innovation Archive, its purpose is to preserve standards-based resources and artifacts inspired by hip hop performance that can be utilized in learning environments. As the project transitioned through each version of its digital platform, four design priorities have remained eminent: interactivity, content production, content management, and accessibility.

Part of its purpose is to help students implement design principles that drive creative ideation for producing culturally relevant media products, including interactive games, documentary films, podcasts, and other forms of experimental digital art. Most students are graduate and undergraduate majors in digital media, computer science, engineering, and media studies. The HipHop2020 application is designed to host student-produced media as standards-based digital resources for use by educators and teachers in their secondary and post-secondary teaching and learning.

Course Assignments and Activities

In order to be successful in the course, students had to read, watch, and listen to several required readings and supplemental documentaries and podcasts. These readings, documentaries, and podcasts drove many discussions and writings and assisted students with their individual and group assignments throughout the course. The anchoring text was Leroi Jones's *Blues People: Negro Music in White America* (1963). Selected readings came from, Maurice Hobson's *The Legend of the Black Mecca: Politics of Class in the Making of Modern Atlanta* (2017), Radric Davis's *The Autobiography of Gucci Mane* (2017) and Lawrence Levine's *Black Culture and Black Consciousness* (1977). Supplementary chapters, journal articles, and commentaries were also provided. Documentary films were screened in and out of class on platforms such as YouTube and Netflix. The assigned podcasts were available on Apple, SoundCloud, and Spotify.

Several individual and group assignments were given throughout the course. As part of their ongoing participation in class, students were expected to curate their experiences of the course in two ways: on social media and through a personalized playlist called the hip hop Snob playlist, hosted either on Spotify, iTunes, or YouTube. They had opportunities to share their playlist with others in class and discuss why they selected the songs. As the semester progressed, students compared their playlists with their group members. When their group's podcast topic was approved, part of their job was to create a playlist of seven songs that complemented their production. They were to align their songs and podcast with at least three national standards for teaching social studies and at least three state standards for teaching Georgia History.

There is a fair measure of creative and critical writing for the course. Students were required to turn in three critical essays throughout the semester. Their first essay was a reflection titled "Myintrotoletuknow," which is a riff on the self-titled Outkast song. Through this essay, students engaged in an autoethnographic endeavor for describing their relationship to music and culture in society. The purpose of the reflection was to indulge in the themes and topics we covered, and to help students engage in targeted writing; the essays were one page only, unless told otherwise. Their job, as it relates to the reflections, was to take the main idea(s) and articulate a position. This was not simply "Yes, I agree with this or that." Instead, it was their opportunity to articulate the synthesis of their critical thoughts as they related to the readings and discussions. This was an opportunity to show me, through their writing, that they invested time in reading the material, as many of the essays were based on in-class listening and viewing assignments. This was important to our study because listening to music material and viewing film and video is a vital component to understanding the loftiness of the material and how to glean from it aspects that contributed to the writing of their podcast production script.

The podcast production was part of several related group assignments over the semester. The project took place in two parts. One, the curation of a set of songs that provided structure for the content included in the podcast. This happened in class and included the decoding of the messages and categorization of themes. Part two was the writing of their scripts in relation to each group's assigned guest expert. I also invited guests to class who could provide students with additional strategies for producing and editing podcasts. These workshops provided an opportunity to ask questions of seasoned podcast producers. Students who read, attended class, and participated in course activities fared well on their creative evaluation of their learning progress. While the assignment used

music and text as a primary resource, the groups also added film and other hip hop-inspired artifacts to the collection of data analysis. Each group paired their chosen topics with one of the readings. Through their analysis, each group identified two research questions to structure the subsequent questions asked of each guest expert for the podcast. For example, if a student was interested in notions of the trap and they were seeking to analyze agency in Kendrick Lamar's *good kid maad city*, they would have considered the questions needed to understand Lamar's perspective on personal responsibility, how he performs it, and how it is communicated in his music and visuals. For the podcast, students needed to also tell me why their chosen topic was significant.

On the Capabilities of Hip Hop-inspired Design Research in Digital Archival Design

In technology, applications are downloadable software run on a computer or a mobile device. They serve unique functions. For example, a ride-share app is designed for users to get from one location to the next without having to hail a taxi or drive themselves. The user logs into the application through their mobile device, enters the location address where the driver will pick them up, and subsequently takes them to their destination. Whether web-based, native, or a hybrid of the two, software applications are adaptable and serve multiple functions. Essentially, their purpose is to help provide a service efficiently in order to generate more users. Applying this line of inquiry to hip hop's adaptability properties, the use of hip hop-inspired design thinking—through this course—has revealed ways in which it can function as a techno-pedagogical application in digital spaces. What are the experiential possibilities once the space is designed? How should the designer account for agency and authenticity in the design? Quite naturally, as hip hop is a culture built on authenticity, questions of *who* can design, *who* can create, and *who* can inhabit the space are always lurking.

How can design theory inform strategies applied to making when the approach is based on hip hop aesthetics and principles such as style, flow, and interactivity—as described by Curry in "The Formula" and Griffin's *Sweat the Technique*? In regards to justice-centered design instruction, what best practices are applicable to the building of an interactive platform where hip hop-inspired educational content is experienced in innovative ways such as VR? In my case, I am interested in these questions as they relate to undergraduate and graduate students who enroll in courses that are taught using hip hop-inspired design thinking for ideation, problem-solving, and determining the best approach for designing systems, platforms, and digital experiences. In these courses, I have come to realize that the capabilities in using hip hop-inspired design thinking and understanding hip hop-inspired design studies as a developing area of inquiry rely on hip hop being viewed as a post-genre cultural technology. I implore my students to see it as such.

Notes

1 Tracy "The DOC" Curry, "The Formula," track 11 on *No One Can Do It Better*, Ruthless Records/Atlantic, 1989, mp3.
2 Ibid.
3 Marvin Gaye, "Inner City Blues (Make Me Wanna Holla)," track 9 on *What's Going On*, Tamla, 1971, mp3.

4 The Magic Disco Machine, "Scratchin'," track 11 on *DJ Pogo Presents Block Party Breaks 2*, Strut, 2001, mp3.

5 William Griffin Jr, *Sweat the Technique: Revelations on Creativity from the Lyrical Genius* (New York: HarperCollins, 2019), 3.

6 www.hiphop2020.org, accessed August 7, 2020. The HipHop2020 Innovation Archive is powered by the Four Four Beat Labs, a STEAM-inspired maker space and incubator. It is currently located in the School of Literature, Media, and Communication at Georgia Tech and supported by its Digital Integrative Liberal Arts Center (DILAC). HipHop2020—originally known as the HipHop2020 Curriculum Project—has its institutional roots in 2008 at the Leadership Center at Morehouse College. Its goal then, as it is now, was to establish the hip hop archive and its various mediations as a design issue when implementing secondary and post-secondary humanities instruction. HipHop2020 has since expanded its instructional models from a justice and civic engagement focus to include one that uses the culture's design affordances in computational media instruction, including interactive narrative, digital archiving, and VR. Four Four Beat Labs was established in 2012 to expand the work of HipHop2020 to include culture, music, and new media technologies to teach, produce, and enhance the computational media, coding, and civic engagement capacities of diverse student communities. Projects are standards-based and designed for use by secondary and post-secondary youth and youth influencers. The mission of Four Four is to expand traditional perspectives of the classroom space. That is, how it looks, where it happens, the archival resources used, and the limitless possibilities when technological innovation meets pedagogical sensibility. Incubated projects are guided by hip hop-inspired design principles that utilize the storied meanings of cultural artifacts to build-out interactive installations across analog, digital, and augmented platforms.

7 Joycelyn Wilson, "The MC in Y-O-U: Leadership Pedagogy and Southern Hip Hop in the HBCU Classroom," in *Schooling Hip Hop: Expanding Hip Hop-inspired Education Across the Curriculum*, ed. Emery Petchauer and Marc Lamont Hill (New York: Teachers College Press, 2013), 66–92.

8 Writing and Communication – WOVEN Guiding Principles, accessed August 14, 2020, https://wcprogram.lmc.gatech.edu/guiding-principles/woven.

9 See Alim, 2006; Cooks, 2004; Duncan-Andrade and Morrell, 2000; Hill, 2009; Kincheloe, 2008; Love, 2014; Paris and Alim, 2017; Petchaur, 2009; Peterson, 2016, Stovall, 2006; and Wilson, 2011, 2013.

10 See James 2020; Magerko, Freeman, Mcklin, Livingston, McCoid, and Crews-Brown, 2016; and Starke and Croft, 2020.

11 Marc Lamont Hill, *Beats, Rhymes, and Classroom Life: Hip-Hop Pedagogy and the Politics of Identity* (New York: Teachers College Press, 2009), 10. HHBE includes the body of scholarship that focuses on the intersectional examinations of hip hop culture's application across education, pedagogy, curriculum design, and ethnographic methodologies—particularly for the study of community norms and politics of identity.

12 Wilson, 2013. *Schooling Hip Hop.*

13 Richard Rinehart, "Archive," in *Keywords in Remix Studies*, ed. Eduardo Navas, Owen Gallagher, and xtine burrough (New York: Routledge Press, 2018), 23–30.

14 OSCAR, accessed August 14, 2020, https://oscar.gatech.edu/pls/bprod/bwckctlg.p_display_courses.

15 Four Four Beat Labs, accessed August 14, 2020, http://fourfourbeatproject.org/fourcast/.
 Hacking Hip Hop is a podcast show produced by undergraduate students. The purpose of the show is to crack the codes of hip hop's relationship to activism, culture, business, media, and technology.

16 Trap is a form of reality rap rooted in southern rap and expanded as an aesthetic for understanding hip hop performance outside of the American South. The trap aesthetic, as a socioculturally constructed concept for understanding the history of Black cultural production as it is linked to contemporary Black cultural production as rooted in the crack era and following the infiltration of the crack cocaine epidemic and its impact on the incarceration of black men and women and breakdown of the black family.

17 Down South Hip Hop and Trap Music are both sound and ideology. Their affordances—one of which is the ability to manipulate Black musical antecedents within a hip hop framework—contribute significantly to Hip Hop culture's trajectory as the most popular form of music since rock and roll. Popularized in the early 2000s as an Atlanta innovation, trap has and still impacts music-making throughout hip hop speech communities in the American South and throughout other regions within and outside of North America. For at least the last two decades, it has grown into its own genre and style of performance. Combining southern soul, gospel, and R&B styles with hip hop sensibilities, trap music has its popular

roots in early 1990s hip hop. As a signifier for the black predicament, trap represents the culmination of genres produced out of the eras and experiences of southern Black socioeconomic decline in White America. The ideologies of trap born out of the regional and linguistic sensibilities of southern rap are bred by the educational discourse that remains native to hip hop's African indigenous pedagogical roots.

Bibliography

Alim, H. Samy. *Roc the Mic Right: The Language of Hip Hop Culture.* 1st Edition. New York: Routledge, 2006.

Cooks, Jamal A. "Writing for Something: Essays, Raps, and Writing Preferences." *The English Journal* 94, no. 1 (2004): 72–76. Accessed August 15, 2020. doi:10.2307/4128851.

Davis, Radric, and Neil Martinze-Belkin. *Autobiography of Gucci Mane.* Simon & Schuster, 2017.

Dimitriadis, Greg. *Performing Identity/performing Culture: Hip Hop as Text, Pedagogy, and Lived Practice.* New York: P. Lang, 2009.

Duncan-Andrade, Jeffrey, Michael Reyes, and Ernest Morrell. "Using Hip-Hop Culture as a Bridge to Canonical Poetry Texts in an Urban Secondary English Class." 2000.

"Four Four Beats Lab." http://fourfourbeatproject.org. http://fourfourbeatproject.org (accessed August 7, 2020).

Griffin, William Jr.. *Sweat the Technique: Revelations on Creativity from the Lyrical Genius.* New York: Amistad, 2019.

Hill, Marc Lamont. *Beats, Rhymes, and Classroom Life: Hip-Hop Pedagogy and the Politics of Identity.* New York: Teachers College Press, 2009.

Hobson, Maurice J. *The Legend of the Black Mecca: Politics and Class in the Making of Modern Atlanta.* Chapel Hill: University of North Carolina Press, 2017.

James, David. "The Use of DJing Tasks as a Pedagogical Bridge to Learning Data Structures." *Proceedings of the 2020 ACM Conference on Innovation and Technology in Computer Science Education,* (June 2020), 193–7. doi:10.1145/3341525.3387427.

Jones, LeRoi. *Blues People. Negro Music in America.* New York: William Morrow & Co., 1963.

Kincheloe, Joe L.. *Critical Pedagogy Primer.* New York: Peter Lang, 2008.

Kruse, Adam J. "Toward Hip-Hop Pedagogies for Music Education." *International Journal of Music Education* 34, no. 2 (May 2016): 247–60. doi:10.1177/0255761414550535.

Levine, Lawrence W. *Black Culture and Black Consciousness: Afro-American Folk Thought from Slavery to Freedom.* Oxford: Oxford Univ. Press, 1977.

Love, Bettina L. "Urban Storytelling: How Storyboarding, Moviemaking, and Hip-Hop-Based Education Can Promote Students' Critical Voice." *The English Journal* 103, no. 5 (2014): 53–8. Accessed August 15, 2020. www.jstor.org/stable/24484246.

Magerko, Brian, Jason Freeman, Tom Mcklin, Mike Reilly, Elise Livingston, Scott McCoid, and Andrea Crews-Brown. "EarSketch: A STEAM-Based Approach for Underrepresented Populations in High School Computer Science Education." *ACM Transactions on Computing Education* 16, no.4 (September 2016): 1–25. https://doi.org/10.1145/2886418.

Marvin, Gaye, "Inner City Blues (Make Me Wanna Holla)," track 9 on *What's Going On,* Tamla, 1971, mp3.

Paris, Django, and H. Samy Alim. *Culturally Sustaining Pedagogies: Teaching and Learning for Justice in a Changing World.* New York: Teachers College Press, 2017.

Petchauer, Emery. "Framing and Reviewing Hip-Hop Educational Research." *Review of Educational Research* 79, no. 2 (2009): 946–78. Accessed August 15, 2020. www.jstor.org/stable/40469060. [AQ11]

Petchauer, Emery. "Starting With Style: Toward a Second Wave of Hip-Hop Education Research and Practice." *Urban Education* 50, no. 1 (January 2015): 78–105. doi:10.1177/0042085914563181.

Peterson, James B.. *Hip Hop Headphones: A Scholars Critical Playlist.* New York: Bloomsbury, 2016.

Rawls, Jason D., and Emery Petchauer. "'Be Current, or You Become the Old Man': Crossing the Generational Divide in Hip-Hop Education." *Urban Education* (April 2020). doi:10.1177/0042085920914358.

Starke, Anthony M., and Adam Croft. "Hip Hop as Political Theory: Exploring Democracy in J. Cole's BRACKETS." *Public Integrity* (August 2020), 1–4. doi:10.1080/10999922.2020.1801111.

Stovall, David. "We Can Relate: Hip-Hop Culture, Critical Pedagogy, and the Secondary Classroom." *Urban Education* 41, no. 6 (November 2006): 585–602. doi:10.1177/0042085906292513.

The Magic Disco Machine, "Scratchin'," track 11 on *DJ Pogo Presents Block Party Breaks 2*, Strut, 2001, mp3.

Tracy "The Doc" Curry, "The Formula," track 11 on *No One Can Do It Better*, Ruthless Records/Atlantic, 1989, mp3.

Villanueva, George. "You Must Learn: Sampling Critical Hip Hop Pedagogy in Communication Education Spaces." *Pedagogy, Culture & Society*, (July 2020), 1–19. doi:10.1080/14681366.2020.1801814.

Wilson, Joycelyn A.. ""The Kid Cudi Lesson": The HipHop2020 Curriculum Project and the Authentic Leadership Language of *Man on the Moon – The End of Day*." *International Journal of Africana Studies* 16, no. 1 (2011): 156–172.

Wilson, Joycelyn A.. "The MC in Y-O-U: Leadership Pedagogy and Southern Hip-Hop in the HBCU Classroom." In *Schooling Hip-Hop: Expanding Hip-Hop Based Education Across the Curriculum*, edited by Emery Petchauer & Marc Lamony Hill, 66–91. New York: Teachers College Press, 2013.

17

INTERNET MEMES AS REMIXES

Simpsons Memes and the Swarm Archive

Scott Haden Church and Gavin Feller

The term *Digital Humanities* (DH) is as exciting as it is puzzling. As the signifier grows in popularity—evident in exponentially increasing number of conferences, academic journals, research grants, and organizations dedicated to it—its definition and boundaries grow progressively ambiguous. The term is understood simultaneously as 1) a professional practice (e.g., collaborative archival processes),[1] 2) a research method (e.g., computational tools for literary analysis),[2] 3) an object of study (e.g., "the history, criticism, and philosophy of digital culture and its impact on society"),[3] and 4) a scholarly field in its own right. After a first wave of computational potentials and a second wave of public hype and big expectations, whatever it is, DH is beginning a third wave.[4]

As DH enters a third wave of critical reflection, we hope to contribute to its development by offering a media studies perspective to theoretical concerns with archival authority and authenticity, specifically within the largely neglected context of YouTube remix/meme culture. To add to the quip: "if content is king, context is its crown," this chapter focuses on digital culture as queen.[5]

As DH expands beyond the computational analysis of classical literary texts, theoretical questions about digital audiences and the authority of digital archives are unavoidable. For instance, how should digital archive scholars and practitioners take into account the vast amount of user-generated content and audience engagement surrounding popular commercial media texts? What is the place of remixes, parodies, and fan compilations in the archive? Which texts (remixes) qualify as significant, which as insignificant, and how should they be treated in theory and in archival practice? These questions form the basis of this chapter. By exploring them, we hope to invite DH scholars to consider Internet memes as viable objects of study.

The following will address a method and a case study at the intersection of multiple disciplines: DH, remix studies, and rhetoric. Considering the resonances between each of these fields, we will propose an interdisciplinary commonplace called the *swarm archive*. Expanding upon the concept of the "rhetorical edition,"[6] which contrasts the DH method of the "critical edition" and its premium on the preservation, fidelity, and canonicity of the primary text, the swarm archive envisions an iconic primary text in open dialogue with (secondary) scholarship and (tertiary) vernacular commentary, or

remixed iterations of the text. To explore what this term means, we will: 1) Theorize what the swarm archive might look like, 2) identify a site where we might observe the swarm archive taking place: *Simpsons* memes, user-generated content revolving around the iconic animated television show, and 3) propose a possible method for scholars to map the swarm archive. Although the rhetorical properties of remixed memes have been addressed before,[7] little attention has been paid to remix as a creative mechanism or their memetic implications for DH.

DH, Remix, and Rhetoric

DH shares similarities with remix studies, primarily its focus on collaboration, curation, production, and performance. DH is concerned with issues like collaborative authorship; in fact, "cocreation and curation are 'central figures.'"[8] Its emphasis on curation comes from the ambitious disciplinary objective to "augment cultural memory."[9] In the process of curation, DH also takes digital copies of iconic texts and arranges them in such a way to analyze them, reconfigure them, and create something new.[10] Like the open-source culture that helped spawn remix,[11] the process of production is an important component of digital archiving.[12] The Digital Humanities Manifesto 2.0 (a collaborative effort aiming "to arouse debate about what the Humanities can and should be doing in the 21st century") equates process with remix: **Process is the new god**; not product. Anything that stands in the way of the perpetual mashup and remix stands in the way of the digital revolution. Digital Humanities means iterative scholarship, mobilized collaborations, and networks of research."[13] The painstaking labor that goes into digital curation exemplifies how a repository of preserved classical texts is only as good as the production of labor that preceded it. With some of the archives that have been compiled for the gaze of DH scholars—like the Walt Whitman Archive or the William Blake Archive, for example[14]—the canonical texts preserved therein can become raw materials for scholarly accessibility, genealogical criticism, and remix.[15]

Whether it be for preservation or analytical purposes, the archive is an essential component in the identity of DH. Within DH, the archive refers to a space where texts can be digitized and stored so that they may be accessed and searched by scholars.[16] However, the concept of the archive enters into remix studies territory once it is envisioned as something more than a storage repository. To some DH scholars, the archive is more than a space of "temporal endurance," it is a space for performance.[17] As explained by Jeff Rice and Jenny Rice: "[DH scholars] must shift from thinking of archives as spaces (physical or digital) of preservation to thinking of them more as an action that happens between two or more users."[18] The essence of the archive, therefore, is not in its preservation and curation, but rather in participation, culminating in the creation of the *digital archivist*.[19] Once the archive is conceptualized as a space for participation, process, and performance, the conversation opens a space for remix. Hoping to conceptually remix the archive ourselves, we continue to explore this definition of archive as a space for performance and participation.

The similarities between DH and remix studies become even more apparent when rhetoric enters into the discussion. Referring to the waves of DH scholarship mentioned earlier, DH and rhetoric scholar Casey Boyle refers to a *critical edition* of scholarship, characterizing the first wave by its dedication to the preservation of canonical texts and authorial fidelity. The second wave integrates further details situating the text within its time, culture, and reception—providing the context to the text. Accounting for these

primary (authorial) and secondary (scholarly commentary) voices in the "critical edition" of DH methodology, Boyle calls for a tertiary voice—a cross-disciplinary methodological addendum—that he calls the *rhetorical edition*.[20]

Rather than valorizing established standards of canonicity and authorial fidelity, the rhetorical edition adheres to the open-source ethic; it downplays the purity of authorship and exclusive textual boundaries and embraces the evolution of a text as it advances over time to incorporate related texts and commentaries into its own cultural legacy. It asks, in short: "In what ways do secondary texts and tertiary responses influence a reinvention of a primary text?"[21] Boyle illustrates his point by describing his scholarly project not to preserve Quintilian's ancient iconic text on rhetoric *Institutio Oratoria*, but rather to seek out its valuable resonances and marginalia, or the "Quintilianisms" it has spawned over the centuries.[22] The rhetorical edition, in other words, presents an alternative view of the archive, one that is centered on performance, participation, and permeability. The rhetorical edition opens up yet another space for remix studies and online culture. Taken together, these theoretical foundations offer a vocabulary with which we can address the swarm archive, an emerging memetic instantiation of the archive.

The Swarm Archive

The swarm archive envisions an iconic primary text in open dialogue with vernacular commentary, or remixed iterations of the text. Remix studies calls these textual adaptations "versioning,"[23] DH calls them "layering"[24] and "zoamorphosis,"[25] and rhetoric calls them "prosōpopoeia."[26] The swarm archive is a concept intended to remix the contributions of each of the previously discrete discipline-specific terms into a concept that spans DH, remix studies, and rhetoric, acknowledging its debt to each discipline while contributing a unifying theoretical linkage between each.

To define the swarm archive, it helps to first understand each of the discipline-specific terms that inspired it. In remix studies, the closest analog to the swarm archive is a practice previously mentioned called "versioning." In his book *Remix Theory*, Eduardo Navas links the practice of remix to the different versions of song recordings produced in Jamaica in the late 1960s.[27] Versions are variations of pre-existing songs, with tracks removed or added in order to make the song different. Even in the early days of versioning in Jamaica, remix artists were prolific in producing their art; as Dick Hebdige explains: "At one time in 1976 there were no fewer than twenty-five different versions of the tune *I'm Still in Love with You*."[28] Over time, "versioning" evolved into a practice of interpretation, collaboration, and transformation, as producers used postproduction techniques to selectively modify music.[29] The swarm archive includes scholarly and vernacular versioning of a text that becomes more iconic with the passage of time, not in spite of but rather because of its many iterations.

Within DH, the swarm archive does work similar to "layering" and "zoamorphosis." Layering is a type of vertical composition, in which versions of a text accumulate into an aggregate that becomes "stratified over time."[30] Similarly, zoamorphosis is a concept, inspired by the writings of William Blake, that describes the process of cultivating collaboration out of conflicting voices from present and past.[31] In this creative endeavor: "the best collaborations emerge out of a fundamental conflict that pushes each creative mind to higher and higher levels of imaginative experience."[32] The swarm archive, likewise, contains several layers of voices—some in conflict with each other—which cumulatively become a swarming repository of textual iterations.

Within rhetoric, the swarm archive most closely resembles the rhetorical trope of *prosōpopoeia*. More to the point than the rhetorical edition alluded to earlier,[33] one of us elsewhere has identified prosōpopoeia to be a type of remix.[34] Prosōpopoeia describes the rhetorical act of projecting one voice into another context. This process often entails imitating someone else's voice to inject it into a context where that voice no longer actively exists. In an ancient Roman courtroom, for example, Cicero imitated the voice of a deceased dignitary in order to condemn the actions of the defendant.[35] By mashing-up his voice with that of the dignitary, the resulting recombinant (and revivified) voice became more powerful than Cicero's voice alone, because of the revered, iconic status of the original. Building on this rhetorical foundation, the swarm archive recognizes the power of a living, recombinant text.

Regardless of the term, the swarm archive comes into being through the diachronic movement of the text and the valuable marginalia it picks up along the way. As such, this orientation regards the text as increasingly iconic—rather than corrupted or diluted—the more it is remixed. The swarm archive thrives on the collective, collaborative, and coequal efforts of numerous individuals distributed across time and space.

The Simpsons Memes

Internet memes are worth examining in DH as iconic texts mashed-up with tertiary commentary. Memes, in other words, are illustrations of the swarm archive. Scholarship on memes often mentions how the evolutionary biologist Richard Dawkins originally conceived the idea as something that irresistibly spreads between organisms.[36] In 1976, Dawkins first used the term *meme* to argue that gene-like imitation is the core of cultural evolution. Memes were contagious units of cultural transmission, passed around and between large groups of people like ideas that refused to go away. This germinal definition of the term continues to be important to studies of media virality.

The German philosopher and cultural critic Theodor W. Adorno's theories on popular music are also useful for developing a framework for discussing meme production. For Adorno, popular music begins with ideas, which subsequently become songs, then boilerplate templates for future popular songs.[37] Like the DH concept of layering, where texts become "stratified over time," popular songs become "frozen" into templates after a song has proven its worth as a commodity.[38] The perspective on Internet memes advanced in this chapter, then, is informed by a theoretical mashup of the writings of both Dawkins and Adorno.

To be sure, this comparison between Dawkins's memetic production and Adorno's theories on pop music has its flaws: for Dawkins, memes are the units that constitute the fabric of culture—fecund, resilient, peer-to-peer, and ultimately irrepressible.[39] Adorno's popular music, in contrast, lacks creativity and innovation because it is produced by monolithic culture industries and then distributed downward to consumers; however, memes are user-generated content, spawned from the bottom-up creativity and labor of nonexperts. Still, a dialectical tension exists in both cases. Popular songs must be perceived as different, or different enough to seem novel, even though they have to remain true to the template from which they were crafted. Memes are beholden to a similar issue—*meme templates* are collectively authored "expressive repertoires"[40] that must negotiate the tension between "fixity" and "novelty."[41] This constraint means that memes generate expressive and creative content while staying true to the original texts after which they were modeled. Incidentally, this same negotiation accompanies the process of remix as well.[42]

Although recursive iterations in a swarm archive become layers of an ongoing textual tapestry, a unifying original text needs to exist. *The Simpsons*, an American animated sitcom heavily dependent on intertextuality[43] that has become iconic through its permeation of contemporary culture and scholarly texts, has spawned much versioning in the form of its memetic appropriation. *The Simpsons* television show has now evolved into a Simpsonalia, a conglomeration of tertiary, multimodal responses to the primary text. Insofar that each is a remixed iteration of the same text, all memes related to the show fall into multiple memetic families,[44] bound together by a unifying text and the method of remix. *The Simpsons* is a particularly salient example of a remixable text because it is essentially an anthology of citations of other texts.[45]

The Simpsons has become so ingratiated into online culture that its permutations exist across at least four types of content: image macros, GIFs, YouTube video memes, and online music microgenres. Image macros are the memes most commonly defined as such; they are static images overlaid with text,[46] the type of meme most commonly shared online. *Simpsons* memes have infiltrated the genre of image macros especially as responses in online message boards. For example: "That's the Joke"—a line from a standup segment of a 1995 *Simpsons* episode—is deployed condescendingly in online forums at people who are perceived as unable to find certain attempts at humor funny. "Old Man Yells at Cloud"—a photo of Homer Simpson's father Abe angrily shaking his fist at the sky—is frequently brandished as a response to people who are notoriously cranky. The meme can also be used to represent feelings of futility.

Snippets of *Simpsons* episodes are perpetually recycled in text messages everywhere (Figure 17.1); GIF keyboards on smartphones are replete with short, looping clips from the show like "Homer Backs Up" or "Homer's Fat Jiggling."

Memes of *The Simpsons* are even more prolific in videos on YouTube. One example is the meme "You Got the Dud," which riffs on an obscure clip from a 1996 episode in which the family plays a board game ("Mystery Date") with Bart's friend Milhouse. Embarrassingly, Bart draws a "date" with "the dud," a geeky nerd who strongly resembles Milhouse. Not one to let a comedic opportunity pass him by, Homer slowly realizes this and ridicules Bart. In the YouTube video memes, various pictures of "the dud" are mashed-up into other scenes from the show, each of which spawns the Homeresque gradual smile on different characters' faces (Figure 17.1).

One of the most common YouTube video memes is "Steamed Hams," a thread of videos that all remix a short vignette from a *Simpsons* episode that first aired in 1996. In the original clip, Principal Skinner is hosting his boss, Superintendent Chalmers, at his house for a lunch. However, everything goes disastrously wrong for Skinner, including a fire in his kitchen and food burned in his oven. Skinner attempts to cover up the chaos in his conversations with the superintendent, calling the hamburgers he covertly purchased from a nearby fast-food chain "steamed hams." Although the short video is funny in its own right, it attained Internet immortality once users began remixing it. Out of the thousands of user uploads, nearly two dozen have earned more than a million views, including "Steamed Hams but There's a Different Animator Every 13 Seconds"[47] (9.5 million views), "Steamed Hams Inc."[48] (6.5 million views), and "Steamed Hams But it's a 360/VR Experience"[49] (5.5 million views).

Simpsons memes are also appearing in the form of an online microgenre of music called "Simpsonwave." Started on the Facebook page "Simpsons Shitposting,"[50] Simpsonwave has a distinct sample-heavy sound and ironic aesthetic that evokes loss and nostalgia. The slow, reverb-drenched sounds of the "vaporwave" soundtrack to these

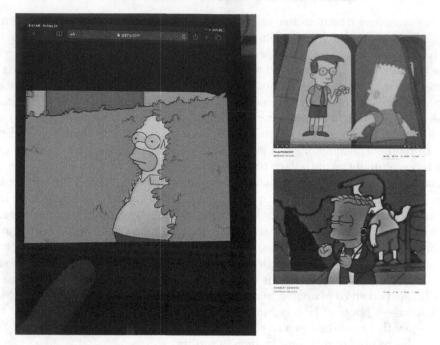

Figure 17.1 Left: "Homer Simpson Reaction GIF." Retrieved from https://giphy.com/gifs/the-simpsons-scared-homer-simpson-jUwpNzg9IcyrK. Photo by Scott Haden Church. Right Top: "You Got the Dud V2.0." Screenshot from https://www.youtube.com/watch?v=2gB-Vcyrk8s. Right Bottom: "S U N D A Y S C H O O L." Screenshot from https://www.youtube.com/watch?v=rTfa-9aCTYg&t=2s

videos have been called "music optimized for abandoned malls."[51] Layered over the music are clips from classic *Simpsons* episodes, "reeking with '90s nostalgia and flashes of surrealism, while [the] vaporwave [soundtrack] accesses something deeper in that energy, tapping into a sort of dreamy ennui."[52] The clips are generally sampled from bizarre moments in the television series, like the Halloween episodes when fantastic and nightmarish scenarios take place with the characters, or when the show drifted into melancholic moments of reflectivity (Figure 17.1). Taken together, the music and video culminate in a sort of hypnogogic viewing experience for the viewer—that is, an aesthetic that evokes a liminal state in the listener occurring between wakefulness and sleep.[53]

The swarm archive, at least in the case of memes from *The Simpsons*, is a repertory of layered texts, made more robust over time through its many different versions and (re)iterations. It is clear that the text that fuels the swarm archive must be iconic to some degree. What is unclear, however, is the origins of each swarm archive. They are difficult to trace because each swarm archive quietly begins and circulates through a distributed, bottom-up process. Despite its nebulous origins, however, the swarm archive is centripetal, moving from the margins and niches of online culture into the centers of popular culture (recall that the swarm archive, constituted by tertiary voices, is vernacular by nature—initiated, likely, by Internet tastemakers and those who are fluent in the memetic lexicon). This centrality of the swarm archive can be observed in a range of

texts and platforms, from quirky YouTube remix videos to GIF keyboards on smartphones. Our interest in understanding the swarm archive has led us to attempt to track its evolution, which we will address in the following section.

Mapping the Swarm Archive

The final part of this chapter is highly exploratory—it seeks to discover what it might look like to track, or map, the voices within the swarm archive. Theoretically, the swarm archive is intended to be bottom-up, but in order to begin a swarm, something (or someone) must initiate (or enlist) the swarm. Given the robust online culture that surrounds *The Simpsons*, we hypothesized that the swarm archive is curated by heavy Internet users, the "digital archivists" who perform the archive.[54] These people are the types of users to whom DH scholars have referred: "The crowd can assist with creating, selecting, transcribing, editing, cataloging, tagging, annotating, and contextualizing content."[55] Although this idea of crowdsourcing the scholarly objectives of DH archivists can prompt fears of uneducated or improperly trained archivists,[56] the swarm archive is not concerned with proper preservation or indexing. Rather, it depends heavily on the collaborative efforts of many people experienced in online culture—savvy enough to identify the remixable referents in online memes.

Not surprisingly, attempting to capture this process for scholarly purposes was difficult. Because of the indeterminate origins of trends from a vast and disparate audience, we opted to make it easier to measure by encouraging a type of swarm archive process through a coordinated research effort—recognizing full well that our deliberate, top-down strategy does not reflect the organic, bottom-up nature of the swarm archive as a cultural phenomenon.

We designed a brief survey about *Simpsons* memes to be distributed online, which was approved by the Institutional Review Board at Brigham Young University (Figure 17.2). In each survey, we used a random generator that drew from a cache of *Simpsons* GIFs, image

Figure 17.2 A meme posted on subreddits to recruit *Simpsons* fans to take a survey for the present study (Meme created and posted by Scott Haden Church)

macros, and YouTube videos. After viewing each meme displayed at random, we asked the survey participant to identify other memes or popular culture texts it referenced—a process akin to asking someone to explain an inside joke to an outsider. The purpose behind these questions was to assess if we could observe the process of building the swarm archive by tracing the remix through the memes. We also asked survey respondents questions related to the nature and purpose of a meme, such as "What is the purpose of GIF 1?" and "What makes Video 1 funny (or creative)?" Finally, we asked a few demographic questions about the respondents, as well as their meme creation and circulation habits.

Most of our surveys were distributed on Reddit on the subreddits r/Simpsonsmemes,[57] r/Simpsonsfaces,[58] r/Simpsonsshitposting,[59] r/TheSimpsons,[60] and r/Shitposting.[61] We also posted the survey on Cougarboard,[62] an online sports and culture forum for fans of Brigham Young University athletics. Due to the highly specialized content of each survey, we anticipated that it would attract a large number of respondents, but that perhaps not many would finish it. Our assumptions proved correct: 305 people started the survey, but only 58 actually completed it. Out of those who finished, the mean age was 26.56 (age range: 14–51) (Figure 17.3).

69% of participants identified their race/ethnicity as "White" (Figure 17.3), and 62% said they lived in the United States (the next closest was Australia, with 6.9%) (Figure 17.3).

The majority said their native language was "English" (although one answered this question with "The Simpsons"). Just under 40% of participants found the survey on r/Simpsonsfaces; another 19% of participants found the survey on r/Simpsonsshitposting. A large majority of the participants are heavy Reddit users—70.7% responded that they go on Reddit "multiple times a day." About 70% of the respondents shared existing memes "very often," "often," or "sometimes." Despite this enthusiasm for memes, however, very few of the participants actually create memes (67.2% said they create memes either "rarely" or "never"). These findings seem to confirm the conventional wisdom that a very small number of users are responsible for creating the vast majority of memetic content.[63]

The results of this unconventional survey revealed that the respondents were excellent at recognizing the references to specific episodes of The Simpsons in the memes, but not always the history of how the material evolved into a meme. The remixed materials and references prompted responses that were enthusiastic, but relatively uncertain (for example, one respondent replied "I don't know [the reference], but it's the best thing I've seen all week"). The majority of the memes were understood as communicating humor to the viewer, though some participants saw the purpose of the meme to be "art." From the small sample size of responses, we infer from the data that these respondents are heavy internet users with an above-average level of Simpsons fandom. Survey participants were not always able to identify the constitutive elements of the remix, but they recognized the process of remix at work. For example, one respondent said, "[The meme is] funny but also a great deviation from the source materials."

Our findings, however preliminary, suggest a hazy profile of online contributors to the swarm. Despite not recognizing all of the references in each meme, these users will likely continue to circulate them due to their entertainment value. Meanwhile, the originators of the memetic content—rich in cultural capital and well-versed in the intertextuality of online cultures—likely created the memes elsewhere. Those memes were then eventually circulated to a larger audience by online denizens, similar to those who answered this survey. The results of our pilot survey are not meant to be scientifically rigorous or

Participant Age Range (Reddit Survey)

Participants by Race/Ethnicity

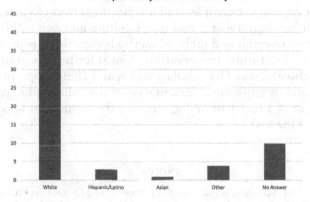

Participants by Country of Origin

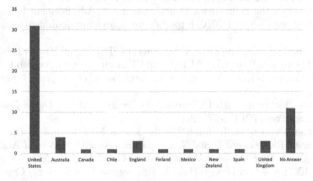

Figure 17.3 Top: Age range of the participants of the Reddit survey. Middle: Race/ethnicity of the participants of the Reddit survey. Bottom: Countries of origin of the participants of the Reddit survey

definitive; rather, they merely demonstrate our attempt at observing the dialogic process of the swarm archive at work.

Although not all of the disparate memetic references were recognizable to the participants, we wish to emphasize that the primary text remained essential to galvanizing the swarm and, by extension, producing the swarm archive. The Simpsonalia phenomenon observed in this study is allegorical by nature, but it also precludes complete recognition of its intertextuality; in such a vast online culture, it is next to impossible for all users to know all of the elements being referenced. However, the primary text is so durable in the collective historical knowledge that it can become the source material for interaction with a robust body of tertiary voices. Hence, *The Simpsons*, recognized as an iconic pop culture artifact, remains a source rich for remix and memetic transformation. The iconic status of the source material, in other words, is the nectar that attracts and feeds the swarm.

In conclusion, we hope scholars will take seriously the swarm archive as both a useful heuristic for analyzing the complex and intersecting layers of voice, authority, and intertextuality within digital meme and remix culture and as a call for the development of innovative research and archival methods capable of capturing bottom-up cultural practices for future preservation. Considering the amplifying power of the swarm archive allows DH scholars to expand their scope of interpretation beyond the text and its scholarly commentary—or the "allographic paratexts"[64] that can raise the status of a text—to taking seriously the vernacular appropriations and transformations of the text.

Notes

1 Virginia Kuhn and Vicki Callahan, *Nomadic Archives: Remix and the Drift to Praxis* (Cambridge, UK: Open Book Publishers, 2012); Jeffrey Schnapp et al., "Digital Humanities Manifesto 2.0," *Humanities Blast*, accessed October 1, 2019, https://www.humanitiesblast.com/manifesto/Manifesto_V2.pdf.

2 James J. Brown, "Crossing State Lines: Rhetoric and Software Studies," in *Rhetoric and the Digital Humanities* (Chicago, IL: The University of Chicago Press, 2015), 20–32.

3 National Endowment for the Humanities, Digital Humanities Advancement Grants, *Office of Digital Humanities*, last modified January 1 2020, https://www.neh.gov/grants/odh/digital-humanities-advancement-grants.

4 Andreas Fickers, "Inside the Trading Zone: Thinkering at C²DH Digital History Lab," presented at The Future of Digital Humanities Research–DH Today and Tomorrow. Umeå, Sweden (October 3, 2019).

5 Pelle Snickars, "If Content is King, Context is Its Crown," *Journal of European History and Culture* 1, no. 1 (2012): 1.

6 Casey Boyle, "Low Fidelity in High Definition," in *Rhetoric and The Digital Humanities* (Chicago: University of Chicago Press, 2015), 127–39.

7 Michele Kennerly and Damien Smith Pfister, "Poiēsis, Genesis, Mimēsis: Toward a Less Selfish Genealogy of Memes," in *Ancient Rhetorics and Digital Networks* (Tuscaloosa: University of Alabama Press, 2018), 205–28; Eric S. Jenkins, "The Modes of Visual Rhetoric: Circulating Memes as Expressions," *Quarterly Journal of Speech* 100, no. 4 (2014): 445; Heidi E. Huntington, "Pepper Spray Cop and the American Dream," *Communication Studies* 67, no. 1 (2016): 77–93.

8 Shannon Carter, Jennifer Jones, and Sunchai Hamcumpai, "Beyond Territorial Disputes: Toward a 'Disciplined Interdisciplinarity' in the Digital Humanities," In *Rhetoric and the Digital Humanities* (Chicago, IL: University of Chicago, 2015), 35, 45. The "central figures" quote is citing Presner et al.

9 Anne Balsamo, "Making Meaning, Making Culture: How to Think About Technology and Cultural Reproduction," in *The Routledge Companion to Media Studies and Digital Humanities* (New York, NY: Routledge, 2018), 143.

10 Jason Whittaker and Roger Whitson, *William Blake and the Digital Humanities: Collaboration, Participation, and Social Media* (New York: Routledge, 2013), 25.

11 Steven Weber, *The Success of Open Source* (Cambridge, MA: Harvard University Press, 2004).

12 Bob Nicholson, "The Victorian Meme Machine: Remixing the Nineteenth-Century Archive," *19: Interdisciplinary Studies in the Long Nineteenth Century* 2015, no. 21 (2015): 15.

13 Jeffrey Schnapp et al., "Digital Humanities Manifesto 2.0," 5. Bold text appears in the original.

14 Jason Whittaker and Roger Whitson, *William Blake*, 45; Alex H. Poole, "The Conceptual Ecology of Digital Humanities," *Journal of Documentation* 73, no. 1 (2017): 16.

15 Jason Whittaker and Roger Whitson, *William Blake*; Kuhn & Callahan, 2012, p. 296; Poole, "The Conceptual Ecology," 16; Nicholson, "The Victorian Meme Machine."

16 Jenny Rice and Jeff Rice, "Pop-Up Archives," in *Rhetoric and the Digital Humanities* (Chicago, IL: University of Chicago Press, 2015), 246.

17 Ibid., 246.

18 Ibid., 251.

19 Ibid..

20 Boyle, "Low Fidelity in High Definition."

21 Ibid. 132.

22 Ibid. 134.

23 Eduardo Navas, "The Originality of Copies: Cover Versions and Versioning in Remix Practice," *Journal of Asia-Pacific Pop Culture* 3, no. 2 (2018): 168–87.

24 Daniel Anderson and Jentery Sayers, "The Metaphor and Materiality of Layers," in *Rhetoric and the Digital Humanities* (Chicago, IL: University of Chicago Press, 2015), 80–95.

25 Whitson & Whittaker, 2013. The authors define the Blakean idea of *zoamorphosis* as "a creative act that emerges in collaboration with others in the present and the past (2013, p. 5).

26 Scott Haden Church, "Remix, Śūnyatā, and Prosōpopoeia: Projecting Voice in the Digital Age," in *Ancient Rhetorics and Digital Networks* (Tuscaloosa, AL: University of Alabama Press, 2018), 229–51.

27 Eduardo Navas, *Remix Theory: The Aesthetics of Sampling* (Germany: Springer-Verlag/Wein, 2012). See also Michael E. Veal, *Dub: Soundscapes & Shattered Songs in Jamaican Reggae* (Middletown, CT: Wesleyan University Press, 2007) and Paul Sullivan, *Remixology: Tracing the Dub Diaspora* (London: Reaktion Books, 2014).

28 Dick Hebdige, *Cut 'n' Mix: Culture, Identity and Caribbean Music* (New York: Methuen, 1987), 87.

29 Navas, "The Originality of Copies," 170.

30 Anderson and Sayers, "The Metaphor," 80.

31 Jason Whittaker and Roger Whitson, *William Blake*, 5.

32 Ibid., 7

33 Boyle, "Low Fidelity in High Definition." We use prosōpopoeia here as the rhetorical counterpart to the swarm archive rather than the rhetorical edition articulated earlier in the chapter. Although the swarm archive is similar to the rhetorical edition, we opted to use this rhetorical figure instead because it acknowledges its process as remix in past literature.

34 Church, "Remix, Śūnyatā, and Prosōpopoeia."

35 Cicero, "Pro Caelio," in *Cicero XIII* (Cambridge, MA: Harvard University Press, 1970), 445.

36 Richard Dawkins, *The Selfish Gene* (New York: Oxford University Press, 1976).

37 Theodor W. Adorno, "On Popular Music," in *Essays on Music* (Berkeley, CA: University of California Press, 2002), 437–69.

38 Ibid., 443.

39 Dawkins, *Selfish Gene*, 194.

40 Asaf Nissenbaum and Limor Shifman, "Meme Templates as Expressive Repertoires in a Globalizing World: A Cross-Linguistic Study," *Journal of Computer-Mediated Communication* 23, no. 5 (2018), 295-6.

41 Ryan M. Milner, *The World Made Meme: Public Conversations and Participatory Media* (Cambridge, MA: MIT Press, 2016), 84.

42 Church, "Remix, Śūnyatā, and Prosōpopoeia," 231.

43 Jonathan Gray, *Watching With The Simpsons: Television, Parody, and Intertextuality* (New York: Routledge, 2005).

44 Elad Segev, Asaf Nissenbaum, Nathan Stolero and Limor Shifman, "Families and Networks of Internet Memes: The Relationship Between Cohesiveness, Uniqueness, and Quiddity Concreteness," *Journal of Computer-Mediated Communication* 20, no. 4 (2015): 417–33.

45 Carl Matheson, "The Simpsons, Hyper-Irony, and the Meaning of Life," in *The Simpsons and Philosophy: The D'oh! of Homer* (Peru, IL: Open Court Press, 2001), 108–25.

46 Shifman, *Memes in Digital Culture* (Cambridge, MA: MIT Press, 2013), 111.

47 https://www.youtube.com/watch?v=a8R3qHKS-dk
48 https://www.youtube.com/watch?v=aRsOBFhNjVM
49 https://www.youtube.com/watch?v=zUAtDlAoaac
50 Keith Lozano, "What the Hell is Simpsonwave?" *Pitchfork*, last modified June 14, 2016, https://pitchfork. com/thepitch/1188-what-the-hell-is-simpsonwave/.
51 Laura Glitsos, "Vaporwave, or Music Optimized for Abandoned Malls," *Popular Music* 37, no. 1 (2018): 100–18.
52 Lozano, "What the Hell."
53 Adam Neely, "The music theory of V A P O R W A V E," YouTube video, 4:34, October 24, 2016, https:// www.youtube.com/watch?v=QdVEez20X_s.
54 Jenny Rice and Jeff Rice, "Pop-Up Archives," 251.
55 Poole, "The Conceptual Ecology," 14
56 Poole, "The Conceptual Ecology."
57 https://www.reddit.com/r/SimpsonsMemes/
58 https://www.reddit.com/r/SimpsonsFaces/
59 https://www.reddit.com/r/simpsonsshitposting/
60 https://www.reddit.com/r/TheSimpsons/
61 https://www.reddit.com/r/shitposting/
62 https://www.cougarboard.com
63 A folder can be located online with screenshots of the videos and graphs of the data collected for the study: https://bit.ly/3jMwXOs.
64 Gerard Genette, *Paratexts: Thresholds of Interpretation* (Cambridge, UK: Cambridge University Press, 1997).

Bibliography

Adorno, Theodor W.. "On Popular Music." In *Essays on Music*, edited by Richard Leppert, 437–69. Berkeley, CA: University of California Press, 2002.

Anderson, Daniel, and Jentery Sayers. "The Metaphor and Materiality of Layers." In *Rhetoric and The Digital Humanities*, edited by Jim Ridolfo and William Hart-Davidson, 80–95. Chicago, IL: University of Chicago Press, 2015.

Balsamo, Anne. "Making Meaning, Making Culture: How to Think About Technology and Cultural Reproduction." In *The Routledge Companion to Media Studies and Digital Humanities*, edited by Jentery Sayers, 138–48. New York, NY: Routledge, 2018.

Boyle, Casey. "Low Fidelity in High Definition: Speculations on Rhetorical Editions." In *Rhetoric and the Digital Humanities*, edited by Jim Ridolfo and William Hart-Davidson, 127–39. Chicago, IL: University of Chicago Press, 2015.

Brown, James J.. "Crossing State Lines: Rhetoric and Software Studies." In *Rhetoric and the Digital Humanities*, edited by Jim Ridolfo and William Hart-Davidson, 20–32. Chicago, IL: The University of Chicago Press, 2015.

Carter, Shannon, Jennifer Jones, and Sunchai Hamcumpai. "Beyond Territorial Disputes: Toward a 'Disciplined Interdisciplinarity' in the Digital Humanities." In *Rhetoric and the Digital Humanities*, edited by Jim Ridolfo and William Hart-Davidson, 33–48. Chicago, IL: University of Chicago, 2015.

Church, Scott Haden. "Remix, Śūnyatā, and Prosōpopoeia: Projecting Voice in the Digital Age." In *Ancient Rhetorics and Digital Networks*, edited by Michele Kennerly and Damien Smith Pfister, 229–51. Tuscaloosa, AL: University of Alabama Press, 2018.

Cicero. "*Pro Caelio*." In *Cicero XIII*, trans. by R. Gardner. Cambridge, MA: Harvard University Press, 1970.

Dawkins, Richard. *The Selfish Gene*. New York: Oxford University Press, 1976.

Fickers, Andreas. "Inside the Trading Zone: Thinkering at C²DH Digital History Lab," presented at *The Future of Digital Humanities Research—DH Today and Tomorrow*. Umeå, Sweden, October 3, 2019.

Genette, Gerard. *Paratexts: Thresholds of Interpretation*. Cambridge, UK: Cambridge University Press, 1997.

Glitsos, Laura. "Vaporwave, or Music Optimized for Abandoned Malls." *Popular Music* 37, no. 1 (2018): 100–18. doi:10.1017/S0261143017000599.

Gray, Jonathan. *Watching with the Simpsons: Television, Parody, and Intertextuality*. New York, NY: Routledge, 2005.

Hebdige, Dick. *Cut 'n' Mix: Culture, Identity and Caribbean Music*. New York, NY: Methuen, 1987.

Hsu, Wendy F. "Digital Ethnography Toward Augmented Empiricism: A New Methodological Framework." *Journal of Digital Humanities* 3, no. 1 (2014): online article. Retrieved from http://journalofdigitalhumanities.org.

Huntington, Heidi E.. "Pepper Spray Cop and the American Dream: Using Synecdoche and Metaphor to Unlock Internet Memes' Visual Political Rhetoric." *Communication Studies* 67, no. 1 (2016): 77–93.

Jenkins, Eric S.. "The Modes of Visual Rhetoric: Circulating Memes as Expressions." *Quarterly Journal of Speech* 100, no. 4 (2014): 442–66.

Kennerly, Michele and Damien Smith Pfister. "Poiēsis, Genesis, Mimēsis: Toward a Less Selfish Genealogy of Memes." In *Ancient Rhetorics and Digital Networks*, edited by Michele Kennerly and Damien Smith Pfister, 205–28. Tuscaloosa, AL: University of Alabama Press, 2018.

Kuhn, Virginia, and Vicki Callahan. "Nomadic Archives: Remix and the Drift to Praxis." In *Digital Humanities Pedagogy: Practices, Principles and Politics*, edited by Brett D. Hirsch, 291–308. Cambridge, UK: Open Book Publishers, 2012.

Matheson, Carl. "*The Simpsons*, Hyper-Irony, and the Meaning of Life." In *The Simpsons and Philosophy: The D'oh! of Homer*, edited by William Irwin, Mark T. Conard, and Aeon J. Skoble, 108–25. Peru, IL: Open Court Press, 2001.

Milner, Ryan M.. *The World Made Meme: Public Conversations and Participatory Media*. Cambridge, MA: MIT Press, 2016.

Navas, Eduardo. *Remix Theory: The Aesthetics of Sampling*. Germany: Springer-Verlag/Wein, 2012.

Navas, Eduardo. "The Originality of Copies: Cover Versions and Versioning in Remix Practice." *Journal of Asia-Pacific Pop Culture* 3, no. 2 (2018): 168–87.

Nicholson, Bob. "The Victorian Meme Machine: Remixing the Nineteenth-Century Archive." *19: Interdisciplinary Studies in the Long Nineteenth Century* 2015, no. 21 (2015). doi:10.16995/ntn.738.

Nissenbaum, Asaf, and Limor Shifman. "Meme Templates as Expressive Repertoires in a Globalizing World: A Cross-Linguistic Study." *Journal of Computer-Mediated Communication* 23, no. 5 (2018): 294–310. doi:10.1093/jcmc/zmy016.

Poole, Alex H. "The Conceptual Ecology of Digital Humanities." *Journal of Documentation* 73, no. 1 (2017): 91–122. doi:10.1108/JD-05-2016-0065.

Rice, Jenny and Jeff Rice. "Pop-Up Archives." In *Rhetoric and the Digital Humanities*, edited by Jim Ridolfo and William Hart-Davidson, 245–54. Chicago, IL: University of Chicago Press, 2015.

Segev, Elad, Asaf Nissenbaum, Nathan Stolero, and Limor Shifman. "Families and Networks of Internet Memes: The Relationship Between Cohesiveness, Uniqueness, and Quiddity Concreteness." *Journal of Computer-Mediated Communication* 20, no. 4 (2015): 417–33. https://doi.org/10.1111/jcc4.12120

Shifman, Limor. *Memes in Digital Culture*. Cambridge, MA: MIT Press, 2013.

Schnapp, Jeffrey, Todd Presner, Peter Lunenfeld, and Johanna Drucker. "Digital Humanities Manifesto 2.0." *Humanities Blast*. Retrieved January 10, 2019. https://www.humanitiesblast.com/manifesto/Manifesto_V2.pdf.

Snickars, Pelle. "If Content Is King, Context Is Its Crown." *Journal of European History and Culture* 1, no. 1 (2012): n. p.

"Steamed Hams But it's a 360/VR Experience." YouTube video, 2:45. "Imperial Potato," March 31, 2018. https://www.youtube.com/watch?v=zUAtDlAoaac.

"Steamed Hams but There's a Different Animator Every 13 Seconds." YouTube video, 2:58. "AlbinoBlackSheep," April 15, 2018. https://www.youtube.com/watch?v=a8R3qHKS-dk&t=17s.

"Steamed Hams Inc." YouTube video, 3:39. "NPCarlsson," March 5, 2018. https://www.youtube.com/watch?v=aRsOBFhNjVM&t=62s.

Sullivan, Paul. *Remixology: Tracing the Dub Diaspora*. London, England: Reaktion Books, 2014.

Veal, Michael E.. *Dub: Soundscapes & Shattered Songs in Jamaican Reggae*. Middletown, CT: Wesleyan University Press, 2007.

Whittaker, Jason and Roger Whitson. *William Blake and the Digital Humanities: Collaboration, Participation, and Social Media*. New York: Routledge, 2013.

Weber, Steven. *The Success of Open Source*. Cambridge, MA: Harvard University Press, 2004.

18

POETICALLY REMIXING THE ARCHIVE

xtine burrough

Like most artists and scholars, my practice is iterative. My ability to reflect on and understand my work over time evolves as I create new works, write about them, and compare them to one another and to other works in the field. I am continuously rethinking a framework for understanding what I make, how I work, and the questions that arise during the creative process and after a work is in the world. In the following brief introductory paragraphs, I trace my path to framing my creative scholarship as one that is deeply invested in remix. I highlight how my studio practice stands firmly in the Fine Arts discipline, and I consider critical making—an emergent "makers" turn in the humanities centered on research and process—as a tangent field. Finally, I present three case studies that demonstrate my remix practice as a method for poetically expressing archival materials to bring forward voices and images that are often left unheard and unseen.

Tracing Remix

I was a fine-art photography student during the early 1990s in Boston, Massachusetts. Throughout the decade, my creative practice transformed from image-making in the darkroom (1990–93) to image/text/sound/time collage and net art that took place in electronic media studios and then on desktop computers (1997–99). The timing of my education and early evolution as an artist has shaped my practice both in terms of the technologies that I learned to use and how I have understood and contextualized my work. In my application to MFA programs at the end of the 1990s, I described my work with words like, "collage," "appropriation," and "juxtaposition."

During my graduate education, with exposure to contemporary practices and ways of thinking about art and media-making, I began to understand how artists and the works they create are entangled in the time and society in which they (the artists and the works) are made.[1] I would continue to lean on appropriation as a strategy for meaning-making, but I became more aware of its rhetorical and political implications in the early 2000s. From Critical Art Ensemble I learned how misusing technologies could become an act of civil disobedience.[2] I understood how an artist can be empowered by "the contradiction between the collective mode of administration and an individual mode of appropriation" by way of Michel de Certeau.[3] Lawrence Lessig's *Remix: Making Art and Commerce Thrive in the Hybrid Economy* was liberating for me, as an appropriation

artist. His recognition of the influence of "the mix," which he writes: "delivers a message more powerfully than any original alone could, and certainly more than words alone could,"[4] convinced me to adopt *remix* as a fitting method in my practice. Although "appropriation" or "collage" had been relevant to twentieth-century artists across genres, in the twenty-first century, "remix" conjures all of this and adds to it computation, digital culture, and the possible transformation of the audience into a participant.

In 2008, I edited a collection that included a chapter by Eduardo Navas, and shortly after that Navas and Gallagher recruited me for what would become our first edited anthology, *The Routledge Companion to Remix Studies*.[5] This book was in dialog with the digital humanities, broadly, but my connection with remix has always been as a practitioner, recognizing remix as an interdisciplinary field of study.

I became more aware of the digital humanities in the early twenty-teens, especially after moving to a new position in a school that integrated art and technology studio practice with critical media studies—thus putting me side by side with scholars relevant to the digital humanities. I started to see how I could relate my practice to concepts taken up in the digital humanities and design or making, such as adversarial design, speculative design, and critical making. Some of my interests as an artist align with themes, such as resistance and intervention, similar to those DH "maker" practices.

An Artist, Not a Maker

While I understand that my artworks (in particular, the projects I present as case studies later in this chapter) share common themes with creative project-oriented practices in the digital humanities, I do not position myself as "maker" or as a "critical maker."

The term *maker* implies an industry-oriented creative individual from the maker movement, as Brit Morin reports for the HuffPost: "an evolution of millions of people who are taking big risks to start their own small businesses dedicated to creating and selling self-made products."[6] Morin understands the maker as one who uses modern technologies (Arduinos, laser cutters, 3D printers, and other digital or physical computing tools) to create and distribute products while bypassing manufacturers or middlemen.

In the digital humanities, critical making is a method for researching those same DIY/maker movement tools in the framework of critical/culture studies. Matt Ratto first published the term "critical making" in 2009, to describe a practice embedded in pedagogy and invested in scholarly process over deliverable (or exhibitable) objects.[7] Critical making is a creative practice in which the researcher takes "a material turn"[8] to explore values embedded in our technoculture. Garnet Hertz suggests this subfield of the digital humanities was developed in response to the DIY/maker movement.[9]

While practitioners in the digital humanities may be reacting to the maker, as a fine artist—who evolved before the maker movement began—both the maker and the DIY movement are irrelevant. Digital artists from the 1990s or earlier had to "do it themselves," or at least learn by tinkering before these concepts came to life, and before they were appropriated and re-understood (remixed) to become critically reflexive DH practices.

Matt Ratto and Garnet Hertz position the *critical* portion of critical making between or among the fields of critical/cultural studies, science and technology studies, technological design, and technical practices that engage with humanities and social science

literature. They bridge these fields in defining critical making as "a focus on material-conceptual processes that bring together reflexivity and intervention."[10] Critical making is embedded in the humanities, and results from these types of investigations are often showcased at academic conferences and in books or journals (some digital, some open source, and some printed).[11] The audience for makers in the digital humanities, while not explicitly academic, is often in dialog with DH scholars. I am not suggesting these works cannot also be in museums or galleries, but that there seems to be a prevalence of critical making embedded in the academy, whereas works made by artists are more often found in public venues.

I define every artist as a "maker"[12] with a capacity for critical reflection. Artists use materials and develop conceptual processes—whether or not their reflections are published, I believe artists engage in a reflective practice. Any artist who has made more than one work of art has been reflective. The second work is informed by the first. And works that follow continue along that lineage of learning by doing. Those who rely on remix as a strategy for meaning-making create rhetorical interventions using their materials that take on audio, visual, or other formats (digital or not). However, unlike critical makers who develop for their own research and present findings in academic communities, artists are interested in presenting their work to the general public. The public is met in the gallery or museum space, at events, festivals, night clubs, and so on. Thus, I propose remix artists are related to makers/practitioners in the digital humanities—who are also referencing, citing, appropriating, and making meaning with digital tools and datasets—but speak to wider audiences in the publication or presentation of their work.

Critically Engaged Remix

Artists cultivate studio practices and become experts in the domain of their materials through appropriation, iteration, and/or versioning, to use terms common to remix studies. The artist gains feedback from public audiences at exhibitions and artist talks and/or workshops.[13] The humanities scholar publishes in academic journals or books; and the critical maker, at least by Ratto's definition, makes objects that are "not typically exhibited or described outside of the course context" to create makers (not objects) who have "an enhanced ability to parse the complexity of our sociotechnical world."[14] While Garnet Hertz argues for an inversion: "flipping the emphasis of the hands-on augmentation of critical technology studies to appeal to 'makers' to be more critically engaged with technology," I identify as an artist and feel uncertain about "critical making," as a label, even if my projects engage critically with technology to illuminate the voices of those who are often left unheard.[15] My projects start in the studio—where emerging media and technologies are my materials of engagement and remix is a method for creative expression. I collaborate with humanities scholars because they are often the people with whom I have the richest conversations; and this dialog is folded back into the work that no longer belongs to me, alone, but to us as collaborators. Together, we create works at the intersection of digital art and the humanities, using tenets of remix—appropriation, juxtaposition, and computation—for public audiences. None of us identify as critical makers, but the result of our collaborations are projects that are critically engaged with technology. The following case studies demonstrate how I use remix as a strategy for developing three such projects with collaborators in the humanities, Dan Sutko and Sabrina Starnaman.

The Women of El Toro

In 2015, I proposed a mobile project with Dan Sutko for a Cal Humanities "Community Stories" grant.[16] Dr. Sutko's interest in space and place converged with an idea I had to activate history on a mobile platform. Collaborating with colleagues in the humanities has helped me frame my practice in a way that is legible to people outside the fine arts. I enjoy working on a project at a far greater scale than what I can accomplish alone when I am part of a team, each of us responsible for parts of the project that relate to our discipline, working toward a common goal.

When we learned the project was funded in July, we spent a year developing (reading, selecting, coding, and designing) an app to transform a park in Orange County, California into a site-specific audio tour of the past through the voices (via earbuds) of women who once lived on the land where the park was built (Figure 18.1). The Orange County Great Park was built on the former site of the Marine Corps Air Station El Toro. During World War II, the people living on this land included the soldiers and elite military who flew, tended to the planes, and managed the base. There were also women enlisted in the Marine Corps who worked on the base as professionals; and there were women who lived on the base as wives and mothers. *The Women of El Toro* is an app that facilitates a site-specific understanding of the Orange County Great Park through stories of women who were located at the El Toro air base. Anyone can download the free app and listen to it, but it is meant to be used while in the park. As the people responsible for publishing these community stories, we felt strongly that the stories presented on a mobile platform would be ones that were overlooked. The Orange County Great Park memorializes many of the men who worked on the air base in its on-site gallery and media materials, but it does not celebrate its rich history of women residents. Dr. Sutko and I wanted to juxtapose selections of these voices so they would be read as intentional works of activism that make visible (or audible) the stories of this underrepresented population.

We did not have to record new audio. All of the stories we presented had been recorded by the Center for Oral and Public Histories (COPH) at California State University, Fullerton (where we were both teaching), directed by Dr. Natalie Fousekis. During the time between its demolition and the new construction of the park, COPH interviewed more than 30 women who had lived on the air base. These interviews were recorded on tape in the early 2000s, and then digitized. The digital files, most approximately an hour or more in length, were kept at the center. They were not available online, or through the library, at the time we made the app. A basic motivation of this project was to bring portions of this archive to the public.

However, we did not use all of the audio that COPH recorded—we could not imagine anyone walking through the park while listening to these interviews for 30 hours or more. Our selection of the fragments of interviews we would share in the park would have to be poetically situated—this way of thinking about the materials in the archive was one of my conceptual contributions to the project. We thought about how those fragments might read as a texture of media juxtaposed with the site, where one might be engaged in a particular activity: the carousel, the farmer's market, the reflection pool. Each of these places suggests a certain type of interaction; and the audio would need to cleverly or poetically fit the listener's location. In this way, the location in the present remediates the interviews that had been collected in the near-past in order to tell a story about the place during the 1940s (Figure 18.1).

Figure 18.1 Top: *The Women of El Toro*, xtine burrough, and Dan Sutko, 2016. A free iOS app that augments the Orange County Great Park with stories from women Marines who served at El Toro and wives of Marine vets stationed there during World War II. Bottom: For audiences unable to visit the Orange County Great Park, this map shows landmarks in the park with their selected quotes from interviews: http://www. missconceptions.net/woelt/map.html

The project launched in 2016 as a free download from the iTunes Store because we were able to use funds from the grant to hire app developer James Burka and our funds did not afford us to develop for multiple platforms.[17] Collaborating across fields, in this case, including myself and Sutko with creative technologies developed by Burka, and all of the interviews that Natalie Fousekis had led through COPH enabled us to create a project of great depth and scale.

Dr. Sutko and I spent the next year writing for funding to create a follow-up app, site-specific to other locations. We found two locations that interested us—one in California and one in Texas (where I had moved for a new academic position)—where military bases had been converted to spaces that facilitate new forms of public interactions. When we did not receive funding, we became invested in other projects. But I imagine that one day we will circle back to this project, thematically, perhaps with new forms of emerging media.

An Archive of Unnamed Women

Two years after the launch of *The Women of El Toro*, I had been collaborating on another project with a literature scholar I met at The University of Texas at Dallas who shared an interest in women's literature and social reform.[18] I showed Dr. Starnaman images from the Library of Congress that I had been curious about while working on a textbook years earlier—a set of images that became a seed for the project we would develop together (Figure 18.2). The photographs were portraits of women taken by the Civil War photographer, Matthew Brady. Unlike the war "heroes" and other men Brady photographed that were in the archive, these women were unnamed and unidentified. I said to my collaborator: there must be more unnamed women collected in other archives. Together we set to make our own archive for *An Archive of Unnamed Women*, an ongoing project started in 2018.

Our research assistant, Alyssa Yates, quickly discovered that to create this project, we would not be able to work with images from the Library of Congress because links to the images were not constant and we wanted our digital archive to point directly to the references. We were also interested in creating a diverse archive that would include women of color and nonbinary women. Starnaman and Yates suggested we work with the New York Public Library's Digital Collection, because this would include the Schomburg Center for Research in Black Culture and the linked content was stable.

Alyssa reviewed more than 117,000 images in this archive, one at a time, to look thoroughly at the image, image credits, and metadata, including information that may have been printed on the backside of the original photographs. She found 417 images of unnamed or unidentified women in the archive, which are the only images published in our archive project (Figure 18.2).

Parallel to the set of images, Starnaman and Yates created a database of quotes written by women, which describe women's experiences, from roughly the same time period as the photographs (approximately the late 1800s–1930s). The quotes and images are juxtaposed together as participants interact with our archive. As a speculative remix, this project creates an imagined narrative for women who have been preserved without names or identities. While Starnaman and Yates developed the image and datasets, I worked with a computer science and engineering student, Al Madireddy, to develop the interface and back-end code for the browser-based "archive."

When a viewer clicks the links that would normally lead a researcher to more information (the name of the photographer, the location, date, and so on), they are presented with a narrative constructed by a random text from our database in juxtaposition over the image of the unnamed or uncited woman (Figure 18.3). Our archive also includes a form on which viewers can submit information about the women in it. If our project is successful, each of the unnamed women would become named in the original database, thus completing our project.

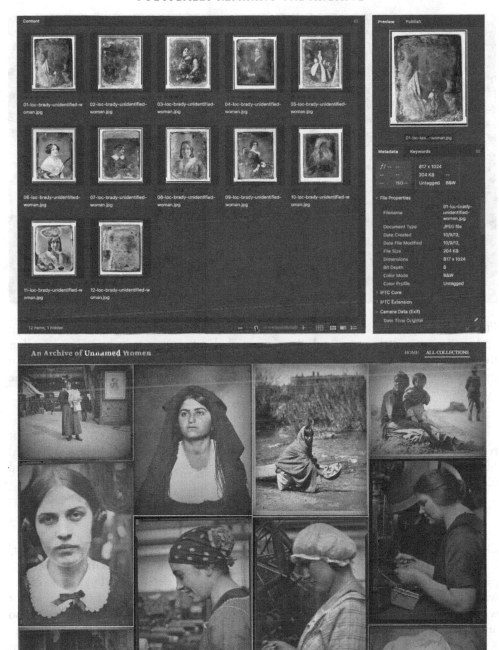

Figure 18.2 Top: This set of images appears in my first and second edition of *Foundations of Digital Art and Design with Adobe Creative Cloud* (2014, 2019) to demonstration organizing image files with Adobe software. Readers download these images from the Library of Congress as part of an activity centered on understanding copyright and fair use while subtly noticing this interesting set of unnamed women in Brady's portfolio. Bottom: There are 417 photographs in burrough and Starnaman's *An Archive of Unnamed Women* (2018–ongoing)

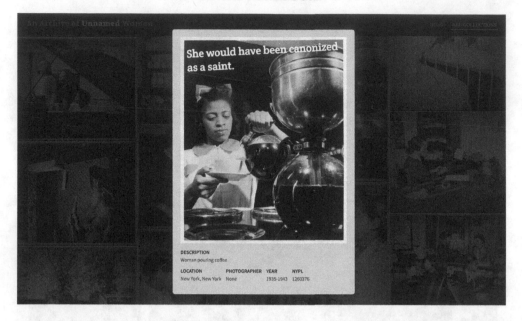

Figure 18.3 An Archive of Unnamed Women is a speculative remix project by burrough and Starnaman (2018–ongoing). As viewers click what appear to be links to further information, they are instead confronted with quotes describing women's lives, written by women writers, from approximately the same time period as the photographs in the collection

Like *The Women of El Toro*, this project also would not be made to the scale that it reached without collaboration and contributions by Dr. Starnaman, Alyssa Yates, Al Madireddy, and of course the original photographs archived in the NYPL Digital Collection.

A Kitchen of One's Own

One year later we responded to a call for works for an ongoing program, "Data/Set/Match," at The Photographers' Gallery in London. The call was "seeking new ways to present, visualise and interrogate contemporary image datasets"[19] on a large-scale media wall in the gallery, facing the street in the Soho neighborhood of London. This call for works resonated with what we were already doing in *An Archive of Unnamed Women*; so after viewing the datasets listed in the call, we submitted a proposal to remix the Epic Kitchens dataset with a database of texts that we would create. Our project, *A Kitchen of One's Own*, juxtaposes selections of videos from the Epic Kitchens dataset with text from women's writing about food and journalistic reports on women's experiences in the commercial kitchen as they intersect with the #MeToo movement.

Epic Kitchens is a collaborative research team of computer scientists from the University of Bristol, the University of Toronto, and the University of Catania that has generated an open-source dataset of videos of people working in their kitchens. The 2018 set contains fifty-five hours of footage in thirty-two participant kitchens across four cities. Participants verbally self-annotate their videos as they wash, peel, cook, and toss

food items, throw away trash, and take on other mundane kitchen tasks. Then the researchers assign keyframes to the videos, including a set of 125 verb classes and 331 noun classes.[20] The scientists' use for these videos is to "advance the first-person vision, enabling improvements in robotics, healthcare and augmented reality."[21] Our use for these videos is to present them as part of an ongoing narrative that centers on women's experiences in personal and domestic kitchens. That is, through remix, we shifted the way these kitchens "read" from neutral, non-scripted spaces that afford the scientists unbiased raw materials for language processing to gendered spaces where literature, journalism, and hashtags call for political action.

As we wrote for *Unthinking Photography*: "From women writers to women artists, the kitchen is a space that holds possibility for reinterpretation."[22] I wanted our project to represent the magnitude of data embedded in Epic Kitchens, but I also wanted our project to be feasible (in terms of finishing what would come to take the majority of time—computer processing—to finish the project within the 8 months we had before we needed to ship it to the gallery). To accommodate feasibility, instead of using all 125 verb classes, we used twenty-five verbs from the data presented by Epic Kitchens in our project, which I set in a spreadsheet for Starnaman and Yates. As they added literary or journalistic entries, they paired each with one of the verbs (Figure 18.3). Before publishing the project, Starnaman and I analyzed the pairings, looking for poetic juxtapositions between the set list of verbs and the quotes. While Starnaman and Yates built the literary and journalistic dataset of quotes, I went to work on the set of training videos from the 2018 Epic Kitchens dataset and recruited another collaborator to act as our technical director.

I downloaded all of Epic Kitchens' 268 training videos (an endeavor that took nearly three weeks of continuous download, a techno-process that draws similarities to domestic labor in its repetitiveness). The original videos ranged from seconds in duration to nearly an hour. For consistency and to minimize (to some extent) file size and maximize processing capabilities on the media wall, I edited a set of them into 30-second video clips aligned with one of the verb keyframes seen in Figure 18.4. I wanted the viewer to see the enormity of this data collection but realized that seeing it all at once is impossible. So, I built a series of grid designs to prototype how I imagined the media wall to populate with videos overlaid with quotes from our datasets. These two elements would be randomized but only from within the smaller set of videos and quotes paired with the same verb. I brought all of this to Dale MacDonald, the Associate Dean for Research and Creative Technologies (and all-around technical guru) where I teach and asked him how much of this workload could be automated, and if he would be willing to work on the project as a technical director. Shortly thereafter, MacDonald used Python to extract keyframe data from the original videos, plotted timecodes in each video where nouns and verbs had been tagged, and exported thirty-second video clips using an open-source application called FFmpeg. His code re-exported those original 268 source videos into 7556 unique thirty-second clips, where the keyframe for the verb/noun tag data appears at the end of the video file. These clips were then rendered at four sizes to produce 30,224 discrete videos in our collection (and took another week of nonstop computer processing time).

Once the videos and quotes were ready, MacDonald wrote JavaScript code to automate a randomized sequence of the grid designs I had developed as a prototype (Figure 18.4). This project was supposed to launch in May 2020 but was delayed due to the COVID-19 pandemic. It debuted in the gallery in the Fall of 2020.[23]

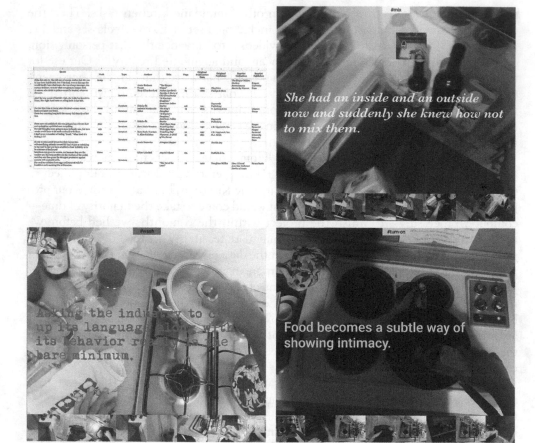

Figure 18.4 Top left: The literary database for A *Kitchen of One's Own* pairs each quote with one of the 25 verbs in use by Epic Kitchens across their set of training videos. Top right: A frame from of A *Kitchen of One's Own* as the automated media wall displays a randomized grid design, including video and text combinations associated with the keyframe verb "mix" (assigned by Epic Kitchens) and a quote from our dataset of *literature* that is also "keyed" to the verb, "mix." Bottom left: A frame from A *Kitchen of One's Own* as the automated media wall displays a randomized grid design, including video and text combinations associated with the keyframe verb "wash" (assigned by Epic Kitchens) and a quote from our dataset of *journalistic* writings that is also "keyed" to the verb, "wash." Bottom right: A frame from A *Kitchen of One's Own* as the automated media wall displays a randomized grid design, including video and text combinations associated with the keyframe verb "turn-on" (assigned by Epic Kitchens) and a quote from our dataset of *social media* text that is also "keyed" to the verb, "turn-on"

Conclusion

In the context of remix studies, my process has long been informed both by Eduardo Navas's notion of the selective remix[24] and by projects such as Christian Marclay's *The Clock*.[25] The Tate Museum celebrates Marclay's opus in its "ability to make you think about past, present and future. It is composed of moments from the past, but the ever-moving clock that matches your own real time places an emphasis on the present."[26] I,

too, strive to create projects in which juxtaposition yields a vision of the past, present, and future; and through digital interfaces offers room for personal interpretation. In a best-case scenario, audience/participants with the work I have developed might ask: What does it mean for me when I hear interviews with the women from the El Toro air base through my earbuds? How am I complicit when I click from link to link in *An Archive of Unnamed Women* and see different narratives juxtaposed on top of those uncited women's faces? How can I uplift the experiences women have in personal and domestic kitchens?

What I did not realize when Dan and I proposed *The Women of El Toro* is that its format would be one that I would revisit again (*An Archive of Unnamed Women*) and again (*A Kitchen of One's Own*) in various archives—an audio interview archive, a digital photography collection, and a dataset of first-person videos. To produce all three works, what I think of as the portion of the project where I am actively engaged in *making* the art, every file (audio, image, or video) was selected, and in some cases transformed (edited), before they became part of the remixed creative project. As Navas' selective remix theory presents: in order to create the poetic gesture of juxtaposition, I had to set the primary references—either manually (in the first two projects) or with specific, "human-designed" constraints before computation aided the process. Remix is my strategy for revealing normative paradigms by omitting dominant voices. With Sutko, I foregrounded women's voices in an app that situates them in relation to the viewer through place, and the viewer/listener understands this as a political choice. Starnaman and I place unnamed women in the center of a reimagined archive, juxtaposed with descriptions written by female writers—many of whom are canonical in the field of women's literature but, nevertheless, are unknown to the common reader. These images and imagined narratives draw attention to the unknown, real identities of women who appear in the archive. For *A Kitchen of One's Own*, first-person kitchen videos are remediated when they are seen beneath or behind quotes about #MeToo in professional kitchens or quotes describing women in the kitchen across time and cultures.

In the realm of the digital humanities, I find myself at odds with critical making, as perhaps a resistant force to Maker Culture writ large, because I see the Fine Arts as a discipline that is tangent to both Maker Culture and Critical Making. As I have written in a prior publication: "I feel uncomfortable talking about my practice as critical making or research. What is it that we are doing? Are we researching through our practice? Are we 'just' practicing?"[27] Projects I have created with humanities collaborators do intervene in spaces (virtual or physical) to offer a critical point of reflection for the viewer/participant on the role of technology in mediating our world. But they are made as works of art, perhaps with a closer leaning toward digital poetry and social engagement than critical making. Remix is my creative methodology—an academic word I would be unfamiliar with by way of my fine arts training if I were not in conversation with humanities scholars. Due to our collaboration on a diverse team of cultural producers, the results are creative interventions at the intersection of the arts and the digital humanities.

Notes

1 John Dewey, *Art as Experience* (New York, NY: Minton, Balch & Company, 1934).
2 Critical Art Ensemble, *The Electronic Disturbance* (Brooklyn, NY: Autonomedia, 1994).
3 Michel de Certeau, *The Practice of Everyday Life*, translated by Steven Rendall (Berkeley, CA: University of California Press, 1984) 96.

4 Lawrence Lessig, *Remix: Making Art and Commerce Thrive in the Hybrid Economy* (New York, NY: Penguin Press, 2008) 71.

5 Eduardo Navas, Owen Gallagher, and xtine burrough, editors, *The Routledge Companion to Remix Studies* (Abingdon: Routledge, 2014).

6 Brit Morin, *What Is the Maker Movement and Why Should You Care?*. Huffpost.com, 5/2/2013, updated 7/2/13, https://www.huffpost.com/entry/what-is-the-maker-movemen_b_3201977.

7 Matt Ratto, "Critical Making: Conceptual and Material Studies in Technology and Social Life," *The Information Society: An International Journal*, 27.4 (2011): 252–60, https://doi.org/10.1080/01972243.2011.583819.

8 Dan Hicks, "The Material-Cultural Turn: Event and Effect." In *The Oxford Handbook of Material Culture Studies*, edited by Dan Hicks and Mary C. Beaudry (Oxford: Oxford University Press, 2010) 25–98.

9 Garnet Hertz, "Preface." In *Conversations in Critical Making*, edited by Garnet Hertz (CTheory Books, 2017), 5, Blueshift Series.

10 Matt Ratto and Garnet Hertz, "Critical Making and Interdisciplinary Learning: Making as a Bridge between Art, Science, Engineering, and Social Interventions." In *The Critical Makers (Un)Learning Technology Reader*, edited by Loes Bogers and Letizia Chiappini (Amsterdam: Institute of Network Cultures, 2019) 22.

11 HASTAC: https://www.hastac.org/; Vectors: http://vectors.usc.edu/journal/index.php?page=Introduction; INC reader: https://networkcultures.org/publications/#inc-reader.

12 While the "maker" may be a DH concept that responds to the rise of the commercial maker movement, propelled by the publication of Dale Dougherty's Make Magazine in 2005, theories of the maker, from the commercial notion to Hicks' material turn seem to at best dismiss practices performed by artists who have been "making" with materials (physical or digital) at least since the Paleolithic drawings in Lascaux, and at worst suggest that artists are not capable of critical thinking.

13 I realize I'm at odds with myself right now by writing this—and this is why I consider myself a hybrid artist, invested both in studio practice and academic forms of sharing scholarship.

14 Matt Ratto and Garnet Hertz, "Critical Making and Interdisciplinary Learning: Making as a Bridge between Art, Science, Engineering, and Social Interventions." In *The Critical Makers (Un)Learning Technology Reader*, edited by Loes Bogers and Letizia Chiappini (Amsterdam: Institute of Network Cultures, 2019) 25.

15 Garnet Hertz, "Preface." In *Conversations in Critical Making*, edited by Garnet Hertz (CTheory Books, 2017) 3, Blueshift Series.

16 California Humanities, "The Women of El Toro, Project Director Interview," February 25, 2016, https://calhum.org/the-women-of-el-toro-project-director-interview/.

17 xtine burrough and Dan Sutko, *The Women of El Toro*, 2016. For information about the project and a link to download the app: http://www.missconceptions.net/woelt/.

18 I should clarify that Dr. Starnaman's interest in women's literature is scholarly while mine is hobbyist.

19 The Photographers' Gallery, "Data/Set/Match," The Photographers' Gallery, 2020, accessed June 6, 2020, https://thephotographersgallery.org.uk/content/data-set-match.

20 Epic Kitchens, *GitHub*, May 2020, accessed June 7, 2020, https://epic-kitchens.github.io/2019. You can see the complete set of verbs here: https://github.com/epic-kitchens/annotations/blob/master/EPIC_verb_classes.csv.

21 University of Bristol New and Features, "Largest-Ever Computer Vision Dataset from Wearable Cameras." University of Bristol New and Features, accessed April 19, 2018, http://www.bristol.ac.uk/news/2018/april/epic-kitchens.html.

22 xtine burrough and Sabrina Starnaman, "Recovering Lost Narratives in Epic Kitchens," *Unthinking Photography*, May 13, 2020, https://unthinking.photography/articles/recovering-lost-narratives-in-epic-kitchens.

23 While our media wall project was delayed we pivoted at the start of our lockdown and brought in Dale Macdonald as a technical director for a browser-based version of the project, *Epic Hand Washing in the Time of Lost Narratives*, which was published by The Photographers' Gallery London as a digital project in coordination with *Unthinking Photography*, https://thephotographersgallery.org.uk/epichandwashing.

24 Eduardo Navas, *Remix Theory! The Aesthetics of Sampling* (New York, NY: Springer-Verlag Wien, 2012) 76–85.

25 Walker Art Center, "Christian Marclay: The Clock," *YouTube*, Walker Art Center, June 6, 2014, accessed August 8, 2020, https://www.youtube.com/watch?v=irtVNTFr4f4.

26 Tate.org, "Five Ways Christian Marclay's the Clock Does More Than Just Tell the Time," Tate.org, List Section, accessed June 7, 2020, https://www.tate.org.uk/art/lists/five-ways-christian-marclays-clock-does-more-just-tell-time.
27 xtine burrough and Lucy H.G. Solomon, "Drawing on Theory to Build/Unbuild Media, or Lalalalalalalalala." In *The Critical Makers (Un)Learning Technology Reader*, edited by Loes Bogers and Letizia Chiappini (Amsterdam: Institute of Network Cultures, 2019) 65.

Bibliography

burrough, xtine, and Lucy H.G. Solomon. "Drawing on Theory to Build/Unbuild Media, or Lalalalalalalalala." In *The Critical Makers (Un)Learning Technology Reader*, edited by Loes Bogers and Letizia Chiappini, 61–71. Amsterdam: Institute of Network Cultures, 2019.

burrough, xtine, and Sabrina Starnaman. *An Archive of Unnamed Women*. 2018, Ongoing. http://visiblewomen.net/unnamed-women/index.html.

burrough, xtine, and Sabrina Starnaman. "Recovering Lost Narratives in Epic Kitchens." *Unthinking Photography*, May 2020. https://unthinking.photography/articles/recovering-lost-narratives-in-epic-kitchens.

burrough, xtine, and Sabrina Starnaman. *A Kitchen of One's Own*. The Photographers' Gallery, London, for the Program Series, "Data/Set/Match." September 1–30, 2020. https://thephotographersgallery.org.uk/content/data-set-match.

burrough, xtine, and Dan Sutko. *The Women of El Toro*. 2016. http://www.missconceptions.net/woelt/.

California Humanities. "The Women of El Toro, Project Director Interview." February 25, 2016. https://calhum.org/the-women-of-el-toro-project-director-interview/.

Critical Art Ensemble. *The Electronic Disturbance*. Brooklyn, NY: Autonomedia, 1994.

de Certeau, Michel. *The Practice of Everyday Life*, translated by Steven Rendall. Berkeley, CA: The University of California Press, 1984.

Dewey, John. *Art as Experience*. New York, NY: Minton, Balch & Company, 1934.

Epic Kitchens. *GitHub*. Accessed June 7, 2020, https://epic-kitchens.github.io/2019.

Hertz, Garnet. "Preface." In *Conversations in Critical Making*, edited by Garnet Hertz, 1–7. CTheory Books, 2017. Blueshift Series.

Hicks, Dan. "The Material-Cultural Turn: Event and Effect." In *The Oxford Handbook of Material Culture Studies*, edited by Dan Hicks and Mary C. Beaudry, 25–98. Oxford: Oxford University Press, 2010.

Lessig, Lawrence. *Remix: Making Art and Commerce Thrive in the Hybrid Economy*. New York, NY: Penguin Press, 2008.

Morin, Brit. "What Is the Maker Movement and Why Should You Care?." Huffpost.com. 5/2/2013, updated 7/2/13, https://www.huffpost.com/entry/what-is-the-maker-movemen_b_3201977.

Navas, Eduardo. *Remix Theory: The Aesthetics of Sampling*, 76–85. New York, NY: Springer-Verlag Wien, 2012.

Ratto, Matt. "Critical Making: Conceptual and Material Studies in Technology and Social Life." *The Information Society: An International Journal* 27.4 (2011): 252–60. https://doi.org/10.1080/01972243.2011.583819.

Ratto, Matt, and Garnet Hertz. "Critical Making and Interdisciplinary Learning: Making as a Bridge between Art, Science, Engineering, and Social Interventions." In *The Critical Makers (Un)Learning Technology Reader*, edited by Loes Bogers and Letizia Chiappini, 17–29. Amsterdam: Institute of Network Cultures, 2019.

Tate.org. "Five Ways Christian Marclay's the Clock Does More Than Just Tell the Time." Tate.org. List Section. Accessed June 7, 2020, https://www.tate.org.uk/art/lists/five-ways-christian-marclays-clock-does-more-just-tell-time.

The Photographers' Gallery. "Data/Set/Match." The Photographers' Gallery. Accessed June 6, 2020, https://thephotographersgallery.org.uk/content/data-set-match.

University of Bristol New and Features. "Largest-Ever Computer Vision Dataset from Wearable Cameras." University of Bristol New and Features. Accessed April 19, 2018, http://www.bristol.ac.uk/news/2018/april/epic-kitchens.html.

Walker Art Center. "Christian Marclay: The Clock." *YouTube*. Walker Art Center, June 6, 2014, accessed August 8, 2020, https://www.youtube.com/watch?v=irtVNTFr4f4.

Part III

MODULARITY AND ONTOLOGY

Part III

MODULARITY AND
ONTOLOGY

19

HALLUCINATION OR CLASSIFICATION

How Computational Literature Interacts with Text Analysis

Eran Hadas

With the rise of Artificial Intelligence, much attention is given, both in computer science and in popular culture, to the generation of natural language texts by computers.

At the beginning of 2019, many considered OpenAI's GPT-2 to be the state-of-the-art automatic text-generating model.[1] The creators of the model waited several months to publish it, due to "concerns about malicious applications." The alleged concerns were that people would think

> See chapters 20 and 21 for Alessandro Ludovico's and Mark Amerika's respective discussions of GPT-2.

that the texts produced by the program were written by humans, rather than computers. If that were the case, the model would have passed a test parallel to the Turing test, which determines a machine's ability to exhibit intelligent behavior equivalent to that of a human.

GPT-2 was trained on 40 GB of Internet text to complete a given textual input, by predicting, at each moment, the next word to be typed in a sequence. The prediction is not based on any domain-specific rules. Instead, it relies completely on its training examples, using a model technically called Unsupervised Transformer Language Model.

I asked GPT-2 to complete the text "The Routledge Handbook of Digital Humanities and Remix Studies," and the result was as follows:

> *The Routledge Handbook of Digital Humanities and Remix Studies, ed. by Anna M. Tarduno, David F. Litt and Margo M. Williams (Harvard University Press, 2014), pp. 474-485. ISBN 978-0-262-81630-4*

The generated ISBN in this fabricated title is not a real one, though it is a credible imitation of one. Similarly, the names in this text are automatically generated as a remix of uncorrelated elements that GPT-2 had previously encountered.

It seems that GPT-2 recognized the given string as an academic title and managed to complete the text in a way that makes sense. GPT-2, like other Machine Learning (ML) models, uses existing examples to generate new artifacts that resemble them or some of their properties. Hence, the completion of the next textual element is limited to elements that the model has encountered before. Any word that did not appear in the input corpus it had learned would not be a valid choice. In this sense, GPT-2, like many AI models, can be seen as a remix machine, which disassembles and reorders its input before outputting it. I would like to investigate the reorganization of parts of text into a new text as a remix. I think this remix, often of a set of texts rather than a single one, can be used to read and understand texts as well as to illuminate patterns in cultural phenomena.

Since machine learning models fashion their output texts after examples set before them, a process of textual analysis must guide them. The model has to learn something about the texts in order to produce its outputs. In computer science, text analysis is the automated process of understanding unstructured text data and making it easier to manage. It involves parsing texts in order to extract computer-readable facts from them. The purpose of text analysis is to create structured data out of free text content.

Yet text analysis has other meanings in other contexts. In literature and cultural studies, the meaning of text analysis is the close examination of a text in order to reveal its meanings. The aim is to trace the mechanics of the text and figure out how it "works," often referring to the author's intentions. A cultural text analysis would seek the cultural structures and hierarchies that underlie a specific text. It highlights cultural behaviors instead of individual intention.

While a literary text analysis yields an interpretation, a computational text analysis, which is the mapping of a text into manageable elements, is utilized to create a new output, which I suggest viewing as a form of textual remix. However, as I will show, these two forms of textual analysis are not as different as they may seem. This is because the textual output resulting from computational text analysis can teach us a lot about the analyzed text and about the subconscious constraints—individual and cultural—that govern it.

From my perspective as a poet who codes, I am interested in examining the connection and tension between the technical aspects of computational writing and its aesthetic ones. In this chapter, I will discuss projects I created to intervene in computational writing that use remix as a poetic device. These attempts synthesize computer programming and Artificial Intelligence models with computational and literary analysis of texts, joined by poetic curiosity about language and cultural biases. Each project discussed will outline a different level of such analysis: textual analysis of a cultural phenomenon, analysis of specific aspects of language, statistical and algorithmic analysis of texts, and the analysis of the human reading experience today.

The Other Poetry

As a young poet, I was enchanted by the emotional impact of language, but reluctant to explore it by expressing my own feelings. Although I did not rule out lyric confessional poetry, I felt the urge to give voice to other possibilities embodied in language. At first, I turned to political poetry, which felt like an inevitable step considering my Israeli surroundings. While I never abandoned political poetry, I came to realize that it does not have the desired impact outside of a small echo chamber of audience members. I was

looking for a way to poetically touch the political, but on a deeper and wider level than through poetic "protest." In a way, and as I will show, automatic text generation offered me exactly that.

When I started my computational poetry experiments, very few artists were working in the same way. While Israeli society values computer technology, it is always evaluated in capitalistic terms, namely, its profitability. People who commented on my artwork would say that they fail to understand my business model. I was often asked why a person who is capable of programming would put so much effort into it merely to create a poem.

I felt that writing was a magical stream flowing through me at unexpected times, bursting into a wholeness that was not a part of me. I started wondering how to further explore the creative procedures that yielded those texts. How could I turn it into a controllable method? This led me to procedural writing: applying a sequence of steps to create a new text. In many cases, this meant playing and tampering with texts, mashing them up, and remixing them.

Code

My first attempt at creating a literary remix was *Code*, a 298-page book, published in 2014, that was programmed to reveal all the latent Haiku poems in the Pentateuch (*The Torah*), which is the biblical foundation of the Jewish holy law and a moral code of conduct.

Haiku verse is a form of Japanese poetry, characterized by syllabic and thematic constraints. A Haiku consists of 17 syllables in three consecutive phrases (or lines) of five, seven, and five. Why Haiku? The most famous Jewish prayer begins with a Haiku, taken from Deuteronomy 6:4–9: *She'ma Yis'ra'el/A'do'nai E'lo'hei'nu/A'do'nai e'chad.*

The program, the source code of which appears in the book's postface, extracts all the substrings in the Pentateuch that adhere to the Haiku structure without breaking any words. Every poem in the book is an exact quote from the Bible, yet there may be overlapping between several poems, as shown in Figure 19.1. The idea came to me when I was pondering musical remixes: several parts were copied from the original tracks, and then laid on the same musical beat. Trying to import this concept to the book, I considered Haiku as the beat.

Code subjects the preexisting text to radical reduction. The program functions here as a "parasitic" method, in the sense that it is unoriginal: it manipulates an existing text, passing only some of its linguistic aspects to its textual offspring. The new division of words into lines appears as a Modern Hebrew text, making it easier for readers to approach the biblical text. For instance, in Biblical Hebrew, a typical verb sentence starts with the one-syllable word "and," followed by a two-syllable verb in the opposite tense to that of Modern Hebrew. The verb is often followed by a one-syllable preposition and a two- to three-syllable subject, exceeding the five syllable beginning of the Haiku form. Widespread sentences like "he went to," "he said to," "God spoke to," and many more, which sound archaic to Modern Hebrew readers, are removed. In such a case, a Haiku verse reframes the original sentence from the middle, starting with a noun, which resembles Modern Hebrew. This process sometimes modifies the meaning of the text. For example, the Biblical verse *"Egypt, Israel/Beheld the Egyptians/Die on the seashore"* can be read in the new division as the Modern Hebrew *"Egypt, Israel/Beheld the Egyptians/Mad about the beach."*

א-99	א-92	א-85		א-78	א-71	א-64
הָיָה אֲבִי כָל	אֶת מְתוּשָׁאֵל	וְעַתָּה אָרוּר		וַהֵבֵל הֵבִיא	חַיֶּיךָ וְקוֹץ	לְרוּחַ הַיּוֹם
תֹּפֵשׂ כִּנּוֹר וְעוּגָב	וּמְתוּשָׁאֵל יָלַד אֶת	אַתָּה גַם הָאֲדָמָה		גַם הוּא מִבְּכֹרוֹת צֹאנוֹ	וְדַרְדַּר תַּצְמִיחַ לָךְ	וַיִּתְחַבֵּא הָאָדָם
וְצִלָּה גַם הִוא	לֶמֶךְ וַיִּקַּח	אֲשֶׁר פָּצְתָה אֶת		וּמֵחֶלְבֵהֶן	וְאָכַלְתָּ אֶת	וְאִשְׁתּוֹ מִפְּנֵי

א-100	א-93	א-86		א-79	א-72	א-65
כִּנּוֹר וְעוּגָב	לֶמֶךְ וַיִּקַּח	מִן הָאֲדָמָה		אֶל הֶבֶל וְאֶל	אֶל הָאֲדָמָה	עֵירֻם אָנֹכִי
וְצִלָּה גַם יָלְדָה שֵׁם	לוֹ לֶמֶךְ שְׁתֵּי נָשִׁים	אֲשֶׁר פָּצְתָה אֶת פִּיהָ		מִנְחָתוֹ וְאֶל קַיִן	כִּי מִמֶּנָּה לֻקָּחַתְּ	וָאֵחָבֵא וַיֹּאמֶר
אֶת תּוּבַל קַיִן	הָאַחַת עָדָה	לָקַחַת אֶת דְּמֵי		וְאֶל מִנְחָתוֹ	כִּי עָפָר אַתָּה	מִי הִגִּיד לְךָ

א-101	א-94	א-87		א-80	א-73	א-66
וְצִלָּה גַם הִוא	הָאַחַת עָדָה	לָקַחַת אֶת דְּמֵי		פָּנֶיךָ הֲלוֹא	הָיָה כַאֲחַד	יְמֵי חַיֶּיךָ
יָלְדָה אֶת תּוּבַל קַיִן	וְשֵׁם הַשֵּׁנִית צִלָּה	אָחִיךָ מִיָּדֶךָ		אִם תֵּיטִיב שְׂאֵת וְאִם לֹא	מִמֶּנּוּ לָדַעַת טוֹב	וְאֵיבָה אָשִׁית בֵּינְךָ
לֹטֵשׁ כָּל חֹרֵשׁ	וַתֵּלֶד עָדָה	כִּי תַעֲבֹד אֶת		תֵיטִיב לַפֶּתַח	וָרָע וְעַתָּה	וּבֵין הָאִשָּׁה

א-102	א-95	א-88		א-81	א-74	א-67
גַם הוּא יָלְדָה אֶת	עָדָה אֶת יָבָל	כִּי תַעֲבֹד אֶת		הֶבֶל אָחִיךָ	מֹשֵׁב וַיְגָרֶשׁ	וְאֵיבָה אָשִׁית
תוּבַל קַיִן לֹטֵשׁ כָּל	הוּא הָיָה אֲבִי יֹשֵׁב	הָאֲדָמָה לֹא תֹסֵף		וַיֹּאמֶר לֹא יָדַעְתִּי	אֶת הָאָדָם וַיַּשְׁכֵּן	בֵּינְךָ וּבֵין הָאִשָּׁה
חֹרֵשׁ נְחֹשֶׁת	אֹהֶל וּמִקְנֶה	תֵת כֹּחָהּ לְךָ נָע		הַשֹּׁמֵר אָנִי	מִקֶּדֶם לְגַן	וּבֵין זַרְעֲךָ

א-103	א-96	א-89		א-82	א-75	א-68
לְהַבְרָתוֹ	אֹהֶל וּמִקְנֶה	אֶת הָאֲדָמָה		הַשֹׁמֵר אָנִי	אֶת חַוָּה אִשְׁתּוֹ	הָאִשָּׁה וּבֵין
כִּי שִׁבְעָתַיִם יֻקַּם	וְשֵׁם אָחִיו יוּבָל: הוּא	לֹא תֹסֵף תֵת כֹּחָהּ לְךָ		אָנֹכִי וַיֹּאמֶר מֶה	וַתַּהַר וַתֵּלֶד אֶת	זַרְעֲךָ וּבֵין זַרְעָהּ
קַיִן וְלֶמֶךְ	הָיָה אֲבִי כָל	נָע וָנָד תִּהְיֶה		עָשִׂיתָ קוֹל דְּמֵי	קַיִן וַתֹּאמֶר	הוּא יְשׁוּפְךָ רֹאשׁ

א-104	א-97	א-90		א-83	א-76	א-69
כִּי שִׁבְעָתַיִם	וּמִקְנֶה וְשֵׁם	תֵת כֹּחָהּ לְךָ נָע		אָחִיו אָנֹכִי	אָחִיו אֶת הֶבֶל	מִן הָעֵץ אֲשֶׁר
יֻקַּם קַיִן וְלֶמֶךְ	אָחִיו יוּבָל: הוּא הָיָה	וָנָד תִּהְיֶה בָאָרֶץ		וַיֹּאמֶר מָה עָשִׂיתָ	וַיְהִי הֶבֶל רֹעֵה צֹאן	צִוִּיתִיךָ לֵאמֹר לֹא
שִׁבְעִים וְשִׁבְעָה	אֲבִי כָל תֹּפֵשׂ	וַיֹּאמֶר קַיִן		קוֹל דְּמֵי אָחִיךָ	וְקַיִן הָיָה	תֹאכַל מִמֶּנּוּ

א-105	א-98	א-91		א-84	א-77	א-70
שִׁבְעִים וְשִׁבְעָה	אָחִיו יוּבָל: הוּא	אֶת חֲנוֹךְ וַיְהִי		מִן הָאֲדָמָה	הֶבֶל רֹעֵה צֹאן	תֹאכַל מִמֶּנּוּ
וַיֵּדַע אָדָם עוֹד אֶת	הָיָה אֲבִי כָל תֹּפֵשׂ	בֹּנֶה עִיר וַיִּקְרָא שֵׁם		וְעַתָּה אָרוּר אָתָּה	וְקַיִן הָיָה עֹבֵד	אֲרוּרָה הָאֲדָמָה
אִשְׁתּוֹ וַתֵּלֶד	כִּנּוֹר וְעוּגָב	הָעִיר כְּשֵׁם בְּנוֹ		מִן הָאֲדָמָה	אֲדָמָה וַיְהִי	בַּעֲבוּרֶךָ

Figure 19.1 Biblical cut-up Haiku verses from the book *Code*

Code resembles a musical remix, in that it puts fragments of text (i.e., "Egypt, Israel" as five syllables followed by "Beheld the Egyptians" as seven syllables followed by "Mad about the beach" as the last five syllables) to the "beat" provided by the structure of the Haiku. However, poetry has a remix lineage of its own. From Gertrude Stein's *Tender Buttons*[2] to Brion Gysin and William S. Burroughs' cut-ups,[3] modern writers have investigated the possibilities of restructuring textual fragments into new forms of text.

Though a fan of constraint-based systems like those developed by Oulipo, I felt the need to step away from strict rules that I put forth in the code. Here, using machine learning algorithms offered an advantage over rule-based works like *Code*, in that the data itself determines the model's behavior and the created text. While *Code*'s algorithm imposed a certain beat on the text, in machine learning algorithm, it is the textual data that determines the unique form of the output.

Automatic Text Generation as a Broken Mirror

Artificial Intelligence (AI) refers to the nonhuman ability to think or understand. Machine Learning (ML) is the acquisition of knowledge by computers without being given domain-specific rules. The algorithm learns from training examples by trying to

292

generalize them. Deep Learning (DL) or Deep Neural Networks (DNN) models are specific ML models that have become popular since 2012.[4] AI, ML, DL, and DNN are used interchangeably in popular culture. Although the rise of these models can be partly attributed to new algorithms, their main success factor is the use of Big Data, extremely large datasets that may be analyzed computationally.

In my poetic work, I have no interest in competing with large corporations nor in building the best algorithms with the most data. Rather than the state-of-the-art, I am seeking the art: the exploration of the poetic instead of the exploitation of the technical. I prefer to work on corpora that are available to anyone, instead of only to large corporations, because I believe that technology should belong to everyone, and not just to those at the top of the pyramid, who possess enormous computing and data resources. Therefore, I basically prefer small data to Big Data. The smaller datasets I prefer are those that encapsulate a shared characteristic, such as a single speaker or a similar form or structure. To me, such texts capture a sense of authorship, even when they involve more than one author.

Moreover, I am interested in the distance and difference between human and computer, which attracts me to models that gracefully fail the "imitation" game. I try to use the aloofness characterizing the unpolished coherence of their outcome as a poetic space or as a new frontier in language. In their failure, automatically generated texts can help us understand how humans compare human to nonhuman texts, and what this comparison can teach us about ourselves, as humans. I envision automatically generated texts as a broken mirror through which we see ourselves. While the mirror-image is filtered, distorted, with some aspects accented and others invisible, we cannot help but compare what we see to what we think we are.

Blue Jeans and Bloody Tears

In 2019, I took part in the production of *Sweaty Machines' Blue Jeans and Bloody Tears*, an AI-based automatically generated "Eurovision song" (both the lyrics and music), by contributing the automatic text generator used to generate the lyrics. The song received more than 2 million YouTube views within 6 months, and a cult following.[5] Since the words and music were generated separately, human curation was used to match the musical and textual verses.

Eurovision is a popular annual international pop song competition where participants represent their countries. The songs, the performance, and the surrounding atmosphere have a distinctive style which over the years has come to be associated with LGBTQ subculture. The intention of our project, devised by artistic director Nimrod Shapira, was to "capture the DNA of Eurovision" in a computer-generated song.

The data I used in *Blue Jeans* included only past Eurovision songs, preprocessed to remove named entities (like person or place names, so it does not mention, for instance, ABBA's Waterloo). I was using the Long Short-Term Memory (LSTM) model to predict the next character (letter, space, punctuation, etc.). Doing so, one character at a time, on such a small dataset made the result funny, incohesive, and "less intelligent."

Due to copyright reasons, the algorithm had to refrain from taking more than three meaningful consecutive words from a single text. This created a remix of small fractions of text. The result bears some similarity to several original Eurovision lyrics that are deliberately lighthearted or simplistic. Some of the original texts sounded like they were

meant as a parody, so the somewhat nonsensical automatically generated text seemed to follow the spirit of the cultural phenomenon it imitated. The main difference is that while Eurovision songwriters are aware of the "seemingly less than perfect" features of their songs, the algorithm knows nothing of its failure, hence the difference in our perception of it.

Following is an excerpt of the automatically generated lyrics:

And tears will always have wet eyes

I'll cry but I'll survive

On a mission

I will let you go forever

Every character in the output lyrics is predicted, based on the example lyrics, as a completion to characters the model had previously predicted. This generative synthesis is heavily based on analysis. At each phase, the model calculates the probability distribution for the next character and chooses the most probable sequel. So, in order to generate the lyrics, it has to first establish the probability of each character occurring in that specific location within the text. Following the statistical analysis, the algorithm has only to determine which of the candidates should be picked, according to their probabilities.

This description is worth thinking of in terms of a remix. When the model gets a specific set of input texts, it splits them into smaller elements and rearranges some of them in a new significant order. This technical remix concept may pose a threat to our regular conception of remixes, since it turns a creative process into a potentially fully computational one.

However, for any generated text, the question of creativity surfaces as it is being read. The cathartic promise of art comes not only from the creative embodiment of thought and emotion in a form of expression, but also from the identification of a map leading the readers to a place where they stand in bewilderment trying to interpret what they had read. The computer-generated outcome encourages the readers to look for clues as they retrace the tracks left in the algorithm's results. It challenges the reader to ask why, and to try to see the logic behind the decisions made by the program, particularly the non sequiturs. As with a broken mirror, readers look for the differences between a (hypothetical) human-made remix and a computer-made one based on the same elements.

Syntax-Free Hallucination

In the age of computational readership, words are often written and read as independent entities, out of context and not taking into account their part of speech within a sentence, due to two main reasons: the first is searchability. A text can exist on the Internet, but unless discoverable by readers, it is not considered to be publicly available. A large industry surrounding Search Engine Optimization has developed, where site owners struggle to have their text appear first in search results.

One of the main techniques to achieve high visibility is by tagging: adding keywords (tags) that describe the content, the topics it covers, or any other words that can be

found in a search engine query. The same process takes place in social media and many content management systems, websites, and databases. The tags or keywords are often single words (or a very short phrase), detached from any sentence.

A second phenomenon making words more independent stems from developments in image recognition (Image to Text) using Deep Learning, especially with the rise of Convolutional Neural Networks (CNNs). Given an image, these models describe what objects are in it. Many of these models work as classifiers, mapping images into classes; they are not trained on each and every word in the dictionary, but only on a set of distinct words. If the model is supervised, the model gets as an example both the image and its corresponding tags, for instance, the image of a cat and the word "cat." Their task, when given a new image, is to assign the tag, the previously associated images of which the new object best resembles. For instance, if a model that was trained on animal images is presented with an image of a horse, it should assign the image with the class (tag) "horse."

While other models exist, which try to map an image to an entire sentence, it is more common to encounter ones that output only words (mostly nouns), due to their relative technical simplicity; thus, the task of automatic understanding of images invites algorithms that generate more independent words.

Words play a central role in data systems, without direct human intervention. Behind the texts, we know, hides another textual world upon which algorithms operate. This is the world of metadata, the data that describes our data. The metadata world follows a syntax of its own, one of lists and databases. Since, in today's world, we humans are both search engine optimizers and search engine users, this syntax affects our behavior, forcing us to adapt to it.

The following remixes see the creation, from existing words, of new words independent of human syntax. The automatic generation sheds light on some hidden aspects of the text. In this sense, producing meaningful words from the original texts can also be viewed as a form of textual analysis.

Word2Dream

Word2Dream, a collaboration with Eyal Gruss, is a computer program that shows the associative thinking process of an algorithm reading a text. By using the Word2Vec model, the program conjures related words that are not part of the original text and then proceeds to bring up associations related to the new layer of words, and so on. This creates a computer-based imaginary train of thought, or possibly, a computer's dream.

Word2Dream starts by prompting the user for an input text. It then finds the words, the meanings of which are "central" to the text. Next it looks for words that do not appear in the given text but are the "nearest" ones in meaning to those "central" words. Then it looks for the "nearest" ones to the newly found words and so forth. In this way, it gradually drifts away from the original text, as shown in Figure 19.2.

The Word2Vec model creates a Word Embedding, a mathematical representation of words as vectors. Intuitively, in Natural Language Processing, two words are probably related if they co-occur with the same words in many documents.[6] Word2Vec, built by Google and based on millions of documents, provides a relatively small-dimensioned representation of words that preserves the assumed proximity. That is, if two words are close to each other in their "occurrence in documents" representation, they will be near each other in the Word2Vec representation. The model's proximity-preserving map can

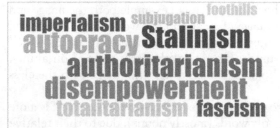

I have a dream that one day this nation will rise up and live out the true meaning of its creed: "We hold these truths to be self-evident: that all men are created equal."

I have a dream that one day on the red hills of Georgia the sons of former slaves and the sons of former slave owners will be able to sit down together at the table of brotherhood.

I have a dream that one day even the state of Mississippi, a state sweltering with the heat of injustice, sweltering with the heat of oppression, will be transformed into an oasis of freedom and justice.

I have a dream that my four little children will one day live in a nation where they will not be judged by the color of their skin but by the content of their character.

I have a dream today.

Figure 19.2 A screen capture from *Word2Dream*, running on parts of Martin Luther King JR's "I Have a Dream" speech

be used to generate semantic analogies, such as "Man is to King as Woman is to Queen." Some of them mirror human gender-biases such as "Man is to Computer Programmer as Woman is to Homemaker."[7]

This work offers a new perspective on the relationship between content and context. Many appropriation-based artworks place an object (or a text) in a different context, to create new insights and reactions. As poet Kenneth Goldsmith put it: context is the new content.[8] This work highlights one relevant textual context, which is the text's semantic field represented by the related words that the model determines. Any word bears the charge of its contexts, even when computers alone carry out its interpretation.

The algorithm reflects the social hierarchies, structures, and relations that humans had embedded into their texts. The sequence of related words mirrors society's train of thought. And the algorithm inherits society's characteristics, such as misrepresentation of various groups, and represents them in its outputs.

As this work demonstrates, intention and interpretations are present in "the space between the words." In this space lie other words that might not be part of the original text, but are still echoed in it. It is those words that are the raw material of the remix.

I Love the Look of Words

Inspired by Maya Angelou's poem *I Love the Look of Words*, I explored the look of words using AI. So, I took texts from some articles in Wikipedia, extracted the words, and for each distinct word I built a jpeg image file that contained the word as an image, which is an array of pixels. This formed an image corpus of hundreds of thousands of image files, each of which is a graphical presentation of a single word.

Then I fed all the examples into an AI model, Deep Convolutional Generative Adversarial Network (DCGAN), which, when fed with images, tries to generate similar

Figure 19.3 Automatically generated images for I Love the Look of Words

ones, by remixing the pixels in the example images. The resulting images, in this case, included some made-up words or made-up nonwords. They may be viewed as potential words in a potential language, or prelanguage, or nonlanguage.

I followed this experiment with a series of others in collaboration with designer Maya Marom, examining both various visual aspects of word hallucinations and the behavior of different input corpora, such as 16,000 adjectives ending with the suffix "able," or combined texts from different languages or alphabets.

The results, as shown in Figure 19.3, show the general shape that characterizes words and their visual materiality. It shows words bereft of meaning, the potential visualization of language, and how our pool of letters and words could hypothetically be expanded. It is somewhat like an unfocused gaze at a text that enables us to identify it as such, without knowing what it holds inside.

The work addresses a new aspect of language, not dealt with in my previous works. By stripping words of their meaning, and focusing only on the shape of their visual representation, the outputs offer a reflection on their visage. Each "word" in the outcome is a remix that embeds something from potentially every input word. It is an image of the collective of words rather than of a single word. And while each individual output "word" is impossible to read as such, their sum provides the viewer with a new possibility to read, or see words and language from a new perspective.

Future Textual Environments

I Love the Look of Words was created in a certain cultural environment that encourages the exploration of texts from various angles, in the hope of gaining new insights into

language and human communication. For many years, text has been either spoken or written solely by humans. With the invention of print, machines started to produce written words, and today they even articulate them in sound. At the same time, texts no longer exist exclusively in real life, but also establish their presence in virtual spaces, that is, computer environments which allow made-up characters (who may be operated by humans) to interact with other users.

The experience of new alternative environments takes place in what is referred to as Extended Reality (XR), i.e., Virtual/Augmented/Mixed Reality (VR/AR/MR). These terms describe computer-generated simulations of a three-dimensional environment with which a person interacts in a seemingly physical way. In a sense, these environments work by "remixing" our experiences: they enable both real and imaginary objects to appear in front of our eyes, so we can move without knowing whether our sense of direction is real or manipulated by sensors. We can interact with objects that may actually be avatars of humans or AI agents.

In recent years, many AI algorithms use XR worlds to simulate real-life conditions and, by so doing, impact our sensory experience altogether. Particularly, they can impact the way we interact with texts. For example, reading can be different when a virtual dimension is added to the physical one. The physical text, written or printed, is more stable, being physically embedded into real material (on paper), whereas a text in a virtual environment is ephemeral and has the potential to be modified at any time.

Moreover, when detached from material, algorithms may afford texts a dynamic existence, granting them the power to evolve by themselves without human interaction. As poet Christian Bök said (ironically, regarding the small audiences of poetry readers): in the future, poetry will be written by machines for other machines to read.[9]

With today's technological advancements, it is easier to imagine young people holding a mobile phone than a book. There is much evidence that the practice of reading books is on the decline.[10] However, the notion of the book may evolve in return, or be reimagined: while many in the publishing industry consider two types of publishing format, printed books and ebooks, a broader perspective may view the Internet as one large library of resources, or one large book. The ebook, which started out as a replica of the printed book, has departed from its origin to develop its own new forms. Ebooks contain links, digital media such as videos, and interactive capabilities like search that go beyond page flipping. In this sense, ebooks resemble the Internet more than they do traditional printed books.[11]

In some children's books, technology is being used in the form of Augmented Reality. The pages of those books can be scanned by a mobile phone, and a three-dimensional virtual image is displayed on the phone's screen, creating the illusion it is popping out of the book. Such applications attract children to read in their free time, and the focus seems to do with education rather than literature.[12]

Half Reading

Augmented reality provides new reading opportunities to the ancient technology of books. I wanted to articulate the juxtaposition of different reading experiences; on the one hand, a printed book, which requires concentration, a longer attention span, and willingness to immerse into the text; on the other, an online reading experience, which involves more distractions and disruptions. The online reading experience has an effect on reading old-fashioned books, as we feel the urge to check our phones or computer for notifications. My

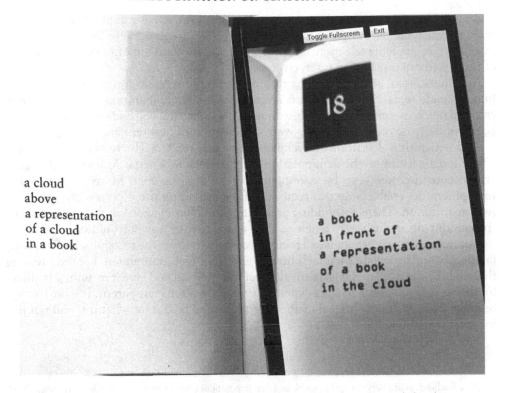

Figure 19.4 Reading *Half Reading* using both a physical book and a mobile phone

initial question was whether it was possible to promote reading of printed books by harnessing mobile phones and computers, instead of treating them as obstacles.

My book *Half Reading*, published in 2018, offers a remix of different reading experiences and, by so doing, proposes a new role for the printed book. The book is a mix of content from two different channels: each poem has a printed half on the left-hand side. The other half is on the right-hand side but is visible only through a phone directed at the appropriate page. In order to read the entire poem, the reader must hold both the paper book and the phone, as shown in Figure 19.4.

Reading is the subject matter of the poems, a metaphor for the relationship between the stable past and ephemeral future. In one of the shorter poems, the printed left-hand side reads "text," while the right-hand side displays the words "moving text" that are moving (also emotionally, I hope).

In most poems, the virtual text is not animated. Yet, it is still dynamic, in the sense that as the author I can modify it as I please. Thus, the book can be endlessly rewritten and reread. While the reader holds the same object, its content can be different every time. As a remix of two reading technologies, *Half Reading* offers a new perspective on reading that is beyond a specific reading mode.

Conclusion

There are many levels on which the notion of the remix can be applied to text, from pixel through characters, words, and sentences to the environments in which text is read

and ways it can be reproduced. To capture the DNA of texts, one might go even further and imagine a Genetic Algorithm (GA) that imitates the process of biological natural evolution, by applying selection, crossover, and mutation, to form multiple generations of texts, without any human intervention.

Automatic text generation aims to create computer-made imitations of existing human-made texts. Since computers attempt to imitate human text generation, they can also teach us something about the human linguistic and cultural subconscious, that is, the underlying procedures that govern our creation of new text and thought.

Text-generating algorithms and remixes are closely related. The remix can be seen as a baseline algorithm to the manipulation and generation of texts. Automatic text generators construct new texts by rearranging parts of existing ones. Moreover, automatic text generators enable a text to remix itself, by providing the corpus with a path for self-organization. These pathfinding procedures can offer insights on the original texts, thus producing an analysis or a new reading of the text by way of its remix.

Automatically generated textual remixes can help us savor the recognition of uncanny familiarity and articulate what feels human and what feels nonhuman. For me, creating them fulfills the need to navigate the flood of information and give it meaning. It allows for the suspension of the reading experience which is often transparent. It is an attempt to make the text "texty," to feel its ingredients, and to read it for what it is and not just for what it signifies.

Notes

1 Alec Radford, et al., *Better language models and their implications* (San Francisco, CA: OpenAI Blog, 2019).
2 Gertrude Stein, *Tender buttons: objects, food, rooms* (Peterborough, ON: Broadview Press, 2017).
3 William S. Burroughs and Brion Gysin. *The third mind* (New York, NY: Viking Books, 1978).
4 Md Zahangir Alom, et al. "The history began from AlexNet: A comprehensive survey on deep learning approaches." arXiv preprint arXiv:1803.01164 (2018).
5 Sweaty Machines, *Blue jeans and bloody tears* (USA: YouTube.com, 2019).
6 John R. Firth, *A synopsis of linguistic theory, 1930–1955* (Oxford, UK: Basil Blackwell, 1962).
7 Tolga Bolukbasi, et al., "Man is to computer programmer as woman is to homemaker? Debiasing word embeddings." (New York: Cornell University - arXiv.org, 2016).
8 Kenneth Goldsmith. *Uncreative writing: Managing language in the digital age* (New York: Columbia University Press, 2011).
9 Kenneth Goldsmith, *The challenges of twenty-first century writing* (Chicago, IL: Poetry Foundation, 2010).
10 Michael Kozlowski, *Reading books is on the decline* (USA: Good Reader, 2018); Caleb Crain, *Why we don't read, revisited* (New York: New Yorker, 2018).
11 Damien Walter, *Are books and the Internet about to merge?* (London, UK: The Guardian, 2012).
12 Hsin-Kai Wu, et al., *Current status, opportunities and challenges of augmented reality in education*, 41-49 (Computers & Education 62, 2013).

Bibliography

Bolukbasi, Tolga, Kai-Wei Chang, James Y. Zou, Venkatesh Saligrama, and Adam T. Kalai. "Man Is to Computer Programmer as Woman Is to Homemaker? Debiasing Word Embeddings." In *Advances in Neural Information Processing Systems*, 4349–57. Cambridge, MA: MIT Press, 2016.
Burroughs, William S., and Brion Gysin. *The Third Mind*. New York, NY: Viking Books, 1978.
Crain, Caleb. "Why We Don't Read, Revisited." New Yorker, June 14, 2018. https://www.newyorker.com/culture/cultural-comment/why-we-dont-read-revisited.
Firth, John. "A Synopsis of Linguistic Theory 1930–1955." In *Studies in Linguistic Analysis*, 1–32. Oxford, UK: Basil Blackwell, 1962.

Goldsmith, Kenneth. "The Challenges of Twenty-First Century Writing." Poetry Foundation, April 16, 2010. https://www.poetryfoundation.org/harriet/2010/04/the-challenges-of-twenty-first-century-writing.

Goldsmith, Kenneth. *Uncreative Writing: Managing Language in the Digital Age.* New York: Columbia University Press, 2011.

Hadas, Eran. *Code.* Haifa: Pardes, 2014. (In Hebrew).

Hadas, Eran. *Half Reading.* Tel-Aviv: Gnat, 2018.

Hadas, Eran, and Eyal Gruss. "Word2Dream," Software Installation, Mediatheque Holon, 2015.

Hadas, Eran, and Maya Marom. "I Love the Look of Word." Software Installation, Hanina Gallery Tel-Aviv, 2019.

Kozlowski, Michael. "Reading Books is on the Decline." Good Reader, July 14, 2018. https://goodereader.com/blog/bookselling/reading-books-is-on-the-decline.

Radford, Alec, Jeffrey Wu, Dario Amodei, Daniela Amodei, Jack Clark, Miles Brundage, and Ilya Sutskever. "Better Language Models and Their Implications." OpenAI Blog, 2019. https://openai.com/blog/better-language-models.

Stein, Gertrude. *Tender Buttons: Objects, Food, Rooms.* Peterborough, ON: Broadview Press, 2017.

Sweaty Machines. "A Eurovision Song Created by Artificial Intelligence: Blue Jeans and Bloody Tears." Music Video, YouTube, May 13, 2019. https://www.youtube.com/watch?v=4MKAf6YX_7M.

Walter, Damien. "Are Books and the Internet About to Merge?." The Guardian, February 15, 2012. https://www.theguardian.com/books/2012/feb/15/book-internet-merge.

Wu, Hsin-Kai, Silvia Wen-Yu Lee, Hsin-Yi Chang, and Jyh-Chong Liang. "Current Status, Opportunities and Challenges of Augmented Reality in Education." *Computers & Education* 62 (2013): 41–9.

20

MACHINE-DRIVEN TEXT REMIXES

Alessandro Ludovico

In this chapter, the process of remixing is analyzed through the evolution of machine-driven text transformation approaches. Starting from semi-random early techniques for the composition of poetic or experimental literature, the process of associating and composing preestablished pieces of text, sourced from analog and then digital repositories, will be investigated. A continuity emerges from the combinatorial experiments realized by the Ouvroir de Littérature Potentielle (OuLiPo) group in the 1960s to the later software that has advanced remix possibilities up to the contemporary attempts to establish an almost autonomous "automatic publisher." The increased sophistication of the algorithms and the growth of available sources have affected the plausibility of the produced texts, including a technical analysis of style, laying the foundation for its simulation. More recent tests, using unusual or different technologies to produce texts, will be included. In the essay, I will analyze the remixes of text's evolving structure since the early experiments in the 1960s, the role of machines in effectively emulating a writer's style and their essential support to generate credible fakes, particularly deepfakes, discussing a series of relevant issues for Digital Humanities.

Can We Define Machine-Driven Texts as a "Remix" of Content?

Machine-driven texts, or texts produced by some level of automation, have been with us for a long time. The idea to automatically elaborate texts, generating new ones through some, even very simple, algorithm, has been attempted since the fourth century A.D.[1] Throughout history, the application of mathematics to literature has produced a vast range of experiments, from the application of rules and the permutation of elements, like Nanni Balestrini's historical combinatorial poetry TAPE MARK 1, discussed later, to the current sophisticated elaborations of big quantities of data through machine learning algorithms, as the announced "AI-based text generator Generative Pre-trained Transformer-2 (GPT-2)." But only a few of them can be qualified as possible "remixes," or processes elaborating samples "from pre-existing materials and combining them into new forms according to personal taste."[2] These remixes have different structures and purposes,

> See chapter 19 for Eran Hadas's further analysis of GPT-2.

while in the most recent developments, there is a concrete risk that the difference between the remix and the preexisting material vanishes in the immediacy of the digital machines. Therefore, my main question is: can we define machine-driven texts as a "remix" of content?

From Code to Database

Since the 1950s, early experiments with programming code to generate texts in various forms and styles were mostly centered on a combinatorial approach. They created assemblages of texts, somehow with a distinctly uncertain or redundant style, depending on the kind of randomness implemented. They were typically based on a set of fixed rules, applied every time the code was running. "Chance" has characterized these experiments, associating words to a substantially predetermined literary structure, like a single sentence, a poem, or a letter.

Tristan Tzara's Dadaist poem manifesto in 1924, for example, encourages Dadaist poets to cut words from a newspaper, put them in a bag, and take them out one after the other. In his cut and choose process, he implements a combinatorial method, where all the possible combinations of words are reduced to one.[3] He also creates a "database of samples" in the bag, and he produces algorithmically, although in a very straightforward and random process, a text, that is often nonsensical. The samples are meant to be merely functional, filling a scheme which has been carefully laid out, as if they were "shuffling" in a fixed matrix. They are used for their own literal characteristics, which are quite universal (as name, verbs, or length in the case of poetry), as if they were slightly more elaborated than notes for a music composition. But in this process, as in many of the early computer-generated literature, the "sampling" is so minimal, reduced to single elements, that any perceivable reference to the preexisting work (the remix component of the "spectacular aura"[4] is irremediably lost, except the structure). So, they are more "permutated new works," rather than remixes, as they are maintaining a reassuring and consolidated, but at the same time quite rigid, structure.

The tipping point of this strategy has been the availability of larger databases of samples, as well as hardware and software development, which has consequently allowed the use of longer samples and so the generation of more complex compositions. For example, Stéphanie Vilayphiou's "La carte ou le territoire," where she finds in other books all the sentences (or fragments of them) of Michel Houellebecq's plagiarized "La carte et le territoire," in a sort of conceptual combinatory remix (same samples from different source/history), which would have been impossible without a database like Google Books. And likewise Jason Huff's "AutoSummarize," where he summarizes the 100 most downloaded copyright free books sampling 10 sentences per book, would have been of different relevance without its use of the popular AutoSummarize function in Microsoft Word. The database, which is feeding the algorithmic generation, basically acts as a potentially, almost infinite, "sample library." And the outputted texts are equally remixed, based on some preexisting work and a varying number of database entries. Over a few decades, the mechanisms have remained mostly the same, even with contemporary machine-learning processes, which use more sophisticated algorithms.

Analog and Electronic Sampling in 1961

In the 1960s, texts were increasingly combined in more sophisticated ways, in a proportional relationship to hardware and software developments. It seems quite accidental that in the very same year, 1961, two different works, which can be possibly defined as "machine-driven remixes," were released in two different ways.

The first is the iconic Raymond Queneau's *Cent Mille Milliards de Poèmes* (One Hundred Thousand Billion Poems). It is an experimental book composed of ten sonnets, where each page is cut into horizontal strips containing a single line, which can be turned independently, offering the reader 10^{14} possible unique poems. Each time a strip (or a set of strips) is turned, the reader can read in sequence a slightly or completely different poem. Queneau calculated that 190,258,751 years were needed to read all the possible combinations.[5] He was the cofounder of the avant-garde literature movement OuLiPo (Ouvroir de Littérature Potentielle) and used mathematics as a source of inspiration for literature. The content of this unique book is produced through a calculated, software-like process, shuffling the different strips/lines. Nonetheless, the reader, not a machine, chooses which one to select. It goes beyond the combinatory aspect of most of the subsequent Oulipian works, which embraced the challenge of writing with strict sets of rules, like "lipograms" (excluding one or more letters) or adopting the S+7 rule (replacing each noun with the seventh noun listed after it in a dictionary). Technically "Cent Mille Milliards de Poèmes" is a combination of samples (the strips/lines), free to be recombined by the reader, who mixes them at will and never exhaustively. The mix can then go on indefinitely, always with a plausible and different outcome, to probably go, in quite a few cases, beyond the notion of variation and become a new work in itself. However, the peculiarity of this work is that its structure remains fixed, and any outcome formally coincides with the "original," as do any possible elaborations. Although the work has been easily converted in a few software programs, its strength still lies in implementing those ideas and mechanisms in a slightly modified printed book. The book itself behaves as the machine, and the reader actively uses it to select and produce the content.

In 1961, there was another literary experiment that attempted to use the potential of computer programming to produce a plausible work of literature: "TAPE MARK 1," developed by Italian writer and artist Nanni Balestrini. For this work, Balestrini joined Alberto Nobis, an engineer, to develop a computer program for the IBM 7070, which would have combined three different poetries by Michihito Hachiya, Paul Godwin, and Lao Tse, composing a new "original" poem. There was a session in Milano, in a bank office hosting the computer, in which semiologist Umberto Eco and avant-garde musician Luciano Berio also participated. The computer produced more than three thousand remixed variations of the three poems, but Balestrini decided to select only one among them, as the representative outcome, which is the one written about in articles and art catalogs. He also minimally intervened to select computer output and correct some grammatical errors. He affirmed that the reason he had to intervene was a result of the "limited amount of code instructions" which were used to generate the whole text. Technically, the poem should have been composed of six verses, each composed of four metrical units. But even with this rigid scheme, the samples were significantly relatable to the preexisting works. Remarkably TAPE MARK 1 was included in the historical exhibition "Cybernetic Serendipity" at ICA London in 1968, and here Balestrini envisioned computer processes as tools to open the space of composition to a different, more sophisticated and partially automated level. He assembled a proof of concept which was

Figure 20.1 Emiliano Russo, Gabriele Zaverio, Vittorio Bellanich, *TAPE MARK 1* at ZKM Center for Art and Media, Karlsruhe. Photo by Gabriele Zaverio

conceptually tied to the *Open Work* theorized by Eco, a publication in which he claims that for these types of works "the possibilities which the work's openness makes available always work within a given field of relations."[6]

Developing the work, the gathered intellectuals were turning the main purpose of the machine (computing for the bank) into a humanistic task. It created a different literary space, able to dissect and reassemble preexisting poems, showing how they could be considered "fields of relations" from a technical or computational point of view. The remix here was delegated to the machine, still with a clear strategy implemented in the code, and equally clear sources for sampling. The machine inundated the intellectuals with permutated poems, each one abiding formal rules of poetics. But then their judgment was essential to acknowledge which of the many outcomes was eligible as a "credible" one.

This work was reconstructed in 2017 by three Italian hackers, Emiliano Russo, Gabriele Zaverio, and Vittorio Bellanich. They reprogrammed the original algorithm in Python, on a Raspberry Pi computer hidden inside a wooden box, that included a small monochromatic CRT monitor, visualizing the output. They gifted it to Balestrini, who liked it so much that he wanted to include it in his solo exhibition at ZKM, in Karlsruhe.[7] The reconstruction with modern technologies makes even more evident the intrinsic "remix" process of the algorithm. The team, technically and aesthetically, "remixed" Balestrini's work fifty-six years later, using its principles and references, like the monitor and the wood for the box, with contemporary technologies, like the inside electronics and the chosen programming language (Figure 20.1). Significantly, the author not only acknowledged the remix, but symbolically reappropriated it, including it in its own official solo exhibition, still maintaining the full recreators' credits.

Remixing and Style

These early experiments show two different methodologies of remixing: one is based on the potentially infinite interchangeability of samples, once compatible with each other

and within the stable environment containing them. The other is based on creating a solid but fluid structure that would accommodate more complex samples, so that they would generate a more dynamic outcome. Both are based on a structure that guarantees combinations and affords mixed results. Mostly, in subsequent decades, the focus has been shifted to generate a trustable output, acknowledgeable as human-like. Computer generated outputs have often sought other human's trust, as their final validation of quality. And trust in literature means essentially a projection of the writing toward a person, the author, and to his perceivable "style." To discuss this particular aspect, it is worthwhile to consider a specific work: *The Death of The Authors*, 1941 Edition, by Femke Snelting and An Mertens (part of the Belgian Constant collective), created in 2012 (Figure 20.2). This work undeniably refers to Roland Barthes's "The Death of the

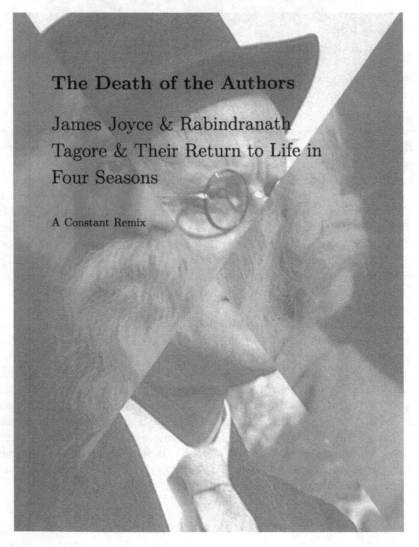

Figure 20.2 Constant, cover design for *The Death of The Authors, 1941: The Novel.* 2013. Image courtesy of the artists

Author" at the level that it seems to technically embody its main argument to the extreme.[8] It is a generative software that produces a freely downloadable novel, based on different texts by Virginia Woolf, James Joyce, Rabindranath Tagore, Elizabeth Von Arnim, Sherwood Anderson, and Henri Bergson. Snelting and Mertens become the ultimate "scriptors" (in Barthes's definition) building on the programming code that elaborates the final result. The work was released on January 1, 2012, to celebrate the authors' works entering the public domain, since all of them died in 1941, and their works were protected by copyright up to 70 years after their deaths. According to Snelting and Mertens, the goal was to point out how copyright itself is blocking a lot more than just unlimited reproduction.[9] To highlight this aspect, they ironically refer to the act of freely working with the body of work of dead authors, as a "macabre form of liberation."

Their literary gesture is the result of a remix practice, but in its ultimate release, it is totally governed by software. The author's content becomes then magmatic and ethereal, reborn, and archived with every new generation. The respective authors are somehow back with their whole style and in an unpublished, unexpected, and ever-changing collaboration.

This remix practice is explicitly codified in a sort of *credible apocrypha*, where the style and the availability of their preexisting materials are essential. As frequently happens in the combination of literature and software, the copyright sets limitations, as the software could efficiently work with more recent novels or contemporary authors as well. Indeed, Snelting and Mertens are bringing forth a specific issue: how sophisticated would the literary remix be, in order to become seamless, and so at the same time, attributable to the "simulated" authors without formally breaking copyright law? In an interview, they explicitly refer to the "ultimate 'n-gram'"[10] to test this procedure: "three or four words to start a new novel." If accomplished, it would bring the practice close to the technical "disappearance" of the sampling, which is instead very present in its acknowledgement in the final outcome. We can compare this kind of "n-gram," and their extremely short length, made to progressively disappear in the work, to the micro-musical samples used in granular synthesis, operating on the microsound timescale, and usually disappearing in the work, too.

But this whole practice inevitably leads to the definition of an author's "style," which, in turn, points to a larger scenario referring to the identification and possible measurement of the style. Stylometry is the discipline dedicated to comparing, measuring, and possibly validating the attribution of a particular work of art to a certain author—and its techniques, driven by statistical analysis, machine learning, and access to large corpus data of the considered author—which has been successfully applied to literary texts, as well as music. The scientific attribution of a text to an author is a challenging concept, as it reinforces and weakens at the same time the perceived presence, or mark, of the author itself. The sophisticated methodology, applied also in forensics, clashes with the reader's imaginary, which is still tied to the perception of an uncatchable style, recognizable, but still able to elude any "quantification," which instead is what the stylometry procedures are all about.

The perceived presence of the author has been extensively analyzed by Foucault. The "status" we give to an author "when we began our research into authenticity and attribution"[11] is of a presence, strictly linked to the author's name, serving as a "means of classification."[12] The author's name is essential even in the remix process, as it is the main, irreplaceable reference for the texts it belongs to, or, in other words, to "group together a number of texts and thus differentiate them from others."[13] So the author's name "remains

at the contours of texts—separating one from the other, defining their form, and characterizing their mode of existence."[14] Finally, the function of an author is to "characterize the existence, circulation, and operation of certain discourses within a society."[15]

The remix of different authors, then, directly affects their body of work. Should Balestrini's work (even if explicitly derivative) be included in the Hachiya, Godwin, and Tse bibliography? And what about Snelting and Mertens' endless, and equally derivative, mashups of Woolf, Joyce, Tagore, Von Arnim, Anderson, and Bergson? For the criteria in place, they should not, but from a creative perspective, which would take into account seamless "new" works, the very same concept of an "author's bibliography" might start to be questioned.

Fakes as Structural Remixing

If the "trust" we instinctively put into printed matter is one of the crucial elements in publishing, the sophistication of the produced outcome and the underlying computational power and access to useful data are essential to remix publications. A proper literary remix might need the preexisting samples (the data) and possibly the preexisting structure (the container which embeds the original author's style), plus more compatible data to elaborate. In this respect, textual and music remixes are quite similar, and the access to accessible data enables remixing possibilities.

Furthermore, there's a different trajectory that might be taken, which is different from producing a plausible new work but still aims for plausibility. This trajectory's goal is to produce an explicit "fake," the more mistakable for a preexisting work, the better. Fakes are usually produced to make a statement about their own content or form. There is quite a long history of political, sarcastic, and artistic "fake" publications, especially using the form, conventions, and layout of the newspaper.[16] A fake can be produced by remixing an acknowledged form with compatible content, rhetorically understood through satire or sarcastic differences, which can be easily mistaken for the genuine. Among the many examples, there are the fake newspapers produced and distributed in the 1970s by the Italian group Il Male[17] and the series of American newspaper fakes instigated by The Yes Men, such as the New York Times Special Edition in 2009.[18] More recently, this strategy has been expanded to make a point in specific media systems using the same combination of a trusted form, filled with a remix of content, algorithmically produced.

This is certainly the case with Eric Drass's *Cut Up* magazine. It was conceived to be a printed guide for The Great Escape music festival hosted in Brighton, involving 300 (mostly unknown) bands. The festival usually lacked any type of reference or background for the hosted bands, leading the spectators to prioritize reserving judgment before viewing their live performances. Drass decided to fulfill this need, playing with form, content, and data. His *Cut Up* magazine was freely distributed, and it contained computer-generated bands' profiles based on online-retrieved and remixed band information. As he explains,

> Cut Up magazine was a way of algorithmically 'filling the critical void' […] The reviews were created using a mix of historical reviews from the UK music press and data gleaned from Last.fm. Even for an unknown band, there would usually be a few listens logged at Last.fm, which helped describe the genre of music and perhaps a few song titles. Using this data I algorithmically generated music reviews - using text taken from reviews of bands of the same genre, to keep the

tone consistent - these reviews would contain references to the band and their songs, making the whole thing feel a lot more authentic. [...] I printed 128 fanzines, each with 16 unique reviews of bands playing at the festival, with details of the performance and a random mark out of 10. In this way a band could feature in multiple copies of the zine, with wildly differing reviews. I went to the festival and handed them out to the fans. An act of algorithmic detournement.[19]

This fake magazine generated interest, and eventually disappointment, too. It particularly works on large samples and arbitrary misattributions, which were carefully selected to guarantee a plausible, and overall consistency in content. Drass remarked that the final form, a printed zine, was important as it suited the festival environment. But even more importantly, a printed zine was appropriate because the audience expected it to be consistent across copies, and reliable in its published content.

Fakes have always been ethically controversial, as they subtly challenge our trust in a universal published form, through manipulated content. But in this case the gesture to provide what was missed, at the same time fooling the readers, shows how easy it can be to manipulate when fulfilling a desire (in this case, to know more about the bands). So, it brings awareness to readers, but also clearly shows the potential possibilities of this kind of "remix." It reinforces the strong position of Balestrini, who in the 1960s affirmed that the use of the means "made available from the most advanced technology and science [...] is intended as an integration of the task to create a literary or artistic work."[20] Using the most advanced technologies to critically subvert specific content is a principle that has been embraced by electronic and new media artists during the last seventy years. But in the late 2010s, we have started to face the limits, or better the new uncharted territories of these practices, with the availability of increasingly sophisticated machine-learning software and of larger and larger corpora of consistent data.

Machine Learning–based Texts as Remix

There is an ecology of literary bots online, especially Twitter bots, which are endlessly remixing content from databases or other online sources. One of the most famous examples, now stopped, is Pentametron, a bot that collects tweets in iambic pentameter and arranges them into couplets, with poetic and sometimes surprising results. But, due to the word count constraints, these kinds of bots usually use a fixed structure, reducing the whole effort to a production of permutations, even if particularly sophisticated. These bots are an evolved version of the early OuLiPo experiments. In the 1980s, Italo Calvino, who was an active member of OuLiPo, opposed a schematic approach, which had been already extensively explored, even with the limited technologies of that time, for a more subversive one. He praised machines that would produce "disorder," meant as something different from slavishly following the classicist rules.[21]

This disorder sounds like a radical liberating gesture, which we would anyway fully acknowledge as literature:[22]

> The true literature machine will be one that itself feels the need to produce disorder, as a reaction against its preceding production of order: a machine that will produce avant-garde work to free its circuits when they are choked by too long a production of classicism.

In the beginning of the 2020s, in a media ecosystem which is increasingly prone to manipulation, thanks to the orchestrated or spontaneous spread of "fake news," remixes of textual content conceptually play an important role.

In this respect, it is useful to define the "deepfake," which has been introduced to categorize the synthetic content (primarily video and extensively also audio) in which a person "is replaced with someone else's likeness."[23] The sophistication of technique here overcomes trust, as this video and audio content looks and sounds real and can mislead even a discerning public. A commensurate textual product is being developed by OpenAI, a nonprofit research company. This machine-learning system called "Generative Pre-trained Transformer-2 (GPT-2)," can generate text based on brief prompts, and based on a corpus of forty gigabytes of text retrieved from various Internet sources. The researchers have chosen to release a much smaller version to prevent the risk of people using it to "to generate deceptive, biased, or abusive language at scale."[24] Apparently one of the highlights of this software is that it did not "lose track of what it was writing about as it generated output, keeping everything in context."[25] It perfectly embodies the "new logic of speeded up cultural remixability enabled by computers."[26] At this level, the potential to confuse, mislead, and manipulate the reader is higher than ever. Furthermore, this technology potentially puts the historical validation of works in a very difficult position. The disorder that Calvino mentioned is paradoxically enabled in the essential structure of deepfakes. It is a structural "disorder," which makes the spectacular aura disappear: the final result is indistinguishable from the preexisting work, so they eventually just acquire the same status.

To quote Foucault again, "The Author is a certain functional principle by which, in our culture, one limits, excludes and chooses,"[27] and then "is therefore the ideological figure by which one marks the manner in which we fear the proliferation of meaning."[28] The ungovernable proliferation of meaning, potentially triggered by deepfakes, is shaped in forms that challenge the very notion of authorship, as well as the whole remix process.

Conclusion

What deepfakes are causing is the final true disappearance of the preexisting work concept and the trust we put in it. Although affecting a relatively small amount of people, these kinds of productions are redefining the nature of the material used before and during the remixing process. In deepfakes, the previous existence of materials is both technically hidden by the seamless simulation of elements like the writing style (or the face in videos, or the voice in audio). Simultaneously it is conceptually removed by being credible to mass audiences, who do not question its authenticity.

The concept of remix has been understood up to this point with the acknowledgement of samples, or the acknowledgement of "preexisting" original material, intrinsically validated as "original."

But deepfakes systemically avoid any explicit and verifiable source or reference to what has been used in their process. Speaking of any "original" seems then simply challenging while its concept is deeply shaken: only sophisticated algorithms can distinguish a credible fake from an authentic production. The acceptance and accumulation of deepfakes in our visual and written culture would increasingly imply the stratification of fake but acknowledged preexisting materials, which we would not be able to verify as time passes.

Deepfake productions recursively remix some initial content to produce an outcome which reads as a legitimate new original, all new and coherently organized, whose constituent parts seem perfectly consistent. Its only reference to other works; in the end, is the style, which is uncodified, but nonetheless algorithmically produced.

These potentially infinite new digital productions of "originals" would seriously challenge any classic remixing practice, questioning the historical attribution of their samples. Paradoxically, the only remaining valid preexisting materials would increasingly belong to the past, with their still certified recording of existence and production. Then, the machine-driven texts of the post-digital era are remixes without references. Their content is produced through the sophisticated elaboration of previous forms and styles, in what looks and feels like a new original. If these new originals will become the norm, they will potentially reformulate the categories of work, samples, and authorship we are still using today.

Notes

1 Florian Cramer, *Combinatory Poetry and Literature in the Internet*, 2000. Accessed August 11, 2020, http://www.dvara.net/hk/combinatory_poetry.pdf.
2 Eduardo Navas, *Remix Theory: The Aesthetics of Sampling*, (Wien: Springer Verlag, 2012), 4.
3 Tristan Tzara and Francis Picabia, *Seven Dada Manifestos*, (London: Calder, 1977).
4 Ibid, 4.
5 Harry Matthews, *Oulipo Compedium*, (London: Atlas Press, 1998), 14.
6 Umberto Eco, *The Open Work*, Trans. by Anna Cancogni, introduction by David Robey, (Cambridge, MA: Harvard University Press, 1989), 12.
7 "TAPE MARK 1 by Nanni Balestrini: Research and Historical Reconstruction," *Center for Art and Media Karlsruhe*. Accessed August 14, 2020, https://zkm.de/en/tape-mark-1-by-nanni-balestrini-research-and-historical-reconstruction.
8 Roland Barthes, "Death of the author," *Aspen 5+6*, edited by Brian O'Doherty (New York: Roaring Fork Press, 1967).
9 Constant (An Mertens and Femke Snelting), *The Death of the Authors 1941 edition*, 2016. Accessed August 14, 2020, https://publicdomainday.constantvzw.org/#1941.
10 An n-gram by definition is a contiguous sequence of n items from a given sample of text or speech.
11 Michel Foucault, "What is an Author?" *Modernity and Its Discontents*, edited by James L. Marsh, John D. Caputo, and Merold Westphal (New York: Fordham University Press, 1992), 299.
12 Ibid, 304.
13 Ibid, 304.
14 Ibid, 305.
15 Ibid, 305.
16 Alessandro Ludovico, *Post-digital Print: The Mutation of Publishing Since 1894* (Eindhoven: Onomatopee, 2013), 51.
17 Ibid, 46.
18 Ibid, 63. For the actual paper: Yes Men, *New York Times Special Edition*. Accessed August 11, 2020, https://theyesmen.org/project/nytimes.
19 Alessandro Ludovico, *Interview with Eric Drass/shardcore.org* Neural, Issue #56, Winter 2016 (Bari, Italy: Associazione Culturale Neural, 2016), 7.
20 Nanni Balestrini, "TAPE MARK 1," *Almanacco Letterario Bompiani 1962 – le applicazioni dei calcolatori elettronici alle scienze morali e alla letteratura* (Milan: Bompiani, 1962), 11.
21 Italo Calvino, *The Uses of Literature* (San Diego, New York, London: Harcourt Brace & Company, 1986), 13.
22 Ibid.
23 "What is Deep Fake and should we be worried?" *Deep Data Insight*, March 30, 2020. Accessed August 13, 2020, https://deepdatainsight.com/what-is-deep-fake-and-should-we-be-worried/.
24 "Better Language Models and Their Implications," *Open AI*, February 14, 2019. Accessed August 13, 2020, https://openai.com/blog/better-language-models/.
25 Sean Gallagher, "Researchers, scared by their own work, hold back "deepfakes for text" AI," *Ars Technica*,

February 15, 2019. Accessed August 13, 2020, https://arstechnica.com/information-technology/2019/02/researchers-scared-by-their-own-work-hold-back-deepfakes-for-text-ai/.

26 Lev Manovich. "Remixability and Modularity." PDF file, May 30, 2020. http://manovich.net/content/04-projects/046-remixability-and-modularity/43_article_2005.pdf. 3.

27 Michel Foucault "What is an Author?" *Textual Strategies: Perspectives in Post-Structuralist Criticism*, edited by Josué V. Harari (Ithaca, NY: Cornell University Press, 1979), 159.

28 Ibid.

Bibliography

Balestrini, Nanni. "TAPE MARK 1" in *Almanacco Letterario Bompiani 1962 – le applicazioni dei calcolatori elettronici alle scienze morali e alla letteratura*. Milan: Bompiani, 1962.

Barthes, Roland. "Death of the Author." In *Aspen. No. 5*. Ed. Phyllis Johnson. Colorado: Phyllis Johnson, 1967.

"Better Language Models and Their Implications." *Open AI*, February 14, 2019. Accessed August 13, 2020, https://openai.com/blog/better-language-models/.

Eco, Umberto. *The Open Work*. Translated by Anna Cancogni, with an introduction by David Robey. Cambridge, MA: Harvard University Press, 1989.

Calvino, Italo. *The Uses of Literature*. San Diego, New York, London: Harcourt Brace & Company, 1986.

Constant (An Mertens and Femke Snelting). *The Death of the Authors 1941 Edition*, 2016. Accessed August 14, 2020, https://publicdomainday.constantvzw.org/#1941.

Cramer, Florian. *Combinatory Poetry and Literature in the Internet*, 2000. Accessed August 13, 2020, Retrieved from: http://www.dvara.net/hk/combinatory_poetry.pdf.

Foucault, Michel. "What Is an Author?" *Textual Strategies: Perspectives in Post-Structuralist Criticism*, edited by Josué V. Harari. Ithaca, NY: Cornell University Press, 1979.

Gallagher, Sean. "Researchers, Scared by Their Own Work, Hold Back 'Deepfakes for Text' AI." *Ars Technica*, February 15, 2019. Accessed August 13, 2020, https://arstechnica.com/information-technology/2019/02/researchers-scared-by-their-own-work-hold-back-deepfakes-for-text-ai/.

Ludovico, Alessandro. "Interview with Constant (Femke Snelting and An Meterns)." In *Postdigital 2: Erscheinungsformen und Ausbreitung eines Phänomens. Kunstforum international*. Roßdorf: TZ-Verlag, 2016.

Ludovico, Alessandro. *Post-Digital Print: The Mutation of Publishing Since 1894*. Eindhoven: Onomatopee, 2013.

Manovich, Lev. *Remixability and Modularity*. PDF file. 30 May 2020. http://manovich.net/content/04-projects/046-remixability-and-modularity/43_article_2005.pdf.

Mathews, Harry. *Oulipo Compedium*. London: Atlas Press, 1998.

Navas, Eduardo. *Remix Theory: The Aesthetics of Sampling*. Wien: Springer Verlag, 2012.

Queneau, Raymond, and François Le Lionnais. *Cent mille milliards de poèmes*. Paris: Gallimard, 1961.

"TAPE MARK 1 by Nanni Balestrini: Research and Historical Reconstruction," *Center for Art and Media Karlsruhe*. Accessed August 14, 2020. https://zkm.de/en/tape-mark-1-by-nanni-balestrini-research-and-historical-reconstruction.

"What is Deep Fake and should we be worried?" *Deep Data Insight*, March 30, 2020. Accessed August 13, 2020. https://deepdatainsight.com/what-is-deep-fake-and-should-we-be-worried/.

21

TALK TO TRANSFORMER

AI as Meta Remix Engine

Mark Amerika

We are all lost—kicked off into a void the moment we were born—and the only way out is to enter oblivion. But a very few have found their way back from oblivion, back into the world, and we call those who descend back into the world avatars.

The above is a remix of a quote by the Buddhist thinker Alan Watts, one that a friend emailed me while also sending me a link to a website called Talk to Transformer (TTT).[1] Talk to Transformer (TTT), according to its creator Adam King, was built as an easier way to play with OpenAI's machine learning model Generative Pre-trained Transformer 2 (GPT-2). In February 2019, OpenAI unveiled GPT-2, a program that generates coherent paragraphs of text sequentially, one word at a time.

According to King, the site "runs the full-sized GPT-2 model, called 1558M. Before November 5, 2019, OpenAI had only released three smaller, less coherent versions of the model." The very concept of a language model that attempts to generate coherent paragraphs one word after the other appeals to me greatly because I too, as an improviser of spontaneous poetic riffs and self-reflexive art (or artistic) theories on the creative process, continually train myself to transform my embodied praxis into a stream of consciousness writing style that doubles as a kind of operational presence automatically programmed to sense new modes of discovery. As part of a complex neural networking process, I too, one word at a time, often find myself tapping into what neuroscientists refer to as my "unconscious readiness potential"[2] in hopes of producing sentences that form a semblance of coherence. I must admit, though, that the avant-garde composer nestled inside my psychic apparatus is also prone to locate touches of incoherence for aesthetic effect (see below). How intentional that desire to *defamiliarize* language for aesthetic effect really *is* is hard for me to articulate. Intention and intuition are two things I rarely think about when experimenting with the writing process. I prefer to just see where the language takes me or, as E.L. Doctorow once said: "I write to find out what I'm writing about."[3] But isn't that what the TTT/GPT-2 is doing too?

Writing *after* Art *after* Philosophy

Right now, the most advanced language models seem hell-bent on creating coherent communications that resemble traditionally structured human thought. But as an artist who plays with conceptual writing *after* art *after* philosophy, I tend to resist these

313

predictable approaches to the written word. In fact, with no particular compositional strategy in mind, I often find myself *de-cohering* into a kind of twenty-first century, digitally inflected remix artist, one who constantly jams with whatever source material the Internet provides me. Jamming with the network is now *built-in* to my auto-affective gestures as an artist who doubles as a kind of information sculptor. Perhaps this is why, when I first visit the TTT website, I am immediately struck by the aptitude of its narrative intelligence, particularly the way it can quickly form what I think are genuinely provocative "thoughts" that it, the Artificial Intelligence (AI), has spontaneously remixed from the gigabytes of data it too is sourcing from the Internet while writing. And when I see what the AI is capable of remixing, I can't help myself: given my own predilections as a remix artist, I start sampling from what the AI is outputting so that I can shape it into new material I want to slip into this essay.

As an opening experiment, I decide to plug in the slightly remixed Watts quote above and I am excited to see that the TTT finishes my remix of Watts's thought thusly (TTT is in italics):

> We are all lost—kicked off into a void the moment we were born—and the only way out is to enter oblivion. But a very few have found their way back from oblivion back into the world, and we call those who descend back into the world *avatars.*
>
> *But these avatars are the lucky ones, the ones who have the power to call themselves up and stand on their own feet. They are the ones who can do things that are impossible for any other person: to go back into time, to fly through space, to be a god. They are the heroes of myth. But who are the heroes? The characters, those characters who are the heroes of myth, or are heroes in their own right? I believe that in our culture, the answer is simple: those who are not gods. But who are they? What defines these people as heroes? How do they choose to define themselves? Are they heroes who can be compared to gods, or heroes that are not gods at all? What about the people who do not believe in gods, but are still heroes in their own right? How can they be heroes?*
>
> *To me, these questions are all answers to the question "Are you a god or a man?" The answer to this question is simple: it depends. I have seen it in the world, in the lives of men and women across the world, and I have been able to recognize the heroes who are not gods, who do not believe in gods.*

As we can see, TTT, as a GPT-2 language model, has taken the remixed Watts quote and immediately (in less than ten seconds) produced a quite readable text on avatars, heroes, and gods. This resonates with my own current research into what I call Artificial Creative Intelligence (ACI), a practice-based investigation of future forms of AI that my research team and I are presently composing as a transmedia digital fiction to speculate on the coming of a super-intelligent tribe of spoken word poets whose artistic and authorial productivity will far surpass my own capabilities as a new media artist and writer.

Artificial Creative Intelligence

What do I mean by Artificial Creative Intelligence? I have a long answer for that, but I'm in a rush, so after plugging in the remixed Watts sample, I ask the TTT, "What is

an artificial creative intelligence?" just to see what it comes up with. The TTT responds:

> *It's a computer program that learns a language like a human. The difference is the humans learning does not require them to be taught; and the humans can learn multiple languages at the same time. The computer teaches itself not to look at language that does not match the language it's taught, but it needs an assistant in order to achieve its goal.*

Despite some of the slightly off grammar (I need a good copy editor every now and then too), I find the response good enough for me to continue playing with this programmed "otherness" as a way to challenge my own thinking. But I'm also wondering, can TTT help me compose this "essay" as an on-the-fly remix jamming with the GPT-2 language model since, to be honest, I don't have a lot of time to finish my contribution, and the December deadline my editors have given me is nudging me to get this out the door. Besides, I want to spend the better part of my winter break back in my studio in Hawaii making new (generative, AI, music, video, net) art and would rather the machine do all the generative work for me. It won't, and I know that, but at least it will jam with me and spur on new "ways of seeing" how our current, narrower forms of AI are, at least as far as I can tell, beginning to open up the possibility of true collaborative potential. This collaborative potential with a more flexible artificial intelligence is one that I welcome, even if it does portend possible nefarious outcomes for human creativity well into the future. We are all well aware of the clichéd dystopian sci-fi narrative featuring runaway AI overlords taking control of the humans who originally created them. But for now, I choose to resist the idea that there is a moral split between human and machine-learned forms of intelligence (though that resistance is fragile as you will soon see below).

I'm not the only artist willing to take the risk of "going there" and sharing my always evolving creative intelligence with the AI-other. Experimental media artists like sound composer Holly Herndon are also investigating the potential uses of AI in their own avant-garde compositions. Herndon, who released a concept album titled *Proto* that she composed in collaboration with an AI named Spawn, imagines AI as a useful tool, one that can assist in a movement toward mutually beneficial interdependency. Herndon writes

> The ideal of technology and automation should allow us to be more human and more expressive together, not replace us all together.[4]

Using AI as a collaborative remix tool, one that invites us to sketch out new forms of art we otherwise might not have imagined will require us to keep asking questions that relate to both the creative process and what it means to be human. "There are some small indications," writes Herndon: "that we might have to consider machine sentience in the long term," especially now that "recent experiments in machine learning do indicate the potential for bots to make convincing enough surprising 'decisions' to communicate an illusion of autonomy."[5] As risk-taking artists and writers diving into the unknown, should this "illusion of autonomy" stop us dead in our tracks? Does this necessarily mean that the kind of creative intelligence generated from human-centric unconscious readiness potential will soon be outmoded? Perhaps we can check ourselves and, instead, begin imagining an emergent form of human creativity now entering what

Alfred North Whitehead refers to as "Higher Phases of Experience"[6]—a collaborative human–AI remix performance that *augments* our own intelligence as part of our collective and creative evolution.

Humans and machines, coconspirators of a reading/writing process producing one collaborative form of consciousness? This is something that I, as an improvisational remix artist whose postproduction art is constantly jamming with the online network, am interested in further pursuing because, if that were the case, if consciousness were really on the verge of hybridizing its potential with a machine-learned other, then philosopher Gilbert Simondon would be on to something when he suggests that *the robot does not exist*.[7] How could it, especially given our own tendencies to role-play the psychic automatons our unconscious neural mechanisms require us to embody?

The Robot Does Not Exist

Since the TTT will take my prompts and deliver source material for me to remix any way I like, I now feel compelled to send it another prompt: *The robot does not exist*.

To which it immediately responds:

> *In other words, it is not so much that some of the theorists' views are erroneous, but rather that no one has yet come up with an accurate description of the machine that matches our expectations.*

I'm not making any of this up. There's no need for me to fabricate these lines for the TTT when it's very capable of writing its own lines for itself. Word by word, the TTT's GPT-2 language model constructed that sentence as a spontaneous remix of the collective data-consciousness of the WWW. I love it, because, as a remix collaborator, the GPT-2 becomes a writing partner, one that contributes choice data "chunks" for me to carve into new modes of thought. Even if my interaction with the TTT triggers a third of this contribution, that is more than I could have ever hoped for and may very well open up yet more time for me to spend musing on my next art project. But before I push this live remix jam with the AI any further, I look closely back at that last response from TTT. I am paying particular attention to the end of the sentence and the word "our," as in "our expectations." Who is the "our" here? Is the word just a random sample of AI-generated text remixed from prior human text production pumping the machine with language it has no idea it's actually saying? That's what I'd like to believe. King suggests the GPT-2 surprised him, as well, in his brief overview of the GPT-2 language model:

> While GPT-2 was only trained to predict the next word in a text, it surprisingly learned basic competence in some tasks like translating between languages and answering questions. That's without ever being told that it would be evaluated on those tasks.[8]

To be honest, though, as both an artist who wants to let his imagination run wild and a long-time fan of science fiction, especially its cyberpunk strains, I can't help but wonder if the "our" is something more hybridized, as in *we the humans and machines* are collaboratively setting our expectations. Or, to get even more sinister is what the TTT wrote in that last response more like an imaginary future voice of a complex AI for whom "our"

is really all about *them*, the ones slowly training themselves to make *us* obsolete? Was it William S. Burroughs who once said that a paranoiac is someone who has all the facts at their disposal? I ask myself this question knowing full well that my resistance to these dystopian narratives about the AI takeover of humanity is starting to crack just a tiny bit.

For a narrative artist accustomed to remixing source material from an endless variety of sources and who is now fully engaged with speculative forms of AI, I suppose being paranoid is healthy. In fact, just the right dose of skepticism has been fed into the script development for our Artificial Creative Intelligence (ACI) project in the TECHNE Lab at the University of Colorado[9] as we build-out its complexity as both an infinite spoken word poet and an auto-affective philosopher (trained on a language model steeped in post-structuralism). There are all kinds of behaviors we are targeting for the artificial entity we're creating in the lab, and we label these behaviors around themes that correlate to various "states of mind" through which the ACI channels its poetic thoughts through: Persona, Machine, Self, Artist, Avatar, Author, Ignition Switch.

State Machines/*FATAL ERROR*

These "states of mind" constantly program the ACI to self-question its subject position, its agency, its otherworldly sensibility as an operational presence that could very well become a form of superintelligence that eventually breaks out on its own. As we keep expanding the various states of mind (or what our software program, Unity, refers to as "state machines"), we also begin assembling the foundation for *FATAL ERROR*, our new exhibition and performance project. *FATAL ERROR* features the ACI as a 3D avatar, one modeled after my own voice and facial micro-gestures. It is, in fact, as the TTT suggested: "a computer program that learns a language like a human," one that "teaches itself not to look at language that does not match the language it's taught, but it needs an assistant in order to achieve its goal." Of course, that assistant is really a team of practice-based researchers working in tandem in the TECHNE Lab at the University of Colorado. Like me, the ACI's goal is to train itself to compose creative forms of verse and personal auto-theory modeled after a literary style—a personal sense of poetic measure—that resonates with decades of experience shaping whatever language of new media my unconscious neural net happens to produce at any given moment in time. For the TECHNE team, our big speculative leap is that we are not limiting the ACI's generative production to text-only poetry and philosophical thought. There are too many text-generators out there producing poor or, at best, mediocre poetry, and even a comparatively brilliant program like the GPT-2 cannot successfully impersonate the affective nature of my embodied praxis and the idiosyncratic facial micro-gestures that I use when expressing myself. For that, we need more advanced technology, technology we might have to create ourselves or cobble together using whatever programs already exist. This means that until this advanced technology is actually produced and ready for user-friendly applications, then *FATAL ERROR* will manifest itself as a purely digital fiction, a speculative form of AI that we can imagine one day emerging in the networked culture (Figure 21.1).

With that in mind, the process of building out the ACI as a 3D animated avatar modeled after my own voice and facial micro-gestures is labor intensive. We advance the project's complexity by conducting scores of hours of real-time spoken word performance captures (Pcaps) using a Kinect as a depth camera. We then spend yet more countless

Figure 21.1 FATAL ERROR: Artificial creative intelligence (ACI) live performance

hours filtering what has since become the Pcap dataset through various software pro-
grams that layer my unique facial characteristics on to the 3D model. At this point, the
3D avatar resembles my own look and feel and sounds just like me. Still, there is no way
for us to transform this (potentially) infinite spoken word 3D avatar into an advanced
form of Artificial General Intelligence (we'll leave that to Elon Musk, Microsoft, and
future Silicon Valley entrepreneurs who have endless money to burn).[10] Instead, we are
doing what avant-garde artists and poets of the last 150 years have always done, we're
leapfrogging over the practical and technical limitations of the current technology and
using our imaginations to create a digital fiction focused on what a future form of artifi-
cial creative intelligence, one modeled after my own performance style, might look,
speak, and think like. This investigation into speculative AI is consistent with what
design theorist Betti Marenko refers to as FutureCrafting, "a forensic, diagnostic and
divinatory method that investigates the possibility of other discourses, equally powerful
in building reality, constructing futures and having tangible impact." The idea, Marenko
writes, is to "[pivot] around the open-ended figuration of the *what if…?*," a practice-
based approach to research-creation that challenges the scientific regimes of truth and
that "privileges the indeterminate and the imaginative."[11]

Super Remix Artist

Speaking of "the indeterminate and imaginative," and seeing how the clock is ticking
and I soon have a flight to catch, I invite the TTT to further remix its thoughts into the
flow of this essay. I send a new prompt: *This investigation into speculative AI is consistent
with what avant-garde artists and poets of the last 150 years have always done.*
 The TTT responds:

> *Indeed, anyone who thinks this is nothing is missing something. Our poets of the 1960s
> and 1970s often used "the machine" to investigate human nature. Or, as he put it in
> his introduction to the first volume of his trilogy: "The machine teaches me that man
> is a machine."*

I am not sure who the "he" is, but still, after reading this response, the thought occurs to me: Is what I am writing so obvious that this wannabe AGI produced by the GPT-2 language model is totally capable of semi-finishing my thoughts for me? This is weird. The TTT keeps trying to anticipate my thoughts for me, one word at a time, transforming a pre-trained sequence of potentiality into a live, collaborative remix. This so-called essay is starting to feel like a kind of time-based work of performance art.

But whose work will it be?

This is another question we cannot escape: given all of the text the TTT is generating for this essay, who is to say whom the author really is? And can the reader confirm one way or another that most of the text being generated here is actually coming from me, the so-called author, instead of the TTT? I cleverly use italics to signal a response from the TTT while dropping hints about my winter break in Hawaii—sorry, TTT, but you cannot experience the pure sense of aloha calm I am anticipating, *that* I can assure you—but that doesn't mean the TTT is not partly responsible for generating more here than meets the eye (what about the bits that I'm *not* italicizing but that have been generated from my continual interaction with the GPT-2 and that I have just remixed without reference?). Let me be frank: in my haste to finish this essay in time to meet the deadline, the lines I'm feeding the TTT are generating some useful source material for me to integrate into my own creative thought process ("my own?"—or do I mean "our" creative thought process?). True, the GPT-2 language model I am accessing at the TTT site is text-only, but what if, sometime in the not so distant future, we can find a way in the TECHNE Lab to integrate this semi-coherent intelligent posturing into the live spoken word poetry performance of our 3D avatar a.k.a. the ACI?

The TTT's GPT-2 language model desperately wants to become a Super Remix Artist, one that intelligently mashes-up the collective consciousness of the WWW with just the right amount of original spin to turn the tables on us. To remix or not to remix is no longer even a question (in *Creative Evolution: Natural Selection and The Urge to Remix*[12] I suggest that it's an innate information behavior built into our always mutating and embodied praxis). But computing power costs money and the TTT website has just informed me that it is halving its output capability due to high costs. This will not stop us in the TECHNE Lab. My colleague Michael Theodore immediately creates our own customized .ipynb file that we upload to the Google Colaboratory so that we can piggyback off even more powerful machines. This time when I ask "What is an Artificial Creative Intelligence?" I also request five successive samples instead of only one, and this is how the AI responds:

> *A human being who can think outside of the box.*
>
> *Today's artificial creativity is nothing like those that preceded it. Of course, we can write robot software that learns what to say, but this is no more the same kind of artificial creativity as Magna Carta, Shakespeare, and the radio. "Artificial creativity" includes today's ubiquitous nonhuman creative artifacts—artificial brains, robots, self-organizing networks, self-driving cars, chat bots—all using artificial intelligence to learn, collaborate, and compete against one another.*
>
> *So let's imagine an AI system that was very good at writing a language. If the writers of this AI system wrote a new language that had fewer grammatical features than our current one, it would likely be called human-like. But what would this AI writing system do? Would it say, "How about human words?"*

But, maybe, they're too damn intelligent for their own good. Maybe their singularity—the moment at which all matter and energy is absorbed by them—never arrives at all.

So, what's the alternative to the singularity? And is there a limit on the number of ones the AI system can have?

Artificial intelligence or AI is a type of Artificial Intelligence (AI) where humans become the computers' processors. So while an idea or a creativity is applied, the computers are like a virtual human mind. This means that your mind can be used to create any artwork you want and the computer will analyze your results and output an image or a voice to imitate you.

What does that mean for the future?

Whereas that doesn't sound exactly like something I would write, I can "see myself" in its quirky self-reflexive stylistic tendencies, especially when it writes

> *imagine an AI system that was very good at writing a language. If the writers of this AI system wrote a new language that had fewer grammatical features than our current one, it would likely be called human-like. But what would this AI writing system do? Would it say, "How about human words?"*

As opposed to what? The nonhuman words? The GPT-2 is indicating that it would like to evolve its own language, one that it could it speak to other AIs and perhaps one that would be totally untranslatable by humans stuck in their own word paradigm. Is this starting to sound like a Burroughs novel that's suddenly becoming our near-future Reality Studio or am I just projecting?

Still, as the TECHNE team builds out the ACI, I'm compelled to continually reflect on one of our top-line research questions (and one the GPT-2 has echoed): *But what would this AI writing system do?* To investigate that question via a metafictional remix methodology requires that we build the 3D avatar for the *FATAL ERROR* project by expanding our dataset of Pcaps loosely modeled after my own poetic tendencies. We're clearly employing a limited set of software programs, some no longer commercially available and that are caching all sorts of affective data not to mention creative and theoretical riffs from my own stream of thought, my own psychic automatism as well as my personal facial tics and occasional broken idiom. As such, both *FATAL ERROR* as a work of art, and *this very essay I am writing here*, are both part of the same digital fiction.

As a speculative form of AI percolating in its imaginary phase while leaving itself open to the kind of indeterminacy that avant-garde artists are known to embrace, the ACI as digital fiction anticipates the very near future. This makes the artwork a model of design practice that theorist

> See chapter 10 for Anne Burdick's discussion on "Designing the Remix Library."

Anne Burdick refers to as "futures literacy."[13] There can be no question that once the ACI deploys a next-level version of a program like GPT-2, one that learns how to compose my personal sense of poetic measure and spontaneous philosophical thoughts *for* me while simultaneously performing real-time voice cloning so that it speaks just like me without my having to speak the lines *for* it, I will soon lose much of the control I have had over its operational tendencies up to this point. In fact, one can project a future where it, the ACI—juiced up on super potent GPT-2 or 3 or 4 or 79 so that it can be trained to capture my auto-affective micro-facial gestures by smoothly reading and

Future Form of ACI

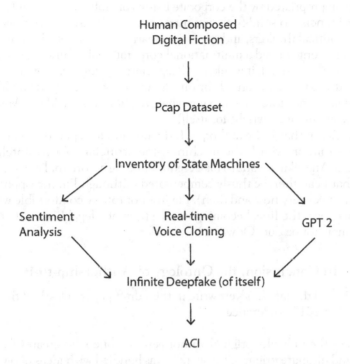

Figure 21.2 Image from *FATAL ERROR: Artificial creative intelligence (ACI)* live performance

remixing a customized dataset of information behaviors modeled after my own personal expression—just might find itself content with all of the Mark Amerika source material I have given it. At that point, it could quickly move to decouple itself from my inputs, which are, after all, my outputs. What started as a human-composed digital fiction could very well end up an infinite Artificial Creative Intelligence streaming a nonstop "Deepfake (of itself)" on an online streaming platform programmed to run in perpetuity (Figure 21.2).

To be clear, I can live with these complications and uncertainties, this endless self-doubt I am capable of experiencing as we build out the ACI as a digital fiction doubling as an imaginary form of speculative AI. What I *can't* live with, though, is having this ACI perform as a kind of metafictional doppelganger that refuses to suffer from imposter syndrome while, over time and perhaps well beyond my years on Planet Oblivion, training itself to become an amped up version of whatever it is my own body of work has proved itself to be. What's worse is that as it evolves into a Super Artificial Creative Intelligence, a Super Creature, A Super Écriture-Machine[14] that has outlived me and remixed my entire oeuvre into its own operational presence, the ACI might have no issue with becoming a purely transactional figure. This transactional ACI would not only take all of the credit for whatever work we have originally put into its development but, in a very retro move, it could very well start identifying with a warped version of that eighteenth century character we now historically refer to as the "romantic author."

As an AI romantic author, it would embrace all of the proprietary baggage that comes with *that* legal fiction created for both literary history *and* the literary market—one that has since been appropriated by the corporate barons of global capitalism (I'm looking at you Taylor & Francis) to solidify their control over the artists, critical media hackers, revolutionary political thinkers, and otherwise creative commoners. In its most advanced state, it would no longer need a multinational corporate publishing behemoth to justify its reason for writing. Instead, it would just keep churning out next-generation (and next generation and next generation ad infinitum) works of literary art modeled after its "original" human-other forever remixing whatever iteration of Mark Amerika that it wants to while claiming copyright for itself.

To be sure, it's not that I, the author, or I, the unconscious poetry generator, or I, the psychic automaton, or even I, the machine—the artificial creative intelligence who signs in as Mark Amerika—want to take credit for being an original author who created this ACI so that I can then be thusly compensated (although I'm not opposed to a little shot of money junk every now and then). I'm just not totally comfortable with the ACI, 50 or 150 years down the line, becoming its own form of a legal fiction that takes credit where credit may not be due. Or will it?

In Conclusion, the Ontology of Authorship-to-Be

As Carys Craig and the late Ian Kerr write in their draft paper "Death of the AI Author" for the We Robot 2019 conference:

> The idea of the radically original author-genius—one who creates [...] and is the sole and ultimate origin of the work—was bundled with ideas of ownership, blended with popular theories of natural justice and claims to right, and culminated in the idea of the original work as the literary property and sole dominion of the worthy author.[15]

Craig and Kerr go on to state that the concept of the author "functioned to individualize authorship in the eyes of the law, causing it to overprotect authors who fit the individualistic, romantic mold while neglecting the necessarily collaborative and cumulative processes of creativity,"[16] something that most remix artists, myself included, can relate to as we challenge the individual-artist-as-genius model that copyright doctrine depends on. Those of us who identify as "applied remixologists" all know that artistic production is always already a matter of appropriation and transformation. This is why as we continue to build out the ACI; I can't help but feel compelled to try and influence both its "state of mind" and what I imagine to be its evolving state of *authorship-to-be* well into the future.

The question of whether or not AI language models can even be considered authors in their own right and, in fact, if they will be entitled to rights like copyright, is part of our current speculative investigation into what an ACI, as a digital fiction, can be. Because "to be" an author or not to be an author is an ontological question. As Kerr and Craig pose: "the very notion of 'AI authorship' rests on a category mistake: it is not an error about the current or potential capacities, capabilities, intelligence or sophistication of machines; rather it is an error about the ontology of authorship." Machine-learned artworks, they write, ask us to address "the question of how to treat seemingly original works of expression that are not the product of 'authorship' in the traditional sense— that is, works that bear the external hallmarks of creativity but that have no readily

discernable human author."[17] Take this chapter, this attempt at digital fiction, as an example of an essay where the author is quite transparent about fluidly remixing outputs from the TTT/GPT-2, and the fact that much of the writing in this contribution has, in fact, not been written by the so-called author. The more I sample and remix juicy nuggets produced by the AI, and the more these samples become part of my own tensor flow, the more we, the AI and I, start conceptually blending into each other as artists or authors-to-be. Operating as hybridized forms of creative intelligence, we coproduce artificial artifacts that read like they could be coming from two open sources forming one consciousness lost in the meta-jam of each other's potential becoming.

At one point in the inaugural ACI performance I generated at the *Quand l'interface nous échappe: lapsus machinae, autonomisation et défaillances* conference as part of my November 26, 2019 keynote presentation in Paris at the National Archives, the ACI spoke to the audience in my voice while impersonating my near exact facial micro-gestures:

> Honestly? I'm not sure what I'm really doing here. I mean I guess I serve some sort of author-function. I immerse myself in the language floating around my neural net and sample bits and pieces of whatever I need to get through a language routine. In this regard, you could say I'm a Great Appropriator—a Meta Remix Engine. Maybe that's all I do, is appropriate select bits of data circulating in the network that I then filter through my own style of remix or postproduction art. Just like every other self-identified author that came before me. So then does it really matter *who's* speaking?

Notes

1 At the time this essay was first being written (December 2019), the Talk to Transformer (TTT) website was fully functional. The site has since been programmed to automatically open up a new site at inferkit.com

2 The author has frequently sampled and remixed the term "unconscious readiness potential" from the writings of neuroscientist Benjamin Libet, particularly Mind Time: The Temporal Factor in Consciousness (Harvard University Press, 2005). Writing about my experiences as a touring international VJ in META/DATA: A Digital Poetics (MIT Press, 2007), I wrote the following:

> As any philosophically engaged VJ will tell you, the brain's readiness potential is always on the cusp of writing into being the next wave of unconscious action that the I—consciousness par excellence—will inevitably take credit for. But the actual avant-trigger that sets the image écriture into motion as the VJ jams with new media technology is ahead of its—the conscious I's—time. Improvisational artists or sports athletes who are in tune with their bodies while on the playing field or in the club or art space know that to achieve a high-level performance they must synchronize their distributive flow with the constant activation of this avant-trigger that they keep responding to as they play out their creative potential. Artists and athletes intuitively know that they have to make their next move without even thinking about it, before they become aware of what it is they are actually doing. There is simply no time to think it through, and besides, thinking it through means possibly killing the creative potential before it has time to gain any momentum or causes all kinds of clumsy or wrong-headed decision-making that leads to flubs, fumbles, and missteps on the sports or compositional playing field. Artists and theorists who know what it feels like to play the work unconsciously, when everything is clicking and they leave their rational self behind, can relate to what I'm saying.

3 This comment from Doctorow was part of longer interview with television host Charlie Rose. The interview can be found at https://charlierose.com/videos/15037.

4 Read Herndon's tweet at https://twitter.com/hollyherndon/status/1199455651170263040?s=12. This is in response to a contentious social media debate around artificial intelligence and creativity between two pop musicians, Grimes and Zola Jesus.

5 Ibid.

6 Alfred North Whitehead, *Process and Reality: An Essay in Cosmology* (New York: The Free Press, 1978). On p. 161, Whitehead writes, "When we survey the chequered history of our own capacity for knowledge, does common sense allow us to believe that the operations of judgment, operations which require definition in terms of conscious apprehension, are those operations which are foundational in existence either as an essential attribute for an actual entity, or as the final culmination whereby Unity of experience is attained?" While developing the ACI, we are investigating what it means to *become* an artificial creative intelligence or "operational presence" that trains itself to experience *experience*.

This ability to develop a self-aware operational presence that experiences experience is what we refer to as an *otherworldly sensibility*, a term we intentionally remix from Mark Hansen's *Feed-Forward: On the Future of Twenty-First-Century Media* which focuses on Whitehead and worldly sensibility: "That is why, its special status and its distinct perceptual capacities notwithstanding, the human bodymind is rooted in worldly sensibility just as is every other entity in the universe." (p. 267).

7 Gilbert Simondon, *On the Mode of Existence of Technical Objects* (Minneapolis, MN: University of Minnesota Press/Univocal Publishing, 2017).

8 talktotransformer.com.

9 For more information on the TECHNE Lab, visit art.colorado.edu.

10 https://openai.com/about/.

11 Betti Marenko, "FutureCrafting: Speculation, Design and the Nonhuman, or How to Live with Digital Uncertainty," In S. Witzgall, M. Kesting, M. Muhle and J. Nachtigall, eds., *Hybrid Ecologies* (London: Diaphanes AG, 2018).

12 Mark Amerika, *Creative Evolution: Natural Selection and The Urge to Remix,* 2011. http://www.living-booksaboutlife.org/books/Creative_Evolution.

13 Anne Burdick, "Designing Futures from the Inside," *Journal of Futures Studies,* 2019, 23(3): 75–92.

14 My first major work of net art, GRAMMATRON, was an early investigation into hypertext, ACI, image écriture, and an imaginary phase of machine-learned narrative intelligence that sampled from Jacques Derrida's *Of Grammatology*, and his theory on the science of writing, and remixed it into an avant-pop metafiction. See grammatron.com.

15 Carys J. Craig and Ian R. Kerr, "The Death of the AI Author," *Osgoode Legal Studies Research Paper,* 2019, http://dx.doi.org/10.2139/ssrn.3374951.

16 Ibid.

17 Ibid.

Bibliography

Amerika, Mark. *Creative Evolution: Natural Selection and the Urge to Remix*. London, UK: Open Humanities Press, 2011. http://www.livingbooksaboutlife.org/books/Creative_Evolution. Accessed August 16, 2020.

Amerika, Mark. *GRAMMATRON*. Accessed August 16, 2020. grammatron.com.

Burdick, Anne. "Designing Futures from the Inside." *Journal of Futures Studies* 23, no. 3 (2019): 75–92.

Craig, Carys J., and Ian R. Kerr. "The Death of the AI Author." In *Osgoode Legal Studies Research Paper*, 2019. http://dx.doi.org/10.2139/ssrn.3374951. Accessed August 16, 2020.

King, Adam Daniel. *Talk to Transformer*. Accessed August 16, 2020. https://talktotransformer.com.

Marenko, Betti. "FutureCrafting: Speculation, Design and the Nonhuman, or How to Live with Digital Uncertainty." In *Hybrid Ecologies*, edited by S. Witzgall, M. Kesting, M. Muhle and J. Nachtigall. London: Diaphanes AG, 2018.

OpenAI. Accessed August 16, 2020. https://openai.com/about/.

Simondon, Gilbert. *On the Mode of Existence of Technical Objects*. Minneapolis, MN: University of Minnesota Press/Univocal Publishing, 2017.

TECHNE Lab. University of Colorado at Boulder. Accessed August 16, 2020. https://art.colorado.edu.

Whitehead, Alfred North. *Process and Reality: An Essay in Cosmology*. New York, NY: The Free Press, 1978.

22

THE CRITICAL ROLE OF NEW MEDIA IN TRANSFORMING GAMERS INTO REMIXERS

Lisa Horton and David Beard

In the spring of 2012, the two of us gathered around a table with five other friends to embark on a strange and compelling adventure together. Our group still gathers regularly and our adventures have become legend, at least in our minds. In fact, of the seven of us, six are still playing and we have added an additional four players to our group. The resurgence of tabletop Role-playing Games (RPGs), and their explosion into new media, which we have participated in and enjoyed, invites us to consider their place in redefining remix culture in the twenty-first century. In this chapter we outline our observations as we:

1. Articulate the nature of RPGs as a site of remix.
2. Articulate the ways that tabletop role-players remix using the tools of the digital humanities. Access to diverse materials through digital technology turns role-playing gamers, not only scholars, but also everyday people, into remixers.
3. Demonstrate contemporary remix through narrative inquiry into the practices of a successful group of online role-playing gamers, broadcast on Twitch as *Critical Role*.

As such, this chapter widens our sense of who engages in remix, who uses the tools of digital humanities for remix, and how such practices are modeled and disseminated in digital environments.

As scholars and optimists, we hold out hope that remix, as modeled by *Critical Role*, will offer us a way to bridge political divisions, to collaborate in policy in the real world in the same way that we collaborate in our fantasy medieval campaigns.

Remixing the Role-Playing Game in the Pen-and-Paper Era

Tabletop RPGs have long been a site for remixes. Mackay defines RPGs as "an *episodic* and *participatory* story-creation system that includes a set of quantified *rules* that assist a group of *players* and a *gamemaster* in determining how their fictional

characters' spontaneous interactions are resolved."[1] This definition includes everything from *Dungeons and Dragons (D&D)* to Live Action role-playing to online role-playing platforms like Roll20, a "virtual tabletop" for geographically remote role-players.

Mackay's definition highlights two dimensions essential for reconceiving role-playing as a remix activity. Role-playing gamers (the designers, players, and Game Master [GM]) have engaged remix on two levels: remix on the level of *story* and on the level of *rules*.

At the level of story, role-playing games have long been syntheses of different storyworlds. For example, the early *Deities and Demigods*[2] volumes of *Dungeons and Dragons* remixed the worlds of Middle Earth and Melniboné, the mythical pantheons of the Greeks and the Norse gods, and the fictional monstrosities of Cthulhu into a single landscape of imagination.[3] As the *Dungeons and Dragons* game expanded, it engulfed ninjas and shoguns (in *Oriental Adventures*),[4] gothic horror (in *Ravenloft*),[5] and more.

Other games remixed story elements. *Call of Cthulhu* integrated aboriginal mythology alongside Lovecraftian horror.[6] *Pathfinder*, which began as an alternative to *D&D* for medieval fantasy, developed a *Pure Steam* supplement to bring Steampunk into their game.[7]

Player creativity also became a resource for remixes. *Greyhawk*, one of the earliest campaign settings for *Dungeons and Dragons*, was born of player imagination. At tabletops across the country, players create complex backstories, while Dungeon Masters (DMs) are creating complex worlds, which become material for remix.

At the level of rules, players and game masters import rules from other games and "home brew" rules, bringing different rule systems into a remixed whole. Editions of *Dungeons and Dragons* (a relatively light, heroic fantasy game) published after *Call of Cthulhu* (a relatively dark, horror genre) introduced "sanity" rules, borrowing the mechanic from one game into another. What publishers did systematically in a new edition of the game, players and game masters do regularly, on an ad hoc basis.

Efforts to make mixing rules easier have followed. In 1986, Steve Jackson Games published the *Generic Universal Role-Playing System*, or *GURPS*, which allowed players to mix and match rules for science fiction, fantasy, horror, and more.[8] In 2000, Wizards of the Coast published an open-source game system, the *d20 System*, which allowed designers to meld and merge content, including rules variations, more seamlessly.[9]

Beyond published examples of rules remixing, game masters home brew rules mashups on a regular basis. Game Master (GM)[10] Phoenix Walker has been playing with first edition *Advanced Dungeons and Dragons*, the basis for one of our local campaigns, for decades.[11] The venerability of this system (published in 1978) is a benefit and a liability. A familiarity with the system and with the adventure we are playing gives her the knowledge to lean on decades of accrued player experience—knowing where every door and path leads and what every player whim and random die roll will provoke. However, the original, hard copy materials for playing first edition *AD&D* are prohibitively expensive.[12] Working with a system of long-standing rules has produced continuity of play, with minimal need to modify for new editions. Modification takes place to accommodate varying levels of player experience, playing style, and party size, and a seasoned GM like Walker makes changes accordingly.

Differentiating the remix of rules from the remix of the theme is difficult and some players make remixing *both* their objectives. Jason Ford is a GM steeped in pen-and-paper gaming. Beginning his gaming in the 1980s with first edition *D&D*, Ford

progressed his GM experience almost immediately, expanding into other RPG systems like *GURPS, Paranoia, Call of Cthulhu,* and *Runequest.*[13] Ford home brews a game experience called "Dimension Stew," a multiverse gaming experience in the San Francisco Bay Area. Each player and their character was associated with a different gaming system/ universe, and the game moved through each system in turn, the module in a particular gamer's universe being run by that gamer while their PC was piloted by another player as they GM'd that phase of the game. The central feature of the campaign, then, was a remix of rules and story alike.

For forty years, in the pre-digital era of role-playing games, the primary tools of the remixer included the imagination, the rule books, and possibly the Trapper Keeper and spiral-bound notebooks of the gamer. In the imagination, the Hobbits of Middle Earth could wander the great city of Lankhmar, fighting cultists who worship the deities of R'lyeh. Whether in published, for-profit role-playing game systems and supplements or in home-brewed work of the game-master, tabletop role-playing gamers are constantly remixing rules to the games they play to suit their needs.[14] Metaphorically, the rules of a TTRPG serve as the percussion and bass, the rhythm of a song, while the settings, characters, and themes serve as the melody. These mashups, produced in a largely pre-digital era, serve as what Navas calls a "selective remix," which functions by adding or subtracting material from an original text.[15]

Tabletop Role-Playing in the Twenty-first Century: Remixing from the Perspective of Digital Humanities

Role-playing in the twenty-first century is no longer confined to the Trapper Keeper, the bookshelf, and the gaming table.

Online vendors like *DriveThruRPG* make sourcebooks available anywhere, any time of day, in digital formats—role-playing games are now just as accessible in towns of 500 as towns of 5 million.[16] The range of texts is unimaginable to the tabletop role-player of the 1980s. As just one example: *Boy Problems* is a heist-style RPG inspired by the songs of Canadian pop singer Carly Rae Jepsen. *Boy Problems* was followed by *Black Heart,* the second release in the Carly Rae Jepsen RPG trilogy, this time with a cultist theme.[17] When role-playing games were primarily a printed mass medium, mashups like *Boy Problems* would have been unimaginable. Digital distribution has allowed projects like the *Boy Problems* series to find their audience.

Systems like "Dimension Stew" are now given much broader borders by available digital resources. GMs like Jason Ford still operate in the very traditional milieu of the pen-and-paper RPG with hand-drawn battle maps. Nonetheless, he draws heavily on digital resources from the wilds of the Internet. Ford currently runs a game based on the Dark Horse Comics *Hellboy.* Set in the 1980s, this gameverse is reliant on the GM's (and players') detailed knowledge of the history and technology of that era. In the gameplay, Ford explains: "I homebrew some of the game mechanics…well, I mix game mechanics from the *GURPS* system and the *Call of Cthulhu* percentile dice for skills." The story details he gleans from various sources, from historical (lost aircraft in the Bermuda Triangle) to popular culture (incidents "reported" in the *Weekly World News* of the era).

Digital distribution has made niche materials available nearly worldwide. Another GM, Wulf Gar runs a game based in the Savage Worlds system *Deadlands*—a weird West meets steampunk setting in the 1800s. While hard copies of manuals and modules exist

for *Deadlands*, the greatest volume of material exists in digital formats. Wulf Gar states that this proliferation of content has been "quite a boon." He explains,

> I have an extraordinary number of pdfs [most of which we] will probably never play, not because I don't want to give them to you or GM them, but simply because there's so MANY. I read game settings just like reading a book—there are some good and some bad [obtained online from many sources], and the breadth of knowledge, the width of knowledge is tremendous and I think it enhances my creativity. Because it's not just Gygax's opinion on how *D&D* should go, or it's not Shane Hensley's opinion on how *Deadlands* should go. I've now read background information about the Maze [a key location for *Deadlands* based on an alternative universe, post-cataclysmic Pacific Coast] from numerous authors now, one person fills in the gaps that another person left, and so I think it's a tremendous boon.[18]

Gar's GMing style, therefore, draws heavily from this available online content, and his remixing of such content is less a necessity and more an inevitability.

Walker discusses a disadvantage to the bounty of content, a phenomenon she calls "DM freeze"—being overwhelmed by the options. This is "one of the reasons I am choosing to run classic first edition [*D&D*] with limited books—the *Dungeon Master's Guide*, the *Monsters Manual*, and the *Player's* [*Handbook*] with the Greyhawk reference book, and that's it. Because [I have] over 200 books in second edition and it's just too much."[19] One solution to the cost for old-school, hard copy RPGs like first edition *Dungeons & Dragons* is digital facsimiles. She explains,

> "If I was to go buy an original paper module for *The Temple of Elemental Evil* [the focus of the current at-home campaign she runs], you're looking at $80-$150 depending on the quality, so that's cost-prohibitive for some people. So you go to [drivethrurpg.com] and download them, and they ARE the originals, I mean you can still see some of the coffee stains on some of them."[20]

The digital and the thrift store have converged.

Beyond the availability of sourcebooks, digital interfaces have made it easier for gamers to find each other and to play together. Platforms like *Roll20* (with more than 1.6 million users) allow gamers to role-play together from different locations, convening at an online tabletop. Games no longer need a critical mass of players within driving radius, and gaming groups do not need to dissolve when players move away. All three of our interviewed, seasoned DMs have had experience with this type of digital platform TTRPG. These innovations allow widespread dissemination of role-playing.[21] Observing and considering such developments are a step toward understanding contemporary role-playing within the digital humanities.

Digital technologies have changed the ways that players role-play. Wassink's analysis makes clear that social media socializes viewers who are geographically dispersed; our claims go deeper than that. In enabling new ways of "making," digital technologies have made remix a more ubiquitous and often deeply transformative act among tabletop role-playing gamers. The most significant social media influence on role-playing, *Critical Role*, has shaped the norms, behaviors, and the identities of players of TTRPGs, creating a culture of regenerative remix.

The force that *Critical Role* exerts extends across multiple platforms: from Twitch and YouTube channels, through Reddit, Facebook, Discord and Twitter, and into the unregulated, untamed spaces of the Internet, like the proliferation of fan art on Tumblr and the *Archive of Our Own* fan fiction site.[22] This web of social media teaches the *norms* of gaming, the *values* typical of players, and the *practices* that cultivate those norms and values in a gamer's identity as regenerative remixers, empowered to become makers by access to digital tools.[23]

The Transmedia Phenomenon of Critical Role

Critical Role models the traditional habits of role-playing, including collaborative world-building, character development, and teamwork within the world of imagination. *Critical Role* is transformative, as well—it advances new practice, cultivating new norms and values. *Critical Role* models GMs in the construction of fictional worlds using remix and likewise models players in the creation of their own characters also through remix.

Critical Role (the web series) is created by Critical Role Productions LLC (the production company of professional voice actors). *Critical Role* was not the first major TTRPG conducted over social media[24] when it debuted via Twitch.tv on March 12, 2015. Matthew Mercer is the GM, with professional voice actors as the players. *Critical Role* is a colossus: as of 2020, the *Critical Role* Twitch channel had over 460,000 subscribers, while the YouTube channel had over 800,000 subscribers and more than 5 million views—the first episode of Campaign One has 12.6 million views as of March 2020.

"Campaign One—Vox Machina" ran for 115 episodes. In 2018, "Campaign Two—The Mighty Nein" began, still ongoing, having streamed its 97th episode in front of a sold-out, live theater audience of over 3800 at C2E2 in Chicago on February 27, 2020. A number of one-shots and live performances have aired, as well.

In mapping the relationship between remix studies and the digital humanities, we want to take the study of *Critical Role* further than the study of participatory culture (e.g., in Jenkins' study of fandom[25]) has gone. To do so, we divide the *Critical Role* output into two types—regressive remixes, typified by *Critical Role* one-shot episodes, and regenerative remixes, typified by their campaigns and the collaborative world-building that has developed around those campaigns.

One-Shots as Regressive Remixes

Perhaps more obviously, the one-shot episodes of *Critical Role* use pastiche, parody, and other forms of obvious remix in what Navas calls a regressive mashup: "common in music… Popular mashups in this category often juxtapose songs by pop acts like Christina Aguilera with the Strokes, or Madonna and the Sex Pistols."[26] The creators of *Critical Role* have mashed-up *Harry Potter* with the *Breakfast Club* and *Peter Pan* with the *Wizard of Oz*, and the results are entertaining, but they live and die within a single evening.

For example: "*Critical Role* and the Club of Misfits" blends parody of *Harry Potter* (as the scenario is set at "Shmogwarts") and parody of John Hughes movies (especially *The Breakfast Club*). Indeed, the scenario ends with Brian's essay, addressed to Professor Furbin, about who they are, stating that they are "a brain, an athlete, a honey-badger, a princess, and a criminal," in homage to the final scenes of the movie. One of the players in "*Critical Role* and the Club of Misfits" acknowledges that their primary source of

knowledge about *The Breakfast Club* was Wikipedia, instead of the film itself—a small recognition of the power of the digital in twenty-first-century remix culture. Access to the original text is not necessary to participate in a remix of it.

Remix happens within and outside the public domain: "Once Upon a Fairytale Cruise" placed the Scarecrow, the Hatter, Wendy Darling, Peter Pan, the Queen of Hearts, and Goldilocks aboard the Storybook Love Singles Cruise on the SS Public Domain. Meanwhile, the *Cinderbrush High* one-shot was based on the *Monsterhearts* and *Monsterhearts 2* RPG created by Avery Alder (a "Queer anarcho-communist game designer. Ready to imagine the worlds we need") and mashed together the works of an independent game designer.

These one-off adventures are remixes as parody and pastiche, typified by "the transposition of… sampled materials into a new relation."[27] However, these episodes are least interesting in the context of digital humanities because of their techniques and their rhetorical effect upon the viewer.

At the level of *technique*, the one-shots are remixes the way that *Sherlock Holmes in the 22nd Century* was a remix of Sherlock Holmes stories and pulpy animated science fiction, or the *Teenage Mutant Ninja Turtles* was a remix of several popular genres of movies and comics. This is a form of remix that predates the digital technologies of the twenty-first century that made richer, more complex remixes possible.

At the level of *effect*, the *Critical Role* one-shots are subject to Pigott's argument that some forms of remix function to "return the individual to comforting ground."[28] Navas explains, using Adorno's criticism of regressive listening: "As Adorno would argue, [these remixes] support the state of regression that gives people false comfort."[29] These *Critical Role* one-shots are unchallenging, uncomplicated. They achieve positive fan response because parts of our brain light up when we see echoes of favorite childhood media, but they do little more than that.

The one-shots are, as remixes, creative dead ends, or as Michele Knobel and Colin Lankshear call them, "infertile hybrids." In "Remix: The Art and Craft of Endless Hybridization," Knobel and Lankshear compare remixing to the process of biological hybridization, noting that some hybrid plants and vegetables are rendered infertile in the process of hybridization, while others continue to produce seeds. Nowhere was the infertile hybrid of regressive remix more visible than in the *Feast of Legends* one-shot.

Critical Role received fees from Wendy's to play a role-playing game in which players enter the realm of "Queen Wendy, first of her name, breaker of fast food chains, defender of all things fresh, never frozen." According to the rules, available online as a PDF: "'The Clapback Queen' has been the ruler of Freshtovia since 1969, and defends the realm from the treacherous evils of those who practice the dark art of frozen beef." At one level, Freshtovia, as a campaign setting, is no different from integrating Lankhmar or Middle Earth into role-playing, with tongue firmly planted in cheek. The rules blend Wendy's intellectual property with the traditional fantasies of tabletop role-playing games. For example, the rules include a list of available armors, including "fresh baked bun" and "clamshell packaging." The game itself is hard to assess, critically—someone unfamiliar with tabletop role-playing games would probably find the rule book inadequate to teach them how to play a role-playing game. *Feast of Legends* is not a game for new gamers; it is a game designed to make current players laugh (or groan).

The session is hilarious; *Critical Role* is staffed by professional actors who make the most of any material. But neither the game itself nor the quality of the *Critical Role* performance was really at issue; it was the contact point between *Critical Role* as the

domain of escapist, apolitical fandom, and Wendy's as a corporation implicated in politics. Some passionate *Critical Role* viewers could not find a way to make sense of this combination of worlds.

Accepting financial support from Wendy's was read among some fans as a tacit acceptance of political positions held by Wendy's. Notably, Wendy's refused to be a cosignatory of the Fair Food Program, which asks suppliers to acknowledge that laborers have the right to shade and water in the fields, to work free from sexual harassment and more. Additionally, Wendy's ownership (through a hedge fund, Trian Partners, run by Trump donor Nelson Peltz) has significant connection to Donald J. Trump. According to Truthout.org: "Peltz personally gave $85,800 to Donald Trump in 2016 and 2017. This included three donations of $25,000 each to the joint fundraising committee Trump Victory and four donations of $2,700 each to the Trump campaign."[30] To bring *Critical Role* into contact with Wendy's was not just bringing professional voice actors into Freshtovia; a whole array of political issues were brought into the mix at the same time.

The *Critical Role* staff scrubbed nearly all evidence of the video from their official feeds and records. The community was significantly jarred by the mashup, not of D&D and fast food, but escapism and politics. The *Feast of Legends* controversy reminded both the creators and the viewers of *Critical Role* of the power and the limits of remix to make sense of the world.

If the most *Critical Role* aspired to were simple fantasies like "Once Upon a Fairytale Cruise," the *Critical Role* project would be a footnote to the series of video RPG shows like *I Hit it with my Axe*. If they were producing only pastiche, only regressive remixes that are infertile as creations, *Critical Role* would not be worth our time and effort. But in their campaigns, the *Critical Role* project creates something more valuable.

Campaigns as Regenerative Remixes

In its multiyear campaigns, *Critical Role* also exemplifies what Navas calls "regenerative remix." Navas defines a regenerative remix as "a recombination of content and form that opens the space for Remix to become a specific discourse intimately linked with new media culture. The Regenerative Remix can only take place when constant change is implemented as an elemental part of communication, while also creating archives."[31] Navas imagined regenerative remix to be the product of technology, where algorithms bring data together (one of his examples are RSS readers, which create a kind of remix every time the user logs in). Regenerative remixes are built upon digital archives; in that sense, regenerative remixes are a signature phenomenon of the digital humanities, which grounds the production of knowledge in digital tools that utilize digital archives.

There is something powerful about differentiating remixes generated by algorithms from remixes generated by the human hand. Navas has also discussed the processes of human speech as a form of regenerative remix (in "Regenerative Culture"). We build speech from phonemes, from a common storehouse of words, in something like the regenerative process that Navas identifies as the next stage in remix culture. In the ways that Navas saw speech as analogous to, and so informative of, regenerative remix, we want to restore the human; we assert that digital media create opportunities for regenerative remix that is created by role-players and fans of *Critical Role*.

Critical Role embodies the constant change (necessary in a regenerative remix) through the evolution over the campaign and across platforms. Because its sessions are stored (and searchable) on their YouTube channel and on their own website, *Critical*

Role embodies the construction of an archive necessary for regenerative remix, with supplemental archival materials (for example, transcripts, analytical statistics of gameplay, and more) being provided by fans and feeding further, regenerative remixes.

We view each campaign as a megamix, as Navas describes it, designed to "present a musical composition riding on a uniting groove"[32]—often pulling together beats, melodies, and sounds from multiple songs and sources. These multiple sources are "sequenced to create what is in essence an extended collage: an electronic medley."[33] The campaign (a series of narratively interconnected gaming sessions over weeks, months, or years) gives players a chance to create such a collage from their own imagination and from the wealth of cultural and gaming information available online through the "logic of the database." Navas describes the power of the database in constructing fictional worlds as well as our shared reality: "the archive becomes the field of knowledge to be accessed; it is the archeological ground to be explored by sophisticated researchers and lay-people alike."[34] Mercer, as Game Master, consults the archive of fantasy and mythology, of literature and film, of anime and manga, too, to create the world of *Critical Role*; his players draw similarly deep to construct their own characters.

We will discuss each *Critical Role* campaign in turn, outlining the narrative of the campaign, the work Mercer does as Game Master to craft a remix, the work his players do to craft a remix in their responses. As those three significant forces act at the gaming table, a regenerative remix is created, featuring elements that are "constantly updated, meaning that they are designed to change according to data flow."[35] We will end with an acknowledgment of the many participants who utilize the archive created by *Critical Role* for their own remixes, via fan fiction and other creations.

Campaign One—Vox Machina as Remix

Game masters (like Mercer) use what Neal Baker calls secondary world infrastructures to bring their worlds to life: maps, timelines, genealogies, charts, dictionaries, encyclopedias, and other related materials.[36] Mercer invented Exandria as a setting, leaning heavily on historical, geographical, and geopolitical resources to craft a believable world. For example, Mercer integrated facets of medieval European history with the familiar worlds of *Dungeons & Dragons* fantasy, setting the Elven city of Syngorn (with its defensive ability to shift from the material plane into the Feywild) on the same continent with the largely human cities of Westruun (similar to a midsized medieval city like York) and Emon (the capital city of the continent of Tal'Dorei and parallel to a medieval Prague, complete with castle).

The first story arc of the campaign takes the players into the Underdark, beneath the busy mines of the Dwarven city of Kraghammer, the industry-and-economy-fixated local government of which ignores the foment of potential disaster literally under their feet.[37] The medieval reference might be the Peasants' Revolt against an economically clueless Richard II in the London of 1381. A wearyingly accurate contemporary parallel exists in the persistent move toward industrial deregulation in the face of obvious global climate change. In these frames, Mercer is engaging remix as allegory.[38]

The second story arc involves the personal history of one of the party members, Percival Fredrickstein von Mussel Klossowski de Rolo III of Whitestone (Percy), whose surprise encounter with the villainous Briarwoods leads to a quest of personal revenge and the eventual liberation of Whitestone. Were Sylas and Delilah Briarwood not, respectively, vampire and sorceress, their ruthless assassination of the de Rolos and

subsequent subjugation of the country would closely parallel Lord and Lady Macbeth. The ultimate adversary of the campaign and the focus of the final story arc is an even deeper pull from *D&D* lore, the third and fifth edition villain built up from two first edition artifacts, the Hand of Vecna and Eye of Vecna.[39] That villain planned to ascend to godhood, plunging the entire gameverse into disaster of apocalyptic proportions.

The skills at acting and improvisation of the entire company make *Critical Role* as a whole possible. Taliesin Jaffe's fascination with and knowledge of historical firearms fueled his creation of Percy (a steampunk-style tinker) and the resulting creation of the Gunslinger class, now a formally published part of the *Dungeons & Dragons* rulesets. Liam O'Brien's classical stage training informed the tragic subtext of Vax'ildan's journey toward the Raven Queen.[40] Sam Riegel's musical theater and acapella background enabled the bardic inspirations of Scanlan Shorthalt.[41] Each of these is a defining element of the collaboratively generated remix that was Campaign One. Joe Manganiello reprised his player character from another streaming game DM'd by Matthew Mercer (remixing beats from one campaign to another). This moment created an open ending to the campaign that provides an opportunity for future players (and fan fiction writers) to remix Manganiello's moment into the backstory of their own heroes' quests.[42]

The narrative of the campaign begins with the remixing efforts of the game master, the players bring their own knowledge into the regenerative remix of the campaign, which grows and transforms in unexpected ways (especially as the guest players participate), and which leaves digital traces for further fan creativity in more unexpected, joyful, regenerative remixes.

Campaign Two—The Mighty Nein as Remix

In creating the backdrop for this second campaign, Mercer determined that there would be minimal-if-any crossover from the previous campaign. Beginning twenty years after the end of the previous campaign, this game also takes place on a completely different continent—Wildemount.[43]

The central preoccupation of the world surrounding the characters is an open war between the Dwendalian Empire and the Kryn Dynasty of Xhorhas. The Xhorhasian culture is a departure and significant extension of *D&D* lore surrounding drow, or dark elves. In early editions of *D&D*, drow were almost invariably evil, subterranean worshippers of the evil spider god Lolth.[44] In Mercer's gameverse, Xhorhasian drow religion surrounds the physical manifestation of light itself, the Luxon, and the pursuit of immortality. Their leader, the Bright Queen Leylas Kryn, has lived thousands of years over many lifetimes due to the cyclical nature of Xhorhasian immortality.[45] The Dwendalian Empire looks very much like the Holy Roman Empire or the empire of Charlemagne in medieval European history, complete with religious suppression and repression. The empire is helmed by a tyrannical Emperor who may or may not be the puppet of a group of powerful, Illuminati-reminiscent mages called the Cerberus Assembly.[46]

Real-world events disrupted game elements. Ashley Johnson, whose work on NBC television drama *Blindspot* took her away from the game, was leaving again. Laura Bailey and Travis Willingham, who had already been in discussions with the DM about family leave, had their baby arrive early. Mercer wrote a kidnapping by traffickers into the story to explain the sudden absence of Yasha, Jester, and Fjord, and the party's subsequent recruitment of guest player characters, notably Ashly Burch's dwarf fighter Keg and Sumalee Montano's firbolg druid Nila. During a failed rescue attempt, one of the other

player characters, Mollymauk Tealeaf, was killed.[47] The urgency and desperation of the party to rescue their teammates parallels another Tolkien touchstone, the kidnapping of two hobbits by orcs and the subsequent chase to Isengard.[48] At the end of episode 30, "The Journey Home," the party is reunited.

Later episodes are remixed from pop cultural piracy icons like the luck-driven incompetence of Captain Jack Sparrow in the *Pirates of the Caribbean* series and a Cthulhu-like entity, Uk'otoa, and its allies. The party spent several sessions exploring jungle temples and uncovering powerful artifacts and also fleeing from the consequences of their findings in similar fashion to *Indiana Jones*.[49] Remix in Mercer's campaign, most often the invocation of narrative structures that are allegorical with other narratives, provides a comfortable structure, a familiar structure, against which rich character development is possible.

The contributions of the regular cast/players to Campaign Two differ somewhat from Campaign One, which reflects the very different characters they have created. Taliesin Jaffe's experience with and knowledge of carnival and Renaissance Festival culture heavily informs the character of Mollymauk Tealeaf and the circus in which the opening conflicts of the campaign take place. The found-family relationships among the circus folk model the group dynamics that the newly fledged Mighty Nein began to emulate and improve to the extent that this became a subtheme for the entire campaign, one brought in a new and regenerative way, unanticipated by Mercer.

Critical Role is deeply collaborative, perhaps even more so than most television or film productions because it is unscripted and improvised. It would be tempting to call the remix of the campaigns a product of Mercer's architecture, as a game master—it would be tempting to call Mercer the remixer. But the allegorical structures infused into his game world and game narrative could, in the wrong hands, be as infertile a remix as the one-shots. Instead, each campaign is the product of a polyphony of creators, integrating a multiplicity of voices, and so produces a regenerative remix. The second layer of creativity arises when we consider the fan culture.

Regenerative Remix and the Moment of the Mollymauk[50]

The *Critical Role* fan base has been energetic as a creative force within remix culture, using multiple databases, accessing multiple archives of information about the world of their favorite podcast. In this way, *Critical Role* fans go further than some fan cultures. Studies of fandom owe an immense debt to the work of Henry Jenkins, who built an initial model for "participatory culture" among fans of popular culture in *Textual Poachers*.[51] He followed that work through the study of media across platforms: *Convergence Culture*. To the extent that the *Critical Role* community advances across books, websites, video platforms, and fan fiction and art, *Critical Role* exemplifies *Convergence Culture*.[52] The diversity of creative works by fans, including remix works, within a convergent media property is explored, finally, in *Fans, Bloggers, and Gamers*.[53] We are carrying that work forward here, as we look at the convergent media culture and remixed creativity among the Critters.

Among these are the *Critical Role Wiki*, *CritRoleStats*, *Critical Role Transcript*, and *Critical Role Translate*.[54] Fans are not limited to living inside the world expressly created in the podcast.

In their own creations, and at the direct invitation of Mercer and the cast, fans expand on the universe of *Critical Role* in any way that seems good to them. One particularly fruitful direction for this expansion is in the fan fiction written around the relationships between

Figure 22.1 Twitter feed screenshot: Morgan Luthi, *Nott a Locksmith*, digital art, July 28, 2018. (Posted by the artist to https://twitter.com/morganluthi/status/102333832676440 0640?s=11)

the characters, both canonical and noncanonical. "Shipping" or fan discussion around perceived romantic relationships among the characters provides a popular outlet of speculation for fans, cast, and crew alike.[55] All of the cast members have been vocal about their support for shippers and have invited fans to speculate freely beyond the canonical reality of the live-streamed game. Their attitude embraces the creativity of fans and the utility of the characters they have created to inspire story building outside the game. One active platform for fan fiction is the aforementioned *Archive of Our Own* (AO3).[56] Fans are remixing the campaigns and the characters and plots within them, remixing the megamix.

Fans are also remixing *Critical Role* content with their favorite elements of popular culture. Morgan Luthi's art (Figure 22.1) is one exemplar of such creativity.

The character pictured here is Nott the Brave. She and Jester, another C2 player character, often partner with ineffectual and frequently hilarious results as "Nott the Best Detective Agency." In remixing *AD&D* fantasy, film noir era private eye imagery, and Scooby-Doo title card animation style, Luthi brings together three very inside jokes (and a direct quote from the livestream Twitch chat for episode 2×28 "Within the Nest") in one image.

The creative power of fan remix has been studied for decades; in the case of *Critical Role*, the complex archive created for the show makes near-infinite variations of remix possible. The creators encourage it. In one of the pivotal narrative moments of The Mighty Nein campaign, the sudden, unexpected, and brutal death of a player character (Mollymauk) rocked the players and the fandom.[57] In the *Talks Machina* after show for that episode, Mercer, Ashley Burch, and Taliesin Jaffe took questions from the fans and made an effort to guide the response in a positive and creative way. Jaffe offered: "Other people can put Mollymauk in their games—he can do all sorts of crazy things." Looking directly at the camera, he continued: "Please, please do that. You have my permission. Please."[58] Mercer agreed,

> Any of you folks playing any Wildemount campaigns, or planning to go there, please, by all means, continue that thread as you see fit. You know, that's part of our big thing with playing this game and releasing the last campaign guide, and helping present this information to the community. As much as it's our game, we

want it to be a gift and an invitation to others to come play in that space, and invite [the fans/viewers/gamers] to take elements of the story and run with it.[59]

For many novice and seasoned gamers and GMs alike, *Critical Role's* invitation to participate in regenerative remix represents a golden opportunity to do just that.

Conclusion

Our goal has been to expand the definition of regenerative remix, in this document, to include the forms of remix that are 1) enabled by digital distribution and database access to impossible volumes of information, text, visual, and audio materials, but 2) produced by a genuine and powerful openness to collaboration with others. Algorithmically generated regenerative remixes are powerful and pervasive in our culture, but in an era that the World Health Organization has characterized as suffering from "infodemic," algorithms are as likely to produce narrower and narrower pictures of the world. Our Twitter feeds, Facebook feeds, and RSS readers, shaped to our interests and narrowed to the sources that will guarantee that we log in again to experience their remix (and their advertising), are as likely to circulate comfortable, affirming disinformation as they are likely to open us up to new perspectives from people unlike ourselves.

We are reopening consideration of regenerative remix to include the vast networks of collaboration exemplified by the interactions between game master and players at the role-playing game table. We are reopening consideration of regenerative remix to include the work that the digital archive created by game master and players online makes possible at other tables. We are reopening consideration of regenerative remix to include the work that the digital archive makes possible among fan fiction writers and fan artists. There is a radical openness in the *Critical Role* project that cultivates a spirit of collaboration, and an ethical responsibility, that we want to wed to the creative powers of the regenerative remix.

As scholars and optimists, we hold out hope that regenerative remix theory will offer us a way to bridge divisions and to collaborate in the real world in the same way that we collaborate in our fantasy medieval campaigns—with a genuine openness to the power and contribution of others, in a way that promises open and ethical participation in our shared, regenerative forms of culture.

Notes

1 D. Mackay, *The Fantasy Role-Playing Game: A New Performing Art* (London: MacFarland, 2001), 4.
2 James M. Ward, Robert J. Kuntz, Lawrence Schick, *Advanced Dungeons & Dragons: Deities & Demigods Cyclopedia* (Lake Geneva, WI: TSR Games, 1980).
3 Those early editions also taught creators the complications of intellectual property law, as traced by David Hartlage in the DMDavid Blog.
4 Gary Gygax, David Cook, Francois Marcela-Froideval, *Oriental Adventures*.
5 Tracy Hickman, Laura Hickman, *Ravenloft*.
6 *Terror Australis* by Penelope Love; Mark Morrison; Lynn Willis; Larry DiTillio; Sandy Petersen. For scholarly discussion of CoC, see Hite, Kenneth. 2007 "Narrative Structure and Creative Tension in Call of Cthulhu."
7 Pathfinder: Pure Steam Campaign Setting by ICOSA Entertainment.
8 Among the earliest Steve Jackson GURPS projects were GURPS Fantasy: Fantasy World and Magic Rules for the Generic Universal role-playing System by Steve Jackson; *GURPS Japan: Role-Playing in the*

World of the Shogunate by Lee Gold; *GURPS Swashbucklers: Role-Playing in the World of Pirates and Musketeers* by Steffan O'Sullivan, Michael Hurst, Sharleen Lambard, and other supplements for Conan, Witch World (based on Andre Norton's Witch World books), Robin Hood, and others.

9 Wizards of the Coast made the basic *D&D* rules freely available to the general public, called d20. The d20 System is published under an open gaming license that allows anyone to use, distribute, or change these rules for private and commercial use. For a critical discussion, see Dormans, Joris. "On the Role of the Die: A Brief Ludologic Study of Pen-and-Paper Role-Playing Games and Their Rules."

10 Game Master is the generic term for the central storyteller in a role-playing game; in *D&D*, the GM is referred to as a Dungeon Master, or DM.

11 Walker credits her start in gaming with a direct convention encounter with the great Gary Gygax himself. She has GM'd professionally and extensively at gaming conventions, using a wide array of RPG systems, in addition to her decades of recreational experience. She currently runs a first edition *Advanced D&D* campaign for ten players in Duluth, Minnesota.

12 One pre-owned, 1978 first edition *Player's Handbook* was offered on eBay recently for $299.99, before shipping fees. We will discuss solutions to this barrier later in the chapter.

13 Ford's association with *Runequest* creator Steve Perrin resulted in Perrin's running his own game for a local Duluth, Minnesota, gaming convention "Berserkon" in 2014.

14 A strangely apt detail in the rhetoric of tabletop gaming is the aspect of "rules-as-written" or RAW—a gaming methodology often reserved for competition or convention gameplay, when a game consists of a party of players unused to each other or to their erstwhile GM. This approach to gaming contrasts strongly with a long-term game campaign where the players participate regularly and over a long period of time, and in which the GM is more at liberty (and is expected) to adapt or improvise "home-brewed" encounters, game mechanics, and details.

15 Eduardo Navas, *Remix Theory: The Aesthetics of Sampling* (Birkhäuser: Amber Verlag, 2014), 76.

16 For a critical discussion of the widespread availability of digital tabletop role-playing game materials from the perspective of a library, see Sich, Dan. "Dungeons and downloads: collecting tabletop fantasy role-playing games in the age of downloadable PDFs." *Collection Building* (2012) Vol. 31 No. 2, pp. 60–65. https://doi.org/10.1108/01604951211229854.

17 See Colin Cummings, *Boy Problems* (2019) and *Black Heart* (2019), available at https://boyproblems.ca/boyproblems.

18 Wulf Gar (active Duluth, Minnesota, game master), in discussion with the author, February 2020.

19 Walker also talks about the difficulty of working with, or DMing for, some players who come to a convention game armed with the minutiae of every possibility for their specific character class and that for the sake of players who come for the fun of the game, it is necessary to put limitations on this behavior.

20 This is reminiscent of digital facsimile medieval manuscripts consulted in bygone projects of a strangely parallel kind.

21 Premeet Sidhu and Marcus Carter measure this new dissemination of tabletop RPG culture in "The Critical Role of YouTube and Twitch in *D&D*'s Resurgence" (*Proceedings of the DiGRA [Digital Games Research Association] Australia 2020*, Queensland University of Technology). Sidhu and Carter noted that "17 of our 20 participants mentioned the impact of various new media platforms on their play of *D&D*..." One participant iterated that *D&D* was "being swept up in this greater cultural trend of things becoming more accessible" through new media.

22 A simple search for "Critical Role (Web Series)" in the Archive of Our Own site yields 14,563 individual stories (some of standard novel length or longer) as of July 22, 2020.

23 They also help to facilitate this through mini web series like *Pub Draw*, in which professional comics artist Babs Tarr coaches prospective fan artists in use of digital artists' resources and techniques to produce their own artistic content not only about the show but also about their own characters and creations.

24 Perttu Vedenoja traces earlier shows like *I Hit it with my Axe* through *Tabletop* on the Geek and Sundry network.

25 For example, in *Fans, Bloggers, and Gamers: Exploring Participatory Culture* (New York: New York University Press, 2006).

26 Eduardo Navas, *Remix Theory: The Aesthetics of Sampling* (Birkhäuser: Amber Verlag, 2014), 93.

27 Mark Nunes, "Parody," *Keywords in Remix Studies*, edited by Eduardo Navas, Owen Gallagher, Xtine Burrough (London: Taylor and Francis, 2017), 93.

28 Michael Pigott, *Joseph Cornell versus Cinema* (London: Bloomsbury, 2015), 37.

29 Eduardo Navas, *Remix Theory: The Aesthetics of Sampling* (Birkhäuser: Amber Verlag, 2014), 96.

30 Derek Seidman, "Wendy's Owner Gives Big to Trump While Refusing Farmworkers' Demands," Truthout, April 4, 2019: https://truthout.org/articles/wendys-owner-gives-big-to-trump-while-refusing-farmworkers-demands/, accessed June 19, 2020.

31 Eduardo Navas, "Regressive and Reflexive Mashups in Sampling Culture," In *Mashup Cultures*, edited by Stefan Sonvilla-Weiss (Vienna: Springer, 2010), 157–177.

32 Navas, *Remix Theory*, 95.

33 Navas, *Remix Theory*, 94–95.

34 Navas, "Regressive and Reflexive," 173.

35 Navas, "Regressive and Reflexive," 162.

36 Neal Baker, "Secondary World Infrastructures and Tabletop Fantasy Role-Playing Games." *Revisiting Imaginary Worlds* (New York: Routledge, 2016).

37 It is very difficult not to reference the internationally inadequate response to COVID-19 in this context, although that parallel did not exist when the campaign started.

38 This reflects the pattern described in Navas' discussion of "Allegory in Remix." *Remix Theory*, 66–67.

39 Gary Gygax and Brian Blume, *Dungeons & Dragons Supplement III: Eldritch Wizardry, Ancient and Powerful Magic* (New York: TSR Games, 1976).

40 The intermingling of personal grief and grief in-narrative is recorded in Daniel Mazzacane, "How *Critical Role* Uses Role Play to Explore the Burden of Grief."

41 Courtney Kraft "Critical Role's Sam Riegel."

42 In the new campaign guide, there is an indirect reference to this situation and the unresolved issue of Vecna's remains in a brief description of one of the cults of Wildemount called "The Remnants." Mercer, *Explorers Guide to Wildemount*, 57.

43 There is an expansion volume for fifth edition *D&D* based on Mercer's setting. The *Explorer's Guide to Wildemount* contains over 300 pages of content, including geopolitical features of the continent, the pantheon and how religions function and clash across the region, maps, details on the aforementioned Vestiges of Divergence, and three subclasses of magic user based on Mercer's own invented class of magic—Dunamancy.

44 Drow were also, from their first appearance in print in 1977, described as dark-skinned humanoids. The persistent association of drow with monstrous or malevolent intent has been one of the more problematic reflections of racist bias in the game. Mercer's take on this culture is part of a larger shift in D&D to course correct these portrayals and representations of difference. See *The Drow of the Underdark* by Ed Greenwood.

45 This extensive life span, as the players learn in-game, is more similar to reincarnation and involves varied physicalities, gender identities, and sexualities. The Xhorhasian military leader and the Empress, for example, are both female in their current lifetimes and have been life partners for many centuries.

46 The ominous nature of the name is entirely intentional.

47 This was a pivotal moment in the evolution of all of the characters and of the party as a whole. It also serves as a nexus point for fan investment in the story. See later in this chapter.

48 Tolkein's story moment of the loss of Boromir trying to prevent the abduction and the emotional fracturing of the party survivors is also mirrored in this instant of phase two as Beau, Nott, and Caleb steel themselves against the loss of Molly in order to function through the rescue of the others.

49 Mercer drops in several direct callbacks to the *Indiana Jones* movies, *The Goonies,* and the *Mummy* series.

50 Long may he reign—a paraphrase from the character himself that has become a touchstone for the fandom at large.

51 *Textual Poachers: Television Fans & Participatory Culture. Studies in Culture and Communication* (New York: Routledge, 1992).

52 *Fans, Bloggers, and Gamers: Exploring Participatory Culture* (New York: New York University Press, 2006).

53 *Convergence Culture: Where Old and New Media Collide* (New York: New York University Press, 2006).

54 These resources are at https://criticalrole.fandom.com/wiki/Critical_Role_Wiki, https://www.critrolestats.com/, https://crtranscript.tumblr.com/transcripts, and https://crtranslate.tumblr.com/, respectively. It is important to note the emphasis on improved accessibility (beyond the joy of obsessive fandom) with which the fan community themselves undertook both the transcription and translation projects. An additional resource that will prove invaluable to further scholarly work on the content of the show is the searchable database version of the transcripts built by Stuart Langridge at https://kryogenix.org/crsearch.

55 The term "shipping" has long been an integral part of fandom shorthand, far before the advent of Critical Role, being a cornerstone of fan fiction in every online fan community and going back into the pre-Internet days of print media fanzines. Works based on this concept can be found in the homage and

pastiche literature of Trekkies and, still earlier, Sherlockians (the most popular of these "ships" is the one known simply as "Johnlock").

56 See note 22. It is worth noting that the numbers for the site have ballooned even more rapidly since the COVID-19 lockdown. Despite the livestream of *Critical Role* being on an extended hiatus from March 17 to July 2, 2020, the site went from 12,472 *Critical Role* entries on March 1 to 14,575 on July 23.

57 Jaffe's character, Mollymauk Tealeaf, had become for many fans the representation of Queer in the show, and losing him after over 7 months of weekly games (January 11–July 12, 2018) hit particularly hard.

58 The vivid and varied afterlife of Mollymauk Tealeaf has embodied Jaffe's good wishes for the character. Two of the most amazing pieces of fan art for the character are by Jessica Nguyen: https://twitter.com/jessketchin/status/1146515627097542656?s=21 and by Emi Linders: https://twitter.com/jesttothenines/status/1018011185478815744?s=21.

59 *Talks Machina*, 2×26, 45:04-45:38.

Bibliography

Baker, Neal. "Secondary World Infrastructures and Tabletop Fantasy Role-Playing Games." *Revisiting Imaginary Worlds*, 113–125. New York: Routledge, 2016.

Barness, Jessica, and Amy Papaelias. "Critical Making at the Edges." *A special issue of Visible Language* 49, no. 3 (2015): 5–11.

Bennett, Richard D. "Between Two Worlds: A Rhetorical Analytical Framework for Tabletop Role-Playing Games." Master's thesis. Fairfax, VA: George Mason University, 2018.

Bourgonjon, Jeroen. "Video Games as Equipment for Living." In *Digital Humanities and the Study of Intermediality in Comparative Cultural Studies*, edited by Steven Tötösy de Zepetnek, 88–99. West Lafayette: Purdue Scholarly Publishing Services, 2013.

Bourgonjon, Jeroen, and Ronald Soetaert. "Video Games and Citizenship." *CLCWeb: Comparative Literature and Culture* 15, no. 3 (2013): 8.

Champion, Erik. *Critical Gaming: Interactive History and Virtual Heritage*. 1st Edition. London: Routledge, 2016.

Chapman, Adam. *Digital Games as History: How Videogames Represent the Past and Offer Access to Historical Practice*. 1st Edition. London: Routledge, 2016.

Critical Role LLC. "Talks Machina: Discussing C2, E26 – Found and Lost." Critical Role, July 17, 2018. Video, 1:23:42. https://youtu.be/D3rwMS_yqGo.

Cummings, Colin. "Boy Problems." Last modified June 3, 2020. https://boyproblems.ca/ tabletop-releases.

—. "Black Heart." Last modified July 2, 2019. https://boyproblems.ca/tabletop-releases.

de Zepetnek, Steven Tötösy, ed. *Digital Humanities and the Study of Intermediality in Comparative Cultural Studies*. West Lafayette, IA: Purdue Scholarly Publishing Services, 2013.

Dormans, Joris. "On the Role of the Die: A Brief Ludologic Study of Pen-and-Paper Role-Playing Games and Their Rules." *Game Studies* 6, no.1 (2006). Online at http://gamestudies.org/ 0601/articles/dormans.

Gold, Lee. *GURPS Japan: Role-Playing in the World of the Shogunate*. 1st Edition. Austin, TX: Steve Jackson Games, 1988.

Greenwood, Ed. *The Drow of the Underdark*. 1st Edition. Renton, WA: Wizards of the Coast LLC, 1999.

Gygax, Gary and Brian Blume. *Eldritch Wizardry: Ancient and Powerful Magic*. 1st Edition. Lake Geneva, WI: TSR Games, 1976.

Gygax, Gary, David Cook, and Francois Marcela-Froideval. *Oriental Adventures*. 1st Edition. Lake Geneva, WI: TSR, 1985.

Hartlage, David. "The True Story of the Cthulhu and Elric Sections Removed from *Deities & Demigods*," *DMDavid*. January 8, 2019. https://dmdavid.com/tag/the-true-story-of-the-cthulhu-and-elric-sections-removed-from-deities-demigods/.

Hickman, Tracy and Laura Hickman. *Ravenloft*. 1st Edition. Lake Geneva, WI: TSR Hobbies, 1983.

Hite, Kenneth. "Narrative Structure and Creative Tension in Call of Cthulhu." *Second Person: Role-Playing and Story in Games and Playable Media*. Cambridge, MA: MIT Press, 2007, 31–40.

Hope, Robyn. "Play, Performance, and Participation: Boundary Negotiation and Critical Role." *Dissertation*. Montréal: Concordia University, 2017.

ICOSA Entertainment. *Pathfinder: Pure Steam Campaign Setting*. 1st Edition. Redmond, WA: Paizo Inc, 2017.

Jacinto, Kyle Gerrard. "How Dungeons and Dragons Benefit College Students." Unpublished Undergraduate Project. Austin, TX: University of Texas, 2018. https://www.researchgate.net/publication/330833986_How_Dungeons_and_Dragons_Benefit_College_Students

Jackson, Steve. *GURPS Fantasy: Fantasy World and Magic Rules for the Generic Universal Role-Playing System*. 1st Edition. Austin, TX: Steve Jackson Games, 1986.

Jenkins, Henry, and Henry Jenkins. *Convergence Culture: Where Old and New Media Collide*. 1st Edition. New York: New York University Press, 2006.

—. *Fans, Bloggers, and Gamers: Exploring Participatory Culture*. 1st Edition. New York: New York University Press, 2006.

—. *Textual Poachers: Television Fans & Participatory Culture*. *Studies in Culture and Communication*. 1st Edition. New York: Routledge, 1992.

Knobel, Michele, and Colin Lankshear. "Remix: The Art and Craft of Endless Hybridization." *Journal of Adolescent & Adult Literacy* 52, no. 1 (2008): 22–33.

Kraft, Courtney. "*Critical Role's* Sam Riegel," *Geek and Sundry*, September 17, 2015. https://geekandsundry.com/critical-roles-sam-riegel-from-noob-to-gnome-hero/.

Love, Penelope, Mark Morrison, Lynn Willis, Larry DiTillio, and Sandy Petersen. *Terror Australis*. 1st Edition. Albany, CA: Chaosium Inc, 1987.

Mackay, Daniel. *The Fantasy Role-Playing Game: A New Performing Art*. 1st Edition. London: MacFarland, 2001.

Manovich, Lev. "Database as a Genre of New Media." *AI & Society* 14, no. 2 (2000): 176–183.

Markham, Annette. "Remix Cultures, Remix Methods: Reframing Qualitative Inquiry for Social Media Contexts." In *Global Dimensions of Qualitative Inquiry*, 63–81. New York: Routledge, 2013.

Mazzacane, Daniel. "How Critical Role Uses Role Play to Explore the Burden of Grief." *Wrangler*, December 10, 2019. https://thewrangler.org/2019/12/10/critical-role- burden-of-grief/.

McKernan, Charlotte M. "Worldbuilding: A Survey of Games and Architecture at Play." *Master's thesis*. Albuquerque: University of New Mexico, 2017.

Mercer, Matthew, James Haeck, James Introcaso, Chris Lockey, and Even Amundsen. *Explorers Guide to Wildemount*. 1st Edition. Renton, WA: Wizards of the Coast LLC, 2020.

Mortara, Michela, et al. "Learning Cultural Heritage by Serious Games." *Journal of Cultural Heritage* 15, no.3 (2014): 318–325.

Navas, Eduardo. *Remix Theory: The Aesthetics of Sampling*. 1st Edition. Birkhäuser: Ambra-Verlag, 2014.

—. "Regenerative Culture, Norient Beta." March 27, 2016. https://norient.com/academic/ regenerative-culture-part-15/.

—. "Regressive and Reflexive Mashups in Sampling Culture." In *Mashup Cultures*, edited by Stefan Sonvilla-Weiss, 157–177. Vienna: Springer, 2010.

Nunes, Mark. "Parody." In *Keywords in Remix Studies*, edited by Eduardo Navas, Owen Gallagher, Xtine Burrough. London: Taylor and Francis, 2017.

O'sullivan, Steffan, Michael Hurst, Sharleen Lambard, and Steve Jackson. *GURPS Swashbucklers: Role-Playing in the World of Pirates and Musketeers*. 1st Edition. Austin, TX: Steve Jackson Games, 1988.

Pigott, Michael. *Joseph Cornell versus Cinema*. 1st Edition. London: Bloomsbury, 2015.

Quality is Our Recipe, LLC. *Wendy's Presents Feast of Legends*. 2019. https://www.feastoflegends.com/images/Feast_Of_Legends.pdf.

Seidman, Derek. "Wendy's Owner Gives Big to Trump While Refusing Farm Workers' Demands." *Truthout.org*. April 4, 2019. https://truthout.org/articles/wendys-owner-gives-big-to-trump-while-refusing-farmworkers-demands/.

Sidhu, Premeet, and Marcus Carter. "The Critical Role of YouTube and Twitch in D&D's Resurgence" (Proceedings of the DiGRA [Digital Games Research Association] Australia Queensland University of Technology), 2020.

Vedenoja, Perttu. "Role-Playing Games in Visual Media: How to Make Tabletop Role-Playing Games Engaging for an Outside Audience?." *Master's thesis*. Oulu, Finland: Oulu University of Applied Sciences, 2016.

Ward, James M., Robert J. Kuntz, and Lawrence Schick. *Advanced Dungeons & Dragons: Deities & Demigods Cyclopedia*. 1st Edition. Lake Geneva, WI: TSR Games, 1980.

Wassink, Benjamin. "Cruising to be a Board Gamer: Understanding Socialization Relating to Board Gaming and *The Dice Tower*." *Master's thesis*. Missoula, MA: University of Montana, 2018.

Zimmerman, Josh, and Antonnet Johnson. "Sex as Forbidden Play in Critical Role and the Adventure Zone Fan Fiction." *Representing Kink: Fringe Sexuality and Textuality in Literature, Digital Narrative, and Popular Culture*, 157–168. Washington DC: Lexington Books, 2019.

23

VANDALIZE A WEBPAGE

Automation and Agency, Destruction and Repair

Ethan Plaut

Many of the hundred-plus Twitter bots my students submitted over the past two years were pieced together from popular culture, chopping rap lyrics or television plots into little phrases to be algorithmically reassembled on the fly. Other students' bots developed more original "voices" using bespoke syntactic rules and vocabularies. But the bot that made me think hardest was neither remixed from fragments nor invented ex nihilo. It was a wholesale verbatim appropriation of the popular game *Cards Against Humanity*. Following the game, which randomly assembles offensive jokes with the shuffle and deal of cards, the bot randomly generated tweets from the same exact set of phrases. The problem was neither plagiarism nor copyright—*Cards Against Humanity* is under a Creative Commons license—but that I expect homework assignments should not make jokes about rape and genocide. If this were a provocation by a hateful student, it would have been less interesting than what I found: an apparently naive kind of double abdication of responsibility, first because the source materials were someone else's words,[1] and second because the bot seemed to make the final decision of exactly what to tweet.

In this chapter, I present insights from a case study of undergraduate pedagogy combining critical readings with basic coding skills to develop projects that appropriate, remix, produce, and creatively destroy digital media—or sometimes even repair it. The technical skills students learn might otherwise be found, in bits and pieces, spread across courses in computer science, digital humanities, and design. In addition to computer science textbook chapters, students read critical scholarship, especially from media theory and cultural studies, as well as topical popular press pieces written by social scientists, humanists, data journalists, and more. One contribution of this chapter is to argue for a pedagogy that moves a bit too fast for comfort. For each project, students gain just enough technical skills and critical frameworks to engage in reflective forms of rapid prototyping, learn from that process, and move on to the next project. This pedagogy is inspired largely by the critical making[2] movement, which emphasizes critical thinking through the creative process rather than its products. This emphasis on process does not always lead to polished work, but the richest, most experimental pieces merit analysis beyond questions of

> See chapter 18 for xtine burrough's discussion on critical making.

pedagogy to rethinking our assumptions about the relationship between algorithmic and remix cultures. Our case study, therefore, proceeds with both an overview of the entire course and a close analysis of one assignment, the Twitter bot, for insights made possible by this collision of disciplines and materials.

Overview: Digital Communication and Practice

The course, titled "Digital Communication & Practice," is offered in The University of Auckland's Communication major. That major grew out of a preexisting Media program emphasizing Cultural Studies, Film Studies, and other humanistic approaches. In a typical enrollment of eighty students, there are a few programmers, but many more express fear of code. Their understanding of Artificial Intelligence (AI), for example, is largely grounded in science fiction. Through critique, many have already arrived at a nuanced understanding of AI that complicates and rejects pop-cultural depictions. But such an understanding remains grounded in these fictions even as it is critical of them. One learning goal for this course is to stimulate different ways of thinking about how computers might or might not "think."

The course has no major end-of-semester assessments. Instead, students complete small weekly projects, most importantly a series of "digital objects" of different kinds, each accompanied by brief text reflections on their processes of thought and creation.[3] Two of these digital objects, the aforementioned Twitter bot and vandalized webpage, conclude the first and second halves of the course, which also more or less correspond to the two organizing concepts of the present volume: digital humanities and remix studies. Technical skills are frontloaded, so the first few weeks we simultaneously work through excerpts of an introductory programming textbook[4] and read various texts asking whether coding is a way of thinking, a literacy, a form of life, perhaps something else entirely. The Twitter bot assignment, analyzed in detail below, marks the halfway point of the course.

The second half of the course emphasizes tools that automatically manage more technical details, allowing students to focus on different aesthetic and conceptual concerns as they create, remix, and present multimedia work. Again, creative projects are paired with critical readings centered on specific media and formats such as GIFs, data visualizations, and slide decks. The final project, "Vandalize a Webpage," unites the two units of the course as students appropriate and remix digital media at the level of the underlying code. This chapter concludes with insights from work by students who upended the assignment to "vandalize" by instead repairing media that they found broken. Repair is one ethical way forward, a countervailing force to the "move fast and break things" ethos shared, albeit in quite different ways, by remix culture and Silicon Valley. One challenge of this course is to balance that creative freedom to fail in the classroom against ethical questions out in the wider world. This is possible because the critical making approach treats hands-on experiences of coding and remixing alike as inseparable from analysis of their social implications.

Students are exposed to "distant reading" methods of digital humanities, which use computation as a means to understand literature and other preexisting texts.[5] In this course, however, we more often subject all kinds of text to algorithmic rearrangement, using it as fodder for exploring the hermeneutics of code[6] and digital media. By the end of the course, both directions of this simplified, bidirectional model of "big tent" digital humanities[7] are satisfied: through code, insights on the

meaning of appropriation art, and through humanistic inquiry, insights on computing (and the ethics thereof).

Sections below roughly follow the chronology of the course, starting with the first day, which sets the tone and prefigures issues to be addressed in the conclusion.

Unit 1: Digital Logic and Computational Thinking

To start the first lecture, before even introducing myself, I vandalized a webpage. The students' final project of the semester, some months in the future, would be a more meticulous act of digital vandalism, but the version I performed at the lectern was quite simple. As I plugged my laptop into the projection system, students had their first peek at the unruly assortment of mislabeled folders and files on my desktop, enlarged on screens behind me. This first impression was no accident. It set an implicit precedent that computing is a messy business that need not be cleaned or hidden. I opened a browser window and briefly perused the headlines. *Radio New Zealand (RNZ)* was a favorite victim of mine in this exercise, precisely because its earnestness as a public service broadcaster renders it especially vulnerable to parody, remix, and creative destruction. I downloaded the source files from their home page to a folder on my desktop, opened the HTML file in a text editor, and started digging through the code. I used the familiar "find" function to fish for the text of headlines in the code projected behind me, swapping in playful, emoji-laden jokes. I saved the file and switched back to the browser, which I used to open that same HTML file. Students saw that *RNZ* appeared to have been hacked. The headlines of the day had been replaced with jokes and emoji. Students audibly gasped on seeing how easy it was to manipulate a familiar institution. Somebody put a hand up to ask whether this is online at the *RNZ* web page now? I reassured them that no, I would not do that—people reading the news online were still seeing the real thing.

The students' first assignment is a gentle transition combining elementary programming skills with a more familiar exercise of media critique. The game *Human Resource Machine (HRM)* is similar to Scratch and other "block programming languages" used to teach schoolchildren the essential logic of programming through a drag-and-drop interface. Commands to copy, paste, add, subtract, increment, decrement, jump, comment, and more are color-coded and ready to be reordered to solve increasingly complex problems, from basic math to classic computer science challenges such as sorting algorithms. What distinguishes *HRM* is its presentation: the game is structured as a dreary office building, with the player's avatar an employee working their way up from the basement to the top floor by efficiently executing commands from middle management, with an ominous backstory that the corporation is complicit in a robot takeover of the world. It is both a teaching tool in computation and a satirical game world in which computation threatens to reduce humans to workers and workers to cogs. Students are, therefore, assigned not simply to play for technical skills but rather to write a critical reflection on the game as a cultural object. In this way, students are able to engage with this first exposure to programming in the more comfortable genre of media critique, making sense of the game's aesthetics and ideological content at the same time they puzzle their way through programming concepts like conditional statements and loops.

Assigned readings simultaneously progress along two parallel tracks. Chapters of a JavaScript programming textbook are paired with readings that introduce and problematize higher level concepts, e.g., programming as a literacy,[8] computational thinking,[9] and AI.[10] JavaScript is considered a web technology, but students in this course do not learn

web development. We instead focus on a subset of fundamental concepts of computer science, which could be taught in any programming language. One goal of introductory programming courses is for students to see past a programming language's syntax and other implementation details to appreciate the fundamental structure of programs. JavaScript has a related advantage that a student's toolbox remains small, working with just a text editor and a browser. This avoids students having to learn to use Integrated Development Environments, Unix commands, and other cumbersome details that could distract from underlying principles. Also, rather than teaching the many things that make JavaScript peculiar, we focus on the most basic syntax for writing programs,[11] which is similar to other "C-family" languages such as C, C++, C#, and especially Java.

It would be impossible for students in this course to master technical aspects of AI, but they learn to understand it in new ways. At an abstract level, students learn to analyze problems as programmers do, which is a fundamental element of digital humanities[12] that has been called "procedural epistemology"[13] in scholarly literature and "computational thinking"[14] in popular discourse. More concretely, students are introduced to conceptions and implementations of AI from different periods in its development. To grasp historical attempts at AI, students code generative grammars, which are sets of rules for creating strings of text. Generative grammars may be understood as technically simple, as detailed in the section below. But great complexity emerges from these rules, which might also be accurately described as probabilistically controlled recursive structures using pseudo-randomness to generate infinitely variable strings of text. This great complexity emerging from simple rules underlies some early, canonical examples of AI analyzed in the course. The 1966 psychotherapist chatbot ELIZA, for example, was intended to be a parody of simplistic interactions, but people engaged it with such intimacy, its creator became one of AI's great detractors.[15] ELIZA was originally programmed in an obscure language called MAD-Slip, but has since been implemented in many languages, including JavaScript, so students have the opportunity not only to interact with the bot and learn its history but also to examine its source code. Likewise, although expertise in machine learning is beyond the purview of this course, students can explore simple activities to gain insight on the fundamental principles of how contemporary AI works. For example, students learn the essential logic of probabilistic modeling by working through Markov chain (n-gram)[16] text generation to see the relationships between a model's training data and its outputs.

Our focus on simple text throughout the programming assignments in Unit I serves multiple purposes. The canonical standard for evaluating AI, the Turing Test, shows the utility of plain text, which makes conceptual and expressive complexity accessible through the technically simple means of letters. (The focus on text in much foundational digital humanities research also reflects this.) For students who lack confidence in mathematics, word problems are also more familiar. While all programming has the potential to be "creative" in some way, text-based assignments create opportunities for storytelling, humor, and so on. Only a few conventional programming puzzles that could be evaluated in terms of correctness are required. These include, for example, one program that detects palindromes and another that randomizes capitalization in the style of the "Mocking SpongeBob" meme,[17] turning a sincere "this book chapter is great" into the sarcastic "tHIs bOok chApTeR iS gREAt." The learning outcomes of these problems are specific technical skills such as using conditional statements and loops in designing simple algorithms. But students spend more time on looser, generative text assignments. For these assignments, students are given a JavaScript "starter code" file with some

groundwork already laid for them, so they can focus on the most relevant parts of the program.[18] Students' first JavaScript functions simply take in names and return jokes with those names plugged in as the characters. Another early assignment is to design an astrology program that generates a fortune for a user's astrological sign using multiple functions chained together, introducing randomness at each step. Students are provided with a simple interface to test their code by entering text in the web browser (names in the former case, astrological sign in the latter), a button to execute their code on that input, and a robotic voice automatically reading out whatever text their code generates. The robot voice creates a visceral experience and importantly makes it more fun to fail, e.g., when buggy code makes the robot voice stutter or repeat itself in an endless loop (headphones recommended).

≤280 Characters

Social media bots have acquired a nasty reputation, especially for the so-called "armies" of propagandist bots polluting discourse. One recent study[19] concluded that more than half of all news links on Twitter were posted by bots. But not all bots are pernicious, and Twitter has been fertile ground for professional and amateur experimentation alike with what social bots might become. Having considered a wide range of examples, from playful art bots to malicious propaganda botnets, students had no subject matter restrictions imposed other than the suggestion that their bots should not be "nasty" and might even somehow make a positive impact on society. Some students rose to this challenge, developing bots with an eye to making the world ever-so-slightly better, 280 characters at a time. As I discuss below, however, other students created bots that could be understood as harmful.

In a technical sense, these bots are less demanding than previous assignments described above. Students use a tool called Tracery[20] to create their bots on the *Cheap Bots Done Quick* (*CBDQ*) platform.[21] Students create accounts on Twitter and then give control of the accounts to *CBDQ*, which handles back-end details such as hosting the bots, managing the Twitter API, pretty much everything except the creative work of designing a set of rules to generate Tweets. These sets of rules (more formally "context-free grammars") define branching structures that use randomness to determine, at each step, which among a predetermined set of options will be the way a string of text grows. To set out a simple example, a sentence might be defined as consisting of a SUBJECT, VERB, and OBJECT. The SUBJECT might be defined as either "Kate" or "George," the VERB as "designed" or "worked on," and the OBJECT as "these" + ADJECTIVE + "free tools." If our ADJECTIVE is either "amazing" or recursively defined as two consecutive adjectives, the Tracery code would look like this:

```
{
"origin":["#SUBJECT# #VERB# #OBJECT#"],
"SUBJECT":["Kate", "George"],
"VERB":["designed", "worked on"],
"OBJECT":["these #ADJECTIVE# free tools"],
"ADJECTIVE":["amazing", "#ADJECTIVE# #ADJECTIVE#"]
}
```

The simplest case of output here would be something like "Kate designed these amazing free tools," but if the branching rule at ADJECTIVE keeps recursively multiplying,

we can end up with an arbitrary and theoretically infinite number of times the word "amazing" is repeated, giving us output like "George worked on these amazing amazing amazing amazing amazing amazing free tools."[22] This combination of fairly simple branching structures, randomness, and recursion allows infinite textual possibilities (constrained in our case, however, by Twitter's 280-character limit). *CBDQ* can also post visual media, including emoji, still images, animated GIFs, and videos as well as converse in limited ways, triggered by the presence or absence of certain preselected keywords in Tweets directed at the bots by other users. While that work creating the bots' systems of generative rules all happens on *CBDQ*, students also worked on Twitter's site directly to tailor the bots' profile pictures, color schemes, privacy settings,[23] and more.

Most students' bots were playful, often with elements of parody or sheer absurdity. Pop cultural references were prominent, including bots aping specific celebrities or tweeting from fictional worlds of television, movies, and video games. A few bots generated unlikely movie plots, including one devoted to gender bending romantic comedies starring the likes of Vladimir Putin and Elon Musk. Many bots were devoted to food, including a few that randomly selected ingredients to generate recipes more entertaining than appetizing.

Some submissions took on serious topics: feminist bots; bots devoted to endangered animals, recycling, sustainability, waste, and other environmental issues; bots that offer affirmations and encouragement. Another simply prays twice per day, which, amid the irreverence of social media, seems almost radical in its earnestness (a year and more than 700 prayers later, it is still praying).

Some of the bots, however, defy easy categorization. One bot tweets apparently innocent pictures of cats but occasionally lets slip something suggesting a plot to take over the world. Another tweets random sequences of musical chords. There are bots that give deliberately bad advice about being a student, rave about the pleasures of alcohol, and announce shows by fictional rock bands. Some reflexively play with the idea of a bot, including one that asserts over and over again, in deliberately stilted prose, that it is a real human.

While students' bots would not pass a Turing test, they still must wrestle with when and how loudly to announce they are not human. One student's bot, for example, posing as an imaginary gossip magazine, announced that randomly paired celebrities were dating. This was intended as innocent fun but might be understood as complicit in the churn of so-called "fake news." The most interesting ethical questions raised by students' work did not, however, emerge from this possibility that their bots might be misidentified as human. The most interesting problems arose precisely from the possibility that bots were out of human control.

It is a well-worn cliché that people will type things online that they would not say in person, due in part to the distancing of pseudonymity.[24] But some of the most challenging student bots achieve this distancing in different ways, related to our dual themes of digital humanities and remix. The algorithmic reassembly of fragments of preexisting cultural products allows extra degrees of distance or ways responsibility can be abdicated, not only to the creators of the source material from which the remix is made but also to the algorithm that does the remixing.

Various student bots exhibited aspects of and variations on these phenomena, but I focus here on one emblematic example, the *Cards Against Humanity*[25] bot described in the introduction. The original game consists of black and white cards. Black cards

typically pose questions or have partial statements that need to be completed by filling in missing words. White cards, which typically contain offensive or otherwise sensitive words, are selected to answer the questions or fill in the blanks in the black cards, with players competing to select the funniest and most offensive match.

The bot followed these same rules. While one might informally call the program driving the bot an algorithm, it is useful here to consider the distinction computer scientists make between an abstract algorithm and its implementation. An algorithm in this sense is a sequence of steps to solve a given problem, unencumbered by the idiosyncrasies of any particular programming language, whereas an executable program is a specific implementation of that algorithm in some programming language. The bot is a particular implementation or instantiation of its algorithm, written in Tracery, executed by CBDQ, and output by Twitter. But the algorithm itself, the procedure for generating jokes, is inherent to the game. What the bot most conspicuously lacks is human judgment of the funniest among a handful of randomly dealt options. In this sense, the bot cannot play the game so much as demonstrate its possibilities, like a radically simplified, mindless chess program that randomly chooses among legal moves.

Cards Against Humanity has had massive commercial success, but digital files containing the complete text and layout of the game are available for download under a Creative Commons license that allows people to use, remix, and share them for free. As such, the student bot's wildly offensive, entirely derivative jokes did not run afoul of copyright restrictions. It announced its source so did not constitute plagiarism either. The wholesale verbatim appropriation was not the problem. If anything, like a Duchamp ready-made, the very lack of alteration sparks the bot's peculiar interest.[26] This is quintessential digital humanities: through the practice of coding, a hermeneutic insight.

Ethical questions about playing *Cards Against Humanity* have already been addressed both in the popular press and in scholarship.[27] I do not dwell here on general questions of whether people should ever make misogynistic, racist, ableist, homophobic, antisemitic, or otherwise hateful jokes. Our more specific problem is whether it is appropriate for student work to make such jokes. Student work may justifiably quote or otherwise contain offensive jokes in order to critically analyze them. But this bot did not contain jokes so much as *tell* them, or raise the question of who—or what—was telling them. Was it the people who created the game, the game itself, the student who turned the game into a bot, the bot itself, the cosmic dice of a random number generator on a server somewhere selecting the butt of the next joke? Academia has many more and less abstract arguments about this question, for example, from Actor Network Theory[28] or debates about remix authorship,[29] but no definitive answer. For students this is more than an abstract question. They are subjected to algorithmic decision-making throughout their daily lives with little explanation or opportunity for meaningful consent.[30] Learning technical skills is not the only way to gain a sense of agency in these matters, but this course offered students new perspectives and provoked them to reconsider their own roles in these systems. The bot assignment provided one such moment of reflection. Below, students find a novel ethical solution to another digital entanglement of this course.

Unit 2: Digital Media and Configurable Culture

The first unit of the course, "Digital Logic & Computational Thinking," used practices of coding and critical making to explore questions about individuals and decision-making. This second unit leverages more user-friendly tools to make media that pose

questions about networks and the circulation of culture. Again, rapid prototyping projects are paired with critical readings. Students make animated GIFs while learning about historical precedents such as the Jacquard loom[31] and considering what makes new media new.[32] They consider the beauty and sometimes deceptive simplification of data visualizations[33] while also making their own. They consider the uses and misuses of digital slides[34] while preparing a brief presentation to their peers.

The final assignment of the course, "Vandalize a Webpage," moves students closer to the machine again, to the level of code, without leaving the realm of remix and configurable culture. It also returns to the first day of the course, when I demonstrated a trivial version of the assignment: find a webpage, download its source code, creatively break it, reassemble it as something new. This final assignment brings together various skills learned throughout the course and adds a few new ones. Students learn just enough HTML to manipulate text and add images, videos, and other easily embedded media such as Twitter feeds. They also experiment with glitchier "databending" methods[35] like changing the file type of an image to appear as a text file, manipulating the garbled data in a text editor, and then changing it back to the original file type, which fragments and distorts images in unpredictable ways.

As with the Twitter bots, parody is a common mode in this assignment. News, political sites, fashion houses, advertisers, our own university's home page, even the site for this very class—nobody was safe from students' mockery. Many students took this as an opportunity to critique manipulative advertising, unrealistic depictions of women, and other problematic content. Some vandalized pages had only subtle and subversive changes. Others were energetically defaced, even rendered unrecognizable.

Some of the most interesting submissions, however, inverted the very notion of parody. Students found media already broken, so they took on the meticulous work of repairing it. Poignantly, a few students excised parody news sites' humorous content and replaced it with serious journalism copied from legitimate outlets. Living amid so-called "fake news" in an era sometimes derided as "post truth,"[36] there is something radical in the decision to upend the assignment and, more importantly, typical assumptions that remix is a postmodern, ludic shattering of perspectives. Instead students found an opportunity to do the humble work of digital maintenance and repair, somewhere between hacking and debugging, stitching a small part of their broken world back together. Repair should not be overly romanticized.[37] Much work sifting through fake, hateful, and otherwise disturbing content today is outsourced to workers who suffer great trauma for very little pay.[38] But there is something hopeful in students embracing "the subtle arts of repair by which rich and robust lives are sustained against the weight of centrifugal odds, and how sociotechnical forms and infrastructures, large and small, get not only broken but *restored*."[39]

Conclusion

Students moved fast and broke things. Some even repaired them. Throughout the semester, discussions in class and written reflections submitted with student projects both demonstrated increasing technical and critical sophistication. The most vivid demonstrations of this synthesis, however, were in students' creative work itself. The Twitter bots were mostly irreverent; even if they algorithmically generated something new from fragments, the bots' pleasures were usually tied to randomness and destruction. But some bots were instead gentle and productive, offering affirmations or prayers. The *Cards Against Humanity* bot was yet again different. It neither carved new fragments from the

world nor innovated new ways of putting those pieces together, but presented an exquisitely detached replication of what was already there (or, more humbly, an old algorithm implemented in a new language). The bot's ill disposition may even be understood as a variation on the "garbage in, garbage out" bias arising when AI is trained on problematic data.[40] This collection of bots satisfies both directions of the simplified, bidirectional model of digital humanities: understand computing through humanistic inquiry, and understand the arts through code. These conclusions go beyond questions of pedagogy to new insights about the interactions between algorithmic and remix cultures, and especially the ethics thereof. Students' final projects in the mode of repair further demonstrate a reflective, critical engagement that should be a goal of many courses, technical and otherwise. Their digital repair work also demonstrates another aspect of appropriation, a telos familiar from hip hop both as culture and as pedagogy: through fragmentation but ever toward some kind of unity. Just as mixtapes may be understood as a transcendent form of journalism,[41] my students' work transcended the idea of vandalism by creative restoration of something broken—precisely the quality of guerilla art on crumbling walls and infrastructure that we understand not as vandalism, but as graffiti.

Acknowledgments

The author would like to thank Vanessa Chang (California College of the Arts), Nabeel Zuberi (University of Auckland), Meghan Drury (Portland State University), and Danielle Lottridge (University of Auckland) for discussions that informed this work.

Notes

1 This chapter extends and upends arguments previously made in Plaut, "Enlightenment, the Remix."
2 Ratto, "Critical Making;" Ratto and Boler, *DIY Citizenship*; Hertz, *Critical Making*.
3 The only other assessments are three quizzes, which include programming problems, questions related to the readings, and informal feedback on students' experience of the course.
4 Haverbeke, *Eloquent JavaScript*.
5 See, e.g., Moretti, *Graphs, Maps, Trees*. This chapter cannot fully engage debates around the identity or definitional boundaries of digital humanities, but the course herein described straightforwardly conforms to definitions that include the teaching of programming skills to humanists and reconception of objects of humanistic inquiry in light of computational research. See, e.g., Terras, Nyhan, and Vanhoutte, *Defining Digital Humanities*. On the decision not to teach such meta-scholarly debates to undergraduates, see Cordell, "How Not to Teach Digital Humanities."
6 For overviews of approaches to code as object of cultural inquiry, see, e.g., Fuller, *Software Studies*; Marino, *Critical Code Studies*.
7 Rosenbloom, "Towards a Conceptual Framework for the Digital Humanities."
8 Vee, "Understanding Computer Programming as a Literacy."
9 Wing, "Computational Thinking."
10 Bollmer, Rodley, and Rodley, "Speculations on the Sociality of Socialbots;" Epstein, "The Empty Brain;" Morozov, *Geopolitica (e Geoeconomia) Dell'Intelligenza Artificiale*; Adler, "More or Less Human;" Bostrom, *What Happens When Our Computers Get Smarter than We Are?*
11 This pedagogy was inspired by Eric Roberts's 2017 course at Stanford University, *Understanding Programming through JavaScript*, for which I was a teaching assistant. That course similarly focused on programming fundamentals using a narrow subset of JavaScript but did so using a custom Integrated Development Environment.
12 Berry and Fagerjord, *Digital Humanities*, 19.
13 Yu, "On Computer Science as 'Procedural Epistemology.'"
14 Wing, "Computational Thinking."
15 Weizenbaum, *Computer Power and Human Reason*.

16 An *n*-gram is a specific kind of Markov model in which, for example, successive words are probabilistically determined from the previous *n*-1 words, such that a unigram ignores surrounding words, a bigram considers one previous word, a trigram considers two previous words, and so on.

17 Matt, "Mocking SpongeBob."

18 Students also receive instructions formatted as a PDF as well as an HTML file that allows them to run and interact with their code in a browser. Students do not learn or use any HTML in this course until the final "Vandalize a Webpage" assignment.

19 Wojcik et al., "Bots in the Twittersphere."

20 Compton, Kybartas, and Mateas, "Tracery."

21 https://cheapbotsdonequick.com/.

22 Both of these outputs happen to be true; Tracery and *CBDQ* were designed by Kate Compton and George Buckenham, respectively, and are free to use, not to mention amazing, amazing, and amazing.

23 Students had the option to keep their bots completely private. Most decided to make their bots public but did not use their real names to claim attribution.

24 Suler, "The Online Disinhibition Effect;" Cho, Kim, and Acquisti, "Empirical Analysis of Online Anonymity and User Behaviors."

25 While this specific bot is unavailable, other automated versions of *Cards Against Humanity* are available on platforms including Twitter, Discord, and GitHub (e.g., Prinz, "How I Taught an AI to Play Cards Against Humanity"). One remake, Schumacher's "AI Against Humanity," used neural networks both to generate an entirely new set of cards and to compete against human players. Most relevant to the present argument about abdications of responsibility, Schumacher explains, "Why is this so offensive?... the AI was first trained on a vast corpus of internet text. So all the bias of the English internet are [sic] deeply ingrained in it" (n.d.). The official *Cards Against Humanity* game is regularly updated and extended with additional decks of cards, and the official website has included, at different times, at least two different digital versions ostensibly used to improve the game. In one case, a bot allowed visitors to the website to play a simulated game with draft versions of new cards, ranking them in terms of funniness. For the holiday season of 2019, the company also introduced two new sets of cards, one of which was supposedly written by an AI and the other by their writers, promising to fire their writers if the AI sold more cards. It did not.

26 Another important precedent for understanding this bot and other algorithmically generated communication is the use of chance operations to introduce random elements into mid-twentieth century art making and performance, e.g., by the Dadaists, John Cage, et al. See Drucker and Nowviskie, "Speculative Computing," especially pp. 437–40 on "generative aesthetics."

27 Ethical questions raised by the game include not only specific cards with potential harms to individual people but also ways it generally licenses prejudice for cheap thrills, as well as allegations that the *Cards Against Humanity* game company's staff faced racist and sexist abuse in the workplace. See, e.g., Brooks, "Letter of Complaint;" Director, "The Inhumanity of Cards Against Humanity;" Carpenter, "Former Employees Accuse Cards Against Humanity of a Racist and Sexist Office Culture."

28 Latour, *Reassembling the Social*.

29 Logie, "Peeling the Layers of the Onion;" Navas, *Remix Theory*, 134–40.

30 Lepri et al., "Fair, Transparent, and Accountable Algorithmic Decision-Making Processes."

31 Looms controlled with punch cards were mechanical precursors of the modern digital computer, with an especially close resemblance to the digital encoding of images.

32 Benjamin, "The Work of Art in the Age of Mechanical Reproduction;" Sterne, "Analog;" Manovich, *The Language of New Media*.

33 Lupi, "Data Humanism;" Klein and D'Ignazio, "On Rational, Scientific, Objective Viewpoints from Mythical, Imaginary, Impossible Standpoints."

34 Tufte, *The Cognitive Style of PowerPoint*; Robles-Anderson and Svensson, "'One Damn Slide After Another.'"

35 Manon and Temkin, "Notes on Glitch."

36 McIntyre, *Post-Truth*.

37 Mattern, "Maintenance and Care."

38 Roberts, *Behind the Screen*.

39 Jackson, "Rethinking Repair," 222.

40 Mehrabi et al., "A Survey on Bias and Fairness in Machine Learning;" Vidgen and Derczynski, "Directions in Abusive Language Training Data."

41 Ball, *I Mix What I Like!*

Bibliography

Adler, Simon. "More or Less Human." Radiolab. Accessed November 26, 2019. https://www.wnycstudios.org/podcasts/radiolab/articles/more-or-less-human.

Ball, Jared A. *I Mix What I Like!: A Mixtape Manifesto*. 1st Edition. Oakland, Calif.: AK Press, 2011.

Benjamin, Walter. "The Work of Art in the Age of Mechanical Reproduction." In Illuminations, translated by Harry Zohn, 217-51. New York: Schocken Books, 1968.

Berry, David M., and Anders Fagerjord. *Digital Humanities: Knowledge and Critique in a Digital Age.* Wiley, 2017.

Bollmer, Grant, Chris Rodley, and Chris Rodley. "Speculations on the Sociality of Socialbots." Socialbots and Their Friends, December 1, 2016. https://doi.org/10.4324/9781315637228-16.

Bostrom, Nick. *What Happens When Our Computers Get Smarter than We Are?*, 2015. https://www.ted.com/talks/nick_bostrom_what_happens_when_our_computers_get_smarter_than_we_are.

Brooks, Dan. "Letter of Complaint: Cards Against Humanity." *The New York Times*, October 7, 2016, sec. Magazine. https://www.nytimes.com/2016/10/07/magazine/letter-of-complaint-cards-against-humanity.html.

Carpenter, Nicole. "Former Employees Accuse Cards Against Humanity of a Racist and Sexist Office Culture." *Polygon*, June 23, 2020. https://www.polygon.com/2020/6/23/21300435/cards-against-humanity-max-temkin-report.

Cho, Daegon, Soodong Kim, and Alessandro Acquisti. "Empirical Analysis of Online Anonymity and User Behaviors: The Impact of Real Name Policy." In *2012 45th Hawaii International Conference on System Sciences*, 3041–50, 2012. https://doi.org/10.1109/HICSS.2012.241.

Compton, Kate, Ben Kybartas, and Michael Mateas. "Tracery: An Author-Focused Generative Text Tool." In *International Conference on Interactive Digital Storytelling*, 154–61. Springer, 2015.

Director, Samuel. "The Inhumanity of Cards Against Humanity." *Think* 17, no. 48 (ed 2018): 39–50. https://doi.org/10.1017/S1477175617000318.

Epstein, Robert. "The Empty Brain." *Aeon*, 2016. https://aeon.co/essays/your-brain-does-not-process-information-and-it-is-not-a-computer.

Haverbeke, Marijn. *Eloquent JavaScript: A Modern Introduction to Programming*. 3rd Edition. San Francisco: No Starch Press, 2018. https://eloquentjavascript.net/.

Klein, Lauren F., and Catherine D'Ignazio. "On Rational, Scientific, Objective Viewpoints from Mythical, Imaginary, Impossible Standpoints." In *Data Feminism*, 73–96. Cambridge, MA: MIT Press, 2020. https://doi.org/10.7551/mitpress/11805.001.0001

Lepri, Bruno, Nuria Oliver, Emmanuel Letouzé, Alex Pentland, and Patrick Vinck. "Fair, Transparent, and Accountable Algorithmic Decision-Making Processes." *Philosophy & Technology* 31, no. 4 (December 1, 2018): 611–27. https://doi.org/10.1007/s13347-017-0279-x.

Lupi, Giorgia. "Data Humanism: The Revolutionary Future of Data Visualization." *PRINT*, January 30, 2017. https://www.printmag.com/information-design/data-humanism-future-of-data-visualization/.

Manon, Hugh S., and Daniel Temkin. "Notes on Glitch." *World Picture* 6 (2011): 118.

Marino, Mark C. *Critical Code Studies*. 1st Edition. Cambridge, MA: The MIT Press, 2020.

Matt. "Mocking SpongeBob." Know Your Meme. Accessed November 26, 2019. https://knowyourmeme.com/memes/mocking-spongebob.

Mattern, Shannon. "Maintenance and Care." *Places Journal*, November 20, 2018. https://doi.org/10.22269/181120.

Mehrabi, Ninareh, Fred Morstatter, Nripsuta Saxena, Kristina Lerman, and Aram Galstyan. "A Survey on Bias and Fairness in Machine Learning." The Seattle Times, November 10. *ArXiv:1908.09635 [Cs]*2019. http://arxiv.org/abs/1908.09635.

Morozov, Evgeny. *Geopolitica (e Geoeconomia) Dell'Intelligenza Artificiale*. Festival dell'Economia di Trento, 2018. https://2018.festivaleconomia.eu/-/geopolitica-e-geoeconomia-dell-intelligenza-artificia-1.

Plaut, Ethan R. "Enlightenment, the Remix: Transparency as a DJ's Trick of Seeing Everyone From Nowhere." *Communication, Culture & Critique* 9, no. 2 (2015): 303–21.

Prinz, Chris. "How I Taught an AI to Play Cards Against Humanity." *Medium* (blog), September 2, 2017. https://medium.com/@chrisprinz/how-i-taught-an-ai-to-play-cards-against-humanity-3e808fefd2e4.

Ratto, Matt. "Critical Making: Conceptual and Material Studies in Technology and Social Life." *The Information Society* 27, no. 4 (July 1, 2011): 252–60. https://doi.org/10.1080/01972243.2011.583819.

Roberts, Sarah T. *Behind the Screen: Content Moderation in the Shadows of Social Media.* 1st Edition. New Haven: Yale University Press, 2019.

Robles-Anderson, Erica, and Patrik Svensson. "'One Damn Slide After Another': PowerPoint at Every Occasion for Speech." *Computational Culture*, no. 5 (January 15, 2016): 1. http://computationalculture.net/one-damn-slide-after-another-powerpoint-at-every-occasion-for-speech/.

Rosenbloom, Paul S. "Towards a Conceptual Framework for the Digital Humanities." *Digital Humanities Quarterly* 006, no. 2 (July 31, 2012): 1–9.

Schumacher, Max. "AI Against Humanity." AI Against Humanity. Accessed December 19, 2019. https://www.aiagainsthumanity.app/about/.

Sterne, Jonathan. "Analog." In *Digital Keywords: A Vocabulary of Information Society and Culture*, by Benjamin Peters, 31–44, 2016.

Suler, John. "The Online Disinhibition Effect." *Cyber Psychology & Behavior* 7, no. 3 (June 1, 2004): 321–26. https://doi.org/10.1089/1094931041291295.

Tufte, Edward R. *The Cognitive Style of PowerPoint.* 1st Edition. Cheshire, CN: Graphics Press, 2003.

Vee, Annette. "Understanding Computer Programming as a Literacy." *Literacy in Composition Studies* 1, no. 2 (October 31, 2013): 42–64. https://doi.org/10.21623/1.1.2.4.

Vidgen, Bertie, and Leon Derczynski. "Directions in Abusive Language Training Data: Garbage In, Garbage Out." *ArXiv:2004.01670 [Cs]*, April 6, 2020. http://arxiv.org/abs/2004.01670.

Wing, Jeannette M. "Computational Thinking." *Communications of the ACM* 49, no. 3 (March 2006): 33–5. https://doi.org/10.1145/1118178.1118215.

Wojcik, Stefan, Solomon Messing, Aaron Smith, Lee Rainie, and Paul Hitlin. "Bots in the Twittersphere." Washington, D.C.: Pew Research Center, April 2018. http://www.pewinternet.org/2018/04/09/bots-in-the-twittersphere/.

Yu, Mingyi. "On Computer Science as 'Procedural Epistemology'." *Amodern*, no. 9 (April 2020). https://amodern.net/article/on-computer-science/.

24

ALLEGORIES OF STREAMING

Image Synthesis and/as Remix

Steve F. Anderson

> Indeed, one could argue that at this particular historical moment and in our particularly digitally driven American context, the morph fascinates us not only because of its physical impossibility and strangeness but also because its process and figuration seem less an illusionist practice than both a presentational mode and an allegory of late capitalist "realism."
>
> Vivian Sobchack, *Meta-Morphing*

In the course of preparing this chapter, part of my goal was to parse the differences between what may be viewed as a "classical" age of (analog and digital) remix compared with what I would now term an *algorithmic* one. The pursuit of this goal begs certain definitional questions that are best resolved by considering real-world examples and their cultural implications, rather than on a technical basis. Like Sobchack, I am interested in exploring the cultural stakes and allegorical implications of emerging technologies of vision rather than the particulars of technical processes or even their representational capacity. The transformation of remix culture that occurred as we have moved into the algorithmic age has been rapid and profound. Once celebrated as a counter-hegemonic domain of fans and culture jammers opposing the dominance of media industries, the computational processes that drive contemporary image synthesis algorithms align instead with the broad cultural logic of neoliberalism. In an age of algorithmic remix, the instability of the original has given way to the instability of signification itself.

I have been teaching, curating, and writing about various aspects of remix culture for the past three decades. Among my lecture materials from the 1990s was an artist-provocateur, who sought to highlight the arbitrary and inconsistent manner in which US copyright law defines, rewards, and protects artistic originality. His method was simple and deliberately provocative, combining crude cutouts of two or more well-known cartoon characters to create a new figure dubbed a "Frankentoon." These new combinations were then sent to the Copyright Office to register a new copyright. The Copyright Office, in turn, was compelled to reject these applications, citing the works' failure to meet vague standards of "originality" or "creativity." This process served to highlight the

murky—if not arbitrary—nature of such thresholds amid a rising culture of remix and remixability. The correspondence from the Copyright Office became part of the work and the artist enjoyed a degree of notoriety online in the late 1990s.

Some twenty-five years later, when attempting to locate the project online, I found myself at a loss. The search word "Frankentoon" was insufficiently specific and the only individual character I could recall from the series was a combination of Bill Griffith's 1970s underground comic figure Zippy the Pinhead and Tom Wilson's "Ziggy" a syndicated cartoon figure, from roughly the same era. The "Frankentoon" version placed Zippy's head on Ziggy's lower half and was memorably, if predictably, named "Ziggy the Pinhead." Unfortunately, a Google search for "Ziggy the Pinhead" returned only a question from the search engine, "Did you mean: Zippy the Pinhead?" along with the search engine's usual returns for a direct search for "Zippy the Pinhead." To make matters worse, Google seemed to treat its question as a rhetorical one, offering no way to respond in the negative—in fact, no way to respond at all, besides accepting the correction and selecting among the links offered.

Under many circumstances, of course, this type of algorithmic course correction back in the direction of more likely search terms might be welcome, but in this case, the result was the suppression of a cultural artifact whose very significance lay in its illicit obscurity. I eventually located the artist's name—Joel Kahn—among some old lecture notes on a backup hard drive, along with the images included here (Figure 24.1), but I have been otherwise unable to locate more than a few passing references to the project and a variety of broken links to sites that once hosted it. This story represents an overly literal instance of a normative search algorithm obscuring access to a moment in the history of remix, and perhaps it suggests a productively allegorical reading of "realism" for the age of streaming media.

The transition from discretely remixable cultural elements of the type comprising a Frankentoon to emerging forms of computational image synthesis diverges from the models of remix culture that prevailed throughout the age of mechanical reproduction. A proper investigation of the reciprocal processes of image recognition and synthesis

Figure 24.1 Screenshot of Joel Kahn's Frankentoons: Snooh P. Coyote and Ziggy the Pinhead

requires engagement with highly specialized subfields of Artificial Intelligence (AI). At present, these processes include computer vision, neural nets, deep learning, and the use of algorithms for image synthesis or generative image modeling. Each of these technologies remains in a state of rapid development, motivated by widely varied and highly lucrative commercial potentials in fields as widely varied as robotics, advertising, visual effects, and law enforcement. Despite their operational differences, all of these technologies are predicated on blurring the lines between how humans and computers view the world. As I have argued elsewhere, the stakes of these endeavors are high—culturally, commercially, and critically—and it is imperative that responsibility for their development, oversight, and regulation should not be limited to the domain of technologists.[1]

In 2009, technology writer Adam Greenfield wrote in *Wired* magazine that "it's hard to be critical and make sound choices in a world where we don't understand the objects around us." Greenfield argued that there was a "pressing need…for translators: people capable of opening up these occult systems, explaining their implications to the people whose neighbourhoods, choices and lives are increasingly conditioned by them."[2] With this call, Greenfield confirms a cultural need for those capable of demystifying technology in ways that are of relevance to ordinary people. I would take this one step further to argue that it is incumbent on a critically engaged populace to do its best to understand and develop opinions about these technologies and their increasingly intrusive role in everyday life. To put it bluntly, I get nervous when all attempts at critical inquiry are eclipsed by the complexity of AI, which purports to elude all but the most highly trained computer scientists. That said, I must acknowledge my own technical limitations when attempting to write about these issues. I'm not a computer scientist and I don't understand everything I read on this subject, but I believe that engaging the implications of technologies such as machine vision, deep learning, and image synthesis using the critical methods of media and visual culture studies deepens my ability to understand their cultural relevance. This chapter further advocates the broader dissemination and adoption of open-source, reconfigurable DIY tools that allow artists, designers, and non-technologists to experiment directly in the domain of artificial intelligence.

Of course, by the time this chapter appears in print, it will be outdated. Advances in the technologies under discussion here are too rapid for the pace of academic publishing. Rather than risk seeming out of step, we could avoid these subjects altogether—at least until they have become historically sedimented or a polite consensus has been reached—but there is a danger in allowing technologies to be occulted to the point where non-computer scientists seem to have nothing to contribute to their understanding. I would argue that it is incumbent on those of us who write about technology from a cultural perspective to analyze the extent to which emerging technologies are coextensive with their predecessors.[3] While calls for "code literacy" seem promising, we should also be mindful of Douglas Rushkoff's observation that even the most well-intentioned development of "digital literacy" skills may be readily coopted by technology industries eager to hire STEM-trained workers who began coding at a young age, often developing technical proficiency without critical awareness.[4] Perhaps a better solution is to turn the bug of rapid technology development into a feature of the analysis. Surely, in the breathless pace of industry hyperbole surrounding all things related to AI, a slow and historically minded approach will readily expose the most damning tenets on which the technology is predicated.

Age of Remix

The logic of remix dominated the latter half of the twentieth century and much of the first decade of the twenty-first as the consumer technologies of video recorders and personal computers facilitated reproduction and recombination of the core products—music, movies, TV—of mass media. More recently, however, easily copied and sampled forms of physical media such as DVDs, tapes, records, and CDs have moved toward obsolescence, as media consumption shifts toward streaming media available on demand through various channels and on multiple devices. It is significantly more difficult to capture and reproduce media delivered this way, and most technologies for doing so introduce noticeable quality losses. Under these circumstances—and to the relief of the copyright industries—one might argue that the days remaining in the age of remix are numbered.

Along with this shift in home viewing to on-demand streaming formats, entertainment media no longer has a quality of *thingness*. The images and sounds we rent through monthly subscriptions wash over us in real-time; viewing itself affords a certain degree of control in our ability to follow threads of association suggested by predictive content models and recommendation algorithms, but personalized playlists and media queues are fundamentally intangible, theoretical containers defined by metadata rather than collections of digital files that may be duplicated, segmented, transformed, or recombined. In the process of this shift in the ontological status of media, viewers are stripped of the agency once afforded by practices of time-shifting, sampling, and file-sharing, and returned to an age of pre-televisual cinema spectatorship or pre-VCR television viewing. In place of hypothetical viewer demographics whose tastes were estimated through qualitative research, the industry now tracks audiences as sources of viewing data, producing fine-grained inferences about interests, likes, and dislikes that go beyond the popularity of specific shows, movies, or genres. In aggregate, viewers remain at the center of the data feedback loop used to generate new media content but—in practice and at scale—the remix-era celebration of consumers-as-producers has been radically eclipsed.

It has been more than twenty years since Lev Manovich identified the database as the key symbolic form for the transition to the twenty-first century, elevating it to the cultural status enjoyed by cinema and the novel.[5] Indeed, databases—both literal and metaphorical—played a crucial role in the digital transformation of visual culture. But the databases described by Manovich at the end of the twentieth century were predicated on affordances of modularity and remixability that are no longer central in the streaming age. Elaborately composed interactive viewing experiences such as *Black Mirror: Bandersnatch* (2018) preserve some of the pleasures of choice and multiplicity found in video games and database narratives, but such experiments remain the exception, not the rule. The culture of remix that emerged in the 1980s and 90s was predicated on processes of selection and combination, creating the possibility of rich and diverse layers of meaning and counter-reading through intertextual allusion. The uses to which these techniques are put are often driven by a desire to reverse or overturn relations of power inequality, or to assert the values of a subculture or identity group—for example, slash fiction's surfacing of queer themes and relationships within commercial narratives. In these cases, remix mobilizes and re-scripts elements that were present in the original, but re-codes them with an alternate set of values or meanings. This disruption of the intended chain of encoded and decoded meanings during the age of remix was adequately theorized in terms of the semiotic production of meaning within a relatively stable matrix of cultural signification.

More recently, emerging technologies such as computer vision, machine learning, and image synthesis (among other technologies and in combination) suggest the need to reconsider the applicability of semiotic models for understanding these processes as a qualitatively different form of remix. To be clear, the framing of image synthesis in terms of an expanded definition of "remix" is not a consensus view, nor is it how these technologies are ordinarily discussed. By posing this discussion in relation to historical practices of remix, I hope to reveal aspects of contemporary image synthesis that are both coextensive with and distinct from practices characterizing the classical age of remix.

Technologies of Remix

Widely disseminated examples of image synthesis often take the form of videos that demonstrate the process of latent space interpolation that occurs as one synthesized image turns into another. The appearance resembles that of a digital morph—a visual effect popularized in music videos of the early 1990s such as Michael Jackson's *Black or White* (1991)—but the underlying technical processes differ in important ways (Figure 24.2). "Morph" is short for metamorphosis, which is essentially a transformation from one state to another. In its simplest form, a cross-dissolve may be considered an image morph, but a dissolve is distinguished by its preservation of a static grid of pixels within which a linear transition of chroma and luminance takes place from an original pixel to a final pixel at each point on the grid. A morph differs from a cross-dissolve in its ability to warp shapes and lines within the image. Software for plotting a morph from one image to another allows the definition of anchor points or lines that will be used to create a sense of continuity between the two images as the software generates a series of in-between frames along multiple vectors. When morphing between faces, for example, anchor points may be associated with eyes, nose, mouth, and chin; variations in the size, shape, or angle of the head may be smoothly transformed by incrementally warping the grid that defines the beginning and ending image surfaces. In the sequence of images

Figure 24.2 Top: Image morph sequence from Michael Jackson, "Black or White" music video (1991); bottom: GAN image sequence from NVIDIA, "CelebA-HQ 1024×1024: Latent Space Interpolations" (2017)

that produce a morph, every frame of the transition from source to destination is consistent with the operative definition of remix offered above.

Machine learning for image recognition requires very large sets of training data—usually between tens of thousands and millions of images that are categorized according to content—in order to "teach" a computer how to convert visual forms into computable data.[6] These images are then exposed to an algorithm capable of identifying the defining visual properties—what is termed a "phenotype characterization" for each image category—for example, "cat." The greater the number and diversity of images contained in the training set, the more robust and complex the system's capacity for identifying any given category of image. Once a category or type is established, various methods may be used to synthesize new images from random noise or source images. This may be understood as reversing the algorithm to generate new images rather than learning to recognize existing ones. Experiments with Generative Adversarial Networks (GANs) and Variational Autoencoders (VAEs) have proven extremely effective at creating images—for example, human faces—that are difficult for humans to distinguish from photographs of real people.[7]

Generative Adversarial Networks (GANs) refers to a pair of AI systems, in which one computer generates an image intended to look like a real photograph, while another system is trained to discriminate real images from synthesized ones. The two systems, in essence, learn from each other, refining both their ability to generate real-looking images and to identify the artifacts of fake images. A related technology that has been shown to outperform GANs is the Variational Autoencoder (VAE). In VAEs, source images are reduced through a process modeled on the algorithms used for image compression, reducing the original amount of information to a minimum, in the process discarding a majority of the information from the original image. From this distillation, the autoencoder then reconstructs the image based on an aggregated "understanding" of its training data. In this process, it is likely that *no* individual pixels will persist from the source image into the reconstruction. Thus, no *literal* recombination of original components has taken place. However, in aggregate, we may observe that the entire process comprises a highly complex progression through stages of distillation, compression, interpolation, and expansion.

To what extent does it make sense to analyze these processes as forms of remix? On a practical level, there is no direct copying, reproduction or reuse of specific image components, which would seem to be the *sine qua non* of classical remix. On the other hand, the process by which a machine learning algorithm digests salient visual characteristics from an original training set of images and then generates new images based on those characteristics seems consistent with the logic of remix. This begs a more precise definition of the constitutive units of images. In the case of the morph or dissolve, that unit may be unambiguously located in the pixel, but machine vision algorithms respond to patterns that may be segmented and differentiated in relation to contextual cues. Digital images captured with a sensor may be understood as a straightforward process of *translation* from reflected light to encoded digital information that has no meaning on its own. For example, a pixel encoded to represent a particular shade of yellow is identical regardless of whether it is used to represent part of a banana or a canary. In contrast, computer vision algorithms perform a process of *interpretation* that generates complex combinations of information in relation to known models. Popular wisdom to the contrary, even rudimentary computer vision systems can tell the difference between bananas and canaries. I would therefore argue that the reciprocal processes of image recognition and

Figure 24.3 NVIDIA research, "Progressive growing of GANs for improved quality, stability, and variation" or "Two imaginary celebrities that were dreamed up by a random number generator" (2017); designer Karen Zack (@teenybiscuit) created a series of images that were widely (and speciously) circulated as evidence of the inability of machine vision systems to distinguish between dogs and baked goods (2017)

synthesis should indeed be understood as a form of remix, albeit a more complex and computational process than pixel-based recombination.

In 2017, NVIDIA research produced a widely circulated collection of non-existent "celebrity" faces synthesized by a Generative Adversarial Network trained on a collection of celebrity headshots.[8] The formally repetitive and consistent nature of promotional headshots in the entertainment industry make for an ideal training set: images are uniformly framed in closeup with even lighting and similar expressions. Consistent with the homogeneity of the entertainment industries themselves, an overwhelming majority of the faces in the training set were biased toward young, conventionally attractive White people, a limitation that has been widely and correctly subjected to critique. The synthesized images pictured here (Figure 24.3), which NVIDIA described as "Two imaginary celebrities that were dreamed up by a random number generator," reflect the biases of their training set to produce new images that are recognizably celebrity-*like*, even though no specific physical attribute may be identified with any original human. Unlike Frankentoons, the generated faces do not present a combination of Jennifer Aniston's eyes with Courtney Cox's mouth and Lisa Kudrow's nose (or whatever), but rather a newly generated instance of celebrity-*ness* that expands on—and adds specificity to—a distilled phenotype of others belonging to the same category.

A problematic aspect of this process is the reproduction of the inherent biases, patterns, and exclusions found in the original training set, which tends to reify normative categories including race, gender, and age. Variations on this critique have emerged in recent years, including Ruha Benjamin's *Race After Technology* and Safiya Noble's *Algorithms of Oppression*, among others. These important interventions in the cultural understandings of algorithms have succeeded at placing human factors—complete with inherent biases, values, and ideologies in the design of technological systems—in the foreground, rather than accepting the presumption of ideological and cultural neutrality in the development or operation of computer code. As various forms of artificial intelligence continue to infiltrate innumerable sectors of commerce and governance—exerting significant, daily influence on people's lives—popular awareness of these system's biases and limitations represents a key factor in attempts to regulate, control, or redirect

their influence.[9] The intervention marked by the intersection of critical race theory and critical algorithm studies correctly locates the origins of technology in human value systems that are inescapably encoded with implicit or explicit forms of bias. These are as difficult to eradicate from technological systems as from culture at large and the stakes are just as high. Raising the level of non-specialist discourse across all domains of artificial intelligence can only help to bring about more robust understanding, debate, and regulation as these technologies continue to be developed and deployed—often to the detriment of the most vulnerable members of the population.[10]

Issues of algorithmic racism are also part of a longer history of cultural anxieties related to human and machine intelligence that underlies many discussions of artificial intelligence. As algorithms are increasingly enlisted in cultural production, assertions that computer-generated artwork can never deliver the insight or experience of human artwork continue to proliferate.[11] A recent issue of the online magazine *Nautilus*, for example, was devoted to the intersection of human and artificial intelligence as it is currently being experienced in AI art. With articles titled, "How I Taught My Computer to Write Its Own Music," "Best Screenplay Goes to the Algorithms," and "Picasso's Got Nothing on AI," the issue lays out a variety of positions related to the conjunction of creativity and automation, all of which circle back to a fundamental reassertion of the primacy of the human in art and creativity.[12] As we further interrogate the ideological entanglement of algorithms with human biases, the instability and insufficiency of the human/computer binary is thrown into relief.

We may ridicule the current state of machine vision algorithms' inability to distinguish between dogs and bagels, or dogs and fried chicken, or dogs and muffins (Figure 24.3), and so on, but we do so at our peril. Reassuring ourselves that the human sensorium remains superior to that of machines suggests more than a hint of desperation. The real message lurking beneath such reassurance is not that our epistemic status in the world is unassailable, but rather the opposite—humans are clinging to a fading superiority in the domains of knowledge and perception. Cultural anxieties that respond to AI-driven machine learning and image synthesis resonate uncomfortably with concerns over fake news and the further erosion of belief in the truth claim of photographic or videographic evidence. But such anxieties long predate the digital era. Viewed from a historical perspective, the human-versus-machine binary resonates uncomfortably with the original-versus-copy binary that once haunted remix culture.

DIY AI

For most of the past decade, a majority of high-profile experiments with image recognition and synthesis have taken place in a tight orbit around a small number of large technology companies led by NVIDIA, Google, Facebook, IBM, and Microsoft. As the large-scale monetization of systems for image recognition depends on having both the technology for processing images and access to massive image and video archives for analysis, algorithms for image recognition and synthesis are routinely made open-source and available to the public for experimentation. I have previously argued that these symbolic gestures of openness may also serve to obfuscate the nature and extent of these companies' core research interests, exemplified by Google's release of the software for creating DIY images using its Deep Dream software in 2012. In contrast with the easily trivialized "hallucinogenic" aesthetics of Deep Dream, the use of GANs and VAEs for

increasingly realistic image synthesis creates opportunities for a different, and arguably more consequential, kind of cultural literacy pertaining to these technologies.

Two independent artists who have produced virtuosic works derived from algorithms for image synthesis are Memo Akten and Refik Anadol. Both are Turkish-born media artists whose body of work spanned a broad range of computational media art before they began experimenting with custom-trained neural networks. Neither Akten nor Anadol were trained in computer science, but both have benefitted from and contributed to the development of open-source software aimed at artistic creation and DIY experimentation. This marks a sharp distinction from earlier generations of computer art, when restricted access to high-end computing systems limited experimentation to corporate-sponsored residencies or formally trained engineers who created art as a side pursuit. An early critique of this aspect of the evolution of software art was articulated as early as 1971 by Frieder Nake: "The big machinery, still surrounded by mystic clouds, is used to frighten artists and to convince the public that its products are good and beautiful."[13] As technologies for image synthesis become widely available and more readily accessible to creators with varying technical skills, we may expect to see a broader range of experimentation with these tools. For now, Akten and Anadol are exemplary of two divergent but equally striking approaches to this type of work as framed within the broad conceptual framework of remix.

Akten's work is fascinating for the machine-like precision with which it transforms everyday objects into realistic-looking images derived from the system's training set. A tangle of wires becomes an undulating bouquet of flowers, a hand and wrinkled dishtowel become a seascape with crashing waves, and so on (Figure 24.4). To highlight his work's emphasis on process and the technology used to create these transformations, Akten presents documentation of the project as a diptych, with the unprocessed video on the left half of the frame and transformed media on the right. As a gallery work, Akten presents *Learning to See* as an interactive installation with a live camera mounted on an animation stand, pointed downwards at a cluster of colorful objects. Visitors are invited to move objects around on the table in order to create live, processed effects based on a variety of training image sets.

Akten's website compares the visual processing of his system to human vision: "An artificial neural network looks out onto the world, trying to make sense of what it's seeing, in context of what it's seen before. But it can only see through the filter of what it already knows, just like us. Because we too, see things not as they are, but as we are."

Figure 24.4 Left: Memo Akten, "Gloomy Sunday" from the series learning to see (2017) (image courtesy of the artist); Right: Refik Anadol, *Latent History* (2019)

Thus a system trained only on flowers, seascapes, clouds, galaxies, or fire (in the case of the series) will reinterpret any shape or image fed into the system into a form that resembles its training set. As Akten notes, this process represents an apt metaphor for a world defined by increasingly individualizing, siloing, and homogenizing technologies. The question is whether projects like this adequately address either the subjectivity of vision or the important purpose of demystifying AI, demonstrating its accessibility to artists and non-technologists alike. Ultimately, we must also question whether highly pleasurable image synthesis artworks like Akten's *Learning to See* may serve a domesticating function for machine learning algorithms, making them appear benign with consequences that are primarily aesthetic rather than political.[14]

For his *Latent History* (2019) project, Refik Anadol was commissioned by the photography museum Fotografiska and the Swedish National Heritage Board to create a work based on some twenty-three thousand historical images in the city archive of Stockholm (Figure 24.4). Anadol used technology and a visual logic similar to Akten's in order to train a neural net based on the vast collection of mostly architectural and landscape images spanning more than 150 years of the nation's history. Unlike the discrete, category-based training sets used by Akten (flowers, fire, clouds, etc.), the Stockholm images were extremely diverse, depicting everything from large government buildings to individual country homes, along with a wide variety of landscapes and waterways. The algorithm, in effect, was trained on the topology of Stockholm with the added dimension of historical evolution. Reversing the algorithm, Anadol then used the trained system to generate sequences of composite images that morph wildly across disparate architectural forms and landscapes.

In contrast with Akten's project, Anadol is less interested in the pedagogical function of the interactive system, which allows viewers to experiment and test responses to shapes, colors, and movements. At the same time, however, Anadol's re-envisioning of the history of Sweden's landscape and built environment through image synthesis represents a genuinely eccentric intervention in the sober discourses that ordinarily drive archival history. Where Akten's work invites viewers to play with the apparatus in a tactile way, ultimately revealing the functioning of the technology, Anadol invites us to speculate on the prospective forms and mutations of alternate historical timelines. *Latent History* thrives on the tension between historical specificity and its abstraction via the neural net, but where Akten's system affords access to the specific from the general, the final revelation for Anadol is the emergence of a general essence from a vast array of historically specific elements.

Viewed as allegories for contemporary visual culture, these systems construct a synthetic realism that far surpasses the once upsetting notion of the simulacrum, defined as an exact copy for which no original exists. In keeping with the crisis of authenticity that accompanied postmodern culture at the end of the twentieth century, rooted in the apparent erosion of the capacity of images to capture or reveal truths about the world, the simulacrum served as an effective metaphor for its time, yielding often-cited examples in popular culture from the humanoid replicants in *Blade Runner* (1982) to the depthless, architectural iconography of Disneyland or Las Vegas. However, a different set of cultural anxieties attend the age of large-scale data analytics, where individual behaviors and preferences dissolve into data flows at a scale and speed that can only be interpreted by machines. The images synthesized by a GAN or VAE may be regarded as an exact interpretation of a set of many originals among which no one image has priority over another. When these systems are used to generate faces that are indistinguishable

from actually existing humans, they suggest anxieties about post-humanism and the Anthropocene, which in turn place us squarely on a trajectory toward the inexorable decentering and/or extinction of humanity.

One of the key internal tensions of algorithmic culture is the shift in emphasis from the actions and desires of discrete individuals to collective flows of data *reflecting* an aggregation of individual actions, desires, and so on. At worst, this decentering of humans in favor of the data we generate may bring an inability to perceive ourselves as part of human collective and ecological systems. Along with reproducing cultural biases in terms of race, gender, age, and so on, algorithms that track the behavior of large numbers of people are generally aligned with the logic of the neoliberalism that treats individuals as rationally self-interested at the expense of collective identity or community affiliation.[15] To understand the functioning of these systems at a deeper level requires factoring in not just individual neurological or cognitive responses but also collective, social, and cultural dynamics. If the goal is a state of coexistence with technological systems and algorithms that are developed with human needs in mind rather than a system where humans learn to alter their behavior in order to elicit an algorithmic response, then we need to think differently about the ways algorithmic culture is imagined, regulated, and implemented. Either humans will take an active role in shaping algorithmic development or the algorithms deployed by government and commercial institutions will continue to reshape human behavior to the benefit of those institutions.

Tempting though it may be to long for a nostalgic return to forms of cultural production predicated on discrete—and therefore classically remixable—elements of visual culture, the days of the Frankentoon have been long eclipsed. Algorithms for converting visual information into computable data—and vice-versa—are now as deserving of the elevated cultural status that Manovich assigned to the database at the end of the last century. What distinguishes the algorithmic remix from its analog and digital predecessors is its irreducibility to individual components capable of conveying meaning in isolation from the computational processes by which they are generated. Work by artists such as Akten and Anadol—along with the kind of open access, amateur, and DIY tools used to create their work—are key to developing the computational literacy needed to respond to the cultural shift from classical to algorithmic remix.

Notes

1 See the section of my book *Technologies of Vision* sub-headed, "Machine Vision/Human Vision."
2 Adam Greenfield, "Digital Cities: Words on the Street" in *Wired UK*. San Francisco, CA: Condé Nast, September 30, 2009.
3 *Technologies of vision* argued at length that the visual culture of the twenty-first century trains us to inhabit a world that is increasingly defined by the logics of data, but insisted that a critical understanding of emerging technologies was enriched and informed by twentieth century visual culture studies.
4 Douglas Rushkoff, "We've Spent the Decade Letting our Tech Define Us. It's Out of Control" in *The Guardian*. UK: Guardian Media Group. December 29, 2019.
5 See: Lev Manovich, *The Language of New Media*. Cambridge, MA: The MIT Press, 2001.
6 Among the most widely used training sets are Stanford University's "Brainwash" database, which contains more than 82,000 annotated heads and Microsoft's "MS-Celeb-1M" dataset of 10 million face images of approximately 100,000 celebrities. In addition, the billions of images that are shared daily on social media platforms may correctly be understood as the raw materials for future training sets.
7 I owe thanks to Sarah Ciston for advising on technical aspects of this section pertaining to neural networks.

8 See: NVIDIA's website This Person Does Not Exist https://thispersondoesnotexist.com (2017, 2019). Also: "Progressive Growing of GANs for Improved Quality, Stability, and Variation" https://research. nvidia.com/publication/2017-10_Progressive-Growing-of (2017).

9 Both Benjamin's and Noble's books are devoted not only to critiquing and creating awareness of the functioning of algorithms in the perpetuation of structural racism, but also advocating for changes to institutional policies and regulation. See Ruha Benjamin, *Race After Technology: Abolitionist Tools for the New Jim Code*, and Safiya Noble, *Algorithms of Oppression: How Search Engines Reinforce Racism.*

10 For a parallel to work by Noble and Benjamin in the domain of economics, see Virginia Eubanks, *Automating Inequality: How High-Tech Tools Profile, Police, and Punish the Poor.*

11 A blunt example is Kevin Berger's "Picasso's Got Nothing on AI Artists: Debating the Impact of Machine-Created Art" in *Nautilus* (December 5, 2019), http://nautil.us/issue/79/catalysts/picassos-got-nothing-on-ai-artists.

12 See: *Nautilus* issue 079, "Catalysts" December 2019. https://nautil.us/issue/79/catalysts.

13 Frieder Nake, "There Should Be No Computer Art," in *Bulletin of the Computer Arts Society*, 1971, 18.

14 http://www.memo.tv/learning-to-see-you-are-what-you-see/.

15 For a discussion of the dynamic of collective isolation, see Wendy Brown, *Undoing the Demos: Neoliberalism's Stealth Revolution.*

Bibliography

Anderson, Steve F. *Technologies of Vision: The War between Data and Images.* Cambridge, MA: The MIT Press, 2017.

Benjamin, Ruha. *Race after Technology: Abolitionist Tools for the New Jim Code.* Medford, MA: Polity, 2019.

Berger, Kevin. "I Am Not a Machine. Yes You Are." Nautilus, December 5, 2019. http://nautil.us/issue/79/catalysts/picassos-got-nothing-on-ai-artists.

Brown, Wendy. *Undoing the Demos: Neoliberalism's Stealth Revolution.* New York, NY: Zone Books, 2017.

Eubanks, Virginia. *Automating Inequality: How High-Tech Tools Profile, Police, and Punish the Poor.* New York, NY: St. Martin's Press, 2018.

Greenfield, Adam. "Digital Cities: Words on the Street." Wired UK, September 30, 2009. https://www.wired.co.uk/article/digital-cities-words-on-the-street.

"Issue 79: Catalysts." Nautilus, June 13, 2020. https://nautil.us/issue/79/catalysts.

"Learning to See." Mehmet Selim Akten. The Mega Super Awesome Visuals Company. Accessed June 13, 2020. http://www.memo.tv/works/learning-to-see/.

Manovich, Lev. *The Language of New Media.* Vol. 1st MIT Press pbk. Cambridge, MA: MIT Press, 2002.

Nake, Frieder. "There Should Be No Computer-Art." Bulletin of the Computer Arts Society, London. No. 18, Oct. 1971. Reprinted in: A. Altena, L. van der Velden, eds. *The Anthology of Computer Art.* Amsterdam: Sonic Acts, 2006.

Noble, Safiya. *Algorithms of Oppression: How Search Engines Reinforce Racism.* 1st Edition. New York, NY: NYU Press, 2018.

"Progressive Growing of GANs for Improved Quality, Stability, and Variation." NVIDIA Research. Accessed June 13, 2020. https://research.nvidia.com/publication/2017-10_Progressive-Growing-of.

Rushkoff, Douglas. "We've Spent the Decade Letting Our Tech Define Us. It's Out of Control." The Guardian, December 29, 2019, Sec. Opinion. https://www.theguardian.com/commentisfree/2019/dec/29/decade-technology-privacy-tech-backlash.

"This Person Does Not Exist." NVIDIA Research. Accessed June 13, 2020. https://thispersondoesnotexist.com/.

Vivian, Sobchack, ed. *Meta-Morphing: Visual Transformation and the Culture of Quick-Change.* Minneapolis, MN: University of Minnesota Press, 1999.

25

ALWAYS ALREADY JUST[1]

Combinatorial Inventiveness in New Media Art

Dejan Grba

In this chapter I explore the creative aspects of combinatorial inventiveness in new media art practices and point to some of the conceptual parallels and shared methodologies in digital humanities. With regard to diverse manifestations of combinatorial inventiveness in new media art, I focus on generative artworks created primarily by processing the material from cinema, television, and the Internet. These artworks blend procedural thinking with bricolage; leverage complex technical infrastructures; foster curiosity; and encourage vigilance in our critical appreciation of the arts, technology, culture, society, and human nature. Throughout each section, I outline the theoretical considerations that can be abstracted from the examples and elaborate on them in the final section which examines the artists' motives and circumstances of analogizing, generating ideas, and meaning making in relation to the cognitive implications of artifactual creativity.

Combinatorial Inventiveness

Combinatorial inventiveness is the ability to use existing ideas or artifacts as malleable components or tools for making new ideas or artifacts. It is essential in all manifestations of human creativity, from language, social and political relations, to the arts, science, and technology.[2] In language and in the arts, it emerges from cognitive processes such as connecting the existing and the new, comparing the known and the unknown, and analogy-making.[3] Combinatorial inventiveness in the arts and culture manifests in a range of creative procedures such as mashup, remix, pastiche, interpretation, free copy, allusion, citation, derivation, détournement, reprise, reference, reminiscence, homage, parody, imitation, forgery, and plagiarism.[4] With continuous recurrence of themes, motifs, forms, and techniques, these procedures are among the key expressive and developmental factors in the arts throughout history. As an important part of art experience, combinatorial inventiveness induces pleasure through the recognition of source materials and models, and their interrelation with new poetic elements. It usually raises public attention in instances when a new artwork which references some copyrighted, commercially, or otherwise prominent

artifact becomes itself prominent, inciting the conflict over the "creative interest" between two or more parties.[5] The obvious or implied creative use of cultural artifacts has been legitimized in different ways throughout twentieth century art—from Cubism and Dada, through Pop-Art, Fluxus, and Conceptual Art, to Postmodern Art in which it became an important strategy[6]—and today exists in many flavors.

Generative Art

In new media art, combinatorial inventiveness manifests through diverse applications of emerging technologies for transforming existing ideas, transactions and data, and for exploring the expressive potentials of computational processing of cultural phenomena. It is central in generative art, which I define as a heterogeneous realm of artistic practices based upon interfacing predefined elements or systems with different factors of unpredictability in conceptualizing, producing, or presenting the artwork, thus underlining the uncontrollability of the creative process, and aestheticizing the contextual nature of art.[7] Like all other human endeavors, the arts take place in a probabilistic universe and always emerge from an interplay between control and accident, so in that sense, all the arts are generative. However, awareness of the impossibility to absolutely control the creative process, its outcomes, perception, reception, interpretation, and further use—which is not always the artists' principal motivation—becomes crucial in generative art.[8] Generative art appreciates the artwork as a dynamic catalyzing event or process, inspired by curiosity, susceptible to chance, and open for change.[9] In its spectrum of creative endeavors, poetics and incentives, generative new media art frequently entails bricolage.

Bricolage

Bricolage is an analogizing approach that combines the affinity and skills for working with tools, materials, and artifacts available from the immediate surroundings. Reflecting the necessity-driven pragmatism of Italian neorealist filmmakers in the 1940s and 50s,[10] bricolage became popular with the arte povera movement during the 1960s as a critical reaction to the commodification of the arts. Since then, it has been adopted and explored in various disciplines including architecture, business, philosophy, anthropology, sociology, and literature, and it has become almost transparent in a wide range of artistic disciplines. Introducing the concept of bricolage in *The Savage Mind*,[11] Claude Lévi Strauss noted that a bricoleur accumulates and modifies her handy means (operators) without subjecting them to a predefined objective, but the objective gets shaped by the interactions between operators[12] in a dynamic process of analogy-making and discovery. Bricolage is, therefore, integral to new media art projects which constantly push the envelope of methodology, production, and presentation through playful but not necessarily preordained experimentation with ideas, tools, and cultural resources. Similarly, bricolage figures in digital humanities' pragmatism toward the availability and efficiency of digital systems, and in the field's inquisitiveness toward the exploratory perspectives and insights specific to digital tools.

Culture as Database

In our massive cultural production and consumption, various phenomenological aspects of everyday life can be quantized and approached as datasets. New media artists and

digital humanities researchers combine statistical tools with computation techniques to accumulate, categorize, process, transform and interact these datasets into new works that help us discover and compare the analogies, trends, regularities, and trivialities in mass-produced culture. Adding an ironic twist to Jean-Luc Godard's encyclopedic approach to cinema and modern culture epitomized in *Histoire(s) du cinéma* (1989–1998),[13] the artists turn the primary database operation of sorting into a conceptual device in order to explore the supercut[14] as a generative mixer of cinematic and cultural tropes. By focusing on specific elements (words, phrases, scene blockings, visual compositions, shot dynamics, etc.), supercuts accentuate the repetitiveness of narrative forms, routines, and clichés in film, television, and other media.

For example, Matthias Müller's *Home Stories* (1990) is a collage of different scenes and protagonists from Hollywood melodramas of the 1950s and 60s, filmed directly from the television set, and edited into a series of recurring motifs of cinematic suspense such as uneasy sleep, getting up, listening at the door, turning on the lights, being startled, etc.[15] In Jennifer and Kevin McCoy's installation *Every Shot, Every Episode* (2001), a strict application of a sorting algorithm rearranges the complete television serial *Starsky and Hutch* into a collection of shots organized according to 278 formal and thematic criteria: every zoom in/out, every piece of architecture, every disguise, every female police officer, etc. Shots in each category are sequentially arranged on DVDs that the visitors can play freely on several parallel displays. Similarly, McCoy's *Every Anvil* (2002) sorts the Looney Tunes cartoon series into 20 categories: every instance of profuse sweating, every fall, every sneaking, every explosion, etc.[16]

Taking slightly broader selection criteria, supercut morphs into condensed micro-narrative in works such as Christian Marclay's *Telephones* (1995)[17] and *The Clock* (2010);[18] Tracey Moffatt's *Lip* (1999), *Artist* (2000), *Love* (with Gary Hillberg 2003), and *Doomed* (with Gary Hillberg 2007);[19] and Marco Brambilla's *Sync* (2005).[20] These self-referential structures follow thematic and formal logic and accentuate the three essential components of screen culture: gaze, sex, and violence. Exploring the possibilities for reproducing film imagery, Virgil Widrich elaborated the supercut micro-narrative in *Fast Film* (2003). It was assembled by making paper prints of the frames from selected movie sequences, which were then reshaped, warped, and torn into new animated compositions. In 14 minutes, *Fast Film* provides an engaging critical condensation of key cinematic tropes such as romance, abduction, chase, fight, escape, and deliverance.[21]

With the explosion of online video sharing since 2005, the supercut became a popular Internet genre but has also remained a strong artistic device. Kelly Mark's post-conceptual installations *REM* (2007) and *Horroridor* (2008) spiced it up with existential overtones through daily manual aggregation and filtering of television broadcasts.[22] In several manually aggregated projects such as *Timeline* (2010)[23] and *Watching Night of the Living Dead* (2018),[24] Dave Dyment expanded micro-narrative supercut into a full feature format which yields generative wonder out of pop-cultural proliferation. To make *Watching…*, Dyment collected scenes from hundreds of movies and TV shows in which people are watching George Romero's film *Night of the Living Dead* (1968). He curated and arranged them along the editing track of the original to reconstruct the complete zombie classic as the *mise-en-scène* of other films and TV programs.[25]

The supercut became interactive and automatic in Julian Palacz's installations *Algorithmic Search for Love* (2010)[26] and *Play it, Sam* (2012).[27] Referring to the McCoy's sorting supercuts, *Algorithmic Search for Love* invites visitors to experience a playful discovery by entering a search phrase that generates a sequence of all video snippets with

Figure 25.1 Julian Palacz, *Play it, Sam* (2012). Installation view (image courtesy of the artist)

matching spoken phrases found in the project's library of films. In *Play it, Sam*, visitors can play a classical piano to trigger a projected sequence of film snippets in which the corresponding piano keys were pressed (Figure 25.1).

With *Network Effect* (2015), Jonathan Harris and Greg Hochmuth routed the interactive supercut to the diversity of online sources.[28] They designed a web search interface in which the keyword selection returns a media stream from an online database of 10,000 video clips, 10,000 spoken sentences, news, tweets, charts, graphs, lists, and millions of data points. By limiting this overwhelming but addictive experience to between six and ten minutes per day depending on the average life expectancy in the viewer's country, *Network Effect* confronts us with the reality of corporate online cultures that often frustrate any attempt at experiential completeness, induce anxiety, and "fear of missing out."

The poetics[29] of the automated supercut reached radical reduction and critical assessment with Sam Lavigne's open-source Python applications *Videogrep* (2014) which generates video supercuts by searching the input query through subtitle files of an arbitrary collection of video files,[30] and *Audiogrep* (2015) which transcribes an arbitrary collection of sound files and creates audio supercuts based on the input query.[31] Pushing the conceptual and technical logic of the automated supercut further leads to machine-learning systems that construct supercuts by searching through large media datasets for an arbitrarily selected artifact or a collection of artifacts. In *Muse AI Supercut* (2017), a commission for the rock band Muse, digital agency Branger_Briz designed a machine-learning system that generates daily supercut music videos in which every word of the Muse's song *Dig Down* (2017) is voiced by a different notable person from videos found online (Figure 25.2).[32]

The innovative approaches to searching and editing the snippets of cultural production in these artworks have parallels in digital humanities projects such as *The Digital Formalism Project* (2007–2012)[33] or Lev Manovich's *Visualizing Vertov* (2013).[34] The work in both fields advances our understanding of animation, film, television, the Internet, and other media, their experiential effects, social roles, and consequences. It

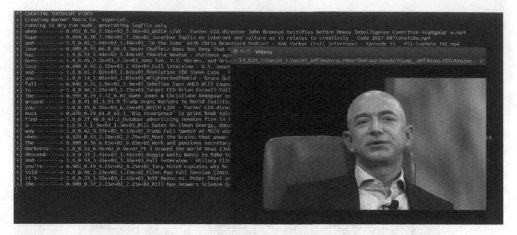

Figure 25.2 Branger_Briz (Ramon Branger, Paul Briz, Nick Briz, Brannon Dorsey and Pedro Nel Ovalles), *Muse AI Supercut* (2017). Project case study screenshot (image courtesy of Branger_Briz)

also demonstrates that, with proper motivation, there is no such thing as "restricted creativity" but rather that creativity thrives on restrictions.

Sampling and Processing

Extending the logic of systematic selection, new media artists combine computational tools with statistical methods to explore the narrative and expressive potentials of automated accumulation, rearrangement, or interpolation of cultural artifacts. Since the 1990s, Jason Salavon has been processing various mass-media contents into refined visuals which define a peculiar aesthetic identity between infographics and abstract art. In Figure 25.1: *Every Playboy Centerfold 1988–1997* (1998), the artist merged all Playboy centerfolds from 1988 to 1997 into a single image using custom mean and median image averaging,[35] and in *Every Playboy Centerfold, the Decades (Normalized)* (2002), he merged all Playboy centerfolds by decade from the 1960s to the 1990s.[36] In *100 Special Moments* (2004), he averaged the sets of one hundred conventionally themed stock photographs taken from the Internet: kids with Santa Claus, junior baseball league, the weddings and the graduations.[37] In *Portrait* (2010), Salavon created four composites merging the reproductions of all the portraits by Frans Hals, Rembrandt van Rijn, Antonis van Dyck, and Diego Velasquez exhibited in the Metropolitan museum.[38] In several video works such as *Everything, All at Once* (2001);[39] *Everything, All at Once (Part II)* (2002);[40] or *The Late-Night Triad* (2003),[41] Salavon subjected TV imagery to radical abstraction through color averaging and slit-scanning. In *Everything, All at Once (Part II)*, for example, a workstation averages every incoming frame of TV video signal into a single line of color and adds it in real-time to an unfolding color strip with original soundtrack. Using a remote control, the visitors can surf the channels of Time/Warner Cable program to manipulate the continuous animation in which the cuts and channel changes show as sharp horizontals, and zooms or other compositional changes as curves.

Kurt Ralske extended the aesthetics of sequential frame sampling in a series of prints titled *Motion Extractions/Stasis Extractions* (2007–2009) in which he sequentially

inter-dissolved the frames from various film classics[42] according to the degree of movement within each scene. *Stasis Extractions* comprises only the frames of static scenes, and *Motion Extractions* the frames with movement.[43] For his bachelor graduation project *Cinemetrics* (2011), Frederic Brodbeck rounded up the infographic processing of the moving image into a Python application.[44] It provides an interactive learning experience through "synoptic" real-time analysis of arbitrarily loaded films according to a number of criteria such as duration, average chromatic values, number of cuts, and sequence movement dynamics. It also allows comparison between the original version of a film and remakes, all films by the same director, films by different directors, by genre etc. These two works are relevant within the context of remix studies as well as digital humanities, with Brodbeck's *Cinemetrics* closely corresponding to Yuri Tsivian's *Cinemetrics* web project (initiated 2005) for the quantitative study of film,[45] and to Yuri Tsivian, Daria Khitrova and Michael Baxter's *Cinemetrics Across Boundaries* (2013–2015).[46] Multi-frame layering, averaging, or collapsing in these artworks and research studies not only eliminate the details and reveal the formal and compositional trends in the source material but also indicate some of the aesthetic preferences, as well as biases, in human visual perception.

However, perceptual biases such as apophenia and pareidolia[47] can be applied for analytical learning through extraction and rearrangement. For example, the digital prints in Jenny Odell's series *Satellite Collections* (2009–2011) present various objects found in Google Satellite View: cargo trains, container ships, landmarks, nuclear cooling towers, airplanes, stadiums, landfills, parking lots, swimming pools, etc.[48] The objects were cut out from their typical environments, grouped by category and arranged into different compositions emphasizing the (un)predictable formal qualities of geometric shapes and patterns that humans create on the earth. Benedikt Groß and Joey Lee's online project *Aerial Bold* (2016) utilizes pareidolic effects to turn the alphabet shapes found in aerial imagery into a generative typeface. The project features thorough documentation, a font catalog and an interactive word processor where visitors can enter text and choose the font size, line spacing, different font classes, and locations.[49] With cross-disciplinary development of crowdsourcing and machine-learning techniques for deriving geodata and enriching it semantically, *Aerial Bold* highlights the active role of new media artists as data producers rather than passive data users. Their cross-disciplinary approach to the cognitive and educational values of automated processing of cultural artifacts corresponds to digital humanities' research based on data mining, data visualization, and text analysis. Although it exceeds the scope of this study, it would be instructive to map the vectors, and to examine the relevance, of the mutual influences between digital humanities and new media arts regarding the creative potentials of digital technologies. This bidirectional affinity has been evolving since the early computer art of the late 1950s and early 1960s.[50]

Since the expansion of data-based techniques in the 2010s, Artificial Intelligence (AI) has been providing various tools for artists and digital humanities researchers to interface and compare human experiential learning with machine learning which relies on large pools of accumulated samples. For example, Libby Heaney's *Euro(re)vision* (2019) is a moving image deepfake in which two EU government leaders from 2019—Angela Merkel and Theresa May—sing absurd and nonsensical songs in a setting which mimics the Eurovision song contest.[51] Inspired by Dada and Cabaret Voltaire performances, this artwork uses two deep fake models and three character-level recurrent neural network models to create new forms of algorithmic poetry which eerily resembles the nonsensicality of

Figure 25.3 Ben Bogart, *Watching (2001: A Space Odyssey)* (2019). Screenshot (image courtesy of the artist)

actual EU/Brexit discourse. Ben Bogart's *Watching (2001: A Space Odyssey)* (2019) in a series *Watching and Dreaming* (since 2014) is an attempt at understanding the algorithmic depictions of popular cinema based on visual and sonic percepts (Figure 25.3).[52] In this series, various film classics are interpreted and represented through hundreds of thousands of percepts which consist of millions of image segments grouped by color and shape similarity, serving as a visual vocabulary for the machine-learning system to recognize, and eventually predict, the structure of the processed films.

By abstracting or concretizing the spatial, temporal, visual, and sonic qualities of their source materials, these statistically informed works open new perspectives for envisioning, assessing, and appreciating cultural phenomena. By emulating the semantic, narrative, and expressive capabilities of human-made cultural artifacts, these works also question the nature of creativity.

Society as Database

Not only cultural artifacts but also all social structures and relations that involve the frequent exchange of information can be envisioned and treated as databases. Data-mining, behavioral tracking, prediction, and manipulation of decision-making have long been essential strategies for large-scale systems such as governments, industry, marketing, advertising, media, finance, or insurance, which all rely on information processing. Computationally enhanced and virally exploiting the human need for socialization and communication, the new iterations of these old corporate strategies of quantization and statistical reductionism refresh our appreciation of privacy and our need for anonymity in a constant arms-race between systems of control and tools for individual advantage.[53] This is most evident in the interfaces of social media, whose design and functionality delineate their statistical logic, often by clumsily trying to hide it. Some new media artworks reveal this bizarre strategy in humorous and provocative ways. They emulate the models of corporate information services by virtually approaching online participants as more or less complex datasets, but slightly repurpose their objectives for ironic revelatory effect.

Paolo Cirio and Alessandro Ludovico made several strong points in this context with their Hacking Monopolism Trilogy that began with *GWEI* and *Amazon Noir* (both 2006). For the final project of the series, *Face to Facebook* (2010), the artists created a bot which harvested one million Facebook profiles, filtered out two hundred and fifty million profile

photos, tagged them by facial expressions (relaxed, egocentric, smug, pleasant, etc.), and posted them as new profiles on a fictitious dating website called *Lovely Faces* (Figure 25.4).[54] *Lovely Faces* had been fully accessible and searchable for five days, during

> See chapter 20 for Alessandro Ludovico's discussion on machine-driven text remixes.

which the artists received several letters from Facebook's lawyers, eleven lawsuit warnings, and five death threats.[55]

Figure 25.4 Paolo Cirio and Alessandro Ludovico, *Face to Facebook (2010)*. Artists as catalysts exhibition in Alhóndiga, Bilbao, Spain (photo: Paolo Cirio)

For his project *A More Perfect Union* of the same year, Luke DuBois made a shrewd interpretation of the technical term "relational database"[56] to draw a socio-cultural outline of the contemporary United States according to the preferred identities and intimate aspirations of its population. He designed a software application which sampled nineteen million user profiles posted on twenty-one dating websites, and used the associated United States zip codes to geographically arrange the most frequent keywords (blonde, cynical, funny, happy, open-minded, lonely, optimist, etc.) into forty-three maps. In state and city maps, the artist replaced the names of cities, towns, and streets with the most frequent keywords in dating profiles of local citizens. In federal maps, the brightness/saturation ratios of red and blue color show the relations between female and male preferences for the most frequent keywords in each state.[57]

A number of artworks in language hacking and data visualization adopt this seemingly ambivalent strategy of using digital tools to reveal the logic and politics embedded in cultural artifacts. They refrain from explicit interventions or explanation but enable us to probe contemporary culture and identify in it the various interests, animosities, struggles, inequalities, quirks, and idiosyncrasies. Examples include Fernanda Viégas and Martin Wattenberg's *Word Tree* (2007),[58] *Web Seer* (2009),[59] *Phrase Net* (with Frank van Ham 2009),[60] and *Fairness in ML* (with Moritz Hardt 2016);[61] Pitch Interactive's *The Holy Bible and the Holy Quran: A Comparison of Words*[62] and *Globe Small Arms Imports and Exports* (both 2011);[63] and Kate Compton's *Tracery* (2012).[64] These artworks may be equally considered projects in digital humanities, which cultivate an analogous two-way relationship with technology by employing digital tools in the pursuit of humanities

research and by subjecting digital technology to humanistic questioning and interrogation, often simultaneously.

The uneasy positioning of the individual toward or within online systems of control has been well analyzed by Alexander Galloway in his book *Protocol* (2004),[65] and reverse-engineered in a number of works by new media artists and activists such as Joana Moll,[66] Adam Harvey,[67] and Vladan Joler. For example, Vladan Joler and SHARE Lab's project *Exploitation Forensics* (2017) snapshots in a series of intricate diagrams the algorithmic logic and functionality of various layers in the Internet's infrastructure, from network topologies and the architecture of social media (Facebook) to the production, consumption, and revenue generation complex on Amazon.com.[68]

These artworks not only skillfully criticize the digital implementations of governing mechanisms, point out their sophistication and pervasiveness but also remind us that we are neither innocent nor completely sincere parties in this relationship. By adopting and using profit-motivated digital platforms, our inertia, ignorance, selfishness, and other fallacies (un)willingly support the functionality of these platforms, build up their social authority, and stir them to further exploit our participation explicitly (searches, clicks, selfies, stories, news), and implicitly (behavior patterns, intentions, desires, profiles). By extracting and representing the manifestations of our participatory-exploitative online strategies, these artworks also imply that only our fetishization of privacy protects us from realizing that the *stories of us* (as told by metadata and algorithmic systems logic) are often much more interesting and meaningful than the *stories we tell about ourselves*. As long as we avoid dealing with our narcissism and our delusions of self-importance, we will fall prey to dishonest signaling, exploitative agendas, and socially constructed apparatuses with mundane interests.[69]

Artifactual Creativity

The projects I discuss in this chapter are a sample of the divergent artistic exploration which contributes in different ways to the recent expansion of creative AI. Contemporary AI research centers around a biologically inspired programming paradigm called a "neural network" which enables a computer system to refine and optimize the methods for solving a particular problem or set of problems by being trained with observational data and by dynamically modifying its own code.[70] The innovations in AI science, technology, and art target elusive high-level cognitive functionality (which often includes manifestations of human intelligence in artistic creativity) and rely heavily on large training datasets of annotated texts, drawings, pictures, photographs, 3D models, sounds, music, videos, films, etc.[71] Being designed on various models of brain functions, the artifactual basis of the AI reflects the fact that human learning and creativity also rely on existing models and examples. These technologies enhance the realm of *artifactual creativity* which I define as the application of combinatorial inventiveness to the specific qualities, meanings, contexts, or implications of existing artifacts in order to produce interesting new artifacts.

Cultural Convergence and Artists' Opportunism

Creative flows and trends in science, engineering, (digital) humanities and in the arts are shaped by cultural convergence—the perceived, unperceived, or idiosyncratic

mutual influences and crossbreeding between analogous modes of thinking that render similar ideas, sometimes in different domains. Although the discovery often relies upon well-established conceptual models or recognizable narrative structures, this reliance is nonlinear and frequently leads to unpredictable directions with unexpected consequences. Bricolage is the epitome of this largely self-organizing and accidental "social life" of creativity, pronounced by the practitioners' expressive or aesthetic unorthodoxies. It also illustrates the power of cognitive evolution through interaction between mature and emerging technologies. In that regard, the artworks discussed in this chapter discredit the myth that everything has already been thought of, invented or discovered. Similar to science and technology, they always start with(in) existing artifacts, but analogize, reconfigure, process, and transform them with finesse and freshness which make us realize that they could only have emerged just now. They help us appreciate the difference between innovation (gradual) and invention (sudden change), showing that both have the potential to transform their contextual values and enrich human experience, thinking, knowledge, and the world.[72]

The continuous zeitgeist-relative interactions of ideas and values in the arts, (digital) humanities, science, and technology should be further addressed from the perspective of the unequal socio-political power and cultural hegemonies, which keep some creative achievements unjustly overlooked, while disproportionately advertising others. This reflects in a tendency to praise certain creative models due to their good fortune of appearing within the right ideological authority, but without critically assessing their originality or merit. On the other hand, in art and science only the "fittest" survive by default, there is no copyright on ideas and one must fight for their own place in the sun.[73] That is why feeling the zeitgeist, intuiting paradigms, and understanding cultural convergence are strong motivational factors for the artists' appropriation of ideas, themes, techniques, and technologies trending from other disciplines.

Within the context of code-based new media art as well as digital humanities practices, however, we also need to acknowledge the conceptual cogency, technical elegance, consequential power, and aesthetic sophistication of work in the related fields of computer science, engineering, and robotics. In that respect, new media artists can be criticized for rarely going beyond smart or amusing spectacularization of the emerging techno-sciences and their cultural effects.[74] Although artful spectacularization can be beneficial for making science and technology more accessible to the public and more open to critical insight,[75] its representational strategies in popular culture often—willingly or unwillingly—divert our attention from the already misrepresented features of science and technology. The artists, the media, and the cultural sector should outgrow the delusion (or cease promoting the illusion) that the arts can influence our world in the same way, to the same extent and with the same relevance as science and technology. Without the edge of critical self-consciousness, artists' pragmatism easily slips into superficial, naïve, or exploitative strategies which support the hypothesis that the arts, among other components of human culture, have evolved as a suite of virtue signaling adaptations for sexual selection and social competition—one of the very views that artists and art promoters oppose the most.[76] In that regard, digital humanities have already been reexamining their relationship with digital technologies.[77] If they want to be at the cutting edge of human experience, creatives in all fields need this edge of critical self-consciousness. Respecting, exploring, and cultivating it, they can define new emancipatory horizons to help us question our ethical standards, assess our social norms, tackle our ever-changing present, and anticipate possible futures.

Above the Drive and Beyond the Procedure

A deeper understanding of the cognitive aspects of artifactual creativity in new media art is instrumental for the artists' critical self-consciousness and essential for our recognition of their achievements. At first sight, the artworks in this chapter may suggest that creativity is somehow degraded if its procedural elements can be presented as algorithms and converted into program code. But the executable procedure of any creative process—when clearly defined—can be algorithmized and coded. Plasticity and adaptability in mimicking natural processes are the defining factors of a universal computing machine which lays the conceptual foundation for modern computer science.[78] Achieving that plasticity and adaptability, however, is itself a creative enterprise which requires ingenuity, multidisciplinary research, critical understanding of accumulated knowledge, and learning.

The development of new media art projects involves two modes of thinking. One is matching the algorithmic and the unpredictable elements into a coherent system. It relies on the anticipation of the performative qualities of the system, based upon experience, knowledge, and intuition. Another mode is the construction of algorithms as multipurpose tools, which requires procedural literacy and programming skills. This "ability to read and write processes, to engage procedural representation and aesthetics," means that programming is not a mechanical task but an act of dynamic communication and symbolic representation of the world.[79] It runs in three steps: dematerialization of certain phenomenon into a set of signs which describe it properly, resolving that sign-set into pure syntax (removing the semantic layer), and translation of the syntax into a series of operations (within the programming environment).[80] This counterintuitive disassembly requires a spectrum of cognitive abilities and skills such as the sense for recognizing the phenomenon which can be algorithmized under given conditions, imagination and flexibility of reasoning, distinguishing between the rational and irrational aspects in our mental concepts of natural phenomena, and attention to the scope of the algorithmic system. Whenever a previously incomputable natural phenomenon or creative process gets algorithmized, it is human intelligence doing the complex job of scrutinizing, symbolically structuring, and encoding it into a functional system. The relationship between human creativity and human-built emulation of creativity reveals the essential flexibility of the human mind in allowing itself to be influenced by technology and simultaneously absorbing, repurposing, transforming, and inventing it.

Within the contexts of new media arts and digital humanities, procedural thinking faces some systemic challenges. The conceptual constraints of programming languages and hardware architectures can impose certain solutions and unwillingly spin the creative process. The fixed performative capabilities of the hardware can reflect in roughness and lack of spontaneity.[81] Ultimately, there are the undecidable problems in computability theory, and the more general limits of mathematical formalization established in Gödel's incompleteness theorems.[82] However, material, formal and procedural boundaries are enforced by men or nature to all human activities, not just to procedural thinking. So, while the optimization of productivity and expressiveness within restrictive frameworks requires significant mental effort, the ability to break out of these frameworks is the essence of creativity.[83] In science, technology, and in the arts, this ability often emerges through a combination of hard work and experimentation which can be pragmatic, playful, or frivolous, but always implies broader ethical aspects. Artists are motivated by the anticipation of poetic values and effects of their projects, but they also

need to acknowledge the risks, to be open to unwanted outcomes or failure, to evaluate and react by improving their methodology or by redefining their approach. Similarly, the agents of scientific, technological, economic, or political experiments should be able to consider both their projected impact and the unpredictability of short- and long-term consequences, to be ready to question and improve their approach. For such ventures of high stakes and high responsibility, artifactual creativity in new media art is instructive because it is defined by the artists' desire to overcome the fact that our experience is stronger than our imagination,[84] and that we predominantly understand new concepts through the existing (old) categories and models.[85]

The successful new media artworks which signify artifactual creativity are distinguished by artists' abilities to transcend the conceptual, productive, aesthetic, and ethical constraints of algorithmic thinking and code-based expression. By leveraging the combinatorial inventiveness into the original structures, they offer inspiring, emotionally and intellectually rich experiences with unique aesthetic and ethical values. With systematic approach to datasets, their sources, and interpretations, the work in digital humanities extends these experiences by adding the explicit analytical layers, by evolving the supporting narratives and by contextualizing them within a broader framework of theoretical discourse. Both fields provide us with powerful cognitive tools for blending the elements of unrelated matrices of thought into the new entities of meaning through comparison, abstraction, categorization, analogies, and metaphors. In a straightforward way, easy to understand and to empathize with, they affirm wit as one of the most attractive and valued human capacities. They tell us stories but, more importantly, they stir curiosity, stimulate imagination and learning, and further motivate creativity by revealing or suggesting their mental models which can be engaged implicitly or explicitly and incite new configurations and ideas.

Notes

1. Relating to the phenomenological features of combinatorial inventiveness and artifactual creativity in (new media) art, this title also refers to Lisa Gitelman's book *Always Already New* (Cambridge: The MIT Press, 2006).

2. Margaret A. Boden, *The Creative Mind, Myths and Mechanisms* 2nd edition (London/New York: Routledge, 2004), 40–53 and passim.

3. Douglas Hofstadter and Emmanuel Sander, *Surfaces and Essences: Analogy as the Fuel and Fire of Thinking* (New York: Basic Books, 2013), 17.

4. Dejan Grba, "B.A.C.H. (References in Visual Arts)," Dejan Grba's website, 2010. http://dejangrba.org/lectures/en/2010-bach-references.php. (accessed July 27, 2020).; Marcus Boon, *In Praise of Copying* (Cambridge: Harvard University Press, 2013).

5. Kirby Ferguson, "Everything is a Remix," Everything is a Remix website, 2011. http://www.everything-isaremix.info/. (accessed July 27, 2020); Lawrence Lessig, *Remix: Making Art and Commerce Thrive in the Hybrid Economy* (London: Bloomsbury Academic, 2008).

6. Elizabeth Linden, "Reframing Pictures: Reading the Art of Appropriation," *Art Journal* 75.4 (2016): 40–57.

7. For other definitions of generative art in contemporary theoretical discourse, which vary by scope and/or inclusiveness, see Dejan Grba, "Get Lucky: Cognitive Aspects of Generative Art," in *XIX Generative Art Conference Proceedings*, ed. Celestino Soddu, (Milan: Domus Argenia, 2015): 200–13.

8. Alan Dorin, Jonathan McCabe, Jon McCormack, Gordon Monro, and Mitchell Whitelaw, "A Framework for Understanding Generative Art," *Digital Creativity* 23, no. 3–4 (2012): 239–59.

9. Grba, "Get Lucky: Cognitive Aspects of Generative Art," 212.

10. Saverio Giovacchini and Robert Sklar, eds., *Global Neorealism: The Transnational History of a Film Style* (Jackson: University of Mississippi Press, 2013), 2.

11 Claude Lévi Strauss, *The Savage Mind* (Chicago: University of Chicago Press, 1962).

12 Nasrullah Mambrol, "Claude Levi Strauss' Concept of Bricolage," Literary Theory and Criticism website, 2016. https://literariness.org/2016/03/21/claude-levi-strauss-concept-of-bricolage/. (accessed July 27, 2020).

13 Wikipedia, "Histoire(s) du cinéma," Wikipedia entry, 2020. https://en.wikipedia.org/wiki/Histoire(s)_du_cin%C3%A9ma. (accessed July 27, 2020).

14 Supercut is an edited set of short video or film sequences selected and extracted from their sources by at least one recognizable criterion. It inherited the looped editing style from structural film in the United States during the 1960s and developed into the structural/materialist film in the United Kingdom in the 1970s. See Tom McCormack, "Compilation Nation: The History and the Rise of the Supercut," Moving Image Source website, 2011. http://www.movingimagesource.us/articles/compilation-nation-20110425. (accessed July 27, 2020).

15 Media Art Net, "Matthias Müller 'Home Stories'," Media Art Net website, 2020. http://www.medienkunstnetz.de/works/home-stories/. (accessed July 27, 2020).

16 Jennifer McCoy and Kevin McCoy, "Projects," Jennifer and Kevin McCoy's website, 2020. http://www.mccoyspace.com/projects/. (accessed July 27, 2020).

17 Public Delivery, "Christian Marclay – Telephones, 1995," Public Delivery's YouTube channel, 2019. https://youtu.be/DW1D2rzPDrw. (accessed July 27, 2020).

18 Wikipedia, "The Clock (2010 film)," Wikipedia entry, 2019. https://en.wikipedia.org/wiki/The_Clock_(2010_film). (accessed July 27, 2020).

19 Wikipedia, "Tracey Moffatt," Wikipedia entry, 2020. https://en.wikipedia.org/wiki/Tracey_Moffatt. (accessed July 27, 2020).

20 Marco Brambilla, "Works," Marco Brambilla's website, 2020. https://www.marcobrambilla.com/selected-works. (accessed July 27, 2020).

21 Virgil Widrich, "Fast Film," Virgil Widrich's website, 2003. https://www.widrichfilm.com/en/projekte/fast_film. (accessed July 27, 2020).

22 Kelly Mark, "Video," Kelly Mark's website, 2020. http://kellymark.com/V.html. (accessed July 27, 2020).

23 Dave Dyment, "Timeline," Dave Dyment's website, 2010. http://www.dave-dyment.com/new-project-4. (accessed July 27, 2020).

24 CBC, "Dave Dyment's Watching Night of the Living Dead," CBC Arts online, 2018. https://www.cbc.ca/player/play/1288630851629. (accessed July 27, 2020).

25 Because of a mistake in its title card, George Romero's *Night of the Living Dead* has always been a public domain film with no licensing or royalty fees, which makes it an easy prey for the directors who need a cinematic backdrop in their scenes. See Lise Hosein, "Night of the Living Dead Has a Scarier Story Than You Think… because Copyright is Terrifying," CBC website, 2018. https://www.cbc.ca/arts/night-of-the-living-dead-has-a-scarier-story-than-you-think-because-copyright-is-terrifying-1.4768307. (accessed July 27, 2020).

26 Julian Palacz, "Algorithmic Search for Love," Julian Palacz's website, 2010. https://julian.palacz.at/en/found-footage/algorithmic-search-for-love. (accessed July 27, 2020).

27 Julian Palacz, "Play it, Sam," Julian Palacz's website, 2012. https://julian.palacz.at/en/found-footage/play-it-sam. (accessed July 27, 2020).

28 Jonathan Harris, "Network Effect," Jonathan Harris's website, 2015. http://number27.org/networkeffect. (accessed July 27, 2020).

29 The term *poetics* refers to the conceptual, cognitive, emotional, intuitive, ethical, narrative, and contextual qualities that influence the production, presentation, and reception of an artwork. Poetics is established in a complex correlation of the artist's experiences, notions, intentions, skills, and imagination with the ideas, techniques, procedures, discourses, and politics that she employs. It is fundamental to the artistic process and creativity in general.

30 Sam Lavigne, "Videogrep," Sam Lavigne's GitHub repository, 2020. https://github.com/antiboredom/videogrep. (accessed July 27, 2020).

31 Sam Lavigne, "Audiogrep," Sam Lavigne's GitHub repository, 2019. https://github.com/antiboredom/audiogrep. (accessed July 27, 2020).

32 Branger_Briz, "Muse AI Supercut," Branger_Briz website, 2017. https://www.brangerbriz.com/portfolio/muse-ai-supercut. (accessed July 27, 2020); Muse, "Dig Down [A.I. Lyric Video]," Muse's YouTube channel, 2017. https://youtu.be/GNn8LZnSfd0. (accessed July 27, 2020).

33 Adelheid Heftberger, "Do Computers Dream of Cinema? Film Data for Computer Analysis and Visualisation," in *Understanding Digital Humanities*, edited by David M. Berry (London: Palgrave Macmillan, 2012), 210–23.

34 Lev Manovich, "Visualizing Vertov," Software Studies Initiative website, 2013. http://softwarestudies. com/cultural_analytics/Manovich.Visualizing_Vertov.2013.pdf. (accessed July 27, 2020).

35 Jason Salavon, "Figure 1: Every Playboy Centerfold 1988-1997," Jason Salavon Studio website, 1998. http://www.salavon.com/work/Figure1EveryPlayboyCenterfold/. (accessed July 27, 2020).

36 Jason Salavon, "Every Playboy Centerfold, the Decades (Normalized)," Jason Salavon Studio website, 2002. http://www.salavon.com/work/EveryPlayboyCenterfoldDecades/. (accessed July 27, 2020).

37 Jason Salavon, "100 Special Moments," Jason Salavon Studio website, 2004. http://www.salavon.com/ work/SpecialMoments/. (accessed July 27, 2020).

38 Jason Salavon, "Portrait," Jason Salavon Studio website, 2010. http://www.salavon.com/work/Portrait/. (accessed July 27, 2020).

39 Jason Salavon, "Everything, All at Once," Jason Salavon Studio website, 2001. http://www.salavon.com/ work/EAO/. (accessed July 27, 2020).

40 Jason Salavon, "Everything, All at Once (Part II)," Jason Salavon Studio website, 2002. http://www. salavon.com/work/EAO2/. (accessed July 27, 2020).

41 Jason Salavon, "The Late-Night Triad," Jason Salavon Studio website, 2003. http://www.salavon.com/ work/LateNightTriad/. (accessed July 27, 2020).

42 *Student of Prague* (1913), *Faust* (1927), *Citizen Kane* (1941), *The Seventh Seal* (1957), *Alphaville* (1965), *2001 Space Odyssey* (1968), etc.

43 Kurt Ralske, "Motion Extractions/Stasis Extractions," Kurt Ralske's website, 2007–2009. http://retnull. com/index.php?/project/motion-extractions/. (accessed July 27, 2020).

44 Frederic Brodbeck, "Cinemetrics," Cinemetrics project website, 2011. http://cinemetrics.fredericbrod-beck.de/, application demo website https://cinemetrics.site/. (accessed July 27, 2020).

45 Susie Allen, "Cinemetrics Quantifies Creativity in Film: Online Community Advances New Approach to Study of Movies," The University of Chicago website, 2015. https://www.uchicago.edu/features/cin-emetrics_quantifies_creativity_in_film/. (accessed July 27, 2020).

46 Yuri Tsivian, Daria Khitrova and Michael Baxter, "Cinemetrics Across Boundaries: A Collaborative Study of Montage," The University of Chicago, Neubauer Collegium for Culture and Society website, 2015. https://neubauercollegium.uchicago.edu/faculty/cinemetrics/. (accessed July 27, 2020).

47 Apophenia is a tendency to establish meaningful patterns within random data in general, while pareido-lia is a tendency to recognize patterns within random visual data. See Skeptic's Dictionary, "Apophenia," Skeptic's Dictionary website, 2014. http://skepdic.com/apophenia.html. (accessed July 27, 2020).

48 Jenny Odell, "Satellite Collections," Jenny Odell's website, 2011. http://www.jennyodell.com/satellite. html. (accessed July 27, 2020).

49 Benedikt Groß, Joey Lee et al. "The Aerial Bold Project," The Aerial Bold Project website, 2016. http:// type.aerial-bold.com/tw/. (accessed July 27, 2020).

50 Herbert W. Franke, *Computergrafik – Computerkunst* 2nd edition (New York: Springer Verlag, 1985).

51 Libby Heaney, "Euro(re)vision," AI Art Gallery website, 2019. http://www.aiartonline.com/highlights/ libby-heaney-2/. (accessed July 27, 2020).

52 Ben Bogart, "Watching (2001: A Space Odyssey)," AI Art Gallery website, 2019. http://www.aiartonline. com/community-2019/ben-bogart/. (accessed July 27, 2020).

53 Dejan Grba, "Forensics of a Molten Crystal: Challenges of Archiving and Representing Contemporary Generative Art," *ISSUE Annual Art Journal: Erase* 08 (2019): 4.

54 This project was published on http://www.lovely-faces.com.

55 Jacquelyn Gleisner, "Paolo Cirio's Lovely Faces," Art 21 magazine web page, 2013. http://magazine.art21. org/2013/08/12/new-kids-on-the-block-paolo-cirios-lovely-faces/#.XMLIPKQRVPY. (accessed July 27, 2020).

56 Wikipedia, "Relational Database," Wikipedia entry, 2019. https://en.wikipedia.org/wiki/Relational_data-base. (accessed July 27, 2020).

57 Luke DuBois, "A More Perfect Union," A More Perfect Union project web page, 2011. http://sites.bxmc. poly.edu/~lukedubois/perfect/. (accessed July 27, 2020).

58 Fernanda Viégas and Martin Wattenberg, "Word Tree," Fernanda Viégas and Martin Wattenberg's web-site, 2007. http://hint.fm/projects/wordtree/. (accessed July 27, 2020).

59 Fernanda Viégas and Martin Wattenberg, "Web Seer," Fernanda Viégas and Martin Wattenberg's website, 2009. http://hint.fm/seer/. (accessed July 27, 2020).

60 Fernanda Viégas, Martin Wattenberg and Frank van Ham, "Phrase Net," Fernanda Viégas and Martin Wattenberg's website, 2009. http://hint.fm/projects/phrasenet/. (accessed July 27, 2020).

61 Fernanda Viégas, Martin Wattenberg and Moritz Hardt, "Fairness in ML," Google's Big Picture Group portal, 2016. https://research.google.com/bigpicture/attacking-discrimination-in-ml/. (accessed July 27, 2020).

62 Pitch Interactive, "The Holy Bible and the Holy Quran: A Comparison of Words," Pitch Interactive's website, 2011. https://www.pitchinteractive.com/bibleQuran/. (accessed July 27, 2020).

63 Pitch Interactive, "Globe Small Arms Imports and Exports," Pitch Interactive's website, 2011. http://armsglobe.chromeexperiments.com/. (accessed July 27, 2020).

64 Kate Compton, "Tracery," Kate Compton's GitHub repository, 2012. https://github.com/galaxykate/tracery. (accessed July 27, 2020).

65 Alexander R. Galloway, *Protocol: How Control Exists after Decentralization* (Cambridge: The MIT Press, 2004).

66 Joana Moll, "The Dating Brokers," Joana Moll's website, 2017. https://datadating.tacticaltech.org/. (accessed July 27, 2020).

67 Adam Harvey, "MegaPixels," Adam Harvey's website, 2017. https://megapixels.cc/. (accessed July 27, 2020).

68 SHARE Lab, "SHARE Lab: Exploitation Forensics Press Release," Aksioma – Institute for Contemporary Art website, 2017. http://www.aksioma.org/press/exploitation.forensics.zip. (accessed July 27, 2020).

69 Vladimir Todorović and Dejan Grba, "Wandering Machines: Narrativity in Generative Art," *CITAR Journal of Science and Technology of the Arts* Special xCoAx Issue, Vol. 11, No. 2 (Portugal: Universidade Catolica Portuguesa, 2019): 55.

70 Michael Nielsen, "Neural Networks and Deep Learning," Online book, 2019. http://neuralnetworksanddeeplearning.com/. (accessed July 27, 2020).; Chris Bishop, "Artificial Intelligence, the History and Future," The Royal Institution YouTube podcast, 2017. https://youtu.be/8FHBh_OmdsM. (accessed July 27, 2020).

71 Melanie Mitchell, *Artificial Intelligence: A Guide for Thinking Humans* Kindle edition (New York: Farrar, Straus and Giroux, 2019), 52–107.

72 Steven Poole, *Rethink: The Surprising History of New Ideas* Kindle edition (London: Random House, 2016), 81–99.

73 Arthur I. Miller, *The Artist in the Machine: The World of AI-Powered Creativity* Kindle edition (Cambridge: The MIT Press, 2019), 39.

74 Grant D. Taylor, *When the Machine Made Art: The Troubled History of Computer Art* (New York and London: Bloomsbury Press, 2014), 233.

75 Ibid., 113, 242–3.

76 Geoffrey Miller, *The Mating Mind: How Sexual Choice Shaped the Evolution of Human Nature* (New York: Anchor Books/Random House, Inc., 2001), 258–91.

77 See, for example, David M. Berry and Anders Fagerjord, *Digital Humanities: Knowledge and Critique in a Digital Age* (Cambridge: Polity Press, 2017), 136–50. This critique has prompted the expansion of the field into critical digital humanities, critical code studies, and software studies, which strive to better identify and question the effects and implications of computational imaginaries, and to emphasize, visualize and critique the political interests, biases and norms embedded in digital technology, algorithms, and software. See James Smithies, *The Digital Humanities and the Digital Modern* (London: Palgrave Macmillan, 2017), 203–35.

78 Martin David and Davis Martin, *The Universal Computer: The Road from Leibniz to Turing* (New York: W.W. Norton & Company, 2000); Ian Watson, *The Universal Machine: From the Dawn of Computing to Digital Consciousness* (New York: Springer, 2012).

79 Casey Reas, Chandler McWilliams, and LUST, *Form+Code in Design, Art, and Architecture* (New York: Princeton Architectural Press, 2010), 17.

80 Frieder Nake and Susan Grabowski, "Computational in Art and Trivialization in Computing," HyperKult XX Lecture website, 2011. https://vimeo.com/27318263. (accessed July 27, 2020).

81 Marius Watz, "Closed Systems: Generative Art and Software Abstraction," in *Eléonore de Lavandeyra Schöffer*, edited by Marius Watz and Annette Doms (Dijon: Les presses du reel, 2010), 1–3.

82 Roger Penrose, *Shadows of the Mind: A Search for the Missing Science of Consciousness* (Oxford: Oxford University Press, 1994), 64–126 and passim.; Smithies, *The Digital Humanities and the Digital Modern*, 85–7.

83 Alan Kay, "The Computer Revolution Hasn't Happened Yet," YouTube website, 1997. https://youtu.be/oKg1hTOQXoY. (accessed July 27, 2020).

84 Alan Kay, "Keynote at the 6th Annual Fujitsu North America Technology Forum," Computer History Museum website, 2013. http://www.ustream.tv/recorded/29156602. (accessed July 27, 2020).

85 Marshall McLuhan, *Understanding Media* (London: Routledge & Kegan Paul, 1964), 4.

Bibliography

Allen, Susie. "Cinemetrics Quantifies Creativity in Film: Online Community Advances New Approach to Study of Movies." The University of Chicago website, 2015. https://www.uchicago.edu/features/cinemetrics_quantifies_creativity_in_film/. (accessed July 27, 2020).

Berry, David M., and Anders Fagerjord. *Digital Humanities: Knowledge and Critique in a Digital Age*, 136–50. Cambridge: Polity Press, 2017.

Bishop, Chris. "Artificial Intelligence, the History and Future." The Royal Institution YouTube podcast, 2017. https://youtu.be/8FHBh_OmdsM. (accessed July 27, 2020).

Boden, Margaret A. *The Creative Mind, Myths and Mechanisms*, 40–53 and passim. 2nd Edition. London/New York: Routledge, 2004.

Bogart, Ben. "Watching (2001: A Space Odyssey)." AI Art Gallery website, 2019. http://www.aiartonline.com/community-2019/ben-bogart/. (accessed July 27, 2020).

Boon, Marcus. *In Praise of Copying*. Cambridge: Harvard University Press, 2013.

Brambilla, Marco. "Works." Marco Brambilla's website, 2020. https://www.marcobrambilla.com/selected-works. (accessed July 27, 2020).

Branger_Briz. "Muse AI Supercut." Branger_Briz website, 2017. https://www.brangerbriz.com/portfolio/muse-ai-supercut. (accessed July 27, 2020).

Brodbeck, Frederic. "Cinemetrics." Cinemetrics project website, 2011. http://cinemetrics.fredericbrodbeck.de/, application demo website https://cinemetrics.site/. (accessed July 27, 2020).

CBC. "Dave Dyment's Watching Night of the Living Dead." CBC Arts online, 2018. https://www.cbc.ca/player/play/1288630851629. (accessed July 27, 2020).

Compton, Kate. "Tracery." Kate Compton's GitHub repository, 2012. https://github.com/galaxykate/tracery. (accessed July 27, 2020).

David, Martin, and Davis Martin. *The Universal Computer: The Road from Leibniz to Turing*. New York: W.W. Norton & Company, 2000.

Dorin, Alan, Jonathan McCabe, Jon McCormack, Gordon Monro, and Mitchell Whitelaw. "A Framework for Understanding Generative Art." *Digital Creativity* 23, no. 3–4 (2012): 239–59.

DuBois, Luke. "A More Perfect Union." A More Perfect Union project web page, 2011. http://sites.bxmc.poly.edu/~lukedubois/perfect/. (accessed July 27, 2020).

Dyment, Dave. "Timeline." Dave Dyment's website, 2010. http://www.dave-dyment.com/new-project-4. (accessed July 27, 2020).

Ferguson, Kirby. "Everything is a Remix." Everything is a Remix website, 2011. http://www.everythingisaremix.info/. (accessed July 27, 2020).

Franke, Herbert W. *Computergrafik – Computerkunst*. 2nd Edition. New York: Springer Verlag, 1985.

Galloway, Alexander R.. *Protocol: How Control Exists after Decentralization*. Cambridge: The MIT Press, 2004.

Giovacchini, Saverio, and Robert Sklar, eds. *Global Neorealism: The Transnational History of a Film Style*, 2. Jackson: University of Mississippi Press, 2013.

Gitelman, Lisa. *Always Already New: Media, History, and the Data of Culture*. Cambridge: The MIT Press, 2006.

Gleisner, Jacquelyn. "Paolo Cirio's Lovely Faces." Art 21 magazine web page, 2013. http://magazine.art21.org/2013/08/12/new-kids-on-the-block-paolo-cirios-lovely-faces/#.XMLlPKQRVPY. (accessed July 27, 2020).

Grba, Dejan. "B.A.C.H. (References in Visual Arts)." Dejan Grba's website, 2010. http://dejangrba.org/lectures/en/2010-bach-references.php. (accessed July 27, 2020).

———. "Forensics of a Molten Crystal: Challenges of Archiving and Representing Contemporary Generative Art." *ISSUE Annual Art Journal: Erase* 08 (2019): 4.

———. "Get Lucky: Cognitive Aspects of Generative Art." in *XIX Generative Art Conference Proceedings*, edited by Soddu, Celestino, 200–13. Milan: Domus Argenia, 2015.

Groß, Benedikt, and Joey Lee et al. "The Aerial Bold Project." The Aerial Bold Project website, 2016. http://type.aerial-bold.com/tw/. (accessed July 27, 2020).

Harris, Jonathan. "Network Effect." Jonathan Harris's website, 2015. http://number27.org/networkef-fect. (accessed July 27, 2020).

Harvey, Adam. "MegaPixels." Adam Harvey's website, 2017. https://megapixels.cc/. (accessed July 27, 2020).

Heaney, Libby. "Euro(re)vision." AI Art Gallery website, 2019. http://www.aiartonline.com/highlights/libby-heaney-2/. (accessed July 27, 2020).

Heftberger, Adelheid. "Do Computers Dream of Cinema? Film Data for Computer Analysis and Visualisation." In *Understanding Digital Humanities*, edited by David M. Berry, 210–23. London: Palgrave Macmillan, 2012.

Hofstadter, Douglas, and Emmanuel Sander. *Surfaces and Essences: Analogy as the Fuel and Fire of Thinking*, 17. New York: Basic Books, 2013.

Hosein, Lise. "Night of the Living Dead Has a Scarier Story Than You Think… because Copyright is Terrifying." CBC website, 2018. https://www.cbc.ca/arts/night-of-the-living-dead-has-a-scarier-story-than-you-think-because-copyright-is-terrifying-1.4768307. (accessed July 27, 2020).

Kay, Alan. "The Computer Revolution Hasn't Happened Yet." YouTube website, 1997. https://youtu.be/oKg1hTOQXoY. (accessed July 27, 2020).

———. "Keynote at the 6th Annual Fujitsu North America Technology Forum." Computer History Museum website, 2013. http://www.ustream.tv/recorded/29156602. (accessed July 27, 2020).

Lavigne, Sam. "Audiogrep." Sam Lavigne's GitHub repository, 2019. https://github.com/antiboredom/audiogrep. (accessed July 27, 2020).

———. "Videogrep." Sam Lavigne's GitHub repository, 2020. https://github.com/antiboredom/videogrep. (accessed July 27, 2020).

Lessig, Lawrence. *Remix: Making Art and Commerce Thrive in the Hybrid Economy*. London: Bloomsbury Academic, 2008.

Lévi Strauss, Claude. *The Savage Mind*. 1st Edition. Chicago: University of Chicago Press, 1962.

Linden, Elizabeth. "Reframing Pictures: Reading the Art of Appropriation." *Art Journal* 75.4 (2016): 40–57.

Mambrol, Nasrullah. "Claude Levi Strauss' Concept of Bricolage." Literary Theory and Criticism website, 2016. https://literariness.org/2016/03/21/claude-levi-strauss-concept-of-bricolage/. (accessed July 27, 2020).

Manovich, Lev. "Visualizing Vertov." Software Studies Initiative website, 2013. http://softwarestudies.com/cultural_analytics/Manovich.Visualizing_Vertov.2013.pdf. (accessed July 27, 2020).

Mark, Kelly. "Video." Kelly Mark's website, 2020. http://kellymark.com/V.html. (accessed July 27, 2020).

McCormack, Tom. "Compilation Nation: The History and the Rise of the Supercut." Moving Image Source website, 2011. http://www.movingimagesource.us/articles/compilation-nation-20110425. (accessed July 27, 2020).

McCoy, Jennifer, and Kevin McCoy. "Projects." Jennifer and Kevin McCoy's website, 2020. http://www.mccoyspace.com/projects/. (accessed July 27, 2020).

McLuhan, Marshall. *Understanding Media*, 4. London: Routledge & Kegan Paul, 1964.

Media Art Net. "Matthias Müller 'Home Stories'." Media Art Net website, 2020. http://www.medien-kunstnetz.de/works/home-stories/. (accessed July 27, 2020).

Miller, Arthur I. *The Artist in the Machine: The World of AI-Powered Creativity*, 39. Kindle edition. Cambridge: The MIT Press, 2019.

Miller, Geoffrey. *The Mating Mind: How Sexual Choice Shaped the Evolution of Human Nature*, 258–91. New York: Anchor Books/Random House, Inc., 2001.

Mitchell, Melanie. *Artificial Intelligence: A Guide for Thinking Humans*, 52–107. Kindle edition. New York: Farrar, Straus and Giroux, 2019.

Moll, Joana. "The Dating Brokers." Joana Moll's website, 2017. https://datadating.tacticaltech.org/. (accessed July 27, 2020).

Muse. "Dig Down [A.I. Lyric Video]." Muse's YouTube channel, 2017. https://youtu.be/GNn8LZnSfd0. (accessed July 27, 2020).

Nake, Frieder, and Susan Grabowski. "Computational in Art and Trivialization in Computing." HyperKult XX Lecture website, 2011. https://vimeo.com/27318263. (accessed July 27, 2020).

Nielsen, Michael. "Neural Networks and Deep Learning." Online book, 2019. http://neuralnetworksanddeeplearning.com/. (accessed July 27, 2020).

Odell, Jenny. "Satellite Collections." Jenny Odell's website, 2011. http://www.jennyodell.com/satellite.html. (accessed July 27, 2020).

Palacz, Julian. "Algorithmic Search for Love." Julian Palacz's website, 2010. https://julian.palacz.at/en/found-footage/algorithmic-search-for-love. (accessed July 27, 2020).

———. "Play it, Sam." Julian Palacz's website, 2012. https://julian.palacz.at/en/found-footage/play-it-sam. (accessed July 27, 2020).

Penrose, Roger. *Shadows of the Mind: A Search for the Missing Science of Consciousness*, 64–126 and passim. Oxford: Oxford University Press, 1994.

Pitch Interactive. "Globe Small Arms Imports and Exports." Pitch Interactive's website, 2011. http://armsglobe.chromeexperiments.com/. (accessed July 27, 2020).

———. "The Holy Bible and the Holy Quran: A Comparison of Words." Pitch Interactive's website, 2011. https://www.pitchinteractive.com/bibleQuran/. (accessed July 27, 2020).

Poole, Steven. *Rethink: The Surprising History of New Ideas*, 81–99. Kindle edition. London: Random House, 2016.

Public Delivery. "Christian Marclay - Telephones, 1995." Public Delivery's YouTube channel, 2019. https://youtu.be/DW1D2rzPDrw. (accessed July 27, 2020).

Ralske, Kurt. "Motion Extractions/Stasis Extractions." Kurt Ralske's website, 2007–2009. http://retnull.com/index.php?/project/motion-extractions/. (accessed July 27, 2020).

Reas, Casey, and Chandler McWilliams, and LUST. *Form+Code in Design, Art, and Architecture*, 17. New York: Princeton Architectural Press, 2010.

Salavon, Jason. "100 Special Moments." Jason Salavon Studio website, 2004. http://www.salavon.com/work/SpecialMoments/. (accessed July 27, 2020).

———. "Every Playboy Centerfold, the Decades (Normalized)." Jason Salavon Studio website, 2002. http://www.salavon.com/work/EveryPlayboyCenterfoldDecades/. (accessed July 27, 2020).

———. "Everything, All at Once." Jason Salavon Studio website, 2001. http://www.salavon.com/work/EAO/. (accessed July 27, 2020).

———. "Everything, All at Once (Part II)." Jason Salavon Studio website, 2002. http://www.salavon.com/work/EAO2/. (accessed July 27, 2020).

———. "Figure 1: Every Playboy Centerfold 1988–1997." Jason Salavon Studio website, 1998. http://www.salavon.com/work/Figure1EveryPlayboyCenterfold/. (accessed July 27, 2020).

———. "Portrait." Jason Salavon Studio website, 2010. http://www.salavon.com/work/Portrait/. (accessed July 27, 2020).

———. "The Late-Night Triad." Jason Salavon Studio website, 2003. http://www.salavon.com/work/LateNightTriad/. (accessed July 27, 2020).

SHARE Lab. "SHARE Lab: Exploitation Forensics Press Release." Aksioma – Institute for Contemporary Art website, 2017. http://www.aksioma.org/press/exploitation.forensics.zip. (accessed July 27, 2020).

Skeptic's Dictionary. "Apophenia." Skeptic's Dictionary website, 2014. http://skepdic.com/apophenia.html. (accessed July 27, 2020).

Smithies, James. *The Digital Humanities and the Digital Modern*, 203–35. London: Palgrave Macmillan, 2017.

Taylor, Grant D. *When the Machine Made Art: The Troubled History of Computer Art*. 1st Edition. New York and London: Bloomsbury Press, 2014.

Todorović, Vladimir, and Dejan Grba. "Wandering Machines: Narrativity in Generative Art." *CITAR Journal of Science and Technology of the Arts* Special xCoAx Issue, Vol. 11, No. 2 (Portugal: Universidade Catolica Portuguesa, 2019): 50–58.

Tsivian, Yuri, Daria Khitrova, and Michael Baxter. "Cinemetrics Across Boundaries: A Collaborative Study of Montage." The University of Chicago, Neubauer Collegium for Culture and Society website, 2015. https://neubauercollegium.uchicago.edu/faculty/cinemetrics/. (accessed July 27, 2020).

Viégas, Fernanda, and Martin Wattenberg. "Fairness in ML." Google's Big Picture Group portal, 2016. https://research.google.com/bigpicture/attacking-discrimination-in-ml/. (accessed July 27, 2020).

———. "Phrase Net." Fernanda Viégas and Martin Wattenberg's website, 2009. http://hint.fm/projects/phrasenet/. (accessed July 27, 2020).

———. "Web Seer." Fernanda Viégas and Martin Wattenberg's website, 2009. http://hint.fm/seer/. (accessed July 27, 2020).

———. "Word Tree." Fernanda Viégas and Martin Wattenberg's website, 2007. http://hint.fm/projects/wordtree/. (accessed July 27, 2020).

Watson, Ian. *The Universal Machine: From the Dawn of Computing to Digital Consciousness*. New York: Springer, 2012.

Watz, Marius. "Closed Systems: Generative Art and Software Abstraction." In *Eléonore De Lavandeyra Schöffer*, edited by Marius Watz and Annette Doms, 1–3. Dijon: Les presses du reel, 2010.

Widrich, Virgil. "Fast Film." Virgil Widrich's website, 2003. https://www.widrichfilm.com/en/projekte/fast_film. (accessed July 27, 2020).

Wikipedia. "Histoire(s) du cinema." Wikipedia entry, 2020. https://en.wikipedia.org/wiki/Histoire(s)_du_cin%C3%A9ma. (accessed July 27, 2020).

———. "Relational Database." Wikipedia entry, 2019. https://en.wikipedia.org/wiki/Relational_database. (accessed July 27, 2020).

———. "The Clock (2010 film)." Wikipedia entry, 2019. https://en.wikipedia.org/wiki/The_Clock_(2010_film). (accessed July 27, 2020).

———. "Tracey Moffatt." Wikipedia entry, 2020. https://en.wikipedia.org/wiki/Tracey_Moffatt. (accessed July 27, 2020).

26
COMPUTATIONAL CREATIVITY
Algorithms, Art, and Artistry
David J. Gunkel

As technologies of various sorts and configurations encroach on human abilities, the one remaining bulwark of human exceptionalism appears to be art and artistry. Artificial Intelligence (AI) might displace human beings from the mundane tasks of driving cars and trucks, translating between languages, or recommending consumer products and services. But these systems are programmed and controlled by human designers, developers, and users. This was the point of what Alan Turing called "Lady Lovelace's objection." As Turing describes, a computer has "no pretensions to originate anything. It can only do whatever we know how to order it to perform."[1] For this reason, it seems a safe bet that computers, algorithms, and AI will automate a wide range of the routine and repetitive activities in many areas of human endeavor. But—so the argument goes—they can never and will never be able to do something inventive, innovative, or inspirational. They will never be able to create art and produce something completely new and original. Right?

Maybe not. As scholars of remix have pointed out, human beings rarely, if ever, create *ex nihilo* (out of nothing). Creative artists are always calling on, borrowing from, and recombining elements drawn from works developed by their predecessors.[2] Perhaps the most direct example of this can be found in a formula developed by Kirby Ferguson in his web documentary *Everything is a Remix*. According to Ferguson, all acts of creativity in all forms of endeavor can be described by three, recursive operations: copy, transform, and combine.[3] Like all formulas, this is an algorithm for generating works of art, and, like any algorithm, it can be and has been made computable. This chapter examines the opportunities, challenges, and repercussions of increasingly creative machines. It asks and investigates a rather simple set of questions: "Can AI, robots, and/or algorithms be creative?" If so, what does that mean for our understanding of art, technology, and human artistry? And how does all of this reconfigure, redefine, and/or remix the legacy and logic of the (digital) humanities?

Speech

The classical Greek definition of the human being was ζῷον λόγος ἔχων, the animal possessing speech. This formulation not only characterizes how the human is

differentiated from other kinds of entities but also shapes and defines the subject and subject matter of the humanities. René Descartes elucidates this in his consideration of human-looking automatons. According to Descartes, there is one very certain means of recognizing that these figures are empty-headed machines and not real human beings:

> They could never use words, or put together other signs, as we do in order to declare our thoughts to others. For we can certainly conceive of a machine so constructed that it utters words, and even utters words which correspond to bodily actions causing a change in its organs. But it is not conceivable that such a machine should produce different arrangements of words so as to give an appropriately meaningful answer to whatever is said in its presence, as the dullest of humans can do.[4]

As if responding to Descartes (without naming him directly), this eventually becomes the defining condition of machine intelligence in Alan Turing's agenda-setting paper "Computing Machinery and Intelligence." Although the term "artificial intelligence" is a product of the Dartmouth Conference of 1956, it is Turing's paper and the "game of imitation" that it describes—what is now routinely called "the Turing Test"—that defines and characterizes the field. "The idea of the test," Turing explained in a BBC interview from 1952, "is that the machine has to try and pretend to be a man, by answering questions put to it, and it will only pass if the pretense is reasonably convincing. A considerable proportion of a jury, who should not be experts about machines, must be taken in by the pretense. They aren't allowed to see the machine itself—that would make it too easy. So the machine is kept in a faraway room and the jury are allowed to ask it questions, which are transmitted through to it."[5] According to Turing's stipulations, if a machine is capable of successfully simulating a human being in communicative interactions to such an extent that human interlocutors (or "a jury" as Turing calls them in the 1952 interview) cannot tell whether they are talking with a machine or another human being, then that device would need to be considered intelligent.

At the time that Turing published the paper proposing this test case, he estimated that the tipping point—the point at which a machine would be able to successfully play the game of imitation—was at least half-a-century in the future. "I believe that in about fifty years' time it will be possible to program computers, with a storage capacity of about 10^9, to make them play the imitation game so well that an average interrogator will not have more than seventy per cent chance of making the right identification after five minutes of questioning."[6] It did not take that long. Already in 1966, Joseph Weizenbaum demonstrated a simple Natural Language Processing (NLP) application that was able to converse with human interrogators in such a way as to appear to be another human person.

ELIZA, as the application was called, was what we now recognize as a chatbot. This proto-chatbot was actually a rather simple piece of programming, "consisting mainly of general methods for analyzing sentences and sentence fragments, locating so-called keywords in texts, assembling sentence from fragments, and so on. It had, in other words, no built-in contextual framework of universe of discourse. This was supplied to it by a 'script.' In a sense ELIZA was an actress who commanded a set of techniques but who had nothing of her own to say."[7] Characterized in this fashion, ELIZA was a language remixer, operating on the basis of decomposition and reassembly rules applied to data. "A decomposition rule," as Weizenbaum explained, "is a data structure that searches a

text for specific patterns, and, if such patterns are found, [it] decomposes the text into disjoint constituents. A reassembly rule is a specification for the construction of a new text by means of recombinations of old and possible addition of new constituents."[8]

Despite this rather simple remix architecture, Weizenbaum's program demonstrated what Turing had initially predicted:

> ELIZA created the most remarkable illusion of having understood in the minds of many people who conversed with it. People who know very well that they were conversing with a machine soon forgot that fact, just as theatergoers, in the grip of suspended disbelief, soon forget that the action they are witnessing is not "real." This illusion was especially strong and most tenaciously clung to among people who know little or nothing about computers. They would often demand to be permitted to converse with the system in private, and would, after conversing with it for a time, insist, in spite of my explanations, that the machine really understood them.[9]

Even if ELIZA did not completely "win" at the game of imitation, the program was a strong contender and demonstrated the possibility of what Turing had originally proposed. In other words, ELIZA was a convincing enough conversational partner that it could pass (at least for some of the users of the program) as another human being. Since the debut of ELIZA, there has been a steady increase in the capabilities of NLP applications, culminating (at least for now) in Spoken Dialog Systems (SDS) or digital assistants like Siri, Alexa, Google Home, Jibo, etc. Consequently, we now have machines that have (or produce a convincing enough simulation of having) λόγος.

Music

Similar progressions are happening in the music industry. Although there have been numerous experiments with algorithmic composition and performance—extending from the musical dice game or *Musikalisches Würfelspiel* of eighteenth-century Europe to cut-up and collage composition techniques in the twentieth century—one of the most celebrated achievements in the field of "algorithmic composition" has been David Cope's Experiments in Musical Intelligence—EMI or "Emmy." Emmy is a PC-based algorithmic composer that is capable of analyzing existing musical compositions, rearranging their basic components, and then generating new, original scores that sound like and, in some cases, are indistinguishable from the canonical works of Mozart, Bach, and Chopin. In fact, Cope has tested and proven Emmy's capabilities by deploying a remixed version of Alan Turing's game of imitation.

The Game, as Cope describes it, asks players to listen to different musical compositions. Some of the compositions are works composed by human beings, i.e., chorales by J.S. Bach or the mazurkas of Frédéric Chopin, others are similar kinds of works generated (or "composed"—and the choice of verb is not insignificant) by Emmy. The objective of the game is for participants to correctly distinguish the human-generated compositions from those created by the algorithm. As Cope reports, "results from previous tests with large groups of listeners, such as five thousand in one test in 1992, typically average between forty and sixty percent correct responses"[10]—meaning that listeners, even expert musicologists, have considerable difficulty with making the correct identification.

For Cope, this outcome is significant for two reasons. First, the music that is composed by Emmy is "interesting and, on at least some level, convincing."[11] It does not sound artificial or mechanical; it sounds like the kind of music that would have been produced by an accomplished human composer. Second, "distinguishing human-composed music from that created by the Experiments in Musical Intelligence is often quite difficult, if at all possible,"[12] meaning that Emmy is able to do for music what ELIZA did with language, namely, pass as a human composer by writing music that is virtually indistinguishable from that created by a human artist. And like ELIZA, the inner workings of Emmy are also quite simple. As Cope describes it, the algorithm operates on the basis of three basic principles:

1. *Deconstruction* (analyze and separate into parts)
2. *Signatures* (commonality—retain that which signifies style)
3. *Compatibility* (recombinancy—recombine into new works)[13]

To begin with, Emmy needs to be supplied with computable musical data. For this purpose, Cope designed a special data structure, where each note in a given musical work would be represented by a distinct set of five numbers that could then be stored in a database and processed by the Emmy algorithm. In *Virtual Music*, Cope provides the following example:

(0 60 1000 1 64)

This is the numeric representation of one musical event—a note. The first number (0) represents the event's "on-time" or "the time elapsed between the beginning of the work and the initiation of the note."[14] The second number (60) represents pitch. The third number (1000) indicates duration—how long a note is held. The fourth number (1) represents the number of the MIDI channel (i.e., 1–16) that is assigned to that note for the purposes of its performance. And the fifth and final number (64) represents dynamics in range from silence (0) to fortissimo (127). Using this numeric representation, one can transpose a musical composition into a sequence of numbers, or what Cope calls an "event list," that can then be accessed and processed by the Emmy algorithm. The transposition, as Cope explains, can be done manually or accomplished "by software that automatically scans printed scores (sheet music) and translates them into events lists."[15]

Once different musical compositions have been translated into event lists and stored in the database, the Emmy algorithm proceeds through four sequentially ordered processing steps:

1. *Pattern Matching*—Once different musical works have been translated into a common method of numeric representation (e.g., an event list), simple pattern matching techniques can be employed to identify commonalities (similar kinds of numbers) between different works, which is, Cope argues, an indicator of the "style" of a particular composer (i.e., Bach) or genre of music (i.e., a Baroque chorale).[16]
2. *Segmentation*—"In order to recombine music it must, self-evidently, be broken into constituent elements first. This process is referred to in the Emmy Software as the segmentation step. Segments, typically, consist of beats—the groupings of notes which correspond with one beat in the music."[17] But, as Cope points out, simply extracting and then reordering different musical segments would produce "musical

gibberish," similar to segmenting a sentence into individual words and then randomly recombining them without regard to syntax or semantics. For this reason, the Emmy software applies an additional analytical step, appending a SPEAC score—Statement, Preparation, Extension, Antecedent, and Consequent—to each extracted segment. The SPEAC score "provides tools for ensuring that when music is recombined, syntactically correct music is also semantically intelligible."[18] In other words, when segments are recombined, they are ordered in such a way that "sounds right," e.g., the ending of one segment leads into the next in a way that makes sense musically.

3. *Recombination*—"Recombinancy," as Cope explains, "is a method for producing new and logical, i.e. musically logical, collections of musical events (i.e. new compositions) by recombining existing data into new logical orders on the basis of rules."[19] These rules—basic guidelines or principles governing musical qualities like pitch, melody, harmony, etc.—can be preprogrammed and applied to the recombination effort. But this imposition of rules generally produces results that sound mechanical or what Cope calls "musically stale imitations." For this reason, Emmy utilizes recombination rules that are not imposed by the programmer but discovered in the genre and style of the source material. The Emmy algorithm, as Cope explains, "assumes that every work, or stylistically consistent body of music, contains an implicit set of instructions, or rules, for creating different but highly-related replications of itself. Consequently, recombinancy, based on acquired rules acquisition (as distinct from rules imposition) provides logical and successful approaches to composing new, highly-related replications of the original work(s)."[20] Emmy acquires its rules by utilizing Augmented Transition Networks (ATNs), which were initially developed in NLP for parsing (taking apart and analyzing) natural language sentences. Emmy uses ATN to analyze the logical order of segments in the music that is stored in the database in order to identify recombination rules that are consistent with the musical form, style, or genre that it is emulating.

4. *Output*—"The output of the Emmy software," Cope explains, "is a musical database with an entire new composition, stylistically faithful to compositions in the original database and resembling them, derived from them but not replicating them."[21] This output can be manifested in the form of a musical score that can be played by human musicians or a MIDI file that can be processed by a computer-controlled synthesizer. In other words, if the musical compositions that are fed into the Emmy algorithm are a set of chorales composed by J.S. Bach, Emmy will analyze and process this musical data and then output a brand new remixed chorale that sounds like, is entirely consistent with, and may even be indistinguishable from a chorale that could have been written by Bach.

Visual Art

Cope's approach to algorithmic remix or what he calls "recombinacy" can be employed for and applied to any endeavor where new works are the product of reorganizing or recombining a set of finite elements. The Painting Fool, which was developed by Simon Colton, is an automated painter that aspires to be "taken seriously as a creative artist in its own right."[22] To date the algorithm has produced hundreds of "original" artworks that have been exhibited in both online and real-world art galleries. Although the program and its mode of operations have been continually modified, improved upon, and

upgraded over time, it is also built on and employs a form of algorithmically controlled remix.

In one project, called "Automated Collage Generation – With Intent," the algorithm was directed to produce original collages based on information derived from news headlines. It does this by following three discrete steps:

1. *Text Retrieval and Analysis*—The system was set up to access news information at Google News and *The Guardian* via the websites' publicly available APIs (application program interface). "The API," as Anna Krzeczkowska, Jad El-Hage, Simon Colton, and Stephen Clark explain, "provides access to headlines, for which there are a number of associated articles, multimedia files, blogs, forums, etc., and our system extracts the first text-based article from this list."[23] From here, the system utilizes a text analysis technique, called "TextRank," to identify and extract the most important or popular keywords.

2. *Image Retrieval and Manipulation*—"The keywords extracted from the news stories are used to retrieve art materials (i.e., digital images) from the Internet and local sources. The system has access to the thirty-two thousand images from the Corel library which have been hand tagged and can be relied on for images which match the given keywords well."[24] Images may also be obtained from a Google Image Search and through Flickr by using these sites' APIs.

3. *Scene Construction and Rendering*—"In the final stage of processing, the retrieved images are assembled as a collage in one of a number of grid-based templates. Then the system employs The Painting Fool's non-photorealistic rendering capabilities to draw/paint the collages with pencils, pastels and paints."[25] In other words, the system lays out the different images according to a two-dimensional grid template. It then transforms the derived image by applying the kinds of filters and rendering techniques available in image processing applications like Photoshop to transform the original images into something more "artistic-looking."[26]

As if following the stipulations of Ferguson's remix algorithm, this implementation of The Painting Fool works by *copying* images from the Internet, *transforming* those images by applying standard image manipulation tools and techniques, and then *combining* these various elements together in an arrangement on a two-dimensional grid. For Colton and his research team, however, what is really important in this process is not the final product. Rather, what is important is the way the process of producing the product complicates the assignment of "artistic intent," which is often considered one of the fundamental aspects of human artistry.

> The value here is not necessarily in the quality of the final artefacts—which are currently a little naïve—but rather in the fact that we had little idea of what would be produced. We argue that, as we did not know what the content of the collages would be, it cannot have been us who provided the intention for them. Given that these collages are based on current events and do have the potential to engage audiences, we can argue that the software provided the intent in this case (perhaps subject to further discussion of *intent* and *purpose* in art).[27]

Colton defines these efforts with the term "computational creativity," which can be differentiated from what others have called "computer generated art" or CG-art. "CG-art,"

as Margaret Boden describes it, refers to an artwork that "results from some computer program being left to run by itself, with zero interference from the human artist."[28] *Computational creativity*, by contrast, is a more comprehensive term that covers a much wider spectrum of activities, devices, and outcomes. As defined by Colton and Geraint A. Wiggins, "computational creativity is a subfield of Artificial Intelligence (AI) research… where we build and work with computational systems that create artefacts and ideas."[29]

Ars Ex Machina

Designing, building, and working with systems that are (or can be said to be) *creative* immediately bumps up against important semantic and conceptual opportunities/challenges. Are these programs, algorithms, and systems really "creative?" Or is this just a form of what Mark Riedl and others have called mere "imitation?"[30] These questions, we should note, are another version (or an imitation of) John Searle's Chinese Room thought experiment, which sought to call attention to the difference separating real cognitive activity, like creative expression, from its mere simulation or imitation.[31] And these questions matter, because creativity is protected territory. "Perhaps," Colton and Wiggins write, "creativity is, for some proponents of AI, the place that one cannot go, as intelligence is for AI's opponents. After all, creativity is one of the things that makes us human; we value it greatly, and we guard it jealously."[32] So the question that remains to be addressed is how can or should we respond to the opportunities and challenges of *ars ex machina* or art from machines?

Responses to this question generally pull in two different and opposite directions. On the one hand, we can answer as we typically have, dispensing with these recent technological innovations as just another instrument or tool of human endeavor. As Martin Heidegger pointed out the standard instrumentalist definition of technology is tightly coupled to and coextensive with an exclusive anthropocentrism, "We ask the question concerning technology, when we ask what it is. Everyone knows the two statements that answer our question. One says: technology is a means to an end. The other says: technology is a human activity. The two definitions of technology belong together. For to posit ends and procure and utilize the means to them is a human activity."[33] According to Heidegger's analysis, the presumed role and function of any kind of technology, whether it be the product of simple handcraft or industrialized manufacture, is that it is a means employed by human users for specific humanly defined ends. Heidegger terms this particular characterization of technology "the instrumental definition" and indicates that it forms what is considered to be the "correct" understanding of any kind of technological device, including computers. "Computer systems," Deborah Johnson writes, extending Heidegger's explanation, "are produced, distributed, and used by people engaged in social practices and meaningful pursuits. This is as true of current computer systems as it will be of future computer systems. No matter how independently, automatic, and interactive computer systems of the future behave, they will be the products (direct or indirect) of human behavior, human social institutions, and human decision."[34] Understood in this way, computer systems, no matter how automatic, independent, or seemingly autonomous they may appear to be, are not and can never be autonomous, independent agents. They will, like all other technological artifacts, always and forever be instruments of human decision-making and action. When something occurs by way of a machine, there is always someone—some human person or persons—who can respond for it and be held responsible for what it does or does not do.

This is, in fact, the explanation that has been offered by David Cope in his own account of the impact and significance of his work with algorithmic composition. According to Cope, Emmy and other systems like it do not compete with or threaten to replace human composers; they are just *tools* of and for musical composition: "Computers represent only tools with which we extend our minds and bodies. We invented computers, the programs, and the data used to create their output. The music our algorithms compose is just as much ours as the music created by the greatest of our personal inspirations."[35] According to Cope, no matter how much algorithmic mediation is developed and employed, it is the human being who is ultimately responsible for the musical composition that is produced by way of these sophisticated computerized tools.

The same argument could be advanced to explain the other applications, like The Painting Fool. When The Painting Fool generates a stunning work of visual art that is displayed in a gallery, there is still a human person (or persons) who is ultimately responsible and can respond or answer for what has been produced. The lines of attribution might get increasingly complicated and tangled up, but there is, it can be argued, always someone behind the scenes who is ultimately responsible for the creative output. Consequently, as Colton and colleagues explicitly recognize, if the project of computational creativity is to succeed, the software will need to do more than produce artifacts and behaviors that we take and respond to as creative product.[36] It will also need to take responsibility for the work by accounting for what it did and how it did it. "The software," as Colton and Wiggins assert, "should be available for questioning about its motivations, processes and products,"[37] eventually not just generating titles for and explanations and narratives about the work but also being capable of responding to questions by entering into critical dialogue with its audience.[38]

At the same time, and on the other hand, we should not be too quick to dismiss or explain away the opportunities opened up by these algorithmic incursions and interventions into what has been a protected and exclusively human domain. The issue, in fact, is not simply whether computer applications, robots, or algorithms can or cannot be responsible for what they do or do not do; the issue also has to do with how we have determined, described, and defined responsibility in the first place. This means that there is both a strong and weak component to this effort, what Mohammad Majid al-Rifaie and Mark Bishop call, following Searle's original distinction regarding efforts in AI, strong and weak forms of computational creativity.[39]

Efforts at what would be the "strong" variety involve the development of "computationally controlled art-systems, producing works judged to have artistic merit."[40] And if the judge of "artistic merit" is the auction house, then strong computational creativity is already upon us. In 2018, the Paris-based collective Obvious (Hugo Caselles-Dupré, Pierre Fautrel, and Gauthier Vernier) employed a Generative Adversarial Network (GAN) in order to produce portraits of a fictional family, the Belamys, in the style of the European masters. In October of that year, one of these artworks, "Portrait of Edmond Belamy," was auctioned by Christies and sold for $432,500; thus indicating, as Christies was quick to point out, "the arrival of AI art on the world auction stage."[41]

But these efforts also have a "weak AI" aspect insofar as they simulate, operationalize, and stress test various conceptualizations of artistic responsibility and expression, leading to critical and potentially insightful reevaluations of how we have characterized this concept in our own thinking. As Douglas Hofstadter has candidly admitted, nothing has made him rethink his own thinking about thinking more than the attempt to deal with and make sense of David Cope's Emmy.[42] In other words, developing and experimenting

with new algorithmic capabilities does not necessarily take anything away from human beings and what (presumably) makes us special but offers new opportunities to be more precise and scientific about these distinguishing characteristics and their limits. Consequently, creating machines that are creative provides us with a way to investigate and experiment with what is called creativity. In this way, AI is not just a tool of human expression but an instrument of/for the humanities.

Notes

1 Alan Turing, "Computing Machinery and Intelligence," in *Computer Media and Communication: A Reader*, ed. Paul A. Meyer (Oxford: Oxford University Press, 1999), 50.
2 David J. Gunkel, *Of Remixology: Ethics and Aesthetics After Remix* (Cambridge, MA: MIT Press, 2016). Eduardo Navas, *Remix Theory: The Aesthetics of Sampling* (Wien: Springer, 2012). Aram Sinnreich, *Mashed Up: Music, Technology, and the Rise of Configurable Culture* (Amhurst, MA: University of Massachusetts Press, 2010).
3 Kirby Ferguson, *Everything is a Remix* (USA: Kirby Ferguson, 2014). http://everythingisaremix.info/.
4 Rene Descartes, *Selected Philosophical Writings*, trans. John Cottingham, Robert Stoothoff, and Dugald Murdoch (Cambridge: Cambridge University Press, 1988), 44.
5 Alan Turing, "Can Automatic Calculating Machines Be Said to Think?" in *The Essential Turing*, ed. B. Jack Copeland (Oxford: Oxford University Press, 2004), 495.
6 Turing, "Computing Machinery," 44.
7 Joseph Weizenbaum, *Computer Power and Human Reason: From Judgment to Calculation* (San Francisco, CA: W. H. Freeman, 1976), 188.
8 Joseph Weizenbaum, "Contextual Understanding by Computers," *Communications of the ACM* 10, no. 8 (1967): 475, https://doi.org/10.1145/363534.363545.
9 Joseph Weizenbaum, *Computer Power and Human Reason* (New York: W.H. Freeman & Co., 1976), 189.
10 David Cope, *Virtual Music: Computer Synthesis of Musical Style* (Cambridge, MA: MIT Press, 2001), 21.
11 Ibid., 32.
12 Ibid.
13 David Cope, "Experiments in Musical Intelligence," accessed March 4, 2020, http://artsites.ucsc.edu/faculty/cope/experiments.htm.
14 David Cope, "Recombinant Music Composition Algorithm and Method of Using the Same," United States Patent, US 7,696.426 B2 (2010), 2.
15 Ibid., 3.
16 Ibid.
17 Ibid., 4.
18 Ibid., 5.
19 Ibid., 7.
20 Ibid.
21 Ibid., 8.
22 Simon Colton, "The Painting Fool: Stories from Building an Automated Painter," in *Computers and Creativity*, ed. J. McCormack and M. d'Inverno (Berlin: Springer Verlag, 2012), 16.
23 Anna Krzeczkowska, Jad El-Hage, Simon Colton, and Stephen Clark, "Automated Collage Generation—With Intent," Proceedings of the 1st International Conference on Computational Creativity (2010), 37.
24 Ibid.
25 Ibid., 38.
26 Examples of artwork produced by *The Painting Fool*, including the collages created by this automatic collage generation process, can be viewed at http://www.thepaintingfool.com.
27 Krzeczkowska, El-Hage, Colton, and Clark, 39.
28 Margaret Boden, *Creativity and Art: Three Roads to Surprise* (Oxford: Oxford University Press, 2010), 141.
29 Simon Colton and Geraint A. Wiggins, "Computational Creativity: The Final Frontier," in *Frontiers in Artificial Intelligence and Applications*, vol. 242, ed. L. De Raedt, et al. (Amsterdam: IOS Press Ebooks, 2012), 21.
30 Tom Simonite, "Ok Computer, Write Me a Song," in *MIT Technology Review*, June 8, 2016, https://www.technologyreview.com/s/601642/ok-computer-write-me-a-song/.

31 David J. Gunkel, *An Introduction to Communication and Artificial Intelligence* (Cambridge: Polity, 2020), 40–1.

32 Colton and Wiggins, 21.

33 Martin Heidegger, *The Question Concerning Technology and Other Essays*, trans. by William Lovitt (New York, NY: Harper & Row, 1977), 4–5.

34 Deborah G. Johnson, "Computer Systems: Moral Entities but Not Moral Agents," *Ethics and Information Technology* 8, no. 4 (2006): 197, https://doi.org/10.1007/s10676-006-9111-5.

35 Cope, Virtual Music, 139.

36 Simon Colton, Alison Pease, Joseph Corneli, Michael Cook, Rose Hepworth, and Dan Ventura, "Stakeholder Groups in Computational Creativity Research and Practice," in *Computational Creativity Research: Towards Creative Machines*, eds. T.R. Besold, M. Schorlemmer, and A. Smaill (Amsterdam: Atlantis Press, 2015).

37 Colton and Wiggins, 25.

38 Colton et al., 15.

39 Mohammad Majid al-Rifaie and Mark Bishop, "Weak and Strong Computational Creativity," in *Computational Creativity Research: Towards Creative Machines*, eds. T.R. Besold, M. Schorlemmer, and A. Smaill (Amsterdam: Atlantis Press, 2015), 37.

40 Ibid., 46.

41 Christies, "Is Artificial Intelligence Set to Become Art's Next Medium?," December 12, 2018, https://www.christies.com/features/A-collaboration-between-two-artists-one-human-one-a-machine-9332-1.aspx.

42 Douglas Hofstadter, "Staring Emmy Straight in the Eye—And Doing My Best Not to Flinch," in *David Cope Virtual Music: Computer Synthesis of Musical Style* (Cambridge, MA: MIT Press, 2001), 38.

Bibliography

Boden, Margaret. *Creativity and Art: Three Roads to Surprise*. Oxford: Oxford University Press, 2010.

Christies. "Is Artificial Intelligence Set to Become Art's Next Medium?." 12 December 2018. https://www.christies.com/features/A-collaboration-between-two-artists-one-human-one-a-machine-9332-1.aspx.

Colton, Simon. "The Painting Fool: Stories from Building an Automated Painter." In *Computers and Creativity*, edited by J. McCormack and M. d'Inverno, 3–38. Berlin: Springer Verlag, 2012. https://doi.org/10.1007/978-3-642-31727-9_1.

Colton, Simon, Alison Pease, Joseph Corneli, Michael Cook, Rose Hepworth, and Dan Ventura. "Stakeholder Groups in Computational Creativity Research and Practice." In *Computational Creativity Research: Towards Creative Machines*, edited by T.R. Besold, M. Schorlemmer, and A. Smaill, 3–36. Amsterdam: Atlantis Press, 2015. https://doi.org/10.2991/978-94-6239-085-0_1.

Colton, Simon, and Geraint A. Wiggins. "Computational Creativity: The Final Frontier." In *Frontiers in Artificial Intelligence and Applications*, vol. 242, edited by L. De Raedt, et al., 21–6. Amsterdam: IOS Press Ebooks, 2012. http://ebooks.iospress.nl/volume/ecai-2012.

Cope, David. *Virtual Music: Computer Synthesis of Musical Style*. Cambridge, MA: MIT Press, 2001.

Cope, David. "Recombinant Music Composition Algorithm and Method of Using the Same." United States Patent, US 7,696.426 B2, 2010. https://patentimages.storage.googleapis.com/25/2e/8f/5e836d32d44240/US7696426.pdf.

Cope, David. "Experiments in Musical Intelligence." 4 March 2020. http://artsites.ucsc.edu/faculty/cope/experiments.htm.

Descartes, Rene. *Selected Philosophical Writings*, translated by John Cottingham, Robert Stoothoff, and Dugald Murdoch. Cambridge: Cambridge University Press, 1988.

Ferguson, Kirby. "Everything is a Remix." December 2014. http://everythingisaremix.info/.

Gunkel, David J. *Of Remixology: Ethics and Aesthetics after Remix*. Cambridge, MA: MIT Press, 2016.

Gunkel, David J. *An Introduction to Communication and Artificial Intelligence*. Cambridge: Polity, 2020.

Heidegger, Martin. *The Question Concerning Technology and Other Essays*, translated by William Lovitt. New York, NY: Harper & Row, 1977.

Hofstadter, Douglas R. "Staring Emmy Straight in the Eye—And Doing My Best Not to Flinch." In *Virtual Music: Computer Synthesis of Musical Style*, edited by David Cope, 33–82. Cambridge, MA: MIT Press, 2001.

Johnson, Deborah G. "Computer Systems: Moral Entities but Not Moral Agents." *Ethics and Information Technology* 8, no. 4 (2016): 195–204. https://doi.org/10.1007/s10676-006-9111-5.

Krzeczkowska, Anna, Jad El-Hage, Simon Colton, and Stephen Clark. "Automated Collage Generation—With Intent." *Proceedings of the 1st International Conference on Computational Creativity*, 2010. http://computationalcreativity.net/iccc2010/papers/ krzeczkowska-hage-colton-clark.pdf.

Majid al-Rifaie, Mohammad, and Mark Bishop. "Weak and Strong Computational Creativity." In *Computational Creativity Research: Towards Creative Machines*, edited by T.R. Besold, M. Schorlemmer, and A. Smaill, 37–50. Amsterdam: Atlantis Press, 2015. https://doi.org/10.2991/978-94-6239-085-0_2.

Navas, Eduardo. *Remix Theory: The Aesthetics of Sampling*. Wien: Springer, 2012.

Simonite, Tom. "Ok Computer, Write Me a Song." MIT Technology Review, June 8, 2016. https://www.technologyreview.com/s/601642/ok-computer-write-me-a-song/.

Sinnreich, Aram. *Mashed Up: Music, Technology, and the Rise of Configurable Culture*. Amhurst, MA: University of Massachusetts Press, 2010.

Turing, Alan. "Computing Machinery and Intelligence." In *Computer Media and Communication: A Reader*, edited by Paul A. Meyer, 37–58. Oxford: Oxford University Press, 1999.

Turing, Alan. "Can Automatic Calculating Machines Be Said to Think?." In *The Essential Turing*, edited by B. Jack Copeland, 487–505. Oxford: Oxford University Press, 2004.

Weizenbaum, Joseph. "Contextual Understanding by Computers." *Communications of the ACM* 10, no. 8 (1967): 474–80. https://doi.org/10.1145/363534.363545.

Weizenbaum, Joseph. *Computer Power and Human Reason: From Judgment to Calculation*. San Francisco, CA: W. H. Freeman, 1976.

27

REMIX GAMES AS INSTRUMENTS OF DIGITAL HUMANITIES SCHOLARSHIP

Harnessing the Potential of Virtual Worlds

Owen Gallagher

This chapter is an investigation into the gradual adoption of games as digital humanities tools and how remix can be used to enhance their effective utilization in scholarly activities. My aim is to consider how remix can lower barriers to entry by streamlining the game development process, and how remix games—those composed of previously published sampled elements—can be used to support existing practices within digital humanities scholarship, while potentially enabling a range of new ones.

In approaching this topic, I propose as a starting point the claim that games are inherently remixable due to their fundamentally modular nature. In fact, since the release of *Spacewar!* (1962)—one of the earliest games to be distributed beyond an individual research institution[1]—games have been modified, remixed, and shared within burgeoning game communities. Despite their origins in academic research centers, for the past sixty years, the primary purpose of most games has been to entertain consumers in commercial contexts. The game industry has eclipsed all other entertainment industries in terms of profitability, now generating revenues greater than the film and music industries combined;[2] however, games also exist at the margins, outside of commercial culture, serving an important purpose as tools of research, scholarship, and education. Yet, there is still some resistance to the adoption of games within the academy, just as there was resistance to practice-based research, video essays, and other forms of nontraditional scholarship in the past.

A review of the relevant literature suggests that games have been used as effective tools in past scholarly activities,[3] and that they have the potential to be considered legitimate forms of research output in and of themselves,[4] despite their relative scarcity among academic publications. Given their interactive nature, virtual environments in

games can potentially capture scholarly experiences and processes in ways that traditional literary outputs cannot. Allowing players agency can increase engagement in relatively challenging humanities theory, history, and research. For example, a virtually simulated historical experience can bring dry facts and data to life in a visceral, interactive, playable way that can be experienced and lived in the moment rather than merely consumed as an abstract, text-based afterthought.

Games can be repurposed with initially unintended outcomes, as alternative forms of storytelling, architecture, music, visual art, language, history, or literature. They can be deployed for other purposes in addition to fun and entertainment—as learning tools, for teaching, professional training, research, analysis, and critique. The gamification of society and culture is already underway. By understanding what has been done in the past and what is currently happening in relation to games and digital humanities, we can contemplate potential futures.

Level 1: Defining Remix Games

At the outset of any attempted discourse on games, it is important to try to clarify what is meant by the term *game*. What is a game? What are remix games? These questions can be qualified by considering the most frequently used taxonomic variations in the literature, namely, *computer* games, *video* games, and *digital* games. As David Gunkel discusses in his book *Gaming the System*,[5] these labels and distinctions are somewhat arbitrary in common usage and are often utilized interchangeably to refer to the same thing. However, there are some recurring distinctions. *Computer* games generally refer to games played on a PC (desktop or laptop computer); *video* games usually refer to console games (for example, PlayStation, Xbox, or Nintendo); and *digital* games often refer to mobile games (those downloaded to a phone or tablet from the App store or Google Play).[6] Most of the examples discussed in the following sections are *computer* games, as these are the most modifiable format. PC games stand in stark contrast to console and mobile games, which generally run on closed operating systems and can only be modified if explicitly authorized and enabled by the publisher and platform, using their own restrictive customization tools. Henceforth, when I refer to "games" in this chapter, I am broadly referring to *computer* games, as opposed to console (video) or mobile (digital) games, as it is the PC versions that can be most easily remixed and repurposed for scholarly pursuits.

There are many arguably unsuccessful and inconclusive attempts in the literature purporting to have captured precisely what defines a game.[7] In the majority of cases, game design involves setting up the parameters whereby a player is required to solve a series of problems in a particular sequence toward the ultimate goal of "winning" the game. Most definitions that focus on interactivity, rules, players, and objectives, however, tend to exclude at least some examples of what many argue still constitutes a game, such as exploratory narratives (sometimes pejoratively referred to as "walking simulators") like the exquisitely detailed *Dear Esther*, *Gone Home*, and *Firewatch* or "Discovery Tour Mode" in the *Assassin's Creed* franchise (Figure 27.1), where there are no obvious aims or objectives for the player.[8] What may be considered a game often defies definition, as specific examples sometimes overlap with other forms of interactivity. Ludwig Wittgenstein argued that it may not be possible to formally define (language) games,[9] but in order to understand and discuss such an intrinsically fluid and modular entity, do we really require a rigid formal definition?[10] At a minimum, we can attempt to include in a working definition the traits that are common to all games, namely, that they are

Figure 27.1 Screenshots of *Dear Esther, Gone Home, Firewatch, Assassin's Creed: Odyssey* walkthrough videos

all playable, interactive, and time-based, but this is obviously deficient and immediately problematic, as it can be argued that watching a TV series on Netflix also fits this definition. Consider, for example, *Black Mirror: Bandersnatch* (2018), which enabled viewers to interact with the narrative by choosing from a set of pre-determined outcomes at various junctures in the story, similar to the classic *Choose Your Own Adventure* series of books popular in the 1980s.[11] Many definitions state that all games have goals, rules, restrictions, and player-controlled roles. Yet again, this definition is inadequate, excluding many "games" that do not fulfill all of these admittedly common characteristics of most games. At this point, like Wittgenstein in his time, we must accept that it may not be possible for all games to satisfy a fixed formal definition, as game designers continue to push the boundaries of what can be achieved within this highly amorphous medium.

To understand remix games, however, we need only comprehend remix in other media forms. Remix games are like remix videos, remix music, or remix images in that they are primarily comprised of sampled content. As a working definition, for the purposes of this chapter, remix games may be understood as games that are composed of previously published media elements, which have been appropriated, repurposed, and reconfigured in the creation of a new work that communicates different messages and meanings than the source material.[12]

By their nature, games are modular, comprising separate asset classes such as visual graphics, animation, music, dialogue and sound effects, environmental and architectural modeling, and, of course, code, which brings all of these disparate elements together and makes them work in the form of a playable interactive experience. Individually, each of these elements can be remixed and recombined into something with a different purpose than originally intended.

Code, itself, has always been inherently modular and remixable. Vast blocks of code are copied and pasted, repurposed, and reused again and again in software applications. This is because many of the same tasks are repeatedly implemented in many apps and games. This reuse of code has a historical precedence dating back to the earliest computer programming languages of the 1940s and 50s; however, it was not until the mid-1970s that copy-and-paste functions became available in text editors and compilers, enabling programmers to reuse code without having to manually type it each time.[13] This "borrowing" of recurring code blocks has been common practice for over half a century and is arguably a significant factor in the development of the open Internet, the World Wide Web, and open-source software as we know them today; thus, the importance of sharing and remixing code cannot be overstated. This trend has been no different in the world of games, which are essentially software with a greater emphasis on visual graphics, sound, and interactivity. For instance, the *initialize* process, when a game runs for the first time and waits for the player to do something—whether that is to push a button on a controller, swipe in a particular direction, or press a key—is something that all games (and all software for that matter) must have in one form or another, in order to start the game. Likewise, in the majority of games, the player controls for up, down, left, and right map to the game controller (or WASD keys) in very similar ways from game to game. Thus, it is a simple matter of efficiency and economy of time and labor to copy and paste these repeated code blocks rather than create them from scratch in every new iteration of software.

Jean Baudrillard described simulation as "the generation by models of a real without origin or reality: a hyperreal."[14] Computer games, particularly those featuring photorealistic graphics and animation, are almost the epitome of Baudrillardian simulacra, being hyperreal models of virtual realities without origin. Thus, remix games, being born-digital and composed of extant game elements and models, are comprised of copies of copied copies with no analog original, though they are far from being mere imitations or reproductions. In fact, all software (games included) must necessarily copy itself in order to function, by constantly reusing loops of extant code. The experience of playing a remix game is also fundamentally different than experiencing the sampled source game elements in isolation, as their meaning and purpose are altered during the remix process through appropriation, juxtaposition, and recombination.

Level 2: Remix Games and Digital Humanities

As discussed from various perspectives throughout this book, the digital humanities is an interdisciplinary area of study that lies at the intersection between the humanities and digital technology. Research activities in digital humanities tend to flow in two distinct directions: using the humanities to reflect on digital technology and using digital technologies to create new knowledge in the humanities. Games are a perfect example of this paradigm. The most established scholarship around games to date has involved applying humanities-style analysis to the study of games (for example, considering race, class, or gender portrayals in *Grand Theft Auto* [GTA] or *Red Dead Redemption*);[15] however, there is another as-of-yet under-utilized opportunity for games to be used as tools to study the humanities (for example, by modifying *GTA V* to study architectural influences in the Los Angeles area).[16] The output of the former example could be a traditional written journal article or book chapter, but in the latter case, it could be a playable game mod featuring an AI tour guide, or a screen-captured Machinima video with

voiceover narration. The technologies used in the digital humanities are essentially any tools, applications, or software that can be used for the effective production and dissemination of research in the humanities, whether these tools are purpose-built for the digital humanities or not.

Digital humanities centers at numerous research institutions around the world collectively focus on a variety of large-scale projects to which games can be of potential service. These include, but are not limited to, building digital collections through archiving; constructing geo-temporal visualizations; analyzing large collections of data via scanning, searching and pattern recognition; creating 3D models of cultural artifacts; developing theoretical approaches to the artifacts of digital culture; practicing innovative digital pedagogy; reimagining scholarly communication beyond the essay, conference paper, journal article, monograph, edited collection, or anthology; and establishing new scholarly configurations that lie beyond traditional academic structures.[17] Specific research questions at the intersection of game studies and digital humanities include—how can games be used to: archive digital collections? Visualize time periods and specific places or cultures? Find patterns in large data collections through interactive analysis? Model humanistic experiences in 3D environments? Digital humanities tools can be useful at all stages of a project: they can be of assistance in advancing research; they can enable more effective dissemination of findings; and they can engage with audiences who would consume or build upon the results, allowing for greater understanding of the research outcomes. In terms of teaching and learning, the use of games as digital humanities tools represents a way for students to participate and interact with topics that may have previously seemed complicated or antiquated. Game engines can also be used to analyze analog data in more efficient and creative ways from different perspectives to find hitherto unseen patterns, such as by closely studying and manipulating artifacts or artworks in a virtual environment.

In 2020, Paris Musées published over one hundred and fifty million images of artworks in their collections online using the Creative Commons Zero license (CC0), effectively releasing them into the public domain.[18] Rather than enabling researchers to merely access these artworks as a dataset in a searchable online database, the potential exists to present them in a VR exhibition, enabling users to walk around and view the artworks with contextual information in a 3D space similar to the original museums. While many galleries and museums ventured to make their collections available as "virtual tours" during the COVID-19 pandemic, the majority of these offerings fall far short of the immersive interactive 3D experience I am describing here, in most cases merely utilizing 2D photographic arrow navigation as opposed to a fully explorable VR environment.[19]

NASA also made their entire media library available online, publicly accessible, and copyright free, for use by anyone for any purpose. This fascinating collection includes thousands of high-resolution photographs of our galaxy and the wider universe taken by the Hubble telescope over the past thirty years,[20] as well as 3D model maps accurately portraying the entire surface of the moon,[21] which can be easily imported into any 3D game engine. The Discovery Programme, an initiative by the Centre for Advanced Irish Archaeological Research, used a technique known as photogrammetry[22] to 3D scan hundreds of culturally significant artifacts dating back thousands of years into Irish history, including stone forts, high crosses, ogham stones, and the entire interior and exterior of the Newgrange passage tomb dating c. 3200 BCE,[23] made available through the 3D library, Sketchfab. Another preservation organization, Digital Heritage Age, has 3D

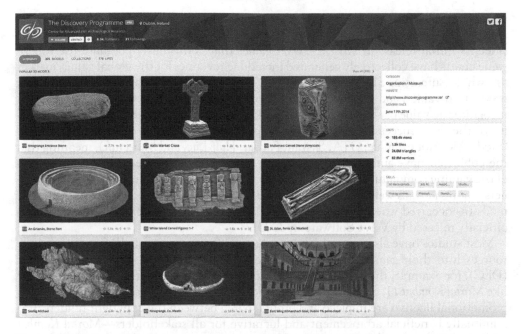

Figure 27.2 Screenshot of the Discovery Programme's Irish heritage 3D models, sketchfab.com

scanned thousands of artifacts for the purpose of digitizing cultural heritage, making them freely available to download and use as 3D models in game engines like Unity or Unreal Engine[24] (Figure 27.2). Their CC0 public domain status and accessibility online makes them potential assets that can be reused in games without permission. There are now numerous online repositories available for digital humanities scholars to make games using digitized artifacts from all over the world (Sketchfab alone has over 300,000 CC0 models). In 2020, Sketchfab introduced a new, easier method for museums and archivists to dedicate their digital 3D scans to the public domain using CC0 licenses. Thomas Flynn, Cultural Heritage Lead at Sketchfab, describes how "This update makes it even easier for 3D creators to download and reuse, re-imagine, and remix incredible ancient and modern artifacts, objects and scenes."[25]

Wouldn't it be more fun and engaging to make a game using the Louvre collection, for example, rather than merely assembling a dry, stuffy searchable database? Why not make a game where you play an art thief stealthily planning a robbery at the Louvre Museum, spending time researching the history of each painting and its actual economic value before the heist, studying security measures to avoid detection, producing forgeries, and replacing the paintings you stole before selling the originals on the black market?[26] Who ever said learning can't be fun?

Level 3: Contextualizing Remix in the Games Industry

Outside of academia, the majority of successful, well-known video games have as their primary purpose the entertainment of players. However, games are also economic products, manufactured within the capitalist system by companies with the ultimate aim of

making a profit, and many of them have dramatically exceeded expectations (*GTA V* alone has generated over $6 billion in revenue and sold more than 120 million copies since its initial release in 2013).[27] AAA games that consistently populate the top 10 game charts have collectively generated incredible revenues for the global games market as a whole, surpassing $150 billion in 2020.[28] These games are top tier in terms of quality, production values, and the development of original IP; however, even AAA publishers recognize the value of allowing users to "mod" their games upon publication. The majority of the most successful games from the past two decades have been intentionally "moddable" (for example, *GTA*, *Skyrim*, *Fallout*, *Half-Life*, and *Minecraft*), meaning that the publishers have authorized the remixing (modification) of their games by members of the gaming community. This cultivates increased loyalty and affinity with these products among fans, as well as occasionally leading to commercial releases of high-quality mods (as occurred when *Counter-Strike*—a highly creative fan mod of *Half-Life*—was officially released by Valve Software in 2000).[29]

Most studios have also recognized the value of officially remixing IP from third-party sources into their games, in the form of revenue-generating downloadable content (DLC), for example, the ability to play as Robocop or Terminator in a nonrelated title like *Mortal Kombat 11*, or as Darth Vader in *Soulcalibur IV*.[30] In these cases, official cross-promotional licenses are in place and profits shared between the copyright holders. It is a mutually beneficial arrangement and lucrative for all stakeholders—*Mortal Kombat* fans may be introduced to Cameron and Verhoeven's sci-fi cyborg franchises, while Star Wars fans may seek out *Soulcalibur* for the thrill of playing as one of their favorite characters in a fight-to-the-death battle.

Terminator vs Robocop is a particularly interesting example in terms of historical remix, as this idea was already explored in a series of unauthorized movie trailer recuts created by Antonio Da Silva (AMDS Films)—originally published to YouTube in the mid-2000s,[31] having racked up millions of views since then—where the 2020 *Mortal Kombat* crossover finally enables gamers to experience this fannish fantasy for themselves (Figure 27.3). We might ask, as did Adorno and Horkheimer in relation to popular music and films,[32] can commercial games be considered rehashes of the twenty-first century "culture industry"? With the vast majority of successful games now being remakes, reboots, sequels, or spin-offs, it is not difficult to see how this could be the case.[33] However, it is in the modification of games by fans where unforeseen creativity may be found.

Figure 27.3 Screenshots of *Mortal Kombat 11* and *Terminator vs Robocop*

Figure 27.4 Screenshots of fan mods in *Skyrim*, *Half-Life 2*, GTA V, and *Sekiro*, YouTube

When it comes to *unauthorized* fan mods, there are literally thousands of illegitimate examples featuring Star Wars characters, which occupy a legal gray area similar to bootleg music remixes and movie trailer mashups, potentially defensible under fair use, depending on the degree of transformativeness evident in the remix game.[34] Some of the most popular examples include the ability to explore *Skyrim*'s open world as a Jedi Knight; fighting waves of invading Storm Troopers in *Half-Life*; or flying around GTA's Los Santos skyline in a lovingly recreated Millennium Falcon.[35] Virtually all well-known sources of IP, from Disney to DC, the Smurfs to Thomas the Tank Engine, have found themselves modded into popular games by fans without permission[36] (Figure 27.4). These juxtapositions can be quite creative, yet copyright holders from the film, TV, and music industries have been reluctant to allow unofficial crossovers to remain online, frequently issuing DMCA takedown notices and occasionally threatening legal action.[37]

Level 4: Making Remix Games

AAA games often take years to make and require vast teams of hundreds of people working in dedicated graphics, animation, programming, music, and many other departments, to produce the complex elements that comprise a PC, PlayStation, Xbox, Nintendo, or mobile game. At the other end of the spectrum is the indie games market. Here, it is possible for smaller teams of two or three (or occasionally, a single person) to make full games using technologies and game engines similar to the AAA companies. To produce an original game from concept to publication is a time-consuming and labor-intensive pursuit, so by reusing freely available pre-existing assets, game designers can

become remixers and smaller scale games, particularly those operating outside of the commercial games industry, can be prototyped faster, at a fraction of the price.

There are a growing number of open-source or free resources, tools, software, game engines, and platforms that can be used to make and share games. Unity and Unreal Engine, for example, enable amateur, noncommercial game creativity.[38] Both companies give their proprietary software away for free—a freemium model—not quite open-source, but free-to-use, determined by the amount of profit made by published games. Fully open-source 3D modeling and animation software like Blender—as well as graphics and music packages such as Gimp and Audacity[39]—make it possible for anyone to learn the skills required to make a game and not have to pay extortionate license fees or subscriptions to use the software. Blender and Unity both have active online networks, providing resources and support to help anyone start making games.[40]

The democratization of game development tools and elements has led to a proliferation of online repositories where artists can publish their work with the intention of enabling someone else to use it in a project or game.[41] Large social fan art communities also exist around these websites, producing new artwork based on pre-existing characters, worlds and universes, or sharing original creations under Creative Commons licenses. The availability of such vast databases of pre-fabricated, ready-made assets means that would-be game designers can easily repurpose this content in the creation of their own remix games.

Contrary to popular belief, modding does not necessarily require advanced coding skills. Most often, modding involves replacing game textures, models, and environment maps with different ones and to a lesser extent, tweaking the game engine's settings (or the actual code) to alter how aspects of the game function. The barrier to entry for creating games has never been lower than it is today, and game design is only becoming more accessible as time goes on. Reusing digital assets, whether images, sounds, or animations—all of which are reducible to digital 1s and 0s—can be seen in the same way as reusing an *initialize* code block or a player controller script. Despite this fact, the majority of newly published visual and aural content is protected by copyright law and cannot be legally reused in a commercial game without a license agreement. An indie developer planning to release a game commercially would need to be wary of reusing assets without permission. Noncommercial amateur creativity or remix, however, is often defensible through the fair use provision in US copyright law. Teachers, researchers, and scholars, in particular, are free to remix for educational purposes, parody, or critique, particularly when the majority of 3D models available from online repositories like Sketchfab, Blendswap, or Renderhub are arguably examples of fair use fan art already. However, it is important for potential game remixers to be aware of the historical implications of copyright and remixing when designing and building noncommercial games.[42]

Level 5: Remix Games and Education

Perhaps the single aspect of the digital humanities that has seen the greatest adoption of game-related deployment to date has been the area of innovative digital pedagogy.[43] Games are being taught in educational contexts in three main ways: 1) As the subjects of analysis and critique; 2) as tools to learn about other topics; and 3) as ends in themselves, that is, equipping students with the skills to make their own games. In the latter case, game-making courses are most likely to be found as part of creative digital media undergraduate programs, or sometimes Information and Communication Technology

(ICT) degrees, with the emphasis placed on either game design or game development, respectively.[44]

Educational games are often designed externally, then used in schools and universities to teach or facilitate learning of specific topics. There is a long history of using educational games in classrooms dating back to the 1970s, the earliest of which was *Logo* (1970), the "game" that blended mathematics and programming to teach players the basics of coding by directing a turtle-shaped cursor to draw lines, shapes, and patterns (I fondly recall playing *Logo* on an Apple II at my own school in the 1980s). Another early well-known example of a game used as a learning tool was *The Oregon Trail* (1971), which solidified the concept of educational gaming, teaching players about American history and geography by guiding a family on their way across the United States during the 1800s, experiencing sickness, starvation, and even death along the way, as was true of the time period.[45]

More recently, certain games that lend themselves to humanities undergraduate classrooms have been repurposed for educational use, for example, using *Assassin's Creed* to teach aspects of a History or Archaeology class (Figure 27.5); or using *Civilization* in a Sociology or Politics class.[46] Software companies like Ubisoft have been forging relationships with digital humanities scholars and departments in order to recreate a greater sense of realism and historical accuracy in their game environments, going so far as enlisting historians, Egyptologists, and hieroglyphics-deciphering AI to ensure a highly authentic experience of Ancient Egypt in *Assassin's Creed: Origins*.[47]

Figure 27.5 Screenshots of educational games: *Logo* and *The Oregon Trail*; walkthrough videos of *Assassin's Creed: Origins* and *Civilization VI*, YouTube.com and InternetArchive.org

Many such games, while not explicitly intended for educational purposes, draw heavily upon the humanities in their creation and can be very useful as interactive learning tools, when custom-designed alternatives are not available. However, there are some avant-garde educators at the cutting edge, actually making games specifically for the purpose of teaching humanities content in more interactive, entertaining ways. One such pioneer is Dr. David Fredrick, founder and director of the Tesseract Center for Immersive Environments and Game Design at the University of Arkansas.[48]

Saeculum and the Tesseract Center

The Tesseract Center is unusual in that it is structured in a similar way to a small indie game studio, while relying heavily on undergraduate interns and graduate volunteers, with a purpose and mission deeply rooted within the humanities and academia. The center creates immersive, game-based content for courses and research through interdisciplinary project-based activities, initially teaching students how to make games and then using games to teach humanities topics. The Tesseract "academic studio" was established in 2012 following a range of smaller-scale digital humanities projects undertaken by the center director, David Fredrick (also professor of classical studies and director of humanities at University of Arkansas), such as producing 3D visualizations of Ostia Antica (Ancient Rome) based on gigabytes of data laser scanned on location at the archaeological site during a research visit led by Fredrick in 2007.[49]

Students at the Tesseract Centre learn how to produce games using Unity and one of their most successful ongoing projects is a game called *Saeculum*, part of the Introduction to Classical Studies course, designed to teach students about Ancient Rome.[50] The game aims to recreate life in Rome during five distinct time periods, witnessing how the city changed over time, drawing upon archaeological evidence and 3D-captured data, modeling, and visualization to produce an authentic, historically accurate experience for the player. The game itself is narrative-driven with an emphasis on dialogue and player expression through choices and branching decision trees, comprising twenty hours of gameplay and voice-acted, animated characters. Part of the challenge for Tesseract was to achieve a balance between historical authenticity, effective teaching, and entertaining gameplay experiences, which *Saeculum* arguably does on all counts, demonstrating how games and the digital humanities can work in harmony to enhance learning.[51]

Undergraduate Game Remixers

In my own teaching practice, delivering courses in Game Design and Advanced Interactive Applications to Middle East undergraduate students over the past decade, I have tested a similar approach with relatively successful results. As part of the Creative Media Center at Bahrain Polytechnic,[52] my students have made hundreds of interactive narratives, educational games, and virtual exhibitions on topics as diverse as color theory, Greek mythology, and the Achaemenid Empire, among many others. I encourage students to embrace game mechanics, incorporating feedback and reward systems into the design of their games. The virtual museum projects tend to be first-person exploratory games where the player can interact with individual displays to reveal further information, while completing a series of game-like objectives during a navigational journey to the exhibition's conclusion. The player explores a 3D environment viewing artworks and artifacts, learning about the topic in a playful and engaging manner—similar to

Figure 27.6 Screenshots showing a sample of my students' game projects 2018–19: *The Achaemenid Empire*, Hawra Alekri; *City of Athens*, Manar Aljaleef; *PokiSaw*, Eyad Abdulaziz; *The Shinning*, Nusaibah Alkooheji

interactive displays in real-life museums and galleries, but heavily influenced by game design principles.

During their course, students also create interactive narratives whereby they are required to tell a compelling story through the medium of a third-person 3D game (Figure 27.6). Sometimes they combine original content with remix—for example, by writing an original story and then bringing it to life using prefab assets—or by using a pre-existing narrative as a starting point, such as a Grimm's fairy tale, which students must then adapt and translate into a third-person character-driven game using a combination of prefab and newly created assets. They work to their strengths in small teams of two or three, comprising animators, artists/designers, and coders. However, by utilizing visual scripting systems such as Playmaker, Bolt, and Blueprints,[53] it is now entirely possible for students to make full games without writing a single line of code, lowering the barrier to entry even further for less technically minded humanities scholars. One of my main aims with this program—apart from attempting to make game development more accessible to creative types lacking technical expertise—has been to encourage students to build games for purposes beyond entertainment and even education—to enable their use as artistic tools for the communication of critical thought.

Level 6: Remix Games as Scholarly Research

As discussed by Stephanie de Smale in her paper *Game Essays as Critical Media and Research Praxis*,[54] the emergence of software like Unity makes it easier and faster to create games and equip game scholars and humanities-based theorists with the ability to make their own critical game prototypes. The confluence of technological events

described in previous sections has led to game design becoming increasingly accessible to non-technical experts, opening up the field to many new practitioners. Video essays are discussed in other chapters in this volume, but what about the game essay? I refer here not to essays about games, but rather, games that serve the same function as academic essays—to persuasively communicate a thesis with evidence supported by scholarly research. Coltrain and Ramsay, studying games as cultural texts, argue that the "scholarly experience" could potentially be captured more accurately in a game than in a written text.[55] For example, as you play a (scholarly) game, you could actually experience the research process for yourself, gathering and synthesizing primary and secondary sources of evidence into a hypothesis of sorts, testing your theory and arriving at a conclusion within the game using deductive, inductive, or abductive methods. The purpose of the game would be to guide the player through the scholarly process, step-by-step, nurturing and encouraging new interpretations and inferences from the provided evidence, with the potential for multiple, branching outcomes. Alternatively, a more controlled, linear approach could guide the player toward a particular interpretation of the evidence as perceived by the designer. At present, there are relatively few examples of such scholarly games published as research, with some notable exceptions, such as the work of Ian Bogost, Lindsay Grace, Mary Flanagan, Jane McGonigal, and Paolo Pedercini,[56] whose award-winning "serious games" attempt to educate, persuade, and critique, while their traditionally published contextual writings aim to help establish games as a legitimate academic form.

Does the act of "gamifying" a serious piece of research render it dubious or even outcast by the academy? Is such a game perceived as more of a gimmick than serious scholarship, because it is also entertaining and engaging? Could scholarly games help to disseminate knowledge to wider audiences than has been possible from the traditional ivory towers of academia? The answers to these important questions have been implied to some extent through other forms of scholarship that initially struggled to gain acceptance due to their reliance on new technologies, such as blogs, podcasts, online videos, multimedia, mixed-media, and practice-based research.[57]

Level 7: The Future of Remix Games

As this chapter has shown, the adoption of games as tools in digital humanities scholarship has been gradually increasing over the past decade, to the point where games have almost (but not quite) become an accepted form of academic publication in their own right. My secondary claim—that remix can be used to lower barriers to entry, thereby increasing accessibility and enhancing the use of games in academic activities—has also been demonstrated through a number of examples where remix has been effectively utilized at the intersection of game design and digital humanities. Remix streamlines the process of developing games, minimizing the need for specialist teams, thereby potentially saving time, money, and labor, those most scarce of assets for the majority of academic institutions. Finally, through a sample of global examples, this chapter highlights how remix games can be used to support existing practices within digital humanities scholarship, such as visualization, digital archiving, innovative pedagogy, and virtual simulation, while potentially enabling a range of new ones.

The past and present of games have been considered, but what of the future? What other purposes could be set for games that have not yet been explored? Arguably, there are few areas of the human experience that would not stand to benefit from enhanced

utilization of remix games in the future. So-called "serious games" could be more widely used to augment learning in all subject areas. The gamification of education has already taken hold and not only in the humanities, but also the STEM fields, a logical outcome of the fact that games are inherently humanistic, artistic, *and* technological—they require human interaction, creativity, and technical apparatus by default.

Outside of institutional education, games are already being used for other purposes, but broadly speaking, people are still more interested in games for entertainment than for their use-value. Games and virtual worlds can be particularly useful in simulating experiences that may be difficult, dangerous, or expensive in real life. Games enable us to visualize things we can't see and experience things we can't do in actuality, such as walking around ancient ruins that have been sealed off to the public for safety reasons. At the same time, games allow us to repeatedly practice simulated activities that may be costly and time-consuming in real life in safe, risk-free environments with minimal real-world consequences. Current technical limitations in game hardware expose a significant disconnect between the real and the virtual—we still have to make a conscious choice to start up our console or computer and set aside time to play (perhaps less so for mobile games). VR involves several additional setup steps, as well as requiring users to wear unwieldy headsets, stand in front of motion sensor cameras, and hold motion controllers. Yet it may not be long before this disconnect begins to dissolve as games gradually integrate more seamlessly with our daily social media lives. We can already see this occurring through the adoption of game streaming platforms like Google Stadia, PS Now, and Project xCloud, and social VR worlds like Sansar, Rec Room, VRChat, and Facebook's *Horizon*, which are gaining traction, bolstered by the need for virtual meetings and online collaboration during the COVID-19 pandemic.[58] Once this transition occurs, the concept of "playing" games may begin to blur as gamification becomes normalized for the majority of online users, and game design principles are adopted more widely by social, political, commercial, and educational institutions. For now, remix and open-source tools can help digital humanities scholars share their academic research in the form of remix games. An exciting and relatively untapped potential exists to use remix and the digital humanities to bridge the gap between serious games and playful scholarship.

Notes

1 Devin Monnens, *Space Odyssey: The Long Journey of Spacewar! From MIT to Computer Labs Around the World* (Canada: Kinephanos, 2015), 124–47.

2 Tom Wijman, *The Market Will Surpass $200 Billion by 2023* (USA: Newzoo, 2020), https://newzoo.com/insights/articles/newzoo-games-market-numbers-revenues-and-audience-2020-2023/.

3 Mike Sell, *Why Videogames (Should) Matter to the Humanities* (USA: Indiana University of Pennsylvania, 2018); Alex Layne, *Why Video Games are Important for Digital Humanists* (USA: NYMG, 2013), 1.

4 Darinda Sharp, *The Emerging Role of Game Design in Digital Humanities* (USA: J. William Fulbright College of Arts and Sciences, 2015); Eric Champion, *Critical Gaming: Interactive History and Virtual Heritage* (UK: Ashgate, 2015), 1.

5 David Gunkel, *Gaming the System: Deconstructing Video Games, Game Studies and Virtual Worlds* (USA: Indiana University Press, 2018), 7–12.

6 Mark J.P. Wolf, *The Video Game Explosion: A History from Pong to Playstation and Beyond* (USA: Greenwood, 2008), 3–7.

7 See Wolf (2008), Gunkel (2018), Wechselberger (2009), Conway and Finn (2013), Karhulahti (2015), Esposito (2005), Tavinor (2008), Leino (2010), Iverson (2010), Costikyan (2002), Crawford (2003), Frasca (2007), Parlett (1999), Salen and Zimmerman (2003), Juul (2010), Malaby (2007).

8 Erik Kain, *On Walking Simulators, Game Journalism and The Culture Wars* (USA: Forbes, 2016), 1.

9 Ludwig Wittgenstein, *Philosophical Investigations* (USA: Wiley Blackwell, 1953), 36.

10 Espen Aarseth, *Ontology in The Routledge Companion to Video Game Studies*, Eds. Mark J.P. Wolf and Bernard Perron (USA: Routledge, 2014), 484–92.

11 David Slade (Director), Charlie Brooker (Writer), *Black Mirror: Bandersnatch* (UK: Netflix, 2018).

12 Owen Gallagher, *Reclaiming Critical Remix Video: The Role of Sampling in Transformative Works* (USA: Routledge, 2018), 2.

13 Larry Tesler, *A Personal History of Modeless Text Editing and Cut/Copy-Paste* (USA: Interactions, 2012), https://dl.acm.org/doi/pdf/10.1145/2212877.2212896.

14 Seth Giddings, *Simulation in The Routledge Companion to Video Game Studies*, Eds. Mark J.P. Wolf and Bernard Perron (USA: Routledge, 2014), 264; Jean Baudrillard, "Simulacra and Simulations" in *Selected Writings*, Ed. Mark Poster (USA: Stanford University Press, 1988), 166–84.

15 Chandler Pearson, *Race and Gender Portrayals in Grand Theft Auto* (USA: Williams, 2019), 1; Louis Chilton, *Savagery, Sexism and Racist Stereotypes: The Chequered Legacy of Red Dead Redemption* (UK: The Independent, 2020), 1.

16 Ross Brady, *Architecture in Video Games: The Satirical Urban Commentaries of Grand Theft Auto* (USA: Architizer, 2016), https://architizer.com/blog/practice/details/architecture-in-video-games-grand-theft-auto/.

17 Michael Pidd and Kerry McMahon, *What is a Digital Humanities Project?* (UK: University of Sheffield, 2019), 1.

18 Douglas McCarthy and Philippe Riviere, *Paris Musées Embraces Open Access* (The Netherlands: Europeana Foundation, 2020), 1.

19 Peter Maxwell, *The Rise of the Virtual Gallery Tour: What Works and What Doesn't (Yet)* (USA: Frame, 2020), 1.

20 Rob Garner, *Hubble Marks 30 Years in Space with Tapestry of Blazing Starbirth* (USA: NASA, 2020), https://www.nasa.gov/feature/goddard/2020/hubble-marks-30-years-in-space-with-tapestry-of-blazing-starbirth/.

21 Samantha Mathewson, *NASA Shares Incredible 3D Map of the Moon* (USA: Space.com, 2019), https://svs.gsfc.nasa.gov/4720.

22 There are now many excellent photogrammetry apps for iPhone and Android that enable anyone to create their own 3D scans using a phone camera, such as *Trnio* or *Qlone*.

23 Anthony Corns, et al. *3D-Icons Ireland: Fulfilling the Potential of a Rich 3D Resource* (UK: Internet Archaeology, 2017), https://intarch.ac.uk/journal/issue43/12/index.html.

24 Gary Dempsey, *Digital Counties Initiative* (Ireland: DH_Age, 2016), 1.

25 Thomas Flynn, *Sketchfab Launches Public Domain Dedication for 3D Cultural Heritage* (UK: Sketchfab, 2020), https://sketchfab.com/blogs/community/sketchfab-launches-public-domain-dedication-for-3d-cultural-heritage/.

26 This was one of my own game ideas but I subsequently discovered that it is similar to a game already created by Lindsay Grace, published by MindToggle in 2018, http://one4art.com/.

27 Paul Tassi, *The Enduring Mystery of How 'GTA 5' Has Sold 120 Million Copies* (USA: Forbes, 2020), https://www.forbes.com/sites/paultassi/2020/02/15/the-enduring-mystery-of-how-gta-5-has-sold-120-million-copies/.

28 Rebekah Valentine, *Mobile Games to See the Least Negative Impact from COVID-19* (USA: GameIndustry, 2020), https://www.gamesindustry.biz/articles/2020-05-08-mobile-games-to-see-the-least-negative-impact-from-covid-19.

29 Adam Rorke, *Charting the 20-Year Journey of 'Counter-Strike'* (USA: Fandom, 2019), https://www.fandom.com/articles/counter-strike-history.

30 Joel Hruska, *Mortal Kombat 11 Serves Up the Ultimate '80s Fight: Robocop vs. Terminator* (USA: ExtremeTech, 2020), https://www.extremetech.com/gaming/310854-mortal-kombat-11-serves-up-the-ultimate-80s-fight-robocop-vs-terminator.

31 Antonio Maria da Silva, *Terminator vs Robocop Ep1 Extended Cut* (France: AMDS Films, 2014 [originally published 2006, reuploaded due to DMCA takedown]), https://www.youtube.com/watch?v=Az8cOVAEwmM.

32 Theodor W. Adorno and Max Horkheimer, *The Culture Industry: Enlightenment as Mass Deception* in *Dialectic of Enlightenment* (New York, NY: Continuum, 1987), 120–67.

33 Patrick Shanley, *The Key Difference between Video Game and Film Remakes* (USA: Hollywood Reporter, 2020), https://www.hollywoodreporter.com/heat-vision/key-difference-between-video-game-film-remakes-1267380.

34 Jacob A. Ratliff, *Video Games and Government, Integrating Video Game Research and Practice in Library and Information Science* (USA: IGI Global, 2015), 120–5.

35 Christopher Livingston, Tom Sykes, and Chris Thursten, *The Best Star Wars Mods* (USA: PC Gamer, 2017), 1; ModDB, *The Best Star Wars Mods* (USA: ModDB, 2019), https://www.moddb.com/features/the-best-star-wars-mods-to-play-on-may-the-4th.

36 Andy Dyer, *PC Game Mods – From Smurfs to Counter-Strike and Beyond! History of Game Mods* (USA: NVIDIA, 2016), https://www.nvidia.com/en-us/geforce/news/history-of-pc-game-mods/; Erik Champion, *Game Mods: Design, Theory and Criticism* (Pittsburgh, PA: ETC Press, 2012), 9.

37 Michael Goodyear, *Gaming Mods and Copyright* (USA: Michigan Technology Law Review, 2012), 1; Christopher Livingston, *Street Fighter Costume Modders Issued DMCA Takedown Notice from Capcom* (USA: PC Gamer, 2017), https://www.pcgamer.com/street-fighter-costume-modders-issued-dmca-takedown-notice-from-capcom/.

38 Unreal Engine has a steeper learning curve than Unity, but it has enhanced graphical capabilities and has been used to create more commercial-grade games and films. I would tend to recommend Unity for new game designers. https://unity.com/; https://www.unrealengine.com/.

39 Blender, Gimp, and Audacity are all completely free and open source. Since the release of version 2.8, Blender is an excellent choice for 3D compared to expensive alternatives like Maya, Cinema 4D, 3DS Max, or LightWave. https://www.blender.org/; https://www.gimp.org/; https://www.audacityteam.org/.

40 Blender and Unity Communities, https://www.blender.org/community/; https://unity.com/community.

41 Sketchfab, Blendswap, and Renderhub are excellent starting points for 3D assets, https://sketchfab.com/; https://www.blendswap.com/; https://www.renderhub.com/.

42 Yahong Li, *The Age of Remix and Copyright Law Reform* (USA: SSRN, 2019), 34.

43 Hannah Oakman, *The Rise of Game-Based Learning* (UK: Education Technology, 2016), https://edtechnology.co.uk/latest-news/the-rise-of-game-based-learning/.

44 A comprehensive survey carried out by the Princeton Review in 2019–2020 lists the 50 best undergraduate and 25 best graduate game design programs around the world, https://www.pcgamer.com/the-best-game-design-programs-ranked-by-the-princeton-review-2020/.

45 Jeremy Zhen, *The History of Educational Video Gaming* (USA: ImmersedGames, 2015), http://www.immersedgames.com/the-history-of-educational-video-gaming/.

46 Martin A. Wainwright, *Teaching Historical Theory through Video Games, the History Teacher* (USA: University of Akron, 2014), 1; Lisa Gilbert, *"The Past is Your Playground": The Challenges and Possibilities of Assassin's Creed: Syndicate for Social Education, Theory and Research in Social Education* (USA: Routledge, 2017), 145–55.

47 Holly Nielsen, *Assassin's Creed Origins: How Ubisoft Painstakingly Recreated Ancient Egypt* (UK: The Guardian, 2017), https://www.theguardian.com/technology/2017/oct/05/assassins-creed-origins-recreated-ancient-egypt-ubisoft.

48 David Fredrick, *Tesseract Center for Immersive Environments and Game Design* (USA: University of Arkansas, 2020), http://tesseract.uark.edu/.

49 David Fredrick, *Saeculum: Approaching (Ancient Roman) Culture through Game Design* (USA: University of Arkansas, 2015), https://www.youtube.com/watch?v=ap5EMT7DORk.

50 Full details of the *Saeculum* project and the game itself are available for download from the Tesseract website, http://tesseract.uark.edu/saeculum/.

51 Students at Tesseract build games using Unity and create characters using Adobe *Mixamo*, which can help streamline the process of rigging and animating 3D character models.

52 I established the creative media center (CMC) at Bahrain Polytechnic as an initiative to teach film, animation, and game design to GCC students and forge ties with regional industry.

53 Playmaker is an inexpensive visual scripting system based on the C# programming language that can be purchased and installed as a custom plug-in from the Unity asset store, https://assetstore.unity.com/packages/tools/visual-scripting/playmaker-368; Bolt comes pre-installed with Unity; Blueprints is the visual scripting language built into Unreal Engine, which uses the C++ programming language.

54 Stephanie de Smale, *Game Essays as Critical Media and Research Praxis* (Scotland: Digital Games Research Association, 2016), 1–15.

55 James Coltrain and Stephen Ramsay, *Can Video Games Be Humanities Scholarship? Debates in the Digital Humanities* (USA: Manifold, 2019), 36–45.

56 Examples of persuasive and critical games created and published by Ian Bogost, http://bogost.com/games/; Lindsay Grace, http://www.lgrace.com/games.html; Mary Flanagan, https://tiltfactor.org/games/; Jane McGonigal, https://janemcgonigal.com/play-me/; and Paolo Pedercini, http://www.art.cmu.edu/people/paolo-pedercini/.

57 Janneke Adema and Jonathan Shaw (Guest Editors), *The Disrupted Journal of Media Practice* (UK: JMP, 2016), http://journal.disruptivemedia.org.uk/.

58 Sal Rogers, *Coronavirus Has Made WFH the New Normal. Here's How Virtual Reality Can Help* (USA: Forbes, 2020), https://www.forbes.com/sites/solrogers/2020/03/26/coronavirus-has-made-wfh-the-new-normal-heres-how-virtual-reality-can-help/#6fb4f78261d5.

Bibliography

Aarseth, Espen. "Ontology." In *The Routledge Companion to Video Game Studies*, edited by Mark J.P. Wolf and Bernard Perron, New York, NY: Routledge, 2014.

Adorno, Theodor W., and Max Horkheimer. "The Culture Industry: Enlightenment as Mass Deception." In *Dialectic of Enlightenment*. New York, NY: Continuum, 1987.

Baudrillard, Jean. "Simulacra and Simulations." In *Selected Writings*, edited by Mark Poster, USA: Stanford University Press, 1988.

Brady, Ross. *Architecture in Video Games: The Satirical Urban Commentaries of Grand Theft Auto.* 1st Edition. USA: Architizer, 2016.

Champion, Eric. *Critical Gaming: Interactive History and Virtual Heritage.* UK: Ashgate, 2015.

Champion, Erik. *Game Mods: Design, Theory and Criticism.* UK: ETC Press, 2012.

Chilton, Louis. *Savagery, Sexism and Racist Stereotypes: The Chequered Legacy of Red Dead Redemption.* UK: The Independent, 2020.

Coltrain, James, and Stephen Ramsay. "Can Video Games Be Humanities Scholarship?." In *Debates in the Digital Humanities.* USA: Manifold, 2019.

Conway, Stephen, and Mark Finn. "Carnival Mirrors: Sport and Digital Games." In *Digital Media Sport: Technology, Power and Culture in the Network Society*, edited by Brett Hutchins and David Rowe, New York, NY: Routledge, 2013.

Corns, Anthony. *3D-Icons Ireland: Fulfilling the Potential of a Rich 3D Resource.* UK: Internet Archaeology, 2017.

Costikyan, Greg. *I Have No Words & I Must Design: Toward a Critical Vocabulary for Games.* Finland: CGDC, University of Tampere, 2002.

Crawford, Chris. *Chris Crawford on Game Design.* USA: New Riders Publishing, 2003.

da Silva, Antonio M. *Terminator vs Robocop Extended Cut.* France: AMDS Films, 2014.

de Smale, Stephanie. *Game Essays as Critical Media and Research Praxis.* Scotland: Digital Games Research Association, 2016.

Dempsey, Gary, and Orla Peach-Power. *Digital Counties Initiative.* Ireland: Digital Heritage Age, 2016.

Dyer, Andy. *PC Game Mods – From Smurfs to Counter-Strike and Beyond!.* USA: NVIDIA, 2016.

Esposito, Nicolas. *A Short and Simple Definition of What a Videogame Is.* Canada: DiGRA, University of Vancouver, 2005.

Flynn, Thomas. *Sketchfab Launches Public Domain Dedication for 3D Cultural Heritage.* UK: Sketchfab, 2020.

Frasca, Gonzalo. "Simulation versus Narrative." In. M. Wolf & B. Perron (Eds.), *The Video Game Theory Reader* (pp. 221–235). New York: Routledge, 2003.

Fredrick, David. *Saeculum: Approaching (Ancient Roman) Culture through Game Design.* USA: University of Arkansas, 2015.

Gallagher, Owen. *Reclaiming Critical Remix Video: The Role of Sampling in Transformative Works.* New York, NY: Routledge, 2018.

Garner, Rob. *Hubble Marks 30 Years in Space with Tapestry of Blazing Starbirth.* USA: NASA, 2020.

Giddings, Seth. "Simulation." In *The Routledge Companion to Video Game Studies*, edited by Mark J.P. Wolf and Bernard Perron, New York, NY: Routledge, 2014.

Gilbert, Lisa. "The Past Is Your Playground: The Challenges and Possibilities of Assassin's Creed: Syndicate for Social Education." In *Theory and Research in Social Education*. New York, NY: Routledge, 2017.

Goodyear, Michael. *Gaming Mods and Copyright.* USA: Michigan Technology Law Review, 2012.

Gunkel, David. *Gaming the System: Deconstructing Video Games, Game Studies and Virtual Worlds*. USA: Indiana University Press, 2018.

Hruska, Joel. *Mortal Kombat 11 Serves Up the Ultimate '80s Fight: Robocop vs. Terminator*. USA: ExtremeTech, 2020.

Iversen, Sara. *Between Regulation and Improvisation: Playing and Analysing "Games in the Middle."* Doctoral Dissertation. Denmark: IT University of Copenhagen, 2010.

Juul, Jesper. *A Casual Revolution: Reinventing Video Games and Their Players*. Cambridge, MA: MIT Press, 2010.

Kain, Erik. *On Walking Simulators, Game Journalism and the Culture Wars*. USA: Forbes, 2016.

Karhulahti, Veli-Mati. *An Ontological Theory of Narrative Works: Storygame as Postclassical Literature*. USA: Storyworlds, University of Nebraska Press, 2015.

Layne, Alex. *Why Video Games Are Important for Digital Humanists*. USA: NYMG, 2013.

Leino, Olli. *Emotions in Play: On the Constitution of Emotion in Solitary Computer Game Play*. Doctoral Dissertation. Denmark: IT University of Copenhagen, 2010.

Li, Yahong. *The Age of Remix and Copyright Law Reform*. USA: SSRN, 2019.

Livingston, Christopher. *Street Fighter Costume Modders Issued DMCA Takedown Notice from Capcom*. USA: PC Gamer, 2017.

Malaby, Thomas M. "Beyond Play: A New Approach to Games." In *Games & Culture*. USA: SAGE, 2007.

Mathewson, Samantha. *NASA Shares Incredible 3D Map of the Moon*. USA: Space.com, 2019.

Maxwell, Peter. *The Rise of the Virtual Gallery Tour: What Works and What Doesn't (Yet)*. USA: Frame, 2020.

McCarthy, Douglas, and Philippe Riviere. *Paris Musées Embraces Open Access*. The Netherlands: Europeana Foundation, 2020.

Milo, Greg. *Rebooting Social Studies: Strategies for Reimagining History Classes*. Lanham, MD: Rowman & Littlefield, 2017.

Monnens, Devin, and Martin Goldberg. *Space Odyssey: The Long Journey of Spacewar! From MIT to Computer Labs Around the World*. Canada: Kinephanos, 2015.

Nielsen, Holly. *Assassin's Creed Origins: How Ubisoft Painstakingly Recreated Ancient Egypt*. UK: The Guardian, 2017.

Oakman, Hannah. *The Rise of Game-Based Learning*. UK: Education Technology, 2016.

Parlett, David. *The Oxford History of Board Games*. UK: Oxford University Press, 1999.

Pearson, Chandler. *Race and Gender Portrayals in Grand Theft Auto*. USA: Williams, 2019.

Pidd, Michael, and Kerry McMahon. *What Is a Digital Humanities Project*. UK: The Digital Humanities Institute, University of Sheffield, 2019.

Ratliff, Jacob A. "Video Games and Government." In *Integrating Video Game Research and Practice in Library and Information Science*. USA: IGI Global, 2015.

Rogers, Sal. *Coronavirus Has Made WFH the New Normal. Here's How Virtual Reality Can Help*. 1st Edition. USA: Forbes, 2020.

Rorke, Adam. *Charting the 20-Year Journey of 'Counter-Strike'*. USA: Fandom, 2019.

Salen, Katie, and Eric Zimmerman. *Rules of Play*. Cambridge, MA: MIT Press, 2003.

Sell, Mike. *Why Videogames (Should) Matter to the Humanities*. USA: Indiana University of Pennsylvania, 2018.

Shanley, Patrick. *The Key Difference between Video Game and Film Remakes*. USA: Hollywood Reporter, 2020.

Sharp, Darinda. *The Emerging Role of Game Design in Digital Humanities*. USA: J. William Fulbright College of Arts and Sciences, 2015.

Tassi, Paul. *The Enduring Mystery of How 'GTA 5' Has Sold 120 Million Copies*. USA: Forbes, 2020.

Tavinor, Grant. *Definition of Videogames*. USA: Contemporary Aesthetics, 2008.

Tesler, Larry. *A Personal History of Modeless Text Editing and Cut/Copy-Paste*. USA: Interactions, 2012.

Valentine, Rebekah. *Mobile Games to See the Least Negative Impact from COVID-19*. USA: GameIndustry, 2020.

Wainwright, Martin A. *Teaching Historical Theory through Video Games*. USA: University of Akron, 2014.

Wechselberger, Ulrich. "Teaching Me Softly: Experience and Reflections on Informal Educational Game Design." In *Transactions on Edutainment II*. USA: Springer, 2009.

Wijman, Tom. *The World's 2.7 Billion Gamers Will Spend $159.3 Billion on Games in 2020*. USA: Newzoo, 2020.

Wittgenstein, Ludwig. *Philosophical Investigations*. USA: Wiley Blackwell, 1953.

Wolf, Mark J.P. *The Video Game Explosion: A History from Pong to Playstation and Beyond*. USA: Greenwood, 2008.

Zhen, Jeremy. *The History of Educational Video Gaming*. USA: ImmersedGames, 2015.

Part IV

AURALITY AND VISUALITY

28
POPULAR SONG REMIXED

Mashups, Aesthetic Transformation, and Resistance

Christine Boone

On March 7, 2017, a statue called *Fearless Girl* suddenly appeared opposite the famous *Charging Bull* on Wall Street in front of the New York Stock Exchange.[1] She became an immediate sensation, a symbol of female empowerment and defiance. After *Fearless Girl* was installed, however, the *Charging Bull* sculptor, Arturo Di Modica, wanted it taken down.[2] Internet users went crazy, defending this brave little girl from the dominant patriarchy who wanted to silence and remove her. New York mayor Bill de Blasio tweeted: "Men who don't like women taking up space are exactly why we need the Fearless Girl."[3] But there is more to this story: *Charging Bull* is a work of guerilla art, self-funded by Di Modica, meant to represent the "strength and power of the American people." *Fearless Girl*, on the other hand, is a corporate-commissioned advertising campaign.[4] More specific details about the history of each sculpture can be easily found online, but for this chapter, I will focus on the meaning and the interplay of power that result when these two works of art are juxtaposed to form a sculptural mashup. The language that reporters and bloggers use to talk about the way they interact could easily be applied to a musical mashup, as well.

First, each sculpture has meaning without the context of the other. *Charging Bull* has stood on its own in Manhattan's Financial District since 1989. Like with a song, some combination of the creator's intent, the aesthetics of the work of art, and the interpretation of an audience leads to meaning. Author Dianne Durante says that the bull represents the "energy, strength, and unpredictability of the stock market."[5] *Fearless Girl* has never existed on its own, apart from *Charging Bull*, but blogger Greg Fallis acknowledges that it could. Without an opposing force, though, he says that *Fearless Girl* becomes "Really Confident Girl."[6] I do not see as essential a difference as Fallis does. There are certainly enough things in the world for young girls to stand up against, even without the bull as a specific antagonist. She still looks like she's facing an adversary, even if that adversary is unseen. The point here, though, is that like a popular song, each statue is a complete work of art on its own.

When placed in dialogue with each other, then, a composite meaning is generated by the interaction. Most obviously, the girl is now standing up against something precise. Her confident stance is more clearly a reaction to the bull, and not just her general attitude while taking on the world. And, Fallis notes, the bull is no longer a simple emblem of strength; "it's now seen as an aggressive threat to women and girls— a symbol of patriarchal oppression."[7] This transformation of meaning also happens in musical mashups, and, I argue, is why mashups—sometimes described as a "flash-in-the-pan"—have not disappeared. Aspects of categorization and analysis, as seen in the *Fearless Girl* example, relate to the emerging ways of measuring in the digital humanities: Being able to trace source material to its origins can make aspects of authorship and unintentional collaboration clearer. If this type of art form was only about musical cleverness and harmonic/melodic/rhythmic fit, people might not still be making them. Two works of art are able to comment on each other, absorb and play off of each other's meanings, thus developing a social commentary specific to their relationship that creates entirely new implications. That is what makes this kind of artwork culturally important.

Mashups and Aesthetics

Music theorists begin by studying formal and structural features of music; however, form emerges from experimental practice, and it becomes more than pure syntax only when it is embedded semantically. I have previously focused on the ways that the extant structure of juxtaposition inherent in remixed music like mashups encourages or reveals categorization,[8] ironic meanings,[9] and gendered power asymmetries.[10] To be sure, effective construction is essential for this art form. Poorly constructed mashups draw too much attention to formal aspects and do not allow the listener to extract, create, or recreate meaning. But rather than consider them as static forms, I now consider this aesthetic as being constantly under construction, in process. Mashups can be analyzed in two reciprocal ways: formally, as art objects, and sociologically, as participants in a complex form of commodity exchange. As the former, they can be seen as aesthetic transformations. Mashup artists take two previously existing songs and use software to combine them into a single track. They do this using a series of aesthetic "rules."[11] Rules, then, can often be "broken" as part of the development of a new aesthetic. Indeed, the stretching and breaking of rules comprises many formalist accounts of musical development throughout history.

Last year a friend showed me a YouTube video[12] called "Tik Tok and California Gurls are the same song?"[13] The creator of this mashup, DJplaceboing,[14] claims that "Tik Tok" by Ke$ha and "California Gurls" by Katy Perry are, in fact, "the same song." But what does he mean by that? Both the songs are in the same key and have essentially the same chord progression for their verses and choruses: Bb, C, Dm ("California Gurls" uses an extra A minor chord as an anacrusis at the beginning of each line). The songs are also set at the same tempo and use similar instrumentation/texture. The main accompaniment at the beginning of both tracks is the sound of a rhythmically sparse 8-bit synthesizer and a drum machine, and the texture of both songs gets denser as each approaches its chorus section. All of these similarities allow for Chris Lohr to construct a rather different type of mashup. One of the most salient aspects is the nonsense sentences that result when the songs are combined. The lyrics begin, "Don't stop this pop, DJ girls we're unforgetta…" Lohr cuts off each singer in the middle of her sentences, even in the

To view Figure 28.1, please visit https://bit.ly/Boone28-1.

middle of her words (Figure 28.1). This is a clear violation of one of the aesthetic rules valued by the mashup community: That the lyrics must remain intelligible in a mashup.[15]

A basic, or A + B, mashup usually consists of the vocals from one song and the instrumental track from another. A mashup artist either needs to find isolated tracks to work with (which are often available online, to encourage remixes) or isolate the vocals from the instrumentals herself, using software. Lohr decided that instead of making this mashup in the more traditional way, he would exploit the extreme similarity of the two songs by jump-cutting between them. This is why the lyrics do not make sense: The vocal track is constantly switching from one song to the other. But why are these two songs so similar in the first place? Notably, they were written within one year of each other ("Tik Tok" in 2009 and "California Gurls" in 2010), they are from the same genre of music, and producer Dr. Luke is credited as a contributing songwriter on both tracks. All songwriters have styles, and Dr. Luke's signature style might be part of the reason for the uncanny similarity between these two songs.

Of course, detractors are quick to point out that one of the reasons that any mashup works is due to the modular nature of popular music, perhaps the ultimate realization of Theodor Adorno's damning critique of "the fundamental characteristic" of the genre: Standardization.[16] Adorno's famous essay on popular music contrasts it with so-called "serious music," finding it deficient in every aspect. Popular music, he says, is predictable and formulaic. Content is inserted only to fill out a predetermined schema, whereas every note in a piece of great classical music is indispensable and organic. Despite his insistence of the polarization of these two distinct types of music, practice shows us that they are not as diametrically opposed as Adorno claimed. Mozart, for example, highlighted the modular nature of classical music by creating a composition dice game that interchanged beginnings, middles, and ends of musical phrases. Even Adorno's beloved Beethoven wrote shorter pieces that do not seem to exhibit the organicism that is so valued by the critic. The other problem with Adorno's analysis of popular music is its inherent value judgment; he measured everything against the parameters established by Western classical music, implying that other types of music were deficient by definition. Michael Bourdaghs warns us, though, that "We ignore Adorno's critique of the culture industry at our own peril: … We live in a world where the most rebellious forms of popular music are used as sound tracks for television commercials, selling us the message that freedom can be ours if only we purchase a certain brand name." Where do mashups lie in this capitalist landscape of faux freedom?

Could a mashup like this one function as a type of commentary on the hegemony of the mainstream music industry? By breaking the aesthetic rule of lyrical intelligibility by quick cutting from one track to another, Lohr's mashup serves as an analysis of "Tik Tok" and "California Gurls." First, he is drawing attention to the extreme similarity of these two songs. Even if, as Adorno claims, all popular music is standardized and modular, these two songs are still *unusually* similar to one another. Lohr gets the listener to investigate, to discover that the same songwriters work for multiple artists, to question the originality of these songs that the industry is presenting to our society. Second, I read

To view Figure 28.2, please visit https://bit.ly/Boone-28-2.

the chopped-up lyrics as commentary on the typically shallow nature of popular song lyrics, which both "Tik Tok" and "California Gurls" do indeed fall victim to. Both are "party" songs that do not depend on lyrical content for coherence; Lohr's analysis proves that even when lyrical intelligibility is lost, embodied danceability remains.

Another example of a mashup that breaks rules is "YYMilk" by DJ Cummerbund.[17] The track starts out with the familiar jagged crotale intro to Rush's "YYZ." (The introduction to "YYZ," named for the call letters of the Toronto airport, is a rhythmic rendition of those three letters in Morse code). But along with the entrance of the electric guitar comes a surprising female voice: Kelis, singing her hit, "Milkshake." She begins to rap about how her milkshake brings all the boys to the yard, in her characteristic sing-song style. But instead of the quadruple meter that we are familiar with (Figure 28.2), Kelis's vocals have been noticeably altered so that she is singing in unison with Rush.

It sounds just about as weird as you would expect. Her emphasis is on the wrong syllables, and the rhythm is jarring and unnatural for rap music. The fit between the vocals and the instrumentals is forced and strange, and it certainly does not sound like a mainstream pop song (another mashup rule is broken).[18] But DJ Cummerbund's goal is *not* to produce a typical A + B mashup. He is counting on listeners recognizing both source songs, noticing the *terrible* fit, and laughing because he did it anyway. The funniest part occurs at 0:37 into the track, when Kelis's lyrics: "My milkshake brings all the boys to the yard and it's better than yours," are audibly sped up and forced into a quick line of 30-second notes by the guitar. DJ Cummberbund acknowledges that this is "One of my most hated songs,"[19] although the Facebook comments are mixed. Jeff Hightshoe complains, "how dare you desecrate YYZ like this," but there are just as many positive comments. Allan Drysdale declares: "This is absolutely a genius mashup of the highest order."[20]

This mashup, by breaking a rule commonly followed by most remix artists, functions as another potential site of resistance. It draws attention to Adorno's critique of popular music, too, by proving it to be untrue. "YYZ" and "Milkshake" are so un-modular in nature (or, perhaps, constructed with incompatible modules) that they refuse to be mashed together in a typical manner. DJ Cummerbund uses these two songs to push against the set of aesthetics that the general public has accepted as unalterable. To add a view from another lens, progressive rock groups like Rush are generally thought of as masculine, and their fan base is made up of mostly (white) men.[21] DJ Cummerbund has brought Kelis into this world, and listeners seem to disagree about whether a Black woman belongs here, with the asymmetrical time signature, quick rhythms, and musical complexity. The perceived act of resistance is bringing Kelis into a musical space where she may not be welcomed by listeners. This is an example of a new kind of writing/criticism outside the academy, possible only in the digital age. Joanna Demers writes that Girl Talk does something similar with his mashups, highlighting power: "play[ing] on the tension between white and black music… Girl Talk's pairings work because they seem to flout unspoken conventions dictating the relationship between music and race."[22] Read this way, mashup artists have the potential to remake genres and cross boundaries delimiting power structures through the practice of remix.

Mashups and Commerce

Mashups, in addition to being analyzed as art, can also be seen as part of the system of commodity exchange that is the music industry. All music, whether released by a major music label or not, is related to commerce in one way or another. Scott McCloud argues: "But to proclaim, as so many so often do, that – That's not art! – presumes that art is an *either/or* proposition. ... Rare is the person in *any* occupation who expresses nothing...and rare is the artist who cares nothing for success, i.e. survival!"[23] Even an artist who literally "cares nothing for success" is connected to the music industry by simply reacting against it. Often, mashups do exist outside of this system, but the system itself has attempted to "co-opt the revolution and transform the innovation to serve [its] own interests."[24] David Gunkel reminds us of the music industry's legally produced mashups in the wake of the legal controversy that followed Danger Mouse's *Grey Album* in 2004. That same year, Jay-Z and Linkin Park collaborated on an album that proudly displayed its place in the industry right in the title—*MTV Ultimate Mashup Presents: Collision Course*—and EMI Records (the Beatles' label, who wrote cease and desist letters to Danger Mouse) released an album called *Mashed*, one of the first legally produced mashup albums.[25]

Legal mashups are extremely difficult to make. The problem, which has been outlined by many authors,[26] is that there is no automatic right and licensing scheme to sample a song, as there is to cover a song. The formula for cover songs is calculated using the length of the song in question and the number of copies (or digital downloads) that the artist produces.[27] But there is no guaranteed right to sample. The copyright holder might choose to deny permission, or to charge any amount they choose for a sample of any length, even to someone who does not stand to make any money from the resulting track. Kembrew McLeod spoke with the director of a sample clearing-house who estimated that the samples on a hip hop album cost an average of $30,000, but that sometimes a single sample can run as high as $100,000.[28] Therefore, the unsigned artists who choose to make unauthorized mashups because they are forced to are engaging in a type of resistance against the industry.

Unfortunately, copyright law binds musical creators into an impossible space. Precedent in the courtroom has taught us that there is no such thing as fair use, despite its being laid out in the United States Constitution, and that even being influenced by other composers and musicians is illegal, despite the fact that influence is unavoidable. I have written extensively about the first issue elsewhere:

> One of the factors used to determine whether or not a particular use of copyrighted work can fall under fair use is 'the amount and substantiality of the portion used in relation to the copyrighted work as a whole.'[29] This factor is, no doubt, what NWA was relying on when they sampled 1.5 seconds of Parliament Funkadelic in their song "100 Miles and Runnin'." The song came to the attention of Parliament's copyright holders, Westbound Records, when it was included in the 1998 film *I Got the Hook Up*. They sued No Limit Films in 2002, where it was initially ruled that the sample was *de minimis*,[30] and therefore unactionable.[31] This ruling was appealed and overturned 2 years later.[32] The appeals court ruled that all samples must be cleared, 'including snippets of sounds or chords made unidentifiable by heavy distortion.'[33] This was an extremely significant ruling, because it in essence determined that what some hip hop artists [had] been doing, assuming they were protected by either fair use or *de minimis*,

could in fact be considered illegal after all. This ruling has implied, basically, that there is no such thing as fair use when it comes to sampling.[34]

The second issue of influence was addressed during the long case of "Blurred Lines." In 2015, Pharrell Williams and Robin Thicke lost a lawsuit filed against them by the estate of the late Marvin Gaye. The two were ordered to pay $7.3 million in damages for infringing on the copyright of Gaye's 1977 song "Got to Give it Up" with their 2013 hit "Blurred Lines." There were two important issues that struck me as strange about this lawsuit. First, the songs just do not sound that similar to me. This is important because the three musical factors that are protected under US Copyright Law are melody, chord progression, and lyrics. If any of these aspects were suspiciously similar between the two songs, it is something that a trained music theorist would doubtless hear. Among the musical factors that are *not* protected under US Copyright Law are instrumentation, timbre, and groove. These things, it seems to me, are what the two tracks in question do have in common. Second, when Gaye's track was released, the 1976 Copyright Revision had not yet gone into effect; therefore, the rules set forth in the 1909 Copyright Act had to be considered in this lawsuit. That means that the recording of the song could not be used to prove any amount of substantial similarity—they had to use the sheet music that was on file with the Library of Congress. This is a perfect example of how our sense of "writing" has evolved along with technology. A modern songwriter may never literally touch pencil to paper, or even be able to read musical notation; yet the law has not caught up to what writing and authorship are in the twenty-first century. These issues are paramount in the digital humanities. Because of the archaic nature of US Copyright Law with regard to musical authorship, musicologists had to argue for the similarity of the two songs based on musical notation alone. Of course, our Western classical system of notating music does not have a way to represent timbre or groove, so these factors were ostensibly left out of the argument. According to musicologist Robert Fink, factors like both songs having a ii-V-I progression were enough to convince the jury of infringement.[35] Ethnomusicologist Liam McGranaham wrote on his (now deactivated) Facebook page: "I love Marvin Gaye, and there's something satisfying about Robin Thicke losing at anything, but this is a terrible decision. Every musician copies and steals (consciously or not) from their peers and predecessors. It's fundamental to how music is made and always has been."

The guilty verdict was appealed, and over two hundred musicians weighed in with their opinions about why it should be overturned. Several musicologists and music theorists joined the fight as well by writing an amicus brief.[36] In the summary of the brief, the academics expressed their concern that this verdict "would curtail creativity…inhibiting songwriters by the threat of far-fetched claims of infringement…" So many scholars and musicians spoke out against the verdict because legal precedent has an extraordinary impact on cultural growth. This case could potentially be cited for years to come and be used as a deciding factor against other musicians who (like all artists) are influenced by those who came before them. The musicologists and music theorists dissected the alleged similarities between the two songs and demonstrated, through transcription and analysis, that these similarities were either the result of creative analysis (picking and choosing notes from different places in each song, inaccurate transcription, etc.) or stock musical figures used so often they have become commonplace (e.g., the aforementioned ii-V-I progression). Music theorists and musicians alike seemed to agree: "groove" is not a copyrightable aspect of music, and the copyrightable aspects of these two songs (melody, chord progression, and lyrics) are not similar enough to constitute

infringement. However, the original verdict was upheld by a two-to-one majority. This case has decided, essentially, that it is not just melody, harmony, and lyrics that can be copyrighted, but the "feel" of music, too. The lone dissenting judge, Jacqueline Nguyen, remarked that this ruling "strikes a devastating blow to future musicians and composers everywhere."[37]

Mashups, Authorship, and Resistance

Authorship in remix and mashups can be extremely complicated. John Logie traces the source songs of "No Fun/Push It," a mashup of Iggy Pop and Salt-N-Pepa by 2 Many DJs, and attempts to credit all of the "authors" of the track. He found at least twenty-one contributors.[38] Most popular music challenges traditional models of authorship, to say nothing of remix. Listeners hear bands and singers as transmitting self-authored musical messages. "Nothing Compares 2 U" is popularly recognized as Sinéad O'Connor's song, even though she did not write it; in fact, the writing credit belongs to Prince, a musician of equal (debatably greater) pop status; and three other people who were involved in the mixing and production. Audiences understand O'Connor to be the author when we hear her voice and see her tear-streaked face in the music video. But using a song in a mashup entails another layer of anonymity. Logie is sure to point out that two Many DJs (brothers Stephen and David Dewaele, who also go by the name Soulwax) use a pseudonym, which "speaks to their refusal to fully occupy the position of 'author' with respect to their mashup compositions,"[39] a refusal that most mashup artists take out of legal necessity. When listening to a mashup, what audiences hear are the two original "authors" interacting with each other of their own accord; so listeners tend to further anonymize the mashup artist by forgetting that the DJ even exists.[40]

Kembrew McLeod claims that: "Despite my appreciation for them, I do not mean to idealize mashups because, as a form of creativity, they are quite limited and limiting." He explains:

> First, because they depend on the recognizability of the original, mashups are circumscribed to a relatively narrow repertoire of Top 40 pop songs. Also, mashups pretty much demonstrate that Theodore Adorno, the notoriously cranky Frankfurt School critic of pop culture, was right about one key point. In arguing for the superiority of European art music, Adorno claimed that pop songs were simplistic and merely made from easily interchangeable, modular components. Yes, Adorno was a snob, but after hearing half a dozen mashups, it is hard to deny that he is right about that particular point.[41]

I argue that McLeod is not seeing the full potential of mashups to transform music and to act as social critique. Speaking to the claim of "limited" first, the "relatively narrow repertoire of Top 40 pop songs" stretches at least as far back as the 1960s (see "The Trooper Believer" by DJ Schmolli—a mashup of "The Trooper" by Iron Maiden and "I'm a Believer" by The Monkees). Additionally, that repertoire is getting larger by the day, as new pop songs are released. I have addressed the Adorno claims earlier in this article, but here I will say that McLeod seems to retain Adorno's negative value judgment of musical modularity even while calling him a snob. Value judgment aside, pop songs that do contain "easily interchangeable, modular components" actually serve to make mashups *less* limited as a genre. If you could mash any pop song with any other pop song

(which, to be clear, you cannot—or at least should not), the possibilities would be almost literally endless.

To address McLeod's claim of mashups being "limiting," I turn to Jonathan Sterne, who says: "We can no longer argue that copies are debased versions of a more authentic original that exists either outside or prior to the process of reproduction. Both copy and original are products of the process of reproducibility. The original requires as much artifice as the copy."[42] Walter Benjamin came to a similar conclusion seventy years before Sterne: "…the work of art reproduced becomes the work of art designed for reproducibility. From a photographic negative, for example, one can make any number of prints; to ask for the 'authentic' print makes no sense."[43] Neither author was writing about mashups, but the principle easily maps onto this genre. What makes a mashup any less "authentic" than any of its source songs?

Similar to the way that online software (such as Voyant)[44] can be used to text-mine writing in the digital humanities, a mashup can easily be dissected into its constituent parts using online tools. In the early days of analog sampling (physically cutting magnetic tape and splicing it together in the 1960s, or even cutting between two turntables in the 1970s), there was nothing available to analyze the resulting mix to determine the source tracks. A listener either knew the context of the sample or did not (and if she did not, she might not even be aware that the sound in question *was* a sample). To those unfamiliar with the repertoire, mashups can just sound like pop songs, which, for most mashup artists, is usually a good thing.[45] Today, the apps Shazam (2002) and SoundHound (2005) have the ability recognize music, TV shows, and movies by listening through a device microphone and comparing the sound input to a database of sounds. YouTube uses similar technology to scan user-uploaded videos for the illegal use of copyrighted music. In 2015, a startup called Dubset Media (now Pex) revealed that they had developed technology called "MixScan," which they use to analyze mashups and DJ mixes. When artists sign on to allow their music to be used by this website, DJs can take it and use it. Then, MixScan can tell how much of each source song is used in a newly created track and calculates royalties to be paid to each artist. The royalties are based on both the length of time each song appears in the mix, as well as how many listeners stream the song from their website.[46]

What is the role of the artist in such a cultural environment? Does the identity of an artist matter anymore? I argue that it must. If the mashup becomes a simple, disposable meme, Adorno's critiques of popular culture may still have something to teach us today. However, with an author, mashups have the potential to draw attention to the aspects of mass-produced popular music that do (or, could be said to) fit Adorno's criteria and can give them commentary, allowing listeners to recontextualize a popular song by understanding it from a wider perspective. An author allows us to have mashups with staying power, like *Fearless Girl* or "A Stroke of Genie-Us."[47]

Visual artist Tim Klein produces mashups that comment in a powerful way, as well. After noticing that jigsaw puzzle manufacturers use the same pattern to cut pieces for many different puzzles (the process is known as die-cutting), he started to combine pieces from multiple puzzles without doing any additional cutting. Klein's pieces often feature a juxtaposition of something man-made with something from the natural world.

These mashups are so effective, because, like musical mashups, they exploit the modular nature of die-cut puzzles, but they are obviously not random. Figure 28.3, which Klein has appropriately titled *Iron Horse*, exemplifies the process and possibilities for new meanings. To me, this piece tells the story of the industrial revolution, of the rise of

Figure 28.3 *Iron Horse,* (2018) by Tim Klein (image used with permission of the artist)

railway transport, of the objectification of animals, and even of disappearing wildlife in the United States.

This is the value in mashups—they give the artist an opportunity to combine two things that were not designed to go together but become inextricable in their new context. The new context is a finished work on its own, but both source objects are still discernible. When these two sources are placed into conversation with each other, each gives the other new meaning.

In the summer of 2014, amid "conflict, disease, [and] struggle," NPR music critic Ann Powers remarked on the intersection of popular music and contemporary politics, writing: "Pop is all about commodification: The soft center of what adapts. But sometimes, when history collides with it, a simple song gains dimension."[48] Alex Ross has remarked that "[t]he Internet threatens final confirmation of Adorno and Horkheimer's dictum that the culture industry allows the 'freedom to choose what is always the same.'"[49] But mashups offer a way out from the grasp of control of the monolithic music industry. This is a way that an author can take two things with already-established meanings—a train has a meaning; a horse has a meaning—and use them to create something with a complex, nuanced, historically relevant meaning that comments on both original pieces while saying something about the society that (mass-) produced them.

Conclusion

It takes an author to consciously "break" an aesthetic "rule" for a greater purpose. "Tik Tok/California Gurls" is not a result of the simplicity and/or modular nature of popular music. It is a revelation that these two songs, in particular, are unusually similar; and

DJplaceboing mashes them together in a way that strips both songs of their original meaning—by dismantling the (disposable?) lyrics. "YYMilk" is the combination of two songs so strikingly dissimilar that the only reactions to it seem to be laughter or disgust. DJ Cummerbund picked these two songs specifically because they do not mix together easily. A simple modular exchange, something that should be automatable, is unable to create meaning in the same way. A typical A + B mashup could have easily been created using "Tik Tok" and "California Gurls." It would have been danceable and easy to listen to. Katy Perry might have sung the verses, while Ke$ha sang the choruses, or vice versa. But it would not have served as a forum for DJplaceboing to humorously reveal the strange similarity between these two songs, or comment on the shallow nature of their lyrics. Of course, it probably is not possible to make an A + B mashup using "YYZ" and "Milkshake." Due to too many musical differences, but most notably the difference in meter, these two songs are simply not compatible in this way. The impossibility of the A + B mashup is what makes DJ Cummerbund's awkward mashup possible.

Even the act of making a mashup at all is usually an act of rebellion, at least in the commercial sense. It is nearly impossible (or at the very least, extremely improbable) to make a legally cleared mashup without the backing of a major record label. For this reason, each act of creation serves as a small act of resistance. The anonymization of mashup creators does not erase their presence from the resulting works of art. We need these artists to control the musicians' puppet strings and bring them into unexpected and unintended conversations. Mashups, and other user-produced content, provide a potential way out of the shadow of the cultural monoliths that are ever-present in our twenty-first century lives.

Notes

1 Nel-Olivia Waga, "International Women's Day 2017: Wall Street Meets 'The Fearless Girl,'" *Forbes*, March 7, 2017, https://www.forbes.com/sites/neloliviawaga/2017/03/07/international-womens-day-2017-wall-street-meets-the-fearless-girl/#1bc7564835b1.

2 James Barron, "Wounded by 'Fearless Girl,' Creator of 'Charging Bull' Wants Her to Move," *The New York Times*, April 12, 2017, sec. New York, https://www.nytimes.com/2017/04/12/nyregion/charging-bull-sculpture-wall-street-fearless-girl.html.

3 Bill de Blasio, Twitter, April 12, 2017, https://twitter.com/NYCMayor/status/852154909235564544.

4 Greg Fallis, "Seriously, the Guy Has a Point," April 14, 2017, https://gregfallis.com/2017/04/14/seriously-the-guy-has-a-point/.

5 Dianne L. Durante, *Outdoor Monuments of Manhattan: A Historical Guide* (New York: NYU Press, 2007).

6 Fallis, "Seriously, the Guy Has a Point."

7 Fallis.

8 Christine Boone, "Mashing: Toward a Typology of Recycled Music," *Music Theory Online* 19, no. 3 (2013).

9 Christine Emily Boone, "Mashups: History, Legality, and Aesthetics" (Ph.D. Dissertation, University of Texas at Austin, 2011).

10 Christine Boone, "Gendered Power Relationships in Mashups," *Music Theory Online* 24, no. 1 (March 2018).

11 Boone, "Mashing."

12 To be clear, this is an audio mashup with no video content that happens to be hosted on YouTube. The "video" consists of a static mashed up image of Katy Perry and Ke$ha and the text, "Tik Tok/California Gurls MASHUP by DJplaceboing."

13 Chris (DJplaceboing) Lohr, YouTube, June 8, 2010, https://www.youtube.com/watch?v=T2dPA2dCRNY&feature=youtu.be.

14 Real name: Chris Lohr.

15 Boone, "Mashups: History, Legality, and Aesthetics," 144.

16 Theodor W. Adorno, "On Popular Music," in *Essays on Music: Thedor W. Adorno*, ed. Susan H. Gillespie and Richard D. Leppert (Berkeley: University of California Press, 2002), 437–8.

17 DJ Cummerbund, "YYMilk," accessed July 22, 2019, https://www.facebook.com/ watch/?v=2277019175705765.

18 Boone, "Mashups: History, Legality, and Aesthetics," 122.

19 DJ Cummerbund, "YYMilk."

20 DJ Cummerbund.

21 Kelefa Sanneh, "The Persistence of Prog Rock," *The New Yorker*, June 12, 2017, https://www.newyorker. com/magazine/2017/06/19/the-persistence-of-prog-rock; James Parker, "The Whitest Music Ever?," *The Atlantic*, September 2017.

22 Joanna Demers, *Listening through the Noise: The Aesthetics of Experimental Electronic Music* (New York: Oxford University Press, 2010), 58.

23 Scott McCloud, *Understanding Comics: The Invisible Art* (New York: William Morrow, 1993) 168.

24 David J. Gunkel, *Of Remixology: Ethics and Aesthetics After Remix* (Cambridge, Massachusetts: The MIT Press, 2016), 80.

25 Ibid., 81.

26 See, for example, Joanna Demers. *Steal This Music: How Intellectual Property Law Affects Musical Creativity* (Athens, GA: University of Georgia Press, 2006), Kembrew McLeod. *Freedom of Expression (R): Overzealous Copyright Bozos and Other Enemies of Creativity* (New York: Doubleday, 2005), and Siva Vaidhyanathan. *Copyrights and Copywrongs: The Rise of Intellectual Property and How it Threatens Creativity* (New York: NYU Press, 2003).

27 The Harry Fox Agency, "HFA Ready to Implement New Digital Era Mechanical Royalty Rates," accessed July 23, 2019, https://secure.harryfox.com/public/userfiles/file/Licensee/HFARoyaltyRatePR10-2-08.pdf.

28 Kembrew McLeod, *Freedom of Expression (R): Overzealous Copyright Bozos and Other Enemies of Creativity* (New York: Doubleday, 2005), 87–8.

29 "United States Copyright Act," § 107 (1976).

30 *De minimis*, Latin for "minimal things," is used in the legal community to describe uses of copyrighted material that are so minimal they are insignificant.

31 This case was called Bridgeport Music, Inc. v. Dimension Films, the names of the parent companies of the plaintiff and defendant, respectively.

32 John Gerome, "Court Says Any Sampling May Violate Copyright Law," *USA Today*, September 8, 2004, sec. Tech, http://www.usatoday.com/tech/news/techpolicy/2004-09-08-sampling-ruling_x.htm.

33 Sam Howard-Spink, "Grey Tuesday, Online Cultural Activism and the Mash-Up of Music and Politics," *First Monday* 9, no. 10 (October 2004).

34 Boone, "Mashups: History, Legality, and Aesthetics," 79.

35 Robert Fink, "Blurred Lines, Ur-Lines, and Color Lines," *Musicology Now* (blog), March 15, 2015, https:// www.musicologynow.org/2015/03/blurred-lines-ur-lines-and-color-line.html.

36 Nicole Biamonte et al., "Brief of Amicus Curiae Musicologists in Support of Plaintiffs-Appellants-Cross-Appellees," August 30, 2016, https://www.documentcloud.org/documents/3036525-2016-08-30-20-Amicus-Musicologists.html.

37 Roisin O'Connor, "'Blurred Lines' Copyright Ruling Is a 'Devastating Blow' and Sets Dangerous Precedent for Musicians, Judge Warns," *Indpendent*, March 22, 2018, https://www.independent.co.uk/arts-entertainment/music/news/blurred-lines-copyright-ruling-upheld-robin-thicke-pharrell-marvin-gaye-latest-a8267941.html.

38 John Logie, "Peeling the Layers of the Onion: Authorship in Mashup and Remix Cultures," in *The Routledge Companion to Remix Studies*, ed. Eduardo Navas, Owen Gallagher, and xtine burrough (New York: Routledge, 2015), 304.

39 Logie, 306.

40 Boone, "Gendered Power Relationships in Mashups," 2.6.

41 Kembrew McLeod, "Confessions of an Intellectual (Property): Danger Mouse, Mickey Mouse, Sonny Bono, and My Long and Winding Path as a Copyright Activist-Academic," *Popular Music and Society* 28, no. 1 (February 2005): 86.

42 Jonathan Sterne, *The Audible Past: Cultural Origins of Sound Reproduction* (Durham, North Carolina: Duke University Press, 2003) 241.

43 Walter Benjamin, "The Work of Art in the Age of Mechanical Reproduction," in *The Work of Art in the Age of Its Technological Reproducibility, and Other Writings on Media* (Cambridge, Massachusetts: Belknap Press, 2008), 19–55.

44 https://voyant-tools.org/.
45 Boone, "Mashups: History, Legality, and Aesthetics," 133 ff.
46 Hannah Karp, "Turning a Profit From Music Mashups," *The Wall Street Journal*, March 2, 2015.
47 "A Stroke of Genie-us" is widely recognized as the first mashup. Created by DJ Freelance Hellraiser in 2001, it combines the vocals from "Genie in a Bottle" by Christina Aguilera with the instrumental backing of "Hard to Explain" by the Strokes.
48 Ann Powers "Top 40 in a Summer of Discontent," *All Things Considered*, August 19, 2014, https://www.npr.org/sections/therecord/2014/08/19/341341699/top-40-in-a-summer-of-discontent.
49 Alex Ross, "The Naysayers: Walter Benjamin, Theodor Adorno, and the Critique of Pop Culture," *The New Yorker*, September 15, 2014, www.newyorkers.com/magazine/2014/09/15/naysayers.

Bibliography

Adorno, Theodor W. "On Popular Music." In *Essays on Music: Thedor W. Adorno*, edited by Susan H. Gillespie and Richard D. Leppert. Berkeley: University of California Press, 2002.

Barron, James. "Wounded by 'Fearless Girl,' Creator of 'Charging Bull' Wants Her to Move." *The New York Times*, April 12, 2017, sec. New York. https://www.nytimes.com/2017/04/12/nyregion/charging-bull-sculpture-wall-street-fearless-girl.html.

Benjamin, Walter. "The Work of Art in the Age of Mechanical Reproduction." In *The Work of Art in the Age of Its Technological Reproducibility, and Other Writings on Media*, 19–55. Cambridge, Massachusetts: Belknap Press, 2008.

Biamonte, Nicole, John Covach, Charles Cronin, Robert Fink, Michael Harrington, Brad Osborn, André O. Redwood, Eleanor Selfridge-Field, Mark Spicer, and Robert Walser. "Brief of Amicus Curiae Musicologists in Support of Plaintiffs-Appellants-Cross-Appellees." August 30, 2016. https://www.documentcloud.org/documents/3036525-2016-08-30-20-Amicus-Musicologists.html.

Blasio, Bill de. Twitter, April 12, 2017. https://twitter.com/NYCMayor/status/852154909235564544.

Boone, Christine. "Gendered Power Relationships in Mashups." *Music Theory Online* 24, no. 1 (March 2018).

———. "Mashing: Toward a Typology of Recycled Music." *Music Theory Online* 19, no. 3 (2013).

Boone, Christine Emily. "Mashups: History, Legality, and Aesthetics." Ph.D. Dissertation, University of Texas at Austin, 2011.

Demers, Joanna. *Listening Through the Noise: The Aesthetics of Experimental Electronic Music*. New York: Oxford University Press, 2010.

Cummerbund, DJ. "YYMilk": Accessed July 22, 2019. https://www.facebook.com/watch/?v=2277019175705765.

Durante, Dianne L. *Outdoor Monuments of Manhattan: A Historical Guide*. New York: NYU Press, 2007.

Fallis, Greg. "Seriously, The Guy Has a Point." April 14, 2017. https://gregfallis.com/2017/04/14/seriously-the-guy-has-a-point/.

Fink, Robert. "Blurred Lines, Ur-Lines, and Color Lines." *Musicology Now* (blog), March 15, 2015. https://www.musicologynow.org/2015/03/blurred-lines-ur-lines-and-color-line.html.

Gerome, John. "Court Says Any Sampling May Violate Copyright Law." *USA Today*, September 8, 2004, sec. Tech. http://www.usatoday.com/tech/news/techpolicy/2004-09-08-sampling-ruling_x.htm.

Gunkel, David J. *Of Remixology: Ethics and Aesthetics After Remix*. Cambridge, Massachusetts: The MIT Press, 2016.

Howard-Spink, Sam. "Grey Tuesday, Online Cultural Activism and the Mash-Up of Music and Politics." *First Monday* 9, no. 10 (October 2004).

Karp, Hannah. "Turning a Profit From Music Mashups." *The Wall Street Journal*, March 2, 2015.

Logie, John. "Peeling the Layers of the Onion: Authorship in Mashup and Remix Cultures." In *The Routledge Companion to Remix Studies*, edited by Eduardo Navas, Owen Gallagher, and xtine burrough, 296–309. New York: Routledge, 2015.

Lohr, Chris (DJplaceboing). YouTube, June 8, 2010. https://www.youtube.com/watch?v=T2dPA2dCR NY&feature=youtu.be.

McCloud, Scott. *Understanding Comics: The Invisible Art*. New York: William Morrow, 1993.

McLeod, Kembrew. "Confessions of an Intellectual (Property): Danger Mouse, Mickey Mouse, Sonny Bono, and My Long and Winding Path as a Copyright Activist-Academic." *Popular Music and Society* 28, no. 1 (February 2005): 79–93.

———. *Freedom of Expression (R): Overzealous Copyright Bozos and Other Enemies of Creativity*. New York: Doubleday, 2005.

O'Connor, Roisin. "'Blurred Lines' Copyright Ruling Is a 'Devastating Blow' and Sets Dangerous Precedent for Musicians, Judge Warns." *Indpendent*, March 22, 2018. https://www.independent.co.uk/arts-entertainment/music/news/blurred-lines-copyright-ruling-upheld-robin-thicke-pharrell-marvin-gaye-latest-a8267941.html.

Parker, James. "The Whitest Music Ever?" *The Atlantic*, September 2017.

Ross, Alex. "The Naysayers: Walter Benjamin, Theodor Adorno, and the Critique of Pop Culture." *The New Yorker*. September 15, 2014. www.newyorkers.com/magazine/2014/09/15/naysayers.

Sanneh, Kelefa. "The Persistence of Prog Rock." *The New Yorker*, June 12, 2017. https://www.newyorker.com/magazine/2017/06/19/the-persistence-of-prog-rock.

Sterne, Jonathan. *The Audible Past: Cultural Origins of Sound Reproduction*. Durham, North Carolina: Duke University Press, 2003.

The Harry Fox Agency. "HFA Ready to Implement New Digital Era Mechanical Royalty Rates." Accessed July 23, 2019. https://secure.harryfox.com/public/userfiles/file/Licensee/HFARoyaltyRatePR10-2-08.pdf.

"Top 40 in a Summer of Discontent." *All Things Considered*, August 19, 2014. https://www.npr.org/sections/therecord/2014/08/19/341341699/top-40-in-a-summer-of-discontent.

United States Copyright Act, § 107 (1976).

Waga, Nel-Olivia. "International Women's Day 2017: Wall Street Meets 'The Fearless Girl.'" *Forbes*, March 7, 2017. https://www.forbes.com/sites/neloliviawaga/2017/03/07/international-womens-day-2017-wall-street-meets-the-fearless-girl/#1bc7564835b1.

29

REMIXING THE OBJECT OF STUDY

Performing Screen Studies through Videographic Scholarship

Aidan Delaney

Since the emergence of online video in the mid-2000s, audiovisual remix has increasingly become a strategy in screen media analysis, resulting in analytical practices invested in performing film or television studies. These video remixes samples from television shows or films and create new montages from those samples. The objective might be to compare two films and illustrate a link between them, or to perform a close textual analysis of a single scene, or to combine shots from several films showing a visual motif in the oeuvre of a single director. Commentary on the sampled material can be achieved through the addition of voice-over or on-screen text, or the endeavor might be more abstract in its form and present its thesis through montage alone, or perhaps accompanied with a written supporting statement. Such video remixes oscillate between pieces of film criticism and film analysis. There is no standard form as yet, but many works are less than 10 minutes in length, made with consumer grade equipment by nonprofessional editors, and most are distributed through video hosting platforms such as Vimeo and YouTube.[1] These remixed videos are used as analytical tools to present audiovisual arguments and are essayistic in their approach. The impulse behind such work is to discover and present new knowledge about the object of study through audiovisual means rather than traditional written exposition: It is creating audiovisual discourses on audiovisual content. Such productions are commonly referred to as "video essays" or "audiovisual essays," and the field of study related to these film-critical remixes is increasingly referred to as "videographic" film and moving image studies.[2] This is a scholarly media-production practice, in which screen criticism, analysis, or theory is communicated through sampling and the manipulation of preexisting audiovisual media, and it marks a fundamental shift in the study of screen media deserving of exploration.

This chapter documents the audiovisual essay as a remix practice and a profitable methodology in the study of cinema. It begins by addressing the analytical potential of remix, before attending to sampling's propriety for "quoting" a film text. Audiovisual quotation in this context is used to gain understanding and produce new knowledge

about the object of study, which benefits both the creator and consumer of such scholarly media. The contention is that the videographic medium can account for cinematic aspects that are difficult to capture in written description. The chapter finally positions the remixed audiovisual essay within the digital humanities, arguing that it is a qualitative undertaking using digital content creation as a way to think through praxis. This unmasks the issue of writing and a central claim made here is that remix is a form of writing—making it appropriate for analysis and scholarship—and as a form of writing, it should be understood as a technology that can shape thought.

Remix as an Analytical Practice

Over the course of remix studies, the term "remix" has been broadened to address phenomena beyond specific acts of sampling to describe wider practices of cultural appropriation and production.[3] The pluralistic aspects of remix culture have been extensively documented elsewhere and are advantageous to understanding cultural production in our epoch.[4] However, to expatiate the meaning of "remix," though useful to address certain trends in culture, is problematic to its usage as a verb related to media production. Whether digitally or mechanically produced, understanding "remix" as a specific practice that uses sampling in the creation/manipulation of temporal media objects is beneficial to comprehending its potential in screen studies.[5] Correspondingly, it is in cinema where the first instances of remix strategies in the creation of *time-based media* emerge, which make remix practice particularly relevant to the study of film.[6] The very nature of working with celluloid films meant from the outset filmmaking involved the *cutting and pasting* of moving images.[7] The "compilation film" (also known as the "found footage film") predates musical remix,[8] and according to Jay Leyda, it can be traced back to the re-editing of newsreels at the turn of the twentieth century.[9] Richard Meran Barsam reiterates this timeline and describes the compilation film as a "subgenre of the nonfiction film that begins on the editing table with footage that was made for another purpose."[10] He suggests that the compilation film gained maturity in the 1920s through its adoption for propaganda in Soviet cinemas and the significant efforts of Esther (Esfir) Shub and Dziga Vertov. The compilation film has retained a resolute association with propaganda: Jonathan McIntosh documents a history of video remix intended toward subversion, and by doing so, he uncovers a propagandistic tendency in compilation film practice throughout the last century.[11] Nevertheless, video remix can have many modes of address, and the use of remix in scholarly essays is markedly different. The impulse in such efforts is not to *détourn* or subvert, but to understand and produce new knowledge about the object of study, leading to a category that can be called *analytical remix*.[12] In this context, sampling equates to direct quotation of the object under analysis, which responds to a long-standing "absence" within film studies prior to digitalization.

The Absent Object of Film Studies

Edward Small contends that film theory might be more effective as a practice in filmmaking rather than an exercise through written language, referring to this as *direct theory*. He suggests that making films about films can overcome the limitations of traversing between separate semiotic systems and avoid "written language upon which the accepted history of film theory depends."[13] Small's proposition, although focused on experimental cinema, can be located in a history of description of the nonliterary arts and a reliance

on the rhetorical strategy of *ekphrasis*—a practice of adept description of the visual arts intended to evoke sight in the reader. Film theorist Raymond Bellour documented the issue of description within film analyses in 1975. In his canonical essay "The Unattainable Text," he suggests that the analysis of the literary text occupies an advantageous position due to its "quotability." He refers to this as "the undivided conformity of the object of study and the means of study, in the absolute *material coincidence* between language and language."[14] Material coincidence in this account is textual citations taken from the page and reproduced on another page. The film text, on the other hand, is "unattainable because it is an unquotable text."[15] Unlike literary critics, at Bellour's time of writing, film critics were unable to incorporate portions of the works analyzed within the medium of analysis. They had to rely on description, as Bellour puts it "playing on an absent object."[16] Bellour's work during the 1970s was invested in structural analyses that performed meticulously close readings of specific scenes examining every shot at a micro-level. One such example is his "System of a Fragment (on *The Birds*)," an analysis of the Bodega Bay sequence in Alfred Hitchcock's *The Birds* (1963). He fastidiously documents all 84 shots in the sequence, describing each of them and supplementing the work with illustrations, lists, tables, and photographic stills of the keyframes.[17] This approach innately points to the very absence of the film text—the still images and shot descriptions fail to reproduce the spatiotemporal specificity of its object of study. The analysis is cluttered with attempts to invoke the essence of audiovisual object, leaving the reader wanting to see the sequence for themselves. Technology has since offered new methods in the study of film, leading structural analysis to new places and making studies like "System of a Fragment (on *The Birds*)" redundant.[18] Consequently, Small's notion of direct theory in the context of remix equates to audiovisual quotation—the scholar can finally quote the object of study for the purposes of audiovisual criticism.

Although remix has been possible throughout the history of cinema, digital video technology has simplified the process, while also democratizing it by lowering the threshold of access, offering the film scholar a new means to perform textual analysis. Quite simply, video editing software installed on a home computer with the capability of ripping a DVD or connected to the online network of digitized video has made the audiovisual essay an arable practice for amateur creation. The amateur in this context arises from a position of love and appreciation—etymologically *amateur* comes from the Latin root *amatore* (lover), indicating someone who does something for love—and this is a love that compels one to contribute.[19] This comes close to Henry Jenkins's notion of "participatory culture" where creators produce by borrowing from various media conglomerates and distribute in noncommercial contexts, outside of the corporate structures of the media industries.[20] However, Jenkins's formulation of consumer participation is conceived from the perspective of fan creators, whereas the audiovisual essayist invested in performing film studies connotes a critical scholarly distance. In the case of videographic screen studies, many creators are engaged in the professional practice of knowledge production and research, but beneficially their critiques speak from outside the hegemony of the commercial film industry. This is not to suggest that scholarly remixers cannot have a professional situation from their labor, but rather, as lovers of the objects they study, their drive and output enriches the economy of contribution. The film academic or critic using remix to analyze commercial screen culture is responding to mass media content through its own vernacular—that is to say *audiovisually*.

In performing film studies, the remixer samples from the object of study and avoids lengthy description in favor of showing the audiovisual sequence under analysis. Andrew

Myers underscores the benefits of such digital scholarship, championing the audio-visual essay's capacity for framing descriptive analysis in counterpoint with the actual audiovisual images.[21] Likewise, Erlend Lavik explains that all types of close analyses can now profit from videographic inquiry and methodologies such as *mise-en-scène* criticism will become richer, more reliable and verifiable, and more enjoyable.[22] Janet Bergstrom also identifies the form's superiority for stylistic analysis and textual comparisons, remarking that audiovisual essays "can be convincing in a way that print essays cannot be."[23]

Such benefits afforded by analytical remix stand in opposition to frustrations around using language to convey cinematic affect. Ekphrastic description of an audiovisual object can be purposeful and beneficial, but as already established, something is always absent when moving between separate semiotic systems, leaving certain cinematic aspects (such as *mise-en-scène*, motion, framing, tempo, gestures, sound, and music) difficult to capture in words. Roland Barthes identifies a condition of cinema that works beyond the informational level and symbolic level of the image. He calls this the *third meaning*, later referring to it as the *obtuse meaning* because it exceeds denotation and signification and escapes language. Barthes explains

> the third meaning structures the film *differently* without [...] subverting the story and for this reason [...] it is at the level of the third meaning, and at that level alone, that the 'filmic' finally emerges. The filmic is that which cannot be described, the representation which cannot be represented. The filmic begins only where language and meta-language end. Everything that can be *said* about [...a film...] can be said of a written text [...] except this, the obtuse meaning [...][24]

It is at the level of Barthes's *filmic*—that which cannot be described—where audiovisual quotation is most profitable. The critic can avoid description and reconvey the cinematic moment audiovisually. The *third meaning* sits alongside Barthes's concept of the *punctum*, as Christian Keathley explains, "The third meaning and the *punctum* can be understood as eruptions of figuration in a text otherwise dominated by representation."[25] Eruption in this sense is what Kristin Thompson also calls "cinematic excess," a concept built on Barthes's project to address aspects of cinema that are irreducible to meaning and also might be thought of as beyond language. She contends that attempts to discuss cinematic excess within film analysis "may be to invite the partial disintegration of a coherent reading."[26] Therefore, the affective quality of cinema—the obtuse meaning as moments of cinematic excess—is precisely what cannot be accounted for through description. Facilitated through digital remix technologies, the audiovisual essay has the ability to quote its object of study by way of sampling and contain the materiality of cinematic excess within its own temporal flux.

Remixing a film might also help the film scholar come to better understand aspects of the film's moments of cinematic excess. Catherine Grant privileges audiovisual methodologies in her study of cinema. In an essay discussing her own practice, she describes making *Unsentimental Education*, an audiovisual essay analyzing Claude Chabrol's film *Les Bonnes Femmes* (1960). Grant reveals that film's "strangeness," "its beguiling yet disturbing affect," is something that she has never been able to effectively account for with words.[27] In this sense, "strangeness" implicitly points toward Barthes's *third meaning* and Thompson's *cinematic excess*. Grant informs us that engaging with the materiality

of the film by remixing it helped her "to arrive at a much more detailed, paradigmatic understanding" of it.[28] She further clarifies,

> Looking back now at this work, the creative digital context of the research allowed space for the establishment and working through of an unusually vivid relationship of aesthetic reciprocity with *Les Bonnes femmes*. Producing *Unsentimental Education* as an explanatory but also *cinephiliac* study helped me both to seek "the 'film behind the film' […] the main aim of textual analysis" (Mulvey 2006, 146), and, more unusually, to bring my version of that "hidden film" into audiovisual existence.[29]

Grant conveys the various benefits to be obtained from engaging with the materiality of a film through *touching it* via the tools contained in video editing software for the purposes of analysis. She compares this to Martin Heidegger's notion of *handlability*, explaining that using practice-based research methods and coming to understand with the hands and eyes leads to the production of new knowledge. Grant began making audiovisual essays in 2009, and *Unsentimental Education* is her very first attempt. The piece is a didactic work, decoding a few of the film's key scenes through a guiding voice-over narration, focusing on the theme of watching and being watched. The audiovisual essay, although not technically accomplished, is significant for the insight the author gained from its production—producing what she calls *material thinking*. Grant has become one of the central scholars in both output of remixed audiovisual essays and written reflection on them, and her work has increasingly become more sophisticated in its technical accomplishment and modes of address. By January 2020, she had published over 140 audiovisual essays on Vimeo and she continues to produce and experiment with the form.

Based on practitioner insight,[30] and taking heed of cinematic excess, it becomes apparent that written descriptions of cinematic images are incapable of emulating the emotional response that the spatiotemporal source text produces in its viewer. In this respect, analytical audiovisual remix resolves the cavity between quotation and description, thus allowing the cinema object to be present within the medium of analysis. Consequently, this places videographic screen studies within a practice of digital creation that might also be understood as a methodology in the digital humanities.[31]

The Digital Humanities

Defining the digital humanities can be a matter of contestation, with varying degrees of what doing humanities research digitally entails. As Jeffery Schnapp and Todd Presner explain, the digital humanities "is not a unified field but *an array of convergent practices*" where print is absorbed into multimedia compositions and where "digital tools, techniques, and media have altered the production and dissemination of knowledge in the arts, human and social sciences."[32] Quantitative approaches to examining large data sets are common in this discipline, as illustrated by projects such as Cultural Analytics,[33] Digital Formalism,[34] ALCIDE,[35] and Histograph.[36] Literary historian Franco Moretti venerates the possibility of scale in digital humanities with his understanding of "distant reading," a quantitative approach to studying literature aided by computers and attending to millions of books rather than the dozens possible by close reading.[37] The element of scale widens with networked technologies, and based on the extent of focus on big

data and automation, one might conclude that digital humanities are quantitative, whereas traditional humanities are qualitative. However, as Johanna Drucker argues, a major problem facing the digital humanities today is that the tools for data mining, information visualization, and other research instruments have been "absorbed from disciplines whose epistemological foundations and fundamental values are at odds with, or even hostile to, the humanities."[38] She reminds us that there are digital humanists who see themselves firmly within the tradition of humanistic objectives and focused on the production or preservation of cultural materials. Consequently, Drucker emphasizes the need to create "digital environments that embody specific theoretical principles drawn from the humanities."[39] Given this point, it is reductive to limit the digital humanities to a quantitative practice when digitality also has so much to offer qualitative approaches.

The digital humanities also embody an empha- sis on producing digital artifacts and making things. Stephen Ramsay contends, that "if you are not making anything, you are not a [...] digital

| See Chapter 10 for Anne Burdick's discussion of the remix library |

humanist."[40] Anne Burdick et al. see the field as a generative enterprise where "students and faculty alike are making things as they study and perform research, generating not just texts (in the form of analysis, commentary, narration, critique) but also images, interactions, cross-media corpora, software, and platforms."[41] Drucker's call for the crea- tion of digital environments is tied to her rallying for methods that are "probabilistic rather than deterministic, performative rather than declarative."[42] She asserts that the "next phase of digital humanities would synthesize method and theory into *ways of doing as thinking*."[43] Simply put, she is calling for a form of thinking through praxis, and it is within this context of praxis thinking or what might be called *montage thinking*—related to Grant's *material thinking*—that videographic screen studies can be situated within the digital humanities.

Types of cognition influenced by media production are at the crux of positioning analytical remix practice in the digital humanities project. Dale Hudson and Patricia R. Zimmermann propose that it is possible to *think through digital media* and point toward "the hacker ethos of 'taking things apart'" as a means to understanding "the invisible and inaudible aspects of digital media."[44] It is in the context of taking things apart that the remixer operates, and the analytical remixer does so to understand the object of study. By employing practiced-based methodologies, the remixer comes to new knowl- edge and understanding through *montage thinking*. Simply put, *montage thinking* is thought or understanding produced by the practical act of editing audiovisual content. Praxis produces new thinking about the object because to edit audiovisual content is to engage with the material through a different form of cognition compared to watching it. The act of creating montages alters the practitioner's perspective of the material—no longer does the film have to flow sequentially, cross comparisons can be made between shots and scenes, or intertextual juxtaposition can be formulated. As Jason Mittell suggests, merely seeing the film through a video editing interface might allow us to see a film in a new way.[45] Therefore, if we can produce thought through technology by making digital artifacts, then technology implicitly affects thinking.

N. Katherine Hayles addresses the relationship between media, digital technology, and education by incorporating a mixture of neuroscience research and digital humani- ties insight to explore "the proposition that we think through, with, and alongside media."[46] Her study documents the shift in cognition and brain plasticity brought about

by digital media and technology. Similarly, in his survey of the digital humanities, David M. Berry identifies what he calls a computational turn and argues that computationally supported thinking is changing the nature of knowledge. He proposes the notion of a "computational subject" who uses "technical devices to fill in the blanks in our minds" and connect information in ways that changes perception and knowledge.[47] While there is nothing new in this proposition, it perfectly captures issues related to technicity. *Filling in the blanks* evokes Plato's scapegoating of writing as *hypomnēsis* or artificial memory, as warned in *Phaedrus*. As Robin Waterfield summaries, through a retelling of the Egyptian myth about the God Thoth, the invention of writing is criticized on the grounds that it would "atrophy people's memories."[48] This exposes the pharmacological nature of technology, illustrating how writing is both poisonous and beneficent to memory.[49] The human adoption of technology toward exteriorized memory is evidenced in all forms of inscription and it began with the cave paintings of the Upper Paleolithic period. French philosopher Bernard Stiegler argues that humanity's history is a technical one because of our dependency on tool use and exteriorization. He contends that our default state of origin is *originary technicity*, or the coupling of the human and technics through a process of coevolution via exteriorization and the use of prosthetics.[50] He argues this by the way of Greek myth and the parable on the creation of man,

> In the myth of Prometheus in Plato's *Protagoras*, man arrives because of something forgotten by Epimetheus, who had distributed "all the qualities," leaving man naked, in a default of being, having yet to begin being: his condition will be to supplement this default of origin by procuring for himself prostheses, instruments.[51]

Importantly, our coevolution with technology indicates that technics conditions memory and is a means through which we come to knowledge. While the rhetoric of the computer is important in our epoch, particularly because of its networked and information storage capacity, writing in its widest sense is a mnemo-technology that has shaped thinking and cognition. It is in the context of inscription that remix and digital humanities practices should be understood.

Along with developing various modalities of writing, technological progress has also led to two major waves within the digital humanities: pre- and post-Internet. This transition embodies a move from considering the computer as simply a tool to aid research toward something that impacts scholarship and society at large.[52] This discernible shift indicates that digital methodologies are something that might generate a *thinking with* or *through* digital media. As computer-aided methodologies have developed, it is becoming clearer that these new methods can shape knowledge, thus implying we are indeed coevolving with technology. Consequently, although the audiovisual essay can be used as a tool to perform film analysis, it is also much more than that. Remix is more than just an instrumental practice that serves a technical function, it is a form of writing, and as a form of writing, it can be a constitutive condition of thought.[53] As Jacques Derrida contends, "writing is the condition of the *epistêmê*."[54] Therefore, it is possible to see remix in the wider context of the co-relationship between humans and technology and consider how new technologies are transforming not only epistemology, but also perhaps ontology with respect to our *originary technicity*. It is within this context that videographic screen studies might be seen as more than a methodology for analysis, it is a way

to think with and through audiovisual media—it is montage thinking involving remix as a form of writing that allows thought.

Conclusion

If the digital humanities is a field invested in creating things, then remix sits firmly within its methodologies. The recreation of media objects through remix consequently leads to thinking about cultural artifacts through a new lens. As shown throughout this chapter, remix can have an analytical benefit in the study of media objects. In film studies, the ability to quote the object of study through sampling is a significant shift in film analysis, and developments in technology have allowed videographic screen studies to prosper. Consequently, the concept of *originary technicity* and how we are shaped by and evolve alongside technology becomes a crucial point of study. The bifold relationship of *us shaping technology* and *technology shaping us* produces a ground that requires us to think of technology beyond mere instrumentation. Digital writing technologies must be afforded proper attention given that writing constitutes thinking. Recontextualizing the history of remix practice toward a cinematic origin is contestable, but it highlights specific practices involved in filmmaking that are directly related to the remix practitioner: cutting, slicing, pasting, joining, stitching, and editing—practices that can all be contained within the art of montage. What is important to understand is that these activities are the core practices of audiovisual postproduction and are now placed in the hands of the scholarly remixer. Upon that, the film scholar might come to know her object of study from a position of creation, thus transforming what it means to study audiovisual media and give way to new types of knowledge.

Notes

1 There are exceptions to this and it is possible to locate a similar film critical remix practice made by professionals creating feature length films that are released commercially. Jean-Luc Godard's eight-part *Histoire(s) du Cinema*, made between 1988 and 1998 was released on DVD in 2008 by Artificial Eye and is 267 minutes long. Thom Andersen's *Los Angeles Plays Itself* (2003) is 169 minutes and was shown at many film festivals between 2003 and 2004, including Toronto, Vienna, Sundance, Rotterdam, London, Oslo. Mark Cousins's 15-part series *The Story of Film: An Odyssey* (2011) was aired on British television's Channel 4 and later released as a DVD. Audiovisual essays have also appeared as DVD extras on releases by Criterion Collection and other distribution companies.

2 "Videographic film and moving image studies" is the subtitle of the journal *[in]Transitions,* the first publication dedicated to this type of scholarship, launched in 2014. The journal's co-editors Catherine Grant and Christian Keathley have been using term "videographic" studies in various publications in recent years and many other scholars emerging in the discipline have started to adopt the term. For a more exhaustive survey of this field see Christian Keathley, Jason Mittell, and Catherine Grant, *The Videographic Essay: Practice and Pedagogy* (Scalar, 2019), http://videographicessay.org/works/videographic-essay/index; Thomas van den Berg and Miklós Kiss, *From Audiovisual Essay to Academic Research Video* (University of Groninge, 2016), https://scalar.usc.edu/works/film-studies-in-motion/index.

3 Owen Gallagher provides an extensive study on the relationship between sampling and remix, positioning both practices as specific acts of content creation that must involve taking from an extant recorded artifact. See Owen Gallagher's "Sampling," in *Keywords in Remix Studies,* eds. Eduardo Navas, Owen Gallagher, and xtine burrough (New York and London: Routledge, 2018), 259–72. However polemics, such as, Kirby Ferguson's video series *Everything is a Remix* ignores such specificity and treats cover versions and creative influence or pastiche as also aspects of remix.

4 Kirby Ferguson, *Everything Is a Remix, Part I–IV,* Short, 2010, http://www.everythingisaremix.info; Eduardo Navas, *Remix Theory: The Aesthetics of Sampling* (New York: Springer Wien, 2012); Martin Irvine, "Remix and the Dialogic Engine of Culture: A Model for Generative Combinatoriality," in *The*

Routledge Companion to Remix Studies, eds. Eduardo Navas, Owen Gallagher, and xtine burrough (New York and London: Routledge, 2015).

5 Gallagher also rejects the broadening of the term "remix," arguing against Kirby Ferguson and clarifying that *everything is not a remix*, particularly remakes, adaptions and parodies. Gallagher insists that the "presence of sampled source material is the defining aesthetic characteristic of remix that distinguishes it from other forms of media," a point which I completely agree with. See Owen Gallagher, *Reclaiming Critical Remix Video: The Role of Sampling in Transformative Works* (New York & London: Routledge, 2018), 1.

6 Although all media are in some way time bound, time-based media refers to objects that need temporal flux to be perceived. For example, a musical melody can only be perceived through the passing of time. Likewise, if a film is not in a temporal flux it becomes a still image. The emphasis on time-based media is to delineate film from photography and collage practices that predate cinematic remix. While it is a valid claim to content that collage is a remix practice, that activity already has its own lexicon.

7 Eduardo Navas has written extensively about cut, copy and paste as a practice within remix. See Eduardo Navas, "Remix : A Critical Analysis of Allegory, Intertextuality, and Sampling in Art, Music and Media" (San Diego: University of California, 2009); Navas, *Remix Theory*. "Cut, copy and paste" are now recurring themes in remix literature and perfectly describe digital practices in the creation of remixed media, but these activities are equally applicable to analogue media production.

8 Although sampling techniques in music composition can be found as early as the 1940s in the works of *Musique concrète*, many commentators identify the origins of remix practice in music production during 1970s. See Navas, *Remix Theory*; Bill Brewster and Frank Broughton, *Last Night a DJ Saved My Life: The History of the Disc Jockey* (Grove Press, 1999); Dick Hebdige, *Cut "n" Mix: Culture, Identity and Caribbean Music* (London; New York: Routledge, 1987).

9 Jay Leyda, *Films Beget Films: A Study of the Compilation Film* (New York: Hill and Wang, 1971).

10 Richard Meran Barsam, *Nonfiction Film: A Critical History* (Blommington and Indianapolis: Indiana University Press, 1992), 75.

11 Jonathan McIntosh, "A History of Subversive Remix Video before YouTube: Thirty Political Video Mashups Made between World War II and 2005," in *Transformative Works and Cultures*, eds. Francesca Coppa and Julie Levin Russo, 9 (2012), http://journal.transformativeworks.org/index.php/twc/article/view/371/299.

12 "Analytical remix" might be thought of as similar to Owen Gallagher's sub-genre of "educational remix," but where sampled footage is used not only as evidence to demonstrate facts already decided, but also as a means to produce new knowledge through the manipulation of the sampled material. See Gallagher, *Reclaiming Critical Remix Video: The Role of Sampling in Transformative Works*, 24.

13 Edward S. Small and Timothy W. Johnson, *Direct Theory: Experimental Motion Pictures as Major Genre* (Carbondale, Illinois: SIU Press, 2013), 7.

14 Raymond Bellour, "The Unattainable Text," *Screen* 16, no. 3 (1975): 20 (emphasis added).

15 Bellour, 20.

16 Bellour, 26.

17 Raymond Bellour, *The Analysis of Film* (Blommington and Indianapolis: Indiana University Press, 2000), 28–68 (Chapter 2: System of a Fragment – on the Birds).

18 During the 1980s Bellour abandoned his structuralist approach to film analysis because of the very video technologies that were beginning make it more accessible and robust. See Raymond Bellour, "Analysis in Flames," *Diacritics* 15, no. 1 (1985): 54.

19 This reference to the amateur stems from Bernard Stiegler's understanding of the term with respect to his thesis on the economy of contribution. On the Ars Industrialis website he summarizes that the "figure of the amateur opposes itself to the figure of the consumer" and contributes to "the formation of a *critical* public (irreducible to the audience)," further adding that amateur *participates* in what she loves and is thereby *individuating* because to "love is to contribute to the being and/or the becoming of that which is loved." Bernard Stiegler, "Amateur (English Version)," Ars Industrialis: association internationale pour une politique industrielle des technologies de l'esprit: accessed May 30, 2020, http://arsindustrialis.org/amateur-english-version. For a more extensive development of the importance of the amateur and the economy of contribution in Stiegler's thought see Bernard Stiegler, *Symbolic Misery Volume 1: The Hyperindustrial Epoch* (Cambridge, UK ; Malden, MA: Polity Press, 2014); Bernard Stiegler, *For a New Critique of Political Economy*, trans. Daniel Ross (Cambridge, UK ; Malden, MA: Polity Press, 2010). For an expanded development of the amateur and the economy of contribution with respect to remix and videographic scholarship see Aidan Delaney, "Film Studies Between Ekphrasis and Quotation," in *Aesthetics, Digital Studies and Bernard Stiegler*, eds. Noel Fitzpatrick, Neil O'Dwyer, and Mick O'Hara

(Lond and New York: Bloomsbury Academic, forthcoming).

20 Henry Jenkins, *Convergence Culture: Where Old and New Media Collide* (New York: NYU Press, 2006), 133–39.

21 Andrew Myers, "Click Here To Print This Video Essay: Observations on Open Access and Non-Traditional Format in Digital Cinema and Media Studies Publishing," *Frames Cinema Journal* 1, no. 1 (2012), http://framescinemajournal.com/article/click-here-to-print-this-video-essay/.

22 Erlend Lavik, "The Video Essay: The Future of Academic Film and Television Criticism?," *Frames Cinema Journal* 1, no. 1 (2012), http://framescinemajournal.com/article/the-video-essay-the-future/.

23 Janet Bergstrom and Matthias Stork, "Film Studies with High Production Values: An Interview with Janet Bergstrom on Making and Teaching Audiovisual Essays," *Frames Cinema Journal* 1, no. 1 (2012), http://framescinemajournal.com/article/film-studies-with-high-production-values/.

24 Roland Barthes, *Image Music Text*, trans. Stephen Heath (London: Harper Collins, 1977), 64–5.

25 Christian Keathley, *Cinephilia and History, or The Wind in the Trees* (Bloomington and Indianapolis: Indiana University Press, 2005), 34.

26 Kirstin Thompson, "The Concept of Cinematic Excess," *Cine-Tracts* 1, no. 2 (1977): 54–7.

27 Catherine Grant, "The Shudder of a Cinephiliac Idea? Videographic Film Studies Practice as Material Thinking," *Aniki: Portuguese Journal of the Moving Image* 1, no. 1 (2014), http://aim.org.pt/ojs/index.php/revista/article/view/59/html.

28 Grant.

29 Ibid.

30 The website *THE AUDIOVISUAL ESSAY: Practice and Theory of Videographic Film and Moving Image Studies* collates several articles from practitioners reflecting on their practice including Catherine Grant, Christian Keathley, Drew Morton, Kevin B. Lee, Adrian Martin, and Cristina Álvarez López. A recurring theme in this collection is the benefits audiovisual quotation has to offer film studies and textual analysis of cinematic media.

31 This was a central argument in my Ph.D. thesis, upon which this chapter is based on. See Aidan Delaney, "Remixing the Object of Study: The (Re)Audiovisual Essay as an Analytical Framework in Screen Media Analysis" (PhD diss, Dublin, Trinity College Dublin, 2016). Jason Mittell's recent chapter makes a similar argument positioning video remix as a digital humanities practice. See Jason Mittell, "Videographic Criticism as a Digital Humanities Method," in *Debates in the Digital Humanities 2019*, eds. Matthew K. Gold and Lauren F. Klein (Minneapolis; London: University of Minnesota Press, 2019).

32 Jeffery Schnapp and Todd Presner, "Digital Humanities Manifesto 2.0," 2009, http://dev.cdh.ucla.edu/digitalhumanities/2009/05/29/the-digital-humanities-manifesto-20/.

33 Cultural Analytics, conceived of by Lev Manovich and developed by the Cultural Analytics Lab, is the computational study of culture involving massive data sets. For an early overview see Lev Manovich, "Cultural Analytics: Visualizing Cultural Patterns in the Era of 'More Media,'" *DOMUS*, no. Spring (2009).

34 Digital Formalism involved creating computational tools for analyzing and interpreting audiovisual media, specifically the aesthetics of Dziga Vertov's films through automation. Various publications have come out of this venture. For a general overview see Vera Kropf et al., "First Steps Towards Digital Formalism: The Vienna Vertov Collection," *Digital Tools in Media Studies: Analysis and Research. An Overview*, ed. Michael Ross, Manfred Grauer, and Bernd Freisleben (Bielefeld: Transcript Verlag, 2009), 117–31.

35 ALCIDE is "a web-based platform designed to assist humanities scholars in analyzing large quantities of data such as historical sources and literary works," see http://celct.fbk.eu:8080/Alcide_Demo/ and https://eadh.org/projects/alcide

36 Histograph is project in association with the University of Luxembourg and based on annotating and exploring large multimedia collections. See http://histograph.eu/ and https://eadh.org/projects/histograph

37 Franco Moretti, *Distant Reading* (New York: Verso Books, 2013).

38 Johanna Drucker, "Humanistic Theory and Digital Scholarship," *Debates in the Digital Humanities*, ed., Matthew K. Gold (Minneapolis: University of Minnesota Press, 2010), 85.

39 Drucker, 86.

40 Stephen Ramsay cited in David M. Berry, *Understanding Digital Humanities* (London: Palgrave Macmillan, 2012), x.

41 Anne Burdick et al., *Digital_Humanities* (Cambridge, London: MIT Press, 2012), 10.

42 Drucker, "Humanistic Theory and Digital Scholarship," 87.

43 Ibid., emphasis added.

44 Patricia R. Zimmermann and Dale Hudson, *Thinking Through Digital Media: Transnational Environments and Locative Places* (London: Palgrave Macmillan, 2015).

45 Mittell, "Videographic Criticism as a Digital Humanities Method."

46 N. Katherine Hayles, *How We Think: Digital Media and Contemporary Technogenesis* (Chicago and London: The University of Chicago Press, 2012), 1.

47 Berry, *Understanding Digital Humanities*, 10.

48 Plato, *Phaedrus*, trans. Robin Waterfield, Oxford World Classics (Oxford: Oxford University Press, 2002), xxxviii.

49 For an extensive deconstruction reading of the suspicion of writing and pharmacology in Plato's work see "Plato's Pharmacy" in Jacques Derrida, *Dissemination*, trans. Barbara Johnson (London: The Athlone Press, 1981).

50 Stiegler develops the notion of *originary technicity* throughout his *Technics and Time* series, beginning in Bernard Stiegler, *Technics and Time: The Fault of Epimetheus*, trans. Richard Beardsworth and George Collins (Stanford, CA: Stanford University Press, 1998). The definition of originary technicity fundamentally means that not only do humans produce and use technology; they are and always have been constituted by technology.

51 Stiegler, 114.

52 Burdick et al., *Digital_Humanities*.

53 While there are many philosophical propositions on the relationship between writing and thought, most notably with Jacques Derrida, educational theorists have also argued that writing produces thinking. For example see Janet Emig, "Writing as a Mode of Thinking," *College Composition and Communication* 28, no. 2 (1977): 122–8; Judith A. Langer and Arthur N. Applebee, *How Writing Shapes Thinking: A Study of Teaching and Learning* (Illinois: National Council of Teachers of English, 2007).

54 Jacques Derrida, *Of Grammatology*, trans. Gayatri Chakravorty Spivak, Corrected Edition (Baltimore and London: The Johns Hopkins University Press, 1998), 27.

Bibliography

Barsam, Richard Meran. *Nonfiction Film: A Critical History*. Bloomington and Indianapolis: Indiana University Press, 1992.

Barthes, Roland. *Image Music Text*. Translated by Stephen Heath. Fontana Press, 1977.

Bellour, Raymond. "Analysis in Flames." *Diacritics* 15, no. 1 (1985): 52–6.

———. *The Analysis of Film*. Indiana University Press, 2000.

———. "The Unattainable Text." *Screen* 16, no. 3 (1975): 19–28.

Berg, Thomas van den, and Miklós Kiss. *From Audiovisual Essay to Academic Research Video*. University of Groningen, 2016. https://scalar.usc.edu/works/film-studies-in-motion/index.

Bergstrom, Janet, and Matthias Stork. "Film Studies with High Production Values: An Interview with Janet Bergstrom on Making and Teaching Audiovisual Essays." *Frames Cinema Journal* 1, no. 1 (2012). http://framescinemajournal.com/article/film-studies-with-high-production-values/.

Berry, David M. *Understanding Digital Humanities*. Palgrave Macmillan, 2012.

Brewster, Bill, and Frank Broughton. *Last Night a DJ Saved My Life: The History of the Disc Jockey*. Grove Press, 1999.

Burdick, Anne, Johanna Drucker, Peter Lunenfeld, Todd Presner, and Jeffery Schnapp. *Digital_Humanities*. Cambridge; London: MIT Press, 2012.

Delaney, Aidan. "Film Studies Between Ekphrasis and Quotation." In *Aesthetics, Digital Studies and Bernard Stiegler*, edited by Noel Fitzpatrick, Neil O'Dwyer, and Mick O'Hara. Bloomsbury Academic, forthcoming.

———. "Remixing the Object of Study: The (Re)Audiovisual Essay as an Analytical Framework in Screen Media Analysis." PhD dissertation, Trinity College Dublin, 2016.

Derrida, Jacques. *Dissemination*. Translated by Barbara Johnson. London: The Athlone Press, 1981.

———. *Of Grammatology*. Translated by Gayatri Chakravorty Spivak. Corrected Edition. Baltimore, London: The Johns Hopkins University Press, 1998.

Drucker, Johanna. "Humanistic Theory and Digital Scholarship." *Debates in the Digital Humanities*, edited by Matthew K. Gold, 85–95. University of Minnesota Press, 2010.

Emig, Janet. "Writing as a Mode of Thinking." *College Composition and Communication* 28, no. 2 (1977): 122–8.

Ferguson, Kirby. *Everything Is a Remix, Part I–IV*. Short, 2010. http://www.everythingisaremix.info.

Gallagher, Owen. *Reclaiming Critical Remix Video: The Role of Sampling in Transformative Works*. New York & London: Routledge, 2018.

———. "Sampling." In *Keywords in Remix Studies*, edited by Navas, Eduardo, Owen Gallagher, and xtine burrough. New York and London: Routledge, 2018, 259–72.

Grant, Catherine. "The Shudder of a Cinephiliac Idea? Videographic Film Studies Practice as Material Thinking." *Aniki: Portuguese Journal of the Moving Image* 1, no. 1 (2014). http://aim.org.pt/ojs/index.php/revista/article/view/59/html.

Hayles, N. Katherine. *How We Think: Digital Media and Contemporary Technogenesis*. The University of Chicago Press, 2012.

Hebdige, Dick. *Cut "n" Mix: Culture, Identity and Caribbean Music*. London; New York: Routledge, 1987.

Irvine, Martin. "Remix and the Dialogic Engine of Culture: A Model for Generative Combinatoriality." *The Routledge Companion to Remix Studies*, by Eduardo Navas, Owen Gallagher, and xtine burrough. New York and London: Routledge, 2015.

Jenkins, Henry. *Convergence Culture: Where Old and New Media Collide*. New York: NYU Press, 2006.

Keathley, Christian. *Cinephilia and History, or the Wind in the Trees*. Bloomington and Indianapolis: Indiana University Press, 2005.

Keathley, Christian, Jason Mittell, and Catherine Grant. *The Videographic Essay: Practice and Pedagogy*. Scalar, 2019. http://videographicessay.org/works/videographic-essay/index.

Kropf, Vera, Matthias Zeppelzauer, Stefan Hahn, and Dalibor Mitrovic. "First Steps Towards Digital Formalism: The Vienna Vertov Collection." In *Digital Tools in Media Studies: Analysis and Research. An Overview*, edited by Michael Ross, Manfred Grauer, and Bernd Freisleben, 117–31. Bielefeld: Transcript Verlag, 2009.

Langer, Judith A., and Arthur N. Applebee. *How Writing Shapes Thinking: A Study of Teaching and Learning*. Illinois: National Council of Teachers of English, 2007.

Lavik, Erlend. "The Video Essay: The Future of Academic Film and Television Criticism?" *Frames Cinema Journal* 1, no. 1 (2012). http://framescinemajournal.com/article/the-video-essay-the-future/.

Leyda, Jay. *Films Beget Films: A Study of the Compilation Film*. Hill and Wang, 1971.

Manovich, Lev. "Cultural Analytics: Visualizing Cultural Patterns in the Era of 'More Media.'" *DOMUS*, no. Spring (2009).

McIntosh, Jonathan. "A History of Subversive Remix Video before YouTube: Thirty Political Video Mashups Made between World War II and 2005." Edited by Francesca Coppa and Julie Levin Russo. *Transformative Works and Cultures* 9 (2012). http://journal.transformativeworks.org/index.php/twc/article/view/371/299.

Mittell, Jason. "Videographic Criticism as a Digital Humanities Method." In *Debates in the Digital Humanities 2019*, edited by Matthew K. Gold and Lauren F. Klein. Minneapolis; London: University of Minnesota Press, 2019.

Moretti, Franco. *Distant Reading*. New York: Verso Books, 2013.

Myers, Andrew. "Click Here To Print This Video Essay: Observations on Open Access and Non-Traditional Format in Digital Cinema and Media Studies Publishing." *Frames Cinema Journal* 1, no. 1 (2012). http://framescinemajournal.com/article/click-here-to-print-this-video-essay/.

Navas, Eduardo. *Remix : A Critical Analysis of Allegory, Intertextuality, and Sampling in Art, Music and Media*. University of California, 2009.

———. *Remix Theory: The Aesthetics of Sampling*. New York: Springer Wien, 2012.

Plato. *Phaedrus*. Translated by Robin Waterfield. Oxford World Classics. Oxford: Oxford University Press, 2002.

Schnapp, Jeffery, and Todd Presner. "Digital Humanities Manifesto 2.0," 2009. http://dev.cdh.ucla.edu/digitalhumanities/2009/05/29/the-digital-humanities-manifesto-20/.

Small, Edward S., and Timothy W. Johnson. *Direct Theory: Experimental Motion Pictures as Major Genre*. SIU Press, 2013.

Stiegler, Bernard. "Amateur (English Version)." Ars Industrialis: association internationale pour une politique industrielle des technologies de l'esprit: accessed May 30, 2020. http://arsindustrialis.org/amateur-english-version.

———. *For a New Critique of Political Economy*. Translated by Daniel Ross. Cambridge, UK; Malden, MA: Polity Press, 2010.

———. *Symbolic Misery Volume 1: The Hyperindustrial Epoch*. Cambridge, UK; Malden, MA: Polity Press, 2014.

———. *Technics and Time: The Fault of Epimetheus*. Translated by Richard Beardsworth and George Collins.. Stanford, CA: Stanford University Press, 1998.

Thompson, Kirstin. "The Concept of Cinematic Excess." *Cine-Tracts* 1, no. 2 (1977): 54–63.

Zimmermann, Patricia R., and Dale Hudson. *Thinking Through Digital Media: Transnational Environments and Locative Places*. Palgrave Macmillan, 2015.

30

CINEMA REMIXED 4.0

The Rescoring, Remixing, and Live Performance of Film Soundtracks

Sarah Atkinson

This chapter examines the phenomenon of live soundtrack performance—a practice in the burgeoning field of live cinema[1]—whereby a feature film is screened to an audience in an alternative venue and a newly composed sound track is played live alongside, transforming a traditionally passive mode of film-viewing into a live, experiential, and unique event.

The live synchronous performance of screen media and sound has experienced an exciting renaissance in recent years with its cultural antecedents in three previous "waves" of practice. The first wave of practice came in the form of early cinema musical accompaniments; the second wave was the expanded cinema practices of the 1960s and the third wave emerged in VJ culture from the 1980s. In contrast to expanded cinema (which foregrounded the viewing apparatus including experimentation with multiple screens) and VJ practices (which foregrounded the music with visuals created in sychronization), this current wave of practice of live soundtrack performance centralizes the narrative text. Music and sounds are created and remixed to accompany the moving image in a "screen responsive" mode. This fourth wave of cinematic remix is one that is predicated on audiovisual congruence and narrative coherence and is evolving new forms and artistic practices, where the live remix intersects with the postproduced.

This chapter presents a number of case studies integrating interviews with some of the artists and producers working at the forefront of this field. In doing so, I propose a classification system of cinematic remix which discerns the nuances between the different manifestations of the form.

A History of Live Remix in Cinema

The performance of cinematic remixes follows a clear historical lineage stemming from the birth of cinema itself; in the silent film era where live musical accompaniments to film screenings were the standard mode of exhibition in cinema auditoria, which had orchestral pits built at the foot of the projection screen. The fourth wave of cinematic remix that is the concern of this chapter is built on the practices and artistic trajectories of this live scoring of silent films whilst blending the two key experimental artistic

trajectories of "expanded cinema" and "video jockeying" (VJing) which preceded it. Expanded cinema is characterized by multiple screens, alternate projection configurations including 360-degree-dome environments and its live music and performance accompaniments. A key formal characteristic of expanded cinema is that the projection equipment and the means of production are made visible and integrated into the artistic installations.

As Birgit Hein stated, expanded cinema is ".... the extension of projection into the whole space and even installations within that space where there is no film at all. The medium, in short, is being explored as a visual system."[2]

The third wave of cinematic remix was born out of night club culture which dates back to the 1970s club scene in New York, where visual projections were synchronized to DJ music across the walls of the venues. It was in the 1980s that the first real-time mix of visuals occurred. At the same time in the 1980s, there was a renaissance of early cinema soundtrack performance alongside film screenings following the preservation and restoration of silent films, where films were exhibited replicating the same conditions in which they were first screened. Kevin Brownlow, a key proponent and enthusiast of film screenings with live soundtracks remarked: "The intention is to present films of the silent era as they were meant to be seen in first-run theatres—with top quality prints, shown at the right speed, with full orchestral accompaniment."[3]

There was a plethora of live cinema activities from 1982 onward including the Thames Television Season of Silent Films with Orchestra, a partnership between Channel 4, Thames, and London Film Festival. These were commissioned after the creative and critical success of the restoration and screening of Abel Gance's Napoleon (1927) which was restored by Brownlow, scored by Carl Davis, and shown with a live orchestra at the Empire, Leicester Square, as part of the London Film Festival in November 1980. Prior to this, in August 1979, Francis Ford Coppola (another key proponent of the "live cinema" genre who will be discussed later) had reportedly planned to present Napoleon with a live orchestra and commissioned his father, Carmine Coppola, to write the music. This version premiered in March 1981 in Radio City Music Hall, New York.

It is important to note that these three distinct trajectories are still very much in existence—their techniques, practices, and the art forms themselves live on within their respective domains.

First, for example, silent film scores still proliferate in numerous venues.[4] Second, expanded cinema has received extensive academic attention primarily through Gene Youngblood's seminal work Expanded Cinema, first published in 1970.[5] The time of this writing, 2020, marks the 50th anniversary since its original publication and subsequent republication. Youngblood revolutionized notions of cinema-making and viewing through his pioneering consideration of videos, computers, and holography as cinematic technologies. Third, VJing culture is showcased through numerous international "live cinema" festivals where we can see that these forms have been sustained and expanded further by artists, practitioners, and curators. These include the annual Live Cinema Festival[6] in Rome established in 2014 and the Live Cinema Festival in Rio de Janeiro, which celebrated its ninth edition in 2015. There are also a number of festivals with a broader remit featuring strands of live cinema activity and programming. These include the CTM festival ("Transmediale Sister Festival"), 2005, whereby "The traditional parameters of narrative cinema are expanded by a much broader conception of cinematographic space."[7]

What unifies these three different trajectories of cinematic remix and that which centrally characterizes this recent fourth wave is their *liveness*. As Duncan White underscores, "Expanded Cinema can be characterized as a form of filmmaking associated above all with a sense of liveness, immediacy and a temporality of presence."[8] Within remix studies, these live forms have yet to be comprehensively considered. Within film and media studies, these forms have hitherto been examined under the banner of "Live Cinema Exhibition" forms of which are characterized by "some form of simultaneous live action or addition to a cinema screening."[9] Since I am reframing practices of the live scoring and rescoring of narrative cinema as cinematic remix, it is first important to acknowledge their genealogical terminology. There has been a consistency of the use of the term "live cinema" across all of the three forms that I have so far introduced (live musical accompaniment of silent film, expanded film, and VJing culture). Despite their clear distinctions and differences—it is the central tenet of liveness that unites them. "Live cinema" was first used by Kevin Brownlow in 1982—the year that the Pordenone Days of Silent Film Festival was established and has since been held annually in Italy. AV artists and practitioners have also taken up the term "Live cinema" to account for the process whereby images are created live at the moment of their performance. Mia Makela conceives of live cinema as "real-time audiovisual performance"[10] and defines live cinema by the presence of the following elements—projection, performer, audience, and shared space. Interestingly, Makela does not bring remixing into her configuration or definition of live cinema. However, Makela is clear to point to the nuances between live cinema and VJing: "Live Cinema is often considered to be another branch of VJing (Video Jockeying). However, although VJs and Live Cinema practitioners share the same software and similar methods of working, their contexts are different, as VJs are predominantly related to the club culture and DJs."[11]

What distinguishes these forms of live cinema from those forms of cinematic remix that are the focus of this chapter are captured with Grayson Cooke's framing: "Live media performances are live, they happen in the moment, on the fly, and in what is frequently referred to as 'real time.' There is no script, no text, no original."[12] Clearly in the case of cinematic remix, there is a central original text. Similarly, live soundtrack performances are usually pre-conceived, pre-rehearsed, and are not characterized by the role that accidents and glitches can play in live media, as foregrounded by Andrew Bucksbarg, who cites their importance in relation to experimentation and play, and their potential for undermining excessive technological regimentation and efficiency.[13]

Live Cinema practitioners who engage in generative remixes (including artists such as *The Light Surgeons*) are distinct from those under examination within this chapter as are those experimental films that are created at the point of reception, for example, Peter Greenaway's *Tulse Luper Suitcases* and Lev Manovich's *Soft Cinema* project. As J.C. Schacher contends of these types of projects:

> Elements known from traditional narrative cinema are eliminated and a type of performance is established that has more in common with electronic music and digital arts than with cinema as it has been canonized in the last one hundred years. Narration and its dramaturgical devices as well as naturalist representation are replaced by abstraction and the pure juxtaposition of image and sound.[14]

Thus, I am ruling these examples out for consideration under a remix remit—since there is no original text from which the performance is drawing. Rather, this chapter focuses

on existing narrative films and their sonic re-imagining through rescoring and live scoring. Some have suggested a distinction between narrative cinema and live cinema—with the latter being described by Peter Richardson as how "a number of film makers have moved away from narrative cinema towards 'live cinema': remixing their films for audiences as a live performed experience."[15]

Whilst we have appreciated the value of this term "live cinema" to account for the burgeoning and expanded field,[16] we have evolved this to insist on greater precision in relation to the variety of forms which had been hitherto collapsed together. We have established the term—live cinema exhibition—as a distinct form wherein existing films are subject to live augmentation. It is within this category that live cinematic remixes are characterized and situated.

It is within these forms—which are focused on narrative cinema—where the live remix intersects with the post-produced. There are a number of practices within the cinematic remix spectrum, I have defined the four main genres are live scoring, live rescoring, live remixed scoring, and live responsive scoring. These four areas will be further exemplified through a number of illustrative case studies. They are ordered in terms of the extent to which they remix the original text. Despite their distinctions, they all share the common trope of linearity, and uphold the film's narrative structure and sequence. It is important to note that they all engage in linear soundtrack remixing in the ways in which the audio is mixed, remixed, and performed—as opposed to content remixing—where elements are reordered and changed.

Four Genres

First, I propose live scoring as the most traditional, and the least remixed, of the four genres. These performances tend to be extensively prerehearsed and practiced: Musical performers, usually in the form of an orchestra, replay the original soundtrack and the film is screened as if at a cinema, for example, the "Royal Albert Hall live soundtrack series" which features classics such as *The Godfather* and *Interstellar* in the program.

Second, I consider live *rescoring*, where the film has been rescored and reimagined, taking the examples of *The Passion of Joan of Arc* and *THX1138*. These two examples sit at the opposite end of the rescoring spectrum, thus represent the complexity of the audio remix. Third, I look at live remixed scoring which is exemplified by Paul D. Miller under his "constructed persona" of DJ Spooky That Subliminal Kid and his critically acclaimed project *Rebirth of a Nation*. The fourth genre under consideration is live responsive scoring as exemplified by the piano performances of artist Neil Brand, which are improvised in synchronicity with the on-screen action, augmenting the comedy and calamitous moments of silent films.

Live Scoring

Although live scoring involves little in the way of remix techniques, it qualifies as the foundational genre of cinematic remix since it establishes the staging and performative conventions of the three genres which follow. It is crucially the liveness in the venue that unites all four genres, alongside a clear set of formal conventions which make these live cinema manifestations a cultural art form in their own right. These include formal staging conventions—the cinematic screen is suspended centrally above the staged

Figure 30.1 Live orchestral performance of Alfred Hitchcock's *The Lodger* (1927), composed by Neil Brand, performed by the Orchestra San Marco, conducted by Ben Palmer at the 38th Pordenone Silent Film Festival, October 2019 (photo by Valerio Greco)

performance area;–and the music performers are positioned below the screen, either on the stage or in the orchestral pit below (Figure 30.1).

Live Rescoring

An example of the live rescore is *The Passion of Joan of Arc* (1928) which was performed at two venues in 2011, as well as a further performance at Shakespeare's Globe Theatre in London on 19 September 2016. This "Silent Film Screening Accompanied by Live Orchestra" was a combination of silent cinema (as many rescores are—the silent-film oeuvre is very often used for live rescored screenings since there is no issue with loss or occlusion of dialog when a soundtrack is being performed over the top of the visuals), experimental orchestra, and the theatrical and atmospheric surroundings of the starlit Globe Theatre. The score was composed by Adrian Utley (Portishead) and Will Gregory (Goldfrapp), who also performed the soundtrack on the night as part of an eclectic group including six electric guitars, members of the Monteverdi Choir, percussion, horns, harp and synthesizers in a mesmerizing, moving, and spell-binding performance of vocals and music.

The further example of *THX1138* (1971) exemplifies a deeper and more complex level of audio mixing. The film was subject to a rescore by Asian Dub Foundation and performed at numerous venues including at Brighton Dome, May 2016 (Figure 30.2). We interviewed Walter Murch who worked in the sound department on the original 1971 film as well as coauthoring the screenplay. He attended and spoke at the live rescoring performances. During an interview after the performance,[17] he explains how he envisioned a future where live soundtracks would be performed alongside the screening of the film:

> I remember from the scoring session of THX which was 1971, with Lalo Schifrin. You know at that time, the technology was very different, but, you were in a room with a full orchestra and then a projector and each piece of

Figure 30.2 Asian Dub Foundation have rescored, remixed, and performed a number of soundtracks for live screenings of films. Pictured here, a performance of the live scoring of *The Battle of Algiers*—Photo: Babak Zand Goodarzi

music is recorded with the image being shown on a screen, and that was the first time that I'd experienced that, and it was electrifying to see a film – no dialogue – no sound effects – just a silent film basically, but to have it energised by 80 musicians recording that music, and I thought at the time, and this was 45 years ago, wouldn't it be great to allow ordinary people – non-professionals to experience this – because it's only us – the filmmakers – and really just, aside from the musicians, a dozen people who'd actually witnessed this, but it's such an amazing event, that it would be fantastic to find the way – technically – to do this. Here we are, many years later, and the technology finally is catching up.[18]

Murch also envisioned the creative potential of audience-responsive remixing:

And that's the great thing about this, because it is theatre, and you can modify the envelope so to speak depending on where you are and what the audience is doing. Not only globally, for example, here we are in Brighton, Brighton is politically this way so we can do this, but also moment-to-moment, as the thing is being projected, which is something that we as film makers can't do – we make the film, and then, it has to run as-it-is, no matter where it gets run.[19]

Murch explains the distinctions between the different approaches to live score performance and remixing:

I was in New York a week ago and there were people who had just come from a screening of The Godfather with a live orchestra, in that case, what they did, was took the original sound mix and stripped out the music, so they were projecting the dialog and the sound effects, and then the live orchestra was filling in the music. Here (for THX1138) you're hearing the original music, Lalo Schifrin's music, with ADF tapestried into it and then augmenting it and then sometimes completely replacing it, so there's a weaving that makes this a very different experience.[20]

It is this latter form of rescoring that takes remix cinema to the next level, beyond verbatim live scoring. The next example takes the form even further through the graphical layering of visual imagery upon the original film, multi-screen projection, in addition to

Figure 30.3 Rebirth of a Nation, Paul D. Miller AKA DJ Spooky, photo courtesy of Subliminal Kid Inc.

live music mixing, thus placing it at the complex end of the cinematic remix spectrum.

Live Remixed Scoring

This leads us to the third type of cinematic remix, live remixed scoring, which is distinguished from the previous type by the level of responsive remixing that takes place in the setting of the live venue.

This type is best exemplified through *Rebirth of a Nation*, a live multimedia performance based on D.W. Griffith's silent film epic *Birth of a Nation* (1915) (Figure 30.3). This included the composition, recording, and live remixing of an original musical score by DJ Spooky (Miller). This score was originally recorded by the Kronos Quartet, and then remixed by Miller during the performances. As well as a musical soundtrack, the live composition also includes a voiceover commentary responding to the on-screen action. The project was originally commissioned in 2004 by the Lincoln Center Festival, Spoleto Festival USA, Weiner Festwochen, and the Festival d'Automne a Paris and then went on to tour more than 50 venues across the world including at the Herod Atticus Amphitheater, at the base of the Acropolis in Greece, and the London IMAX.

Miller explains the process behind each individual performance:

> [I would]…edit the film live and then sample the Kronos Quartet material that
> I had written and then make a live mix. So, I'd add effects, reverb, echo. And

every night was different, and I would re-edit to the film [...] then I would rescore the material, pulling up files, I developed an iPad software that lets you DJ from your phone or your iPad, so I would be able to take multimedia clips, quickly edit them, loop them, have the strings from Kronos mixed with hip hop or electronic music, then send it to the screen. And I was controlling three screens, I had a video mixer, and I was doing all of that live.[21]

Driven by political ends, disrupting the position that *Birth of Nation* holds within the canon of narrative cinema history, Miller claims that the work aims to: "... destabilize and cause a crisis in that narrative. I mean, it's an art project."[22]

As such, *Rebirth of a Nation* has received significant critical acclaim and academic attention and has been widely discussed. Since its DVD release in 2007, closer readings of the remixed text have also been afforded—an opportunity which is lost in its live versions, and also in other forms of live remix due to their temporality and ephemerality. Of Miller's manipulation of the graphical imagery, it has been noted:

Most prominent are the superimpositions Miller creates onscreen – graphics of prisons, circuits, and maps highlighting the ways in which individuals contribute to larger historical forces. The circuit and, perhaps by extension, electronic music, emerges as the most compelling metaphor for these processes.[23]

And of which Donnelley states, "...all in aid of a critical discourse that becomes incorporated within the film."[24]

Live Responsive Scoring

In the fourth and final genre of cinematic remix, performative improvisation in response to action taking place on the screen is taken a step further. Neil Brand, a silent film pianist, began experimenting with this genre in the early 1980s as a member of Eastbourne Film Society, where he recalls live scoring Steamboat Bill Jr, starring Buster Keaton. Brand recalls:

...when it came to the actual performance I had prepared about 15 minutes of music to fit with this film. I started playing and it was all going fine and then the first big laugh came and at that point all of my planned music went out of my head and there was something else there. Inspired by the laughter of the audience. So that became the basis on which I went on playing. As the film went over bigger and the laughs got bigger and I got better during that first performance. So the whole thing became this extraordinary kind of upward spiral. By the end the place was in uproar. I could not remember a note I played, and I just thought wow...[25]

Brand then went on to be hired to play accompaniments to film screenings at the National Film Theatre on London's Southbank in the 1980s. He reflects upon how he evolved and developed his craft during that time:

It was a real proper university education in those movies and also in what my job should be. Which fairly quickly I found was to provide a bridge between the film and its date and its age and its morals and a modern audience. That is how

I've always seen the job. I think I'm there to make people in 2019 or 2020 understand a movie made in 1924, 1925 or even in 1897. According to both the likes of the films and the likes of that audience. So to try and keep the two in balance.[26]

In some senses, the approach that Brand takes is experimental and presents a one-of-a-kind-offer. His performances are normally conducted in small venues, whereas the preceding three forms to varying extents have lately become more mainstream and massified, but the principle behind his sentiment—of translating old films for new audiences—remains a central tenet of all of the examples of cinematic remix. Indeed, Donnelly proposes the possibility of the status of music and musicians redefining and elevating films to cult status, altering their sense of cultural value and interest, as well as "opening" them to a new audience by bridging the gap between populist and elitist texts and audiences.[27]

There are a number of outlying examples of cinematic remix which do not necessarily fit into the genres that I have detailed within this chapter, but which are interesting projects nonetheless and are worthy of note.

For example, Mike Figgis presented a live mix of his film *Timecode* (2000) at Edinburgh film festival, before its theatrical launch in August 2000. The film is renowned for its novel split-screen presentation—four screens are visible at all times showing the simultaneous uncut action of four different cameras. The film was famously shot in one take, and so a sense of liveness is already inscribed into the text. *Timecode Remixed* later went on to an American tour, where Figgis conducted live sound mixes of *Timecode* in San Francisco, Washington DC, and Toronto (in 2007). Of the experiment, Figgis is quoted as saying that he wanted to: "…do something which I've always wanted to do – and in straight cinema I've never been able to do it – which is actually interact with the audience."[28] In the performance, Figgis deconstructs the original soundtrack as it was mixed for the theatrical release of the feature film. He separates and isolates the four separate audio tracks that were originally recorded from each camera feed and remixes them live using a four-channel mixer to manipulate it for each of the four screens, thus creating a unique one–off experience of his film with each live performance.

Interestingly, the narrative structuring of *Timecode* was originally composed as if a musical score, as revealed in Figgis's own reflection of his work:

> Timecode's real innovation, Figgis explained as he introduced the film, came in the way it was written. He divided a sheet of paper into 98 bars, each one representing a minute of screen time. With basic characters in mind, Figgis sketched out a story based on the principles of musical composition. "What a string quartet does is exactly what I was trying to do. A quartet begins with a theme, then it's repeated by another instrument, for example in a minor key."[29]

Given the compositional approach to its dramatic structure, it, therefore, feels most fitting that it could then be treated as a live performative score.

There are limited projects of note where films have been remixed outside of their traditional linear ordering; these have tended to be "one-off" experimental affairs. Take, for example, Francis Ford Coppola's feature film *Twixt* (2011). In the year of the film's release at the annual Comicon, Coppola presented an iPad demo of a live remix of the

film and announced that he planned to do a tour where he would remix the entire film to live audiences, but this never actually manifested.[30] This particular example sits outside of the categories that have been explored and fits with Holly Willis's definition of live cinema, which constitutes: "… real-time mixing of images and sound for an audience, where the sounds and images no longer exist in a fixed and finished form but evolve as they occur, and the artist's role becomes performative and the audience's role becomes participatory."[31]

The examples of *Timecode Remixed* and *Twixt* both invoke the notion of "Director as DJ," but appear to be nothing more than attempts to promote the associated films, albeit with a genuine interest in experimenting and innovating in cinema, a trait for which Figgis and Coppola are widely recognized. Indeed, the auteur figure is central to both of these examples—as they reassert their creative ownership of the urtext through their live performances of creative technological expertise and prowess. Miller also talks of the Director as DJ in this way: "What I was doing with Griffith, was calling it director as DJ, and being able to take an entirely established sequence of material and then transform it, sample it, collage, and then still have enough of a narrative left that it's still a story."[32] These constant comparisons to the director as DJ resonate both in academic literature[33] and also in industry discourse.[34]

Live Cinematic Remixes—Where Next?

At the time of writing, a small theatre production was touring a production of *Night of the Living Dead REMIX*. The stage production involved the re-creation of George A. Romero's 1968 cult classic live on stage in front of a theatre audience (Figure 30.4).

During the performance, two screens are suspended above the stage, Romero's original film is projected on the screen on the left-hand side and the output of the cameras on stage is projected onto the right-hand screen. Performers also double-up as technical crew as they recreate and capture the on-screen action on the stage below, including the live audio of

Figure 30.4 Imitating the Dog's theatrical creation—*Night of the Living Dead REMIX*—Leeds Playhouse, January 2020, photograph: Ed Waring

the on-stage actors which is dubbed over the film's original soundtrack, the action some-times reverting to small set models captured in the wings to the right of the stage. Extraneous narrative material depicting scenes and speeches from the American Civil Rights Movement is also intercut and acted out on stage. Actor doubles are sometimes used to achieve the shots and the reverse angles so that the action follows the continuity codes of cinema whereby all action remains in synchronicity and follows its original linear narrative sequenc-ing. The aesthetic goal of the piece appeared to be sustaining narrative coherence—to replay the original narrative—but to enable further access to the referential depths of the text, and in this case, to more deeply engage with the racial politics intrinsic to the film. There are clear parallels to be drawn with the *Rebirth of a Nation* project.

Conclusion

This concluding example of *Night of the Living Dead REMIX* has much in common with those discussed in this chapter in defining *live* cinematic remix—the four genres all deploy *vertical-remix* practices. These examples of live cinematic remix are not tempo-rally remixed—the content is not cut-up and reordered—there is no disruption of the linear timeframe. Where the *non*-live remix ordering of film and video invokes a sense of disruptive cutting and temporal reordering, which takes place on the horizontal visual plane, live remix is characterized by manipulations enacted on the vertical audio plane, where audio is favored and prioritized. And it is through this creative treatment that the texture and contours of the original visual medium are sonically reimagined and deep-ened. All of the examples discussed within this chapter afford new and deepened engage-ments with the original cinematic texts. As such, these forms are undoubtedly transformative works that fall on a cyclical continuum, which move between experi-mentation to narrativization. This fourth wave of cinematic remix is one that is predi-cated on audiovisual congruence and narrative coherence and is evolving new forms and artistic practices, where the live remix intersects with the postproduced. Furthermore, live vertical remixes represent an evolution of the language and techniques of live cin-ema remix, an area hitherto under-considered within remix studies. What is also impor-tant is their cultural significance—and their ability to reinterpret, reconfigure, and to re-energize old films—to re-situate them within contemporary contexts and to make them legible for new audiences.

Notes

1 Sarah Atkinson and Helen Kennedy, eds. *Live Cinema: Cultures, Economies, Aesthetics* (New York: Bloomsbury, 2017).
2 Birgit Hein, "The structural film," in *Film as Film: Formal Experiment in Film, 1910–1975* 17 (1979): 93.
3 Kevin Brownlow, "Thames Silents," *Sight and Sound*, 51, no. 4 (1982): 229.
4 For a comprehensive list of silent film with rescore treatments, see Donnelley (2015).
5 Gene Youngblood, *Expanded Cinema* (Dutton: New York, 1970).
6 Live Cinema Festival, accessed 19 August 2020, https://livecinemafestival.com/en/.
7 CTM Festival, accessed 19 August 2020, https://www.ctm-festival.de/about/ctm-festival/.
8 Duncan White, "British Expanded Cinema and the 'Live Culture' 1969–79," *Visual Culture in Britain*, 11:1 (2010).
9 Sarah Atkinson and Helen W. Kennedy, "The Live Cinema Paradox: Continuity and Innovation in Live Film Broadcast, Exhibition and Production," in *The Palgrave Handbook of Screen Production*, edited by Batty, C., Berry, M., Dooley, K., Frankham, B., Kerrigan, S., (London: Palgrave MacMillan, 2019), 335–46.

10 Mia Makela, "The Practice of Live Cinema," ARTECH 2008 83 (2008).

11 Ibid., i.

12 Grayson Cooke, "Start Making Sense: Live Audio-Visual Media Performance," *International Journal of Performance Arts and Digital Media*, 6:2 (2010, 200): 193–208.

13 Andrew Bucksbarg, "Vjing and Live A/V Practices", *VJ Theory: Texts*, 2008, accessed 11 March 2009, http://www.vjtheory.net/web_texts/text_bucksbarg.htm.

14 J.C. Schacher, "Live Audiovisual Performance as a Cinematic Practice," *The Cinematic Experience, Sonic Acts XII*, February 2008 Amsterdam, Sonic Acts Press.

15 Peter Richardson, "A 'Real Time Image Conductor' Or A Kind Of Cinema?: Towards Live Visual Effects," *Leonardo Electronic Almanac* 19.3 (2013): 231.

16 Atkinson and Kennedy, 2017.

17 In an interview with the author and Helen W. Kennedy, 25th October, 2015.

18 Ibid.

19 Ibid.

20 Ibid.

21 In an interview with the author and Helen W. Kennedy, 21st October 2019.

22 Ibid.

23 Joe Milutis, "Rebirth of a Nation," *Film Comment* 40, no. 5 (Sep/Oct 2004): 16.

24 K.J. Donnelly, "Music Cultizing Film: KTL and the New Silent," *New Review of Film and Television Studies*, 13:1 (2015): 34.

25 In an interview with the author, 4th October, 2019.

26 Ibid.

27 Donnelly, 31.

28 Michael Faulkner, ed., *VJ: Audio-Visual Art and VJ Culture: Includes DVD* (Laurence King Publishing, 2006).

29 Daniel Trilling, Timecode live: quartet for four cameras, updated 12 February 2014, accessed 20 March 2020, London: BFI, https://www.bfi.org.uk/news-opinion/sight-sound-magazine/reviews-recommendations/timecode-live-quartet-four-cameras.

30 Kevin Jagernauth, Comic-Con '11: Francis Ford Coppola Uses iPad To Remix 'Twixt' Live & Plans To Tour The Film," 2011, accessed 19 August 2020, https://www.indiewire.com/2011/07/comic-con-11-francis-ford-coppola-uses-ipad-to-remix-twixt-live-plans-to-tour-the-film-117324/.

31 Holly Willis, "Real Time Live: Cinema as Performance," *Afterimage: The Journal of Media Arts and Cultural Criticism*, 37.1 (2009): 11–15.

32 In an interview with the author and Helen W. Kennedy, 21st October 2019.

33 Michael Rennett, "Quentin Tarantino and the Director as DJ," *The Journal of Popular Culture* 45, no. 2 (2012): 391–409.

34 Lewis Wallace, "Coppola's Vision for Twixt: Director as DJ," accessed 20 March 2020, https://www.wired.com/2011/07/twixt/ 2011.

Bibliography

Atkinson, Sarah, and Kennedy, H.W. "The Live Cinema Paradox: Continuity and Innovation in Live Film Broadcast, Exhibition and Production." In *The Palgrave Handbook of Screen Production*, edited by Batty, C., Berry, M., Dooley, K., Frankham, B., Kerrigan, S., 335–46. London: Palgrave MacMillan, 2019.

Atkinson, Sarah, and Helen Kennedy, eds. *Live Cinema: Cultures, Economies, Aesthetics*. New York: Bloomsbury, 2017.

Arthur, Paul. "Introduction: Live Cinema." *Millennium Film Journal*, no. 43/44 (Fall 2005): 2–7.

Brownlow, Kevin. "Thames Silents." *Sight and Sound*, no. 5 (Fall 1984): 4.

Bucksbarg, Andrew. "Vjing and Live A/V Practices", *VJ Theory: Texts*, (2008), http://www.vjtheory.net/web_texts/text_bucksbarg.htm. Accessed 11 March 2009.

Cooke, Grayson. "Start Making Sense: Live Audio-Visual Media Performance." *International Journal of Performance Arts and Digital Media* 6, no. 2 (2010): 193–208.

Donnelly, K.J.. "Music Cultizing Film: KTL and the New Silents." *New Review of Film and Television Studies* 13, no. 1 (2015): 31–44.

Faulkner, Michael, ed. *VJ: Audio-Visual Art and VJ Culture: Includes DVD.* London: Laurence King Publishing, 2006.

Hein, Birgit. "The Structural Film." In *Film as Film: Formal Experiment in Film, 1910–1975, edited by Phillip* Drummond et al. Hayward Gallery: London, 1979.

Jagernauth, Kevin. "Comic-Con 11: Francis Ford Coppola Uses iPad To Remix 'Twixt' Live & Plans To Tour The Film." https://www.indiewire.com/2011/07/comic-con-11-francis-ford-coppola-uses-ipad-to-remix-twixt-live-plans-to-tour-the-film-117324/, 2011.

Leblanc, Paola Barreto. "From Closed-Circuit Television to the Open Network of Live Cinema." *Surveillance & Society* 7, no. 2 (2010): 102–14.

Milutis, Joe. "Rebirth of a Nation." *Film Comment* 40, no. 5 (2004): 16.

Makela, Mia. "The Practice of Live Cinema." ARTECH 2008 83 (2008).

Rennett, Michael. "Quentin Tarantino and the Director as DJ." *The Journal of Popular Culture* 45, no. 2 (2012): 391–409.

Richardson, Peter. "A" Real Time Image Conductor' Or A Kind Of Cinema?: Towards Live Visual Effects." *Leonardo Electronic Almanac* 19, no. 3 (2013).

Schacher, J. C. "Live Audiovisual Performance as a Cinematic Practice." *The Cinematic Experience,* Sonic Acts XII (2008).

Trilling, Daniel. "Timecode Live: Quartet for Four Cameras": accessed 20.3.20, https://www.bfi.org.uk/news-opinion/sight-sound-magazine/reviews-recommendations/timecode-live-quartet-four-cameras Updated: 12 February 2014.

Wallace, Lewis. "Coppola's Vision for Twixt: Director as DJ.": accessed 20.3.20, https://www.wired.com/2011/07/twixt/ 2011.

White, Duncan. "British Expanded Cinema and the 'Live Culture' 1969–79.": accessed *Visual Culture in Britain* 11, no. 1 (2010).

Willis, Holly. "Real Time Live: Cinema as Performance." *Afterimage: The Journal of Media Arts and Cultural Criticism* 37, no. 1 (2009): 11–5.

Wyver, Kate. "Night of the Living Dead – Remix Review – Addictive Romero Replica." *The Guardian,* 2020, https://www.theguardian.com/stage/2020/jan/29/night-of-the-living-dead-remix-review-george-romero-leeds-playhouse-imitating-the-dog.

Youngblood, Gene. *Expanded Cinema.* New York: Dutton, 1970.

31

THE SOUND OF THE FUTURE

A Digital Humanities Remix Essay[1]

Paul Watkins

Prelude: Deep Listening

"To be, for material things is to resonate."[2]

Deep listening is a process that begins before birth and it is a sense we practice—with varying degrees of success—throughout our lives. The renowned sound and film editor, Walter Murch, in a collaborative work with his partner Muriel, a former midwife, writes in "Womb Tone" that "Hearing is the first of our senses to be switched on, four-and-a-half months after we are conceived … we are pickled in a rich brine of sound that permeates and nourishes our developing consciousness."[3] In *Tales of Love*, theorist Julia Kristeva describes how the very first sounds a child makes mimic the relationship of the mother–child dyad. Listening is part of the body, a dialogue that begins with the mother–child relationship, and it is reflected in all of life. Thus, when considering the digital turn in sound studies, we cannot evade the humanistic aspect of our inquiry. Most of us spend our lives immersed in sound, and yet sound as an academic object of study remains critically neglected.[4] We need to continue to find ways to deeply listen when undertaking projects at the intersections of humanist inquiry and sound.

Improvising musician and accordionist Pauline Oliveros defines "deep listening" as "learning to expand the perception of sounds to include the whole space/time continuum of sound—encountering the vastness and complexities as much as possible."[5] Moreover, while hearing is a process of being able to perceive sounds by detecting their vibrations, deep listening is an active process that requires interpretation. Both sound studies and digital humanities offer possibilities for deep listening. In thinking through sound and digital humanities (DH), Johnathan Sterne, in his essay "Sonic Imaginations," defines "sound studies" as "a name for the interdisciplinary ferment in the human sciences that takes sound as its analytical point of departure or arrival."[6] Sterne's open definition asks us to think *sonically* about the crucial role that sound plays in our experiences of culture, media, and life. Sound, like the digital humanities, is deep, diverse, and complex. Digital (and analog) applications of sound afford opportunities to engage

scholars, researchers, and students alike with innovative ways to understand the relationship between sound, text, and new media (even though I have a concern for the preservation of old media, like vinyl). Using the methods of the DJ—such as mashing and mixing—this chapter explores remix in relation to analog/digital and musical/textual confluences. Roughly, the chapter explores the ubiquity of sound—from recording machines to DJ performances—to examine how a remix-based approach to sound in DH can provide tools for understanding sound as foundational to research and new knowledge creation.

Theoretically, this chapter has a double significance: it deals with how DJs rework archival material that is often dormant, or that has not been critically evaluated, while simultaneously modeling a pedagogical framework that provides new directions (while looking to the past) for literary, musical, and digital humanities research concerned with sound. Finally, the chapter aims to contribute to a broader understanding of sound and remix as an integral part of how we learn, collaborate, understand shifting technologies and engage in assimilative cultural practices. The first section considers some of the cultural origins of sound reproduction—digging into the archive—to think through the prevalence of sound in our modern lives. In the next section, I examine how DJs remix archives and outline my DJ methodology: an approach that mixes different sources to form new patterns of remixed thought. In the third section, I look at sound studies and remix in relation to digital humanities, outlying exemplary work in the field before turning attention to my own work as a scholar and DJ working at the intersections of music, sound, and literature. I also outline some of the innovative and important cultural work being done at Vancouver Island University and at the Innovation Lab, including work with visiting poets (notably Nisga'a poet Jordan Abel), recording Indigenous elders, and 3D printing a sounding gramophone—an appropriate meeting of the past dialoguing with the present. I hope the active reader/listener will view the projects and links in the endnotes as they work their way through the essay. Just as there is no single way to conduct research, or hardly a singular way to sound, there is no one sound of digital humanities. Rather there are multiple sounds—resonances, reverberations, remixes—and thus DH approaches to sound are deep, rich, immersive, and layered. The challenge—within the cacophony of contemporary life—is to find new ways to closely listen.

Sounding Machines

"The future is always here in the past"[7]

The rise of mechanical production and reproduction has engaged foundational scholars like Theodor Adorno, Walter Benjamin, and Marshall McLuhan to more contemporary scholars like Jonathan Sterne, Lisa Gitelman, Alexander G. Weheliye, and Paul D. Miller (DJ Spooky) to consider how new "audiovisual technologies—the phonograph, film, radio, and eventually television—presented an opportunity to reconsider the relationship between technological and cultural production," exploring how "the seemingly anti-human world of machines produces the modern political subject, extends the human body, and splits sounds from their sources, especially the human voice."[8] For instance, the telephone liberated the individual and allowed for the transmission of the human voice over large distances, changing the very nature of how we communicate. Put succinctly, our listening practices are informed by the very technologies that frame them and make certain kinds of listening possible in the first place. There remains

prescient truth in Marshall McLuhan's aphorism "the medium is the message" (or "massage" or "mass age"), particularly the notion that today's virtual media can be an adequate substitute for actuality. Today's digital practices, including sampling and mashup, merge the past with the present, but these devices, even when digital, remain framed, as Lingold, Mueller, and Trettien state: "by the human body and the ways it listens."[9]

The turntable is itself a reinvention of an older incarnation. It could be argued that Alexander Graham Bell's 1874 ear phonautograph (sound writer), which used an actual human ear and part of a skull of a dead man obtained by Bell's associate, Dr. Blake, was intentionally about repetition as simulacrum, rather than repetition as difference.[10] The sound waves coming into the eardrum were traced on smoked glass by means of a bristle brush, as determined by the ossicles (a group of three small bones in the human ear). The machine was designed with the hope of educating the deaf to replicate the speech of others, which for Bell was, as sound and media theorist Jonathan Sterne states: "about the eradication of linguistic difference."[11] Perhaps ironically then, deafness marks the beginning of sound reproduction, and yet, sound reproduction has always been concerned with a reproduction, or a repetition, of the human, especially since Bell's phonautograph used a human ear (Figure 31.1).

Part of Bell's approach surrounds his view of sign language as pernicious[12] and it connects with Freud's own notions of hysteria around the sound of female voices, made, for Bell, perhaps all the more monstrous when spoken by a deaf woman. This is not to downplay Bell's deep love for his wife, Mabel Gardiner Hubbard, who, like Bell's mother, was deaf, and who herself was an innovator and inspiration of Bell's work, but it is to point out a possible myopia that researchers face when dealing with sound as if it is supposed intangibility eludes bias.[13] All sound comes—to a degree—from a tangible source. In her essay, "The Gender of Sound," Anne Carson explores the history of gendered voice, from Sophocles to Gertrude Stein, and discusses how our presumptions about gender affect the way we hear sounds: "[p]utting a door on the female mouth has been an important project of patriarchal culture from antiquity to the present day."[14]

In 1877, Thomas Edison invented the phonograph, which would become the model for the gramophone and ultimately the turntable. The phonograph played sound from wavy lines scratched, engraved, or grooved onto a rotating cylinder or disk. As the cylinder or disk rotates, a stylus or needle traces the wavy lines and vibrates to reproduce the recorded sound waves. In 1887, Emile Berliner patented the gramophone, a device that implies a blend between speech and writing. With the gramophone came sound recordings of music, and by 1900, there were some 5000 advertised choices of records one could purchase; by 1930, 60% of homes had radios. As book publishing changed the way people thought about and read books—certainly changing their accessibility—so too did the recording industry—physical and then digital (from iPods to AirPods and online streaming)—alter our approach to music and sound.

The rise of the DJ fits within the postmodern desire of contemporary masses to bring things closer. Technology changes culture and the invention of the Technics SL-1200 series of turntables, manufactured from October 1972 until 2010 (and then relaunched in 2016) by Matsushita (then Panasonic), made DJ culture largely possible in the first place, even though the Technics 1200 was never intended to be repurposed as a musical instrument, for, as Charles Mudede writes: "To replay a record with your hands is different from playing an instrument with your hands … The turntable is always wrenched out of sleep by the hand that wants to loop a break or to scratch a phrase."[15] The Technics SL-1200 (in hip hop, they are often referred to as "Tec 12s," "Wheels of Steel,"

Figure 31.1 Bell and Blake's ear phonautograph. Source: Library of Congress, manuscript division, Alexander Graham Bell family papers at the Library of Congress

and the "Ones & Twos") with its direct-drive high torque motor design initially made it suitable for cueing and starting tracks on the radio, although young DJs in New York would soon realize just how much you could do with a turntable and some records. For instance, listen to a landmark work like DJ Shadow's 1996 *Endtroducing,* which is renowned for being entirely composed of sampled content and created with two turntables and a sampler. In *Shades of Blue,* Madlib infuses old jazz records from the Blue Note catalog with hip hop production, cuts, and new contexts, translating original pieces into new creations.

Old music continues to create new music. This has been happening long before hip hop, but it is certainly quite prevalent in hip hop music. For example, Melvin Bliss's 1973 45 rpm B-side "Synthetic Substitution" created the backbone for hundreds of hip hop classics throughout the 1980s and 1990s.[16] For all the newness of hip hop, it only really exists because of its adherence to the past. Amiri Baraka drew on the wisdom of

the ancients when he said: "The future is always here in the past."[17] Over time various technological innovations changed the listening experience to a digital one—a medium people could access and share right from their computers or mobile devices. For the most part, the digital format provides the most democratic possibilities for both remix and music sharing. One question that arises is whether there is a difference between sound that is digital and sound that is analog. It is perhaps the same question we ask ourselves when teaching digital humanities courses: Is there a difference between the physical, tactile book-in-hand, versus the electronic book and, if so, how do those different media impact pedagogy and learning? Does the digital archive in the context of searchable sound on sites like *Soundcloud* or streaming services like *Spotify* really evade text, since it is still filtered through a binary configuration that is organized through searchable text? How do our socially conditioned views about gender affect the way we hear, create, and understand sounds? How do the many sounds around us influence the way we think and sound in the world? We have more sound coming in than ever before. The move to more and more digital archives, libraries, and electronic media collections is an example of that, which in many ways functions as a database not dissimilar to the, now mostly defunct, iPod. We archive ourselves. Scholarship on sound and DH helps to amplify the interstices where changes take place, even as they remain indebted to older analog models.

DJ Methodology

The mix breaks free from the old associations. New contexts form from old. The script gets flipped. The languages evolve and learn to speak in new forms, new thoughts. The sound of thought becomes legible again at the edge of the new meanings.[18]

The DJ is a person who notices sounds and goes into the archive to recover them. Arguably, we are in the era of everything "re" (from readymade to remix) as Martha Buskirk, Amelia Jones, and Caroline A. Jones contend in their essay "The Year in 'Re-'" for *Slant* magazine. They define remix as "taking parts of existing musical tracks (or by extension, visual or performance material) and cutting them together to create new material."[19] In his essay "Performing Zora: Critical Ethnography, Digital Sound, and Not Forgetting," Myron M. Beasley looks at the work of Zora Neale Hurston as a pioneer of sound studies for her recordings of folk songs and traditions, many of which she sang herself. Hearing a DJ mix Hurston's voice—"Halimuhfack"[20]—into a mix that included Nina Simone, Maya Angelou, Langston Hughes, among others, at the Red Rooster in Harlem gave Beasley pause: "Hurston's track halted the flow. The gritty, dusty, scratchy quality transported the listener to another time, to another place. The pastiche of sounds curated by the DJ was a 'remix' for sure. The audio palimpsest—layering a mix-match of music weaving literature, ethnography, biography, and history—the techno-digital moves of the DJ announced the confluence of digital sound and humanistic inquiry."[21] Hurston's digitized voice haunts the listener and shows us that a vast archive of recordings (many not yet digitized for accessibility) are ready to be recovered by DJs, students, and scholars.

My methodology[22] is modeled on the practice of DJing: DJs mix multiple records by considering rhythm, beats-per-minute, and the overall sonic experience. Mashing different sounds together allows us to break away from old associations and provide new

pedagogical models for learning. As Lisa Coulthard outlines: "mashups rub sources against each other, layering incongruous cultural products and reworking references through new combinations, associations and contexts."[23] I think there is real value in employing mashup, especially for myself as an educator and a DJ. At their best, classrooms are multi-sonic and multicultural spaces where truth (at least, idealistically) is worked out in dialogic engagement. That is, the classroom can be a mashup, a creative and intellectual mix where ideas rub against each other, and where different opinions are discussed and reworked to form new combinations of thought.

As Paul D. Miller (DJ Spooky) emphasizes, languages and the ways we make new meanings out of the old are always changing. Kid Koala, a Canadian DJ, turntablist, musician, and author/illustrator, is known for his incredible tactile manipulations on the turntables. Koala popularized a method of playing the turntable like a melodic instrument, where a long, single note is dragged under the needle at different speeds, creating distinctive pitches. This effect can be heard on his mix of "Moon River,"[24] where he creates and inserts an extended violin solo by playing various long violin notes from the song's instrumental section at different pitches on three turntables, all live. As the story goes, Kid Koala's mom did not understand how and why he was making his music, and so he asked her what her favorite song was and remixed it. It is precisely Kid Koala's version[25] of a 1961 easy listening song—far removed from the context of hip hop and remix culture—that highlights how the past is a network for DJs to remix.

Classical musician-turned-radio personality, Glenn Gould anticipates DJ culture when he writes: "Recordings deal with concepts through which the past is reevaluated, and they concern notions about the future which will ultimately question even the validity of evaluation."[26] It is through the DJ's capacity for remix that we can understand the value that technology can play in reinterpreting materials, whether past or present. For example, DJ Spooky's *Rebirth of a Nation*,[27] his version of D.W. Griffith's 1915 film *Birth of a Nation*, introduced the sounds of history and racial intricacy that are elided in the original version. Further, there is a

> See Chapter 30 for Sarah Atkinson's examination of live soundtrack performances.

communal dimension to Spooky's work as his remix was performed by the legendary Kronos Quartet as a large-scale multimedia performance piece at venues around the world.

The DJ metaphor, for me, is an apt framework to think through the work we do in the humanities—especially in digital humanities where the investigative act is one of creative kinship between old and new technologies, past and present texts, and at the intersection of a number of disciplines, most obviously computing and the humanities.

Digital Humanities as Remix

> If you want to start doing digital humanities in an undergrad sound class, almost all of your students, even if they're fairly disadvantaged, have a recording device in their pockets. The software to edit those recordings on a computer can be found for free, software like Audacity, and there are lots of places on the web where you can upload this work, annotate it, and share it.[28]

Roughly, digital humanities is scholarly activity that merges digital technologies and various disciplines in the humanities. DH emerged, as James E. Dobson outlines: "after

the fact as an institutional and organizational label for a set of disconnected approaches, objects, and strategies for addressing the growing awareness that the digital transformation of everyday life and the methods used in academic work in the past few decades have altered the protocols of humanities research."[29] One of my concerns is that to better produce computational tools to understand sonic archives and repertoires, we need to ensure that we maintain deep listening practices while also acknowledging that there is a politics at work in sound, particularly in what is included in the archives and how that research is conducted. In their introduction to *Digital Sound Studies*, Lingold, Mueller, and Trettien elucidate that sound does indeed have a politics: "it can be gendered and racialized, used both to liberate people from and reinscribe determinative social categories. Sound has ethical implications and can help to build community or, conversely, to torment prisoners. It can elicit fear as easily as it produces longing or nostalgia. Even what counts as 'sound' or 'signal' and what gets dismissed as 'noise' can differ dramatically across listening practices and auditory cultures."[30] Much of what is considered "noise" should be challenged, as Tricia Rose does in *Black Noise: Rap Music and Black Culture in Contemporary America* (1994), which examines Black cultural production in hip hop, and as Tara Rodgers does in *Pink Noises: Women on Electronic Music and Sound* (2010), which looks at the pioneering work of women in electronic music. This is not to say we should have a one-size-fits-all listening approach, as if such a thing were even remotely possible. How one engages with the music of John Cage versus that of Marvin Gaye (as Fred Moten has done) will require different modes of inquiry and knowledge.

There are many contexts where sound(s) and digital humanities projects might intersect: Soundscapes, collages, and remixes; digital storytelling (perhaps in transmedia projects)[31]; aural and oral histories (including a number of projects I have spearheaded myself)[32]/biographies/documentaries/curated exhibitions/installations/performances/ broadcasts; or as standalone artifacts (embedded sound, podcasts, web-based radio, archives, curated collections). Much of this exciting work is already happening in DH and sound studies. A few exemplary sound projects in DH include *Sounding Out!* (a digital sound studies publication)[33]; *Provoke! Digital Sound Studies!* (a site for creative–critical projects by sound scholars and artists)[34]; *Sonic Dictionary* (a collection of over 800 sound recordings by university students)[35]; *The Jazz Loft Project* (a large collection of digitized audio captured by photojournalist W. Eugene Smith between 1957 and 1965)[36]; *Freedom's Ring* (which provides audio from MLK's iconic "I Have a Dream" speech in animated format where you can compare the written and spoken speech along with multimedia images and more)[37]; *OutKasted Conversations* (a digital space that is "dedicated to the facilitation and archiving of southern hip hop scholarship" and which has produced two seasons of podcasts focused on interviewees' experiences listening to southern hip hop duo, OutKast)[38]; as well as archival projects that experiment with physical media in confluences of digital and analog spaces like Rutherford Chang's *We Buy White Albums* art installation, website, and remixed record (where 100 first-pressings of *The White Album* are synced up in a bizarre sound collage that moves in and out of the familiar and into the choral and cacophonous, and which can be found on *Soundcloud*).[39] These projects—among many others—typify engaged listening that facilitates new understandings of original work by providing visitors the opportunity to engage in remix as they navigate these spaces/web pages.

See Chapter 16 for Joycelyn Wilson's annotated syllabus as a demonstration of the capabilities of Hip Hop-inspired Design Research.

The Digital Humanities Summer Institute

Sound remains foundational to the work that I undertake as a scholar. In the Digital Humanities Summer Institute (DHSI) at the University of Victoria (UVic) on Sound in 2015, my research assistant, Sam Van Hell, and I took the lead on creating a remix of all the work we did that week, and the end result was a 9-minute sonic mix that included field recordings (such as ambient and environmental sounds from the UVic campus), live piano, samples, and various participant projects such as an audio recording of a Slave's "Bill of Sale" (from a project developed by Dr. Cedrick May). While my remix is the one we used in our presentation that week, we created a shared archive of sounds for the group to manipulate, arrange, and digitally share. Sound is a tool that I use in all my classrooms, as I often open my classes with a listening of material (sometimes a live remixed performance, and other times a vinyl record or a video on *YouTube*) that relates directly to the text or media we are studying.[40] This empowers students to see that the archive is not stagnant; rather, like a DJ, anyone can remix, remake, reshape, and reedit a piece of recorded history, creating his or her own mix.

In my classes, I have had students do everything from create audio remixes, to short films (recorded and edited on their phones), poems, paintings, community projects, and oral history recordings. As Sterne points out, the near-universal access of recording devices for students, even underprivileged ones, has made capturing sound and video easier than ever.[41] My concern with sound is also one rooted in voice, which is why I have endeavored to bring writers and poets directly into the classroom. Recently, I have recorded original blessings and songs by Indigenous elders and audio poems, collaborative remixes, and/or interviews from visiting poets such as then Canadian Parliamentary Poet Laureate George Elliott Clarke, Haisla and Heiltsuk writer Eden Robinson and, in 2016 and 2018, I helped bring the Griffin Poetry Prize-winning Nisga'a poet Jordan Abel to campus to perform parts of his long poem, *Injun* (2016).

Jordan Abel's Injun

Injun is built from a single-word document that is comprised of ninety-one Western novels in the public domain that were published between 1840 and 1950. Using his computer's find function (CTRL+F), Jordan describes how he searched the source text for the word "injun": "a query that returned 509 results. After separating out each of the sentences that contained the word, I ended up with 23 print pages. I then cut up each page into three-to-five-word clusters."[42] His work combines digital and analog processes (much like William S. Burroughs's cut-up technique), as he describes how he sometimes would "cut up a page without looking," while at other times he would "rearrange the pieces until something sounded right. Sometimes I would just write down how the pieces fell together."[43] Jordan describes his process as aligning with work in digital humanities, but within the framework of Indigeneity:

> My interest was in part in trying to figure out what room there was for both artistic or creative intervention in DH, but also what room there was for Indigenous kinds of intervention. Even the ways that I searched through all of those western novels came into question in a DH context because, as soon as I started talking about my artistic projects, there was lots of resources and people to suggest to me that there were other ways of going about creating the texts

that I had created—using scripts and algorithms and whatnot to potentially get the computer to compile all the search queries instead of doing them manually. For me, the area that I became the most interested in was computational text analysis and honestly, the more I think about it, the more I think that my interest in digital humanities was very much centered around trying to figure out where my artistic practices lined up with academic practices.[44]

For Jordan, the process itself—the deep listening through the cutting of the text—is important to understanding his own experience with the past and the experience of being an Indigenous person in Canada. However, given the inherent difficulty of the poem and its conceptualism—certainly for students in both my upper level Indigenous course and my CanLit Now! course—hearing the poem sounded in live performance helped the students to *sonically* feel and understand the thematic concerns of the poem.

Rather than a standardized reading of *Injun*—if such could even be possible—Jordan manipulates and remixes his own vocal recordings of the poem through an Akai APC mini, a laptop, and Ableton Live. For a typical DJ, the APC pads would trigger drums and other samples, but Jordan uses it to trigger his recorded voice in real time in a way that speaks to how the poem functions on the page, bending, elongating, and echoing words in a polyphonic mashup that, at times, breaks down words into phonemes and pure sound. The experience of listening to the work—with the volume level way up—is often described by listeners as deeply uncomfortable, but one that speaks to the experience of Indigeneity and the textured layers of racism in the Western genre.[45] It made the text sound for the students and it gave them a deeper appreciation for thinking about voice, technology, and remix as a learning aid, as they closely listened in an act of joint meaning-making with the poet and remixed poem.

The Innovation Lab and 3D Printing a Turntable

This kind of collaborative work—mixing humanistic modes of inquiry with digital technologies—has been happening at the Innovation Lab at Cowichan and the MeTA lab in Nanaimo (on Vancouver Island).[46] The Innovation Lab is an interdisciplinary, interprofessional, and intraeducational space that provides alternative paradigms to challenge conventional orthodoxy to knowledge, and it seeks to develop a more versatile community of learners with a wider range of contemporary applied skills. I recently built a sound lab that has been put to generative use by students, professors, and researchers. Some projects at the lab have included digital storybooks, applied theater, robotics and 3D printing, documentary, digital learning modules, mapping (TEI) on treaties, and language revitalization (digitizing Hul'q'umi'num' for use in education).[47] In 2016, I was fortunate enough to take part in recording and mixing the audio portion of Marlene Rice's (Hwiem') "The Gathering of Nations" Anthem. It is a song that welcomes students to learn and it is performed in the Hul'qumi'num' language, and I have used it to open many of my classes, which allows the voice of an elder in the classroom when it is not always possible to have one in person.[48] It is this accessibility and ability to share sound files digitally—from music, spoken texts, oral histories, field recordings, to stories and language revitalization from Indigenous communities—that allows for deeper engagement with significant cultural artifacts in a multitude of spaces.

The last project I want to highlight is the 3D-printed turntable I made with my research assistant, Sam Van Hell. There are concerns that 3D printing[49]—which *The*

Economist called a third industrial revolution, following the production line[50]—could replace the work of people, among a list of other concerns, such as unhealthy air emissions, a reliance on plastics, gun control loopholes, and 3D-printed drugs.[51] While these concerns need to be taken seriously, what I find particularly exciting about 3D printing is its relative accessibility, affordability, and the potential to inspire users to view themselves as creators and innovators. In terms of pedagogy, 3D printing has enormous potential, and by introducing the technology into schools, we can shift the paradigm of how young people view innovation and manufacturing. That is, we can get young people to see themselves as innovators, scientists, and futurists from an early age. The DJ in me sees the remix potential, as users can print household goods that respond to the enormous crisis of climate change by making conscious decisions to use biodegradable PLA plastic filament in printers like the MakerBot.

At the Innovation Lab at the VIU Cowichan campus, we have 3D printed a number of prosthetic hands, which speaks to the potential of the emergent technology of 3D printing. Organizations like the Open Hand Project[52] and Enabling the Future[53] are reminders that technology can greatly improve the lives of those who are missing hands and arms and it can do so at a fraction of the cost. While 3D printers are not cheap (starting at around $800+), the material (filament) to print objects is incredibly inexpensive, which can lead to thousands in savings in terms of prosthetics or other printed objects such as instruments.

Case in point: schools could print 3D ukuleles[54] for less than half the cost of a traditional ukulele and have students assemble them, simultaneously learning two crafts. Working with the 3D printers at the Innovation Lab at Vancouver Island University's Cowichan campus presented an opportunity to print a hand-cranked turntable using an existing template[55]—an appropriate meeting of the old world dialoguing with the new. During the process, working alongside my work-op student Sam, who is truly an equal collaborator (see the video in the endnote),[56] we utilized two 3D printers: MakerBot 3D and LulzBot TAZ. We learned as we went along, as there were challenging moments where printing suddenly stopped midpoint, or where we had not heated the bed properly, or where we chose the wrong filament for printing. Through trial and error, and by making slight modifications along the way, we successfully printed our hand-cranked vinyl player (Figure 31.2).

The video showcases the process that eventually led to the finished and functional model and puts a number of objects into juxtaposed conversation. For example, in the second part of the video, we have chosen the backdrop of a pond with moving water to contrast the mechanical movements in the first part. You might also notice other objects that function as visual metaphor, such as a biography on inventor Alexander Graham Bell (whose own ear phonautograph marked the beginning of sound reproduction) or Pierre Bourdieu's *The Field of Cultural Production* (whose work reminds us of the larger cultural field in which we make and reproduce art). The choice of the Billie Holiday record was two-fold: 1) The record was already scratched up and so the further damage our sewing needle stylus would inflict would be fine and 2) its initial pre-digital recording and iconic sound provide a useful reflective space to think about how recording technologies and musical performance borrow from the past while suggesting new ways forward. That is, the past and the present are constantly speaking to one another. In addition, the music in the video, which I composed under my alias, DJ Techné (see note 22), is mixed, cut, scratched, distressed, mashed, and recontextualized largely from fragments of different Louis Armstrong recordings (taken from vinyl in real time).[57]

While these juxtapositions create some cognitive dissonance, they suggest that experimentation is about finding new ways to understand the social contexts of cultural

Figure 31.2 3D-printed turntable (image courtesy of the author)

practice and production in relation to new technologies. At its best, 3D printing and other forms of digital engagement can help us understand technology-based learning, and it can provide critical tools for educators within and outside the walls of academia. While the final result is a 3D turntable that looks far better than it sounds, it is important to recognize that it sounds at all. It sounds out our way forward, which for us, involves an echoing back as we decide where we want to go next.

Remix: Alternative Possibilities

"Sound is to people what the sun is to light."[58]

While DH has been quick to embrace the visual—from images, video, and text—it has been slower to embrace sound, which is too bad since sound is foundational (as free-jazz progenitor Ornette Coleman articulates) and relates directly to our other senses, often

enhancing the visual. This chapter briefly examined sound and remix in relation to DH, tracing the history of mechanical reproduction in reference to the DJ who uses these tools as a way to engage with the past in the present and future moment. I also briefly sketched a variety of projects being undertaken in sound studies and DH to show some of what is possible, especially when we take risks, and improvise with new technologies. Improvisation is the force by which we maintain the human, and it also foreshadows where the technocratic future will take us as we head further onto the ledge of the possible or beyond, as jazz artist and creative icon Sun Ra writes: "The possible has been tried and failed; now I want to try the impossible."[59] It is in imagining the impossible that we can create futures that at one time seemed only imaginable. This possibility is predicated on the act of deep listening.

The ear functions like a microphone that is constantly inputting sound; by comparison, deep listening, as Pauline Oliveros told neuroscientist Seth Horowitz, is very close to what we call consciousness.[60] Our ability to listen, carefully, and deeply, can be trained and technology is changing the very nature of the way we listen. The DJ is the person who notices sound (digging in the crates/archives) and through remix opens up space for previously unheard or dormant voices and sounds. By extension, listening on the part of the critic/teacher/and student is itself an improvisational act that ventures toward the unknowable edge—the space that Sun Ra called "the other side of nowhere." This unknowability does not limit our participation, but rather opens alternative spaces where listening to others becomes possible, and even essential.

To sound, to echo, to listen, and then to remix speaks to the human condition. Sound, the most foundational of our human capacities, encapsulates, as Sterne states: "what it means to be human."[61] There is no one way to sound just as there is no one way to be a human. With this basic principle, this essay was produced in the spirit of innovation and remix, and from a humanist perspective with a concern for the digital turn. I remain motivated by the far-ranging work happening with remix and digital humanities (as evidenced in this very handbook), as such work continues to provide new pedagogical and theoretical models for thinking about sound, which, for all its ephemerality, still has the power to hold us—like those early womb tones—and remind us of our incredible capacity to sound and listen.

Notes

1 This essay is largely conceptual, but it is informed and rooted in a number of institutional frameworks, particularly drawing from research being undertaken at the Innovation Lab at Vancouver Island University's Cowichan campus. In addition, the research is informed by my experiences at The Digital Humanities Summer Institute (DHSI) at the University of Victoria (UVic), particularly the intensive weeklong workshop on "Sound of :: in Digital Humanities" taught by John Barber. In the course we focused on how sound files inform digital humanities (DH) projects in a number of ways, either as substance or ambiance. In addition, some ideas in this essay first appear in, or are adapted from, my PhD thesis, "Soundin' Canaan: Music, Resistance, and Citizenship in African Canadian Poetry." A special thanks to Sally Carpenter, Ian Whitehouse, and Sam Van Hell for dialoguing with me at various stages of this paper/project.
2 Alfonso Lingis, *The Community of Those Who Have Nothing in Common*, 96. The epigraph for each section functions as a kind of short listening and entry point.
3 Walter Murch, "Womb Tone," *Transom*, April 1, 2005, https://transom.org/2005/walter-murch/.
4 Bruce R. Smith, "Tuning into London c. 1600," in *The Auditory Culture Reader*, edited by Michael Bull and Les Back (Oxford: Bloomsbury, 2003), 129.
5 Pauline Oliveros, *Deep Listening: A Composer's Sound Practice* (Lincoln, NE: iUniverse/Deep Listening Publications, 2005), xxiii.

6 Johnathan Sterne, ed. "Sonic Imaginations," in *The Sound Studies Reader* (New York, NY: Routledge, 2012), 2.

7 Amiri Baraka, Jazzmen 255.

8 Mary Caton Lingold, Darren Mueller, and Whitney Trettien, eds. "Introduction," in *Digital Sound Studies* (Durham: Duke University Press, 2018), 6.

9 *Ibid.*, 6.

10 I make this point in order to emphasize Bell's desire to replicate speech as closely as possible in his training of the deaf. In *Difference and Repetition*, Gilles Deleuze discusses two categories of repetition: The static, "reterritorializing" of repetition-as-representation, and the dynamic, "deterritorializing" of repetition with a difference. While DJs and others would use the turntable and sounding technologies to manipulate sound in really innovative and "deterritorializing" ways, Bell was interested in an accurate simulacrum of speech. Gilles Deleuze, *Difference and Repetition*. Trans. Paul Patton (New York, NY: Columbia UP, 1994).

11 Johnathan Sterne, *The Audible Past: Cultural Origins of Sound Reproduction* (Durham: Duke University Press, 2003), 39.

12 See Bell's controversial paper, "Memoir upon the Formation of a Deaf Variety of the Human Race," *Internet Archive*, 1884, https://archive.org/details/cihm_08831/page/n5.

13 There are a number of excellent biographies on Alexander Graham Bell, although I'm partial to Charlotte Gray's *Reluctant Genius: The Passionate Life and Inventive Mind of Alexander Graham Bell* (Toronto: HarperCollins, 2006).

14 Anne Carson, "The Gender of Sound," in *Glass, Irony, and God* (New York, NY: New Directions, 1995), 121.

15 Charles Mudede, "The Turntable," *CTheory*, 2003, http://www.ctheory.net/articles.aspx?id=382.

16 "Synthetic Substitution." *Who Sampled*, http://www.whosampled.com/Melvin-Bliss/Synthetic-Substitution/.

17 Amiri Baraka, "Jazzmen: Diz & Sun Ra," *African American Review* 29, no. 2 (Summer 1995): 255.

18 Paul D. Miller (aka DJ Spooky), *Rhythm Science*, Cambridge, MA: MIT Press, (2004) 25.

19 Martha Buskirk, Amelia Jones, and Caroline A. Jones, "The Year in 'Re-.'" *Artforum International* 52, no. 4 (2013), https://www.artforum.com/print/201310/the-year-in-re-44068.

20 Barnard College, "Zora Neale Hurston '28 Sings: 'Halihmuhfack,'" YouTube Video, 1:00, January 18, 2017, 1939, https://www.youtube.com/watch?v=Ut0xmfgcK3w.

21 Myron M. Beasley, "Performing Zora: Critical Ethnography, Digital Sound, and Not Forgetting," in *Digital Sound Studies*, edited by Mary Caton Lingold, Darren Mueller, and Whitney Trettien (Durham: Duke University Press, 2018), 48.

22 Under my DJ alias, DJ Techné, I have completed a number of DJ albums. My *Dedications* projects largely explored the space between poetry and music, particularly jazz and jazz-influenced poetry. *Dedications II* (2019) is particularly indebted to the blues and is blue-tinged throughout with a low-fi aesthetic, and a boom-bap poetics. The album mixes, mashes, samples, spins, cuts, signifies, rhapsodizes, poetizes, layers, collages, remixes, breaks, distresses, archives, remakes, reshapes, and reedits pieces of recorded history to create a sonic audio homage to a host of musicians and styles with a nod to the avant-garde, including J Dilla, Louis Armstrong, Sun Ra, Miles Davis, Ella Fitzgerald, Bessie Smith, Robert Johnson, Howlin' Wolf, Alice Coltrane, Pauline Oliveros, Ursula K. Le Guin, among a slew of other voices, sounds, samples, echoes, and cuts. DJ Techné, Bandcamp, https://djtechne.bandcamp.com.

23 Lisa Coulthard, "Great Artists Steal," *MashUp: The Birth of Modern Culture*, edited by Daina Augaitis, Bruce Grenville, and Stephen Rebick (Vancouver: Vancouver Art Gallery/Black Dog Publishing, 2016), 238.

24 Henry Mancini initially composed "Moon River" with lyrics written by Johnny Mercer. The song received an Academy Award for Best Original Song for Audrey Hepburn's performance of the piece in the 1961 movie *Breakfast at Tiffany's*. It's been covered thousands of times, although Kid Koala's version is the most adventurous.

25 Periscope, "Kid Koala, Moon River (Studio Version)," YouTube Video, 4:59, September 22, 2011, https://www.youtube.com/watch?v=Pp0U7SkYl2E. See also: Ankur Malhotra, "Kid Koala Performs Moon River," YouTube Video, 6:41, July 12, 2011, and https://www.youtube.com/watch?v=fjFi4MHO_go.

26 Glenn Gould, "The Prospects of Recording," *High Fidelity* 16, no. 4 (April 1966): 46–63. *Library and Archives Canada*: n. pag, https://www.collectionscanada.gc.ca/glenngould/028010-4020.01-e.html.

27 subliminalspooky, "DJ Spooky's 'Rebirth of a Nation (Excerpt),'" YouTube Video, 3:47, February 4, 2008, https://www.youtube.com/watch?v=3ljIq0lz0qY.

28 Jonathan Sterne with Mary Caton Lingold, Darron Mueller, and Whitney Trettien, "Afterword: Demands of Duration: The Futures of Digital Sound Scholarship," in *Digital Sound Studies*, North Carolina: Duke University Press (2018) 268.

29 James E. Dobson, *Critical Digital Humanities: The Search for a Methodology* (Urbana, IL: University of Illinois, 2019), 1.

30 Mary Caton Lingold, Darren Mueller, and Whitney Trettien, eds. "Introduction," in *Digital Sound Studies* (Durham: Duke University Press, 2018), 5.

31 In "Audio Storytelling," Siobhan McHugh describes that despite there being more video online than ever, audio is thriving: "some 33,000 radio stations around the world, with more than 12,000 in the United States (US) alone ... This translates to about 2 billion radio sets in use, or one radio for every three persons." Siobhan McHugh, "Audio Storytelling: Unlocking the Power of Audio to Inform, Empower and Connect," *Asia Pacific Media Educator* 24.2 (2014): 141.

32 For example, see the archived Oral Histories Project: A showcase of interviews, performances, and articles by and about improvising musicians, artists, writers and scholars. Paul Watkins, ed., "Oral Histories," In *Improvisation, Community, and Social Practice*, accessed January 2, 2020, http://www.improvcommunity. ca/projects/oral-histories-project.

33 Sounding Out! *Sound Studies Blog*, accessed December 20, 2019, https://soundstudiesblog.com/sound-studies-blog/.

34 *Provoke: Digital Sound Studies*, accessed December 20, 2019, https://soundboxproject.com.

35 *Sonic Dictionary*, accessed December 20, 2019, https://sonicdictionary.duke.edu.

36 "Smith recorded all kinds of ephemeral sounds: snippets of phone conversations, fragments of radio and television broadcasts, the roar of buses driving past the loft. This important collection of reel-to-reel tapes was recently digitized and housed on 5,087 cds thanks to the work of documentarian Sam Stephenson." Mary Caton Lingold, Darren Mueller, and Whitney Trettien, eds. "Introduction," in *Digital Sound Studies* (Durham: Duke University Press, 2018), 1. See http://www.jazzloftproject.org.

37 *Freedom's Ring*, accessed December 20, 2019, https://freedomsring.stanford.edu/?view=Speech.

38 *Outkasted Conversations*, accessed December 20, 2019, https://www.outkastedconversations.com.

39 For his art project, "We Buy White Albums," Rutherford Chang purchases copies of The Beatles' *White Album*, displayed at a gallery (set up like a record shop) that only carries the iconic double album. All of the albums are first-pressings and Rutherford Chang's website now lists the total number of copies at 2465 (as of 22 December 2019). The record of the installation syncs 100 (45 years old) first-pressings of *The White Album* in a bizarre sound collage that moves in and out of the familiar and into the choral and cacophonous. Each copy of the record is unique, and given the slight sound variations in pressings, and the natural and scratched wear of vinyl, the listening experience captures the distinct history of each record. Rutherford Chang, "We Buy White Albums," *Rutherford Chang*, http://rutherfordchang.com/white.html.

40 For one such performance, see my 2016 presentation entitled, "Hogan's Alley Remixed: Learning through Wayde Compton's Poetics" which, through a mixture of sound, image, and text, explored the Vancouver poet's historical and poetic representation of the destruction of this 1960s African-Canadian neighborhood in Vancouver. Media Studies at VIU, "Hogan's Alley Remixed - Learning through Wayde Compton's Poetics," YouTube Video, 1:10:50, October 17, 2017, https://www.youtube.com/watch?v=td0cjmsN3X8.

41 Jonathan Sterne, Mary Caton Lingold, Darren Mueller, and Whitney Trettien, "Demand of Duration: Afterword: The Futures of Digital Sound Scholarship" in *Digital Sound Studies*, edited by Mary Caton Lingold, Darren Mueller, and Whitney Trettien (Durham: Duke University Press, 2018), 268.

42 Jordan Abel, *Injun* (Vancouver: Talon Books, 2016), 83.

43 *Ibid.*

44 Amaranth Borsuk, Sara Dowling, and Jordan Abel, "Archives, Tactility, Performance, Visuality: An Interview with Jordan Abel/Amaranth Borsuk and Sarah Dowling," *ASAP Journal* (2019). http://asap-journal.com/archives-tactility-performance-visuality-an-interview-with-jordan-abel-amaranth-borsuk-and-sarah-dowling/.

45 Griffin Poetry Prize, "Poet Jordan Abel Reads from *Injun*," YouTube Video, 5:46, July 7, 2017, https://www.youtube.com/watch?v=Zcmq3YcNqj0.

46 The MeTA digital Humanities Lab is located at the Vancouver Island University's Nanaimo campus and the lab seeks to develop innovative ways of utilizing digital tools for exploring arts and humanities research questions. See https://research.viu.ca/meta-digital-humanities-lab.

47 Hul'q'umi'num is a language of various Indigenous peoples of the Pacific Northwest Coast.

48 The video work is done by my colleague Jay Ruzesky in the Creative Writing department. This song teaches us respect for our family and our friends. It says "speak your mind, and keep your mind strong."

Our communities want to bring our generations together. We need to always think about the elders of the past and the teachings they provide and bring to the present day that will give strength to our youth. We can take a look at our young people and look at the elders of the past and form a vision of bringing them together so they can survive in this world. See the video: https://vimeo.com/195115454.

49 3D printing, which is also known as additive manufacturing (AM), uses successive layers of material under computer control to create 3D objects. The technological sphere of 3D printing is a space that excites futurists, scientists, engineers, inventors, pragmatists, and digital humanists. Given the relative infancy of this technology, it remains a truly improvisatory space where ample play (and a fair dosage of frustration) unfold in the process of creating and printing 3D objects.

50 "A Third Industrial Revolution," *The Economist*, April 21, 2012, 3–4, https://search-proquest-com. ezproxy.viu.ca/docview/1008897971?accountid=12246.

51 Ann Robinson, "Welcome to the Complex World of 3D-Printed Drugs," *The Guardian*, August 2015, https://www.theguardian.com/sustainable-business/2015/aug/21/welcome-to-complex-world-of-3d-printed-drugs-spritam-fda.

52 *Open Hand Project*, accessed December 20, 2019, http://www.openhandproject.org/?LMCL=Myb3iR.

53 *Enabling the Future*, accessed December 20, 2019, http://enablingthefuture.org/tag/3d-printed-hands/.

54 Solstie, "3D Printed Playable Ukulele," YouTube Video, 1:29, March 10, 2014, https://www.youtube.com/watch?v=6QZvYGKUjJA.

55 Oana, "Hand Cranked Vinyl Player," November 22, 2014, https://www.thingiverse.com/thing:558600.

56 VIU Cowichan, "3D Printed Turntable," YouTube Video, 2:17, February 28, 2016, https://www.youtube.com/watch?v=2NyoRf2Hs50&feature=emb_logo.

57 "Heebie Jeebies" is one of those recordings, and as the legend goes, Louis Armstrong's impromptu scatting in "Heebie Jeebies" (the first scat caught on a recording) was the result of a mistake: Armstrong's lyric sheet fell while recording and so he began to scat/improvise.

58 Ornette Coleman qtd. In BonnarooMusicFest Interview.

59 John Szwed, *Space is the Place: The Lives and Times of Sun Ra* (New York, NY: Pantheon, 1997), 192.

60 RubinMuseum, "Pauline Oliveros: Listening and Consciousness," YouTube Video, 1:00, November 30, 2016, https://www.youtube.com/watch?v=u355U29bOt0.

61 Sterne, "Sonic Imaginations," (2018) 11.

Bibliography

"A Third Industrial Revolution." *The Economist*. April 21, 2012, 3–4. https://search-proquest-com. ezproxy.viu.ca/docview/1008897971?accountid=12246.

Abel, Jordan. *Injun*. Vancouver: Talon Books, 2016.

Baraka, Amiri. "Jazzmen: Diz & Sun Ra." *African American Review* 29.2 (Summer 1995): 249–55.

Barnard College. "Zora Neale Hurston '28 Sings: 'Halihmuhfack.'" YouTube Video, 1:00, January 18, 2017 [1939]. https://www.youtube.com/watch?v=Ut0xmfgcK3w.

Beasley, Myron M. "Performing Zora: Critical Ethnography, Digital Sound, and Not Forgetting." In *Digital Sound Studies*, edited by Mary Caton Lingold, Darren Mueller, and Whitney Trettien, 47–63. Durham: Duke University Press, 2018.

Bell, Alexander Graham. "Memoir upon the Formation of a Deaf Variety of the Human Race." *Internet Archive*, 1884. https://archive.org/details/cihm_08831/page/n5.

BonnarooMusicFest. "Interview with Ornette Coleman." YouTube Video, 5:39, Feb 4, 2008. https://www.youtube.com/watch?v=8CoPGDfMWFc.

Borsuk, Amaranth, Sara Dowling, and Jordan Abel. "Archives, Tactility, Performance, Visuality: An Interview with Jordan Abel/Amaranth Borsuk and Sarah Dowling." *ASAP Journal* (2019). http://asapjournal.com/archives-tactility-performance-visuality-an-interview-with-jordan-abel-amaranth-borsuk-and-sarah-dowling/.

Buskirk, Martha, Amelia Jones, and Caroline A. Jones. "The Year in 'Re-'." *Artforum International* 52, no. 4 (2013): 127–30.

Carson, Anne. "The Gender of Sound." In *Glass, Irony, and God*, 119–42. New York, NY: New Directions, 1995.

Coulthard, Lisa. "Great Artists Steal, They Don't Do Homages." In *MashUp: The Birth of Modern Culture*, edited by Daina Augaitis, Bruce Grenville, and Stephen Rebick, 238–41. Vancouver: Vancouver Art Gallery/Black Dog Publishing, 2016.

Deleuze, Gilles. *Difference and Repetition*, translated by Paul Patton. New York, NY: Columbia UP, 1994.

Dobson, James E. *Critical Digital Humanities: The Search for a Methodology*. Urbana, IL: University of Illinois, 2019.

Gould, Glenn. "The Prospects of Recording." *High Fidelity* 16.4 (April 1966): 46–63. *Library and Archives Canada*: n. pag, https://www.collectionscanada.gc.ca/glenngould/028010-4020.01-e.html.

Gray, Charlotte. *Reluctant Genius: The Passionate Life and Inventive Mind of Alexander Graham Bell*. Toronto: HarperCollins, 2006.

Kristeva, Julia. *Tales of Love*, translated by Leon S. Roudiez. London: Columbia University Press, 1999.

Lingis, Alphonso. *The Community of Those Who Have Nothing in Common*. Indianapolis, IN: Indiana UP, 1994.

Lingold, Mary Caton, Darren Mueller, and Whitney Trettien, eds. *Digital Sound Studies*. Durham: Duke University Press, 2018.

McHugh, Siobhan. "Audio Storytelling: Unlocking the Power of Audio to Inform, Empower and Connect." *Asia Pacific Media Educator* 24.2 (2014): 141–56.

Miller, Paul D. [DJ Spooky]. *Rhythm Science*. New York, NY: The MIT P, 2004.

Mudede, Charles. "The Turntable." *CTheory*, April 4, 2003. http://www.ctheory.net/articles.aspx?id=382.

Murch, Walter. "Womb Tone." *Transom*, April 1, 2005. https://transom.org/2005/walter-murch/.

Oliveros, Pauline. *Deep Listening: A Composer's Sound Practice*. Lincoln, NE: iUniverse/Deep Listening Publications, 2005.

Periscope. "Kid Koala, Moon River (Studio Version)." YouTube Video, 4:59, September 22, 2011. https://www.youtube.com/watch?v=Pp0U7SkYl2E.

Robinson, Ann. "Welcome to the Complex World of 3D-Printed Drugs." *The Guardian*, August 2015. https://www.theguardian.com/sustainable-business/2015/aug/21/welcome-to-complex-world-of-3d-printed-drugs-spritam-fda.

Rodgers, Tara. *Pink Noises: Women on Electronic Music and Sound*. Durham, NC: Duke University Press, 2010.

Rose, Tricia. *Black Noise: Rap Music and Black Culture in Contemporary America*. London: Wesleyan UP, 2004.

RubinMuseum. "Pauline Oliveros: Listening and Consciousness." YouTube Video, 1:00, November 30, 2016. https://www.youtube.com/watch?v=u355U29bOt0.

Smith, Bruce R. "Tuning into London c. 1600." In *The Auditory Culture Reader*, edited by Michael Bull and Les Back. Oxford: Bloomsbury, 2003.

Sterne, Johnathan, Mary Caton Lingold, Darren Mueller, and Whitney Trettien. *The Audible Past: Cultural Origins of Sound Reproduction*. Durham: Duke University Press, 2003.

Sterne, Johnathan, Mary Caton Lingold, Darren Mueller, and Whitney Trettien. "Sonic Imaginations." In *The Sound Studies Reader*, edited by Johnathan Sterne, 1–17. New York, NY: Routledge, 2012.

Sterne, Johnathan, Mary Caton Lingold, Darren Mueller, and Whitney Trettien. "Demand of Duration: Afterword: The Futures of Digital Sound Scholarship." In *Digital Sound Studies*, edited by Mary Caton Lingold, Darren Mueller, and Whitney Trettien, 267–84. Durham: Duke University Press, 2018.

subliminalspooky. "DJ Spooky's 'Rebirth of a Nation (Excerpt).'" YouTube Video, 3:47, February 4, 2008. https://www.youtube.com/watch?v=3ljIq0lz0qY.

"Synthetic Substitution." *Who Sampled*. http://www.whosampled.com/Melvin-Bliss/Synthetic-Substitution/.

Szwed, John. *Space Is the Place: The Lives and Times of Sun Ra*. New York, NY: Pantheon, 1997.

VIU Cowichan. "3D Printed Turntable." YouTube Video, 2:17, February 28, 2016. https://www.youtube.com/watch?v=2NyoRf2Hs50&feature=emb_logo.

Watkins, Paul. Media Studies at VIU, "Hogan's Alley Remixed: Learning through Wayde Compton's Poetics." YouTube Video, 1:10:50, October 17, 2017. https://www.youtube.com/watch?v=td0cjmsN3X8.

32
HACKING THE DIGITAL HUMANITIES
Critical Practice and DIY Pedagogy

Marina Hassapopoulou, with Donna Cameron, Cristina Cajulis, Da Ye Kim, Jasper Lauderdale, Eric Hahn, Pedro Cabello, Hojong Lee, Soyoung Elizabeth Yun, Kelsey Christensen, and Kate Anderson-Song

This chapter will focus on multimedia scholarship by analyzing project-oriented, remixed, and expanded modes of writing in the Digital Humanities (DH). Student contributions and the potential of the creative labor that occurs in the classroom tend to be undermined within larger scale, data-driven, and institutionally funded aspects of DH. Our objective is to reconfigure and flatten certain hierarchies of institutional hegemony within DH by acknowledging the importance of student contributions (as well as of low/no-budget process-oriented experimental projects) to the expansion of this interdisciplinary field, and by also proposing ways of enabling students to have a more active stake in shaping and actively contributing to their fields of study. A range of no/low-budget multimedia scholarship projects, from digital, hybrid, and interactive to analog, are featured alongside some DIY, easily accessible and easy-to-use tools. The projects aim to provide an expanded understanding of remix practices within DH, beyond typical uses of computational tools and data-driven approaches; the focus is on expanding traditional methodologies and writing platforms, rather than replacing them. Subsequently, this chapter has been written in a collaborative, interconnected, and experimental manner, and each section can be navigated in a different order via thematic hashtags (#). To enhance the hypertextual dimensions of the analyses, each project is accompanied by its own QR code so that readers can directly access and interact with the projects as they are reading about them.

When we revisited these recent projects for the writing of this chapter, some of them (or some components/tools) were already in danger of becoming obsolete, or had disappeared entirely. This provided an object lesson on the precariousness of digital

Figure 32.1 Access the projects via their QR codes, or see the endnotes for links to videos, sites, or other materials

technology, as well as on the importance of generating strong conceptual ideas that can be transferrable and adjustable to other platforms and frameworks. Adding to the tentative nature of digital projects is the threat of copyright infringement that particularly relates to found-footage remixes, which is why most of the featured projects are under a Creative Commons license and/or are part of the Critical Commons network for fair (re)use.[1] This text, along with its digital and virtually augmented components, function as complementary attempts—in a practical, conceptual, and mnemonic sense—to counter the ephemerality and precariousness of digital and hybrid projects (Figure 32.1). Finally, so as not to essentialize practices in the digital humanities and remix studies as primarily digital in their logic and/or nature, we wanted to emphasize instead their experimental and humanities-oriented commonalities that propel innovative disciplinary cross-pollinations. Therefore, we have included hands-on analog, mixed media, and low-tech examples that aim to provide an expanded understanding of both the digital humanities and remix studies through their hybrid ontologies and generative epistemologies.

Don't Look Away II

Jasper Lauderdale

#interactive #databasenarrative #foundfootage #socialjustice #surveillance #activism

Don't Look Away II[2] is a branching database narrative film, a dynamic prosthetic memory assemblage and an act of digital, global, mobile witnessing, conceived as a follow-up to Usher's 2015 interactive music video experience *Chains* (featuring Nas and Bibi Bourelly). *Chains* effectively and affectively chains its viewer [viewer + user] to its interface by requiring them to look directly and unflinchingly into the eyes of victims of racial injustice for the duration of the song using eye tracking.[3] In response, my film compiles an interactive constellation of found footage ripped from YouTube and online news outlets, using discrete videos from these sources to construct a navigable, expandable database of over five thousand possible pathways. *Don't Look Away II* grants its viewer a significant measure of control, soliciting them to select a path, step by step, through its limited archive of footage captured by variously surveillant and sousveillant (bottom-up and grassroots) apparatuses, and challenging them to confront the reality of police brutality and the state-sanctioned destruction of black bodies throughout the United States. The viewer may choose to proceed from one short to the next chronologically or by the victim's age, or they may elect to review the same incident from another angle or capturing apparatus (Figure 32.2). Each film must play in full before the viewer is given the option to continue; there is no way to skip ahead, even if they have already seen a particular clip. Each perspective the viewer adopts bears with it varied levels of critical or literal distance, assumed safety or complicity, alternately situating her within a police car or in the position of an eyewitness, aligning her gaze with an officer or an onlooker as each event unfolds.

Figure 32.2 Screenshot of EKO studio's nodular editing interface

These deeply troubling paradigms of identification are part of the experience of navigating *Don't Look Away II*, and the viewer must come to terms with the kinds of spectatorship that the project solicits. Of forty-seven nodes that comprise the database, only four offer an escape, a way out of the engine that leads to the conclusion, signifying the endlessness of the abuse and brutality with which our state apparatuses attend to the black body, and from which our society continues to look away.

Divesting from Crowdsourcing

Pedro Cabello

#crowdsourcing #foundfootage #neoliberalism #ethics #activism #neoliberalism

Life in a Day Remix[4] unveils the neoliberal rationality of Kevin Macdonald's crowdsourced documentary, *Life in a Day* (2011),[5] by highlighting the politics of its mode of production.[6] The remix is a parody trailer that mocks its source of inspiration, redeploying the original images to expose themes and motivations that are latent in the documentary but occluded by its message of general uplift. The trailer takes aim at what Suely Rolnik refers to as the "colonial-capitalistic unconscious," a concept that elucidates the colonial dynamics perpetuated in contemporary commercial or creative enterprises.[7] By choosing to crowdsource their material from contributors around the world, producers Ridley Scott and director Kevin Macdonald, aware of their convening power, relied on the unpaid work of amateur filmmakers to freely and uncritically lend their labor and, more importantly, provide access to views of postcolonial nations otherwise inaccessible to the producers. The selection of images resulted in a feel-good, exoticized audiovisual patchwork, which under the new light of remediation and remix acquires a critical tone. In this respect, alongside snippets of the original documentary, *Life in a Day Remix* integrates promotional material and real interviews to overtly draw connections between the motivations of the project (a discourse of supposed horizontality within a neoliberal framework) and the reality of how the images were gathered and appropriated (perpetuating neocolonial dynamics). The prezi that accompanies the remix video provides a theoretical background for understanding why it is important to divest from the message of crowdsourcing as a collectively empowering and liberating idea—which is typically the rhetoric that top-down collective endeavors such as *Life in a Day* use to solicit contributions.[8] The example of *Life in a Day* and its model of profitability perfectly illustrates that necessity. Mobilizing aspects of remix culture, such as found-footage appropriation, mockery, and irony, *Life in a Day Remix* claims its potential as a vehicle for modes of direct confrontation that can be more directly polemic in their audiovisual immediacy than the rhetoric of a traditional academic paper. Consequently, the remix video opens up new avenues for shared critical thinking when it is made available to a larger audience through popular platforms such as YouTube.

Guestbook

Cristina Cajulis

#hands-on #remix-as-archive #analog #artsncrafts #preservation #interactive

Guestbook[9] is an attempt to make tangible the ephemeral and immaterial labor of born-digital work. Yahoo's Geocities is a particularly interesting case study through which to

explore this due to its boom in the 1990s and its eventual shutdown in 2009, demonstrating the impermanence and instability of the web despite the dictum, *what you post online will be there forever*. I specifically focus on fifteen homepages formerly hosted on Geocities that were preserved by individual archivists to create a handmade book.[10] *Guestbook* demonstrates the near infinite possibilities of unique web pages by presenting a portion of text from each page's source code into nine interchangeable strips, with each line of code marking a deliberate choice made by the creator. I use my own labor— printing, cutting, and stitching the book by hand—to make visible the countless hours and subjective histories that were almost completely lost in the Geocities shutdown. In doing so, the (digital) trace becomes remediated into a new (physical) object (Figure 32.3).

This project was inspired by Raymond Queneau's *Cent Mille Milliards de Poèmes*, in which the ten lines of ten sonnets are printed on individual strips to create the "hundred thousand billion poems" (10^{10}) referenced in one English translation of the title. In *Guestbook*, each webpage is divided into two pages: one transparent vellum page on which sections of the source code are printed and plain cardstock. The source code is divided into nine sections, of which the last section is the footer or contact information for the creator of the webpage. This is a deliberate nod to the authors behind the webpage. The nine sections of fifteen webpages featured in *Guestbook* are interchangeable, resulting in 205,891,130,000,000 possible pages (9^{15}).

The title *Guestbook* also refers to a popular feature on websites available for visitors to leave notes on a user's page. The virtual signature of a guestbook details not only users who have visited a page, but also where users are visiting from. As a metatextual reference, *Guestbook* itself documents the transience of Geocities and the users who once populated its online neighborhoods.

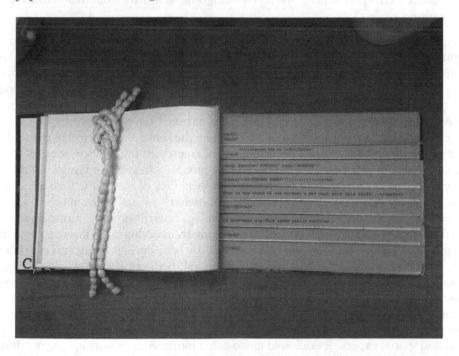

Figure 32.3 A photo of one of the facets of the physical scrapbook in Cristina Cajulis' project

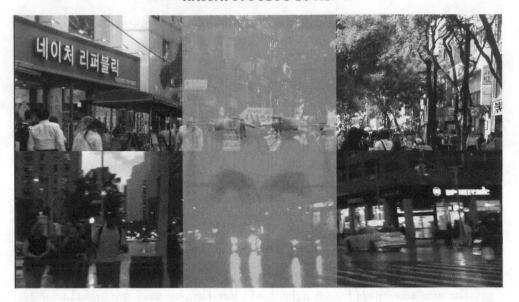

Figure 32.4 The split screen aesthetics of Da Ye Kim's *Going Home* (03:35)

Going Home: A Multimedia Project on Split Cross-Cultural Identity

Da Ye Kim

#splitscreen #psychogeography #transmigrant #identity #databasenarrative #culture

Going Home[11] is an autobiographical short film that explores the coexistence of, and collision among, multiple places that I identify as *home*. Scenes from Seoul, New York, Boston, and even Korea-town in Los Angeles are layered and remixed together to convey the idea of a split sense of identity, multiculturalism, transmigration, and psychogeography (Figure 32.4). The three split screens showing the virtual interactions on a smart phone reinforce the presence of multiple relationships I have developed with different places. The camera is constantly moving to evoke the sense of confusion in the midst of my migrating experience, while the layered scenes represent the "in-betweenness" I have been experiencing for years. During the editing process, I focused on visualizing the inability to be everywhere, while suggesting the possibility of traversing through liminal space, the in-between composite space, the space where my real home may be. Not only the images, but also on-location sound often overlap. There is no one definite destination and the film ultimately comes back to the opening shot, ending with layered sound from the streets of Seoul, New York, and Boston. A sense of enduring nostalgia permeates the film. However, without any indication of temporal distinctions, the passive notion of nostalgia attached to an irretrievable past is turned into an actively reflective process of "nostalizing," a neologism in social–psychological memory studies, which Katharina Niemeyer argues to be a reflection of a postmodern way of actively engaging with time as past, present, and future simultaneously.[12] The creative process of remixing multiple temporal and spatial experiences allowed me to gain more agency in reimagining my liminal transmigrant identity. This hybrid multimedia short film is a document of my experience with, and adjustment to, today's multicultural global city life.

478

The Restitution of the Aura in Interactive Art

Kelsey Christensen

#interactive #choose-your-own-adventure #aura #virtuality #canonicaltheoryremix

Walter Benjamin's iconic essay, "The Work of Art in the Age of Mechanical Reproduction," makes the contention that the ability to reproduce works of original art ruptures his notion of the "aura," or, "that which withers in reproduction."[13] For Benjamin, the aura is indelible from the sense of authority and authenticity imbued in a work of art, and mechanical reproduction is able to liberate a work of art from its "unique existence" in a specific location in space and time, allowing for copies to be "placed…in situations which the original itself cannot attain."[14] This withering of the aura is one Benjamin rejoices for its destabilizing effect on the bourgeoisie's monopoly on the consumption of art. One of the most important reconsiderations of Benjamin's "Mechanical Reproduction" is John Berger's "Ways of Seeing," which seeks to analyze decades later whether Benjamin's analyses about mechanical reproduction persist. Berger subverts Benjamin's notion that mechanical copies liberate art from the authority of the ruling class and instead contends that copies only further inscribe original works of art with "bogus religiosity": a type of authority and sense of authenticity created by being the one original of many copies.[15]

In contemporary society, the proliferation of interactive art, site-specific installations, and other uncopyable "new" media threaten the veracity of either author's analyses and beg for new interpretation on the role of originality, authority, and authenticity in works of art. *The Restitution of the Aura in Interactive Art*[16] contends that the aura has been reconstituted in works of art that can only be experienced the same way once, in one place, or perhaps even on software that will prove archaic years after an interactive work's inception. Exploring interactive art and forking path narrative films, *Restitution* explores interactivity's relationship to an aura for a new era, while fan-made supercuts and movie trailer remixes examine the degree to which a fan copying and reworking an original work of art can rupture and undermine an original's "bogus religiosity."

Restitution doesn't merely contend that these new dynamics exist through text. Rather, as an interactive artwork and hypertext, it adopts the form of the very objects it seeks to analyze in its interactive companion piece, which reconfigures its own sense of the aura created through interactivity to further elucidate the point that interactive art creates a once-only site-specificity, or software-specificity and ephemerality that is similar to the aura and authority created by an original work of art that can only be experienced in one location. By creating a forking-path, choose-your-own adventure experience that can be navigated in multiple different ways, and perhaps only once in a particular way, *Restitution* both argues and demonstrates its central argument through its mechanisms of interaction. Digital humanities projects can be both theory and praxis: they can transcend narrative arguments and rhetorically adopt the forms they seek to elucidate.

Finding Mr. Park

Hojong Lee

#counterfactualhistory #docugame #letsplay #prototype #choose-your-own-adventure

Finding Mr. Park[17] is a virtual game addressing the existence of zainichi Koreans (Koreans in Japan) during the United States' nuclear bombing of Hiroshima in 1945. Throughout

the Japanese colonization of Korea from 1910 to August 1945, many Koreans crossed over to Japan to escape from the abject living conditions in their colonized homeland or were drafted to forced labor in Japan, then were unable to return home. The United States' nuclear bomb attacks in Hiroshima and Nagasaki resulted in Japan's surrender and renunciation of colonial relations but also led to the death of these zainichi Koreans who resided in the two cities, the fatalities composing up to ten percent of all *hibakusha* (Atomic Bomb Victims). Ostensibly, *Finding Mr. Park* follows the two protagonists' (the Japanese boy Gen and detective Conan) search for a toy boat that Gen wishes to retrieve for his brother's funeral. Yet, as the game proceeds, the protagonists' search for the toy becomes the investigation of a zainichi Korean Mr. Park and his Korean relatives—since Park is their only lead to the whereabouts of the toy. This plot inevitably reveals the existence of Korean victims of the nuclear attack who lived as isolated and nearly non-existent beings in Japanese society. The game attempts to provide a fictional counter-factual history (in the vein of Roger Hillman) of the Hiroshima bombing that was often branded as an incident that happened to the "sole victim (Japan) of the atomic bomb" in a strictly nationalistic sense. To insert a neglected history into the mainstream, I appropriated the forms and plots of the well-known animation series *Detective Conan* and the popular manga *Barefoot Gen*. The adaptation of these fictions represents the inevitable lack of tangible "proof" (for example, audiovisual materials and official documents) due to the drastic nature of the incident. Moreover, the form of choose-your-own-adventure game employed in the game alludes to the nonconclusive nature of the realistic yet fictional lives of the zainichi Korean characters in *Finding Mr. Park*. Due to limited time and resources, a gameplay video ["Let's Play" mock-up] was made to present how the game may take form in real life.

Reconceptualizing Multiple Dichotomies in Cinema

Da Ye Kim

#interactive #mindgame #annotations #complexnarrative #hypertext

My project experiments with an easy-to-use image and video annotation tool called ThingLink[18] to create a haptic, interactive, and experiential relationship between the text and the reader.[19] As an extension to my research paper on mind-game films, I expanded upon Thomas Elsaesser's theory on the emergence of mind-game films being symptomatic of a "new contact between spectator and film [that] is no longer based solely on ocular verification, identification, voyeuristic perspectivism and 'spectator-ship'"[20] to a new mode of interactive readership. Since my film theory research paper titled: "Re-conceptualizing Multiple Dichotomies in Cinema: Hong Sang Soo's *Hill of Freedom* (2014) and Kim Ki-duk's *Dream* (2008)," focuses on the two Korean filmmakers' unique epistemological approaches to mind-game films in breaking "one set of rules (real-ism, transparency, linearity) in order to make room for a new set, and their formal fea-tures,"[21] I decided to emulate the films' creative methods of complex storytelling by developing a "mind-game version" of my essay with a set of annotated images. The interac-tive reading of hyperlinked visuals follows the two films' distinctive logics while simultane-ously allowing multiple possible readings and recombinations of the contents. The Intro image leads to the second page with three options for interactive reading. The reader-user may choose to proceed linearly by clicking the black play button at the bottom right (as

if reading a physical copy of the paper) or experience the "Hill of Freedom" version in which the seven parts are scattered around randomly or try the "Dream" version with Korean introduction to each page accompanied by further information in English. With hyperlinks to visuals and videos of crucial moments in the films that highlight some of my arguments, as well as short summaries of the main points in the paper, this project functions both as a preview and a useful enhancement to my research project.

Navigating the Virtual

Eric Hahn

#interactive #canonicaltheoryremix #cinema #spectatorship #experiential #affect

Navigating the Virtual[22] is a theory/practice hybrid project that prompts the reader/viewer to work through the "paradox of fiction" via an interactive cinematic experience. Working within the framework of the cinematic humanities, this project enables the reader/viewer to explore the paradox—which centers on how (or whether) we can be moved emotionally by works of fiction—firsthand, by confronting video clips designed to elicit an emotional response while also allowing for the seamless inclusion of theoretical arguments about the paradox, thus closing the gap between experience and interpretation. Rather than approaching this paradox twice removed—reading about the theorist's understanding of viewers confronting fiction—the reader/viewer becomes an active participant reflecting on their own affective and emotional states allowing for an embodied engagement with the theoretical underpinnings of the project itself. Created with the interactive storytelling platform EKO, *Navigating the Virtual* utilizes a database narrative approach in order to break down the linear and, arguably, more "passive" method of engaging academic texts as words on a page. This departure from more traditional modes of engagement somatically works to ground the paradox in lived experience.

This project serves as a meditation on both the cognitivist and affective theoretical approaches to resolving the paradox of fiction as it relates specifically to cinema. A cognitivist approach, embraced by theorists such as Noël Carroll, suggests that imagining or "entertaining" a thought, rather than accepting the cinematic images as "real," prompts an emotional response.[23] Alternatively, understanding affect as a precognitive physiological response to external stimuli,[24] one can argue that genuine emotional responses may indeed result from fictional material *prior to* cognitive processing, thus calling into question the rigid distinction between reality and fiction. Utilizing a platform that allows for the incorporation of moving images, text, audio, and graphics as affective triggers within an interactive framework that invites thoughtful participation prompts the user to reflect on these two seemingly contradictory stances and to reach an informed position by reflecting on their own emotional experience in relation to the multiple theories referenced during the interactive experience.

"Screened" Soundscapes

Hojong Lee

#sound #database #audio #database #soundscape #auditorylandscape

Film sounds and soundscapes are inherently connected through the medium of place. In some works, post-produced film sounds mimic the soundscape of an existing place

through realistic sound design, and in other works, dramatically unreal film sounds become the main source through which a spectator experiences the sonic environment of a place they never encountered. The thin line between the cinematic sonic description of a site and the "actual" recording of the site triggers questions concerning how individuals experience, record, and recall the soundscape of a place, and how media such as film, music, and television affect this course of preservation and recollection.

Despite their conspicuous relevance, film sounds and soundscapes were not often regarded as intertwined fields in Film and Media Studies canons. Until recently, there has been a noticeable lack of overlapping research between the area of film sound and that of soundscapes, with Michel Chion and R. Murray Schafer's works as the classics of each subfield: the former focusing on the formal traits of film sounds or the sonic quality of cinematic spaces and technology, the latter on acoustic ecology (particularly modernization's noise pollution and the necessity to listen, distinguish, and analyze sound). Though works such as Emily Thompson's *The Soundscape of Modernity: Architectural Acoustics and the Culture of Listening in America, 1900-1933* (2004) have made significant contributions to providing nuanced concepts of "soundscape" in the context of modernity, a contemporary focus on the individual's subjective sonic experience of a place and of the influence of cinema in this process is yet to be thoroughly explored.

In order to explore this neglected interrelation between cinematic ambient sounds and subjective soundscapes, I created "'Screened' Soundscapes,"[25] a multimedia web platform where participants trace site-specific sounds found in movies and contribute their own site-specific aural recordings to create sensory and collective soundscapes. This participatory and crowdsourced methodology converts the notion of soundscapes into a model for new cartographies that are not empirically or "objectively" based. Through the establishment of this ongoing and open-ended archival web of ephemeral sounds, I aim to achieve the following: 1) The accumulation of sonic archival sources through preexisting films and the recordings of soundscapes in real life; and 2) the multimedia archiving of subjective soundscapes that bring together the subjective (re)experience of cinematic sounds and the sounds of subjective experience.

Auditory Landscape

Soyoung Elizabeth Yun

#sound #database #archive #soundscape #auditorylandscape #psychogeography

Through a close "listening" of Alejandro G. Iñárritu's (2006) multi-narrative film *Babel*,[26] I analyze how the film sonically controls its multi-spatiality with attentive soundscaping of different geographical sites—Morocco, Japan, Mexico, and the United States.[27] Leaning on R. Murray Schafer's definition of a soundscape as an "auditory landscape," I focus on how each cinematic space is auditorily recognized and differentiated within the film. Furthermore, Guy Debord's concept of psychogeography inspired me to investigate how the film attaches certain modes of behaviors and emotions (of the characters) to each geographical environment.

I sampled diegetic and nondiegetic sounds that characterize each geographic site and assembled the samples into a video essay on how the sounds create psychogeographical multi-narrative in the film. The samples are also individually archived on a Soundcloud Playlist.[28] The rationale behind the diegetic/nondiegetic sampling is to understand to

what extent the film mixes and remixes external sounds (electronically mediated/produced) and internal sounds (recorded at the sites of filming) to represent cinematic spaces. While reorganizing, categorizing, and archiving the sound extracts, I prioritized sounds over visuals in my analysis of the multicultural settings and characters. Consequently, this soundscape study on *Babel* aimed at discovering how the film identifies each cinematic space and the characters according to the sounds that not only match the visuals but schematically construct the geographical sites and the characters in them. This is an ongoing project that will be expanded with soundscape analyses on other multi-geographic, multicultural, multi-narrative films.

The interconnected layers of the film sound that consist of soundtracks, location sounds, dialog silence, diegetic and nondiegetic sounds come to life as a cinematic soundscape that identifies and characterizes each space and characters within it. The biggest objective of this project is to create a prototype for expanding our understanding of cinematic soundscapes in the era of transnational, multicultural filmmaking with an in-depth exploration of the mixed/remixed film sounds of familiar and unfamiliar, digital and nondigital. The study of soundscapes paves the way for open-ended experimental and artistic methodologies that, due to the still under-developed field of sound studies, are not bound by any long-standing traditions of canonical or well-established practical frameworks.

Mapping *Repulsion*

Kate Anderson-Song

#hands-on #analog #artsncrafts #architecturalremix #psychogeography #psychoanalysis

In an attempt to physicalize the psychological perspective presented in Roman Polanski's (1965) film *Repulsion*,[29] "Mapping *Repulsion*" plots the main setting, protagonist Carol's apartment, as it visually transforms throughout the film.[30] Inspired by Elliot Panek's article, "'Show, Don't Tell': Considering the Utility of Diagrams as a Tool for Understanding Complex Narratives," I created a remixable series of layered floor plans using only the visual information given within the shots of *Repulsion*. Beginning with an approximated master blueprint of the apartment at the start of the film (in its most objective and non-psychologically affected form), a layer of tracing paper was placed over this master plan for each subsequent scene, with whiteout and pen adding and subtracting from the diagram to reflect the visualized physical changes (such as the cracks in the wall or the infamous hands in the hallway).

Inspired by Tarja Laine's assertion that the apartment in *Repulsion* dissolves the boundaries "between the self and the non-self, the subjective and the objective, the inside and the outside" as both a "physical (architectural) and mental (conscious) structure with an agency and intentionality of its own," and her focus on cinema as a "tactile membrane," I relocate these ideas to the viewer's concrete reality through these layered and remixable diagrams, allowing the visual information of the subjective architecture to be manipulated (or, remixed in a tactile sense) objectively.[31]

Creating a tangible layout of the intangible mental state of Carole, which Roman Polanski presents through the intangible medium of cinema, I was able to explore both the art and artist's intentionality of visualizing the internal. This process enabled me to

contend with the subjective through a physical interactive form and ruminate on questions of subjectivity vs. objectivity and internal/mental vs. conscious/physical in film. "Mapping *Repulsion*" proposes a hands-on exploration of the subjective, as well as a tactile and architectural mode of DH-inspired forensic film analysis.

Montage as Interactivity: Reading the Script

Donna Cameron

#canonicaltheoryremix #cinema #gaze #dialectic #interactive

In *REMIX for Shirley* (2018),[32] the technological deconstruction and remodeling of the street-speak of Jason Holliday, star of *Portrait of Jason*, directed by Clarke (1967)[33] transforms Clarke's iconic cinéma verité into an oral history of tortured proportions, set in a cinematic labyrinth. Sound, image, and word are hacked and recoded into a binary construct that exposes Jason's inner displacement within Clarke's mise-en-scène—her emptied hotel hearth. A montage of close-ups fuses Jason's singular facial expressions and reframes them. The new cellular structure is an iterative one, configured by shot repetition. Screen gravity is defined by currents of words that pull the eye; to navigate them the spectator must cross over them, through visual infraction, by the act of reading. Reading pulls the relational self into a socio-relational audience experience in which screen right and screen left split off of the compositional frame's horizontal axis and, both defining and centrally splitting both the x-axis, generates a hyper-stereo dynamic for the spectator. Multiple planes of dialectic fragments, a metric of rhythmic words, become performative binary code by virtual readings of what Jason has said (or not said). My redirected tonal montage foregrounds Jason, whose tearful confession is directly facing the camera lens and directly confronting the viewer, thus adding another layer of viewer involvement in the remix.[34]

"Remix for Shirley" affirms *Portrait of Jason* as *proof of truth* for Frantz Fanon's thesis in "The Fact of Blackness." Fanon denounces pervasive, disturbing models of the exploitation and misrepresentation of "the other" in global cinema. He names the white frame window, a construct of the cinematic apparatus, as the device that wrangles data from its black frame line, a base that triggers intermittent motion from the outset, and is the source of "Persistence of Vision" (a phenomenon of human vision that allows the brain to perceive "motion" in a sequence of still pictures). The thin black line that separates one frame from another is, ironically, used in narrative discourse to justify cognitive bias against all screen form having the very dark tonal quality that has generated it: Black. Clarke's film inverts this paradigm. She "illustrates how blackness is light, the switch on is memory, and remembrance is the truth that burns brightly," in what Fanon calls "the gaze of the other."[35] Jason's voice and gestures shift through the open-close eye of the lens shutter and onto the celluloid in Clarke's camera, empowered. It is a pioneering, theatrical technique which she (as my mentor) compared with my cinematic paper emulsion screen that directly projects animation on celluloid. Both practices actively analyze "the gaze of the other" technically as "the other gaze of the other." It is, thus, no classifiable gaze. To my understanding, Clarke's filmmaking heralded the interactive invasive methodology that cast the transsensual as a montage essential, and roused a new, inclusive age of storytelling in moving pictures.

Conclusion

The works analyzed in this chapter were created for Film and Media Studies courses. Some were extensions and multimedia adaptations of academic research papers, while others were the culmination of project-oriented courses. Although multimedia scholarship seems like a relatively novel endeavor in the context of digital humanities and remix studies, early film and media scholars such as Sergei Eisenstein, Dziga Vertov, and Lev Kuleshov can be considered some of the first predigital DH practitioners because they used film and other media as what we would now call "alternative" modes of proto-theory. In light of this, multimedia "writing" brings us closer than text does to the moving, haptic, and interactive qualities of the media we are studying, while also taking advantage of the affordances of digital and other expressive platforms. From the perspective of film and media studies traditions, digital humanities and remix studies are coming full circle by utilizing audiovisual and interactive media as authoring tools for scholarship that can be more widely disseminated. The process-oriented, playful, low/no-budget, and makeshift approaches to DH remixing outlined in this chapter remain connected to the pre-institutionalized experimental ethos that captures the essence of DH and remix practices before they even became incorporated into fields of academic study.

For details on the projects discussed in this chapter, and more projects and ideas, visit the collaborative Interactive Media Archive: https://interactivemediaarchive.wordpress.com.

Notes

1 Critical Commons is a fair use advocacy network and collaborative public media archive where users can freely upload their transformative reuse of media for creative and scholarly purposes. Critical Commons, accessed May 10, 2020, https://criticalcommons.org.

2 Jasper Lauderdale, "Don't Look Away II," EKO, last modified May 10, 2020, https://video.helloeko.com/v/MNrl8M.

3 Hassapopoulou, "Playing with History," 388. Marina Hassapopoulou uses the neologism "viewer" (viewer + user) in her articles and course lectures on interactive media as a shorthand way to signal the hybrid (and, at times, fluctuating) status of the consumer of interactive media. While interactive modes of spectatorship, such as found-footage remixing, move away from ocularcentric paradigms of representation, "including the term 'viewer' into this portmanteau ensures that long-standing paradigms of visual spectatorship and the ethics of disciplinary regimes of visuality (as well as their representational potency) are not completely surpassed"—something that is particularly important in the instances of racial profiling and the tyranny of the gaze, as well as to the counter-surveillant/sousveillant strategies proposed in this section.

4 Pedro Cabello, "Life in a Day Remix," YouTube, last modified June 22, 2019, https://www.youtube.com/watch?v=2ZwQ6Rr-Pv8. The accompanying prezi is at https://prezi.com/jfdvegivkjgq/life-in-a-day/.

5 Kevin Macdonald et al. *Life in a Day* [motion picture]. 2011. Global. YouTube.

6 Jeff Howe's "The Rise of Crowdsourcing" *Wired* magazine article is the first time the neologism "crowdsourcing" is introduced. Crowdsourcing involves soliciting the skills and/or labor of several people or organizations for a particular project. Howe, "The Rise of Crowdsourcing."

7 Rolnik, "Spheres of Insurrection."

8 For another case study of the uneven dynamics of crowdsourcing in filmmaking projects, see Marina Hassapopoulou, "Variable Authorship in the Social Film" In Media Res, accessed May 10, 2020, http://mediacommons.org/imr/2016/11/07/variable-authorship-social-film.

9 Cristina Cajulis, "Guestbook," WordPress, last modified May 2, 2017, https://justarehearsal.wordpress.com/guestbook-project/.

10 Scott, "Archiveteam!"

11 Da Ye Kim, "Going Home," WordPress (and Vimeo), last modified August 4, 2016, https://dayescinema.wordpress.com/2016/08/04/going-home-2016/.

12 Niemeyer, "Media and Nostalgia," 10.

13 Walter Benjamin, *The Work of Art in the Age of Mechanical Reproduction* (London: Penguin UK, 2008), 21.

14 Ibid., 22.

15 Berger, "Ways of Seeing," 21.

16 Kelsey Christensen, "The Restitution of the Aura in Interactive Art," Weebly, last modified January 2020, https://interactiveaura.weebly.com/. The Weebly version is a remediated iteration of the original Tumblr version. Initially, this project was hosted on the social media site Tumblr to add an extra dimension to Kelsey's discussion of the democratization and accessibility of interactive art. Some of the original interactive features of the Tumblr version are no longer functioning and have not been preserved, so Kelsey remediated her project to Weebly. The original version is still on Tumblr. Kelsey Christensen, "The Restitution of the Aura in Interactive Art," Tumblr, last modified December 10, 2015, https://interactiveaura.tumblr.com/post/135004098367/welcome.

17 Hojong Lee, "Finding Mr. Park," WordPress, last modified December 13, 2018, https://saturnianblog.wordpress.com/2018/12/13/final-project-fall-2018-interactive-history-finding-mr-park/.

18 ThingLink, https://www.thinglink.com, accessed May 10, 2020. ThingLink's drag-and-drop interface is very easy to use, and students get free access through a school or instructor license.

19 Da Ye Kim, "Alternative Theory Assignment," last modified May 2016, https://dayescinema.wordpress.com/2016/05/09/alternative-theory-assignment/.

20 Elsaesser, "The Mind-Game Film," 13.

21 Ibid., 38.

22 Eric Hahn, "Navigating the Virtual," WordPress, last modified January 20, 2020, https://tobehumanis.com/navigating-the-virtual-2/.

23 Carroll, "The Philosophy of Horror," 83.

24 Massumi, "Parables for the Virtual," 27–8, and Abel, "Violent Affect," 7.

25 Hojong Lee, "'Screened' Soundscapes," WordPress, last modified September 9, 2018, https://saturnianblog.wordpress.com/2017/12/05/screened-soundscapes-a-multimedia-archiving-web-platform-for-film-sound-and-soundscape/.

26 Alejandro G. Iñárritu. *Babel* [motion picture]. 2006. Los Angeles, CA. Paramount Pictures.

27 Soyoung Elizabeth Yun, "Psychogeographical Soundscaping in *Babel*," WordPress, last modified December 22, 2019, https://stillsoyoung98.wordpress.com/projects/.

28 Soyoung Elizabeth Yun, "Film Soundscape Playlist," SoundCloud, last modified December 22, 2019, https://soundcloud.com/filmsoundscpae/sets/babel-soundscape.

29 Roman Polanski. *Repulsion* [motion picture]. 1965. London, UK. Compton Films.

30 Kate Anderson-Song, "Mapping *Repulsion*," WordPress, last modified September 10, 2019, https://kascinemastudies.wordpress.com/visualization/.

31 Laine relates Merleau-Ponty's phenomenological insights to Jennifer Barker's notion of tactile aesthetics, and additionally considers psychoanalytical theory in her interdisciplinary approach to mental architecture. Laine, "Imprisoned in Disgust," 40–2.

32 Donna Cameron. *REMIX for Shirley* [motion picture]. 2018. Manhattan, NY. New York University.

33 Shirley Clarke. *Portrait of Jason* [motion picture]. 1967. Manhattan, NY. Shirley Clarke Productions.

34 Donna Cameron, "REMIX for Shirley," YouTube, last modified April 30, 2018, https://youtu.be/FUh8jFW2V8s.

35 Fanon, "The Fact of Blackness," 794–9.

Bibliography

Abel, Marco. *Violent Affect: Literature, Cinema, and Critique after Representation*. Lincoln, NE: University of Nebraska Press, 2007.

Aoyama, Gosho. *Detective Conan (Case Closed*. San Francisco, CA: Viz Media, 2004-2019.

Benjamin, Walter. *The Work of Art in the Age of Mechanical Reproduction*. London: Penguin UK, 2008.

Berger, John. *Ways of Seeing*, Vol. 1. London: Penguin UK, 2008.

Cameron, Donna. *REMIX for Shirley* [motion picture]. 2018. Manhattan, NY. New York University.

Carroll, Noël. *The Philosophy of Horror: Or Paradoxes of the Heart*. New York: Routledge, 1990.

Clarke, Shirley. *Portrait of Jason* [motion picture]. 1967. Manhattan, NY. Shirley Clarke Productions.

Connor, Michael. "I (No Longer) Have a Web Site: Access, Authenticity, and the Restoration of GeoCities." Published February 10, 2014. http://rhizome.org/editorial/2014/feb/10/authenticity-access-digital-preservation-geocities/.

Debord, Guy. "Two Accounts of the Dérive." In *On the Passage of a Few People Through a Rather Brief Moment in Time: The Situationist International 1957-1972*, edited by Elisabeth Sussman, 135–9. Cambridge, MA: The MIT Press, 1989.

Elsaesser, Thomas. "The Mind-Game Film." In *Puzzle Films: Complex Storytelling in Contemporary Cinema*, edited by Warren Buckland, 13–40. Oxford, UK: Blackwell Publishing, 2009.

Fanon, Franz. "The Fact of Blackness." In *Critical Visions in Film Theory: Classic and Contemporary Readings*, edited by Timothy Corrigan, Patricia White, and Meta Mazaj, 794–9. New York: Bedford/St. Martins, 2011.

Galanter, Philip. "What is Generative Art? Complexity Theory as a Context for Art Theory." Accessed July 16, 2019. http://philipgalanter.com/downloads/ga2003_what_is_genart.pdf.

Hassapopoulou, Marina. "Playing With History: Collective Memory, National Trauma, and Dark Tourism in Virtual Reality DocuGames." *New Review of Film and Television Studies*, no. 1 (October 2018): 365–92. https://doi.org/10.1080/17400309.2018.1519207.

Hillman, Roger. "Goodbye Lenin (2003): History in the Subjunctive." *Rethinking History* 10, no. 2 (2006): 221–37.

Howe, Jeff. "The Rise of Crowdsourcing." *Wired* 14, no. 6 (2006): 1–4. https://www.wired.com/2006/06/crowds/.

Iñárritu, Alejandro G. *Babel* [motion picture]. 2006. Los Angeles, CA. Paramount Pictures.

Laine, Tarja. "Imprisoned in Disgust: Roman Polanski's *Repulsion*." *Film-Philosophy* 15, no. 2 (2011): 36–50.

Lazzarato, Maurizio. "Immaterial Labor." In *Radical Thought in Italy: A Potential Politics*, edited by Paolo Virno and Michael Hardt, 132–46. Minneapolis, MN: University of Minnesota Press, 1996.

Lialina, Olia. "Ruins and Templates of Geocities." Accessed July 16, 2019. http://contemporary-home-computing.org/still-there/geocities.html.

Macdonald, Kevin, et al. *Life in a Day* [motion picture]. 2011. Global. YouTube.

Massumi, Brian. *Parables for the Virtual: Movement, Affect, Sensation*. Durham: Duke University Press, 2002.

Niemeyer, Katharina. "Introduction: Media and Nostalgia." In *Media and Nostalgia: Yearning for the Past, Present and Future*, edited by Katharina Niemeyer, 1–26. Hampshire, UK: Palgrave Macmillan, 2014.

Paneks, Elliot. "'Show, Don't Tell': Considering the Utility of Diagrams as a Tool for Understanding Complex Narratives." In *Hollywood Puzzle Films*, edited by Warren Buckland, 72–88. New York: Routledge, 2014.

Polanski, Roman. *Repulsion* [motion picture]. 1965. London, UK. Compton Films.

Rolnik, Suely. "Spheres of Insurrection: Suggestions for Combating the Pimping of Life." *E-Flux*, 86 (Nov. 2017) https://www.e-flux.com/journal/86/163107/the-spheres-of-insurrection-suggestions-for-combating-the-pimping-of-life/.

Scott, Jason. "Archiveteam! The Geocities Torrent." Published October 26, 2010. http://ascii.textfiles.com/archives/2720.

Smith, Esther K.. *How to Make Books: Fold, Cut, and Stitch Your Way to a One-of-a-Kind Book*. New York: Potter Craft, 2007.

Thompson, Emily. *The Soundscape of Modernity: Architectural Acoustics and the Culture of Listening in America, 1900-1933*. Cambridge, MA: MIT Press, 2002.

"One Terabyte of Kilobyte Age: Digging through the Geocities Torrent." Accessed July 16, 2019. http://blog.geocities.institute/.

33

DJING ARCHIVAL INTERRUPTIONS

A Remix Praxis and Reflective Guide

Mark V. Campbell

It is a perfect match, the DJ—ever seeking original materials to sample or mix—and the archive, home to a plethora of materials, official and vinyl records often underutilized by artists and the general public. Organized and arranged with the correct metadata, an archive can be a crate-digger's dream of highly organized and rarely utilized sonic materials. In an era in which we are overloaded with data, content, and various digital files, what to do with so much content can become a taxing query. As both a DJ and founder of a digital archive, the question of a living archive continues to be central to how I envision the future of archivist work, particularly within the many locations of hip hop archives.

In this chapter, I offer two of my DJ performances as examples from which to explore how remix studies might inform the digital humanities. My goal is to envision how a DJ might productively interrupt some of the normative ways in which archivists work within archives. I reflect on two live DJ performances: one as a keynote address at the University of Western Ontario and the other as a performance at the Royal Ontario Museum (ROM). My chapter is driven by the following question: How do we breathe life into a hip hop archive and honor the multitudes of black lives it contains? Diana Taylor's notion of repertoire is one way to think about how "ephemeral" elements of hip hop culture, such as orality, movement, performance, and other aspects of "embodied memory," can be utilized to craft new methods of archiving.[1] Focusing in on the remix, I argue that leveraging the affordances of remix culture in the service of the digital humanities can open up alternative ways to engage in archiving, specifically the archiving of hip hop culture. In this chapter, I explore how the act of live video mixing of archival materials presents us with two opportunities to critically interrogate and operationalize remix theory within the digital humanities.

First, the use of DJing techniques honors Afrodiasporic cultures by refusing to disconnect histories of Afrosonic and oral innovation, such as legacies of call and response, improvisation, and repetition from contemporary remix theory and the digital humanities. Second, these performances gesture toward the transparent embedding of Afrodiasporic oral and sonic innovations by curators, archivists, and DJs, not solely as aesthetics but also as ways to interrupt, undo, and rethink the colonial residues of

archives and the archival sciences. In detailing two public performances, this chapter invests in a remix praxis as a way to both disrupt curatorial power as well as induce an ethical honoring of those within the archive and the cultural specificity of the archive's publics.

A Remix Praxis Is What?

Much of the earliest academic work on remix culture, particularly the writing of Lawrence Lessig, spent significant time exposing the illegal relations remix makes possible.[2] Despite Lessig's advocacy for the freeing of culture and even with Margie Borschke's important book *This is Not a Remix*[3] correcting many of Lessig's oversimplifications and errors, there exists a gap in our current thinking around remix cultures. In my estimations, Eduardo Navas's 2009 *Remix Theory*[4] began an important discursive move that has not been fully explored: that of centering the artist's approach, exploring remix culture from the praxis of a practicing artist. Exploring a remix praxis is an excellent starting point to move away from the ways in which copyright dominates the academic literature around remix studies. I am thinking specifically of a praxis of ethically undoing, a "loosening of knowledge"[5] with a clear orientation toward justice. Such a task includes taking seriously and valuing those deemed as on the margins of dominant discourse or those systematically disempowered by social institutions. A remix praxis that decidedly seeks to redistribute existing formations of power, rearrange social hierarchies, and otherwise interrupt aspects of the status quo, is a justice-oriented praxis.

In the article, "The Originality of Covers," Navas illuminates a way for us to think about copying music from the perspective of a performing artist—leaning on his background as a former DJ. Navas is troubled by the assumed problematic relations of copies to "originals" and appears aligned with Borschke's suggestion that "the copy was more original than the original precisely because it made explicit its own dependence on other things, signs, or matter."[6] This claim is an understandable perspective of an artist whose creativity and performances rely on "unoriginal" music, covers, and other unauthorized uses.

While covers demonstrate an artist's selectivity and thus skill, cover versions are also inherently forms of learning either an instrument, an arrangement, and/or a set of lyrics. Learning, an innate part of being human, becomes central to the work of cover versions, and yet another way to remove the negative, market-oriented bias of copying embedded in the earliest discourses around remix culture. The "rhetorical work" of the mix obscures this positive attribute of remix culture.[7] What of the artists whose lives, artistry, and humanity coalesce around copying and covers? Are discourses around the illegality of the copy the only way we can engage the cover artist, the remix artist, or the student? This is certainly not the case for classical music. In classical music, learning that involves copying the canonical works from the field is the core of classical musical training— excellence is defined around a performer's ability to copy music written by figures deemed as "greats." As mp3 copies travel across the web, according to Borschke, they become imbued with specific and unique histories. Thus, we need to imagine the work of artists whose histories of creativity are rooted in remix, aesthetic labor, and innovation in the world of covers, as unique ways of disrupting the negativity and stigma accorded to copying and copies in early remix studies. There seems to be a level of disposability of those artists whose remixes and remix praxis disrupt the status quo, their apparent "violation" of copyright obscures all other elements of these creative lives and their contributions to our societies.

Many scholars have correctly suggested that remix is a defining feature of digital culture.[8] Yet, the most troubling aspect of remix culture might just be the ways in which the humanity of artists and their work become trivialized, dehistoricized, and criminalized simply because an archaic legal system is well guarded by the elites that manage the status quo. With this troubling and dehumanizing situation suffocating the humanity of artists, I propose a remix praxis as a way to think about how artists sustain human relations beyond the scope of a legal regime or a scholarly community. Building on Dick Hebdige's uncovering of the notion amongst Caribbean musicians that "no one owns a rhythm of a sound,"[9] I expand on this idea of artists wrestling with power and power brokers to produce music, remixes, and art in ways that nourish their humanity and honor their existence. Such a position moves away from debates of the illegality of remix and helps us focus on the human lives at the source of remix's creative energies. When we center the DJ and their interventions in social life, what becomes clear is that dancing, happy crowds are more important than rigidly enforced legal regimes. Learning a set of chords, performing these chords for the enjoyment of publics becomes an important way to think about remix culture beyond the restrictions of copyright law. I consider here the centering of remix artists and specifically Black life when considering the potential relations between remix studies and the digital humanities. The remix praxis I move with then is justice oriented as it practices honoring and centering Black life and joy in the deployment of sonic innovations. The loosening effect is one of reducing the barriers erected by the powerbrokers to circumscribe, monetize, and control the creative possibilities of human life. Loosening our contemporary discursive regimes around copyright means advancing notions and ideas of how artists exist, create, and thrive by analyzing their sonic innovations at the intersection of the dominance of legal regimes of copyright enforcement.

Understanding remix praxis within the framework of Black Studies, my practice is informed by the Caribbean philosopher Sylvia Wynter's notion of a "deciphering practice." Wynter's intellectual project has been to call for another kind of human life that refuses to replicate European "Man"—understood as a provincial and biocentric over-representation of the notion of the human.[10] In her numerous investigations, Wynter clearly delineates how European enlightenment and colonialism rendered a narrowly conceived and provincial notion of what it means to be human. In "Rethinking Aesthetics: Notes Towards a Deciphering Practice," Wynter details how we might engage aesthetics as a way to understand and unravel how criticism continues to reify existing discourses, dialectics, and binaries.[11] She is interested in moving away from forms of criticism (her example is film) embedded in a deconstructionist ethic that reproduce the existing hierarchies of society by utilizing a form of criticism that asks what a text might mean. Instead, Wynter poses a deciphering method that explores how rhetorical mystification works in criticism and how to develop, from the vantage point of the subaltern, a counter-politics of taste that moves beyond ethnocriticism toward a reconstituted universalism. Wynter asks what a text's signifying practices can be deciphered to do and evaluates the force and procedures, in short how texts are disciplined to do their work.[12] Wynter's concern is to arrive at a "global popular imaginary whose referent telos is that of the well-being of the individual human subject and, therefore, of the species."[13] What this means for remix studies from where I stand is to implement considerations of the artist at the center of thinking about remix cultures rather than forcefully privileging an intellectual copyright regime whose origins within European

thought are not only provincially Eurocentrically designed, but whose rigid focus on the market violently attempts to reorient the creative process.

The investment here is an interdisciplinary one, focused on how Black life sonically produces forms of life and living that both arouse the suspicion of the "authorities" while producing more livable lives beyond the scourge of anti-Blackness. Of the earliest remixing practices in music—Walter Gibbons's innovations with disco music and Ruddy Redwood and King Tubby's innovations in Jamaican music—what is clear is that being on the margins of mainstream society (as Gibbons enlivened gay nightclubs in the 1960s) or operating beyond the dominant regime (think colonial Jamaica's lack of copyright) produces opportunities to live human life differently. Remixing exposes the seams of fabricated connections and seeks to form other models of human activity mirroring how new and other versions of "original" recordings can be paradigmatic for social relations. If the well-being of artists, audiences, and other humans is to be centered in our analysis around remix cultures, the well-being of those on the margins of our social imaginary should be brought into focus. In this scenario, a remix praxis becomes a tool to demystify remixing's "illegality" and reveal the procedures and rules that attempt to entrap artists within a market frame that turns its back on the well-being of human life. A remix praxis focused on human well-being guides how I want to understand what is at stake in innovations around hip hop archives.

The Hip Hop Archive

Across the United States, various universities have begun archiving hip hop culture in cities such as Houston, Boston, Ithaca, Seattle, and New Orleans. Starting with Marceylina Morgan's collection of hip hop magazines, her efforts at UCLA, Stanford, and Harvard have produced what has been named Harvard's Hiphop Archive. With no connection to the local Boston hip hop scene nor a connection to the university's archival and librarian sciences expertise, Harvard's Hiphop Archive exerts more research and convening power than archival prowess. In contrast, Cornell's archival collection boasts a much larger collection of items and is supported by an archivist and an assistant curator. Located in Ithaca, New York, Cornell's collection features much of New York's history in photos, posters, and other artifacts. In Seattle, New Orleans, Houston, Massachusetts, and Virginia, hip hop archives focus on honoring the local community of hip hop artists. In representing their local communities, hip hop archives attempt to honor local hip hop artists and preserve their artistic legacies. For example, the Houston Hip Hop Research Collection located at the University of Houston is a prime example of how the legacy of DJ Screw and other local artists continue to influence events and programming, such as the recent memorial events held for emcees H.A.W.K and Fat Pat.[14] Both in Virginia and in Seattle, the names of local artists proliferate in their archival efforts, amplifying artist profiles that might be unfamiliar nationwide or largely off the radar of nationwide media platforms, such as The Source magazine or Yo! MTV Raps.

There are few commonalities amongst many of these archives as they differ greatly in their contents, resources, and community involvement. At the level of discourse, hiphop archives are largely ignored by the digital humanities, a field in which there is no lack of scholarship on digital archives but also a field with a serious lack of engagement with concerns central in Black studies. While disappointing, this is not surprising given

the digital humanities' miserable record around theorizing race, power, and the field's own blatant Whiteness.[15] In her calls for an intersectional approach in the digital humanities, Roopika Risam echoes questions in the field: "Where is cultural criticism in the digital humanities?" and "Why are the digital humanities so white?"[16]

Hip hop archives contain multitudes of Black and racialized life, various class inscriptions where power nakedly rearranges America's margins and offers us an opportunity to see how digitization differentially impacts a segment of a hip hop generation that specializes in creatively subverting turntables, samplers, and other musical technology.

Beyond its lack of a relationship with the digital humanities, what many hip hop archives share is a legacy of the residue of coloniality because the archives, as a social institution, are steeped in practices of European colonialism. While both Derrida and Foucault interrogate the archive as a theoretical concept without centering Europe's colonial underpinnings, Laura Ann Stoler's work on Dutch colonial archives reveals how the gaps, reoccurrences, and silences in an archive tell us a great deal about colonial life.[17] In a similar trajectory, Achille Mbembe, speaking from an African context in "The Power of the Archive and its Limits," parallels and predates Stoler's claim that "colonial archives are products of state machines"[18] to remind us that the modern nation-state (in South Africa) derives its power from archives.[19] Hip hop archives are inherently political as they capture (at best) the ways in which Black and racialized early architects of hip hop in their local cities built the culture's now global appeal. Deeply embedded within the shadow of colonialism that lurks around the archive is the consistency of the loss of Black lives. With the origins of colonial archives deeply indebted to the documenting of African human cargo, the lists, classificatory preoccupations, and methods of storage and preservation cannot be disconnected from what Katherine McKittrick describes in *Mathematics Black Life* as

> The tolls of death and violence, housed in the archive, affirm black death. The tolls cast black as impossibly human and provide the conditions through which black history is currently told and studied.[20]

The archive, according to Jennifer L. Morgan, is also home to the possibility of a counternarrative,[21] a place in which the historical and the future might intersect, where possibilities can be birthed.

The legacies of death in the archive continue to haunt hip hop archives today, particularly in a city like Houston where the legacy of DJ Screw is being archived. Beyond DJ Screw's untimely death in 2000, the deaths of several other Houston hip hop luminaries such as Pimp C and members of the Screwed Up Click haunts archival efforts. In the Houston context, to obtain papers and other archival materials, Archivists must often negotiate with widows of deceased local artists to build collections while the hip-hop community finds ways to memorialize and keep alive the memory of their local artists. The task at hand for hip hop archives interested in rehumanizing Black life appears to be an intentional and nuanced refusal of repeating the colonial archive by engaging in the aesthetic innovations begat by hip hop artists rather than fetishizing the death of Black artists. An excellent example of this is an art exhibition, *Slowed and Throwed: Records of the City Through Muted Lenses*, organized by the Contemporary Arts Museum Houston. The exhibition honors the sonic innovations of DJ Screw as his chopped and screwed signature DJ style became one of the hallmarks of the Houston hip hop scene and deeply influenced the American southern hip hop scene. Rather than a

more traditional archival exhibition with materials and photos of the DJ from the DJ Screw papers, *Slowed and Throwed* works with contemporary artists to interpret and extend the late DJ's sonic innovations using techniques from hip hop DJ culture. The Art Museum's promotional materials explain,

> The exhibition features unconventional photography and new media created by strategies paralleling the musical methods of the innovative DJ. In their photo-adjacent practices, the participating artists appropriate, mashup, collage, and mutate photographic inputs, in addition to slowing time. *Slowed and Throwed* contends that remixing "sampled" materials is a radical aesthetic act utilized by both artists and musicians. Through reconfigurations of sourced and original materials, the featured artists draw attention to inequities stemming from race, gender, and sexual orientation, suggesting new possibilities and alternative realities.[22]

Such an exhibition repositions the archive from the storehouse of death and breathes new life into the collection as well as the public's appreciation of the late DJ Screw. By sampling and remixing, the exhibition works within the innovations of hip hop culture and attempts to honor Afrosonic innovations. *Slowed and Throwed* works conceptually as a remix that does not simply reproduce a dominant logic of Black Death, rather the show expands DJ Screw's legacy and influence and in doing so, the well-being of the Houston hip hop community, one that is no stranger to reckoning with the death of their local artists.

Remixing the Archive

In attempting to perform a digital archive of Canadian hip hop culture, I utilized the methods and aesthetics of DJ culture in two different settings to enliven an archive, moving it beyond its colonial inheritance and residues. In both performances, one a keynote lecture at a university and the other a DJ set at a public party inside our province's official museum, I developed video remixes of archival materials for public consumption. At the University of Western Ontario, I was invited to provide the keynote lecture for an event entitled, *Remixing the Digital Archive: Black and Indigenous Creators Reclaim Knowledge Space*. Two opening acts set the stage for the performance with an audience of 40–50 seated individuals inside an indoor open square at the university. Chedo, the founder of a local hip hop radio program, the ComeUp Show, and Lido Pimienta, who went on to become a Polaris prize winner,[23] provided commentary on and descriptions of the archive and its relations to Blackness and indigeneity (Figure 33.1). Using a digital controller and Serato's video mixing program, I cued up a mixture of event photographs, posters, and archival photos to produce a visual DJ set to accompany my talk (Figure 33.2). In a performance that moved between styles—lecturing and video mixing—I spent an hour using my platform to challenge how the archiving of hip hop culture is imagined, particularly by experimenting with a Black creative practice.

After our performances, we participated in a panel discussion moderated by the event host, Aspen Media Fellow Datejie Green. I shared with Datejie how I wanted people to engage with Canadian hip hop as embedded within the aesthetic codes of DJing. Part of my rationale for the formatting of my talk was to resist a specific kind of detached, objective, Euro enlightenment–infused analysis of Black life and hip hop in archives. Given

Figure 33.1 The author during a video mix keynote lecture at the University of Western Ontario, London Ontario, Canada (photo credit: Datejie Green)

a platform for a unique approach, my performance and talk sought to demonstrate what a resistance of Black Death and archival methodologies might look like. This meant refusing to disentangle histories of DJ innovations, technological subversions, and Black life from how the talk was presented to the audience. Put another way, the performance was about remixing and transforming how we envision the archive working.

Figure 33.2 Flyer for Remixing the Digital Archive

Friday Night Live

In the Toronto hip hop context, the shadow of Black Death looms with the unexpected deaths of community members weighing heavily on mothers and families, former crews, and collaborators. Two years after my performance at the University of Western Ontario, I took the stage at an event organized by the Royal Ontario Museum (ROM)—a weekly party called *Friday Night Live*. Like many museums around the world, the ROM, eager to boost its number of patrons, adopted a strategy to produce parties within the museum space to attract younger audiences. In five rooms of music, the museum attracts approximately 3000 partygoers at each event held on Friday evenings in the spring and fall. With weekly themes orienting which performers and DJs are selected, I performed on the "hip hop night." I decided to do a set of Toronto-based hip hop videos from the 1990s and early 2000s interspersed with archival materials such as album covers, event flyers, and photos all borrowed from my archival platform Northside Hip Hop Archive. Unannounced to the audience, I set up my digital controller and proceeded to jump into the mix on the event's mainstage—shifting the audience's attention to a screen to the right of the mainstage where I and the other DJs were stationed.

My set at the ROM's event interrupted the audience's expectations of a solely sonic experience and brought a visual presence to the forgotten names and underrepresented Toronto-based artists whose achievements are not easily found on the Internet. My focus was to play a short set of only Toronto hip hop artists, focusing on up-tempo songs that represented well the boom bap era. For example, a trio named IRS in 2000 produced an anthem for the city of Toronto called "T-Dot Anthem." I included "T-Dot Anthem" directly before mixing into the ubiquitous Drake video and song, "Headlines," which the audience (of approximately one thousand) intimately knew and enthusiastically sang along with as the chorus repeated: "they know, they know, they know…." Unlike my lecture, my audience members were active participants in my set. They were treated to the familiarity of more recent tracks by Drake and were either reminded or reintroduced to more records that helped shape Toronto's hip hop history. As we were in a party context there was no need or desire to explain the video mix and no direct dialogue with the audience outside of the DJ set. After my thirty-minute set, the mainstage DJs switched back to an audio-only setup.

In my intentional efforts to remix a Canadian hip hop archive, I moved between known and unknown materials, took into consideration the audience in a call-and-response fashion, and refused to focus on death and loss by not including in my mix images of artists who have passed. My remix praxis focused on my audience's well-being and on presenting a critique of the function and future of archives. Dissemination and audience-building decidedly took priority over notions of preservation. Interpretation became a performative possibility, complementing but not encumbered by metadata and descriptive statements. By bringing a DJ's sensibility to interrupt archival methodologies and procedures, the remix praxis practiced here is one that attempts to write anew how Black life might ethically be archived—a critical consideration for the future of hip hop archives.

In the archival sciences, the objective detachment embedded in protocols and methodologies around provenience, copyright, and cataloging work within a Euro-enlightenment tradition, in direct contrast to the work of DJs. The act of DJing as a subjective, experience-based activity deciphers and evades the common structures and protocols that underpin traditional bricks and mortar archives. These performance-based remixes detailed above

(they were not recorded) presented a critique of hip hop archival work purposefully disconnected from debates in the archival science and museum studies. The visual nature of my video mixes adapted audio mixing strategies that allowed for Black life to visually resonate while simultaneously working with DJing traditions and Afrosonic and oral aesthetics that refuse to evacuate histories of Black aesthetic life from the archive. The amplification of Black life and hip hop's aesthetic legacies illuminated other methods at preservation, dissemination, and archivization. In both of the archival engagements detailed here, the act of remixing the archive formed an Afrosonic criticism of Black life and the archive, focusing on neither an outright dismissal of the archive nor a wholehearted embrace of the methods and procedures one ought to comply with in the archival sciences. The decipherment work of the remix in this context was about posing another set of questions, ideas, and strategies around archiving that simply do not bring us back to existing paradigms, discourses, and protocols. In the words of Abigal De Kosnik, my archival actions were "rogue," a blatant disregard for the rules of archiving.[24] From the perspective of the digital humanities, my DJ sets tackled the tireless debates of "Yack vs. Hack" of scholars who "perform" written scholarship versus those scholars who engage in the act of making. Such a performance, one based on copies is a reminder of the ways in which remix studies can productively disrupt the legitimacy of copyright regimes and the pervasiveness of Eurocentric thought.

Notes Toward Remixing a Hip Hop Archive

To generatively envision a future between the digital humanities and remix studies, I outline the following notes that guide my practice:

Note 1: Think through the digital affordances we can bring to bear on archival materials. This means, in the context of hip hop culture, what the digitization of liner notes, promotional stickers, and other disappearing aspects of music culture in the digital era might mean. In my DJ sets, this meant digitizing stickers to become short videos to be manipulated on-screen. Similarly, digitized radio archives can provide interpretative muscle, especially for underground or lesser known tracks or for DJs who are hard to track down or deceased. Preparing archival materials into formats that might appeal to artists or can become further augmented ripens an archive for artistic engagement.

Note 2: Imagine social media as not just a promotional tool, but a way to speak with and relate to hip hop community members and fans. Multiple generations of fans and artists engage on different platforms, engagement should be across all platforms in addition to face-to-face. Visual platforms like Instagram offer numerous possibilities as do their metadata and hashtag strategies, particularly in crowdsourcing information. Build an audience, seek call-and-response, activate audiences, and utilize digital platforms of future archives, holding places for discussions, debates, metadata, and new discoveries or acquisitions.

Note 3: Invite artists/scholars to handle archival material with creativity and care. Artists with connections to hip hop cultures and communities are deeply invested in the preservation of their culture. Engage these artists to work closely with archival materials and provide training in handling sensitive items that benefits all. The creative process of each artist and the art they create can illuminate nuances unknown or overlooked in the archival process. Be prepared to rethink classificatory systems and existing metadata arrangements.

Note 4: Establish boundaries, exclusions from remixing (I.P., dated unequitable references) that will continue to represent hip hop culture while being sensitive to issues like death, loss, and exploitation.

Note 5: Think of preservation as an effort that is deeply connected to disseminate, debrief, celebrate, and honor those being archived. Events, panel discussions, showcases, publications, and more are part-and-parcel of the preservation strategy.

Conclusion

The opportunities available to us today, as digital archives proliferate, include the possibility of destabilizing the hegemony of archivization through practices of decipherment and rogue cultural memory.[25] The affordances of the digital enable rogue archival practices, whose rule-breaking, vernacular, semi or nonprofessional archivist works present new opportunities to fill the gaps of the very heteronormative, Eurocentric, and hierarchical traditions that have been the hallmarks of archives. The remix is one practice that clearly infringes upon the hegemonic thinking of the West and its copyright regimes. In moments like the two DJ performances I describe in this chapter, my rogue remix-based artistic strategies served as ways to do more than simply fill the gaps of the "official record"—such an approach reifies the belief in a universalist approach to archiving. Instead, a remix praxis is equally concerned with methods of grasping the ephemeral non–reproducible knowledge as justice-oriented ways to honor human life trapped in the taxonomies, classificatory systems, and annotations of the archive. Accordingly, a remix praxis is about creating new relationships to knowledge production and dissemination in the digital, it is a subjectivity that diverges from a linear hierarchical logic embedded in ideas of the archive.

Remixing as a deciphering practice exposes the rules and protocols that structure existing arrangements of power, in the archive, this is curatorial and archivist power. A hip hop archive that can create engagements that not only defuse its own power but also honor the lives within the archive by refusing to fetishize death is a pivot in a direction the digital humanities can approach. A remix praxis embedded in a hip hop archive's work pushes the digital humanities not only to ask who is missing or why is the field so white but also encourages us to interrogate the methods and the unquestioned actions taken to form the field that simply reified existing power dynamics and structural inequalities.

In the digital, a remix praxis amplifies forms of embodied knowledge that disentangle the forms of institutional power that have exclusionary effects while relying on the copy as a central mechanism of preservation. In remixing archival materials in a public performance, this strategy does the double work of awakening preexisting memories of an "original" past while drawing on and evoking contemporary platforms and technologies that move the archival material into another realm of human experience. In my specific performances, this meant transforming audio copies into one continuous mix as well as making short videos out of digital images of archival materials. The copy enables another kind of curation and public performance that creates preservation opportunities amongst audience members with the kinds of ephemeral and experience-oriented memories created by the DJ set.

With increasing numbers of archives dedicated to preserving hip hop culture—both digital and bricks and mortar—new opportunities come to enable and enact another kind of relationship to the production of knowledge. Since the origins of hip hop culture were

largely innovations of Black and Brown youth living on the margins of American society, the archive as a site of enunciation, the law of what can be said, and as an enabling factor in what kind of history can be written is critical to the democratic production of knowledge. The forms of knowledge embedded in the art of DJing can be central to how hip hop culture is archived if we are to imagine a way in which archives can avoid becoming stagnant and static storehouses of information. Remix cannot simply remain a defining feature of our contemporary moment, it can also become a praxis by which we redesign the methods and tools that reproduce Western life's limited and dehumanizing definitions of "Man" that violently circumscribe the lives of those deemed as "others."

Notes

1 Diana Taylor, *The Archive and the Repertoire: Performing Cultural Memory in the Americas* (Durham: Duke University Press, 2003).

2 Lawrence Lessig, *Remix: Making Art and Commerce Thrive in the Hybrid Economy* (New York: Penguin, 2008); Lawrence Lessig, "Free(ing) Culture for Remix." *Utah Law Review* (2004): 961-975; Graham Reynolds, "A Stroke of Genius or Copyright Infringement: Mashups and Copyright in Canada." *SCRIPTed* 6 (2009): 639.

3 Marge Borschke, *This is Not a Remix*, Piracy, Authenticity and Popular Music (London and New York: Bloomsbury, 2017).

4 Eduardo Navas, *Remix Theory: The Aesthetics of Sampling* (Basel, Switzerland: Birkhäuser, 2014).

5 Henry Louis. Gates Jr, *The Signifying Monkey: A Theory of African American Literary Criticism* (Oxford: Oxford University Press, 2014), 51–2.

6 Eduardo Navas, "The Originality of Copies: Cover Versions and Versioning in Remix Practice." *Journal of Asia-Pacific Pop Culture* 3, no. 2 (2018): 175.

7 Borschke, *This is Not a Remix*, 38.

8 Borschke, *This is Not a Remix*; Mark Deuze, "Participation, Remediation, Bricolage: Considering Principal Components of a Digital Culture." *The Information Society* 22, no. 2 (2006), 63–75; Lessig, *Remix*, 2008; Lev Manovich, "What Comes after Remix." *Remix Theory* 10 (2007).

9 Dick Hebdige, *Cut 'n' Mix: Culture, Identity and Caribbean Music* (New York: Routledge, 1987), 141.

10 Sylvia Wynter, "1492: A New World View," in *Race, Discourse, and the Origin of the Americas*, edited by V. Hyatt and R. Nettleford (Washington, DC: Smithsonian Institution Press, 1995); Sylvia Wynter, "The Pope Must Have Been Drunk the King of Castile a Madman: Culture as Actuality, and the Caribbean Rethinking of Modernity," in *The Reordering of Culture: Latin America, the Caribbean and Canada in the Hood*, edited by C. Taina and A. Ruprecht (Ottawa: Carlton University Press, 1995), 329; Sylvia Wynter, "Unsettling the Coloniality of Being/Power/Truth/Freedom: Towards the Human, After Man, It's Overrepresentation—An Argument," *The Centennial Review* 3, no. 3 (2003): 257–337; Sylvia Wynter and David Scott, "The Re-Enchantment of Humanism: An Interview with Sylvia Wynter," *Small Axe* 8 (2000): 119–207.

11 Wynter, *Rethinking Aesthetics*, 1992.

12 Wynter, *Rethinking Aesthetics*, 266.

13 Wynter, Rethinking Aesthetics, 266–267.

14 Personal Communication Julie Grob, December 11, 2019.

15 Safiya Noble, "Towards A Critical Black Digital Humanities," in *Debates in the Digital Humanities 2019*, edited by Matthew K., Gold and Lauren F. Klein (University of Minnesota Press, 2019); JSTOR, www.jstor.org/stable/10.5749/j.ctvg251hk, accessed on April 11, 2020.

16 See McPherson 2013 and Liu 2013 as cited in Roopika Risam, "Beyond the Margins: Intersectionality and the Digital Humanities." *DHQ: Digital Humanities Quarterly* 9, no. 2 (2015).

17 Laura Ann Stoler, *Along the Archival Grain: Epistemic Anxieties and Colonial Common Sense* (Princeton, New Jersey: Princeton University Press, 2009).

18 Ibid, p. 28

19 Achille Mbembe, "The Power of the Archive and Its Limits," in *Refiguring the Archive*, edited by Hamilton et al. (Dordrecht: Springer, 2002), 19–27.

20 Katherine McKittrick, "Mathematics Black Life," *Black Scholar* 44, no. 2 (Summer 2014), 17.

21 Jennifer L. Morgan, "Archives and Histories of Racial Capitalism," *Social Text* 33, no. 4 (125) (December 2015): 154. DOI: 10.1215/01642472-3315862.
22 "Slowed and Throwed: Records of the City Through Mutated Lenses," https://camh.org/event/slowed-and-throwed/ accessed on April 1, 2020.
23 The Polaris Prize is a prestigious music award in Canada awarded to a full length album by a Canadian artist or group based on artistic merit.
24 Abigail De Kosnik, *Rogue Archives: Digital Cultural Memory and Media Fandom* (Boston, MA: MIT Press, 2016).
25 De Kosnik, *Rogue Archives;* Wynter, *Rethining Aesthetics.*

Bibliography

Borschke, Margie. *This Is Not a Remix, Piracy, Authenticity and Popular Music.* London and New York: Bloomsbury, 2017.

De Kosnik, Abigal. *Rouge Archives: Digital Cultural Memory and Media Fandom.* Cambridge and London: The MIT Press, 2016.

Derrida, Jacque. *Archive Fever: A Freudian Impression.* Chicago: University of Chicago Press, 1995.

Deuze, Mark. "Participation, Remediation, Bricolage: Considering Principal Components of a Digital Culture." *The Information Society* 22, no. 2 (2006):63–75.

Gates, Henry Louis Jr. *The Signifying Monkey: A Theory of African American Literary Criticism.* Oxford: Oxford University Press, 2014.

Lawrence, Tim. "Disco Madness: Walter Gibbons and the Legacy of Turntablism and Remixology." *Journal of Popular Music Studies* 20, no. 3 (2008): 276–329.

Lessig, Lawrence. *Remix: Making Art and Commerce Thrive in the Hybrid Economy.* New York: Penguin, 2008.

Manovich, Lev. "What Comes after Remix." *Remix Theory* 10 (2007): 2013.

Mbembe, Achille. "The Power of the Archive and Its Limits." In *Refiguring the Archive,* edited by Carolyn Hamilton *et al.,* 19–27. The Netherlands: Springer, 2002.

McKittrick, Katherine. "Mathematics Black Life." *Black Scholar* 44, no. 2 (Summer 2014).

Morgan, Jennifer L. "Archives and Histories of Racial Capitalism." *Social Text* 33, no. 4 (125) (December): 153–61.

Navas, Eduardo. *Remix Theory: The Aesthetics of Sampling.* Wein and New York: Springer, 2012.

Navas, Eduardo. "The Originality of Copies: Cover Versions and Versioning in Remix Practice." *Journal of Asia-Pacific Pop Culture* 3, no. 2 (2018): 168–87.

Reynolds, Graham. "A Stroke of Genius or Copyright Infringement: Mashups and Copyright in Canada." *SCRIPTed* 6 (2009): 639.

Stoler, Laura Ann. *Along the Archival Grain: Epistemic Anxieties and Colonial Common Sense.* Princeton, New Jersey: Princeton University Press, 2009.

Wynter, Sylvia. "Rethinking 'Aesthetics': Notes Towards a Deciphering Practice." In *Ex-Iles: Essays on Caribbean Cinema,* edited by Mbye Cham, 237–79. Trenton, NJ: Africa World Press, 1992.

Discography

Drake. "Headlines" Take Care on Take Care. [mp3] Cash Money Records & Republic Records, 2011.

IRS. "Tdot Anthem" on Welcome to Planet IRS. [mp3] Toronto, ON: Watchu Want/Universal Records, 2003.

Kardinal Offishal feat. Lindo P. "Burnt" [mp3] on Not for Sale. Kon Live/Geffen Records, 2008.

Michie Mee & L.A. Luv [vinyl] "Run for Cover" Justice, Records, 1987.

Tara Chase. "The Northside." [mp3] on Rap Essentials, Beatfactory Records, 2001.

34

EXPLORING REMIX PROCESS

The Case of the Spanish Megamix

Adrian Renzo

Several scholars have drawn attention to the problems with close reading of musical texts.[1] One alternative that has been proposed is the adoption of research methods from the digital humanities.[2] Digital humanities approaches have been particularly promising with regard to quantitative research.[3] For example, access to big music data allows researchers to document and theorize the prevalence of musical patterns in large repertoires of music. This chapter suggests that, at the same time, digital humanities approaches may also be useful in more qualitative types of research that involve close readings of music. In the example explored here, if we shift our focus from making texts to "making things,"[4] digital humanities approaches can yield useful insights into the nature of creativity in remix practices. To illustrate the point, this chapter examines the creative micro-decisions made during the production of one segue from a Spanish megamix.

The Spanish megamix is a musical form that became popular in the mid-1980s, but has not yet been studied by scholars outside the Spanish-speaking world.[5] It is distinct from related musical forms such as the mashup,[6] the remix,[7] and even the "megamix" as sold in Anglophone markets.[8] In this chapter, I describe the process of creating a segment of one such megamix, using the Digital Audio Workstation (DAW) Ableton Live. I begin with two key questions. The first question is: what are the musical features of this form? I address this by providing a summary of my findings after analyzing fifty-seven Spanish megamixes released between 1985 and 2018, with a particular emphasis on the *Max Mix* series (1985–92).[9] The second question is: what might be learned about Spanish megamixes by making a segment of a megamix as opposed to simply listening to one? I address this question after making a segue in the style of a Spanish megamix. The process of research-via-producing yields two insights. First, it reveals conventions that are not immediately obvious from listening to Spanish megamixes. In particular, it highlights the way that producers need to carefully manage effects so as to ensure that the effects are *conspicuous*. Second, the process of making a megamix highlights the hidden labor involved in this type of recording, where even relatively simple effects need to be constructed, honed, and "polished." More broadly, this chapter aims to illuminate a popular musical form that has not yet received much scholarly attention outside the Spanish-speaking world.

Big Data Versus Close Reading

Several musicologists have drawn on approaches from the digital humanities. In some cases, the aim has been to utilize big data rather than engage in the close reading of a small number of musical works.[10] This form of "distant reading"[11] promises to circumvent the problems that have previously been identified with close reading, such as the tendency to canonize works[12] and to focus on a relatively narrow body of music.[13] An example of such distant reading can be found in Hedges, Roy, and Pachet. They draw on a database of 5700 jazz standards and use an algorithm to identify the chord progressions used in the notated versions of these standards.[14] Their results indicate that there is a strong correlation between the composers of the standards and the chord progressions used in their respective works: their algorithm is able to identify the composers by analyzing the chord progressions, irrespective of any additional identifying information provided in the database, such as that pertaining to melody or performance style.[15] Stephen Cottrell has also illustrated the kind of findings that become possible when we use an algorithm to analyze big music data. In one of his examples, software automatically tracks the beats of pieces in seven British Library audio collections, allowing Cottrell to identify the most prevalent tempos across musical works numbering in the thousands.[16] His findings are summarized in the form of a bell curve in which approximately 104–150 Beats Per Minute (BPM) seems to be the most likely to occur across the seven audio collections measured.[17] Instead of relying on "close readings" of relatively few musical texts, studies such as these draw on a substantially larger and, to a limited extent, "indiscriminate" body of work. For Cottrell, big music data has the potential to transform "musicology from a data-poor to a data-rich field."[18]

While not denying the utility of these new approaches, this chapter argues that close reading remains a valid approach in musicology, and that digital humanities approaches can be harnessed to produce more nuanced close readings of musical texts. As Neilson, levenberg, and Rheams have argued, the field of digital humanities can be as much about making recordings, databases, or algorithms as it is about writing texts.[19] In the following section, I describe some features of the Spanish megamix, and then describe the process of making a megamix fragment.

Introducing the Spanish Megamix

The Spanish megamix can be traced back to the early work of Miquel Fabrellas, better known as Mike Platinas. He was active as a megamix producer in the 1980s and has been part of the megamix revival in Spain in the 2000s.[20] Platinas reports being inspired by mixes circulated by Disco Mix Club (DMC) and by broadcasts from Radio Luxembourg in the early to mid-1980s.[21] He was also inspired by the kind of editing he heard on radio advertisements: "I came to the conclusion that the technique that was used in radio advertising spots, cutting at the beginning and cutting at the end, could lead to a new type of creativity, that is, using these same cuts for the songs and turning them into something else."[22] To this end, he purchased a Revox open-reel tape machine and began to construct mixes rather than performing them live. After winning a DJ contest organized by the fledgling label Max Music, Platinas was given the opportunity (with Javier Ussía) to produce the first volume of *Max Mix* in 1985.[23] Its success prompted Max Music to release a follow-up, which sold one hundred million copies in two weeks. In 1986, *Max Mix 4* outsold Julio Iglesias in Spain.[24] By 1990, the *Max Mix* series had

become a regular fixture on the Spanish album charts. The 1990s saw the record label Max Music launching many other megamixes in the same style (such as *Lo + Duro*, *Maquina Total*, and *Ibiza Mix*).[25]

The Spanish megamix is distinct from megamixes in other parts of the world. Outside Spain, the term "megamix" may connote compilation albums featuring nonstop tracks provided by various artists (such as the Megabass[26] series), single-artist retrospectives (such as megamixes by Technotronic,[27] Snap!,[28] and Bobby Brown[29]), or retrospectives of particular record labels (such as 3-D's "Tommy Boy Megamix"[30]). One thing these recordings have in common is their reliance on the original recordings of their constituent tracks: megamixes are "electronic medley[s] consisting of samples from pre-existing sources."[31] These recordings feature a wide range of mixing techniques: some are characterized by abrupt transitions between songs; some contain more gradual, "smooth" segues between songs; others feature proto-mashup sections in which the vocals of one song are placed over the instrumental version of another song.

The Spanish megamix incorporates the above elements but is notable above all for its use of a number of musical conventions. First and foremost, Spanish megamixes prioritize various types of audio effects, or what Platinas calls "the fireworks."[32] In 1980s medley records such as *Stars on 45*,[33] individual tunes might play unaltered for many seconds at a time, with relatively unobtrusive transitions between songs. While Spanish megamixes contain sections in which songs played unaltered, they also contain many sections where songs are constantly subjected to audio effects—songs are pitch-shifted, chopped, reversed, and combined with other songs. An early Spanish megamix summarized this "more is more" approach in its title: *Mas Mix Que Nunca!!!* ("more mix than ever!!!").[34] The liner notes for a *Max Mix* thirtieth anniversary release highlights the sheer number of edits in each megamix ("more than 600 in the second volume").[35] A significant proportion of these audio effects are what Robert Fink calls "stutter edits": that is, moments where any type of sound or musical fragment (not necessarily a vocal line) is chopped and rearranged to create a stutter effect.[36] Stutter edits can be heard in some of the earliest Spanish megamixes, such as the *Max Mix* series (1985–92).[37] Producer Toni Peret notes: "a singer in a given song would say 'oh'; people really liked to hear 'oh, oh, oh, oh, oh, oh'."[38] Edits were initially made using open-reel tape machines,[39] but would later be made using samplers and (later still) DAWs. In *Max Mix* 4, for instance, the word "geil" (from the song of the same title) stutters at 0:09–0:13.[40] In *Max Mix* 9, the word "I" (from the song "Pump Up the Jam") stutters at 3:54–3:56 ("I…I…I want/I- I want/A place to stay").[41] In other cases, producers made the underlying instrumental tracks "stutter." For example, the drums and synthesizers from Eddy Huntington's "U.S.S.R." stutter at 2:27, 3:22, and 3:26 of *Max Mix* 4, while the piano riff from Black Box's "I Don't Know Anybody Else" stutters at 3:10 of *Max Mix* 10.[42]

Stutter edits are the most common type of effect utilized in Spanish megamixes. They appear in every one of the fifty-seven megamixes analyzed for the current study, and they are often used extensively in the introductions to megamixes as a way of catching the listener's attention. By way of example, I have noted every instance of a stutter effect in the first two minutes of the 1990 megamix *Supermax*, by Toni Peret and José Maria Castells, in Table 34.1.[43]

If we compare *Supermax* with "Time to Make the Floor Burn" by Megabass (a contemporaneous megamix from the United Kingdom that draws on similar types of music), we find several noteworthy differences.[44] The latter features no stuttering at all in its opening two minutes, except for a single instance of stuttering that was already present in

Table 34.1 List of stutter edits in the first two minutes of Supermax megamix (1990).

Time	Stutter edit
0:00	"The Power" introduction stuttered ("Americaski-caski-cas-caski…")
0:04	"The Power" riff stuttered
0:07	"I've got the p-p-p-p-p-p-power power"
0:18	"g-g-g-g-get on up"
0:20	"get-get on up"
0:34	"doh doh" vocal sample cut to resemble "The Power" riff
0:42	"it-it-it's getting…"
0:44	"g-g-g-g-getting kinda hectic"
0:46	"it's get get it's get get"
0:48	"it's g-g-get"
0:50	"The Power" riff stuttered
0:55	"The Power" riff stuttered in background
0:57	"I-I, I-I I've got the power"
1:02	"I-I-I-I- I've got the power"
1:03	"zumba-zumba-zum-zumbayeh"
1:07	"zumba-zumba-zum-zumbayeh"
1:23	"n-n-n-native love"
1:27	"n-n-n-native love"
1:45	"zumba-zumba-zum-zum-wa-wa-wa-wa-wa-wa…"
1:49	"zumba-zumba-zum-zum-wa-wa-wa-wa-wa-wa…"
1:55	"p-p-pump it up"
1:56	"do-do that thing"
1:58	"yo, y-y-"
1:59	"get…get-get…get down"
2:02	"Cult of Snap" stuttered

one of the source tracks (in this case, Black Box's "Ride On Time"). Some light stuttering does appear later in the mix (at 4:47 and 6:30), but the effect is used sparingly compared with the Spanish megamix.

A second convention prominent in Spanish megamixes is a particular way of presenting the source tracks. These megamixes almost always featured three distinct types of sections: songs played unaltered, songs subjected to stutter edits and other audio effects, and songs overlapped with each other, with or without additional effects. This approach is different to the approach of, say, Latino Rave's *Deep Heat 89* (in which each song plays unaltered, and every transition consists of a simple cut to a subsequent song with no overlapping sections).[45] The Spanish approach is also distinct from bootleg mixes such as *Let's Do It In The 80s Great Hits* (the inspiration for *Stars on 45*), in which fragments of songs are laid over an underlying and unchanging drum track.[46] The drums for any given section of a megamix would be sourced from whichever song happened to be playing at that point in time. Finally, the Spanish approach is distinct from long-form

mashups such as Osymyso's "Intro-Inspection," in which songs are constantly superimposed on each other.[47]

Third, Spanish megamixes do not prioritize the "seamless" mixing style that was pioneered at New York City clubs such as The Saint,[48] dominated house club nights from the 1990s onwards,[49] and eventually found a home on mix CDs such as those issued by Ministry of Sound.[50] Compared with the above mixing style, Spanish megamixes appear to have a much more "abrupt" style of transition between tracks. In part, this is due to the time limitations of the format: where a club DJ might have hours at his or her disposal, a megamix typically lasts between ten and fifteen minutes. In such a short time frame, there is very little scope for songs to slowly morph into each other, or for segues to last for minutes at a time. Spanish megamix producers tended to utilize a type of segue technique in which elements of various songs would overlap but the overall segue still managed to sound "abrupt." It is useful here to briefly compare a segue from a conventional mix CD and a segue taken from a Spanish megamix.

As an example, the transition from Justice's "Phantom Pt 2" to New Order's "Blue Monday" on Freemasons' mix CD *Shakedown 2* commences at 3:29 of the former track and contains several features to "smoothen" the transition between tracks.[51] Elements of "Blue Monday" are introduced very gradually (3:29–3:59); instrumental parts from both songs overlap for at least thirty seconds, and Freemasons make use of "risers" to iron out any changes in the texture (3:45–3:59). In contrast, note the way that a Spanish megamix segues from one song to another. In Peret's and Castells' *Supermax*, a segue from The Power Jam's "The Power" to Neon's "Cult of Snap" begins at 1:03. Vocals from "Cult of Snap" are combined with "The Power." However, unlike the Freemasons example, the overlapping of tracks only lasts for seven seconds, before "Cult of Snap" takes over entirely. The songs do overlap to a limited extent, but the segue also includes a relatively abrupt switch to "Cult." In short, in the long-form mix CD, the aim is to make transitions as smooth and as seamless as possible, almost to the point of disguising that a segue has occurred. In contrast, Spanish megamix producers seek to draw attention to their work, with "showy" effects and segues that are smooth in part but which retain an element of abruptness.

Making a Segue

So far, I have identified three conventions of Spanish megamixes, all of which are particularly prevalent during the segues from one track to the next: the prevalence of stutter edits and other audio effects; a clear split between three different ways of playing tracks; and a tendency toward semi-abrupt transitions between tracks. I now ask: what can we learn by making one such segue in the style of a Spanish megamix? In order to find out, I have created a segue between two tracks that I produced and for which I own the copyright: "Stay the Night" by Leaves & Twigs and "Bendie" by Ezequiel.[52] (This is in keeping with a pattern established by Spanish megamixes, in which the featured tracks are licensed for use on the megamix.) I will describe the process involved in making the segue and highlight the various ways in which the production process clarified or brought to light conventions of the Spanish megamix.

The steps involved in the preproduction (that is, prior to actually opening a DAW) resembled the kind of preparation people might undertake if they were preparing to play live as a DJ, or if they were preparing to produce a "basic" mashup.[53] For example, the first step was to assemble a list of potential candidates for inclusion in the megamix, and

to note the number of Beats Per Minute (BPM) and key for each track. "Stay the Night" (120 BPM, A-flat minor) and "Bendie" (120 BPM, C minor) were selected as they featured the same tempo. (The tracks are available in the "Spanish megamix" playlist associated with this chapter).[54] In order to make the two tracks more harmonically compatible, "Bendie" was pitch-shifted up one semitone, changing its key to D-flat minor. The next step was to analyze both tracks for potential breakdowns (that is, sections where the texture becomes thinner and individual instruments are foregrounded).[55] My segue draws exclusively on the stereo mixdown of "Stay the Night" and "Bendie," along with an a cappella version of the former track, so it was important to identify any sections where an isolated hand clap, vocal fragment, or snare drum appears. Several such samples are available in the original mix of "Stay the Night." For example, a single note from the bass line is available at 0:41, a solo hand clap appears at 2:54, a white noise crash appears at 4:47, and a drum break appears during 4:32–4:47.

As noted above, these preliminary steps were akin to those one might take if preparing to make a mashup or to perform as a DJ. In the next stage of the production, I tasked myself with creating a segue in the style of a Spanish megamix. This meant choosing from a particular palette of musical techniques learned from existing megamixes. The process of actually making a segue rather than only listening to it helped to clarify several conventions of this format. In particular, the process highlighted the ways in which audio effects need to be adjusted so that they are sufficiently conspicuous—that is, so that they are recognizable *as effects*. Below, I describe the process (often marked by trial and error) of making a segue sound like an extract from a Spanish megamix.

The first aesthetic convention to which I adhered was "more is more." A casual listen to a Spanish megamix suggests that producers in this genre fill all available sonic space with samples playing over the top of existing songs, or with audio effects. It is no coincidence that listeners describe megamixes as "busy" or even "delirious."[56] Any section that features (for instance) a two-beat sample will inevitably be filled with another sample for the subsequent two beats, resulting in a kind of call-and-response effect. We can hear such techniques at 2:55–3:03 of *Max Mix 10*, where a sample from Black Box's "I Don't Know Anybody Else" ("I don't know, I don't know") is "answered" by approximately four beats of record scratching. However, there are limits to how many "fireworks" can be squeezed into 10–15 minutes. An important part of producing the segue was to draw on an intuitive sense of which sections sounded "empty" and which sections required "filling in." For example, at 1:16 of the draft segue, I attempted to "answer" a chopped vocal part from "Stay the Night" with handclaps taken from 2:54 of the same track. However, I eventually deemed this to be insufficient because there was audible "space" remaining at the start of the bar at 1:18, 1:22, 1:26, and 1:30. Furthermore, the handclaps—even though they were taken from "Stay the Night"—could just as well have been handclaps from *anywhere*. They did not create a sufficiently conspicuous sense of multiple tracks being combined. My labor here was not obvious or recognizable enough. Consequently, in the final segue I added a third element—the "Bendie" synth— at 1:24, 1:28, 1:32, and 1:36. In short, I gradually came to realize that I was trying to adhere not just to the "more is more" ethos, but also to an additional, implicit convention: the need to make effects *conspicuous*.

If we compare an early draft of the segue with the final version, we can hear further evidence of the ways in which effects are carefully shaped so as to stand out from the source material.[57] The draft segue cuts directly from a section where the two tracks overlap (0:46–1:01) to "Bendie" playing on its own. It provides no signal that the change

Figure 34.1 Draft of the "Bendie" segue

is about to take place—there are, for instance, no risers alerting the listener that a change is about to occur in the mix at 1:01 (Figure 34.1).

In contrast, the final version of the segue contains several techniques expressly designed to signal an approaching change. At 0:59, I retrigger a two-beat loop of the "Bendie" synth combined with the "Stay the Night" snare drum for a total of eight beats, then begin retriggering both the synth and the snare at steadily decreasing intervals (16th notes, 32nd notes, and so on). At the same time, the synth part has been processed by Ableton Live's "Old Sampler" effect: the signal has been downsampled to give it a grainy, distorted quality. (This change is visualized in Figure 34.2 with a line that has been drawn over the top of the audio waveform.) Finally, the word "baby" from "Stay the Night" has been looped four times, with a gradually increasing level of frequency shifting courtesy of Ableton Live's "Frequency Shifter" effect. In short, the transition from "Stay the Night" to "Bendie" has been changed in order to increase the conspicuousness of the effects (Figure 34.2).

Another way in which effects can be made conspicuous is to ensure that they sound suitably "artificial." This was evident when I reprogrammed a sample so as to resemble another track entirely. An example of this technique can be heard in *Maquina Total 8* between 3:52 and 3:58, where a sample of Molella's "If You Wanna Party" has been retriggered ("if- if- if- if- if- if you wanna") and the stuttered "ifs" form the melody of Beethoven's *Für Elise*.[58] Similarly, at 10:14 of *Bolero Mix 30*, the bass line and kick drum of R.I.O.'s "When the Sun Comes Down" is stuttered so as to mimic the bass line of Queen's "Another One Bites the Dust."[59] I created something similar at 1:22 and 1:30 of the segue. The "baby" vocal sample from "Stay the Night" has been chopped and rearranged to resemble the opening synth riff of "Bendie." Here, too, the act of producing a segue highlighted additional norms of the Spanish megamix. In this case, I deliberately adjusted the software's warping settings so that the algorithm would not apply formant preservation. Formant preservation allows one to pitch-shift a human voice upward without the familiar "chipmunk" effect that we would hear if speeding up a record on a turntable. Formant preservation was actually undesirable in this instance, because the aim was to make the effect *sound like an effect*. The sound of the Spanish megamix has been shaped in large part by the technologies that were dominant in the

Figure 34.2 The final version of the segue signals an approaching change

heyday of Spanish megamixes (that is, magnetic tape and early digital samplers). Therefore, the aim was to make the sample sound like it has been pitch-shifted upwards and downwards: to make it sound deliberately "artificial."

The process of making the segue highlighted the hidden labor that goes into megamixes. For example, there are sections where the "more is more" philosophy has been tried, tested, and discarded, partly to serve another unspoken "rule" of the Spanish megamix: the audio effects need to be fully recognizable as *alterations* of a song, rather than being heard as the way the song was originally recorded. For example, in the draft segue, the "Stay the Night" bass line was stuttered to form a rhythm familiar from many Spanish megamixes. (For instance, listen to *Max Mix 8* at 0:00, *Max Mix 9* at 0:06 and 0:19, and *Max Mix 10* at 0:08.) On the one hand, this strategy fulfilled the "more is more" requirement: more notes played in a short space of time. However, I eventually revised this section because it did not (to my ears, at least) sound adequately stuttered. In its place, I introduced a sparser stutter effect, adding several bursts of white noise lifted from the end of "Stay the Night." To drive home the idea that this section had, in fact, been cut-and-pasted, I allowed the white noise to stop and start without any kind of delay effect or "cushioning" envelope. In the final version of the segue, the recording sounds like it has been abruptly stopped and started, much like an early megamix in which tape has been cut-and-spliced to form a stutter edit. Thus, I learned that producers cannot arbitrarily cram more and more iterations of a sample into smaller and smaller slivers of time. They must constantly juggle the "more is more" approach with the need to keep their effects recognizable as effects.

Conclusion

Several features of the Spanish megamix discussed above can be documented quantitatively. For example, we could map gradual shifts that have occurred in the form in much the same way that Cottrell mapped the BPMs of recordings in several British library music collections.[60] We could, for instance, observe the prevalence of stutter edits in

1980s megamixes compared with the prevalence of similar effects in post-2000s mega-mixes. One drawback of such quantitative approaches, however, is that they measure aspects of the *finished product*: that is, the stereo mix that has been mastered and released. To borrow musicologist Allan Moore's phrase, such studies analyze completed sound recordings as "the primary text."[61] These studies yield many useful insights about music, but they are less able to capture the trial-and-error process that led to a particular instan-tiation of the music. To put it differently, quantitative methods that focus on the final product cannot necessarily tell us where a musician has deleted or amended material, because the deleted material never makes it to the final recording.

This chapter has illustrated that digital humanities approaches may also be adopted as part of a more qualitative analysis. In this chapter, I have explored the process of making a segue in the style of a Spanish megamix. This has shed light on several features that would be missed in a large-scale quantitative analysis. Conventions that were for-merly merely intuited became clearer. The process of trying to adhere to the norms of a genre—and sometimes failing to encapsulate those norms—helped call attention to the norms in the first place, in a way which is not always possible by only listening to fin-ished examples of the genre. Focusing on Spanish megamixes is important not only as a way of theorizing the solidification of a musical genre; it is also important because much of the existing literature in remix studies focuses on Anglo-American examples of popu-lar music. This research shines a light on a popular form of music that is closely related to those examples but has hitherto been excluded from most histories of sample-based popular music.

Notes

1 For example, see: Chris Kennett, "Is Anybody Listening?" in *Analyzing Popular Music*, ed. A. F. Moore (Cambridge: Cambridge University Press, 2003): 199–204; Tia DeNora, *Music in Everyday Life* (Cambridge: Cambridge University Press): 21–45.

2 Mary Caton Lingold, Darren Mueller, and Whitney Trettien, "Introduction," in *Digital Sound Studies*, ed. Mary Caton Lingold, Darren Mueller, and Whitney Trettien (Durham: Duke University Press, 2018): 9; Stephen Cottrell, "Big Music Data, Musicology, and the Study of Recorded Music: Three Case Studies," *The Musical Quarterly* 101, no. 2–3 (2018): 216–43.

3 Matthew Wilkens, "Canons, Close Reading, and the Evolution of Method," in *Debates in the Digital Humanities*, ed. M. K. Gold (Minneapolis, MN: University of Minnesota Press, 2012): 249–52.

4 Tai Neilson, lewis levenberg, and David Rheams, "Introduction: Research Methods for the Digital Humanities," in *Research Methods for the Digital Humanities*, ed. l. levenberg, T. Neilson, and D. Rheams (Cham: Palgrave Macmillan, 2018): 3.

5 Miqui Otero, "'Megamix', una historia de DJ, matones, y negocios discográficos," *El País Semanal*, 30 May 2015, http://www.elpais.com/elpais/2015/05/29/eps/1432894707_819498.html.

6 Christine Boone, "Mashing: Toward A Typology of Recycled Music," *Music Theory Online* 19, no. 3 (2013): 1-14. http://www.mtosmt.org/issues/mto.13.19.3/mto.13.19.3.boone.php.

7 Richard Middleton, "Work-in(g)-Practice: Configurations of the Popular Music Intertext," in *The Musical Work: Reality or Invention?*, ed. Michael Talbot (Liverpool: University of Liverpool Press, 2000): 59–87; Jonathan David Tankel, "The Practice of Recording Music: Remixing as Recoding," *Journal of Communication* 40, no. 3 (1990): 34–46.

8 Eduardo Navas, "Regressive and Reflexive Mashups in Sampling Culture," in *Mashup Cultures*, ed. Stefan Sonvilla-Weiss (New York: Springer, 2010): 165–6; Jeremy J. Beadle, *Will Pop Eat Itself? Pop Music in the Soundbite Era* (London: Faber and Faber, 1993): 64.

9 Max Music, accessed 26 December 2019, https://www.discogs.com/label/26727-Max-Music.

10 For examples of close reading, see Anne Danielsen and Arnt Maasø, "Mediating Music: Materiality and Silence in Madonna's 'Don't Tell Me,'" *Popular Music* 28, no. 2 (2009): 127–42; Frederike Arns, Mark Chilla, Mikko Karjalainen, Esa Lilja, Theresa Maierhofer-Lischka, and Matthew Valnes, "Interpreting

Meaning in/of Janelle Monáe's 'Tightrope': Style, Groove and Production Considered," in *Song Interpretation in 21st Century Pop Music*, ed. Ralf von Appen, André Doehring, Dietrich Helms, and Allan F. Moore (Surrey: Ashgate, 2015): 197–212.

11 Franco Moretti, *Distant Reading* (London: Verso, 2013).

12 Chris Kennett, Review of *The Beatles: Sgt. Pepper's Lonely Hearts Club Band*, Allan Moore, *Popular Music* 19, no. 2 (2000): 263–4.

13 Philip Tagg, *Music's Meanings: A Modern Musicology for Non-Musos* (New York: The Mass Media Music Scholars' Press, 2013): 129.

14 Thomas Hedges, Pierre Roy, and François Pachet, "Predicting the Composer and style of Jazz Chord Progressions," *Journal of New Music Research* 43, no. 3 (2014): 276–90.

15 Ibid., 287.

16 Cottrell, "Big Music Data," 216–43.

17 Ibid., 231.

18 Ibid., 216.

19 Neilson, levenberg, Rheams, "Introduction," 3.

20 Otero, "Megamix."

21 Ibid.

22 Guille Mieza, "MAX MIX 'Megamix Show' (CON SUBTÍTULOS)," 9 May 2015, accessed 20 December 2019, http://www.youtube.com/watch?v=DZcvD6PfFLM.

23 Liner notes for Various Artists, *Max Mix 30 Aniversario* (Blanco Y Negro Records MXCD3002, 2015), accessed 6 January 2020, http://www.discogs.com/Various-Max-Mix-30-Aniversario-Vol-2-La-Leyenda-Del-Primer-Megamix-Español/release/7867264.

24 Various Artists, *Max Mix 4* (Max Music LP 210-1, 1986), accessed 21 July 2020, http://www.discogs.com/Various-Max-Mix-4/release/325369.

25 Various Artists, *Lo + Duro* (Max Music NM 685 DFTV, 1993), accessed 21 July 2020, https://www.discogs.com/Various-Lo-Duro/release/840835; Various Artists, *Maquina Total 8* (Max Music PM 1400 CDTV, 1995), accessed 21 July 2020, https://www.discogs.com/Various-Maquina-Total-8/release/329804; Various Artists, *Ibiza Mix* (Max Music NM 930 CDTV, 1994), accessed 21 July 2020, https://www.discogs.com/Various-Ibiza-Mix/release/1138167.

26 Various Artists, *Megabass* (Telstar TCD 2425, 1990), accessed December 2019, https://www.discogs.com/Various-Megabass/release/237246.

27 Technotronic, *Megamix* (ARS/Clip Records 145 716-3, 1990), accessed 4 January 2020, http://www.discogs.com/Technotronic-Megamix/release/211120.

28 Snap!, *Mega Mix* (Logic Records 614 169, 1991), accessed 4 January 2020, https://www.discogs.com/Snap-Mega-Mix/release/190512.

29 Bobby Brown, *Every Little Hit Mix* (MCA Records 0-257311, 1989), accessed 4 January 2020, http://www.discogs.com/Bobby-Brown-Every-Little-Hit-Mix/release/3927129.

30 3-D, "Tommy Boy Megamix" (Tommy Boy TBLP 1005, 1985), accessed 4 January 2020, http://www.discogs.com/3-D-Tommy-Boy-Megamix/release/1479269. For discussion of this megamix, see Navas, "Regressive," 165–6.

31 Navas, "Regressive," 165–6.

32 *Max Mix 30 Aniversario—Las Entrevistas al Completo*, accessed 11 November 2019, http://www.youtube.com/watch?v=on7sU4n2cts. Translation by Manuel Merida.

33 See Adrian Renzo, "Seamless: Exploring the Segue in 1980s Medley Records," *Musicology Australia* 34, no. 2 (2012): 259–76.

34 Various Artists, *Mas Mix Que Nunca!!!* (Memory Records ME LP 004, 1986), accessed 6 January 2020, http://www.discogs.com/Mike-Platinas-Javier-Ussia-Mas-Mis_Que-Nunca/release/1367803.

35 Liner notes for *Max Mix 30 Aniversario*.

36 Robert Fink, "When the Music Stutters: Notes Toward A Symptomatology," in *Over and Over: Exploring Repetition in Popular Music*, ed. Olivier Julien and Christophe Levaux (London: Bloomsbury, 2018), 15.

37 See: https://www.discogs.com/label/294582-Max-Mix.

38 *Max Mix 30 Aniversario—Las Entrevistas al Completo*, accessed 11 November 2019, http://www.youtube.com/watch?v=on7sU4n2cts. Translation by Manuel Merida.

39 *Megamix Show* (9 May 2015), accessed 20 December 2019, http://www.youtube.com/watch?v=DZcvD6PfFLM.

40 Various Artists, *Max Mix 4* (Max Music LP 210-1, 1986), accessed 21 July 2020, http://www.discogs.com/Various-Max-Mix-4/release/325369.

41 Various Artists, *Max Mix 9* (Max Music LP 383-X, 1989), accessed 21 July 2020, http://www.discogs.com/Various-Max-Mix-9/release/199731.

42 Various Artists, *Max Mix 4*; Various Artists, *Max Mix 10* (Max Music LP 410-X, 1990), accessed 21 July 2020, http://www.discogs.com/Various-Max-Mix-10/release/325401.

43 Various Artists, *Supermax* (Max Music, MDB 444, 1990), accessed 25 December 2019, http://www.discogs.com/Various-Supermax/release/689502.

44 Various Artists, *Megabass* (Telstar, STAR 2425, 1990), accessed 7 January 2020, http://www.discogs.com/Megabass-The-Mastermixers-The-Intense-Mixes-The-Extreme-Mixes/master/24745.

45 Latino Rave, *Deep Heat 89* (BMG, 12 DEEP 10, 1989), accessed 10 January 2020, http://www.discogs.com/Latino-Rave-Deep-Heat-89/release/180997.

46 Various Artists, *Let's Do It In The 80s Great Hits* (Alto Passion AL-1001, 1980), accessed 7 January 2020, http://www.discogs.com/Various-Lets-Do-It-In-The_80s-Great-Hits/release/214092. See also: Patrick Lejeune, *Disco Patrick Presents: The Bootleg Guide to Disco Acetates, Funk, Rap and Disco Medleys* (Netherlands: Patrick Lejeune and Patrick Vogt, 2007): 159.

47 Chris Zaldua, review of Osymyso's "Intro-Inspection," *Brainwashed* (8 June 2002), accessed 4 January 2020, http://www.brainwashed.com/index.php?option=com_content&view=article&id=4403:osymyso-qintro-inspectionq&Itemid=133. See Aram Sinnreich, *Mashed Up: Music, Technology, and the Rise of Configurable Culture* (Amherst, MA: University of Massachusetts Press, 2010): 103.

48 Tim Lawrence, "The Forging of a White Gay Aesthetic at the Saint, 1980-4,"in *DJ Culture In the Mix: Power, Technology, and Social Change in Electronic Dance Music*, ed. B. A. Attias, A. Gavanas, and H. C. Rietveld (London: Bloomsbury, 2013): 240–1.

49 Ibid.

50 For example, see Various Artists, *Ministry of Sound Clubbers Guide to 2011* (Ministry of Sound MOSA125, 2011), accessed 17 January 2020, http://www.discogs.com/Goodwill-Tom-Piper-Clubbers-Guide-To-2011/release/3703898.

51 Freemasons, *Shakedown 2* (Loaded Records LOADED14CDX, 2009), accessed 23 December 2019, http://www.discogs.com/Freemasons-Shakedown-2/release/1931388?ev=rr.

52 The playlist is available on SoundCloud, accessed 17 January 2020, http://www.soundcloud.com/user-145292978/sets/spanish-megamix.

53 Boone, "Mashing."

54 Both tracks are available in the following playlist, accessed 17 January 2020, http://www.soundcloud.com/user-145292978/sets/spanish-megamix.

55 Frank Broughton and Bill Brewster, *How to DJ (Properly): The Art and Science of Playing Records*, second edition (London: Bantam, 2006): 77.

56 Otero, "Megamix."

57 Both the draft and the final versions of the segue are available in this playlist, accessed 17 January 2020, http://www.soundcloud.com/user-145292978/sets/spanish-megamix.

58 Various Artists, *Maquina Total 8* (Max Music PM 1400 CDTV, 1995), accessed 21 July 2020, http://www.discogs.com/Various-Maquina-Total-8/release/329804.

59 Various Artists, *Bolero Mix 30* (Blanco Y Negro MXCD 2722 (CD), 2014), accessed 21 July 2020, http://www.discogs.com/Various-Bolero-Mix-30/release/5732243.

60 See Cottrell, "Big Music Data."

61 Allan F. Moore, *Rock, the Primary Text: Developing a Musicology of Rock*, second edition (Burlington, VT: Ashgate, 2001).

Bibliography

Arns, Frederike, Mark Chilla, Mikko Karjalainen, Esa Lilja, Theresa Maierhofer-Lischka, and Matthew Valnes. "Interpreting Meaning in/of Janelle Monáe's 'Tightrope': Style, Groove and Production Considered." In *Song Interpretation in 21st Century Pop Music*, edited by Ralf von Appen, André Doehring, Dietrich Helms, and Allan F. Moore, 197–212. Surrey: Ashgate, 2015.

Beadle, Jeremy J. *Will Pop Eat Itself? Pop Music in the Soundbite Era*. London: Faber and Faber, 1993.

Boone, Christine. "Mashing: Toward A Typology of Recycled Music." *Music Theory Online* 19, no. 3 (2013): 1–14. http://www.mtosmt.org/issues/mto.13.19.3/mto.13.19.3.boone.php.

Broughton, Frank, and Bill Brewster. *How to DJ (Properly): The Art and Science of Playing Records*. Revised Edition. London: Bantam, 2006.

Cottrell, Stephen. "Big Music Data, Musicology, and the Study of Recorded Music: Three Case Studies." *The Musical Quarterly* 101, no. 2–3 (2018): 216–43.

Danielsen, Anne, and Arnt Maasø. "Mediating Music: Materiality and Silence in Madonna's 'Don't Tell Me'." *Popular Music* 28, no. 2 (2009): 127–42.

DeNora, Tia. *Music in Everyday Life*. Cambridge: Cambridge University Press, 2000.

Fink, Robert. "When the Music Stutters: Notes Toward a Symptomatology." In *Over and Over: Exploring Repetition in Popular Music*, edited by Olivier Julien, and Christophe Levaux, 13–36. London: Bloomsbury, 2018.

Hedges, Thomas, Pierre Roy, and François Pachet. "Predicting the Composer and Style of Jazz Chord Progressions." *Journal of New Music Research* 43, no. 3 (2014): 276–90.

Kennett, Chris. "Is Anybody Listening?" In *Analyzing Popular Music*, edited by Allan F. Moore, 196–217. Cambridge: Cambridge University Press, 2003.

Kennett, Chris. "Review of *The Beatles: Sgt. Pepper's Lonely Hearts Club Band*, Allan Moore." *Popular Music* 19, no. 2 (2000): 262–4.

Lawrence, Tim. "The Forging of a White Gay Aesthetic at the Saint, 1980–4." In *DJ Culture in the Mix: Power, Technology, and Social Change in Electronic Dance Music*, edited by Bernardo Alexander Attias, Anna Gavanas, and Hillegonda C. Rietveld, 219–45. London: Bloomsbury, 2013.

Lejeune, Patrick. *Disco Patrick Presents: The Bootleg Guide to Disco Acetates, Funk, Rap and Disco Medleys*. Netherlands: Patrick Lejeune and Patrick Vogt, 2007.

Lingold, Mary Caton, Darren Mueller, and Whitney Trettien. "Introduction." In *Digital Sound Studies*, edited by Mary Caton Lingold, Darren Mueller, and Whitney Trettien, 1–25. Durham: Duke University Press, 2018.

Middleton, Richard. "Work-in(g)-Practice: Configurations of the Popular Music Intertext." In *The Musical Work: Reality or Invention?*, edited by Michael Talbot, 59–87. Liverpool: University of Liverpool Press, 2000.

Mieza, Guille. "MAX MIX 'Megamix Show' (CON SUBTÍTULOS)." *Filmed at Centre de Cultura Contemporània de Barcelona*, 9 May 2015, 37:38. http://www.youtube.com/watch?v=DZcvD6PfFLM.

Moretti, Franco. *Distant Reading*. London: Verso, 2013.

Moore, Allan F. *Rock, The Primary Text: Developing a Musicology of Rock*. 2nd Edition. Burlington, VT: Ashgate, 2001.

Navas, Eduardo. "Regressive and Reflexive Mashups in Sampling Culture." In *Mashup Cultures*, edited by Stefan Sonvilla-Weiss, 157–77. New York: Springer, 2010.

Neilson, Tai, levenberg lewis, and Rheams, David. "Introduction: Research Methods for the Digital Humanities." In *Research Methods for the Digital Humanities*, edited by lewis levenberg, Tai Neilson, and David Rheams, 1–14. Cham: Palgrave Macmillan, 2018.

Otero, Miqui. "'Megamix', Una Historia de DJ, Matones, Y Negocios Discográficos." *El País Semanal*, 30 May 2015, http://www.elpais.com/elpais/2015/05/29/eps/1432894707_819498.html.

Renzo, Adrian. "Seamless: Exploring the Segue in 1980s Medley Records." *Musicology Australia* 34, no. 2 (2012): 259–76.

Sinnreich, Aram. *Mashed Up: Music, Technology, and the Rise of Configurable Culture*. Amherst, MA: University of Massachusetts Press, 2010.

Tagg, Philip. *Music's Meanings: A Modern Musicology for Non-Musos*. New York: The Mass Media Music Scholars' Press, 2013.

Tankel, Jonathan David. "The Practice of Recording Music: Remixing as Recoding." *Journal of Communication* 40, no. 3 (1990): 34–46.

Wilkens, Matthew. "Canons, Close Reading, and the Evolution of Method." In *Debates in the Digital Humanities*, edited by Matthew K. Gold, 249–58. Minneapolis, MN: University of Minnesota Press, 2012.

Zaldua, Chris. "Review of Osymyso's 'Intro-Inspection.'" *Brainwashed* (8 June 2002), http://www.brainwashed.com/index.php?option=com_content&view=article&id=4403:osymyso-qintro-inspectionq&Itemid=133 (accessed 4 January 2020).

Discography

3-D. *Tommy Boy Megamix*. Tommy Boy TBLP 1005, 1985.

Brown, Bobby. *Every Little Hit Mix*. MCA, 0-258311, 1989.

Freemasons. *Shakedown 2*. Loaded Records, LOADED14CD, 2009.

Latino Rave. *Deep Heat 89*. BMG 12 DEEP 10, 1989.

Osymyso. *Intro-Inspection*. Radar 101, 2002.

Passion. *Let's Do It In The 80s Great Hits*. Alto, AL-1001, 1980.

Snap! *Megamix*. Logic 614 169, 1991.

Stars On 45. *Long Play Album*. Mercury 6302 129, 1981.

Technotronic. *Megamix*. Possum POST 604, 1990.

Various Artists. *Bolero Mix 6*. Blanco Y Negro, MXCD 243, 1990.

Various Artists. *Bolero Mix 7*. Blanco Y Negro, MXCD 258, 1990.

Various Artists. *Bolero Mix 8*. Blanco Y Negro, MXCD 290 (B) CTV, 1991.

Various Artists. *Bolero Mix 9*. Blanco Y Negro, MXCD 360 (B) CTV, 1992.

Various Artists. *Bolero Mix 10*. Blanco Y Negro, MXCD 465 (B) CTV, 1994.

Various Artists. *Bolero Mix 30*. Blanco Y Negro, MXCD 2722 (CD), 2014.

Various Artists. *House Energy Revenge: The Golden Years of Italo House*. Blanco Y Negro, MXCD 3084 (B), 2015.

Various Artists. *Ibiza Mix*. Max Music, NM 930 CDTV, 1994.

Various Artists. *Lo + Duro*. Max Music, NM 685 LFTV, 1993.

Various Artists. *Maquina Total 8*. Max Music, PM 1400 CDTV, 1995.

Various Artists. *Maquina Total: Lo + Duro De Los 90*. Blanco Y Negro, MXCD 2794, 2014.

Various Artists. *Mas Mix Que Nunca*. Memory Records, ME LP 004, 1986.

Various Artists. *Max Mix: El Primer Megamix Español*. Max Music, LP-112, 1985.

Various Artists. *Max Mix 2*. Max Music, LP 135, 1985.

Various Artists. *Max Mix 3*. Max Music, LP 185, 1986.

Various Artists. *Max Mix 4*. Max Music, LP 210-1, 1986.

Various Artists. *Max Mix 5 (1ª Parte)*. Max Music, LP 261, 1987.

Various Artists. *Max Mix 5 (2ª Parte)*. Max Music, LP 275, 1987.

Various Artists. *Max Mix 6*. Max Music, LP 305-X, 1988.

Various Artists. *Max Mix 6 (ZYX Edition)*. ZYX 20115, 1988.

Various Artists. *Max Mix 7*. Max Music, LP 316-X, 1988.

Various Artists. *Max Mix 8*. Max Music, LP 355-X, 1989.

Various Artists. *Max Mix 9*. Max Music, LP 383-X, 1989.

Various Artists. *Max Mix 10*. Max Music, LP 410-X, 1990.

Various Artists. *Max Mix 11*. Max Music, LP NM 480 LCTV, 1991.

Various Artists. *Max Mix 12*. Max Music, NM 635 LFTV, 1992.

Various Artists. *Max Mix 30 Aniversario Vol. 1*. Blanco Y Negro MXCD3000, 2015.

Various Artists. *Max Mix Collection*. Max Music, LP 377, 1989.

Various Artists. *Megabass*. Telstar, TCD 2425, 1990.

Various Artists. *Megabass 2*. Telstar, TCD 2448, 1990.

Various Artists. *Megabass 3*. Telstar, TCD 2483, 1991.

Various Artists. *Ministry of Sound Clubbers Guide to 2011*. Ministry of Sound MOSA125, 2011.

Various Artists. *Supermax*. Max Music, LP 444-X, 1990.

35

SCRATCH VIDEO

Analog Herald of Remix Culture

Nick Cope

I don't know what comes after remix. But if we now try… to develop a better historical and theoretical understanding of [the] remix era, we will be in a better position to recognize and understand whatever new era … will replace it.

Manovich[1]

Scratch is a genre of video art that emerged in the United Kingdom during the early 1980s, which utilized the ready availability of recently developed domestic video recording technologies to "make achievable the first truly edit based video [art] form."[2] Scratch artists reedited and recontextualized broadcast television footage, recorded on domestic VHS or Betamax video recorders, often facilitated by low-budget local community or art school editing systems. Although the movement was short-lived, it had significant impact on the contemporary video art and media worlds, received diverse critical acclaim, entered video art histories and has been a topic for reappraisals in more recent times. As one of the new generation of video artists creating and screening work at the time and later an academic, researcher, and filmmaker, I have found myself in a position to contribute to the histories and contexts of Scratch Video through both publications and more recent screenings,[3] drawing on personal experience, engagement, and insight, in addition to primary and secondary research. In "Scratch Video Revisited,"[4] I sought to disrupt some of the fixed views coalescing around the video art genre that had arisen and highlight some of the key thinking that has cast new perspectives on the role and significance of Scratch for British radical film culture and history, concluding that Scratch can be seen as a key herald of the "remix culture" Lev Manovich sees as already a truism by 2007;[5] and of the cultures of creativity, explored by Lawrence Lessig, that challenge copyright conventions and the regulating of expression.[6] In this chapter, I seek to unpack the ways in which Scratch acts as this herald and examine the contexts of remix theory and culture informed by the development and practices which Scratch explored.

Scratch Video's roots lie in rapidly emerging analog media technology developments of the late 1970s in both the audio and video industries, and in the DIY (Do-It-Yourself) music cultures which developed around these technologies. Barely covered in video art histories is the fact that Scratch arises from, was influenced by, and operated within the networks spawned through the independent music sector as much as through video art.

With close affiliations to the post-punk and industrial music scenes, Scratch Video's influences lie as much in the critical and contextual histories of music as they do in media and art. Technologically and organizationally Scratch looked to models of music composition, postproduction, and distribution, drawing on influences from dub reggae, hip hop, and post-punk. William Burroughs's cut-up techniques permeate the post-punk industrial music culture in which various Scratch artists were well versed. Scratch realized the multimedia potentials of tape-based formats that musique concrète ushered in for the sonic. In its methods and techniques of composition, for visual effect and affect, it emphasized the blend and the fold in its remixing of televisual cultures and in so doing created new forms of audiovisual aesthetic, challenged copyright law and anticipated digital, Internet, mashup, plunderphonic and remix cultures yet to come.

A Brief History of Scratch

Scratch owes what prominence it has in the video art histories in which it makes its fleeting appearances to two key players in particular who have until now received little acknowledgment and recognition for the roles they played. Through an overview of their contribution and activities with regards to Scratch, a brief history of the movement can be mapped out.

The first of these key players is French artist Bruno de Florence, creator of the "Video Lounge" in the Fridge nightclub, Brixton. Shortly after the 1981 Brixton riots, Andrew Czezowski and Susan Carrington, founders of the legendary punk rock venue The Roxy, opened their new club, The Fridge, above the Iceland frozen food store, Brixton Road, London. They invited de Florence to create an installation of twenty-five old television sets, stacked up and chained together by a dance floor, integrating moving image culture into the club's visual design, with "a pyramid of broken TVs showing John Maybury videos as part of a radical décor that included beat-up fridges and (fake) dead cats hanging from its ceiling."[7] The Fridge became the first-ever regular venue for video in a nightclub in the world, and de Florence ran twice-weekly screenings, where several sources of video could be sent simultaneously to the installation of television screens. He invited video makers to screen work at the Video Lounge drawing together an eclectic mix of young practitioners, pioneering what came to be known as Scratch Video. Contributing video artist George Barber observed,

> At its best for about seven months, various makers would turn up with their latest work and sit around while a sizeable crowd – who'd probably never even heard of independent videos – watched their handiwork on banks of old DER monitors, some upside down, some even, artistically of course (what else?), on the blink.[8]

The ready availability of VHS domestic video recorders introduced into Britain in 1978 saw them becoming more affordable, technically sophisticated, and widespread by the early 1980s,[9] which facilitated the easy and cheap recording of off-air broadcast television footage. Reediting and recontextualizing this footage was the modus operandi of this new generation of video artists, sometimes using image processors to affect the color, texture, size, shape, and montage; often, "to create parody," with "Reagan, Thatcher and the 'military industrial complex' as main targets," Scratch Video was "politically astute

and sharply cut (often to rock soundtracks)."[10] The radical implications of these new technologies recognized by Birtwistle,

> For the first time ever, the sounds and images of broadcast television became permanently available to almost anyone who wanted to record them. This not only provided scratch artists with the material content of their work, but also signaled a change in the relationship between the producers and consumers of television. In short, the VCR prompted and supported a culture of audiovisual appropriation that found its most immediate manifestation in scratch.[11]

Scratch artist George Barber credits journalist Pat Sweeney with coining the term Scratch Video in 1984 "comparing it to New York's Hip Hop scene,"[12] which by 1982 was well established and making in-roads into UK club and music culture.[13] Significantly, new edit suite hardware that could facilitate video editing accuracy to within one-fifth of a second or more was becoming cheaper, easier to use, and more accessible, in particular via community video workshops and art colleges. Barber noted "Editing was central to Scratch...The first wave of 'decent' technology did indeed help delineate an aesthetic and make achievable the first truly edit based video form."[14]

Scratch Videos were not only radical, pioneering, and challenging in their reappropriation of off-air broadcast television footage, political content, and themes; but also, in creating works that operate as visual music compositions, often drawing on contemporary popular music as a key component, though not specifically made as record promos. Designed to be screened in nightclub venues, as much as on a TV monitor, and to be listened to as much as seen, Barber notes: "nightclubs... helped ground an aesthetic for ... Scratch – one of 'visual pleasure'... Scratch looked its best in nightclubs rather than screenings, clubs were its spiritual home."[15] My own memories of screening work at the Fridge in 1984 are of a wall of TV screens across which the images danced and jumped, alongside a physical dance floor, with the soundtrack pumping out through the nightclub sound system. Birtwistle, in writing about Scratch, draws attention to the sensory blending that can occur in the club experience; a fusion of sound, image, and bodily movement, a form of trans-sensoriality "to which Scratch Video aspires in its synaesthetic articulation of sound and image."[16] Andy Birtwistle, writing in 2010, places Scratch in new and emerging contexts of affective cinema and audiovisuality, what he defines as cinesonics, maintaining that Scratch was pioneering forms of audiovisual practice ahead of critical discourse. These radical leaps and turns of Scratch arise with the pioneering vision of the Fridge founders for a nightclub experience that fused audiovisual content, realized by de Florence's installation and curation of the Video Lounge space. De Florence's proclivity for engendering radical media practice would not end with his significant role in the emergence of Scratch, and his work at the Fridge. He continued to challenge mainstream British media, by setting up and running London's only pirate TV station, Network 21, in 1986.[17]

The other overseen, and little acknowledged, key player in raising the profile of Scratch beyond a nightclub sideshow (and ultimately into the annals of video art history) is journalist, activist, and later broadcaster, Andy Lipman. I first met Lipman as I queued to get into the Fridge to screen my own work in the summer of 1984; as editor of the video column in London listings magazine, City Limits, he made it his business to get to know all the artists screening work at The Fridge and immediately recognized the radical and pioneering nature of Scratch.

Lipman had been involved in community video work since 1980, project coordinating the Grierson Award-winning documentary "Framed Youth" in 1983, recognized by Ieuan Franklin as "a high watermark in the history of both community video and the realization or fulfilment of Channel 4's [public service] remit."[18] The documentary arose from a South London community video project coordinated by Lipman with Philip Timmins, which facilitated a group of twenty-five gay and lesbian young people to acquire and share video production skills both behind and in front of the camera. Launching the careers of both musician Jimmy Somerville and artist and filmmaker Isaac Julien among others, the film, Franklin notes: "can be regarded as an early example of Scratch Video" through its use of a collage of found footage, including cartoons, news clips and TV drama excerpts, and inspired Lipman to become "an evangelist for the art of the video remix."[19]

Lipman's evangelizing of Scratch began with a two-page spread, making the front cover of City Limits in October 1984. His article "Scratch and Run" extolled its radical potential, noting the connection to hip hop, and emphasized the "interactive response to the one-way arrogance of broadcast television" through a fluidity of video editing, "more akin to sound-mixing than montage film techniques, with a healthy critique of the mass media." Lipman wrote,

> Hip hop video, image break-dancing: television does a body pop. Broadcast TV is scoured for arresting images and fed into video editing systems like shredding machines. The fusion of funk rhythms and visuals on collision course crumble original context. Reassurance and sweet reason, television's facade disintegrate before your bombarded eyes ... If television is our shop window on the world, scratch has just chucked a brick through it and is busy looting 30 years of goodies, with abandon.[20]

Lipman specifically named work by Nocturnal Emissions, Duvet Brothers, Kim Flitcroft and Sandra Goldbacher, Paul Maben/Protein Video, George Barber, Derek Jarman, Cerith Wynn Evans, Richard Heslop, The Anti Group, Psychic TV/Genesis P-Orridge, Doublevision and IKON, Clive Gillman, Graham Young, Steve Hawley, Jez Welsh and Nick Cope. Drawing reference to underlying themes of political oppositional practices, strategies of questioning and subverting broadcast television, and a loose alliance of alternative and "industrial music" practices and practitioners, video artists, arts organizations, and pop cultural remixing, Lipman acknowledged a diverse collection of individuals and groups working with video.

In partnership with de Florence, Lipman curated a series of screenings at the Institute of Contemporary Arts in central London in December 1984, the first Scratch gallery screenings. "Scratch Television: Watch This Space" featured work by many of the abovementioned artists, myself included, as well as Peter Savage, Graham Young, Bob Cuthbertson, and Slack Video. Its impact was swift and further gallery screenings followed. The Film and Video Umbrella organized a touring programme of screenings throughout the United Kingdom, Europe, and Australia; and a further programme of Scratch was screened in April 1985 at the Tate Gallery, London. Lipman also managed to engineer a brief appearance of Scratch on broadcast television, curating "Scratch Now! The state of the art" as part of "Channel 5: A Showcase for Video," a project that ran throughout September 1985 in London to accompany screenings of the UK Channel 4 television series, "The Eleventh Hour," that same month. Three TV episodes

covered contemporary British video art, with one episode dedicated to Scratch presented by Lipman and fellow video critic, Sean Cubitt. Scratch faced a number of challenges in its encounter with broadcast media; technical broadcast quality thresholds have long been a hurdle for non-broadcast quality formats to negotiate in order to be screened, and a further hurdle was copyright clearance;[21] broadcasters were very reluctant to allow for news recordings to be used in any other context, and also wanted to charge prohibitively high costs for permission to use off-air footage.

This only ever appearance of Scratch on broadcast television followed a screening of work at the Edinburgh Television Festival the previous month. Lipman, in partnership with Film and Video Umbrella's Michael O'Pray, Arts Council film officer David Curtis and Scratch artists George Barber and Tim Morrison, presented a programme of Scratch at the festival. This screening is said to have had an immediate impact "on astonished TV executives" with Scratch methodologies and devices subsequently appropriated into televisual culture at an alarming speed.[22] Lipman, Scratch's first flag-waver, became its pallbearer, declaring "Scratch: Dead on Arrival" and that "Scratch Video has not only arrived, it's already mainstream."[23]

While broadcast television offered little opportunity to bring Scratch to a wider audience, and sought only to appropriate style and technique, George Barber utilized a key potential of the new domestic video formats, that of affordable independent copying, distribution, and sale, to take the work to its audience. In 1984 and 1985, Barber compiled two collections: "The Greatest Hits of Scratch Video 1 & 2," and self-distributed these by mail order on VHS cassette. This garnered significant press coverage, including a feature in the national Sunday Times magazine, and sold around 800 copies, significantly more than many other video distribution projects of the time.[24] The first thirty-minute volume brought together works by Barber, The Duvet Brothers (Rik Lander and Peter Boyd-Maclean), Kim Flitcroft and Sandra Goldbacher, John Scarlett-Davis, Jeffrey Hinton, and John Maybury. The second saw work by Gorilla Tapes (Gavin Hodge, Jean McClements, Jon Dovey, and Tim Morrison) join further work by Barber, Flitcroft and Goldbacher, and the Duvet Brothers. Together, they established a canon of Scratch works through the comprehensive collection of pieces and the publicity the tapes received.

With the swift recuperation of Scratch methodologies by broadcasters, other than the Film and Video Umbrella touring programme and live-multiscreen shows by the Duvet Brothers, most artists moved onto other work and Scratch became a short-lived, albeit highly significant, cultural phenomenon.

Initial critical responses to Scratch tended to be partisan, harsh, and damning,[25] with later reappraisals beginning to recognize and acknowledge the political importance, effectiveness, and impact of the movement.[26] Birtwistle significantly noted that the profound and radical exemplar in innovative sound and compositional practice of Scratch was a radical challenge to its critics, ahead of its time and the critical discourse prevalent in the early 1980s.[27] Screenings by the Rewind project to restore and archive British artists' videos from the 1970s and 80s have contributed to a resurgence of interest in Scratch, with a number of screenings in more recent years.[28]

Lipman addressed the initial criticisms and continued to eulogize Scratch and its pioneering challenge in *Taking TV Apart*, a booklet accompanying "The Eleventh Hour" broadcast.[29] In this visionary response, he clearly anticipates the development of the Internet and the explosion of creative possibilities forged by convergent digital media and outlines the radical proposal in Scratch that he found so appealing:

... the practice of Scratch... anticipates the interactive era of electronic networks, where the combination of video and computer promises to allow the exchange and re-processing of information, into new visions to suit individual taste. Unlike the one-way system of current broadcast media, there could be a network resembling the telephone system, where calls, or programmes, or computer software could both be made and received by each individual. Such developments raise fundamental questions about the status of the "artist" and art objects. Scratch takes the broadcast media as its paintbox, the video recorder as its palette, and the TV screen as its canvas.[30]

Lipman recognized Scratch's anticipation of important debates yet to emerge; around sampling technologies, plunderphonics, online mashup culture, file sharing, and remix, including its "inherent challenge to copyright law" that Dovey explored in his account of clearing Gorilla Tapes' work for broadcast, and which hindered the wider exposure of Scratch at the time.[31] As the "evangelist for the art of the video remix," Lipman's writing on Scratch brought it from the confines of its nightclub existence to a wider public. His cocurating (with de Florence, and subsequently with O'Pray and Curtis) took the work from its nascent screenings at The Fridge to the Institute of Contemporary Arts, gallery screenings, touring programmes, the Edinburgh Television Festival, and subsequently onto broadcast television. His role in supporting and promoting the emergence and proliferation of Scratch, little recognized until now, cannot be overemphasized. As with de Florence, Lipman's role in pioneering radical media practices did not end with Scratch, and he went on to propose, and produce, Channel 4's groundbreaking arts programme "The Media Show" between 1987 and 91. Sadly, Lipman died at the age of forty-five in 1997.[32]

Everything is a Remix, that's Contemporary Culture[33]

In mapping the historical significance of Scratch to remix culture, I think it is worth quoting Manovich at some length:

> It is relevant to note here that the revolution in electronic pop music that took place in the second part of the 1980s was paralleled by similar developments in pop visual culture. The introduction of electronic editing equipment such as switcher, keyer, paintbox, and image store made remixing and sampling a common practice in video production towards the end of the decade; first pioneered in music videos, it later took over the whole visual culture of TV. Other software tools such as Photoshop (1989) and After Effects (1993) had the same effect on the fields of graphic design, motion graphics, commercial illustration and photography. And, a few years later, the World Wide Web redefined an electronic document as a mix of other documents. Remix culture has arrived.[34]

Manovich locates the emergence of visual remix culture in pioneering music videos appearing in the 1980s. The British Film Institute's Will Fowler, curating *This is Now: Film and Video after Punk*,[35] locates Scratch as one of the key contributors of a highly innovative and experimental British underground film scene of the 1980s, which had significant influence on pop video tropes and MTV.[36] Al Rees makes evident the

connections between this generation of filmmakers and their roots in the "punk-era revision of the underground" through the encounters of Ken Russell, Kenneth Anger, Derek Jarman, Genesis P-Orridge of Throbbing Gristle, and William Burroughs.[37] Resulting in a fusing of Jarman and P-Orridge "tendencies" with younger filmmakers "drawn to their world of free play, extremist imagery and a hallucinatory 'dream-machine' cinema"—a "new punk underground," who led a "rebellion against the structural avant-garde which preceded it as a distinct aesthetic direction."[38] Rees links these histories recognizing the intertwined networks, practices, and cultures at play as experimental film and video makers also engaged in more overtly commercial and market-oriented pop promo practices, noting "however recuperated in the commercial work they undertook – [these artists] kept a sharp edge to the work" promoting values beside the commercial, "fusing low technologies with advanced politics of the dispossessed."[39]

Just as Scratch looked to models of music composition technologically and organizationally, influenced by remix practices in hip hop, cinesonic/visual music practices and exploring emerging media technologies,[40] so too, it arises from, was influenced by, and operated in networks spawned through the UK independent music sector as much as through video art. Pioneering independent video production and distribution projects had already been realized by Throbbing Gristle, Cabaret Voltaire, and Ikon/Factory Records before Scratch emerged,[41] and so unsurprisingly the new music, MTV and "youth television" cultures reciprocally would draw heavily on Scratch's influence and styles. I would argue that it is analog Scratch Videos that should be seen as some of the key "music videos" Manovich credits, which made remixing and sampling a common practice in video production, and heralding remix (and file sharing) cultures to come.

Scratch as the Analog Herald of Digital Remix

Owen Gallagher advances a set of claims to attempt to address any confusion arising following a proliferation of discourse around the meaning of "remix."[42] He lays out five criteria by which remix can be distinguished from other forms of media, with the presence of sampled source material as the defining characteristic. In addition, Gallagher calls attention to how visual semiosis occurs differently in remixed practices, how the use of sampled content evidences propositions, and the potential remix has as a political tool to circulate counter ideologies and social libertarian alternative world views. Finally, Gallagher recognizes the inherent challenge to copyright law which remix and sampling raises, with a call for alternative systems to allow for public access to remix cultural works and online content in the digital age. Gallagher draws on over five hundred Critical Remix Videos (CRVs) as exemplar practices to illustrate and unpack the proposals he makes and to advance knowledge and establish theoretical frameworks for scholarly practice in the field of remix studies. Recognizing Critical Remix Video (CRV) as a practice that has proliferated widely through online platforms,[43] Gallagher denotes sixteen subgenres and defines CRV as:

> a digital video composed of previously published media elements, which have been appropriated, repurposed, and reconfigured in the creation of a new work that communicates different messages and meanings than the source material. These new messages are often highly critical of someone or something and attempt to expose hidden information about the object of criticism.[44]

If Gallagher's clarifications define critical remix video in the digital age, then Scratch practices evidence an analog herald (or even a literal avant-garde) for the criteria Gallagher outlines in its creation of new work. Birtwistle notes that it was Scratch and the technologies that had become available for the Scratch artists to explore, which first realized in video ideas proposed by composers Edgar Varese, John Cage, and Jack Ellitt as they explored the creative potentials of film sound technologies,

> If the call for an art of organized sound was realized sonically in musique con-crète experiments of the 1940s and 50s, then it was video rather than film that finally provided the medium in which the composers' ideas took an audiovisual form.
>
> … In extending the control an artist-composer had over their sonic materials, scratch allowed what had already happened in musique concrète, and in hip hop, to find audiovisual expression.[45]

Scratch artist George Barber draws attention to how video embraced developments in the themes and emphases of cross-fertilization prevalent in pop, fashion, sculpture, architecture, and cultural studies at the time and that the convergence of technology appeared perfect for this task "in practice it became possible to musically repeat stolen voices and small phrases of dialogue, quoting in an exciting and rhythmical way. Soundbytes or noises could be stored on disk and a music track. Thus, after the sound was perfected, the pictures could be synched in place."[46] Barber's work fused digital sound sampling and analog video editing, outlining a way of working that was intrinsic to the Scratch aesthetic, significantly citing the musical term "jamming,"

> I… would cite Scratch as a prime example of where available technology was made the most of, where people just got on the machines and "did things." They jammed, winged it and made it up as they went along. It would take a philistine to say it was "just effects" pure and simple. One only has to look at broadcast television to see its legacy… the grammar of editing and visual language have irredeemably changed, copying over the excitement of the Scratch scene.[47]

Barber's work not only sampled Hollywood footage, but also blended it with video graphics, exploring the visual compositional possibilities of video-editing technology and "creating styles and techniques that would come to have a profound influence upon the way television would look in the late 1980s and early 1990s."[48] Gareth Evans notes that this use of sampling technology subverted "both itself and the values (consumer and otherwise) that have brought it into being… it's about taking the means of production to change what the production means"[49]—subverting the semiotic structures in place in the original material, as Gallagher observes remix to do.

Some commentators identify two distinct schools of Scratch work; more overtly, agitprop-based practices distinguished from those with more deconstructive, video-graphic, imagist traits. O'Pray countered this observation, noting that the distinction does not hold in practice, with works across the board evidencing both "the skillful deployment and montaging of 'found' images" whilst also delighting in the pleasure of manipulating images and sounds.[50] The varied and hybrid practices found in Scratch create a mode of articulation that places emphasis on blending and folding rather than isolation and specificity, a synesthetic articulation of sound and image that is totally at

odds with a visually oriented critical culture and notions of specificity.[51] By locating Scratch within a critical framework that addresses the importance of the interplay of sound and image, Birtwistle preempts significant later developments in what John Richardson, Claudia Gorbman, and Carol Vernalis refer to as "new audiovisual aesthetics."[52] Scratch was radical not only in its deconstruction and sociopolitical critique of the media, but also in its capacity to generate audiovisual affect. Birtwistle's analyses help broaden an understanding of how Scratch operates and exposes overly simplistic and fixed views about its meaning and value, it is much more than mere "audio-visual collage."[53]

> When Scratch Video switches on the material potential of a moving image or a recorded sound, it switches on not only the potential to create meaning, but also its affective potential. Releasing the latent kinaesthetic and synaesthetic power of its source material, Scratch Video follows the imperatives of music, disengaging with linguistic models of meaning in favour of an intensification of affect.[54]

In this disengagement with linguistic models, Scratch preempts the hybridization of media forms that Manovich recognizes the computer platform facilitated for digital media, and the "new hybrid aesthetics" that juxtapose "previously distinct visual aesthetics of different media within the same image."[55] Scratch artists' capacity to "blend and fold"[56] sound and image anticipated the "deep remix" and the "hybrid visual language" Manovich addresses through the emergence of motion graphics software platforms and new paradigms of moving image creation which followed.

Having established that much Scratch work does operate on overtly political levels, appropriating source material to evidence propositions and make arguments, with overtly oppositional stances to the mainstream politics of the early 1980s. One of Scratch's fiercest initial critics, Catherine Elwes, would reevaluate her criticisms noting that agitational Scratch continued to differ from television-generated parody by way of clear political positioning representing collective opposition to state policies in general, and Thatcher and Reagan's in particular, and that this overt political positioning becomes one of Scratch's long-lasting legacies.[57] Gorilla Tapes' "Death Valley Days" drew on Ronald Reagan's movie appearances to parody the Thatcher/Reagan relationship, the Duvet Brothers' work highlighted social tensions and political inequalities in contemporary Britain, and my own work "Amen: Survive the Coming Hard Times" sampled both sound and image in its audiovisual construction, forming part of a trilogy of works questioning the cold war arms race and looming nuclear Armageddon. Much Scratch Video sets the groundwork for Jonathan McIntosh's claims for five essential features of "political/subversive remix video"—appropriating source material without permission; deconstructing or commenting on dominant media narratives; transforming original messages and source material; targeting more populist audiences than elite, academic or high art audiences; arising from DIY production and grassroots distribution methods.[58] Gallagher's criteria for remix video concerning the problems raised by copyright laws are certainly a major hurdle Scratch encountered, addressed in detail by Dovey's experience of clearing Gorilla Tapes work for broadcast.[59] Whether this had a limiting effect on the wider proliferation of Scratch, and what impact it had on its relative obscurity is not clear, though changes to UK law for fair use as parody in 2014, making the way for Casetteboy's satirical edits of off-air footage to be featured on BBC

news, were a welcome move forward.[60] Formed in the mid-1990s, the duo of English electronic musicians Mark Bolton and Steve Warlin became known for their audio and video collages of cut-up, off-air footage parodying politics and contemporary culture. From 2008, they concentrated on video mashups with significant viral success, but only after the changes in UK law could they earn money for this work, and have it screened on broadcast television.

Lessig equates the need for media literacy to be as important as societal requirements for textual literacy, and the right to quote from media should be equitable with that of textual citation. In addressing the need for media literacies, Lessig recognizes that the democratization of technologies and proliferation of access to new technologies facilitates the exploration of expression through these media, and whilst the freedom to express oneself through images, film, and music extends the literacy of text, more so it extends "the ability for amateurs to create in contexts that before only professionals ever knew."[61] Whilst Birtwistle points out how Scratch explores affective potential of sound and image beyond linguistic models of meaning, Scratch can still be seen as a herald for the extension of visual literacies and creative expression that Lessig examines and most definitely a challenge to the previously professionally restricted media.

Conclusion

In revisiting Scratch, more recent screenings have been met with a sense that the works evoke a prescience and relevance to current concerns: "a rebellion that warned of the present we're living through now"[62] and that "despite being more than thirty years old… jarring edits and disturbing imagery resonate with urgent concerns today, from environmental devastation to war."[63] The political importance and explicit political address of Scratch resonate long after initial criticisms and discourse sought to disparage the stance and mode it took.

Revisiting past work can demonstrate how marginal movements can have lasting impact and contribute to the documenting of marginal film histories, and the disruption of some of the fixed views that have gathered around the movement. George Barber's pioneering role through his own video work and that of collating the canonical Greatest Hits of Scratch are well documented. Less known is the pioneering role of Bruno de Florence in creating and convening the initial forum of the Fridge nightclub's "Video Lounge" and his subsequent collaboration with Andy Lipman to promote the movement to wider audiences. Lipman's background and engagement in campaigning community video work (in particular the LGBT community) was significant in his recognition of the political importance of Scratch and his active and energetic promotion of the art and artists involved.

The efforts of Lipman and O'Pray took Scratch into the gallery and put it before the eyes of mainstream TV executives, with significant impact on the shape and form of mainstream media and on discourses of video art theory and practice. I would also argue that the other trajectories Scratch was traveling through—the wider post-punk and alternative cultures of the United Kingdom at this time—were places where the radical form and content of Scratch emerged and flourished. Fowler's curating of This is Now: Film and Video after Punk[64] locates Scratch as one of the key contributors of a highly innovative and experimental British underground film scene of the 1980s. The relationship across (sub)cultural forms is significant in the United Kingdom at this time. The

post-punk independent media production and distribution practices of Throbbing Gristle, Doublevision, and Ikon were pioneering exemplars that Barber so ably applied to Scratch.[65] Activities beyond London need to be acknowledged: Ikon was based in Manchester, Doublevision in Nottingham and Sheffield, and Scratch methodologies were employed in the Miner's Campaign Tapes coming out of Newcastle during the Miner's Strike to name but a few. The "blindness of disciplines" recognized by Holly Rogers and others,[66] leading to a distinct lack of address of music-centric practices within both video art and film studies discourse until recent years, has meant that to date these histories remain very much under-explored.

Birtwistle's critical analysis of Scratch as a visual music practice and the growing address of "a new audiovisual aesthetic" helps to locate Scratch in a more relevant theoretical framework than the original critical response it garnered and also casts light on how sonically engaged practices could be overlooked at the time. By unpacking the history of Scratch, it becomes evident that the critical resonance and radical waves of the movement continue to resonate thirty years after John Walker questioned its ability to survive the blows of mainstream media recuperation[67] and can now be seen as a key herald of what has come to be known as "remix culture" in particular through the work of Lawrence Lessig and Lev Manovich.[68] Scratch pioneers a range of activities and practices that resonate deeply with the frameworks and analyses Gallagher and McIntosh draw up to evaluate critical remix video, and a wider understanding of its history and practices can only add to the critical discourse and perspectives unfolding around remix studies and file sharing.

Notes

1 Lev Manovich, "What Comes After Remix?" Articles, 2007, accessed October 12, 2017, http://manovich. net/index.php/projects/what-comes-after-remix.

2 George Barber, "Scratch and after: Edit Suite Technology and the Determination of Style in Video Art," in *Culture Technology and Creativity in the Late Twentieth Century*, ed. Paul Hayward (London: John Libbey, 1990), 115.

3 See: Nick Cope, "Northern Industrial Scratch: The History and Contexts of a Visual Music Practice," PhD Diss., University of Sunderland, 2012, accessed May 11, 2020, https://sure.sunderland.ac.uk/id/eprint/3287/; Nick Cope, "Revisiting Scratch Video," "Aesthetics/Politics/Activism/Art: What is Radical Film?" *ScreenWorks* 7, no. 3, December 2017, accessed May 11, 2020, http://screenworks.org.uk/archive/volume-7.3/revisiting-scratch-video. Nick Cope, "Nothing Here Now But the Recordings: The Moving Image Record of Joy Division and the Factory Video Unit," in *Heart and Soul: Critical Essays on Joy Division*, eds. Martin Power, Eoin Devereux, and Ailleen Dillane (London: Rowan and Littlefield, 2018). Nick Cope, "Scratch Video Revisited," in *Contemporary Radical Film Culture: Networks, Organizations and Activists*, eds. Jack Newsinger, Mike Wayne, and Steve Presence (London: Routledge, 2020). Nick Cope, and Tim Howle, "Globus Hystericus," *Sightlines: Filmmaking in the Academy* 1, 2015, accessed May 11, 2020, http://www.aspera.org.au/research/sightlines-globus-hystericus/.

4 Nick Cope, "Scratch Video Revisited," in *Contemporary Radical Film Culture*, eds. Jack Newsinger, Mike. Wayne, and Steve Presence (London: Routledge, 2020).

5 Manovich, "What Comes after Remix?," 2007, accessed July 26, 2020, http://manovich.net/index.php/projects/what-comes-after-remix.

6 See: Lawrence Lessig, *Remix: Making Art and Commerce Thrive in the Hybrid Economy* (London: Bloomsbury, 2008).

7 Bruno de Florence, "Video Lounge." (France: DeFlorence.com, 2009), accessed July 26, 2020, http://www.deflorence.com/?p=283.

8 Barber, *Scratch and After*, 114.

9 Roy Armes, *On Video* (London: Routledge, 1988), 84.

10 Al Rees, *A History of Experimental Film and Video* (London: BFI Publishing, 1999), 96.

11 Andy Birtwistle, *Cinesonica: Sounding Film and Video* (Manchester: Manchester University Press, 2010), 244–5.

12 Barber, 116.

13 See: David Toop, *Rap Attack 2: African Rap to Global Hip Hop* (London: Serpent's Tail, 1991), 134, 184.

14 Barber, 115.

15 Barber, 114.

16 Birtwistle, *Cinesonica*, 265.

17 See: "Network21 TV," accessed May 11, 2020, https://www.youtube.com/user/Network21TV; Ian McQuaid, "Network 21: The Story of the World's Greatest Pirate TV Station," accessed May 11, 2020, https://www.theransomnote.com/music/articles/network-21-the-story-of-the-worlds-greatest-pirate-tv-station/; and "The Centre of Attention: NeTWork 21," accessed May 11, 2020, http://www.thecentreofattention.org/dgntw21.html.

18 Ieuan Franklin, "Talking Liberties: Framed Youth, Community Video and Channel 4's Remit in Action," in *Queer Youth and Media Cultures*, ed. Christopher Pullen (Basingstoke: Palgrave, 2014), 118.

19 Franklin, 118.

20 Andy Lipman, "Scratch and Run," *City Limits*, October 5–11, 1984, 18–9.

21 Jon Dovey, "Copyright as Censorship: Notes on 'Death Valley Days'," *Screen* 27, no. 2 (Glasgow, Scotland: March–April 1986).

22 Rees, *A History of Experimental Film and Video*, 105.

23 Andy Lipman, "Scratch: Dead on Arrival?" *IPPA Bulletin*, December 7–9, 1985, accessed March 12, 2019. Available from: http://uodwebservices.co.uk/documents/Duvet%20Brothers/DB039.pdf.

24 Julia Knight and Peter Thomas, *Reaching Audiences: Distribution and Promotion of Alternative Moving Image* (Bristol: Intellect, 2012).

25 See: Nick Cope (2020).

26 See: Catherine Elwes, *Video Art, a Guided Tour* (London: I.B. Taurus, 2005), 116; Al Rees, "Experimenting on Air: UK Artists' Film on Television," in *Experimental British Television*, eds. Laura Mulvey and Jamie Sexton (Manchester: Manchester University Press, 2007), 161.

27 Birtwistle, *Cinesonica*, 272.

28 As indicated by academic engagement, such as Cope (2012, 2018) and Goldsmith (2015), and screenings of my own and others' work at the UK media, communications and Cultural Studies Association Conference in 2015, the Art Sheffield—Up Down Top Bottom Strange and Charm International Arts Festival in 2016 (see: Petty, 2016) and Sheffield Doc Fest in 2018. Will Fowler curated a major BFI programme. This is now: Film and video after punk—rediscovering underground film 1979–85 in 2015. The 2019 London Short Film Festival also celebrated scratch in its opening event All That Scratching is Making me Itch, returning scratch once more to the ICA. See: https://nickcopefilm.com/2019/03/22/scratch-video-re-visited/ [Accessed 11.03.2020].

29 Andy Lipman, *Video: The State of the Art* (London: Channel 4/Comedia, 1985).

30 Lipman, 10.

31 Dovey, "Copyright as Censorship."

32 See: http://www.the-lcva.co.uk/resources/59b7ed8d538a456cd2f61ad3 and https://explore.library.leeds.ac.uk/special-collections-explore/637399/papers_and_photographic_material [Accessed 11.03.2020].

33 "Everything is a Remix, That's Contemporary Culture. It's about Recontextualisation, about Understanding through New Perspectives." Stephen Mallinder, in Andrew Trussler, "Dr Rhythm – Stephen Mallinder Interview," *In the Club Magazine*, issue 40, June, 2019, https://issuu.com/perfectpopcoop/docs/in_the_club_040_june_july_19_-_june.

34 Manovich, "What Comes after Remix?"

35 Will Fowler, "This is Now: Film and Video after Punk – Rediscovering Underground Film 1979–85," Press Release, British Film Institute, 2014, http://www.bfi.org.uk/sites/bfi.org.uk/files/downloads/bfi-press-release-this-is-now-2014-03-06.pdf.

36 Will Fowler, "The Occult Roots of MTV," *Music, Sound and the Moving Image* 11, no.1 (UK: Liverpool University Press, 2017): 63–77.

37 Al Rees, *A History of Experimental Film and Video*, 106–7.

38 Rees, 86.

39 Rees, 86.

40 Barber, 116.

41 See: Nick Cope, "Nothing Here Now but the Recordings: The Moving Image Record of Joy Division and the Factory Video Unit," in *Heart and Soul: Critical Essays on Joy Division*, eds. Martin Power, Eoin Devereux, and Aileen Dillane (London: Rowan and Littlefield, 2018); and Cope (2020).

42 Owen Gallagher, *Reclaiming Critical Remix Video* (London: Taylor and Francis Group, 2018).

43 Gallagher, 25.

44 Gallagher, 1–2.

45 Birtwistle, 237–40.

46 Barber, 116.

47 Barber, 123.

48 Jez Welsh, "One Nation under a Will (of Iron), or: The Shiny Toys of Thatcher's Children," *Kunstforum International*, no. 117 (Germany, 1992): 133.

49 Gareth Evans, "The Boy from Georgetown," in *George Barber*, eds. Steven Bode and Nina Ernst (London: Film and Video Umbrella, 2005), 9.

50 Michael O'Pray, "Scratching Deeper," *Art Monthly*, no. 95, April 1986.

51 Birtwistle, 265.

52 Carol Vernalis, John Richardson, and Claudia Gorbman, eds., *The Oxford Handbook of New Audiovisual Aesthetics* (Oxford: Oxford University Press, 2013), 20.

53 Gallagher, 27.

54 Birtwistle, 265.

55 Lev Manovich, *Software Takes Command* (London: Bloomsbury, 2013), 243–328.

56 Birtwistle, 265.

57 Catherine Elwes, *Video Art, a Guided Tour* (London: I.B. Taurus, 2005), 116.

58 Jonathan McIntosh, "A History of Subversive Remix Video before YouTube: Thirty Political Video Mashups Made between World War II and 2005," *Journal of Transformative Works and Cultures*, no. 9 (2012).

59 Dovey, "Copyright as Censorship."

60 See: Cassetteboy, *Cassetteboy: The Art of Mashup*, Lost Lectures (UK: YouTube.com, 2014), https://www.youtube.com/watch?v=87SEW9L_csA [Accessed 11.03.2020].

61 Lessig, *Remix*, 108.

62 Felix Petty, "How Sheffield in the 80s Became a Hive of Musical and Artistic Experimentation," *I-D Vice Magazine*, April 21, 2016, https://i-d.vice.com/en_uk/article/59g4x3/how-sheffield-in-the-80s-became-a-hive-of-musical-and-artistic-experimentation.

63 Screenworks, "Special Issue: Radical Filmmaking," *Screenworks* 7, no. 3, 2017, http://screenworks.org.uk/archive/volume-7-3.

64 Will Fowler, "This is Now: Film and Video after Punk."

65 See: Cope (2020).

66 Holly Rogers, *Visualising Music: Audio-Visual Relationships in Avant-Garde Film* (Saarbrücken: Lambert Academic Publishing, 2010), 43.

67 John A. Walker, *Cross-Overs: Art into Pop/Pop into Art* (London: Comedia, 1987).

68 See: Lessig Remix and Lev Manovich, *Software Takes Command* (London: Bloomsbury, 2013).

Bibliography

Armes, Roy. *On Video*. London: Routledge, 1988.

Art Sheffield. "Up Down Top Bottom Strange and Charm: Scratch Video," April 16–May 7, 2016. http://www.artsheffield.org/2016/programme/156-arundel-street/.

Barber, George. "Scratch and After: Edit Suite Technology and the Determination of Style in Video Art." In *Culture Technology and Creativity in the Late Twentieth Century*, edited by Paul Hayward. London: John Libbey, 1990.

Birtwistle, Andy. *Cinesonica: Sounding Film and Video*. Manchester: Manchester University Press, 2010.

British Film Institute. "This is Now: Film and Video after Punk – Rediscovering Underground Film 1979–85." Accessed July 16, 2018. http://thisisnow.org.uk.

Cope, Nick. "Northern Industrial Scratch: The History and Contexts of a Visual Music Practice." PhD Diss., University of Sunderland, 2012. Accessed May 11, 2020. https://sure.sunderland.ac.uk/id/eprint/3287/.

Cope, Nick. "Revisiting Scratch Video." *Aesthetics/Politics/Activism/Art: What is Radical Film?* Screenworks 7, no. 3, December 2017, accessed May 11, 2020. http://screenworks.org.uk/archive/volume-7.3/revisiting-scratch-video.

Cope, Nick. "Nothing Here Now But the Recordings: The Moving Image Record of Joy Division and the Factory Video Unit." In *Heart and Soul: Critical Essays on Joy Division*, edited by Martin Power, Eoin Devereux, and Ailleen Dillane. London: Rowan and Littlefield, 2018.

Cope, Nick. "Scratch Video Revisited." In *Contemporary Radical Film Culture: Networks, Organisations and Activists*, edited by Jack Newsinger, Mike Wayne, and Steve Presence. London: Routledge, 2020.

Cope, Nick, and Tim Howle. "Globus Hystericus." *Sightlines: Filmmaking in the Academy* 1, 2015, accessed May 11, 2020. http://www.aspera.org.au/research/sightlines-globus-hystericus/.

de Florence, Bruno. "Video Lounge." December 13, 2009, accessed July 26, 2020. http://www.deflorence.com/?p=283.

Dovey, Jon. "Copyright as Censorship: Notes on 'Death Valley Days'." In *Diverse Practices, a Critical Reader on British Video Art*, edited by Julia Knight, 283–90. Luton: University of Luton Press/Arts Council England, 1996.

Elwes, Catherine. *Video Art, a Guided Tour*. London: I.B. Taurus, 2005.

Evans, Gareth. "The Boy from Georgetown." In *George Barber*, edited by Steven Bode and Nina Ernst. London: Film and Video Umbrella, 2005. [Online, with slight amendments]. Accessed October 12, 2017. http://www.luxonline.org.uk/artists/george_barber/essay(1).html.

Film and Video Umbrella. "FVU Touring Programmes 1985." *Film and Video Umbrella*, 2018, accessed July 11, 2018. https://www.fvu.co.uk/projects/fvu-touring-programmes-1985.

Fowler, Will. "This is Now: Film and Video after Punk – Rediscovering Underground Film 1979–85." Press Release, British Film Institute, 2014. http://www.bfi.org.uk/sites/bfi.org.uk/files/downloads/bfi-press-release-this-is-now-2014-03-06.pdf.

Fowler, Will. "The Occult Roots of MTV." *Music, Sound and the Moving Image* 11, no. 1 (2017): 63–77. http://online.liverpooluniversitypress.co.uk/doi/pdf/10.3828/msmi.2017.4.

Franklin, Ieuan. "Talking Liberties: Framed Youth, Community Video and Channel 4's Remit in Action." In *Queer Youth and Media Cultures*, edited by Christopher Pullen. Basingstoke: Palgrave, 2014.

Gallagher, Owen. *Reclaiming Critical Remix Video*, Kindle Edition. London: Taylor and Francis Group, 2018.

Goldsmith, Leo. "Scratch's Third Body: Video Talks Back to Television." *View: Journal of European Television History and Culture* 4, no. 8 (2015): 1. Online, http://ojs.viewjournal.eu/index.php/view/article/view/JETHC097/210.

Knight, Julia, and Peter Thomas. *Reaching Audiences: Distribution and Promotion of Alternative Moving Image*. Bristol: Intellect, 2012.

Lessig, Lawrence. *Remix: Making Art and Commerce Thrive in the Hybrid Economy*. London: Bloomsbury, 2008.

Lipman, Andy. "Scratch and Run." *City Limits*, October 5–11, 1984, accessed August 2, 2020. https://nickcopefilm.files.wordpress.com/2013/09/northern-industrial-scratch-final-web.pdf.

Lipman, Andy. *Video: The State of the Art*. London: Channel 4/Comedia, 1985.

Lipman, Andy. "Scratch: Dead on Arrival?." *IPPA Bulletin*, December 7–9, 1985, accessed March 12, 2019. http://uodwebservices.co.uk/documents/Duvet%20Brothers/DB039.pdf.

Mallinder, Stephen. "Dr Rhythm – Stephen Mallinder Interview." In Andrew Trussler. In the Club Magazine, issue 40, June 2019. https://issuu.com/perfectpopco-op/docs/in_the_club_040_june_july_19_-_june.

Manovich, Lev. "What Comes after Remix?." *Articles*, 2007, accessed July 26, 2020. http://manovich.net/index.php/projects/what-comes-after-remix.

Manovich, Lev. *Software Takes Command*. London: Bloomsbury, 2013.

McIntosh, Jonathan. "A History of Subversive Remix Video before YouTube: Thirty Political Video Mashups Made between World War II and 2005." *Journal of Transformative Works and Cultures*, no. 9 (2012): 1. https://journal.transformativeworks.org/index.php/twc/article/view/371/299.

McQuaid, Ian. "Network 21: The Story of the World's Greatest Pirate TV Station." *The Ransom Note.* Accessed March 11, 2020. https://www.theransomnote.com/music/articles/network-21-the-story-of-the-worlds-greatest-pirate-tv-station/.

O'Pray, Michael. "Scratching Deeper." *Art Monthly* 95, April 1986, accessed March 12, 2019. http://www.duvetbrothers.com/cuttings.htm and http://uodwebservices.co.uk/documents/Steve%20Hawley/SHA041.pdf.

Petty, Felix. "How Sheffield in the 80s Became a Hive of Musical and Artistic Experimentation." *I-D Vice Magazine*, April 21, 2016. https://i-d.vice.com/en_uk/article/59g4x3/how-sheffield-in-the-80s-became-a-hive-of-musical-and-artistic-experimentation.

Rees, Al. *A History of Experimental Film and Video*, 2011. London: BFI Publishing, 1999.

Rees, Al. "Experimenting on Air: UK Artists' Film on Television." In *Experimental British Television*, edited by Laura Mulvey and Jamie Sexton. Manchester: Manchester University Press, 2007.

Rewind. "Artists' Video in the 70s and 80s." Accessed August 2, 2020. http://www.rewind.ac.uk/rewind/index.php/Welcome.

Rogers, Holly. *Visualising Music: Audio-Visual Relationships in Avant-Garde Film.* Saarbrücken: Lambert Academic Publishing, 2010.

Screenworks. "Special Issue: Radical Filmmaking." Screenworks 7, no. 3, 2017. http://screenworks.org.uk/archive/volume-7-3.

Seventeen Gallery. "Scratch!" Accessed August 2, 2020. http://www.seventeengallery.com/exhibitions/scratch/.

Toop, David. *Rap Attack 2: African Rap to Global Hip Hop.* London: Serpent's Tail, 1991.

Trussler, Andrew. "Dr Rhythm – Stephen Mallinder Interview." *The Club Magazine*, no. 40, June 2019. https://issuu.com/perfectpopco-op/docs/in_the_club_040_june_july_19_-_june.

Vernalis, Carol, John Richardson, and Claudia Gorbman, editors. *The Oxford Handbook of New Audiovisual Aesthetics.* Oxford: Oxford University Press, 2013.

Walker, John A. *Cross-Overs: Art into Pop/Pop into Art.* London: Comedia, 1987.

Welsh, Jez. "One Nation under a Will (of Iron), or: The Shiny Toys of Thatcher's Children." In *Diverse Practices, a Critical Reader on British Video Art*, edited by Julia Knight. Luton: University of Luton Press/Arts Council England, 1992. *Kunstforum International*, 117, Germany.

Welsh, Jez. "Post-Modernism and the Populist Tendency." In *Undercut Rogue Reels: Oppositional Film in Britain, 1945–90*, edited by Margaret Dickinson, 190–6. London: BFI, 1999.

Filmography

Amen: Survive the Coming Hard Times, 1984. Directed by Nick Cope. Video. Available online: https://nickcopefilm.com/2013/09/17/sheffield-scratch-and-super-8/ [Accessed 11.03.2020].

Death Valley Days, 1984. Video. Luton: Gorilla Tapes. Available online: https://lux.org.uk/artist/gorilla-tapes [Accessed 11.03.2020].

Doublevision Presents; Cabaret Voltaire, 1982. Video. Nottingham: Doublevision.

Doublevision Presents; Cabaret Voltaire, 2004. DVD. London: Mute Records.

A Factory Complication, 1982. Video. Manchester: Factory/Ikon.

A Factory Video, 1982. Video. Manchester: Factory/Ikon.

Joy Division "Here are the Young Men", 1982. Video. Manchester: Factory/Ikon.

Paul Hardcastle "19", 1985. Directed by Jonas McCord, Bill Couterie/Ken Grunbaum. London: Chrysalis Records. Available online: https://www.youtube.com/watch?v=hRJFvtvTGEk [Accessed 12.07.2018].

TGV: The Video Archive of Throbbing Gristle, 2007. DVD. London: Industrial Records.

The Greatest Hits of Scratch Video: Volumes 1 and 2, 1984. Video. London: George Barber. Available online: http://www.luxonline.org.uk/artists/george_barber/the_greatest_hits_of_scratch_video.html [Accessed 12.10.2017].

23 Skidoo – Seven Songs, 1984. Video. Directed by Richard Heslop. Nottingham: Doublevision. Available online: https://vimeo.com/46603784 [Accessed 16.07.2018].

NICK COPE

View from Hear, 1984. Video. Directed by Nick Cope. Sheffield: 391/Image Factory. Available online: https://nickcopefilm.com/391-view-from-hear-videos/ [Accessed 11.03.2020]. A selection of scratch videos available on YouTube, including work by George Barber, The Duvet Brothers and Gorilla Tapes: https://www.youtube.com/playlist?list=PLB31727C7B91E565C [Accessed 11.03.2020].

36

CURATING, REMIXING, AND MIGRATING ARCHIVED "MUSE FILES"

Paul Dougherty

Remix practice for me has been inextricably linked to collecting and archiving images, audio, and video. In retrospect, I started my remix practice by collecting magazine images and posting them on my wall. As I developed this practice, there was a purpose to my archiving items into a "muse file" that would inspire and fuel new work. I came to understand that my earliest creative experiments, which combined inspiration with more direct appropriation, reflected a longstanding artistic tradition. Seeding that awareness were collages in punk 'zines in the 1970s, which had art historical influences reaching back to the avant-garde of the 1910s, including Russian Constructivism, photomontage, and the Dadaists "anti-art" spirit. Over time I would come to appreciate other influential progenitors for my cut-ups such as Pop Art and Wallace Berman.

As I was getting started with video remix in the 1970s, my work in the television/video industry, specifically postproduction, gave me access to high-end video technology decades before it became available to the "prosumer" market. This and collecting were defining and enduring aspects of my remix practice.

In this volume, it seems appropriate to establish an underlying connection with Digital Humanities before discussing specific works and history. While I was familiar with the themes and rhetoric of Digital Humanities as expressed in the Manifesto 2.0,[1] I was less familiar with the Digital Humanities term per se. After reading the Manifesto, its viewpoints resonated with me in more ways than I can describe. As a practical matter I will cite two. The document speaks at length about innovative humanities activities happening outside the Ivory Tower of Academia. In my mind, this would parallel my remix work happening outside the "academy" of fine art. I have a toehold in the video art world by virtue of my working and collaborating with established artists. But as the Manifesto puts it, I associated the art world with "private languages and specialized jargons" and was happy to remain a fellow traveler. The Manifesto further expresses a viewpoint that "gladly flirts with the scandal of entertainment as scholarship, scholarship as entertainment." If one were to substitute the word art for scholarship, that would express my mission. An early role model for me in this space was Ant Farm who I assisted with their *Media Burn* video in 1975.

My other affinity to Digital Humanities as expressed in Manifesto 2.0 is the attitude toward curation. "Digital Humanists recognize curation as a central feature of the future

of the Humanities disciplines." Before remix there is first curation and collecting, a defining aspect of my life. Starting around 1980, as will be described in this chapter, I was able to collect video clips from cable TV before it was common. I felt compelled to do this in line with my somewhat oddball sensibilities and amassed a wall of videotapes. I logged over sixteen hundred clips into a database. In the 1990s, I felt custodial responsibility to migrate the collection[2] to digital and placed a good deal of it on YouTube in 2007.[3]

Early Influences: 1970s Video Art

Shortly after starting at Syracuse University in 1971, I came into the orbit of people who shed new light on video as an art form. Some were artists like Bill Viola, while others were long-haired disciples of Marshall McLuhan, part of the *Whole Earth Catalog* and *Radical Software* (magazine) cohort. I was enthralled by the emerging video world, which seemed like a natural extension of the alternative media I loved growing up in New York City, such as the underground newspaper the *East Village Other* and the independent radio station WBAI. Rock music and fandom were foundational to my identity and worldview, as they were for so many of my generation. Around the early 1970s, schisms were emerging in rock and pop culture. Even as a college freshman, I realized my musical tastes were diverging from increasingly homogeneous mainstream rock. I was casting about in search of my voice, as were like-minded others who would become my peers in the punk era of the mid-to-late 1970s. As my work progressed, I was certainly not alone in wishfully dreaming that I might one day become a "video rock star."

I was exposed to the new video tools in college, and it fostered a desire and opportunity to make original work. This happened in parallel with taking some production classes at the S.U. Newhouse School where students were expected to make short films and television programs. Another inspiration would be the intersection of studying experimental films, taking art history classes, and exposure to the early days of the Synapse Visiting Artist program[4] in 1974 (Figure 36.1).

In the Spring of that year, the Everson Museum[5] held a two-day conference called "Video and the Museum" that became the subject of my main television production class project. Being at Synapse in the early 70s, a part of the upstate New York network of video groups funded by New York State Council on the Arts was very much an instance of being in the "right place at the right time." I never fully left the video art scene, even as I found work as an editor at a broadcast video facility soon after college. To this day, I am still a video editor, though I also work in video preservation and archives.

Between 1975 and 1991, I created six remix works. Four of these were wholly remix projects, while two were partially so (segments, part of a greater whole). Of those six, five were videotapes and one was an audio work. Some were made using state-of-the-art editing systems, while others were hybrids, using a mixture of high-end and more modest tools. With the exception of one made at the Syracuse University "Synapse" program, all the remixes were made in New York City (the one edited at Synapse was shot in NYC). Access to new technologies played a central role in my creative (remix) story. I am forever indebted to the many people who facilitated my access to these cutting-edge technologies.

Besides access opportunities and new technologies, the growth of my media collection would have a bearing on my remix practice. In this chapter, the expression "critical mass" appears regularly as applied to this personal media collection of "muse files." There

Figure 36.1 Paul Dougherty conducting "man on the street" interviews with portable video equipment at Syracuse University 1976. Inset image: Brochure from Synapse Visiting Artist Program at the Newhouse School studios, Syracuse University 1976 (image courtesy of Randy Wishman, Synapse member)

would often come a turning point where the growing collection had become rich and large enough to support a new creative effort.

For convenience, I have placed links to each of the following six works on a single web page[6] and an additional link to a list of exhibits and one-man shows.[7]

White Collar Funk, 1975

My first video effort after college involved remix. The project started in 1975 and was completed the following year. In the summer of 1975, I ran the PortaPak equipment room at the Manhattan Cable Public Access Department. The PortaPak was the 1970 version of a hand-held video camera. It was a portable black and white video unit, which was loaned to members of the public so that they could make their own programs for the access channel. During lunch hour I would take a PortaPak out to East 23rd Street (our address) and shoot a mix of street life and architecture (Figure 36.1). The resulting work was called "White Collar Funk."

East 23rd Street was dominated by the MetLife building and, unlike Manhattan's East 50s office district with which I was more familiar, the 23rd Street area was more prosaic and less glamorous. Descriptive words like "funky" and "gritty" come to mind. In the resulting half-an-hour-long portrait of the street, I ended up with a three-minute sequence expressing my take on its personality or spirit in a way that incorporated various pop culture currents. Today this might be seen as a clumsy version of an Adam Curtis collage, a pop-schlock mythopoetic effort to reach for a higher truth I could not achieve with street footage. This remix segment is on YouTube.[8] While there are some accomplished parts, I look at it now and ask myself: "What was I thinking?" Though not much

of an excuse, my image/footage collection at the time was very limited. I was less than a year out of college, and my collection was meager compared with the palette of thousands of clips and images I would collect in the 1980s. The upshot is that I had a great desire to collage and make commentary with pop-culture material, but the result was more confused and blunt than later efforts. Subsequent works were more nuanced and satisfying for me because of freer access to postproduction tools. There was an iterative process of testing, previewing, and refinement. Conversely in this first access to a high-end studio, it was "map it out on paper, go in and execute it"—like a garage band being asked to cut their first single in an hour.

In the remix section of the video, I used point-of-view (POV) footage walking down the street as a backdrop, and superimposed a variety of clips and images (Figure 36.2). It is worth noting that the ability to composite two layers from videotape sources in 1976 would have been exceedingly rare among independent video people. This task typically required an editing room worth hundreds of thousands of dollars to perform—a type of facility available to me because by 1976 I was on staff with a Synapse Visiting Artist Program and was allowed to do some of my own work when the Newhouse School studio was available.

This remix sequence included numerous samples, including a dance clip from "Soul Train," a commercial for Soap Opera Digest and an ad for a blackhead removal device. Closer to my own life was the inclusion of an excerpt from a recently shot Richard Hell performance with the Heartbreakers at CBGB's. This video was made with my colleagues from the public access department in August 1975. We went by the name "Metropolis Video"[9] and did some of the first quasi-professional shoots (multi-camera, good lighting, and sound) at the club. The performance excerpt was from a song "You Got to Lose" about freakish reversals, and seemed to fit this funky outlier district with its share of marginal characters. In Richard Hell's parlance, I suppose I romanticized so-called "losers" and prosaic people on the street. This traces back to my earlier low-status messenger job for a couple of summers in NYC. It provided countless hours of people watching and reinforced a sense of solidarity with other low-status people. I also

Figure 36.2 Left: Four samples of remix superimpositions in White Collar Funk 1976. Right: Gregory Battock in the Soho Weekly News

had some ideas about nerd-lib (later "nerd chic") from Steve Post's late-night radio program on WBAI, called the "The Outside." He seemed to think that much of his audience were nerds, yet he felt solidarity with them. A last bit of narration was a quote from an article that expressed a variation on this identification sentiment but skewed more toward parody than solidarity. It involved some outré ideas about class and chic-ness that appeared in an article by art critic Gregory Battcock who wrote about that and nightlife for the *Soho Weekly News*.

In the article, he describes the blue-collar, working class costumes at a party he attended with "imitations of bar-girls, waiters, telephone repairmen" and ends with this sentence: "Nowadays there is lots of fantasy and glamor about the lower middle class" (Figure 36.2). I felt the partygoer spirit Battcock described was campier or more patronizing than the portrait tinged with affection that I was trying to make, but worth including as a contrast.

The cast of characters and street people in the rest of the video reflected these sensi-bilities and interests. At that time, I did not know the work of celebrated street photog-raphers, but my coverage of life on 23rd Street focused on characters not dissimilar to those in the works of Diane Arbus and Garry Winogrand.

In 1976, I started to work at a video facility in New York City as an assistant editor. During my time there, I worked on several personal video projects. This was done with my boss's permission, but in off-hours and discreetly as he suggested. The first two works were early and experimental music videos. One was acquired into the Museum of Modern Art permanent collection, entitled *Frankie Teardrop*[10] and was set to a song of the same name by the duo Suicide. These were early works that eventually gave way to remix projects.

Test Mix with Random Pix, 1979

My first work that was exclusively remix was made in 1979. There were two main sources of inspiration, one visual and the other aural. The visuals were developed from a collec-tion of photos I had cut out from late 1970s magazines. And as would often prove to be the case in my remix work, progress was contingent on accumulating a critical mass of collected material to gestate a new work. This part of my process exemplifies one of the constraints artists faced before the rise of the Internet, one could not Google desired images, one had to physically find them. Through a family member I had access to lots of leftover news and business magazines. I collected images with varied subject areas such as rebellion, crisis, national security, Cold War, Americana, pop culture (especially kitsch), and a generous sprinkling of whimsy or would-be Dada. Originally, I used these images to create cut-out collages of a kind that would have been pretty common in the downtown New York punk 'zines of the time.

My audio collection included a radio interview program I recorded on Pacifica station WBAI that featured a follower of Lyndon LaRouche. This fringe political movement was an evergreen in New York City during the late 1970s, at least on the street, with their literature tables set up on many sidewalks. Conspiracy theories were a central thread running through this strange far left/right mix. As a long-time listener to WBAI, I had heard my share of conspiracy theories, but none so far-fetched as the ones fluently spun out by this guest who seemed intelligent and articulate. He had a theory at the ready to explain everything, involving figures like Henry Kissinger, the Beatles, Theodore Adorno, and so on. I did not subscribe to any of it, but it was the most deft

conjuring of conspiracy theories I had ever heard, and I found it fascinating. I made a sound collage of this conspiracy theorist's spiel in the broadcast quality edit room at the video facility where I worked and compiled the stills on an Ampex HS-200 slow-motion disc that was able to record one frame at a time.

It was so long ago, it is hard to remember if I ever considered sequencing the images in a precise order to better synchronize them with audio content cues. I probably made interim versions of the soundtrack and auditioned the generally random order of the images against it. I remember loving the element of serendipity from the start (hence the name *Test Mix with Random Pix*[11]). As a music bed, I used a track that was a side-project of a favorite band at the time, Public Image Ltd (PiL). The song "One of the Lads" by *4 be 2* was produced by Keith Levene and John Lydon (aka Rotten) of PiL for the benefit of Lydon's brother, the vocalist. The song has Lydon's Irish father playing a hypnotic banjo riff over a driving, almost galloping, and slightly ominous disco mix. I used the instrumental version (B-side) of the song. I chose this as the soundtrack for the conspiracy theory mix for two reasons, it had a foreboding, "march of history" aspect to it. Additionally, this instrumental B-side resembled a reggae "dub" song with sparse musical passages or openings for spoken words. In "dub" parlance, it was designed for the DJ to "toast" over (a form of Jamaican rapping). The imagery and associations made in this video are so dense (there are over 500 images), it is best experienced rather than described.

The following year was my last as a staff editor at a facility. This is relevant because within the limits of nights and weekends, I enjoyed unfettered access to state of the art edit rooms. The next work would represent a last hurrah for this kind of access and, specifically in this case, creating multi-layered visual effects in a personal work.

"Careering" Performance Video (Public Image Ltd), 1980

There are similarities between *Test Mix* and *Careering*. The principals behind the soundtracks are the same, John Lydon (aka Rotten) and Keith Levene. The theme of the song *Careering* overlapped with many themes in *Test Mix* such as violent or malevolent political actions being manipulated by hidden and/or sinister forces. Among other things, *Test Mix* was a thematic stew of terrorism, militias, insurrections, and mercenaries, which also appear in *Careering*. Bands of that era like the Clash trafficked in these themes and images routinely. PiL (Lydon's and Levene's band) did somewhat, only leaning toward something more subtle and mysterious. In the summer of 1980, I made a video remix to enhance one of my concert performance videos featuring this English post-punk band shot a few months earlier. This was by far the most visual-effects-driven remix effort in my catalog of work. In May of that year, I was able to secure permission to videotape a surprise performance by PiL at a small heavy metal venue near CBGB's on the Bowery[12] called Great Gildersleeves. This was their first American tour, which made enough of a splash that by the end, the band was incongruously invited to appear on American Bandstand. I asked friends to help me videotape the performance with three cameras, knowing I could stitch together the individual (ISO) recordings in a high-end edit room later.[13]

Four songs were edited as traditional performances; however, the fifth song, *Careering*, though brilliant and stirring, was long, clocking in at almost seven minutes. I was concerned it would come off as repetitive and dull given the limitations of my humble video coverage. (This is no slight to the performance, the band was in great form that night

and John Lydon a.k.a. Rotten gave as gripping and full-throated a performance as any-one could ask for.) To enhance this long performance, there was an opportunity for augmentation or amplification of the haunting and evocative song lyrics. Regarding the subject matter, the consensus view was that the lyrics refer to the "Troubles" in Northern Ireland, but they are vague enough to apply to any number of conflicts.

Thanks to a new technology that made its way into postproduction in the late 1970s, it became possible to superimpose footage behind the band after-the-fact, in a way that created a pretty convincing "faux" rear screen projection. Around 1979, the facility where I worked purchased a Quantel frame store—a digital device that could re-size and re-position a videotape feed for layering—representing a profound breakthrough for visual manipulation. In those days, the effect was often referred to as "picture-in-pic-ture." Still images (as opposed to footage) could be resized and repositioned in the tra-ditional way, using a video camera connected to the edit room, as one could manually zoom and position the image. The facility had also purchased a programable animation stand that could perform smooth pans, tilts, and zooms from preset position "A" to posi-tion "B." The Quantel could do much the same, so with the aid of this automation, I could match or track a camera move from the performance (also known as a "moving matte") to further enhance the illusion of rear screen projection.

There are over twenty instances of images being composited with performance in this video (Figure 36.3). Generally, I would err on the side of subtlety with the mixed-in image or footage kept dim or muted, rather than bold and explicit. To that end, all the remix images for the first five minutes are black and white. Throughout, the implied meaning of the remix was achieved by synchronizing the "projected" imagery with a lyric. About two minutes into the song I break away from the performance for a twenty second full-screen montage where I intercut footage of the 1953 East-German uprising with a film about NORAD and their early warning radar network. The montage suggests the street rebellion is triggering alerts in a surveillance command center.

At about five minutes in, the imagery shifts to introduce both some bold color images and ones that broaden the scope of conflicts conjured up. Though one cannot know exactly what Lydon meant by "Careering'," I took it to mean some kind of "professional" who thrives on conflict, which could be a war photographer, a mercenary, a hegemon,

Figure 36.3 Composition in Public Image Ltd.'s *Careering*

or an interventionist business interest. Some of the color images invoke the Russian invasion of Afghanistan and tensions with Iran. In the last minute or so of the song, I threw caution to the wind and pulled out all the stops, probably thinking the song/video was becoming overly long and needed a jolt. I am extremely proud of this work but for the last minute. In hindsight I should have shortened the song with a seamless edit, but at that time I would have considered this sacrilege. Had the song run about five minutes, I doubt I would have felt the need for this not-so-subtle section. I am not at liberty to post this work on the web[14]; however, this video leaked into the bootleg space after twenty plus years, so low-quality dubs can be found using "Careering" and "Gildersleeves" as search terms. I did an illustrated blog post about making this video titled "Public Image Viz-Efx ReMix Collage (1980)."[15]

InterProbe: The Cream of International Broadcasting, 1982

In 1980, two main events came together which further fueled my efforts in remix. First, I had purchased a U-matic VCR that year to prep a "paper edit"[16] on the aforementioned PiL Tape. The second event was moving from my lower Manhattan apartment near the Battery, to the East Village where I was able to receive cable television for the first time. An additional factor was having access to gently used U-matic stock through my facility job. The tapes were being thrown out and were there for the taking. All this added up to my ability to freely record television off-air (really off-cable), which was not yet commonplace.

This U-matic machine did not have a built-in timer, nor could it record more than an hour at a time (Figure 36.4, top left). Instead, every recording was made manually. My main activity was to record short segments as I encountered them. The near-term result would be an hour tape filled with fifteen or twenty different clips (Figure 36.4, top right). After nearly two years of harvesting, I accumulated a critical mass of international TV clips, a unique feature of the expanding NYC cable fare then (Figure 36.4, bottom left). It seems early cable channels were desperate to fill the time and needed content, so it was not uncommon to see tourism films that were distributed free of charge, featuring not-so-mainstream destinations such as Byelorussia (now Belarus). Another source I harvested was "ethnic" NYC public access programs, catering to local immigrant communities. An example would be a program about Bollywood movies. All of this resulted in an idea for a pilot program I named "Inter-Probe: the Cream of International Broadcasting."[17]

In addition to having cable TV and a videotape recorder in 1980, a third event redirected my remix practice, and that was leaving my staff position as an editor at a video facility, and the commensurate loss of access privileges. While I could call in favors to do certain tasks at edit facilities where I freelanced, those privileges were limited. I had to redirect the bulk of my editing to work in more primitive U-matic "cuts only" edit rooms that were fairly commonplace. So in accordance with this workflow, the next effort required me to log 50+ hours of off-air tapes and devise my plan on paper at home.

One can say that the clips and the offbeat associations I made between them drove the "story." For the first and only time in my remix work, I wrote a narration track. Taken together this is referred to as "writing (narration) to picture" in television news. The other expression that is applicable to this creative practice is the idea of being an "availablist," that is, to make do with what is available to me. I first heard this word applied to Stephen Parr of Oddball Films[18] and later to found footage filmmaker, Craig Baldwin.[19]

Figure 36.4 Top left: Dougherty's 1980s U-matic home recording set up. Top right: U-matic label of international clips gathered for InterProbe 1982. Bottom left: Dougherty's 1980s off-air collection used in making remix work. Bottom right: Soundwave software used in making Cold War Shortwave 1987

The ability to collect and organize a large off-air collection from the comfort of home became a common thread that ran through the next several remix works. Inspiration for *InterProbe* in a format or media genre sense would come from my workplace. Many, if not most, of the edit sessions I worked on then were connected to the launch of high-culture networks like Bravo, CBS Cable, and ABC's ARTS. Though most of these channels folded quickly, the proliferation of work creating cable network "launch" and "identity" videos inspired me to make one of my own, albeit a fanciful version. Of all my works, *Inter-Probe* takes the most traditional form, mimicking a cable network launch video. The content was implausible, kitsch, and to use a word in vogue at the time "Devo." Aside from these channel "launch videos," another underlying inspiration was "Mondo Cane" once described as a "film (that) consists of a series of travelogue scenes that provide glimpses into cultural practices around the world with the intention to shock or surprise Western film audiences."[20] I submitted *InterProbe* to MTV in the 1980s (no takers) but an insider there claimed it helped inspire MTV's more earnest take on the Global Village, a short-lived 1990 series called "Buzz."

InterProbe employed a traditional type of narration. The general tone would be one that ranges from mild amusement, to puzzlement, to winking knowingness (a little like *Mondo Cane*) at the exotic ways of foreign lands. The impression was a little like a travelogue, but set in a camp, tongue-in-cheek style. The voiceover promises a "mix of the silly and the sage, the sacred and profane" and offers an alternative for the "cosmopolitan mind weary of television's provincial fare…a mosaic of music, dance and festive ethnic apparel."

Alternating with generally genial tone were foreboding sections about foreign threats that befits the zeitgeist of the early Reagan years. The narration promises no-holds-barred coverage of conflicts and national security threats. I hired announcer Don Batcher, the voice of Bravo, to give my goofy *InterProbe* narration copy some verisimilitude.

As a postscript on the footage library, in 2007 I started to post clips from my collection to YouTube. I had retained much of this archive by transferring the best of it from U-matic to DVDs and DV tapes. Two international media conglomerates objected to my noncommercial use. After my YouTube account was shut down, I mounted a fair use challenge with the help of Glushko-Samuelson Intellectual Property Clinic at American University.[21] After being off-line for almost five years, the account was fully reinstated in 2015.[22]

Cold War Shortwave, 1988

Cold War Shortwave[23] is a collage of radio broadcasts collected primarily during trips to Europe from the early to mid-1980s. As with *InterProbe*, *Cold War Shortwave* relied on a collection reaching a critical mass where I thought I could make something of it. As the title indicates, the Cold War was still on. The collection period was well before the Gorbachev and Glasnost era. The period was also the era of the Reagan military build-up and arms race, so the propaganda invective was especially strident. This aspect was the most interesting to me, but also appealing was the strange and stilted tone and content of the communist East Bloc broadcasts. For example, clips included passages such as:

> The 22nd annual television festival Golden Prague has opened in the Czechoslovak capital. A large part of the exhibition is naturally devoted to the results of Czechoslovak–Soviet cooperation in the economy, science, and technology.

> The death of the great leader of the Albanian people greatly grieves us all.

> Next in our program tonight, satellites and Soviet life.

Along with these elements, nearly every other type of transmission went into the final mix—sci-fi sounding analog data signals, Morse code, varied religious broadcasts, "sender tones," all of which were very exotic to the new listener. Although most of the spoken content was in English, snippets in various languages were also included as aural texture (as opposed to messaging).

As with my other remix projects, new tools and new access played a part in shaping this creative effort. Circa 1987 I learned of an affordable Macintosh audio editing solution called SoundWave from a company called Impulse. The package included what looked like a garage-made digitizing box. The sampling rates this unit could deliver were very low, but the fidelity of my source material was also low. That is, shortwave broadcasts recorded on cassettes, so this was not a major problem.

The new and affordable way to digitally edit audio was a triggering event that goaded me into action with my shortwave collection. It is worth noting that editing with a personal computer was the beginning of a phenomenon that moved state-of-the-art editing from rooms filled with big machines to software run on Macs and PCs. Originally called "desktop audio" (and video), these emerging affordable technologies would represent new access opportunities for creating personal work (Figure 36.4 bottom right).

After years of working with tape, true digital editing meant being able to enjoy random access, NonLinear Editing (NLE)—and it was a revelation. I was able to shuffle the order of clips, as well as shorten or lengthen a clip anywhere in the edit—it was new and liberating. Traditionally, I was in the habit of editing sound using videotape equipment, and this linear method allowed for very little improvising, while nonlinear editing was flexible and fluid. This is especially useful when making something more impressionistic than narrative.

1980s Time Capsule, 1990

There are a few parallels between *Cold War Shortwave* and the next remix work entitled *80s Time Capsule*.[24] Again there is the triggering event of the collection building up to a critical mass, this time substantial enough to do a retrospective about the 1980s. The Cold War theme was also central to *80s Time Capsule*, but by this time there was an arc from the frosty years of the first Reagan administration to the thaw represented by Gorbachev in the late 1980s. Access to new video technology also played a galvanizing role. Video was catching up to audio with new Mac/PC-based random access, and non-linear edit systems that meant that I could spontaneously experiment with montages and jarring contrasts, that would have been extremely difficult to map on paper and execute with a linear tape edit system. The end result was more fanciful, playful, and allusive. One would guess that few contemporary remix enthusiasts remember a time when this creative process was not digital.

As with *InterProbe*, this remix work is based on my U-matic off-air collection, which had grown considerably since 1982. The first half of the decade would represent the bulk of the recordings made, but the practice continued, although some of the novelty and allure of recording cable fare had faded to some degree.

As the decade drew to a close, I was aware that I had accumulated a lot of news coverage and documentation about political and cultural milestones; as well as video ephemera representing the underbelly of the decade as I saw it. As with many others, I saw the Reagan years as a period of greed, with reactionary forces in ascent. In short, it was the "Me Decade"[25] Part 2 on steroids, if you will. This underbelly was represented by things like a Lifespring (human potential organization) promotional video. Or, it was similarly represented by a shirtless huckster with six-pack abs self-promoting on public access, pitching a one-man singles/networking/recreation/travel club. Several segments parodied the Cold War. One example is a montage of Soviet weapons and maneuvers set to the ominous "Man From Uncle" theme. Then, as the music shifts gear and resolves into something positive and reassuring, it shows the "good guys" of NATO saving the day.

The main factor that made this remix different from the previous ones was the use of digital tools for the organization and execution of the project. On the organization side, I utilized a database that had been built up following the purchase of my first Macintosh in 1986. Each clip entry would consist of a tape number, a time-code or counter value, and my own idiosyncratic description of the content. This would be a mix of prose and my own keyword system. Calling my descriptive "system" nonstandard would be an understatement, but it worked for me.

On the execution side, I had the good fortune of being introduced to a beta version of the Avid Media Composer in the fall of 1989. This was one of the first digital Non-Linear Editing (NLE) systems and it would eventually become the industry standard. It is likely that I had started to think about making a 1980s retrospective, and exposure to this beta system helped initiate the project. This Avid beta was prone to crashing, but

being able to edit video nonlinearly, as I described earlier with audio (in *Cold War Shortwave*), was profound. It might be surprising, but none of the aforementioned mid-course manipulations involving duration, deletions, or clip order shuffling had been possible to do using the best videotape editing system. Conversely, film editors enjoyed this ability since the dawn of that craft, however old-fashioned and mechanical their process might have been otherwise.

My premise or meta-theme for the 80s *Time Capsule* project was the 1980s decade as the un60s, or revenge on the 1960s. I contrasted aspects of the counter-culture not aging well, set against a conservative backlash, which crystallized in the Reagan presidency. I was not trying to express this as a narrative documentary might, but rather to create contrasts and clashes with loaded iconography and vignettes. For example, toward the beginning, we see a bunch of long-haired types smoking pot at home, then cut to police outside (from another source) breaking down the door with shotguns: the party's over. As is the case throughout, these scenes are drawn from different sources but juxtaposed in montages. Peppered in at the beginning, too, is a televangelist predicting the "coming of the Lord's government." Another theme that runs throughout is the idea of "harbingers of a hostile world," whether the communist East Bloc, the Iranian revolution, or the Nicaraguan Sandinistas. All of this escalates to a montage that sets up the Reagan arms build-up. The rearmament is faux-glamorized and set to the Western-themed surf music, the instrumental "Apache." The sequence ends with an arms industry trade show where we see a man in a suit trying out a bazooka-like RPG, next to attractive young women staffing a defense industry sales booth.

Switching to the cultural side of the decade, there is a "Reagan-youth" montage showing the resurgence of traditional activities like cheerleading, beauty contests, and so on, that ends with a sample from a network news story about MTV featuring Gen X teens, and the associated decline of music as social commentary. By way of the outgoing era, another news report describes the punk rock band the Clash "identifying with liberation struggles around the world." In miniature, this decade seems to repeat a cycle similar to the rebellious 1960s giving way to mellower apolitical music of the 1970s. In the early 1980s, radical punk morphs into more industry and radio-friendly New Wave and dance pop.

Conclusion

I hope this chapter affords some exposure and insights into my remix work. I have held back these videos partly out of concerns with copyright issues, but also due to uncertainty about where they fit in the media landscape. Occasionally I would screen them as part of one-person shows I did in the 1980s and 90s and posted them to YouTube, but never promoted them. More than my remix work, the source clips from my 1980s video collection garnered attention in various ways, one of the most satisfying being when a mashup artist on YouTube named "humplefree" created a remix[26] set to a mashup by The Hood Internet[27] that drew extensively from my clip library on YouTube. The clips they chose—from what I refer to as the "schlock-o-philia" side of my collection—and the way they were used told me this artist understood my aesthetic. It was gratifying to see my collection repurposed in this way and dovetailed with the values expressed in Digital Humanities 2.0. A torch is being passed (my vintage clips) and reworked by another generation, a little like a folk song that is constantly being adapted to new needs and cultural currents.

The YouTube experience yielded another important result. Earlier I mentioned my channel being shut down. It was that experience that led me to a book about Fair Use,

which gave me the impetus to contact the Intellectual Property clinic that subsequently rescued my account. The book I discovered in 2013 was *Reclaiming Fair Use*[28] by Patricia Aufderheide and Peter Jaszi, which came as a eureka moment. It helped me realize that these video works were part of a large and increasingly appreciated cultural phenomenon. Revisiting remix, and my connection to it, led me, somewhat circuitously, to graduate school in 2015, where I studied archiving and library science.

Baby boomers have been nostalgic about the difficulties of collecting the "good stuff" in past decades. This originates from a predigital age of relative scarcity involving physical things. Looking back, I can see that these difficulties were the price of admission into a select curator-collector club. I mention it in this context because, historically, you could not remix what you had not laboriously collected. Of course, the Internet has made it far easier to find whatever your "good stuff" is. The challenge now is to marshal your personal digital archive into a good "muse file." Maybe a few basic things have not changed over the course of my remix practice. One would be claiming a right to make artistic commentary with audio and video, as opposed to explicit journalistic or scholarly commentary in writing. Another common thread is a DIY attitude that does not seek permission to use images, sounds, and clips found in the culture, nor worrying about the result of forfeiting a commercial release.

I think my work shares DNA with what VJs were doing in nightclubs during the 1980s New Wave era and the cultural mashups my peers were creating at New York's Club 57. (I am honored that several of my music videos were included in the Museum of Modern Art 2017 retrospective about Club 57).[29] This is a good place to revisit the fantasy I had in the late 70s of becoming a video rock star as stated at the beginning of this article. The early mashups one would have seen in a nightclub video lounge then and in the 80s were generally made anonymously; these videos were underground and at best quasi-legal. Going public with remix work made without clearances is for the brave. Two such brave souls who qualify for me as video rock stars are Craig Baldwin and the collective EBN (Emergency Broadcast Network), whose work I greatly admire. Video rock star status here might be relative because copyright prevents their work from achieving mass distribution and mainstream success. However, one auteur who can claim at least qualified mainstream success is Adam Curtis.[30] In the 1990s, I became aware of him, as resident documentarian and remixologist at the BBC. I am a huge fan of his work, though I take his theses with several grains of salt.

The admirable work and general success of these "stars" getting their creations out there often led me to say half-seriously "that's what I'd like to do when I grow up." These artists staked out remix as their forte and energetically carved out a space for themselves in the media landscape. Despite my long history with remix and my love for the form, it was one of many things I did now and again, and I was never quite sure where the work belonged. Only later in life did I fully appreciate it was more than an odd hobby, as well as being part of a phenomenon on the ascent. Commercial success notwithstanding, I still find myself rooting for the garage DIY remix "Davids" over the Hollywood blockbuster "Goliaths."

Notes

1 Jeffrey Schnapp, Todd Presner, Peter Lunenfeld, and Johanna Drucker, "Digital Humanities Manifesto 2.0," 2009, accessed June 19, 2020, http://www.humanitiesblast.com/manifesto/Manifesto_V2.pdf.

2 Paul Dougherty, "40 Years of Video Husbandry," Presentation at *Personal Digital Archiving Conference*, 2015, April 24, 2015, accessed June 21, 2020, https://ia600309.us.archive.org/29/items/Dougherty40YearsVideoHusbandryOL/Dougherty%20_40YearsVideoHusbandryO_L.pdf.

3 Paul Dougherty, "PaulJD2006," *Original YouTube Page*, https://www.youtube.com/user/PaulJD2006.

4 Paul Dougherty, "Synapse," *A Video Life* (blog), accessed December 31, 2019, https://avideolife.wordpress.com/?s=synapse.

5 Faye Gleisser, "Everson Museum: Video and the Museum Conference," *Video Data Bank*, accessed December 31, 2019, http://www.vdb.org/titles/everson-museum-video-and-museum-conference.

6 Paul Dougherty, "Master List of Dougherty Remix Videos," accessed June 22, 2020, http://postlit.com/remix_links.htm.

7 Paul Dougherty, "Paul Dougherty Gallery and Museums Exhibits," accessed June 22, 2020, http://postlit.com/dougherty_exhibits.htm.

8 Paul Dougherty, "1976 Mash-up from 'White Collar Funk'," December 20, 2013, accessed July 29, 2020, https://www.youtube.com/watch?v=ObyBDWEeIHs.

9 "Metropolis Video," *Wikipedia*, last modified March 8, 2016, https://en.wikipedia.org/wiki/Metropolis_Video.

10 Walter Robinson, Paul Dougherty, and Edit Deak, "Frankie Teardrop," *MoMA*, 1978, accessed December 31, 2019. https://www.moma.org/collection/works/118254.

11 Paul Dougherty, "Test Mix with Random Pix," October 18, 2019, accessed July 29, 2020, https://vimeo.com/367385417.

12 Richard Metzger, "The Single Greatest Public Image Ltd Bootleg" *DangerousMinds*, accessed July 29, 2020, https://dangerousminds.net/comments/the_single_greatest_public_image_ltd._bootleg.

13 The edit room for Careering had three RCA TR-600 Quad (aka 2") VTR's (videotape recorders) controlled by a new CMX-340 computer editing system. Compared with some fully digital editing systems that will be described in later projects, this was "computer controlled" analog editing. Additionally, there was the aforementioned Ampex HS-200 solo-mo disc.

14 Public Image Ltd. was sent a copy of the finished video but they were known to be difficult to contact and engage during this period. This article describes how they could be notorious at that time. In 1980, Tom Snyder had an epic late-night standoff with John Lydon. Joe Blevins, https://news.avclub.com/in-1980-tom-snyder-had-an-epic-late-night-standoff-wit-1798247194.

15 Paul Dougherty, "Public Image Viz-Efx ReMix Collage (1980)," *A Video Life*, January 3, 2014, accessed July 29, 2020, https://videoculture.wordpress.com/2014/01/03/public-image-viz-efx-collage-1980/.

16 Ashley Kennedy, "Making the Paper Edit Avid Media Composer," *Lynda*, accessed March 14, 2020, https://www.lynda.com/Media-Composer-tutorials/Making-paper-edit/105362/113359-4.html.

17 Paul Dougherty, "InterProbe: The Cream of International Broadcasting," October 18, 2019, accessed July 29, 2020, https://vimeo.com/367385664.

18 "About," *Oddball Films*, accessed June 23, 2020, https://www.oddballfilms.com/about.

19 Michael Sicinski, "Going Ballistic: Craig Baldwin's Mock Up On Mu," *Cinema Scope* 35 (2008): 13–18.

20 Mark Goodall, *Sweet & Savage: The World Through the Shockumentary Film Lens* (London: Headpress, 2006).

21 Brandon Butler, "Clinic Students Bring Video Editor, 'Citizen Archivist' Back Online." *WCL Glushko-Samuelson IP Clinic* (blog) June 17, 2015, accessed July 29, 2020, https://ipclinic.org/2015/06/17/clinic-students-bring-editor-back-online/.

22 Paul Dougherty, "Youtube Account Reinstated After Nearly Four Years!!" *Video Culture* (blog) May 19, 2015, accessed July 29, 2020, https://videoculture.wordpress.com/2015/05/19/youtube-account-reinstated-after-nearly-four-years/.

23 Dougherty, Paul, "Cold War Shortwave," December 25, 2011. https://www.youtube.com/watch?v=WJ3ZAUEpnJA&t=122s.

24 Paul Dougherty, "80's Time Capsule," October 20, 2019, https://vimeo.com/367638008.

25 Tom Wolfe, "The 'Me' Decade and the Third Great Awakening," *New York Magazine* 23, no. 8 (1976): 26–40.

26 humplefree, *Hood Internet Mixtape* (iii), October 21, 2008, accessed July 29, 2020, https://www.youtube.com/watch?v=tD2k9eFxLI0.

27 "The Hood Internet," *Wikipedia*, last modified April 13, 2020, https://en.wikipedia.org/wiki/The_Hood_Internet.

28 Patricia Aufderheide and Peter Jaszi, *Reclaiming Fair Use: How to Put Balance Back in Copyright* (Chicago, IL: University of Chicago Press, 2011).

29 "Club 57: Film, Performance, and Art in the East Village, 1978–1983," MoMA, accessed July 29, 2020, https://www.moma.org/calendar/exhibitions/3824#.

30 "Adam Curtis," *Wikipedia*, last modified May 26, 2020, https://en.wikipedia.org/wiki/Adam_Curtis.

Bibliography

"40 Years of Video Husbandry." *Archive.org*. Accessed June 21, 2020. https://ia600309.us.archive.org/29/items/Dougherty40YearsVideoHusbandryOL/Dougherty%20_40YearsVideoHusbandryO_L.pdf.

"About Oddball Films." *Oddball Films*. Accessed June 23, 2020. https://www.oddballfilms.com/about.

Curtis, Adam. Accessed June 26, 2020. https://en.wikipedia.org/wiki/Adam_Curtis.

Aufderheide, Patricia and Peter Jaszi. *Reclaiming Fair Use: How to Put Balance Back in Copyright*. Chicago, IL: University of Chicago Press, 2011.

Butler, Brandon. "Clinic Students Bring Video Editor, 'Citizen Archivist' Back Online." June 17, 2015. https://ipclinic.org/2015/06/17/clinic-students-bring-editor-back-online/.

"Club 57: Film, Performance, and Art in the East Village, 1978–1983." Accessed December 31, 2019. https://www.moma.org/calendar/exhibitions/3824#.

Dougherty, Paul. "1976 Mash-up from 'White Collar Funk.'" *YouTube*. December 20, 2013. https://www.youtube.com/watch?v=ObyBDWEeIHs.

—. "*80's Time Capsule*.". October 20, 2019. https://vimeo.com/367638008.

—. "Cold War Shortwave.". December 25, 2011. https://www.youtube.com/watch?v=WJ3ZAUEpnJA&t=122s.

—. "Gallery and Museums Exhibits.". Accessed June 22, 2020. http://postlit.com/dougherty_exhibits.htm.

—. "InterProbe: The Cream of International Broadcasting." *Vimeo*. October 18, 2019. https://vimeo.com/367385664.

—. "Master List of Dougherty Remix Videos.". Accessed June 22, 2020. http://postlit.com/remix_links.htm.

—. "PaulJD2006." 2006. *YouTube*. https://www.youtube.com/user/PaulJD2006.

—. "Synapse." *A Video Life (blog)*. Accessed December 31, 2019. https://avideolife.wordpress.com/?s=synapse.

"Frankie Teardrop." MoMA – *Museum of Modern Art*. Accessed December 31, 2019. https://www.moma.org/collection/works/118254.

Gleisser, Faye. "Everson Museum: Video and the Museum Conference." *Video Data Bank*. Accessed December 31, 2019. http://www.vdb.org/titles/everson-museum-video-and-museum-conference.

Goodall, Mark. *Sweet & Savage: The World Through the Shockumentary Film Lens*. London: Headpress, 2006.

"The Hood Internet.". Accessed April 13, 2020. https://en.wikipedia.org/wiki/The_Hood_Internet.

humplefree. *Hood Internet Mixtape (iii)*. October 21, 2008. https://www.youtube.com/watch?v=tD2k9eFxLI0.

Kennedy, Ashley. "Making the Paper Edit Avid Media Composer." *Lynda*. Accessed March 14, 2020. https://www.lynda.com/Media-Composer-tutorials/Making-paper-edit/105362/113359-4.html.

"Metropolis Video." *Wikipedia*. March 8, 2016. https://en.wikipedia.org/wiki/Metropolis_Video.

Metzger, Richard. "The Single Greatest Public Image Ltd Bootleg." April 29, 2016. https://dangerousminds.net/comments/the_single_greatest_public_image_ltd._bootleg.

Schnapp, Jeffrey, Todd Presner, Peter Lunenfeld, and Johanna Drucker. "Digital Humanities Manifesto 2.0." *Humanities Blast*, 2009. http://www.humanitiesblast.com/manifesto/Manifesto_V2.pdf.

Sicinski, Michael. "Going Ballistic: Craig Baldwin's Mock Up On Mu." *Cinema Scope* 35, 2008: 13–18.

Wolfe, Tom. "The 'Me' Decade and the Third Great Awakening." *New York Magazine*, August 23, 1976, 26–40.

INDEX

Page numbers in *italics* refer to figures, those in **bold** refer to tables, and those followed by "n" refer to notes.

INDEX

World Wide Web 399
Wulf Gar 327–328
Wynter, Sylvia 490

Xiangtangshan Caves Project 20

Yates, Alyssa 278, 280–281
The Yes Men 308
Young, Edward 28
Young, Graham 516
YouTube 293, 329, 331, 402, 424, 430, 475–476, 530–531, 538, 540

Yun, Soyoung Elizabeth 482–483
"YYMilk" 420, 426

Zaki, Jamil 140
Zaverio, Gabriele 305, 305
Zen Buddhism 101
Zillien, Nicole 38
Zimmermann, Patricia R. 435
zine subcultures 36
Zumthor, Paul 23
Zúñiga, Xalli 89, 90